Real-Time
Collision Detection

The Morgan Kaufmann Series in Interactive 3D Technology

Series Editor: David H. Eberly, Magic Software, Inc.

The game industry is a powerful and driving force in the evolution of computer technology. As the capabilities of personal computers, peripheral hardware, and game consoles have grown, so has the demand for quality information about the algorithms, tools, and descriptions needed to take advantage of this new technology. To satisfy this demand and establish a new level of professional reference for the game developer, we created the **Morgan Kaufmann Series in Interactive 3D Technology**. Books in the series are written for developers by leading industry professionals and academic researchers, and cover the state of the art in real-time 3D. The series emphasizes practical, working solutions and solid software-engineering principles. The goal is for the developer to be able to implement real systems from the fundamental ideas, whether it be for games or other applications.

Real-Time Collision Detection
Christer Ericson

3D Game Engine Architecture: Engineering Real-Time Applications with Wild Magic
David H. Eberly

Physically Based Rendering: From Theory to Implementation
Matt Pharr and Greg Humphreys

Essential Mathematics for Game and Interactive Applications: A Programmer's Guide
James M. Van Verth and Lars M. Bishop

Game Physics
David H. Eberly

Collision Detection in Interactive 3D Environments
Gino van den Bergen

3D Game Engine Design: A Practical Approach to Real-Time Computer Graphics
David H. Eberly

Forthcoming

Artificial Intelligence for Computer Games
Ian Millington

Visualizing Quaternions
Andrew J. Hanson

Better Video Game Characters by Design: Using Psychology to Make Better Games
Katherine Isbister

Real-Time
Collision Detection

Christer Ericson
Sony Computer Entertainment America

CRC Press
Taylor & Francis Group
Boca Raton London New York

CRC Press is an imprint of the
Taylor & Francis Group, an **informa** business

CRC Press
Taylor & Francis Group
6000 Broken Sound Parkway NW, Suite 300
Boca Raton, FL 33487-2742

ISBN-13: 9781558607323

Visit the Taylor & Francis Web site at
http://www.taylorandfrancis.com

and the CRC Press Web site at
http://www.crcpress.com

To mom

About the Author

Christer Ericson is a senior principal programmer and the tools and technology lead at Sony Computer Entertainment America in Santa Monica. Before joining Sony in 1999, he was a senior programmer at Neversoft Entertainment. Christer received his Masters degree in computer science from Umeå University, Sweden, where he also lectured for several years before moving to the US in 1996. Christer has served on the advisory board for Full Sail's Game Design and Development degree program since 2002. His interests are varied, but he takes a particular interest in program optimization, a topic he has spoken on at the Game Developers Conference.

Contents

Chapter 5

Basic Primitive Tests **125**

Chapter 7

Spatial Partitioning **285**

Chapter 8

BSP Tree Hierarchies 349

Chapter 9

Convexity-based Methods 383

Chapter 12

Geometrical Robustness **465**

Supplementary Resources Disclaimer

Additional resources were previously made available for this title on CD. However, as CD has become a less accessible format, all resources have been moved to a more convenient online download option.

You can find these resources available here: www.routledge.com/9781558607323

Please note: Where this title mentions the associated disc, please use the downloadable resources instead.

List of Figures

Preface

Together with a friend, I wrote my first computer game as a preteen, in 1978—the same year as Space Invaders was released. Written in BASIC, our game was a quiz game where you were asked questions about African animals. Compared to Space Invaders, our text-based game was primitive and not very exciting. Still, we were hooked, and it was not long until we were writing copies on our home computers, not only of Space Invaders but also of many other arcade games of that period, not to mention creating an endless number of original games of our own design. My then-hobby of writing games has today become my day job and games have evolved into a multi-billion dollar industry, which—for better or worse—virtually single-handedly drives the development of graphics hardware and fuels the need for increasingly more powerful CPUs.

Back then, one of the main challenges to writing an action game was dealing with *collision detection*: the problem of determining if an object had intersected another object or overlapped relevant background scenery. Since games were (primarily) 2D, collision detection involved determining overlap in screen space in efficient ways. Interestingly, even though computers today are over 1000 times faster, collision detection remains a key challenge. Today, game worlds are predominantly in 3D. They are of incredible complexity, containing tens if not hundreds of millions of polygons. Collision detection solutions now require sophisticated data structures and algorithms to deal with such large data sets, all of this taking place in real-time. Of course, games are not the only applications having to solve complex collision detection problems in real-time; other applications, such as CAD/CAM systems and 3D modeling programs must also address these problems.

The goal of this book is to provide efficient solutions for games and all other real-time applications to address their collision detection problems. To make this possible, this book provides an extensive coverage of the data structures and algorithms related to collision detection systems. Implementing collision detection systems also requires a good understanding of various mathematical concepts, which this book also focuses on. Special care has been taken to discuss only practical solutions, and code and pseudocode is provided to aid the implementation of the methods discussed in the book.

Overall, collision detection is a very large topic. Every chapter in this book could easily form the basis of a book each. As such, the coverage has been restricted to the most important areas and that provide a solid foundation for further exploration into this rich field.

Acknowledgements

This book has greatly benefited from the corrections and suggestions made by the reviewers and I am very grateful for their feedback. Listed alphabetically, the reviewers are: Ian Ashdown, Gino van den Bergen, David Eberly, George Innis, Neil Kirby, Eric Larsen, Thomas Larsson, Amit Patel, Jamie Siglar, Steven Woodcock, plus one reviewer who chose to remain anonymous.

Thanks are also due to: Ville Miettinen, who generously provided code that helped improve sections on bounding volume construction; Matt Pharr for his helpful comments that resulted in major additions to Chapter 13; my co-workers Tim Moss (who let me off the hook many work nights to go home and work on the book) and Bob Soper (for commenting on early drafts and acting as sounding board for many of my thoughts on the book).

My editor at Morgan Kaufmann Publishers, Tim Cox, showed endless patience waiting for this manuscript. Many thanks to him, his editorial assistants Richard Camp and Stacie Pierce, and everyone else at Morgan Kaufmann involved in the process.

Last, but not least, many thanks to Kim, Ellinor, Tekla, and Maja for hanging in there over the four years and the thousand sleepless nights it took me to write this book. I hope you, the reader, find this time was not entirely misspent!

Christer Ericson
Santa Monica, CA, December 2004

Chapter 1

Introduction

This book is concerned with the subject of collision detection, a broad topic dealing with a seemingly simple problem: detecting if two (or more) objects are intersecting. More specifically, collision detection concerns the problems of determining *if*, *when*, and *where* two objects come into contact. "If" involves establishing a Boolean result, answering the question whether or not the objects intersect. "When" must additionally determine at what time during a movement collision occurred. "Where" establishes how the objects are coming into contact. Roughly, these three types of queries become increasingly more complex to answer in the order given.

Gathering information about when and where (in addition to the Boolean collision detection result) is sometimes labeled *collision determination*. The terms *intersection detection* and *interference detection* are sometimes used synonymously with collision detection.

Collision detection is fundamental to many varied applications, including computer games, physically based simulations (such as computer animation), robotics, virtual prototyping, and engineering simulations (to name a few).

In computer games, collision detection ensures that the illusion of a solid world is maintained. It keeps player characters from walking through walls or falling through floors; it provides for line-of-sight queries, telling enemies if they can see the player and therefore can attack; and it keeps a skateboarder attached to an invisible guide surface, ensuring that the player safely makes it back down into a halfpipe after having gone airborne up it.

In computer animation, collision detection is used, for example, to constrain the physical simulation of cloth, ensuring clothing behaves in a lifelike manner and does not slide off a character as the character moves. Collision detection is used for path planning in robotics applications, helping robots steer away from obstacles. In virtual prototyping, collision detection assists in computing clearances, and overall allows prototypes to be refined without the production of physical models. Collision detection is used in crash tests and other engineering simulations.

1

Some applications, such as path planning and animation rendering, do not require real-time performance of their collision systems. Others applications, computer games in particular, have extraordinary demands on the real-time efficiency of collision detection systems. Computer- and console-based action games involve simulations requiring that a large number of queries be performed at frame rates of about 30 to 60 frames per second (fps). With such tight time constraints and with collision detection an integral part of game and physics engines, collision detection can account for a large percentage of the time it takes to complete a game frame. In computer games, a poorly designed collision system can easily become a key bottleneck.

This book is not just on collision detection in general, but specifically on the efficient implementation of data structures and algorithms to solve collision detection problems in real-time applications. While the games domain is often used for examples, several nongame applications have performance requirements similar to (or even greater than) those of games, including haptic (force feedback) systems, particle simulations, surgical simulators, and other virtual reality simulations. The methods described here apply equally well to these applications.

Many of the methods discussed herein are applicable to areas other than collision detection. For instance, the methods discussed in Chapters 6 through 8 can be used to accelerate ray tracing and ray casting (for, say, computing scene lighting), and in regard to geographic information systems (GIS) to answer queries on large geographical databases. Some problems from the field of computer graphics can be solved as collision detection problems. For example, view frustum culling can be addressed using the methods described in Chapters 6 and 7.

1.1 Content Overview

The following sections provide a brief outline of the chapters of this book.

1.1.1 Chapter 2: Collision Detection Design Issues

This chapter talks about issues that must be considered when constructing a collision detection system and what factors affect the design. Such factors include how objects are represented, how many of them there are, how they move, and what types of collision queries the user wants to pose. Chapter 2 also introduces terminology used throughout the rest of the book.

1.1.2 Chapter 3: A Math and Geometry Primer

Any nontrivial collision detection system requires a large portion of geometry-oriented mathematics to work out the *if*, *when*, and *where* of collision queries.

Chapter 3 introduces the mathematical and geometrical concepts necessary to understand the material explored in the remaining chapters.

1.1.3 Chapter 4: Bounding Volumes

To accelerate collision queries, simple geometrical objects such as spheres and boxes are initially used to represent objects of more complex nature. Only if the "simple" bounding volumes (which are large enough to encapsulate complex objects) collide are tests performed on the complex geometry. Chapter 4 describes several bounding volume types, how to perform intersection tests on them, and how to fit a bounding volume to a complex object.

1.1.4 Chapter 5: Basic Primitive Tests

Having introduced some intersection tests in the previous chapter, Chapter 5 describes, in detail, a large number of tests for determining intersection status and distance between pairs of objects of varying types, including lines, rays, segments, planes, triangles, polygons, spheres, boxes, cylinders, and polyhedra. Both static and moving objects are considered in these tests.

1.1.5 Chapter 6: Bounding Volume Hierarchies

For large objects and for collections of objects, performance benefits can be had by constructing hierarchies of bounding volumes over the object(s). Such hierarchies provide quick identification of objects or parts of an object that cannot possibly participate in a collision, allowing queries to restrict testing to a small number of objects or object parts. Chapter 6 talks about desired characteristics of bounding volume hierarchies and ways in which to construct and perform queries over them. The chapter also explores efficient ways of representing these hierarchies.

1.1.6 Chapter 7: Spatial Partitioning

When a large number of objects are considered for collision, the objects must be partitioned into small disjoint subgroups to facilitate fast tests (by avoiding the worst-case quadratic behavior of testing all objects against all other objects). The bounding volume hierarchies discussed in Chapter 6 represent one way of performing such partitioning. Chapter 7 examines other partitioning approaches, based on grids, trees, and object sorting.

1.1.7 **Chapter 8: BSP Tree Hierarchies**

One of the most versatile tree structures for representing collision detection data is the binary space partitioning (BSP) tree. BSP trees can be used to partition space independently from the objects in the space. They can also be used to partition the boundary of an object from the space it is in, thereby effectively forming a volume representation of the object. Chapter 8 talks about robustly constructing BSP trees and how to perform tests on the resulting trees.

1.1.8 **Chapter 9: Convexity-based Methods**

Chapter 9 looks at a number of more advanced methods for performing collision queries on convex objects, exploiting the special properties of convex objects. Presented are hierarchical representations, the V-Clip closest feature algorithm, the mathematical optimization methods of linear and quadratic programming, the efficient Gilbert–Johnson–Keerthi algorithm, and a separating vector algorithm due to Chung and Wang.

1.1.9 **Chapter 10: GPU-assisted Collision Detection**

PC commodity graphics cards have advanced to a point at which they incorporate more computational power than the main PC CPU. This change has triggered an interest in outsourcing computations to the graphics card. Chapter 10 takes a brief look at how to perform collision detection tests using graphics hardware.

1.1.10 **Chapter 11: Numerical Robustness**

Even the smallest errors in a collision detection system can lead to catastrophic failures, such as objects failing to collide with world geometry and thus falling out of the world. This chapter discusses the robustness problems associated with working with floating-point arithmetic and suggests approaches to dealing with these problems.

1.1.11 **Chapter 12: Geometrical Robustness**

Whereas Chapter 11 looked at how to perform calculations robustly, Chapter 12 considers the problem of taking an arbitrary set of polygons and turning it into well-formed geometry, suitable for input into a collision detection system. Presented are methods for welding of vertices, removal of gaps and cracks, merging of coplanar faces, and decomposition of objects into convex (or triangular) pieces.

1.1.12 **Chapter 13: Optimization**

The last chapter of the book talks about how to take the efficient data structures and algorithms presented throughout the book and make them even more efficient by targeting and tuning them for a particular hardware platform. Large performance gains can be had by optimizing code to take advantage of memory hierarchies (caches) and of code and data parallelism. Chapter 13 presents detailed descriptions on how to perform such optimizations.

1.2 **About the Code**

As part of the hands-on nature of this book, many of the presented ideas are supplemented by code examples. Whereas many books rely exclusively on high-level pseudocode to convey the broad ideas of an algorithm, here the majority of the code is given in C++. There are two reasons for presenting code in this detail. First, it provides the minutiae often vital to the understanding (and implementation) of an algorithm. Second, understanding can now additionally be had from running the code and inspecting variable values during execution. The latter is particularly important for a reader who may not be fully versed in the mathematics required for a particular algorithm implementation. Only in a few places in the book is the given code expressed in pseudocode, primarily where it would not be practical to provide a full implementation.

Although C++ is used for the code in the book, it should be stressed that the focus of the book is *not* on C++. C++ is only used as a means to present detailed executable descriptions of the described concepts. Any computer language would serve this purpose, but C++ was chosen for a few reasons, including its popularity and its ability to abstract, in a succinct way, the low-level manipulation of geometrical entities such as points and vectors using classes and (overloaded) infix operators. To make the presented code accessible to as many programmers as possible (for example, those only familiar with C or Java), certain features of C++ such as templates and STL (Standard Template Library) were deliberately avoided where possible. C++ purists may want to take a few deep breaths at the start of each chapter!

Similarly, this is *not* a book on software engineering. To get the basic ideas to come across as best as possible, the code is kept short and to the point. Concessions were made so as not to clutter up the text with verbose C++ syntax. For example, class definitions are deliberately minimalistic (or nonexistent), global variables sometimes substitute for proper member variables, pointers are not declared `const` (or `restrict`), and arrays are often declared of fixed size instead of being dynamically allocated of an appropriate size. Variable names have also been limited in length to make code lines better fit on a typeset page.

To turn the presented code into real production code, some additions may be necessary. For example, tests for division by zero are not always performed to avoid

going into details that would hamper the understanding of the overall approach. Similarly, some code tests may require tolerance values to be added for full robustness. The intent is for the discussion of robustness in Chapter 11 to make it clear what changes (if any) are necessary to turn the presented code into robust production code.

To help make it clear which function arguments are inputs and which are outputs, input variables are often passed by value and output variables are passed by reference. In some cases, it would be more efficient to pass input variables by reference. This is left as an exercise for the reader.

Comments are set in cursive, whereas the code is set in boldface. Names of functions, classes, structs, and user-defined types begin with an uppercase letter. Variables begin with a lowercase letter. Where possible, variable names have been chosen to follow the notation used in the accompanying text. In some cases, these rules conflict. For example, points are denoted using uppercase characters in the text, whereas in the code they are lowercase.

The code presented in the book is available on the companion CD-ROM. However, the reader may want to visit the book's companion web site for the latest version of the code, incorporating corrections, changes, and additions.

Chapter 2

Collision Detection Design Issues

Designing an efficient collision detection system is a bit like putting a puzzle together: a lot of pieces must be connected before the big picture starts to appear. In a similar fashion, the majority of this book is concerned with examining the individual pieces that go into different approaches to collision detection. The big picture will become clear over the course of the book. This chapter provides a quick overview of a number of issues that must be considered in selecting among approaches, and how the components of these approaches relate. This chapter also introduces a number of terms, defined and explained further in following chapters. More in-depth coverage of the items touched upon here is provided throughout remaining chapters of the book.

2.1 Collision Algorithm Design Factors

There are several factors affecting the choices made in designing a collision detection system. These factors will be broken down into the following categories:

1. *Application domain representation*. The geometrical representations used for the scene and its objects have a direct bearing on the algorithms used. With fewer restrictions put on these representations, more general collision detection solutions have to be used, with possible performance repercussions.

2. *Different types of queries*. Generally, the more detailed query types and results are, the more computational effort required to obtain them. Additional data structures may be required to support certain queries. Not all object representations support all query types.

3. *Environment simulation parameters*. The simulation itself contains several parameters having a direct impact on a collision detection system. These include how

many objects there are, their relative sizes and positions, if and how they move, if they are allowed to interpenetrate, and whether they are rigid or flexible.

4. *Performance*. Real-time collision detection systems operate under strict time and size restrictions. With time and space always being a trade-off, several features are usually balanced to meet stated performance requirements.

5. *Robustness*. Not all applications require the same level of physical simulation. For example, stacking of bricks on top of each other requires much more sophistication from a collision detection system than does having a basketball bouncing on a basketball court. The ball bouncing slightly too early or at a somewhat larger angle will go unnoticed, but even the slightest errors in computing contact points of stacked bricks is likely to result in their slowly starting to interpenetrate or slide off each other.

6. *Ease of implementation and use*. Most projects are on a time frame. Scheduling features of a collision detection system means nothing if the system cannot be completed and put in use on time. Decisions regarding implementational simplicity therefore play a large role in what approach is taken.

These issues are covered in further detail in the remainder of the chapter.

2.2 Application Domain Representation

To select appropriate collision detection algorithms, it is important to consider the types of geometrical representations that will be used for the scene and its objects. This section talks briefly about various object representations, how simplified geometry can be used instead of modeling geometry, and how application-specific knowledge can allow specialized solutions to be used over more generic solutions.

2.2.1 Object Representations

Most current hardware uses triangles as the fundamental rendering primitive. Consequently, a *polygonal representation* is a natural choice for scenes and scene objects, as well as for their corresponding collision geometry. The most generic polygonal representation is the *polygon soup*: an unordered collection of polygons with no connectivity information specifying how one polygon relates to another. With no inherent constraints, the polygon soup is an attractive representation for artists and level designers. Algorithms operating on polygon soups apply to any collection of polygons but tend to be less efficient and less robust than those relying on additional information. For example, a polygon soup contains no information regarding the "inside" of an object, so there is no easy way of finding out if an object has somehow

Figure 2.1 Geometrical models, like the one pictured, are commonly built from a collection of polygon meshes.

erroneously ended up inside another object. The additional information mentioned could include which edges connect to what vertices and what faces connect to a given face, whether the object forms a closed solid, and whether the object is convex or concave.

Polygons may be connected to one another at their edges to form a larger polygonal surface called a *polygon mesh*. Building objects from a collection of polygon meshes is one of the most common methods for authoring geometrical models (Figure 2.1).

Polygonal objects are defined in terms of their vertices, edges, and faces. When constructed in this way, objects are said to have an *explicit* representation. *Implicit* objects refer to spheres, cones, cylinders, ellipsoids, tori, and other geometric primitives that are not explicitly defined in such a manner but implicitly through a mathematical expression. Implicit objects are often described as a function mapping from 3D space to real numbers, $f : \mathbb{R}^3 \rightarrow \mathbb{R}$, where the points given by $f(x, y, z) < 0$ constitute the interior, $f(x, y, z) = 0$ the boundary, and $f(x, y, z) > 0$ the exterior of the object (Figure 2.2). An object boundary defined by an implicit function is called an *implicit surface*. Implicit objects can be used as rough approximations of scene objects for quick rejection culling. The implicit form may allow for fast intersection tests, especially with lines and rays — a fact utilized in ray tracing applications. Several examples of implicit tests are provided in Chapter 5.

Convex polygonal objects can also be described as the intersection of a number of halfspaces. For example, a cube can be expressed as the intersection of six halfspaces, each halfspace "trimming away" the portion of space that lies outside a face of

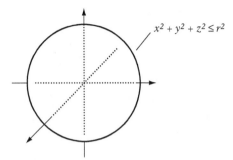

Figure 2.2 An implicitly defined sphere (where the sphere is defined as the **boundary** plus the interior).

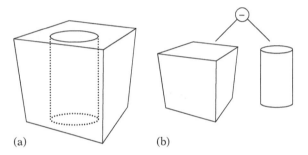

(a) (b)

Figure 2.3 (a) A cube with a cylindrical hole through it. (b) The CSG construction tree for the left-hand object, where a cylinder is subtracted from the cube.

the cube. Halfspaces and halfspace intersection volumes are described in more detail in Chapter 3.

Geometric primitives such as spheres, boxes, and cylinders are also the building blocks of objects constructed via the *constructive solid geometry* (CSG) framework. CSG objects are recursively formed through applying set-theoretic operations (such as union, intersection, or difference) on basic geometric shapes or other CSG objects, allowing arbitrarily complex objects to be constructed. Thus, a CSG object is represented as a (binary) tree, with set-theoretic operations given in the internal nodes and geometry primitives in the leaves (Figure 2.3). CSG objects are implicit in that vertices, edges, and faces are not directly available.

A strength of CSG modeling is that the resulting objects are always valid—without cracks and other problems that plague polygonal representations. CSG is also a volume representation, making it easy to determine if, for example, a query point lies inside the CSG object. CSG on polyhedral objects can be implemented through the processes described in, for example, [Laidlaw86] and [Thibault87]. However, it can be difficult to achieve robust implementations due to numerical imprecision in the calculations involved.

2.2.2 **Collision Versus Rendering Geometry**

Although it is possible to pass rendering geometry directly into a collision system, there are several reasons it is better to have separate geometry with which collision detection is performed.

1. Graphics platforms have advanced to the point where rendering geometry is becoming too complex to be used to perform collision detection or physics. In addition, there is a usually a limit as to how accurate collisions must be. Thus, rather than using the same geometry used for rendering, a simplified *proxy geometry* can be substituted in its place for collision detection. For games, for example, it is common to rely on simple geometric shapes such as spheres and boxes to represent the game object, regardless of object complexity. If the proxy objects collide, the actual objects are assumed to collide as well. These simple geometric shapes, or *bounding volumes*, are frequently used to accelerate collision queries regardless of what geometry representation is used. Bounding volumes are typically made to encapsulate the geometry fully. Bounding volumes are discussed in detail in Chapter 4.

2. For modern hardware, geometry tends to be given in very specific formats (such as triangle strips and indexed vertex buffers), which lend themselves to fast rendering but not to collision detection. Rather than decoding these structures on the fly (even though the decoded data can be cached for reuse), it is usually more efficient to provide special collision geometry. In addition, graphics hardware often enforces triangle-only formats. For collision geometry, efficiency sometimes can be had by supporting other, nontriangle, primitives.

3. The required data and data organization of rendering geometry and collision geometry are likely to vary drastically. Whereas static rendering data might be sorted by material, collision data are generally organized spatially. Rendering geometry requires embedded data such as material information, vertex colors, and texture coordinates, whereas collision geometry needs associated surface properties. Separating the two and keeping all collision-relevant information together makes the collision data smaller. Smaller data, in turn, leads to efficiency improvements due to better data cache coherency.

4. Sometimes the collision geometry differs from the rendered geometry by design. For example, the knee-deep powder snow in a snowboarding game can be modeled by a collision surface two feet below the rendered representation of the snow surface. Walking in ankle-deep swaying grass or wading in waist-deep murky water can be handled similarly. Even if rendering geometry is used as collision geometry, there must be provisions for excluding some rendering geometry from (and for including additional nonrendering geometry in) the collision geometry data set.

5. For simulation purposes, collision data must be kept around even when rendering data can be thrown out as not visible. With the collision geometry being smaller

than the corresponding rendering geometry, the permanent memory footprint is therefore reduced.

6. The original geometry might be given as a polygon soup or mesh, whereas the simulation requires a solid-object representation. In this case, it is much easier to compute solid proxy geometry than to attempt to somehow solidify the original geometrical representation.

However, there are some potential drawbacks to using separate collision geometry.

1. Data duplication (primarily of vertices) causes additional memory to be used. This problem may be alleviated by creating some or all of the collision geometry from the rendering geometry on the fly through linearization caching (as described in Section 13.5 and onward).

2. Extra work may be required to produce and maintain two sets of similar geometry. Building the proxy geometry by hand will impair the schedule of the designer creating it. If it is built by a tool, that tool must be written before the collision system becomes usable. In addition, if there is a need to manually modify the tool output, the changes must somehow be communicated back into the tool and the original data set.

3. If built and maintained separately, the rendering and collision geometries may mismatch in places. When the collision geometry does not fill the same volume as the render geometry, objects may partially disappear into or float above the surface of other objects.

4. Versioning and other logistics problems can show up for the two geometries. Was the collision geometry really rebuilt when the rendering geometry changed? If created manually, which comes first: collision geometry or rendering geometry? And how do you update one when the other changes?

For games, using proxy geometry that is close to (but may not exactly match) actual visuals works quite well. Perceptually, humans are not very good at detecting whether exact collisions are taking place. The more objects involved and the faster they move, the less likely the player is to spot any discrepancies. Humans are also bad at predicting what the outcome of a collision should be, which allows liberties to be taken with the collision response as well. In games, collision detection and response can effectively be governed by "if it looks right, it is right." Other applications have stricter accuracy requirements.

2.2.3 Collision Algorithm Specialization

Rather than having one all-encompassing collision detection system, it is often wise to provide specialized collision systems for specific scenarios. An example of where

specialization is relevant is particle collisions. Rather than sending particles one by one through the normal collision system, they are better handled and submitted for collision as groups of particles, where the groups may form and reform based on context. Particles may even be excluded from collision, in cases where the lack of collision is not noticeable.

Another example is the use of separate algorithms for detecting collision between an object and other objects and between the object and the scene. Object-object collisions might even be further specialized so that a player character and fast-moving projectiles are handled differently from other objects. For example, a case where all objects always collide against the player character is better handled as a hard-coded test rather than inserting the player character into the general collision system.

Consider also the simulation of large worlds. For small worlds, collision data can be held in memory at all times. For the large, seamless world, however, collision data must be loaded and unloaded as the world is traversed. In the latter case, having objects separate from the world structure is again an attractive choice, so the objects are not affected by changes to the world structure. A possible drawback of having separate structures for holding, say, objects and world, is that querying now entails traversing two data structures as opposed to just one.

2.3 Types of Queries

The most straightforward collision query is the *interference detection* or *intersection testing* problem: answering the Boolean question of whether two (static) objects, A and B, are overlapping at their given positions and orientations. Boolean intersection queries are both fast and easy to implement and are therefore commonly used. However, sometimes a Boolean result is not enough and the parts intersecting must be found. The problem of *intersection finding* is a more difficult one, involving finding one or more points of contact.

For some applications, finding any one point in common between the objects might be sufficient. In others, such as in rigid-body simulations, the set of contacting points (the *contact manifold*) may need to be determined. Robustly computing the contact manifold is a difficult problem. Overall, *approximate queries* — where the answers are only required to be accurate up to a given tolerance — are much easier to deal with than *exact queries*. Approximate queries are commonplace in games. Additionally, in games, collision queries are generally required to report specific collision properties assigned to the objects and their boundaries. For example, such properties may include slipperiness of a road surface or climbability of a wall surface.

If objects penetrate, some applications require finding the *penetration depth*. The penetration depth is usually defined in terms of the *minimum translational distance*: the length of the shortest movement vector that would separate the objects. Computing this movement vector is a difficult problem, in general. The *separation distance* between two disjoint objects A and B is defined as the minimum of the distances between points

in A and points in B. When the distance is zero, the objects are intersecting. Having a distance measure between two objects is useful in that it allows for prediction of the next time of collision. A more general problem is that of finding the *closest points* of A and B: a point in A and a point in B giving the separation distance between the objects. Note that the closest points are not necessarily unique; there may be an infinite number of closest points. For dynamic objects, computing the next time of collision is known as the *estimated time of arrival* (ETA) or *time of impact* (TOI) computation. The ETA value can be used to, for instance, control the time step in a rigid-body simulation. Type of motion is one of the simulation parameters discussed further in the next section.

2.4 Environment Simulation Parameters

As mentioned earlier in the chapter, several parameters of a simulation directly affect what are appropriate choices for a collision detection system. To illustrate some of the issues they may cause, the following sections look specifically at how the number of objects and how the objects move relate to collision processing.

2.4.1 Number of Objects

Because any one object can potentially collide with any other object, a simulation with n objects requires $(n-1) + (n-2) + \cdots + 1 = n(n-1)/2 = O(n^2)$ pairwise tests, worst case. Due to the quadratic time complexity, naively testing every object pair for collision quickly becomes too expensive even for moderate values of n. Reducing the cost associated with the pairwise test will only linearly affect runtime. To really speed up the process, the number of pairs tested must be reduced. This reduction is performed by separating the collision handling of multiple objects into two phases: the *broad phase* and the *narrow phase*.

The broad phase identifies smaller groups of objects that *may* be colliding and quickly excludes those that definitely *are not*. The narrow phase constitutes the pairwise tests within subgroups. It is responsible for determining the exact collisions, if any. The broad and narrow phases are sometimes called n-*body processing* and *pair processing*, respectively.

Figure 2.4 illustrates how broad-phase processing reduces the workload through a divide-and-conquer strategy. For the 11 objects (illustrated by boxes), an all-pairs test would require 55 individual pair tests. After broad-phase processing has produced 5 disjoint subgroups (indicated by the shaded areas), only 10 individual pair tests would have to be performed in the narrow phase. Methods for broad-phase processing are discussed in Chapters 6 through 8. Narrow-phase processing is covered in Chapters 4, 5, and 9.

In addition to the number of objects, the relative size of the objects also affects how many tests have to be performed. With both small and large objects present in a scene,

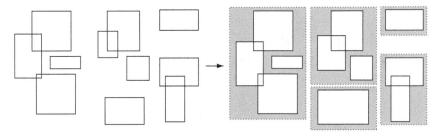

Figure 2.4 The broad phase identifies disjoint groups of possibly intersecting objects.

the broad-phase system generally must work harder (or be more sophisticated) to identify groups than it would for a set of homogeneously sized objects. How object size affects broad-phase methods is discussed further in Chapter 7.

2.4.2 Sequential Versus Simultaneous Motion

In real life, objects are moving *simultaneously* during a given movement time step, with any eventual collisions resolved within the time step. For an accurate computer simulation of the real-life event, the earliest time of contact between any two of the moving objects would somehow have to be determined. The simulation can then be advanced to this point in time, moving all objects to the position they would be in when the first collision occurs. The collision is then resolved, and the process continues determining the next collision, repeating until the entire movement time step has been used up.

Executing a simulation by repeatedly advancing it to the next earliest time of contact becomes quite expensive. For example, as one or more objects come to rest against a surface, the next time of collision follows almost immediately after the current time of collision. The simulation is therefore only advanced by a small fraction, and it can take virtually "forever" to resolve the full movement time step. One solution to this problem is to use the broad phase to identify groups of objects that may interact within the group, but not with objects of other groups during the time step. The simulation of each group can therefore proceed at different rates, helping to alleviate the problem in general.

An alternative option is to move objects simultaneously, but setting a fixed (small) time step for the movement. Simultaneous movement can result in objects interpenetrating, which typically must be dealt with somehow, for example, by backing up the simulation to an earlier state. In both cases, simultaneous updates remain expensive and are therefore often reserved for accurate rigid-body simulations. However, many games, as well as other applications, are not rigid-body simulations and it would be overkill and wasted effort to try to simulate motion with high accuracy. For these, an alternative option is to resolve motion *sequentially*. That is, objects are moved

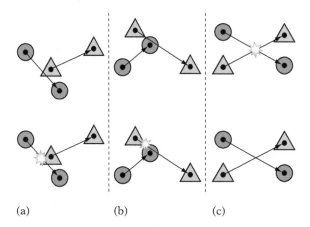

(a) (b) (c)

Figure 2.5 (a) Top: If both objects move simultaneously, there is no collision. Bottom: If the circle object moves before the triangle, the objects collide. In (b), again there is no collision for simultaneous movement, but for sequential movement the objects collide. (c) The objects collide under simultaneous movement, but not under sequential movement.

one object at a time and any collisions are detected and resolved before the process continues with the next object.

Clearly, sequential movement is not a physically accurate movement model. Some objects may collide with objects that have not yet moved in this frame but that would have moved out of the way were the two objects moving simultaneously (Figure 2.5a). Other objects may collide with objects that moved before they did and are now in their path (Figure 2.5b). In some cases, where two simultaneously moving objects would have collided halfway through their motion, collisions will now be missed as one object is moved past the other (Figure 2.5c). For games, for example, the problems introduced by a sequential movement model can often be ignored. The high frame rate of games often makes the movement step so small that the overlap is also small and not really noticeable.

One of the benefits of the sequential movement model is that an object nonpenetration invariant is very easy to uphold. If there is a collision during the movement of an object, the movement can simply be undone (for example). Only having to undo the movement of a single object should be contrasted with the simultaneous movement model using a fixed time step, where the movement of *all* simultaneously moved objects would have to be undone.

2.4.3 Discrete Versus Continuous Motion

Something that can greatly affect both the computational effort needed to determine a collision result and the accuracy of the result itself is if the two objects involved in a pairwise test are moving at the time of testing. *Static collision detection*

involves detecting intersection between the objects, at discrete points in time, during their motion. At each such point in time the objects are treated as if they were stationary at their current positions with zero velocities. In contrast, *dynamic collision detection* considers the full continuous motion of the objects over the given time interval. Dynamic collision tests can usually report the exact time of collision and the point(s) of first contact. Static tests are (much) cheaper than dynamic tests, but the time steps between tests must be short so that the movement of the objects is less than the spatial extents of the objects. Otherwise, the objects may simply pass each other from one time step to the next without a collision being detected. This phenomenon is referred to as *tunneling*.

The volume covered by an object in continuous motion over a given time interval is called the *swept volume*. If the swept volumes of two moving objects do not intersect, there is no intersection between the objects. Even if the swept volumes intersect, the objects still may not intersect during movement. Thus, intersection of the swept volumes is a necessary, but not sufficient, condition for object collision. For complex motions, the swept volume is both difficult to compute and to work with. Fortunately, perfect accuracy is rarely necessary. Dynamic collision testing of complex tumbling motions can usually be simplified by assuming a piecewise linear motion; that is, a linear translation over the range of movement, with an instantaneous rotation at the end (or start) of the motion. Somewhere between these two alternatives is replacement of the unrestricted motion with a screw motion (that is, a fixed rotational and translational motion).

When working with moving objects it is virtually always preferable to consider the relative motion of the objects by subtracting the motion of the one object off the other object, thus effectively leaving one object static. Assuming linear translational motion for the objects makes this operation a simple vector subtraction. A key benefit of considering only the relative motion is that for testing one moving object against a stationary object a swept volume test is now an exact intersection test. In games, the entire swept volume is sometimes just replaced by a *speedbox*: an elongated box covering the object for its full range of motion (or some similarly simple proxy object, not necessarily a box).

2.5 Performance

Taking game consoles as an example, for the best possible visuals games must run at 60 fps (in countries with NTSC TV format; 50 fps in PAL territory). This frame rate leaves 16.7 ms to prepare each game frame. Depending on the type of game, collision detection may account for, say, 10 to 30% of a frame, in turn leaving 2 to 5 ms for collision detection. For an action platform game that may have dozens of collision-dependent objects active at a given time there may be only about 50 to 250 μs available to handle the collision for each object — not a lot of time. Clearly, it is very important to reduce the average running time of collision queries. However, as large sudden drops in frame rate are very noticeable in games (in a bad way) it is

also important to make sure the worst case for the selected algorithms is not taking a magnitude longer than the average case.

A number of things can be done to speed up collision processing, which in large part is what this book is about. Some general ideas of what optimizations are relevant for collision detection are discussed in the next section.

2.5.1 **Optimization Overview**

The first tenet of optimization is that nothing is faster than not having to perform a task in the first place. Thus, some of the more successful speed optimizations revolve around pruning the work as quickly as possible down to the minimum possible. As such, one of the most important optimizations for a collision detection system is the broad-phase processing mentioned in Section 2.4.1: the exploitation of objects' spatial locality. Because objects can only hit things that are close to them, tests against distant objects can be avoided by breaking things up spatially. Tests are then only made against the regions immediately nearby the object, ignoring those that are too far away to intersect the object. There are strong similarities between this spatial partitioning and what is done for view frustum culling to limit the number of graphical objects drawn.

Spatial partitioning can be performed using a flat structure, such as by dividing space into a grid of cells of a uniform size. It also can be implemented in terms of a hierarchy, where space is recursively divided in half until some termination goal is met. Objects are then inserted into the grid or the hierarchy. Grids and hierarchical partitioning are also useful for the pair tests of the narrow phase, especially when the objects have high complexity. Rather than having to test an entire object against another, they allow collision tests to be limited to the parts of two objects nearest each other. Object and spatial partitioning are discussed in Chapters 6 and 7.

Doing inexpensive bounding volume tests before performing more expensive geometric tests is also a good way of reducing the amount of work needed to determine a collision. Say encompassing bounding spheres have been added to all objects, then a simple sphere-sphere intersection test will now show — when the spheres do not overlap — that no further testing of the complex contained geometry is necessary. Bounding volumes are covered in Chapter 4.

The insight that objects tend to take small local steps from frame to frame — if moving at all — leads to a third valuable optimization: to exploit this *temporal* (or *frame-to-frame*) *coherency*. For example, only objects that have moved since the last frame need to be tested; the collision status remains the same for the other objects. Temporal coherency may also allow data and calculations to be cached and reused over one or more future frames, thus speeding up tests. Assumptions based on movement coherency are obviously invalidated if objects are allowed to "teleport" to arbitrary locations. Coherence is further discussed in Chapter 9.

Last, architecture-specific optimizations are also very important. Many platforms support some type of code or data parallelism that when fully exploited can provide

large speedups. Due to big differences between the speed at which CPUs operate and the speeds at which main memory can provide data for it to operate on (with the speed advantage for the CPU), how collision geometry and other data are stored in memory can also have a huge speed impact on a collision system. These issues are covered in detail in Chapter 13.

2.6 **Robustness**

Collision detection is one of a number of geometrical applications where *robustness* is very important. In this book, robustness is used simply to refer to a program's capability of dealing with numerical computations and geometrical configurations that in some way are difficult to handle. When faced with such problematic inputs, a robust program provides the expected results. A nonrobust program may in the same situations crash or get into infinite loops. Robustness problems can be broadly categorized into two classes: those due to lack of *numerical robustness* and those due to lack of *geometrical robustness*.

Numerical robustness problems arise from the use of variables of finite precision during computations. For example, when intermediate calculations become larger than can be represented by a floating-point or an integer variable the intermediate result will be invalid. If such problems are not detected, the final result of the computation is also likely to be incorrect. Robust implementations must guarantee such problems cannot happen, or if they do that adjusted valid results are returned in their stead.

Geometrical robustness entails ensuring topological correctness and overall geometrical consistency. Problems often involve impossible or degenerate geometries, which may be the result of a bad numerical calculation. Most algorithms, at some level, expect well-formed inputs. When given bad input geometry, such as triangles degenerating to a point or polygons whose vertices do not all lie in the plane, anything could happen if these cases are not caught and dealt with.

The distinction between numerical and geometrical robustness is sometimes difficult to make, in that one can give rise to the other. To avoid obscure and difficult-to-fix runtime errors, robustness should be considered throughout both design and development of a collision detection system. Chapters 11 and 12 discuss robustness in more depth.

2.7 **Ease of Implementation and Use**

In the case of a collision detection system implemented from scratch, the issue of expected development time might be as important as the desired feature set. For example, games are often on tight budgets and time frames, and the delay of any

critical component could be costly. In evaluating the ease of implementation it is of interest to look at not just the overall algorithm complexity but how many and what type of special cases are involved, how many tweaking variables are involved (such as numerical tolerances), and other limitations that might affect the development time.

Several additional issues relate to the use of the collision detection system. For example, how general is the system? Can it handle objects of largely varying sizes? Can it also answer range queries? How much time is required in the build process to construct the collision-related data structures? For the latter question, while the time spent in preprocessing is irrelevant for runtime performance it is still important in the design and production phase. Model changes are frequent throughout development, and long preprocessing times both lessen productivity and hinder experimentation. Some of these problems can be alleviated by allowing for a faster, less optimized data structure construction during development and a slower but more optimal construction for non-debug builds.

2.7.1 Debugging a Collision Detection System

Just like all code, collision detection systems are susceptible to errors. Finding these errors can sometimes be both difficult and time consuming. Steps can be taken during development to make this debugging process less painful. Some good ideas include:

- Keep a cyclic buffer of the arguments to the n last collision queries, corresponding to up to a few seconds' worth of data (or more). Then, when something goes visually wrong, the program can be paused and the data can be output for further analysis, such as stepping through the calls with the saved arguments. The logged data may also provide useful information when *assert*s trigger.

- Provide means to visualize the collision geometry. For example, you might visualize tested faces, their collision attributes, and any hierarchies and groupings of the faces. Additionally, visualize the collision queries themselves, preferably with the history provided by the cyclic buffer mentioned earlier. This visualization provides a context that makes it easy to spot bad collision queries.

- Implement a simple reference algorithm (such as a brute-force algorithm that tests all objects or all polygons against each other) and run the reference algorithm in parallel with the more sophisticated algorithm. If the results differ, there is a problem (in all likelihood with the more advanced algorithm).

- Maintain a test suite of queries, and run the collision code against the test suite when the code changes. Code of geometric nature tends to have many special cases, and having a set of comprehensive tests helps in trapping problems early. Whenever a bug is found, add test cases to detect if it is ever reintroduced.

Of course, all general debugging strategies such as liberal use of **assert()** calls apply as well. A good discussion of such strategies is found in [McConnell93, Chapter 26].

2.8 **Summary**

This chapter has outlined the many factors that must be considered when designing and implementing a collision detection system. It talked about possible collision geometry representations, and whether to use rendering geometry or specialized geometry to perform collision tests. Collision processing was defined as taking place in two phases, the narrow and broad phase. The broad phase is concerned with coarsely identifying small subgroups of potentially colliding objects, whereas the narrow phase performs the detailed pairwise collision tests between objects. Narrow-phase testing is the primary topic of Chapters 4 and 5, where many different query types on a wide variety of geometrical object representations are discussed. Narrow-phase testing is also discussed in Chapter 9. Broad-phase methods are discussed in Chapters 6 through 8. The importance of robustness was stressed. This book devotes two full chapters to the topic of robustness, Chapters 11 and 12. Because this book is about collision detection for real-time applications, performance was also stressed as an important system consideration. In some respect, the majority of the book is about performance in that efficient algorithms and data structures are discussed throughout. The book concludes with discussion of optimization, in Chapter 13.

Chapter 3

A Math and Geometry Primer

Collision detection is an area of a very geometric nature. For example, in a world simulation both world and objects of that world are represented as geometrical entities such as polygons, spheres, and boxes. To implement efficient intersection tests for these entities, a thorough grasp of vectors, matrices, and linear algebra in general is required. Although this book assumes the reader already has some experience with these topics, the coverage in this chapter is provided for convenience, serving as a quick review of relevant concepts, definitions, and identities used throughout the book. The presentation is intended as an informal review, rather than a thorough formal treatment. Those readers interested in a more formal and encompassing coverage of vector spaces, and linear algebra and geometry in general, may want to consult texts such as [Hausner98] or [Anton00].

This chapter also presents some concepts from computational geometry (for example, Voronoi regions and convex hulls) and from the theory of convex sets (separating planes, support mappings, and Minkowski sums and differences). These concepts are important to many of the algorithms presented in this book.

3.1 Matrices

A *matrix* \mathbf{A} is an $m \times n$ rectangular array of numbers, with m rows and n columns:

$$\mathbf{A} = \begin{bmatrix} a_{11} & a_{12} & \cdots & a_{1n} \\ a_{21} & a_{22} & \cdots & a_{2n} \\ \vdots & \vdots & \ddots & \vdots \\ a_{m1} & a_{m2} & \cdots & a_{mn} \end{bmatrix} = [a_{ij}].$$

The matrix entry a_{ij} is located in the i-th row and j-th column of the array. An $m \times n$ matrix is said to be of *order* $m \times n$ ("m by n"). If $m = n$, \mathbf{A} is said to be a *square matrix* (of order n). A matrix of a single row is called a *row matrix*. Similarly, a matrix of a single column is called a *column matrix*:

$$\mathbf{A} = \begin{bmatrix} a_1 & a_2 & \cdots & a_n \end{bmatrix}, \qquad \mathbf{B} = \begin{bmatrix} b_1 \\ b_2 \\ \vdots \\ b_m \end{bmatrix}.$$

A matrix is often viewed as consisting of a number of row or column matrices. Row matrices and column matrices are also often referred to as *row vectors* and *column vectors*, respectively. For a square matrix, entries for which $i = j$ (that is, $a_{11}, a_{22}, \ldots, a_{nn}$) are called the *main diagonal* entries of the matrix. If $a_{ij} = 0$ for all $i \neq j$ the matrix is called *diagonal*:

$$\mathbf{A} = \begin{bmatrix} a_{11} & 0 & \cdots & 0 \\ 0 & a_{22} & \cdots & 0 \\ \vdots & \vdots & \ddots & \vdots \\ 0 & 0 & \cdots & a_{nn} \end{bmatrix}.$$

A square diagonal matrix with entries of 1 on the main diagonal and 0 for all other entries is called an *identity matrix*, denoted by \mathbf{I}. A square matrix \mathbf{L} with all entries above the main diagonal equal to zero is called a *lower triangular matrix*. If instead all entries below the main diagonal of a matrix \mathbf{U} are equal to zero, the matrix is an *upper triangular matrix*. For example:

$$\mathbf{I} = \begin{bmatrix} 1 & 0 & 0 \\ 0 & 1 & 0 \\ 0 & 0 & 1 \end{bmatrix}, \quad \mathbf{L} = \begin{bmatrix} 2 & 0 & 0 \\ 1 & -2 & 0 \\ -5 & 0 & -1 \end{bmatrix}, \quad \mathbf{U} = \begin{bmatrix} 1 & 5 & 4 \\ 0 & 2 & 1 \\ 0 & 0 & 3 \end{bmatrix}.$$

The *transpose* of a matrix \mathbf{A}, written \mathbf{A}^T, is obtained by exchanging rows for columns, and vice versa. That is, the transpose \mathbf{B} of a matrix \mathbf{A} is given by $b_{ij} = a_{ji}$:

$$\mathbf{A} = \begin{bmatrix} 5 & 2 \\ -3 & -1 \\ 0 & -4 \end{bmatrix}, \quad \mathbf{B} = \mathbf{A}^T = \begin{bmatrix} 5 & -3 & 0 \\ 2 & -1 & -4 \end{bmatrix}.$$

A matrix is *symmetric* if $\mathbf{A}^T = \mathbf{A}$; that is, if $a_{ij} = a_{ji}$ for all i and j. If $\mathbf{A}^T = -\mathbf{A}$ the matrix is said to be *skew symmetric* (or *antisymmetric*).

3.1.1 **Matrix Arithmetic**

Given two $m \times n$ matrices $\mathbf{A} = [a_{ij}]$ and $\mathbf{B} = [b_{ij}]$, matrix *addition* ($\mathbf{C} = [c_{ij}] = \mathbf{A} + \mathbf{B}$) is defined as the pairwise addition of elements from each matrix at corresponding positions, $c_{ij} = a_{ij} + b_{ij}$, or

$$\mathbf{C} = \mathbf{A} + \mathbf{B} = \begin{bmatrix} a_{11} & a_{12} & \cdots & a_{1n} \\ a_{21} & a_{22} & \cdots & a_{2n} \\ \vdots & \vdots & \ddots & \vdots \\ a_{m1} & a_{m2} & \cdots & a_{mn} \end{bmatrix} + \begin{bmatrix} b_{11} & b_{12} & \cdots & b_{1n} \\ b_{21} & b_{22} & \cdots & b_{2n} \\ \vdots & \vdots & \ddots & \vdots \\ b_{m1} & b_{m2} & \cdots & b_{mn} \end{bmatrix}$$

$$= \begin{bmatrix} a_{11} + b_{11} & a_{12} + b_{12} & \cdots & a_{1n} + b_{1n} \\ a_{21} + b_{21} & a_{22} + b_{22} & \cdots & a_{2n} + b_{2n} \\ \vdots & \vdots & \ddots & \vdots \\ a_{m1} + b_{m1} & a_{m2} + b_{m2} & \cdots & a_{mn} + b_{mn} \end{bmatrix} = [a_{ij} + b_{ij}].$$

Matrix *subtraction* is defined analogously. Multiplication of matrices comes in two forms. If c is a scalar, then the *scalar multiplication* $\mathbf{B} = c\,\mathbf{A}$ is given by $[b_{ij}] = [c\,a_{ij}]$. For example:

$$\mathbf{B} = 4\mathbf{A} = 4\begin{bmatrix} -2 & 0 & 1 \\ 5 & -3 & -1 \end{bmatrix} = \begin{bmatrix} -8 & 0 & 4 \\ 20 & -12 & -4 \end{bmatrix}, \text{ where } \mathbf{A} = \begin{bmatrix} -2 & 0 & 1 \\ 5 & -3 & -1 \end{bmatrix}.$$

If \mathbf{A} is an $m \times n$ matrix and \mathbf{B} an $n \times p$ matrix, then *matrix multiplication* ($\mathbf{C} = \mathbf{AB}$) is defined as:

$$c_{ij} = \sum_{k=1}^{n} a_{ik}\, b_{kj}.$$

For example:

$$\mathbf{C} = \mathbf{AB} = \begin{bmatrix} 3 & 0 & -5 \\ 2 & -1 & -4 \end{bmatrix}\begin{bmatrix} 3 & -1 \\ 4 & 7 \\ 2 & -2 \end{bmatrix} = \begin{bmatrix} -1 & 7 \\ -6 & -1 \end{bmatrix}.$$

In terms of vectors (as defined in Section 3.3), c_{ij} is the dot product of the i-th row of \mathbf{A} and the j-th column of \mathbf{B}. Matrix multiplication is not commutative; that is, in general, $\mathbf{AB} \neq \mathbf{BA}$. Division is not defined for matrices, but some square matrices \mathbf{A} have an *inverse*, denoted $\text{inv}(\mathbf{A})$ or \mathbf{A}^{-1}, with the property that $\mathbf{AA}^{-1} = \mathbf{A}^{-1}\mathbf{A} = \mathbf{I}$. Matrices that do not have an inverse are called *singular* (or *noninvertible*).

3.1.2 Algebraic Identities Involving Matrices

Given scalars r and s and matrices \mathbf{A}, \mathbf{B}, and \mathbf{C} (of the appropriate sizes required to perform the operations), the following identities hold for matrix addition, matrix subtraction, and scalar multiplication:

$$\mathbf{A} + \mathbf{B} = \mathbf{B} + \mathbf{A}$$
$$\mathbf{A} + (\mathbf{B} + \mathbf{C}) = (\mathbf{A} + \mathbf{B}) + \mathbf{C}$$
$$\mathbf{A} - \mathbf{B} = \mathbf{A} + (-\mathbf{B})$$
$$-(-\mathbf{A}) = \mathbf{A}$$
$$s(\mathbf{A} \pm \mathbf{B}) = s\,\mathbf{A} \pm s\,\mathbf{B}$$
$$(r \pm s)\mathbf{A} = r\,\mathbf{A} \pm s\,\mathbf{A}$$
$$r(s\,\mathbf{A}) = s(r\,\mathbf{A}) = (rs)\,\mathbf{A}$$

For matrix multiplication, the following identities hold:

$$\mathbf{AI} = \mathbf{IA} = \mathbf{A}$$
$$\mathbf{A}(\mathbf{BC}) = (\mathbf{AB})\mathbf{C}$$
$$\mathbf{A}(\mathbf{B} \pm \mathbf{C}) = \mathbf{AB} \pm \mathbf{AC}$$
$$(\mathbf{A} \pm \mathbf{B})\mathbf{C} = \mathbf{AC} \pm \mathbf{BC}$$
$$(s\,\mathbf{A})\mathbf{B} = s(\mathbf{AB}) = \mathbf{A}(s\,\mathbf{B})$$

Finally, for matrix transpose the following identities hold:

$$(\mathbf{A} \pm \mathbf{B})^T = \mathbf{A}^T \pm \mathbf{B}^T$$
$$(s\,\mathbf{A})^T = s\,\mathbf{A}^T$$
$$(\mathbf{AB})^T = \mathbf{B}^T\mathbf{A}^T$$

3.1.3 **Determinants**

The *determinant* of a matrix \mathbf{A} is a number associated with \mathbf{A}, denoted $\det(\mathbf{A})$ or $|\mathbf{A}|$. It is often used in determining the solvability of systems of linear equations, as discussed in the next section. In this book the focus is on 2×2 and 3×3 determinants. For matrices up to a dimension of 3×3, determinants are calculated as follows:

$$|\mathbf{A}| = |u_1| = u_1,$$

$$|\mathbf{A}| = \begin{vmatrix} u_1 & u_2 \\ v_1 & v_2 \end{vmatrix} = u_1 v_2 - u_2 v_1, \text{ and}$$

$$|\mathbf{A}| = \begin{vmatrix} u_1 & u_2 & u_3 \\ v_1 & v_2 & v_3 \\ w_1 & w_2 & w_3 \end{vmatrix} = u_1 (v_2 w_3 - v_3 w_2) + u_2 (v_3 w_1 - v_1 w_3)$$

$$+ u_3 (v_1 w_2 - v_2 w_1) = \mathbf{u} \cdot (\mathbf{v} \times \mathbf{w}) .$$

(The symbols \cdot and \times are the dot product and cross product, as described in Sections 3.3.3 and 3.3.5, respectively.) Determinants are geometrically related to (oriented) *hypervolumes*: a generalized concept of volumes in n-dimensional space for an $n \times n$ determinant, where length, area, and volume are the 1D, 2D, and 3D volume measurements. For a 1×1 matrix, $\mathbf{A} = [u_1]$, $|\mathbf{A}|$ corresponds to the signed length of a line segment from the origin to u_1. For a 2×2 matrix,

$$\mathbf{A} = \begin{bmatrix} u_1 & u_2 \\ v_1 & v_2 \end{bmatrix},$$

$|\mathbf{A}|$ corresponds to the signed area of the parallelogram determined by the points (u_1, u_2), (v_1, v_2), and $(0, 0)$, the last point being the origin. If the parallelogram is swept counterclockwise from the first point to the second, the determinant is positive, else negative. For a 3×3 matrix, $\mathbf{A} = [\mathbf{u}\,\mathbf{v}\,\mathbf{w}]$ (where \mathbf{u}, \mathbf{v}, and \mathbf{w} are column vectors), $|\mathbf{A}|$ corresponds to the signed volume of the parallelepiped determined by the three vectors. In general, for an n-dimensional matrix the determinant corresponds to the signed hypervolume of the n-dimensional hyper-parallelepiped determined by its column vectors.

Entire books have been written about the identities of determinants. Here, only the following important identities are noted:

- The determinant of a matrix remains unchanged if the matrix is transposed,

$$|\mathbf{A}| = \left|\mathbf{A}^T\right| .$$

- If **B** is obtained by interchanging two rows or two columns of **A**, then $|\mathbf{B}| = -|\mathbf{A}|$ (swapping two rows or columns changes how the hypervolume is swept out and therefore changes the sign of the determinant).

- If **B** is derived from **A** by adding a multiple of one row (or column) to another row (or column), then $|\mathbf{B}| = |\mathbf{A}|$ (this addition skews the hypervolume parallel to one of its faces, thus leaving the volume unchanged).

- The determinant of the product of two $n \times n$ matrices **A** and **B** is equal to the product of their respective determinants, $|\mathbf{AB}| = |\mathbf{A}||\mathbf{B}|$.

- If **B** is obtained by multiplying a row (or column) of **A** by a constant k, then $|\mathbf{B}| = k|\mathbf{A}|$.

- If one row of **A** is a multiple of another row, then $|\mathbf{A}| = 0$. The same is true when a column of **A** is a multiple of another column.

- For a determinant with a row or column of zeroes, $|\mathbf{A}| = 0$.

An effective way of evaluating determinants is to use row and column operations on the matrix to reduce it to a triangular matrix (where all elements below or above the main diagonal are zero). The determinant is then the product of the main diagonal entries. For example, the determinant of **A**,

$$\mathbf{A} = \begin{bmatrix} 4 & -2 & 6 \\ 2 & 5 & 0 \\ -2 & 1 & -4 \end{bmatrix},$$

can be evaluated as follows:

$$\det(\mathbf{A}) = \begin{vmatrix} 4 & -2 & 6 \\ 2 & 5 & 0 \\ -2 & 1 & -4 \end{vmatrix} \quad \boxed{\text{Adding the second row to the third row} \dots}$$

$$= \begin{vmatrix} 4 & -2 & 6 \\ 2 & 5 & 0 \\ 0 & 6 & -4 \end{vmatrix} \quad \boxed{\text{Adding } -\tfrac{1}{2} \text{ times the first row to the second row} \dots}$$

$$= \begin{vmatrix} 4 & -2 & 6 \\ 0 & 6 & -3 \\ 0 & 6 & -4 \end{vmatrix} \quad \boxed{\text{Adding } -1 \text{ times the second row to the third row} \dots}$$

$$= \begin{vmatrix} 4 & -2 & 6 \\ 0 & 6 & -3 \\ 0 & 0 & -1 \end{vmatrix} \qquad \boxed{\text{Now triangular so determinant is product of main diagonal entries}}$$

$$= -24.$$

An example application of determinants is Cramer's rule for solving small systems of linear equations, described in the next section.

Determinants can also be evaluated through a process known as *expansion by cofactors*. First define the *minor* to be the determinant m_{ij} of the matrix obtained by deleting row i and column j from matrix **A**. The *cofactor* c_{ij} is then given by

$$c_{ij} = (-1)^{i+j} m_{ij}.$$

The determinant of A can now be expressed as

$$|\mathbf{A}| = \sum_{j=1}^{n} a_{rj} c_{rj} = \sum_{i=1}^{n} a_{ik} c_{ik},$$

where r and k correspond to an arbitrary row or column index. For example, given the same matrix **A** as before, $|\mathbf{A}|$ can now be evaluated as, say,

$$|\mathbf{A}| = \begin{vmatrix} 4 & -2 & 6 \\ 2 & 5 & 0 \\ -2 & 1 & -4 \end{vmatrix} = 4 \begin{vmatrix} 5 & 0 \\ 1 & -4 \end{vmatrix} - (-2) \begin{vmatrix} 2 & 0 \\ -2 & -4 \end{vmatrix} + 6 \begin{vmatrix} 2 & 5 \\ -2 & 1 \end{vmatrix} = -80 - 16 + 72 = -24.$$

3.1.4 Solving Small Systems of Linear Equation Using Cramer's Rule

Consider a system of two linear equations in the two unknowns x and y:

$$ax + by = e, \text{ and}$$
$$cx + dy = f.$$

Multiplying the first equation by d and the second by b gives

$$adx + bdy = de, \text{ and}$$
$$bcx + bdy = bf.$$

Subtracting the second equation from first gives $adx - bcx = de - bf$, from which x can be solved for as $x = (de - bf)/(ad - bc)$. A similar process gives $y = (af - ce)/(ad - bc)$.

The solution to this system corresponds to finding the intersection point of two straight lines, and thus three types of solution are possible: the lines intersect in a single point, the lines are parallel and nonintersecting, or the lines are parallel and coinciding. A unique solution exists only in the first case, signified by the denominator $ad - bc$ being nonzero. Note that this 2×2 system can also be written as the matrix equation $\mathbf{AX} = \mathbf{B}$, where

$$\mathbf{A} = \begin{bmatrix} a & b \\ c & d \end{bmatrix}, \quad \mathbf{X} = \begin{bmatrix} x \\ y \end{bmatrix}, \quad \text{and} \quad \mathbf{B} = \begin{bmatrix} e \\ f \end{bmatrix}.$$

\mathbf{A} is called the *coefficient matrix*, \mathbf{X} the *solution vector*, and \mathbf{B} the *constant vector*. A system of linear equations has a unique solution if and only if the determinant of the coefficient matrix is nonzero, $|\mathbf{A}| \neq 0$. In this case, the solution is given by $\mathbf{X} = \mathbf{A}^{-1}\mathbf{B}$.

Upon examining the previous solution in x and y it becomes clear it can be expressed in terms of ratios of determinants:

$$x = \frac{\begin{vmatrix} e & b \\ f & d \end{vmatrix}}{\begin{vmatrix} a & b \\ c & d \end{vmatrix}}, \quad y = \frac{\begin{vmatrix} a & e \\ c & f \end{vmatrix}}{\begin{vmatrix} a & b \\ c & d \end{vmatrix}}.$$

Here, the denominator is the determinant of the coefficient matrix. The x numerator is the determinant of the coefficient matrix where the first column has been replaced by the constant vector. Similarly, the y numerator is the determinant of the coefficient matrix where the second column has been replaced by the constant vector.

Called *Cramer's rule*, this procedure extends to larger systems in the same manner, allowing a given variable to be computed by dividing the determinant of the coefficient matrix (where the variable column is replaced by the constant vector) by the determinant of the original coefficient matrix. For example, for the 3×3 system

$$a_1x + b_1y + c_1z = d_1,$$
$$a_2x + b_2y + c_2z = d_2, \text{ and}$$
$$a_3x + b_3y + c_3z = d_3$$

Cramer's rule gives the solution

$$
x = \frac{\begin{vmatrix} d_1 & b_1 & c_1 \\ d_2 & b_2 & c_2 \\ d_3 & b_3 & c_3 \end{vmatrix}}{d}, \quad y = \frac{\begin{vmatrix} a_1 & d_1 & c_1 \\ a_2 & d_2 & c_2 \\ a_3 & d_3 & c_3 \end{vmatrix}}{d}, \quad z = \frac{\begin{vmatrix} a_1 & b_1 & d_1 \\ a_2 & b_2 & d_2 \\ a_3 & b_3 & d_3 \end{vmatrix}}{d}, \quad \text{where}
$$

$$
d = \begin{vmatrix} a_1 & b_1 & c_1 \\ a_2 & b_2 & c_2 \\ a_3 & b_3 & c_3 \end{vmatrix}.
$$

Solving systems of linear equations using Cramer's rule is not recommended for systems with more than three or perhaps four equations, in that the amount of work involved increases drastically. For larger systems, a better solution is to use a Gaussian elimination algorithm. However, for small systems Cramer's rule works well and is easy to apply. It also has the benefit of being able to compute the value of just a single variable. All systems of linear equations encountered in this text are small.

3.1.5 Matrix Inverses for 2 × 2 and 3 × 3 Matrices

Determinants are also involved in the expressions for matrix inverses. The full details on how to compute matrix inverses is outside the range of topics for this book. For purposes here, it is sufficient to note that the inverses for 2 × 2 and 3 × 3 matrices can be written as

$$
\mathbf{A}^{-1} = \frac{1}{\det(\mathbf{A})} \begin{bmatrix} u_{22} & -u_{12} \\ -u_{21} & u_{11} \end{bmatrix}, \text{ and}
$$

$$
\mathbf{A}^{-1} = \frac{1}{\det(\mathbf{A})} \begin{bmatrix} u_{22}u_{33} - u_{23}u_{32} & u_{13}u_{32} - u_{12}u_{33} & u_{12}u_{23} - u_{13}u_{22} \\ u_{23}u_{31} - u_{21}u_{33} & u_{11}u_{33} - u_{13}u_{31} & u_{13}u_{21} - u_{11}u_{23} \\ u_{21}u_{32} - u_{22}u_{31} & u_{12}u_{31} - u_{11}u_{32} & u_{11}u_{22} - u_{12}u_{21} \end{bmatrix}.
$$

From these expressions, it is clear that if the determinant of a matrix \mathbf{A} is zero, $\text{inv}(\mathbf{A})$ does not exist, as it would result in a division by zero (this property holds for square matrices of arbitrary size, not just 2 × 2 and 3 × 3 matrices). The inverse of a 3 × 3 matrix \mathbf{A} can also be expressed in a more geometrical form. Let \mathbf{A} consist of the three column vectors \mathbf{u}, \mathbf{v}, and \mathbf{w}:

$$
\mathbf{A} = \begin{bmatrix} \mathbf{u} & \mathbf{v} & \mathbf{w} \end{bmatrix}.
$$

The inverse of \mathbf{A} is then given as

$$
\mathbf{A}^{-1} = \begin{bmatrix} \mathbf{a} & \mathbf{b} & \mathbf{c} \end{bmatrix}^{T},
$$

where **a**, **b**, and **c** are the column vectors

$$\mathbf{a} = (\mathbf{v} \times \mathbf{w})/(\mathbf{u} \cdot (\mathbf{v} \times \mathbf{w})),$$
$$\mathbf{b} = (\mathbf{w} \times \mathbf{u})/(\mathbf{u} \cdot (\mathbf{v} \times \mathbf{w})), \text{ and}$$
$$\mathbf{c} = (\mathbf{u} \times \mathbf{v})/(\mathbf{u} \cdot (\mathbf{v} \times \mathbf{w})).$$

In general, whenever the inverse of **A**, inv(**A**), exists, it can always be factored as

$$\text{inv}(\mathbf{A}) = \frac{1}{\det(\mathbf{A})}\mathbf{M},$$

where **M** is called the *adjoint matrix* of **A**, denoted adj(**A**).

3.1.6 Determinant Predicates

Determinants are also useful in concisely expressing geometrical tests. Many, if not most, geometrical tests can be cast into determinant form. If a determinant can be robustly and efficiently evaluated, so can the geometrical test. Therefore, the evaluation of determinants has been well studied. In particular, the sign of a determinant plays a special role in many geometrical tests, often used as topological predicates to test the orientation, sidedness, and inclusion of points. Note that direct evaluation of determinant predicates (without, for example, applying common subexpression elimination) does not, in general, result in the most efficient or robust expressions. Also note that determinant predicates implemented using floating-point arithmetic are very sensitive to rounding errors and algorithms relying on a correct sign in degenerate configurations are likely not to work as intended. For more on robustness errors and how to handle them, see Chapters 11 and 12. With that caveat, as an application of determinants, the next few sections illustrate some of the more useful of these topological predicates.

3.1.6.1 ORIENT2D(*A*, *B*, *C*)

Let $A = (a_x, a_y)$, $B = (b_x, b_y)$, and $C = (c_x, c_y)$ be three 2D points, and let ORIENT2D(A, B, C) be defined as

$$\text{ORIENT2D}(A, B, C) = \begin{vmatrix} a_x & a_y & 1 \\ b_x & b_y & 1 \\ c_x & c_y & 1 \end{vmatrix} = \begin{vmatrix} a_x - c_x & a_y - c_y \\ b_x - c_x & b_y - c_y \end{vmatrix}.$$

If ORIENT2D$(A, B, C) > 0$, C lies to the left of the directed line AB. Equivalently, the triangle ABC is oriented counterclockwise. When ORIENT2D$(A, B, C) < 0$, C lies to the right of the directed line AB, and the triangle ABC is oriented clockwise. When ORIENT2D$(A, B, C) = 0$, the three points are collinear. The actual value returned by ORIENT2D(A, B, C) corresponds to twice the signed area of the triangle ABC (positive if ABC is counterclockwise, otherwise negative). Alternatively, this determinant can be seen as the implicit equation of the 2D line $L(x, y) = 0$ through the points $A = (a_x, a_y)$ and $B = (b_x, b_y)$ by defining $L(x, y)$ as

$$L(x, y) = \begin{vmatrix} a_x & a_y & 1 \\ b_x & b_y & 1 \\ x & y & 1 \end{vmatrix}.$$

3.1.6.2 ORIENT3D(*A, B, C, D*)

Given four 3D points $A = (a_x, a_y, a_z)$, $B = (b_x, b_y, b_z)$, $C = (c_x, c_y, c_z)$, and $D = (d_x, d_y, d_z)$, define ORIENT3D(A, B, C, D) as

$$\text{ORIENT3D}(A, B, C, D) = \begin{vmatrix} a_x & a_y & a_z & 1 \\ b_x & b_y & b_z & 1 \\ c_x & c_y & c_z & 1 \\ d_x & d_y & d_z & 1 \end{vmatrix} = \begin{vmatrix} a_x - d_x & a_y - d_y & a_z - d_z \\ b_x - d_x & b_y - d_y & b_z - d_z \\ c_x - d_x & c_y - d_y & c_z - d_z \end{vmatrix}$$

$$= (A - D) \cdot ((B - D) \times (C - D)).$$

When ORIENT3D$(A, B, C, D) < 0$, D lies above the supporting plane of triangle ABC, in the sense that ABC appears in counterclockwise order when viewed from D. If ORIENT3D$(A, B, C, D) > 0$, D instead lies below the plane of ABC. When ORIENT3D$(A, B, C, D) = 0$, the four points are coplanar. The value returned by ORIENT3D(A, B, C, D) corresponds to six times the signed volume of the tetrahedron formed by the four points. Alternatively, the determinant can be seen as the implicit equation of the 3D plane $P(x, y, z) = 0$ through the points $A = (a_x, a_y, a_z)$, $B = (b_x, b_y, b_z)$, and $C = (c_x, c_y, c_z)$ by defining $P(x, y, z)$ as

$$P(x, y, z) = \begin{vmatrix} a_x & a_y & a_z & 1 \\ b_x & b_y & b_z & 1 \\ c_x & c_y & c_z & 1 \\ x & y & z & 1 \end{vmatrix}.$$

3.1.6.3 INCIRCLE2D(*A*, *B*, *C*, *D*)

Given four 2D points $A = (a_x, a_y)$, $B = (b_x, b_y)$, $C = (c_x, c_y)$, and $D = (d_x, d_y)$, define INCIRCLE2D(A, B, C, D) as

$$\text{INCIRCLE2D}(A, B, C, D) = \begin{vmatrix} a_x & a_y & a_x^2 + a_y^2 & 1 \\ b_x & b_y & b_x^2 + b_y^2 & 1 \\ c_x & c_y & c_x^2 + c_y^2 & 1 \\ d_x & d_y & d_x^2 + d_y^2 & 1 \end{vmatrix}$$

$$= \begin{vmatrix} a_x - d_x & a_y - d_y & (a_x - d_x)^2 + (a_y - d_y)^2 \\ b_x - d_x & b_y - d_y & (b_x - d_x)^2 + (b_y - d_y)^2 \\ c_x - d_x & c_y - d_y & (c_x - d_x)^2 + (c_y - d_y)^2 \end{vmatrix}.$$

Let the triangle ABC appear in counterclockwise order, as indicated by ORIENT2D$(A, B, C) > 0$. Then, when INCIRCLE2D$(A, B, C, D) > 0$, D lies inside the circle through the three points A, B, and C. If instead INCIRCLE2D$(A, B, C, D) < 0$, D lies outside the circle. When INCIRCLE2D$(A, B, C, D) = 0$, the four points are cocircular. If ORIENT2D$(A, B, C) < 0$, the result is reversed.

3.1.6.4 INSPHERE(*A*, *B*, *C*, *D*, *E*)

Given five 3D points $A = (a_x, a_y, a_z)$, $B = (b_x, b_y, b_z)$, $C = (c_x, c_y, c_z)$, $D = (d_x, d_y, d_z)$, and $E = (e_x, e_y, e_z)$, define INSPHERE(A, B, C, D, E) as

$$\text{INSPHERE}(A, B, C, D, E) = \begin{vmatrix} a_x & a_y & a_z & a_x^2 + a_y^2 + a_z^2 & 1 \\ b_x & b_y & b_z & b_x^2 + b_y^2 + b_z^2 & 1 \\ c_x & c_y & c_z & c_x^2 + c_y^2 + c_z^2 & 1 \\ d_x & d_y & d_z & d_x^2 + d_y^2 + d_z^2 & 1 \\ e_x & e_y & e_z & e_x^2 + e_y^2 + e_z^2 & 1 \end{vmatrix}$$

$$= \begin{vmatrix} a_x - e_x & a_y - e_y & a_z - e_z & (a_x - e_x)^2 + (a_y - e_y)^2 + (a_z - e_z)^2 \\ b_x - e_x & b_y - e_y & b_z - e_z & (b_x - e_x)^2 + (b_y - e_y)^2 + (b_z - e_z)^2 \\ c_x - e_x & c_y - e_y & c_z - e_z & (c_x - e_x)^2 + (c_y - e_y)^2 + (c_z - e_z)^2 \\ d_x - e_x & d_y - e_y & d_z - e_z & (d_x - e_x)^2 + (d_y - e_y)^2 + (d_z - e_z)^2 \end{vmatrix}.$$

Let the four points A, B, C, and D be oriented such that ORIENT3D$(A, B, C, D) > 0$. Then, when INSPHERE$(A, B, C, D, E) > 0$, E lies inside the sphere through A, B, C, and D. If instead INSPHERE$(A, B, C, D, E) < 0$, E lies outside the sphere. When INSPHERE$(A, B, C, D, E) = 0$, the five points are cospherical.

3.2 **Coordinate Systems and Points**

A *point* is a position in space, the location of which is described in terms of a *coordinate system*, given by a reference point, called the *origin*, and a number of *coordinate axes*. Points in an n-dimensional coordinate system are each specified by an n-tuple of real numbers (x_1, x_2, \ldots, x_n). The n-tuple is called the *coordinate* of the point. The point described by the n-tuple is the one reached by starting at the origin and moving x_1 units along the first coordinate axis, x_2 units along the second coordinate axis, and so on for all given numbers. The origin is the point with all zero components, $(0, 0, \ldots, 0)$. A coordinate system may be given relative to a parent coordinate system, in which case the origin of the subordinate coordinate system may correspond to any point in the parent coordinate system.

Of primary interest is the *Cartesian* (or *rectangular*) coordinate system, where the coordinate axes are perpendicular to each other. For a 2D space, the two coordinate axes are conventionally denoted the x axis and the y axis. In a 3D space, the third coordinate axis is called the z axis.

The *coordinate space* is the set of points the coordinate system can specify. The coordinate system is said to *span* this space. A given set of coordinate axes spanning a space is called the *frame of reference*, or *basis*, for the space. There are infinitely many frames of reference for a given coordinate space.

In this book, points are denoted by uppercase letters set in italics (for example, P, Q, and R). Points are closely related to vectors, as discussed in the next section.

3.3 **Vectors**

Abstractly, *vectors* are defined as members of *vector spaces*. A vector space is defined in terms of a set of elements (the vectors) that support the operations of *vector addition* and *scalar multiplication*, elements and operations all obeying a number of axioms. In this abstract sense, $m \times n$ matrices of real numbers may, for example, be elements (vectors) of a vector space. However, for the practical purposes of this book vectors typically belong to the vector space \mathbb{R}^n, whose elements are n-tuples of numbers from the domain of real numbers. A vector \mathbf{v} is thus given as

$$\mathbf{v} = (v_1, v_2, \ldots, v_n).$$

The number terms v_1, v_2, \ldots, v_n are called the *components* of \mathbf{v}. In fact, in this book vectors are predominantly restricted to the special cases \mathbb{R}^2 and \mathbb{R}^3 of \mathbb{R}^n, thus being given as tuples of two and three real numbers, respectively.

Informally, vectors are often described as entities having both direction and magnitude. They are therefore usually represented graphically by an arrow, or geometrically as a directed line segment, pointing in a given direction and of a given length. Vectors are denoted by boldface lowercase letters (for example, \mathbf{u}, \mathbf{v}, and \mathbf{w}).

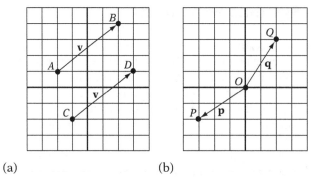

(a) (b)

Figure 3.1 (a) The (free) vector **v** is not anchored to a specific point and may therefore describe a displacement from any point, specifically from point *A* to point *B*, or from point *C* to point *D*. (b) A position vector is a vector bound to the origin. Here, position vectors **p** and **q** specify the positions of points *P* and *Q*, respectively.

A vector **v** can be interpreted as the displacement from the origin to a specific point *P*, effectively describing the position of *P*. In this interpretation **v** is, in a sense, *bound* to the origin *O*. A vector describing the location of a point is called a *position vector*, or *bound vector*. A vector **v** can also be interpreted as the displacement from an initial point *P* to an endpoint *Q*, $Q = P + \mathbf{v}$. In this sense, **v** is *free* to be applied at any point *P*. A vector representing an arbitrary displacement is called a *free vector* (or just *vector*). If the origin is changed, bound vectors change, but free vectors stay the same. Two free vectors are equal if they have the same direction and magnitude; that is, if they are componentwise equal. However, two bound vectors are not equal — even if the vectors are componentwise equal — if they are bound to different origins. Although most arithmetic operations on free and bound vectors are the same, there are some that differ. For example, a free vector — such as the normal vector of a plane — transforms differently from a bound vector.

The existence of position vectors means there is a one-to-one relationship between points and vectors. Frequently, a fixed origin is assumed to exist and the terms *point* and *vector* are therefore used interchangeably.

As an example, in Figure 3.1a, the free vector **v** may describe a displacement from any point, specifically from *A* to *B*, or from *C* to *D*. In Figure 3.1b, the two bound vectors **p** and **q** specify the positions of the points *P* and *Q*, respectively, and only those positions.

The vector **v** from point *A* to point *B* is written $\mathbf{v} = \overrightarrow{AB}$ (which is equivalent to $\mathbf{v} = \overrightarrow{OB} - \overrightarrow{OA}$). Sometimes the arrow is omitted and **v** is written simply as $\mathbf{v} = AB$. A special case is the vector from a point *P* to *P* itself. This vector is called the zero vector, and is denoted by **0**.

In the context of working with vectors, real numbers are usually referred to as *scalars*. Scalars are here denoted by lowercase letters set in italics (for example *a*, *b*, and *c*).

(a) (b)

Figure 3.2 (a) The result of adding two vectors **u** and **v** is obtained geometrically by placing the vectors tail to head and forming the vector from the tail of the first vector to the head of the second. (b) Alternatively, by the parallelogram law, the vector sum can be seen as the diagonal of the parallelogram formed by the two vectors.

3.3.1 **Vector Arithmetic**

The *sum* **w** of two vectors **u** and **v**, **w** = **u** + **v**, is formed by pairwise adding the components of **u** and **v**:

$$\mathbf{w} = \mathbf{u} + \mathbf{v} = (u_1, u_2, \ldots, u_n) + (v_1, v_2, \ldots, v_n) = (u_1 + v_1, u_2 + v_2, \ldots, u_n + v_n).$$

Geometrically, the vector sum can be seen as placing the arrow for **v** at the tip of **u** and defining their sum as the arrow pointing from the start of **u** to the tip of **v**. This geometric view of the vector sum is often referred to as the *parallelogram law of vector addition*, as the vector forming the sum corresponds to the diagonal of the parallelogram formed by the two given vectors, as illustrated in Figure 3.2.

The subtraction of vectors, **w** = **u** − **v**, is defined in terms of the addition of **u** and the negation of **v**; that is, **w** = **u** + (−**v**). The *negation* −**v** of a vector **v** is a vector of equal magnitude but of opposite direction. It is obtained by negating each component of the vector:

$$-\mathbf{v} = -(v_1, v_2, \ldots, v_n) = (-v_1, -v_2, \ldots, -v_n).$$

Componentwise, the subtraction of two vectors is therefore given by

$$\mathbf{w} = \mathbf{u} - \mathbf{v} = (u_1, u_2, \ldots, u_n) - (v_1, v_2, \ldots, v_n) = (u_1 - v_1, u_2 - v_2, \ldots, u_n - v_n).$$

Vectors can also be scaled through the multiplication of the vector by a constant (Figure 3.3). The resulting vector **w**, **w** = k**v**, from a *scalar multiplication* by k is given by

$$\mathbf{w} = k\,\mathbf{v} = k\,(v_1, v_2, \ldots, v_n) = (k\,v_1, k\,v_2, \ldots, k\,v_n).$$

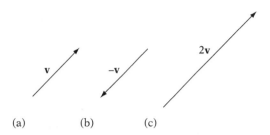

(a) (b) (c)

Figure 3.3 (a) The vector **v**. (b) The negation of vector **v**. (c) The vector **v** scaled by a factor of 2.

When the scalar k is negative, **w** has a direction opposite that of **v**. The *length* of a vector **v** is denoted by $\|\mathbf{v}\|$ and is defined in terms of its components as

$$\|\mathbf{v}\| = \sqrt{(v_1^2 + v_2^2 + \cdots + v_n^2)}.$$

The length of a vector is also called its *norm* or *magnitude*. A vector with a magnitude of 1 is called a *unit vector*. A nonzero vector **v** can be made unit, or be *normalized*, by multiplying it with the scalar $1/\|\mathbf{v}\|$.

For any n-dimensional vector space (specifically \mathbb{R}^n) there exists a basis consisting of exactly n linearly independent vectors $\mathbf{e}_1, \mathbf{e}_2, \ldots, \mathbf{e}_n$. Any vector **v** in the space can be written as a *linear combination* of these base vectors; thus,

$$\mathbf{v} = a_1\mathbf{e}_1 + a_2\mathbf{e}_2 + \cdots + a_n\mathbf{e}_n, \quad \text{where} \quad a_1, a_2, \ldots, a_n \text{ are scalars.}$$

Given a set of vectors, the vectors are *linearly independent* if no vector of the set can be expressed as a linear combination of the other vectors. For example, given two linearly independent vectors \mathbf{e}_1 and \mathbf{e}_2, any vector **v** in the plane spanned by these two vectors can be expressed linearly in terms of the vectors as $\mathbf{v} = a_1\mathbf{e}_1 + a_2\mathbf{e}_2$ for some constants a_1 and a_2.

Most bases used are *orthonormal*. That is, the vectors are pairwise orthogonal and are unit vectors. The standard basis in \mathbb{R}^3 is orthonormal, consisting of the vectors $(1, 0, 0)$, $(0, 1, 0)$, and $(0, 0, 1)$, usually denoted, respectively, by **i**, **j**, and **k**.

3.3.2 Algebraic Identities Involving Vectors

Given vectors **u**, **v**, and **w**, the following identities hold for vector addition and subtraction:

$$\mathbf{u} + \mathbf{v} = \mathbf{v} + \mathbf{u}$$

$$(\mathbf{u} + \mathbf{v}) + \mathbf{w} = \mathbf{u} + (\mathbf{v} + \mathbf{w})$$

$$\mathbf{u} - \mathbf{v} = \mathbf{u} + (-\mathbf{v})$$
$$-(-\mathbf{v}) = \mathbf{v}$$
$$\mathbf{v} + (-\mathbf{v}) = \mathbf{0}$$
$$\mathbf{v} + \mathbf{0} = \mathbf{0} + \mathbf{v} = \mathbf{v}$$

Additionally, given the scalars r and s, the following identities hold for scalar multiplication:

$$r(s\,\mathbf{v}) = (rs)\,\mathbf{v}$$
$$(r + s)\,\mathbf{v} = r\,\mathbf{v} + s\,\mathbf{v}$$
$$s(\mathbf{u} + \mathbf{v}) = s\,\mathbf{u} + s\,\mathbf{v}$$
$$1\,\mathbf{v} = \mathbf{v}$$

3.3.3 The Dot Product

The *dot product* (or *scalar product*) of two vectors \mathbf{u} and \mathbf{v} is defined as the sum of the products of their corresponding vector components and is denoted by $\mathbf{u} \cdot \mathbf{v}$. Thus,

$$\mathbf{u} \cdot \mathbf{v} = (u_1, u_2, \ldots, u_n) \cdot (v_1, v_2, \ldots, v_n) = u_1 v_1 + u_2 v_2 + \cdots + u_n v_n.$$

Note that the dot product is a scalar, not a vector. The dot product of a vector and itself is the squared length of the vector:

$$\mathbf{v} \cdot \mathbf{v} = v_1^2 + v_2^2 + \cdots + v_n^2 = \|\mathbf{v}\|^2.$$

It is possible to show that the smallest angle θ between \mathbf{u} and \mathbf{v} satisfies the equation

$$\mathbf{u} \cdot \mathbf{v} = \|\mathbf{u}\|\,\|\mathbf{v}\| \cos\theta,$$

and thus θ can be obtained as

$$\theta = \cos^{-1} \frac{\mathbf{u} \cdot \mathbf{v}}{\|\mathbf{u}\|\,\|\mathbf{v}\|}.$$

As a result, for two nonzero vectors the dot product is positive when θ is acute, negative when θ is obtuse, and zero when the vectors are perpendicular (Figure 3.4). Being able to tell whether the angle between two vectors is acute, obtuse, or at a right

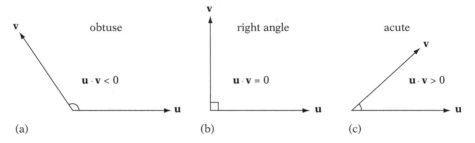

Figure 3.4 The sign of the dot product of two vectors tells whether the angle between the vectors is (a) obtuse, (b) at a right angle, or (c) acute.

angle is an extremely useful property of the dot product, which is frequently used in various geometric tests.

Geometrically, the dot product can be seen as the projection of \mathbf{v} onto \mathbf{u}, returning the signed distance d of \mathbf{v} along \mathbf{u} in units of $\|\mathbf{u}\|$:

$$d = \frac{\mathbf{u} \cdot \mathbf{v}}{\|\mathbf{u}\|}.$$

This projection is illustrated in Figure 3.5a. Given vectors \mathbf{u} and \mathbf{v}, \mathbf{v} can therefore be decomposed into a vector \mathbf{p} parallel to \mathbf{u} and a vector \mathbf{q} perpendicular to \mathbf{u}, such that $\mathbf{v} = \mathbf{p} + \mathbf{q}$:

$$\mathbf{p} = \frac{\mathbf{u} \cdot \mathbf{v}}{\|\mathbf{u}\|} \frac{\mathbf{u}}{\|\mathbf{u}\|} = \frac{\mathbf{u} \cdot \mathbf{v}}{\|\mathbf{u}\|^2}\mathbf{u} = \frac{\mathbf{u} \cdot \mathbf{v}}{\mathbf{u} \cdot \mathbf{u}}\mathbf{u}, \text{ and}$$

$$\mathbf{q} = \mathbf{v} - \mathbf{p} = \mathbf{v} - \frac{\mathbf{u} \cdot \mathbf{v}}{\mathbf{u} \cdot \mathbf{u}}\mathbf{u}.$$

Figure 3.5b shows how \mathbf{v} is decomposed into \mathbf{p} and \mathbf{q}.

Note that because the dot product is commutative the same holds true for seeing it as the projection of \mathbf{u} onto \mathbf{v}, returning the distance of \mathbf{u} along \mathbf{v} in units of $\|\mathbf{v}\|$.

3.3.4 **Algebraic Identities Involving Dot Products**

Given scalars r and s and vectors \mathbf{u} and \mathbf{v}, the following identities hold for the dot product:

$$\mathbf{u} \cdot \mathbf{v} = u_1 v_1 + u_2 v_2 + \cdots + u_n v_n$$

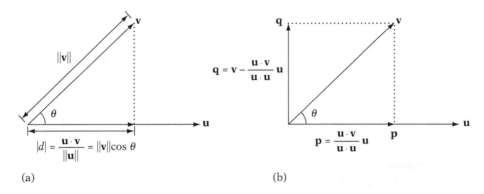

Figure 3.5 (a) The distance of **v** along **u** and (b) the decomposition of **v** into a vector **p** parallel and a vector **q** perpendicular to **u**.

$$\mathbf{u} \cdot \mathbf{v} = \|\mathbf{u}\| \, \|\mathbf{v}\| \cos\theta$$

$$\mathbf{u} \cdot \mathbf{u} = \|\mathbf{u}\|^2$$

$$\mathbf{u} \cdot \mathbf{v} = \mathbf{v} \cdot \mathbf{u}$$

$$\mathbf{u} \cdot (\mathbf{v} \pm \mathbf{w}) = \mathbf{u} \cdot \mathbf{v} \pm \mathbf{u} \cdot \mathbf{w}$$

$$r\,\mathbf{u} \cdot s\,\mathbf{v} = rs(\mathbf{u} \cdot \mathbf{v})$$

3.3.5 **The Cross Product**

The *cross product* (or *vector product*) of two 3D vectors $\mathbf{u} = (u_1, u_2, u_3)$ and $\mathbf{v} = (v_1, v_2, v_3)$ is denoted by $\mathbf{u} \times \mathbf{v}$ and is defined in terms of vector components as

$$\mathbf{u} \times \mathbf{v} = (u_2 v_3 - u_3 v_2, \, -(u_1 v_3 - u_3 v_1), \, u_1 v_2 - u_2 v_1).$$

The result is a vector perpendicular to **u** and **v**. Its magnitude is equal to the product of the lengths of **u** and **v** and the sine of the smallest angle θ between them. That is,

$$\mathbf{u} \times \mathbf{v} = \mathbf{n} \, \|\mathbf{u}\| \, \|\mathbf{v}\| \sin\theta,$$

where **n** is a unit vector perpendicular to the plane of **u** and **v**. When forming the cross product $\mathbf{w} = \mathbf{u} \times \mathbf{v}$, there is a choice of two possible directions for **w**. Here, and by convention, the direction of **w** is chosen so that it, together with **u** and **v**, forms a *right-handed coordinate system*. The *right-hand rule* is a mnemonic for remembering what a right-handed coordinate system looks like. It says that if the right hand is

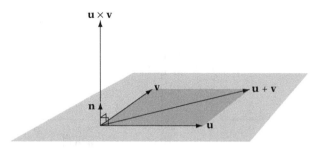

Figure 3.6 Given two vectors **u** and **v** in the plane, the cross product **w** (**w** = **u** × **v**) is a vector perpendicular to both vectors, according to the right-hand rule. The magnitude of **w** is equal to the area of the parallelogram spanned by **u** and **v** (shaded in dark gray).

curved about the **w** vector such that the fingers go from **u** to **v**, the direction of **w** coincides with the direction of the extended thumb.

The magnitude of **u** × **v** equals the area of the parallelogram spanned by **u** and **v**, with base $\|\mathbf{u}\|$ and height $\|\mathbf{v}\| \sin \theta$ (Figure 3.6). The magnitude is largest when the vectors are perpendicular.

Those familiar with determinants might find it easier to remember the expression for the cross product as the pseudo-determinant:

$$\mathbf{u} \times \mathbf{v} = \begin{vmatrix} \mathbf{i} & \mathbf{j} & \mathbf{k} \\ u_1 & u_2 & u_3 \\ v_1 & v_2 & v_3 \end{vmatrix} = \begin{vmatrix} u_2 & u_3 \\ v_2 & v_3 \end{vmatrix} \mathbf{i} - \begin{vmatrix} u_1 & u_3 \\ v_1 & v_3 \end{vmatrix} \mathbf{j} + \begin{vmatrix} u_1 & u_2 \\ v_1 & v_2 \end{vmatrix} \mathbf{k},$$

where $\mathbf{i} = (1,0,0)$, $\mathbf{j} = (0,1,0)$, and $\mathbf{k} = (0,0,1)$ are unit vectors parallel to the coordinate axes. The cross product can also be expressed in matrix form as the product of a (skew-symmetric) matrix and a vector:

$$\mathbf{u} \times \mathbf{v} = \begin{bmatrix} 0 & -u_3 & u_2 \\ u_3 & 0 & -u_1 \\ -u_2 & u_1 & 0 \end{bmatrix} \begin{bmatrix} v_1 \\ v_2 \\ v_3 \end{bmatrix}.$$

It is interesting to note that the cross product can actually be computed using only five multiplications, instead of the six multiplications indicated earlier, by expressing it as

$$\mathbf{u} \times \mathbf{v} = (v_2(t_1 - u_3) - t_4, u_3 v_1 - t_3, t_4 - u_2(v_1 - t_2)),$$

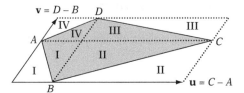

Figure 3.7 Given a quadrilateral *ABCD*, the magnitude of the cross product of the two diagonals *AC* and *BD* equals twice the area of *ABCD*. Here, this **property** is illustrated by the fact that the four **gray** areas of the quadrilateral are pairwise identical to the white areas, and all areas together add up to the area of the parallelogram spanned by *AC* and *BD*.

where

$$t_1 = u_1 - u_2, \quad t_2 = v_2 + v_3, \quad t_3 = u_1 v_3, \quad \text{and} \quad t_4 = t_1 t_2 - t_3.$$

Because this formulation increases the total number of operations from 9 (6 multiplies, 3 additions) to 13 (5 multiplies, 8 additions), any eventual practical performance benefit of such a rewrite is hardware dependent.

Given a triangle *ABC*, the magnitude of the cross product of two of its edges equals twice the area of *ABC*. For an arbitrary non self-intersecting quadrilateral *ABCD*, the magnitude $\|\mathbf{e}\|$ of the cross product of the two diagonals, $\mathbf{e} = (C - A) \times (D - B)$, equals twice the area of *ABCD*. This property is illustrated in Figure 3.7.

There is no direct equivalent of the cross product in two dimensions, as a third vector perpendicular to two vectors in the plane must leave the plane and the 2D space. The closest 2D analog is the 2D *pseudo cross product*, defined as

$$\mathbf{u}^\perp \cdot \mathbf{v},$$

where $\mathbf{u}^\perp = (-u_2, u_1)$ is the counterclockwise vector perpendicular to \mathbf{u}. The term \mathbf{u}^\perp is read "u-perp." For this reason, the pseudo cross product is sometimes referred to as the *perp-dot product*. The 2D pseudo cross product is a scalar, the value of which — similar to the magnitude of the cross product — corresponds to the signed area of the parallelogram determined by \mathbf{u} and \mathbf{v}. It is positive if \mathbf{v} is counterclockwise from \mathbf{u}, negative if \mathbf{v} is clockwise from \mathbf{u}, and otherwise zero.

Again, given the (3D) triangle *ABC*, note that each component of the cross product vector $\mathbf{d} = (B - A) \times (C - A)$ consists of a 2D pseudo cross product (with the middle component being negated). Therefore, each component of \mathbf{d} holds twice the signed area of the projection of *ABC* onto the *yz*, *zx*, and *xy* planes, respectively. A single cross product operation is therefore sufficient for determining the result of a 2D point-in-triangle test, which can be useful if a cross product operation is directly supported in hardware.

3.3.6 **Algebraic Identities Involving Cross Products**

Given scalars r and s and vectors \mathbf{u}, \mathbf{v}, \mathbf{w}, and \mathbf{x}, the following cross product identities hold:

$$\mathbf{u} \times \mathbf{v} = -(\mathbf{v} \times \mathbf{u})$$

$$\mathbf{u} \times \mathbf{u} = \mathbf{0}$$

$$\mathbf{u} \times \mathbf{0} = \mathbf{0} \times \mathbf{u} = \mathbf{0}$$

$$\mathbf{u} \cdot (\mathbf{u} \times \mathbf{v}) = \mathbf{v} \cdot (\mathbf{u} \times \mathbf{v}) = 0 \text{ (that is, } \mathbf{u} \times \mathbf{v} \text{ is perpendicular to both } \mathbf{u} \text{ and } \mathbf{v})$$

$$\mathbf{u} \cdot (\mathbf{v} \times \mathbf{w}) = (\mathbf{u} \times \mathbf{v}) \cdot \mathbf{w}$$

$$\mathbf{u} \times (\mathbf{v} \pm \mathbf{w}) = \mathbf{u} \times \mathbf{v} \pm \mathbf{u} \times \mathbf{w}$$

$$(\mathbf{u} \pm \mathbf{v}) \times \mathbf{w} = \mathbf{u} \times \mathbf{w} \pm \mathbf{v} \times \mathbf{w}$$

$$(\mathbf{u} \times \mathbf{v}) \times \mathbf{w} = \mathbf{w} \times (\mathbf{v} \times \mathbf{u}) = (\mathbf{u} \cdot \mathbf{w})\mathbf{v} - (\mathbf{v} \cdot \mathbf{w})\mathbf{u} \text{ (a vector in the plane of } \mathbf{u} \text{ and } \mathbf{v})$$

$$\mathbf{u} \times (\mathbf{v} \times \mathbf{w}) = (\mathbf{w} \times \mathbf{v}) \times \mathbf{u} = (\mathbf{u} \cdot \mathbf{w})\mathbf{v} - (\mathbf{u} \cdot \mathbf{v})\mathbf{w} \text{ (a vector in the plane of } \mathbf{v} \text{ and } \mathbf{w})$$

$$\|\mathbf{u} \times \mathbf{v}\| = \|\mathbf{u}\| \, \|\mathbf{v}\| \sin\theta$$

$$(\mathbf{u} \times \mathbf{v}) \cdot (\mathbf{w} \times \mathbf{x}) = (\mathbf{u} \cdot \mathbf{w})(\mathbf{v} \cdot \mathbf{x}) - (\mathbf{v} \cdot \mathbf{w})(\mathbf{u} \cdot \mathbf{x}) \text{ (Lagrange's identity)}$$

$$r\mathbf{u} \times s\mathbf{v} = rs(\mathbf{u} \times \mathbf{v})$$

$$\mathbf{u} \times (\mathbf{v} \times \mathbf{w}) + \mathbf{v} \times (\mathbf{w} \times \mathbf{u}) + \mathbf{w} \times (\mathbf{u} \times \mathbf{v}) = \mathbf{0} \text{ (Jacobi's identity)}$$

The Lagrange identity is particularly useful for reducing the number of operations required for various geometric tests. Several examples of such reductions are found in Chapter 5.

3.3.7 **The Scalar Triple Product**

The expression $(\mathbf{u} \times \mathbf{v}) \cdot \mathbf{w}$ occurs frequently enough that it has been given a name of its own: *scalar triple product* (also referred to as the *triple scalar product* or *box product*). Geometrically, the value of the scalar triple product corresponds to the (signed) volume of a parallelepiped formed by the three independent vectors \mathbf{u}, \mathbf{v}, and \mathbf{w}. Equivalently, it is six times the volume of the tetrahedron spanned by \mathbf{u}, \mathbf{v}, and \mathbf{w}. The relationship between the scalar triple product and the parallelepiped is illustrated in Figure 3.8.

The cross and dot product can be interchanged in the triple product without affecting the result:

$$(\mathbf{u} \times \mathbf{v}) \cdot \mathbf{w} = \mathbf{u} \cdot (\mathbf{v} \times \mathbf{w}).$$

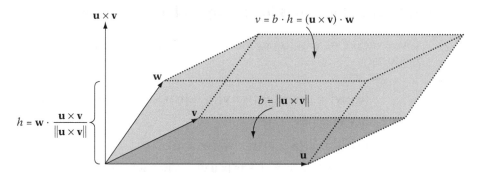

Figure 3.8 The scalar triple product $(\mathbf{u} \times \mathbf{v}) \cdot \mathbf{w}$ is equivalent to the (signed) volume of the parallelepiped formed by the three vectors \mathbf{u}, \mathbf{v}, and \mathbf{w}.

The scalar triple product also remains constant under the cyclic permutation of its three arguments:

$$(\mathbf{u} \times \mathbf{v}) \cdot \mathbf{w} = (\mathbf{v} \times \mathbf{w}) \cdot \mathbf{u} = (\mathbf{w} \times \mathbf{u}) \cdot \mathbf{v}.$$

Because of these identities, the special notation $[\mathbf{u}\,\mathbf{v}\,\mathbf{w}]$ is often used to denote a triple product. It is defined as

$$[\mathbf{u}\,\mathbf{v}\,\mathbf{w}] = (\mathbf{u} \times \mathbf{v}) \cdot \mathbf{w} = \mathbf{u} \cdot (\mathbf{v} \times \mathbf{w}).$$

This notation abstracts away the ordering of the dot and cross products and makes it easy to remember the correct sign for triple product identities. If the vectors read **uvw** from left to right (starting at the **u** and allowing wraparound), the product identity is positive, otherwise negative:

$$[\mathbf{u}\,\mathbf{v}\,\mathbf{w}] = [\mathbf{v}\,\mathbf{w}\,\mathbf{u}] = [\mathbf{w}\,\mathbf{u}\,\mathbf{v}] = -[\mathbf{u}\,\mathbf{w}\,\mathbf{v}] = -[\mathbf{v}\,\mathbf{u}\,\mathbf{w}] = -[\mathbf{w}\,\mathbf{v}\,\mathbf{u}].$$

The scalar triple product can also be expressed as the determinant of the 3×3 matrix, where the rows (or columns) are the components of the vectors:

$$[\mathbf{u}\,\mathbf{v}\,\mathbf{w}] = \begin{vmatrix} u_1 & u_2 & u_3 \\ v_1 & v_2 & v_3 \\ w_1 & w_2 & w_3 \end{vmatrix} = u_1 \begin{vmatrix} v_2 & v_3 \\ w_2 & w_3 \end{vmatrix} - u_2 \begin{vmatrix} v_1 & v_3 \\ w_1 & w_3 \end{vmatrix} + u_3 \begin{vmatrix} v_1 & v_2 \\ w_1 & w_2 \end{vmatrix} = \mathbf{u} \cdot (\mathbf{v} \times \mathbf{w}).$$

Three vectors \mathbf{u}, \mathbf{v}, and \mathbf{w} lie in the same plane if and only if $[\mathbf{u}\,\mathbf{v}\,\mathbf{w}] = 0$.

3.3.8 **Algebraic Identities Involving Scalar Triple Products**

Given vectors \mathbf{u}, \mathbf{v}, \mathbf{w}, \mathbf{x}, \mathbf{y}, and \mathbf{z}, the following identities hold for scalar triple products:

$$[\mathbf{u}\,\mathbf{v}\,\mathbf{w}] = [\mathbf{v}\,\mathbf{w}\,\mathbf{u}] = [\mathbf{w}\,\mathbf{u}\,\mathbf{v}] = -[\mathbf{u}\,\mathbf{w}\,\mathbf{v}] = -[\mathbf{v}\,\mathbf{u}\,\mathbf{w}] = -[\mathbf{w}\,\mathbf{v}\,\mathbf{u}]$$

$$[\mathbf{u}\,\mathbf{u}\,\mathbf{v}] = [\mathbf{v}\,\mathbf{u}\,\mathbf{v}] = 0$$

$$[\mathbf{u}\,\mathbf{v}\,\mathbf{w}]^2 = [(\mathbf{u} \times \mathbf{v})(\mathbf{v} \times \mathbf{w})(\mathbf{w} \times \mathbf{u})]$$

$$\mathbf{u}\,[\mathbf{v}\,\mathbf{w}\,\mathbf{x}] - \mathbf{v}\,[\mathbf{w}\,\mathbf{x}\,\mathbf{u}] + \mathbf{w}\,[\mathbf{x}\,\mathbf{u}\,\mathbf{v}] - \mathbf{x}\,[\mathbf{u}\,\mathbf{v}\,\mathbf{w}] = 0$$

$$(\mathbf{u} \times \mathbf{v}) \times (\mathbf{w} \times \mathbf{x}) = \mathbf{v}\,[\mathbf{u}\,\mathbf{w}\,\mathbf{x}] - \mathbf{u}\,[\mathbf{v}\,\mathbf{w}\,\mathbf{x}]$$

$$\left[(\mathbf{u} \times \mathbf{v})(\mathbf{w} \times \mathbf{x})(\mathbf{y} \times \mathbf{z})\right] = [\mathbf{v}\,\mathbf{y}\,\mathbf{z}]\,[\mathbf{u}\,\mathbf{w}\,\mathbf{x}] - [\mathbf{u}\,\mathbf{y}\,\mathbf{z}]\,[\mathbf{v}\,\mathbf{w}\,\mathbf{x}]$$

$$[(\mathbf{u} + \mathbf{v})(\mathbf{v} + \mathbf{w})(\mathbf{w} + \mathbf{u})] = 2\,[\mathbf{u}\,\mathbf{v}\,\mathbf{w}]$$

$$[\mathbf{u}\,\mathbf{v}\,\mathbf{w}]\,[\mathbf{x}\,\mathbf{y}\,\mathbf{z}] = \begin{vmatrix} \mathbf{u} \cdot \mathbf{x} & \mathbf{u} \cdot \mathbf{y} & \mathbf{u} \cdot \mathbf{z} \\ \mathbf{v} \cdot \mathbf{x} & \mathbf{v} \cdot \mathbf{y} & \mathbf{v} \cdot \mathbf{z} \\ \mathbf{w} \cdot \mathbf{x} & \mathbf{w} \cdot \mathbf{y} & \mathbf{w} \cdot \mathbf{z} \end{vmatrix}$$

$$[(\mathbf{u} - \mathbf{x})(\mathbf{v} - \mathbf{x})(\mathbf{w} - \mathbf{x})] = [\mathbf{u}\,\mathbf{v}\,\mathbf{w}] - [\mathbf{u}\,\mathbf{v}\,\mathbf{x}] - [\mathbf{u}\,\mathbf{x}\,\mathbf{w}] - [\mathbf{x}\,\mathbf{v}\,\mathbf{w}]$$

$$= [(\mathbf{u} - \mathbf{x})\,\mathbf{v}\,\mathbf{w}] - [(\mathbf{v} - \mathbf{w})\,\mathbf{x}\,\mathbf{u}]$$

3.4 **Barycentric Coordinates**

A concept useful in several different intersection tests is that of *barycentric coordinates*. Barycentric coordinates parameterize the space that can be formed as a weighted combination of a set of reference points. As a simple example of barycentric coordinates, consider two points, A and B. A point P on the line between them can be expressed as $P = A + t(B - A) = (1 - t)A + tB$ or simply as $P = uA + vB$, where $u + v = 1$. P is on the segment AB if and only if $0 \le u \le 1$ and $0 \le v \le 1$. Written in the latter way, (u, v) are the barycentric coordinates of P with respect to A and B. The barycentric coordinates of A are $(1, 0)$, and for B they are $(0, 1)$.

The prefix *bary* comes from Greek, meaning weight, and its use as a prefix is explained by considering u and v as weights placed at the endpoints A and B of the segment AB, respectively. Then, the point Q dividing the segment in the ratio $v{:}u$ is the *centroid* or *barycenter*: the center of gravity of the weighted segment and the position at which it must be supported to be balanced.

A typical application of barycentric coordinates is to parameterize triangles (or the planes of the triangles). Consider a triangle ABC specified by three noncollinear points A, B, and C. Any point P in the plane of the points can then be uniquely expressed as $P = uA + vB + wC$ for some constants u, v, and w, where $u + v + w = 1$. The triplet (u, v, w) corresponds to the barycentric coordinates of the point. For the

triangle ABC, the barycentric coordinates of the vertices A, B, and C are $(1, 0, 0)$, $(0, 1, 0)$, and $(0, 0, 1)$, respectively. In general, a point with barycentric coordinates (u, v, w) is inside (or on) the triangle if and only if $0 \leq u, v, w \leq 1$, or alternatively if and only if $0 \leq v \leq 1, 0 \leq w \leq 1$, and $v + w \leq 1$. That barycentric coordinates actually parameterize the plane follows from $P = uA + vB + wC$ really just being a reformulation of $P = A + v(B - A) + w(C - A)$, with v and w arbitrary, as

$$P = A + v(B - A) + w(C - A) = (1 - v - w)A + vB + wC.$$

In the latter formulation, the two independent direction vectors AB and AC form a coordinate system with origin A, allowing any point P in the plane to be parameterized in terms of v and w alone. Clearly, barycentric coordinates is a redundant representation in that the third component can be expressed in terms of the first two. It is kept for reasons of symmetry.

To solve for the barycentric coordinates, the expression $P = A + v(B - A) + w(C - A)$ — or equivalently $v(B - A) + w(C - A) = P - A$ — can be written as $v\,\mathbf{v}_0 + w\,\mathbf{v}_1 = \mathbf{v}_2$, where $\mathbf{v}_0 = B - A$, $\mathbf{v}_1 = C - A$, and $\mathbf{v}_2 = P - A$. Now, a 2×2 system of linear equations can be formed by taking the dot product of both sides with both \mathbf{v}_0 and \mathbf{v}_1:

$$(v\,\mathbf{v}_0 + w\,\mathbf{v}_1) \cdot \mathbf{v}_0 = \mathbf{v}_2 \cdot \mathbf{v}_0, \text{ and}$$

$$(v\,\mathbf{v}_0 + w\,\mathbf{v}_1) \cdot \mathbf{v}_1 = \mathbf{v}_2 \cdot \mathbf{v}_1.$$

Because the dot product is a linear operator, these expressions are equivalent to

$$v\,(\mathbf{v}_0 \cdot \mathbf{v}_0) + w\,(\mathbf{v}_1 \cdot \mathbf{v}_0) = \mathbf{v}_2 \cdot \mathbf{v}_0, \text{ and}$$

$$v\,(\mathbf{v}_0 \cdot \mathbf{v}_1) + w\,(\mathbf{v}_1 \cdot \mathbf{v}_1) = \mathbf{v}_2 \cdot \mathbf{v}_1.$$

This system is easily solved with Cramer's rule. The following code is an implementation computing the barycentric coordinates using this method.

```
// Compute barycentric coordinates (u, v, w) for
// point p with respect to triangle (a, b, c)
void Barycentric(Point a, Point b, Point c, Point p, float &u, float &v, float &w)
{
    Vector v0 = b - a, v1 = c - a, v2 = p - a;
    float d00 = Dot(v0, v0);
    float d01 = Dot(v0, v1);
    float d11 = Dot(v1, v1);
    float d20 = Dot(v2, v0);
```

```
    float d21 = Dot(v2, v1);
    float denom = d00 * d11 - d01 * d01;
    v = (d11 * d20 - d01 * d21) / denom;
    w = (d00 * d21 - d01 * d20) / denom;
    u = 1.0f - v - w;
}
```

If several points are tested against the same triangle, the terms **d00**, **d01**, **d11**, and **denom** only have to be computed once, as they are fixed for a given triangle.

The barycentric coordinates can be computed for a point with respect to a simplex (Section 3.8) of any dimension. For instance, given a tetrahedron specified by the vertices A, B, C, and D, the barycentric coordinates (u, v, w, x) specify a point P in 3D space, $P = uA + vB + wC + xD$ with $u + v + w + x = 1$. If $0 \leq u, v, w, x \leq 1$, then P is inside the tetrahedron.

Given the points specified as $A = (a_x, a_y, a_z)$, $B = (b_x, b_y, b_z)$, $C = (c_x, c_y, c_z)$, $D = (d_x, d_y, d_z)$, and $P = (p_x, p_y, p_z)$, the barycentric coordinates can be solved for by setting up a system of linear equations:

$$
\begin{array}{ccccccccc}
a_x u & + & b_x v & + & c_x w & + & d_x x & = & p_x \\
a_y u & + & b_y v & + & c_y w & + & d_y x & = & p_y \\
a_z u & + & b_z v & + & c_z w & + & d_z x & = & p_z \\
u & + & v & + & w & + & x & = & 1
\end{array}
$$

Alternatively, by subtracting A from both sides of $P = uA + vB + wC + xD$ — giving

$$P - A = v(B - A) + w(C - A) + x(D - A)$$

— it follows that three of the four barycentric coordinate components can be obtained by solving

$$(b_x - a_x)v + (c_x - a_x)w + (d_x - a_x)x = p_x - a_x,$$
$$(b_y - a_y)v + (c_y - a_y)w + (d_y - a_y)x = p_y - a_y, \text{ and}$$
$$(b_z - a_z)v + (c_z - a_z)w + (d_z - a_z)x = p_z - a_z$$

(with the fourth component given by $u = 1 - v - w - x$). Either system is easily solved using Cramer's rule or Gaussian elimination. For example, in the former system the coordinates are given by Cramer's rule as the ratios

$$u = d_{PBCD}/d_{ABCD},$$

$$v = d_{APCD}/d_{ABCD},$$

$$w = d_{ABPD}/d_{ABCD}, \text{ and}$$

$$x = d_{ABCP}/d_{ABCD} = 1 - u - v - w$$

of the following determinants:

$$d_{PBCD} = \begin{vmatrix} p_x & b_x & c_x & d_x \\ p_y & b_y & c_y & d_y \\ p_z & b_z & c_z & d_z \\ 1 & 1 & 1 & 1 \end{vmatrix}, \quad d_{APCD} = \begin{vmatrix} a_x & p_x & c_x & d_x \\ a_y & p_y & c_y & d_y \\ a_z & p_z & c_z & d_z \\ 1 & 1 & 1 & 1 \end{vmatrix}, \quad d_{ABPD} = \begin{vmatrix} a_x & b_x & p_x & d_x \\ a_y & b_y & p_y & d_y \\ a_z & b_z & p_z & d_z \\ 1 & 1 & 1 & 1 \end{vmatrix},$$

$$d_{ABCP} = \begin{vmatrix} a_x & b_x & c_x & p_x \\ a_y & b_y & c_y & p_y \\ a_z & b_z & c_z & p_z \\ 1 & 1 & 1 & 1 \end{vmatrix} \quad \text{and} \quad d_{ABCD} = \begin{vmatrix} a_x & b_x & c_x & d_x \\ a_y & b_y & c_y & d_y \\ a_z & b_z & c_z & d_z \\ 1 & 1 & 1 & 1 \end{vmatrix}.$$

These determinants correspond to the signed volumes of the tetrahedra $PBCD, APCD,$ $ABPD, ABCP,$ and $ABCD$ (strictly 1/6 of each signed volume). As shown further ahead, the ratios simplify to being the normalized relative heights of the point over the opposing planes.

Returning to triangles, just as the barycentric coordinates with respect to a tetrahedron can be computed as ratios of volumes the barycentric coordinates with respect to a triangle can be computed as ratios of areas. Specifically, the barycentric coordinates of a given point P can be computed as the ratios of the triangle areas of $PBC, PCA,$ and PAB with respect to the area of the entire triangle ABC. For this reason barycentric coordinates are also called *areal coordinates*. By using signed triangle areas, these expressions are valid for points outside the triangle as well. The barycentric coordinates (u, v, w) are thus given by

```
u = SignedArea(PBC)/SignedArea(ABC),
v = SignedArea(PCA)/SignedArea(ABC), and
w = SignedArea(PAB)/SignedArea(ABC) = 1 - u - v.
```

Because constant factors cancel out, any function proportional to the triangle area can be used in computing these ratios. In particular, the magnitude of the cross product of two triangle edges can be used. The correct sign is maintained by taking

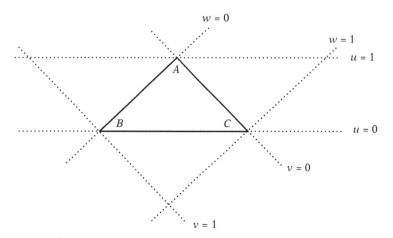

Figure 3.9 Triangle *ABC* with marked "height lines" for $u = 0$, $u = 1$, $v = 0$, $v = 1$, $w = 0$, and $w = 1$.

the dot product of this cross product with the normal of *ABC*. For instance, the signed area for the triangle *PBC* would be computed as

```
SignedArea(PBC) = Dot(Cross(B-P, C-P), Normalize(Cross(B-A, C-A))).
```

Because the area of a triangle can be written as *base · height*/2, and because for each of the previous ratios the triangles involved share the same base, the previous expressions simplify to ratios of heights. Another way of looking at barycentric coordinates is therefore as the components *u*, *v*, and *w* corresponding to the normalized height of the point *P* over each of the edges *BC*, *AC*, and *AB* relative to the height of the edge's opposing vertex. Because the triangle *ABC* is the intersection of the three 2D slabs — each slab defined by the infinite space between two parallel lines (or planes) at height 0 and height 1 of a given triangle edge — it also directly follows why $0 \le u, v, w \le 1$ is required for a point to be inside the triangle (Figure 3.9).

The lines coinciding with the edges of a triangle can also be seen as dividing the triangle plane in seven barycentric regions based on the signs of the barycentric coordinate components: three edge regions, three vertex regions, and the triangle interior (Figure 3.10). These regions are relevant to both mesh traversal and various containment algorithms.

An important property of barycentric coordinates is that they remain invariant under projection. This property allows for a potentially more efficient way of computing the coordinates than given earlier. Instead of computing the areas from the 3D coordinates of the vertices, the calculations can be simplified by projecting all

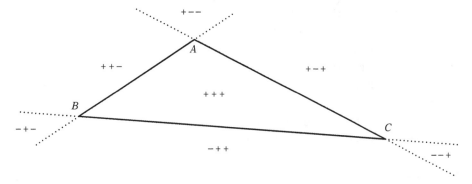

Figure 3.10 Barycentric coordinates divide the plane of the triangle *ABC* into seven regions based on the sign of the coordinate components.

vertices to the *xy, xz,* or *yz* plane. To avoid degeneracies, the projection is made to the plane where the projected areas are the greatest. The largest absolute component value of the triangle normal indicates which component should be dropped during projection.

```
inline float TriArea2D(float x1, float y1, float x2, float y2, float x3, float y3)
{
    return (x1-x2)*(y2-y3) - (x2-x3)*(y1-y2);
}

// Compute barycentric coordinates (u, v, w) for
// point p with respect to triangle (a, b, c)
void Barycentric(Point a, Point b, Point c, Point p, float &u, float &v, float &w)
{
    // Unnormalized triangle normal
    Vector m = Cross(b - a, c - a);
    // Nominators and one-over-denominator for u and v ratios
    float nu, nv, ood;
    // Absolute components for determining projection plane
    float x = Abs(m.x), y = Abs(m.y), z = Abs(m.z);

    // Compute areas in plane of largest projection
    if (x >= y && x >= z) {
        // x is largest, project to the yz plane
        nu = TriArea2D(p.y, p.z, b.y, b.z, c.y, c.z); // Area of PBC in yz plane
        nv = TriArea2D(p.y, p.z, c.y, c.z, a.y, a.z); // Area of PCA in yz plane
        ood = 1.0f / m.x;                             // 1/(2*area of ABC in yz plane)
```

```
    } else if (y >= x && y >= z) {
        // y is largest, project to the xz plane
        nu = TriArea2D(p.x, p.z, b.x, b.z, c.x, c.z);
        nv = TriArea2D(p.x, p.z, c.x, c.z, a.x, a.z);
        ood = 1.0f / -m.y;
    } else {
        // z is largest, project to the xy plane
        nu = TriArea2D(p.x, p.y, b.x, b.y, c.x, c.y);
        nv = TriArea2D(p.x, p.y, c.x, c.y, a.x, a.y);
        ood = 1.0f / m.z;
    }
    u = nu * ood;
    v = nv * ood;
    w = 1.0f - u - v;
}
```

Barycentric coordinates have many uses. Because they are invariant under projection, they can be used to map points between different coordinate systems. They can be used for point-in-triangle testing. Given a vertex-lit triangle, they can also find the corresponding RGB of a specific point within the triangle, which could be used to adjust the ambient color of an object at that position on the triangle. For triangle clipping, they can be used to interpolate any quantity, including colors (Gouraud shading), normals (Phong shading), and texture coordinates (texture mapping). The following code illustrates how barycentric coordinates can be used to test containment of a point P in a triangle ABC.

```
// Test if point p is contained in triangle (a, b, c)
int TestPointTriangle(Point p, Point a, Point b, Point c)
{
    float u, v, w;
    Barycentric(a, b, c, p, u, v, w);
    return v >= 0.0f && w >= 0.0f && (v + w) <= 1.0f;
}
```

A generalized form of barycentric coordinates for irregular n-sided convex polygons is given in [Meyer02]. For $n = 3$, it reduces to the traditional formula for barycentric coordinates. See also [Floater04].

When the barycentric coordinates of a point P ($P = a_0P_0 + a_1P_1 + \cdots + a_nP_n, a_0 + a_1 + \cdots a_n = 1$) with respect to the points P_0, P_1, \ldots, P_n also satisfies $a_0, a_1, \ldots, a_n \geq 0$, P is said to be a *convex combination* of P_0, P_1, \ldots, P_n.

3.5 **Lines, Rays, and Segments**

A *line L* can be defined as the set of points expressible as the linear combination of two arbitrary but distinct points A and B:

$$L(t) = (1 - t)A + t B.$$

Here, t ranges over all real numbers, $-\infty < t < \infty$. The *line segment* (or just *segment*) connecting A and B is a finite portion of the line through A and B, given by limiting t to lie in the range $0 \leq t \leq 1$. A line segment is *directed* if the endpoints A and B are given with a definite order in mind. A *ray* is a half-infinite line similarly defined, but limited only by $t \geq 0$. Figure 3.11 illustrates the difference among a line, a ray, and a line segment.

By rearranging the terms in the parametric equation of the line, the equivalent expression

$$L(t) = A + t\,\mathbf{v} \qquad (\text{where } \mathbf{v} = B - A)$$

is obtained. Rays, in particular, are usually defined in this form. Both forms are referred to as the parametric equation of the line. In 3D, a line L can also be defined implicitly as the set of points X satisfying

$$\| (X - A) \times \mathbf{v} \| = 0,$$

where A is a point on L and \mathbf{v} is a vector parallel to L. This identity follows, because if and only if $X - A$ is parallel to \mathbf{v} does the cross product give a zero vector result (in which case X lies on L, and otherwise it does not). In fact, when \mathbf{v} is a unit vector

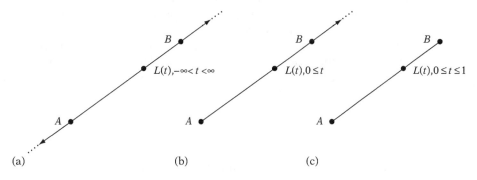

(a) (b) (c)

Figure 3.11 (a) A line. (b) A ray. (c) A line segment.

the distance of a point P from L is given by $\|(P - A) \times \mathbf{v}\|$. This expression relates to the test for collinearity of points, where three or more points are said to be *collinear* when they all lie on a line. The three points A, B, and C are collinear if and only if the area of the triangle ABC is zero. Letting $\mathbf{m} = (B - A) \times (C - A)$, collinearity can be tested by checking if $\|\mathbf{m}\| = 0$, or to avoid a square root if $\mathbf{m} \cdot \mathbf{m}$ is zero. Alternatively, if (m_x, m_y, m_z) are the components of \mathbf{m} the points are collinear if and only if $|m_x| + |m_y| + |m_z|$ is zero.

3.6 **Planes and Halfspaces**

A *plane* in 3D space can be thought of as a flat surface extending indefinitely in all directions. It can be described in several different ways. For example by:

- Three points not on a straight line (forming a triangle on the plane)
- A normal and a point on the plane
- A normal and a distance from the origin

In the first case, the three points A, B, and C allow the parametric representation of the plane P to be given as

$$P(u, v) = A + u(B - A) + v(C - A).$$

For the other two cases, the plane normal is a nonzero vector perpendicular to any vector in the plane. For a given plane, there are two possible choices of normal, pointing in opposite directions. When viewing a plane specified by a triangle ABC so that the three points are ordered counterclockwise, the convention is to define the plane normal as the one pointing toward the viewer. In this case, the plane normal \mathbf{n} is computed as the cross product $\mathbf{n} = (B - A) \times (C - A)$. Points on the same side of the plane as the normal pointing out of the plane are said to be *in front* of the plane. The points on the other side are said to be *behind* the plane.

Given a normal \mathbf{n} and a point P on the plane, all points X on the plane can be categorized by the vector $X - P$ being perpendicular to \mathbf{n}, indicated by the dot product of the two vectors being zero. This perpendicularity gives rise to an implicit equation for the plane, the *point-normal form* of the plane:

$$\mathbf{n} \cdot (X - P) = 0.$$

The dot product is a *linear* operator, which allows it to be distributed across a subtraction or addition. This expression can therefore be written as $\mathbf{n} \cdot X = d$, where

$d = \mathbf{n} \cdot P$, which is the *constant-normal form* of the plane. When \mathbf{n} is unit, $|d|$ equals the distance of the plane from the origin. If \mathbf{n} is not unit, $|d|$ is still the distance, but now in units of the length of \mathbf{n}. When not taking the absolute value, d is interpreted as a signed distance.

The constant-normal form of the plane equation is also often written component-wise as $ax + by + cz - d = 0$, where $\mathbf{n} = (a, b, c)$ and $X = (x, y, z)$. In this text, the $ax + by + cz - d = 0$ form is preferred over its common alternative, $ax + by + cz + d = 0$, as the former tends to remove a superfluous negation (for example, when computing intersections with the plane).

When a plane is precomputed, it is often useful to have the plane normal be a unit vector. The plane normal is made unit by dividing \mathbf{n} (and d, if it has already been computed) by $\|\mathbf{n}\| = \sqrt{a^2 + b^2 + c^2}$. Having a unit plane normal simplifies most operations involving the plane. In these cases, the plane equation is said to be *normalized*. When a normalized plane equation is evaluated for a given point, the obtained result is the signed distance of the point from the plane (negative if the point is behind the plane, otherwise positive).

A plane is computed from three noncollinear points as follows:

```
struct Plane {
    Vector n; // Plane normal. Points x on the plane satisfy Dot(n,x) = d
    float d; // d = dot(n,p) for a given point p on the plane
};

// Given three noncollinear points (ordered ccw), compute plane equation
Plane ComputePlane(Point a, Point b, Point c)
{
    Plane p;
    p.n = Normalize(Cross(b - a, c - a));
    p.d = Dot(p.n, a);
    return p;
}
```

A plane can also be given in a *parameterized* form as

$$P(s, t) = A + s\,\mathbf{u} + t\,\mathbf{v},$$

where \mathbf{u} and \mathbf{v} are two independent vectors in the plane and A is a point on the plane.

When two planes are not parallel to each other, they intersect in a line. Similarly, three planes — no two parallel to each other — intersect in a single point. The angle between two intersecting planes is referred to as the *dihedral angle*.

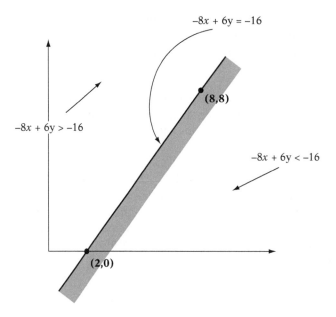

Figure 3.12 The 2D hyperplane $-8x + 6y = -16$ (a line) divides the plane into two halfspaces.

Planes in arbitrary dimensions are referred to as *hyperplanes*: planes with one less dimension than the space they are in. In 2D, hyperplanes correspond to a line; in 3D, to a plane. Any hyperplane divides the space it is in into two infinite sets of points on either side of the plane. These two sets are referred to as *halfspaces* (Figure 3.12). If the points on the dividing plane are considered included in the halfspace, the halfspace is *closed* (otherwise, it is called *open*). The *positive halfspace* lies on the side in which the plane normal points, and the *negative halfspace* on the opposite side of the plane. A 2D halfspace is also called a *halfplane*.

3.7 Polygons

A *polygon* is a closed figure with n sides, defined by an ordered set of three or more points in the plane in such a way that each point is connected to the next (and the last to the first) with a line segment. For a set of n points, the resulting polygon is also called an n-*sided polygon* or just n-*gon*. The line segments that make up the polygon boundary are referred to as the polygon *sides* or *edges*, and the points themselves are called the polygon *vertices* (singular, *vertex*). Two vertices are *adjacent* if they are joined by an edge. Figure 3.13 illustrates the components of a polygon.

A polygon is *simple* if no two nonconsecutive edges have a point in common. A simple polygon partitions the plane into two disjoint parts: the *interior* (the bounded

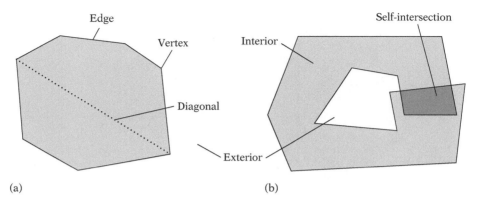

Figure 3.13 The components of a polygon. Polygon (a) is simple, whereas polygon (b) is nonsimple due to self-intersection.

area covered by the polygon) and the *exterior* (the unbounded area outside the polygon). Usually the term *polygon* refers to both the polygon boundary and the interior. A polygon *diagonal* is a line segment that joins two polygon vertices and lies fully inside the polygon. A vertex is a *convex vertex* if the interior angle (the angle between the sides connected to the vertex, measured on the inside of the polygon) is less than or equal to 180 degrees (Figure 3.14a). If the angle is larger than 180 degrees, it is instead called a *concave* (or *reflex*) *vertex* (Figure 3.14b).

A polygon *P* is a *convex polygon* if all line segments between any two points of *P* lie fully inside *P*. A polygon that is not convex is called a *concave polygon*. A polygon with

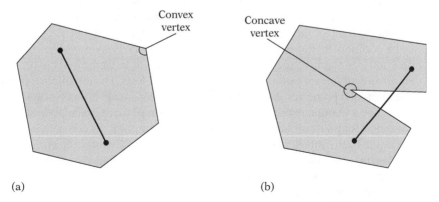

Figure 3.14 (a) For a convex polygon, the line segment connecting any two points of the polygon must lie entirely inside the polygon. (b) If two points can be found such that the segment is partially outside the polygon, the polygon is concave.

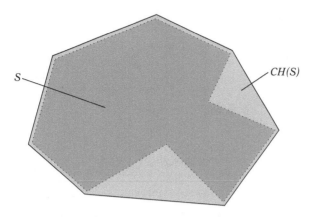

Figure 3.15 Convex hull of a concave **polygon**. A good metaphor for the convex hull is a large rubber band tightening around the **polygonal** object.

one or more concave vertices is necessarily concave, but a polygon with only convex vertices is not always convex (see the next section). The triangle is the only n-sided polygon always guaranteed to be convex. Convex polygons can be seen as a subset of the concept of *convex point sets* in the plane. A convex point set S is a set of points wherein the line segment between any two points in S is also in S. Given a point set S, the *convex hull* of S, denoted $CH(S)$, is the smallest convex point set fully containing S (Figure 3.15). $CH(S)$ can also be described as the intersection of all convex point sets containing S.

Related to the convex hull is the *affine hull, AH(S)*. The affine hull is the lowest dimensional hyperplane that contains all points of S. That is, if S contains just one point, $AH(S)$ is the point; if S contains two points, $AH(S)$ is the line through them; if S contains three noncollinear points, $AH(S)$ is the plane determined by them; and if S contains four (or more) non co-planar points, $AH(S)$ is all of \mathbb{R}^3.

In addition to the explicit vertex representation, convex polygons can also be described as the intersection of a finite number of halfspaces. This representation is convenient for, for example, point containment tests. For the implicit polygon representation, a point lies inside the polygon if it lies inside all halfspaces. Figure 3.16 illustrates a triangle expressed as the intersection of three halfspaces. An alternative definition for point set convexity is therefore that a point set S is convex if and only if S is equal to the intersection of all halfspaces that fully contain S. For polygons (and polyhedra), this is an operative definition in the sense that it can be directly used to implement a convexity test.

Two or more polygons can be joined at their edges to form a *polygon mesh*. In a polygon mesh, the *degree* of a vertex corresponds to the number of edges connected to the vertex. In this text, a mesh will be considered *closed* if all polygons have been joined such that each edge is part of exactly two polygons.

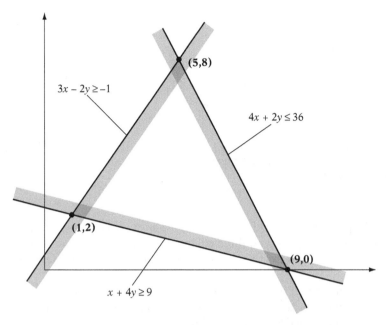

Figure 3.16 A convex polygon can be described as the intersection of a set of (closed) halfspaces. Here, the triangle (1, 2), (9, 0), (5, 8) is defined as the intersection of the halfspaces $x + 4y \geq 9$, $4x + 2y \leq 36$, and $3x - 2y \geq -1$.

3.7.1 Testing Polygonal Convexity

Most intersection tests and other operations performed on polygons in a collision detection system are faster when applied to convex rather than concave polygons, in that simplifying assumptions can be made in the former case. Triangles are nice in this respect, as they are the only type of polygon guaranteed to be convex. However, it may be more efficient to perform an intersection against a single convex n-gon rather than against multiple triangles covering the same area. To guarantee no concave faces are present in the collision geometry database — which would not work with a faster test, specially written for convex faces — all faces should be verified as convex, either at tool time or during runtime (perhaps in a debug build).

Frequently, quadrilaterals (or *quads*, for short) are the only primitives supported in addition to triangles. In such situations, rather than applying a generic convexity test for arbitrary polygons, a simpler convexity test that applies specifically to quads can be used. Assuming all vertices of the quad *ABCD* lie in the same plane, the quad is convex if and only if its two diagonals lie fully in the interior of the quad (Figure 3.17a through c). This test is equivalent to testing if the two line segments *AC* and *BD*, corresponding to the diagonals, intersect each other. If they do, the quad is convex. If they do not, the quad is concave or self-intersecting. If the segments are parallel

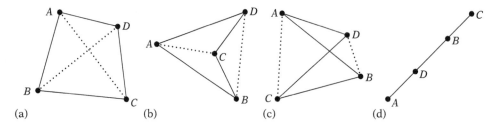

Figure 3.17 Different types of quads. (a) A convex quad. (b) A concave quad (dart). (c) A self-intersecting quad (bowtie). (d) A degenerate quad. The dashed segments illustrate the two diagonals of the quad. The quad is convex if and only if the diagonals transversely intersect.

and overlapping, the quad is degenerate (into a line), as illustrated in Figure 3.17d. To avoid considering a quad with three collinear vertices convex, the segments should only be considered intersecting if they overlap on their interior (and not on their endpoints).

It can be shown that the intersection of the segments is equivalent to the points A and C lying on opposite sides of the line through BD, as well as to the points B and D lying on opposite sides of the line through AC. In turn, this test is equivalent to the triangle BDA having opposite winding to BDC, as well as ACD having opposite winding to ACB. The opposite winding can be detected by computing (using the cross products) the normals of the triangles and examining the sign of the dot product between the normals of the triangles to be compared. If the dot product is negative, the normals point in opposing directions, and the triangles therefore wind in opposite order. To summarize, the quad is therefore convex if

$$(BD \times BA) \cdot (BD \times BC) < 0 \text{ and}$$
$$(AC \times AD) \cdot (AC \times AB) < 0.$$

A straightforward implementation results in the following code:

```
// Test if quadrilateral (a, b, c, d) is convex
int IsConvexQuad(Point a, Point b, Point c, Point d)
{
    // Quad is nonconvex if Dot(Cross(bd, ba), Cross(bd, bc)) >= 0
    Vector bda = Cross(d - b, a - b);
    Vector bdc = Cross(d - b, c - b);
    if (Dot(bda, bdc) >= 0.0f) return 0;
    // Quad is now convex iff Dot(Cross(ac, ad), Cross(ac, ab)) < 0
```

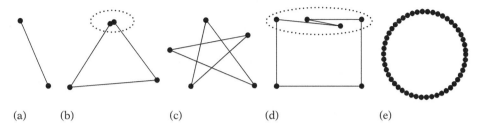

(a) (b) (c) (d) (e)

Figure 3.18 Some inputs likely to be problematic for a convexity test. (a) A line segment. (b) A quad with two vertices coincident. (c) A pentagram. (d) A quadrilateral with two extra vertices collinear with the top edge. (e) Thousands of cocircular points.

```
    Vector acd = Cross(c - a, d - a);
    Vector acb = Cross(c - a, b - a);
    return Dot(acd, acb) < 0.0f;
}
```

Testing two line segments in the plane for intersection is discussed in more detail in Section 5.1.9.1.

For general n-gons, not just quads, a straightforward solution is to, for each polygon edge, test to see if all other vertices lie (strictly) on the same side of that edge. If the test is true for all edges, the polygon is convex, and otherwise it is concave. A separate check for coincident vertices is required to make the test robust. However, although easy to implement, this test is expensive for large polygons, with an $O(n^2)$ complexity in the number of vertices. Polygons involved in collision detection systems are rarely so large that the $O(n^2)$ complexity becomes a problem. It is easy to come up with tests that are faster. However, many of them correctly classify only a subset of convex polygons and incorrectly classify some nonconvex polygons (Figure 3.18). For example, a strictly convex polygon has interior angles that are all less than 180 degrees. However, although this test is a necessary criterion for convexity it is not a sufficient one. Testing the interior angles alone would thus incorrectly conclude that a pentagram is a convex polygon (Figure 3.18c). This test only works if the polygon is known, a priori, not to be self-intersecting.

Another basis for a convexity test is that there are only two changes in direction along any given axis when moving from vertex to vertex of a convex polygon, accounting for wraparound from the first to the last vertex. To detect the zigzag case illustrated in Figure 3.18d, a test for change of direction would have to be performed for two different directions, such as along both the x axis and the y axis. Although seemingly robust, this test fails (for example) when all vertices of an originally convex polygon have been projected onto a single line. It turns out that applying both of these two alternative tests at the same time makes for a rather robust combined test, with the two approaches "covering" for each other (so to speak). An implementation of the combined test is described in [Schorn94].

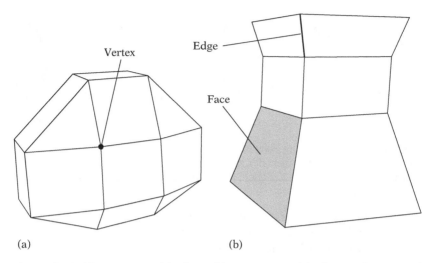

Figure 3.19 (a) A convex polyhedron. (b) A concave polyhedron. A face, an edge, and a vertex have been indicated.

3.8 Polyhedra

A *polyhedron* is the 3D counterpart of a polygon. It is a bounded and connected region of space in the shape of a multifaceted solid. The polyhedron boundary consists of a number of (flat) polygonal faces connected so that each polygon edge is part of exactly two faces (Figure 3.19). Some other definitions of a polyhedron allow it to be unbounded; that is, extending indefinitely in some directions.

As for polygons, the polyhedron boundary divides space into two disjoint regions: the *interior* and the *exterior*. A polyhedron is convex if the point set determined by its interior and boundary is convex. A (bounded) convex polyhedron is also referred to as a *polytope*. Like polygons, polytopes can also be described as the intersection of a finite number of halfspaces.

A d-*simplex* is the convex hull of $d + 1$ affinely independent points in d-dimensional space. A *simplex* (plural *simplices*) is a d-simplex for some given d. For example, the 0-simplex is a point, the 1-simplex is a line segment, the 2-simplex is a triangle, and the 3-simplex is a tetrahedron (Figure 3.20). A simplex has the property that removing a point from its defining set reduces the dimensionality of the simplex by one.

For a general convex set C (thus, not necessarily a polytope), a point from the set most distant along a given direction is called a *supporting point* of C. More specifically, P is a supporting point of C if for a given direction **d** it holds that $\mathbf{d} \cdot P = \max \{\mathbf{d} \cdot V : V \in C\}$; that is, P is a point for which $\mathbf{d} \cdot P$ is maximal. Figure 3.21 illustrates the supporting points for two different convex sets. Supporting points are sometimes called *extreme points*. They are not necessarily unique. For a polytope, one of its vertices can always be selected as a supporting point for a given direction.

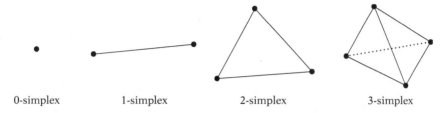

| 0-simplex | 1-simplex | 2-simplex | 3-simplex |

Figure 3.20 Simplices of dimension 0 through 3: a point, a line segment, a triangle, and a tetrahedron.

When a support point is a vertex, the point is commonly called a *supporting vertex.*

A *support mapping* (or *support function*) is a function, $S_C(\mathbf{d})$, associated with a convex set C that maps the direction \mathbf{d} into a supporting point of C. For simple convex shapes — such as spheres, boxes, cones, and cylinders — support mappings can be given in closed form. For example, for a sphere C centered at O and with a radius of r, the support mapping is given by $S_C(\mathbf{d}) = O + r\,\mathbf{d}/\|\mathbf{d}\|$ (Figure 3.21b). Convex shapes of higher complexity require the support mapping function to determine a supporting point using numerical methods.

For a polytope of n vertices, a supporting vertex is trivially found in $O(n)$ time by searching over all vertices. Assuming a data structure listing all adjacent vertex neighbors for each vertex, an extreme vertex can be found through a simple hill-climbing algorithm, greedily visiting vertices more and more extreme until no vertex more extreme can be found. This approach is very efficient, as it explores only a small corridor of vertices as it moves toward the extreme vertex. For larger polyhedra, the hill climbing can be sped up by adding one or more artificial neighbors to the adjacency list for a vertex. Through precomputation of a hierarchical representation of the vertices, it is possible to locate a supporting point in $O(\log n)$ time. These

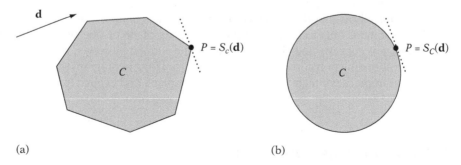

(a) (b)

Figure 3.21 (a) A supporting vertex P of polygon C with respect to the direction \mathbf{d}. (b) A supporting point P of circle C with respect to the direction \mathbf{d}. In both cases, P is given by the support mapping function $S_C(\mathbf{d})$.

ideas of accelerating the search for supporting vertices are further elaborated on in Chapter 9.

A *supporting plane* is a plane through a supporting point with the given direction as the plane normal. A plane is supporting for a polytope if all polytope vertices lie on the same side of the plane as the polytope *centroid*. The centroid of a polytope defined by the vertex set $\{P_1, P_2, \ldots, P_n\}$ is the arithmetic mean of the vertex positions: $(P_1 + P_2 + \cdots + P_n)/n$.

A *separating plane* of two convex sets is a plane such that one set is fully in the positive (open) halfspace and the other fully in the negative (open) halfspace. An axis orthogonal to a separating plane (parallel to its normal) is referred to as a *separating axis*. For two nonintersecting convex sets, it can be shown that a separating axis (or plane) always exists. The same is not necessarily true for concave sets, however. Separating axes are revisited in more detail in Chapter 5.

The surface of a polyhedron is often referred to as a *2-manifold*. This topological term implies that the neighborhood of each point of the surface is topologically equivalent (or *homeomorphic*) to a disk. A polyhedron surface being 2-manifold implies that an edge of the polyhedron must connect to exactly two faces (or the neighborhood of a point on the edge would not be disk-like).

The number of vertices (V), faces (F), and edges (E) of a polyhedron relate according to the *Euler formula* $V + F - E = 2$. It is possible to generalize the Euler formula to hold for polyhedra with holes. The Euler formula is revisited in Chapter 12.

3.8.1 Testing Polyhedral Convexity

Similar to the convexity test for a polygon, a polyhedron P is convex if and only if for all faces of P all vertices of P lie (strictly) on the same side of that face. A separate test for coincident vertices and collinear edges of the polyhedron faces is required to make the test robust, usually with some tolerance added for determining coincidency and collinearity. The complexity of this test is $O(n^2)$.

A faster $O(n)$ approach is to compute for each face F of P the centroid C of F, and for all neighboring faces G of F test if C lies behind the supporting plane of G. If some C fails to lie behind the supporting plane of one or more neighboring faces, P is concave, and is otherwise assumed convex. However, note that just as the corresponding polygonal convexity test may fail for a pentagram this test may fail for, for example, a pentagram extruded out of its plane and capped at the ends.

3.9 Computing Convex Hulls

Among other uses, convex hulls can serve as tight bounding volumes for collision geometry. Many different algorithms for computing convex hulls have been proposed.

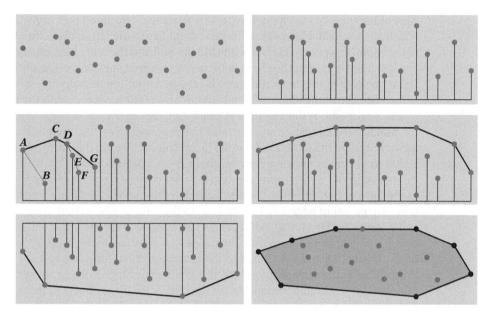

Figure 3.22 Andrew's algorithm. Top left: the point set. Top right: the points sorted (lexicographically) from left to right. Middle left: during construction of the upper chain. Middle right: the completed upper chain. Lower left: the lower chain. Lower right: the two chains together forming the convex hull.

Two of them are briefly described in the next two sections: Andrew's algorithm and the Quickhull algorithm.

3.9.1 **Andrew's Algorithm**

One of the most robust and easy to implement 2D convex hull algorithms is *Andrew's algorithm* [Andrew79]. In its first pass, it starts by sorting all points in the given point set from left to right. In subsequent second and third passes, chains of edges from the leftmost to the rightmost point are formed, corresponding to the upper and lower half of the convex hull, respectively. With the chains created, the hull is obtained by simply connecting the two chains end to end. The process is illustrated in Figure 3.22. The main step lies in the creation of the chains of hull edges. To see how one of the chains is formed, consider the partially constructed upper chain of points, as shown in the middle left-hand illustration. To simplify the presentation, it is assumed there are not multiple points of the same x coordinate (this assumption is lifted further on).

Initially, the two leftmost points, A and B, are taken to form the first edge of the chain. The remaining points are now processed in order, considered one by one for addition to the hull chain. If the next point for consideration lies to the right of the

current last edge of the chain, the point is tentatively assumed part of the hull and is added to the chain. However, if the next point lies to the left of the current last edge of the chain, this point clearly lies outside the hull and the hull chain must be in error. The last point added to the chain is therefore removed, and the test is applied again. The removal of points from the chain is repeated until the next point lies to the right of the last edge of the chain, after which the next point is appended to the hull chain.

The next point in the example is point *C*. *C* lies to the left of edge *AB*, and thus the tentative hull must be in error and *B* is removed from the chain. Because there are no more points to delete (*A* must lie on the hull, being the leftmost point), *C* is added to the chain, making the hull chain *A* − *C*. Next is point *D*, which lies to the right of edge *AC*, and is therefore added to the chain. The next point is *E*, which lies to the right of *CD*, and thus *E* is also added to the chain, as is the next point, *F*. Point *G* lies to the left of edge *EF*, and thus again the tentative hull chain must be in error and *F* is removed from the chain. Next, *G* is found to lie to the left of *DE* as well, and thus *E* is also removed from the chain. Finally, *G* now lies to the right of the last edge on the chain, *CD*, and *G* is added to the chain, which at this point is *A* − *C* − *D* − *G*. Proceeding to the remaining points, the final upper chain ends up as shown in the middle right-hand illustration. An analogous process is applied to form the lower hull chain. Remaining then is to handle the case of multiple points sharing the same *x* coordinate. The straightforward solution is to consider only the topmost point for addition to the upper chain, and only the bottommost point for addition to the lower chain.

It is easy to write an in-situ version of Andrew's algorithm. Thus, it can with benefit be used on point sets represented as arrays.

3.9.2 **The Quickhull Algorithm**

Although Andrew's algorithm works very well in 2D, it is not immediately clear how to extend it to work in 3D. An alternative method that works in both 2D and 3D is the *Quickhull algorithm*. The basic idea of the Quickhull algorithm is very simple, and is illustrated in Figure 3.23 for the 2D case.

In a first step, the bounding box of the point set is obtained, and in the general case the four extreme points of the set (lying on each of the four sides of the bounding box) are located. Because these points are extreme, they must lie on the convex hull, and thus form a quadrilateral "first approximation" of the convex hull (Figure 3.23, top left). As such, any points lying inside this quadrilateral clearly cannot lie on the convex hull of the point set and can be removed from further consideration (Figure 3.23, top right). Some of the points lying outside the quadrilateral must, however, lie on the hull, and thus the approximation is now refined. For each edge of the quadrilateral, the point outside the edge farthest away from the edge (if any) is located. Because each such point is extreme in the direction perpendicularly away from the edge, it must lie on the hull. Therefore, these points are inserted into the hull, between the two points of the edge they were outside of (Figure 3.23, bottom left). Together with the

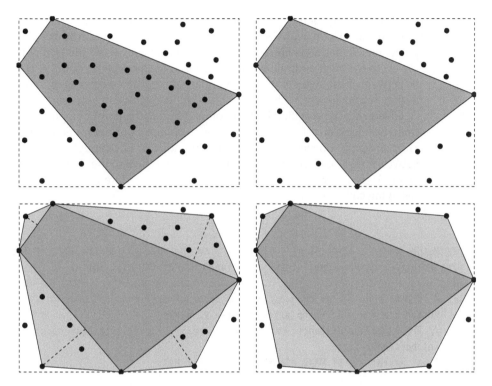

Figure 3.23 First steps of the Quickhull algorithm. Top left: the four extreme points (on the bounding box of the point set) are located. Top right: all points inside the region formed by those points are deleted, as they cannot be on the hull. Bottom left: for each edge of the region, the point farthest away from the edge is located. Bottom right: all points inside the triangular regions so formed are deleted, and at this point the algorithm proceeds recursively by locating the points farthest from the edges of these triangle regions, and so on.

endpoints of the edge, these new points form a triangular region. Just as before, any points located inside this region cannot be on the hull and can be discarded (Figure 3.23, bottom right). The procedure now recursively repeats the same procedure for each new edge that was added to the hull, terminating the recursion when no points lie outside the edges.

Although the preceding paragraph completes the overall algorithm description, two minor complications must be addressed in a robust implementation. The first complication is that the initial hull approximation may not always be a quadrilateral. If an extreme point lies, say, in the bottom left-hand corner, the initial shape may instead be a triangle. If another extreme point lies in the top right-hand corner, it may be a degenerate hull, consisting of only two points. To avoid problems, an implementation must be written to handle an initial hull approximation of a variable number of edges. The second complication is that there might not be a single unique

point on the edge of the initial bounding box, or a single unique point farthest away from an edge. There might be several points on a given bounding box edge, or several points equally far away from an edge. In both cases, one of the two points that lie closest to the edge endpoints must be chosen as the extreme point. Any points that lie between these two points are generally not considered vertices of the convex hull, as they would lie on an edge, collinear with the edge's end vertices.

Given an edge specified by two points A and B, the point of a point set P farthest from the edge can be found by projecting the points onto a perpendicular to the edge. The point projecting farthest along the perpendicular is the sought point. To break ties between two points equally far along the perpendicular, the one projecting farthest along AB is selected as the farthest point. This procedure is illustrated through the following code:

```
// Return index i of point p[i] farthest from the edge ab, to the left of the edge
int PointFarthestFromEdge(Point2D a, Point2D b, Point2D p[], int n)
{
    // Create edge vector and vector (counterclockwise) perpendicular to it
    Vector2D e = b - a, eperp = Vector2D(-e.y, e.x);
    // Track index, 'distance' and 'rightmostness' of currently best point
    int bestIndex = -1;
    float maxVal = -FLT_MAX, rightMostVal = -FLT_MAX;

    // Test all points to find the one farthest from edge ab on the left side
    for (int i = 1; i < n; i++) {
        float d = Dot2D(p[i] - a, eperp); // d is proportional to distance along eperp
        float r = Dot2D(p[i] - a, e); // r is proportional to distance along e
        if (d > maxVal || (d == maxVal && r > rightMostVal)) {
            bestIndex = i;
            maxVal = d;
            rightMostVal = r;
        }
    }
    return bestIndex;
}
```

The Quickhull algorithm can also be made to work in three dimensions (and higher) [Barber96]. In 3D, the initial approximation starts from the (up to) six extreme points that lie on the axis-aligned box that bounds the point set. Now, instead of finding points that are farthest from the edges of a polygon, points farthest from the faces of a polyhedron are located. Instead of breaking the polygon edges up as a new point is inserted into the hull, the polyhedron faces are broken up into two or more faces.

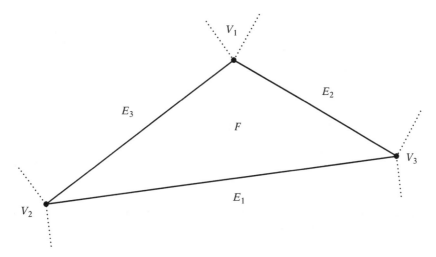

Figure 3.24 A triangle divides its supporting plane into seven Voronoi feature regions: one face region (F), three edge regions (E_1, E_2, E_3), and three vertex regions (V_1, V_2, V_3).

A solid implementation of the Quickhull algorithm, *Qhull* by Brad Barber, is available for download on the Internet. Convex hull algorithms in general are described in some detail in [O'Rourke98].

3.10 Voronoi Regions

A concept important to the design of many intersection tests is that of *Voronoi regions*. Given a set S of points in the plane, the Voronoi region of a point P in S is defined as the set of points in the plane closer to (or as close to) P than to any other points in S. Voronoi regions and the closely related *Voronoi diagrams* (describing the set of points equally close to two or more points in S) come from the field of computational geometry, in which they are used for nearest neighbor queries, among other uses.

Extending the concept of Voronoi regions slightly, it also becomes quite useful for collision detection applications. Given a polyhedron P, let a *feature* of P be one of its vertices, edges, or faces. The Voronoi region of a feature F of P is then the set of points in space closer to (or as close to) F than to any other feature of P. Figure 3.24 illustrates the Voronoi regions determined by the features of a triangle. Three types of Voronoi feature regions of a cube are illustrated in Figure 3.25. The terms *Voronoi region* and *Voronoi feature region* are used interchangeably in this book. It is important not to confuse the Voronoi regions with the barycentric regions discussed in Section 3.4. The boundary planes of a Voronoi region are referred to as *Voronoi planes*.

Given a convex polyhedron P, all points in space exterior to P can be classified as lying in a Voronoi feature region of a vertex, edge, or face of P, with the boundary

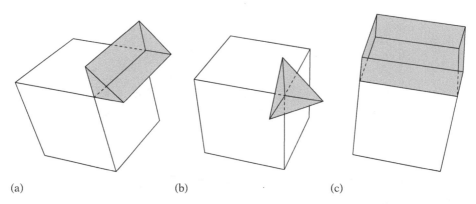

(a) (b) (c)

Figure 3.25 The three types of Voronoi feature regions of a 3D cube. (a) An edge region. (b) A vertex region. (c) A face region.

between two neighboring Voronoi feature regions considered to belong to only one of the regions. Because the Voronoi regions create a partitioning of the space exterior to a polyhedron, they can be used, for instance, to determine the closest point on a convex polyhedral object to some point Q in space. This determination is done by walking from region to region until Q is found to be inside the region. The closest point on the object to Q is then the projection of Q onto the feature with which the given region is associated. For repeated queries, it is possible to exploit coherence by remembering from frame to frame which region the closest point was in and start the new search from there. The concept of Voronoi regions is used in several intersection tests, described in Chapter 5. Voronoi regions are also discussed in Chapter 9, in the context of intersection of convex polyhedra.

3.11 Minkowski Sum and Difference

Two important operations on point sets will be referred to throughout parts of this book. These operations are the *Minkowski sum* and the *Minkowski difference* of point sets. Let A and B be two point sets, and let \mathbf{a} and \mathbf{b} be the position vectors corresponding to pairs of points in A and B. The Minkowski sum, $A \oplus B$, is then defined as the set

$$A \oplus B = \left\{ \mathbf{a} + \mathbf{b} : \mathbf{a} \in A, \mathbf{b} \in B \right\},$$

where $\mathbf{a} + \mathbf{b}$ is the vector sum of the position vectors \mathbf{a} and \mathbf{b}. Visually, the Minkowski sum can be seen as the region swept by A translated to every point in B (or vice versa). An illustration of the Minkowski sum is provided in Figure 3.26.

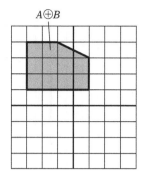

Figure 3.26 The Minkowski sum of a triangle A and a square B.

The Minkowski difference of two point sets A and B is defined analogously to the Minkowski sum:

$$A \ominus B = \{ \mathbf{a} - \mathbf{b} : \mathbf{a} \in A, \mathbf{b} \in B \}.$$

Geometrically, the Minkowski difference is obtained by adding A to the reflection of B about the origin; that is, $A \ominus B = A \oplus (-B)$ (Figure 3.27). For this reason, both terms are often simply referred to as the Minkowski sum. For two convex polygons, P and Q, the Minkowski sum $R = P \oplus Q$ has the properties that R is a convex polygon and the vertices of R are sums of the vertices of P and Q. The Minkowski sum of two convex polyhedra is a convex polyhedron, with corresponding properties.

Minkowski sums both directly and indirectly apply to collision detection. Consider the problem of having a complex object move past a number of other equally complex obstacles. Instead of performing expensive tests on these complex objects, the obstacles can be "grown" by the object at the same time the object is "shrunk," allowing the collision testing of the moving object to be treated as a moving point against the grown obstacles. This idea is further explored in, for example, Chapter 8, in regard to BSP trees.

The Minkowski difference is important from a collision detection perspective because two point sets A and B collide (that is, have one or more points in common) if and only if their Minkowski difference C ($C = A \ominus B$) contains the origin (Figure 3.27). In fact, it is possible to establish an even stronger result: computing the minimum distance between A and B is equivalent to computing the minimum distance between C and the origin. This fact is utilized in the GJK algorithm presented in Chapter 9. The result follows because

$$\text{distance}(A, B) = \min \{ \| \mathbf{a} - \mathbf{b} \| : \mathbf{a} \in A, \mathbf{b} \in B \}$$
$$= \min \{ \| \mathbf{c} \| : \mathbf{c} \in A \ominus B \}.$$

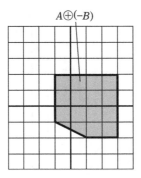

Figure 3.27 Because rectangle *A* and triangle *B* intersect, the origin must be contained in their Minkowski difference.

Note that the Minkowski difference of two convex sets is also a convex set, and thus its point of minimum norm is unique.

There are algorithms for computing the Minkowski sum explicitly (for example, [Bekker01]). In this book, however, the Minkowski sum is primarily used conceptually to help recast a collision problem into an equivalent problem. Occasionally, such as in the GJK algorithm, the Minkowski sum of two objects is computed implicitly.

The Minkowski difference of two objects is also sometimes referred to as the *translational configuration space obstacle* (or TCSO). Queries on the TCSO are said to be performed in *configuration space*.

3.12 **Summary**

Working in the area of collision detection requires a solid grasp of geometry and linear algebra, not to mention mathematics in general. This chapter has reviewed some concepts from these fields, which permeate this book. In particular, it is important to understand fully the properties of dot, cross, and scalar triple products because these are used, for example, in the derivation of virtually all primitive intersection tests (compare Chapter 5). Readers who do not feel comfortable with these math concepts may want to consult linear algebra textbooks, such as those mentioned in the chapter introduction.

This chapter also reviewed a number of geometrical concepts, including points, lines, rays, segments, planes, halfspaces, polygons, and polyhedra. A delightful introduction to these and other geometrical concepts is given in [Mortenson99].

Relevant concepts from computational geometry and from the theory of convex sets were also reviewed. Voronoi regions are important in the computation of closest points. The existence of separating planes and axes for nonintersecting convex objects

allows for efficient tests for the separation of these objects, as further discussed in Chapters 5 and 9. The Minkowski sum and difference operations allow certain collision detection problems to be recast in a different form, which may be easier to compute. Chapters 5 and 9 discuss such transformations as well.

A good introduction to the field of computational geometry is [O'Rourke98]. The theory of convex sets (in the context of convex optimization) is discussed in [Boyd04].

Chapter 4

Bounding Volumes

Directly testing the geometry of two objects for collision against each other is often very expensive, especially when objects consist of hundreds or even thousands of polygons. To minimize this cost, object bounding volumes are usually tested for overlap before the geometry intersection test is performed.

A *bounding volume* (BV) is a single simple volume encapsulating one or more objects of more complex nature. The idea is for the simpler volumes (such as boxes and spheres) to have cheaper overlap tests than the complex objects they bound. Using bounding volumes allows for fast overlap rejection tests because one need only test against the complex bounded geometry when the initial overlap query for the bounding volumes gives a positive result (Figure 4.1).

Of course, when the objects really do overlap, this additional test results in an increase in computation time. However, in most situations few objects are typically close enough for their bounding volumes to overlap. Therefore, the use of bounding volumes generally results in a significant performance gain, and the elimination of complex objects from further tests well justifies the small additional cost associated with the bounding volume test.

For some applications, the bounding volume intersection test itself serves as a sufficient proof of collision. Where it does not, it is still generally worthwhile pruning the contained objects so as to limit further tests to the polygons contained in the overlap of the bounding volumes. Testing the polygons of an object A against the polygons of an object B typically has an $O(n^2)$ complexity. Therefore, if the number of polygons to be tested can be, say, cut in half, the workload will be reduced by 75%. Chapter 6, on bounding volume hierarchies, provides more detail on how to prune object and polygon testing to a minimum. In this chapter, the discussion is limited to tests of pairs of bounding volumes. Furthermore, the tests presented here are primarily homogeneous in that bounding volumes of the same type are tested against each other. It is not uncommon, however, to use several types of bounding volumes at the same time. Several nonhomogeneous BV intersection tests are discussed in the next chapter.

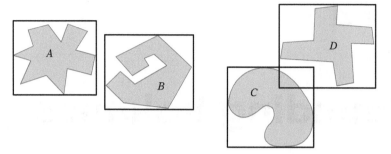

Figure 4.1 The bounding volumes of *A* and *B* do not overlap, and thus *A* and *B* cannot be intersecting. Intersection between *C* and *D* cannot be ruled out because their bounding volumes overlap.

Many geometrical shapes have been suggested as bounding boxes. This chapter concentrates on the shapes most commonly used; namely, spheres, boxes, and convex hull-like volumes. Pointers to a few less common bounding volumes are provided in Section 4.7.

4.1 **Desirable BV Characteristics**

Not all geometric objects serve as effective bounding volumes. Desirable properties for bounding volumes include:

- Inexpensive intersection tests
- Tight fitting
- Inexpensive to compute
- Easy to rotate and transform
- Use little memory

The key idea behind bounding volumes is to precede expensive geometric tests with less expensive tests that allow the test to exit early, a so-called "early out." To support inexpensive overlap tests, the bounding volume must have a simple geometric shape. At the same time, to make the early-out test as effective as possible the bounding volume should also be as tight fitting as possible, resulting in a trade-off between tightness and intersection test cost. The intersection test does not necessarily just cover comparison against volumes of the same type, but might also test against other types of bounding volumes. Additionally, testing may include queries such as

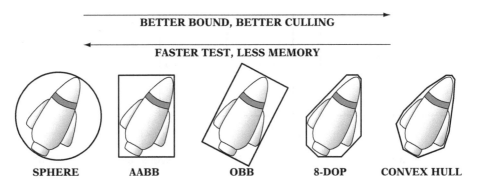

Figure 4.2 Types of bounding volumes: sphere, axis-aligned bounding box (AABB), oriented bounding box (OBB), eight-direction discrete orientation polytope (8-DOP), and convex hull.

point inclusion, ray intersection with the volume, and intersection with planes and polygons.

Bounding volumes are typically computed in a preprocessing step rather than at runtime. Even so, it is important that their construction does not negatively affect resource build times. Some bounding volumes, however, must be realigned at runtime when their contained objects move. For these, if the bounding volume is expensive to compute realigning the bounding volume is preferable (cheaper) to recomputing it from scratch.

Because bounding volumes are stored in addition to the geometry, they should ideally add little extra memory to the geometry. Simpler geometric shapes require less memory space. As many of the desired properties are largely mutually exclusive, no specific bounding volume is the best choice for all situations. Instead, the best option is to test a few different bounding volumes to determine the one most appropriate for a given application. Figure 4.2 illustrates some of the trade-offs among five of the most common bounding volume types. The given ordering with respect to better bounds, better culling, faster tests, and less memory should be seen as a rough, rather than an absolute, guide. The first of the bounding volumes covered in this chapter is the axis-aligned bounding box, described in the next section.

4.2 Axis-aligned Bounding Boxes (AABBs)

The *axis-aligned bounding box* (AABB) is one of the most common bounding volumes. It is a rectangular six-sided box (in 3D, four-sided in 2D) categorized by having its faces oriented in such a way that its face normals are at all times parallel with the axes of the given coordinate system. The best feature of the AABB is its fast overlap check, which simply involves direct comparison of individual coordinate values.

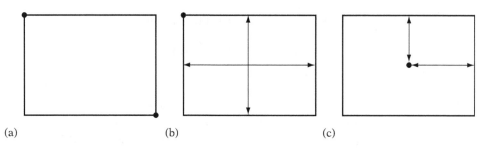

(a) (b) (c)

Figure 4.3 The three common AABB representations: (a) min-max, (b) min-widths, and (c) center-radius.

There are three common representations for AABBs (Figure 4.3). One is by the minimum and maximum coordinate values along each axis:

```
// region R = { (x, y, z) | min.x<=x<=max.x, min.y<=y<=max.y, min.z<=z<=max.z }
struct AABB {
    Point min;
    Point max;
};
```

This representation specifies the BV region of space as that between the two opposing corner points: *min* and *max*. Another representation is as the minimum corner point *min* and the width or diameter extents *dx*, *dy*, and *dz* from this corner:

```
// region R = { (x, y, z) | min.x<=x<=min.x+dx, min.y<=y<=min.y+dy, min.z<=z<=min.z+dz}
struct AABB {
    Point min;
    float d[3];    // diameter or width extents (dx, dy, dz)
};
```

The last representation specifies the AABB as a center point C and halfwidth extents or radii *rx*, *ry*, and *rz* along its axes:

```
// region R = { (x, y, z) | |c.x-x|<=rx, |c.y-y|<=ry, |c.z-z|<=rz }
struct AABB {
    Point c; // center point of AABB
    float r[3]; // radius or halfwidth extents (rx, ry, rz)
};
```

In terms of storage requirements, the center-radius representation is the most efficient, as the halfwidth values can often be stored in fewer bits than the center position values. The same is true of the width values of the min-width representation, although to a slightly lesser degree. Worst is the min-max representation, in which all six values have to be stored at the same precision. Reducing storage requires representing the AABB using integers, and not floats, as used here. If the object moves by translation only, updating the latter two representations is cheaper than the min-max representation because only three of the six parameters have to be updated. A useful feature of the center-radius representation is that it can be tested as a bounding sphere as well.

4.2.1 AABB-AABB Intersection

Overlap tests between AABBs are straightforward, regardless of representation. Two AABBs only overlap if they overlap on all three axes, where their extent along each dimension is seen as an interval on the corresponding axis. For the min-max representation, this interval overlap test becomes:

```
int TestAABBAABB(AABB a, AABB b)
{
    // Exit with no intersection if separated along an axis
    if (a.max[0] < b.min[0] || a.min[0] > b.max[0]) return 0;
    if (a.max[1] < b.min[1] || a.min[1] > b.max[1]) return 0;
    if (a.max[2] < b.min[2] || a.min[2] > b.max[2]) return 0;
    // Overlapping on all axes means AABBs are intersecting
    return 1;
}
```

The min-width representation is the least appealing. Its overlap test, even when written in an economical way, still does not compare with the first test in terms of number of operations performed:

```
int TestAABBAABB(AABB a, AABB b)
{
    float t;
    if ((t = a.min[0] - b.min[0]) > b.d[0] || -t > a.d[0]) return 0;
    if ((t = a.min[1] - b.min[1]) > b.d[1] || -t > a.d[1]) return 0;
    if ((t = a.min[2] - b.min[2]) > b.d[2] || -t > a.d[2]) return 0;
    return 1;
}
```

Finally, the center-radius representation results in the following overlap test:

```
int TestAABBAABB(AABB a, AABB b)
{
    if (Abs(a.c[0] - b.c[0]) > (a.r[0] + b.r[0])) return 0;
    if (Abs(a.c[1] - b.c[1]) > (a.r[1] + b.r[1])) return 0;
    if (Abs(a.c[2] - b.c[2]) > (a.r[2] + b.r[2])) return 0;
    return 1;
}
```

On modern architectures, the **Abs()** call typically translates into just a single instruction. If not, the function can be effectively implemented by simply stripping the sign bit of the binary representation of the floating-point value. When the AABB fields are declared as integers instead of floats, an alternative test for the center-radius representation can be performed as follows. With integers, overlap between two ranges $[A, B]$ and $[C, D]$ can be determined by the expression

```
overlap = (unsigned int)(B - C) <= (B - A) + (D - C);
```

By forcing an unsigned underflow in the case when $C > B$, the left-hand side becomes an impossibly large value, rendering the expression false. The forced overflow effectively serves to replace the absolute value function call and allows the center-radius representation test to be written as:

```
int TestAABBAABB(AABB a, AABB b)
{
    int r;
    r = a.r[0] + b.r[0]; if ((unsigned int)(a.c[0] - b.c[0] + r) > r + r) return 0;
    r = a.r[1] + b.r[1]; if ((unsigned int)(a.c[1] - b.c[1] + r) > r + r) return 0;
    r = a.r[2] + b.r[2]; if ((unsigned int)(a.c[2] - b.c[2] + r) > r + r) return 0;
    return 1;
}
```

Working in integers allows other implementational tricks, many of which are architecture dependent. SIMD instructions, if present, typically allow AABB tests to be implemented in just a few instructions worth of code (examples of which are found in Chapter 13). Finally, in a collision detection system that has to perform a massive number of overlap tests it may be worthwhile ordering the tests according to the likelihood of their being taken. For instance, if operations largely take place in an almost flat xz plane the y-coordinate test should be performed last, as it is least discriminatory.

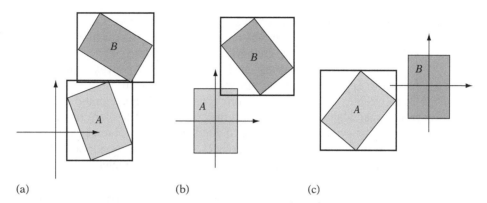

(a) (b) (c)

Figure 4.4 (a) AABBs *A* and *B* in world space. (b) The AABBs in the local space of *A*. (c) The AABBs in the local space of *B*.

4.2.2 **Computing and Updating AABBs**

Bounding volumes are usually specified in the local model space of the objects they bound (which may be world space). To perform an overlap query between two bounding volumes, the volumes must be transformed into a common coordinate system. The choice stands between transforming both bounding volumes into world space and transforming one bounding volume into the local space of the other. One benefit of transforming into local space is that it results in having to perform half the work of transformation into world space. It also often results in a tighter bounding volume than does transformation into world space. Figure 4.4 illustrates the concept. The recalculated AABBs of objects *A* and *B* overlap in world space (Figure 4.4a). However, in the space of object *B*, the objects are found to be separated (Figure 4.4c).

Accuracy is another compelling reason for transforming one bounding volume into the local space of the other. A world space test may move both objects far away from the origin. The act of adding in the translation during transformation of the local near-origin coordinates of the bounding volume can force many (or even all) bits of precision of the original values to be lost. For local space tests, the objects are kept near the origin and accuracy is maintained in the calculations. Note, however, that by adjusting the translations so that the transformed objects are centered on the origin world space transformations can be made to maintain accuracy as well.

Transformation into world space becomes interesting when updated bounding volumes can be temporarily cached for the duration of a time step. By caching a bounding volume after transformation, any bounding volume has to be transformed just once into any given space. As all bounding volumes are transformed into the same space when transforming into world space, this becomes a win in situations in which objects are being checked for overlap multiple times. In contrast, caching updated bounding volumes does not help at all when transforming into the local space of other bounding volumes, as all transformations involve either new objects

or new target coordinate systems. Caching of updated bounding volumes has the drawback of nearly doubling the required storage space, as most fields of a bounding volume representation are changed during an update.

Some bounding volumes, such as spheres or convex hulls, naturally transform into any coordinate system, as they are not restricted to specific orientations. Consequently, they are called nonaligned or (freely) oriented bounding volumes. In contrast, aligned bounding volumes (such as AABBs) are restricted in what orientations they can assume. The aligned bounding volumes must be realigned as they become unaligned due to object rotation during motion. For updating or reconstructing the AABB, there are four common strategies:

- Utilizing a fixed-size loose AABB that always encloses the object
- Computing a tight dynamic reconstruction from the original point set
- Computing a tight dynamic reconstruction using hill climbing
- Computing an approximate dynamic reconstruction from the rotated AABB

The next four sections cover these approaches in more detail.

4.2.3 AABB from the Object Bounding Sphere

The first method completely circumvents the need to reshape the AABB by making it large enough to contain the object at any orientation. This fixed-size encompassing AABB is computed as the bounding box of the bounding sphere of the contained object A. The bounding sphere, in turn, is centered in the pivot point P that A rotates about. Its radius r is the distance to the farthest object vertex from this center (as illustrated in Figure 4.5). By making sure the object pivot P lies in the center of the object, the sphere radius is minimized.

The benefit of this representation is that during update this AABB simply need be translated (by the same translation applied to the bounded object), and any object rotation can be completely ignored. However, the bounding sphere itself (which has a better sound than the AABB) would also have this property. Thus, bounding spheres should be considered a potential better choice of bounding volume in this case.

4.2.4 AABB Reconstructed from Original Point Set

The update strategy described in this section (as well as the remaining two update strategies to be described) dynamically resizes the AABB as it is being realigned with the coordinate system axes. For a tightly fitted bounding box, the underlying geometry of the bounded object is examined and the box bounds are established by finding the extreme vertices in all six directions of the coordinate axes. The straightforward approach loops through all vertices, keeping track of the vertex most distant along

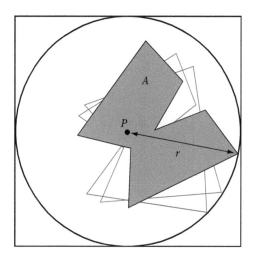

Figure 4.5 AABB of the bounding sphere that fully contains object *A* under an arbitrary orientation.

the direction vector. This distance can be computed through the projection of the vertex vector onto the direction vector. For comparison reasons, it is not necessary to normalize the direction vector. This procedure is illustrated in the following code, which finds both the least and most distant points along a direction vector:

```
// Returns indices imin and imax into pt[] array of the least and
// most, respectively, distant points along the direction dir
void ExtremePointsAlongDirection(Vector dir, Point pt[], int n, int *imin, int *imax)
{
    float minproj = FLT_MAX, maxproj = -FLT_MAX;
    for (int i = 0; i < n; i++) {
        // Project vector from origin to point onto direction vector
        float proj = Dot(pt[i], dir);
        // Keep track of least distant point along direction vector
        if (proj < minproj) {
            minproj = proj;
            *imin = i;
        }
        // Keep track of most distant point along direction vector
        if (proj > maxproj) {
            maxproj = proj;
            *imax = i;
        }
    }
}
```

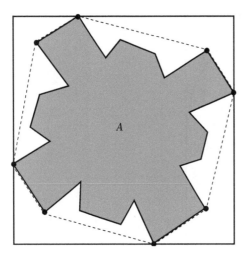

Figure 4.6 When computing a tight AABB, only the highlighted vertices that lie on the convex hull of the object must be considered.

When n is large, this $O(n)$ procedure can be expensive if performed at runtime. Preprocessing of the vertex data can serve to speed up the process. One simple approach that adds no extra data is based on the fact that only the vertices on the convex hull of the object can contribute to determining the bounding volume shape (Figure 4.6). In the preprocessing step, all k vertices on the convex hull of the object would be stored so that they come before all remaining vertices. Then, a tight AABB could be constructed by examining these k first vertices only. For general concave volumes this would be a win, but a convex volume, which already has all of its vertices on its convex hull, would see no improvement.

By use of additional, dedicated, precomputed search structures, locating extremal vertices can be performed in $O(\log n)$ time. For instance, the Dobkin–Kirkpatrick hierarchy (described in Chapter 9) can be used for this purpose. However, due to the extra memory required by these structures, as well as the overhead in traversing them, they have to be considered overkill in most circumstances. Certainly if tight bounding volumes are that important, tighter bounding volumes than AABBs should be considered.

4.2.5 **AABB from Hill-climbing Vertices of the Object Representation**

Another way to speed up the AABB realignment process is to use an object representation in which neighboring vertices of a vertex can be found quickly. Such a representation allows the extreme vertices that define the new AABB to be located through simple hill climbing (Figure 4.7).

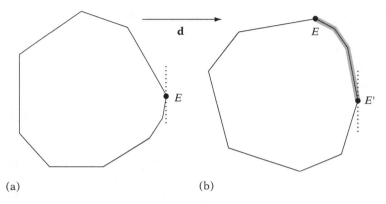

Figure 4.7 (a) The extreme vertex *E* in direction **d**. (b) After object rotates counterclockwise, the new extreme vertex *E'* in direction **d** can be obtained by hill climbing along the vertex path highlighted in gray.

Instead of keeping track of the minimum and maximum extent values along each axis, six vertex pointers are maintained. Corresponding to the same values as before, these now actually point at the (up to six) extremal vertices of the object along each axis direction. The hill-climbing step now proceeds by comparing the referenced vertices against their neighbor vertices to see if they are still extremal in the same direction as before. Those that are not are replaced with one of their more extreme neighbors and the test is repeated until the extremal vertex in that direction is found. So as not to get stuck in local minima, the hill-climbing process requires objects to be convex. For this reason, hill climbing is performed on precalculated convex hulls of nonconvex objects. Overall, this recalculation of the tight AABB is an expected constant-time operation.

Only having to transform vertices when actually examined by the hill-climbing process greatly reduces computational effort. However, this can be further improved by the realization that only one of the *x*, *y*, or *z* components is used in finding the extremal vertex along a given axis. For instance, when finding the extremal point along the +*x* axis only the *x* components of the transformed vertices need to be computed. Hence, the transformational cost is reduced by two-thirds.

Some care must be taken in order to write a robust implementation of this hill-climbing method. Consider an extremal vertex along any axis surrounded by coplanar vertices only. If the object now rotates 180 degrees about any of the remaining two axes, the vertex becomes extremal along the opposite direction along the same axis. However, as it is surrounded by co-planar vertices, the hill-climbing step cannot find a better neighboring vertex and thus terminates with a vertex that is, in fact, the least extremal in the sought direction! A robust implementation must special-case this situation. Alternatively, coplanar vertices can be removed in a preprocessing step, as described in Chapter 12. The problem of finding extremal vertices is revisited in Section 9.5.4.

4.2.6 **AABB Recomputed from Rotated AABB**

Last of the four realignment methods, the most common approach is to simply wrap the rotated AABB itself in a new AABB. This produces an approximate rather than a tight AABB. As the resulting AABB is larger than the one that was started with, it is important that the approximate AABB is computed from a rotation of the original local-space AABB. If not, repeated recomputing from the rotated AABB of the previous time step would make the AABB grow indefinitely.

Consider an axis-aligned bounding box A affected by a rotation matrix \mathbf{M}, resulting in an oriented bounding box A' at some orientation. The three columns (or rows, depending on what matrix convention is used) of the rotation matrix \mathbf{M} give the world-coordinate axes of A' in its local coordinate frame. (If vectors are column vectors and multiplied on the right of the matrix, then the columns of \mathbf{M} are the axes. If instead the vectors are multiplied on the left of the matrix as row vectors, then the rows of \mathbf{M} are the axes.)

Say A is given using min-max representation and \mathbf{M} is a column matrix. The axis-aligned bounding box B that bounds A' is specified by the extent intervals formed by the projection of the eight rotated vertices of A' onto the world-coordinate axes. For, say, the x extents of B, only the x components of the column vectors of \mathbf{M} contribute. Therefore, finding the extents corresponds to finding the vertices that produce the minimal and maximal products with the rows of \mathbf{M}. Each vertex of B is a combination of three transformed min or max values from A. The minimum extent value is the sum of the smaller terms, and the maximum extent is the sum of the larger terms. Translation does not affect the size calculation of the new bounding box and can just be added in. For instance, the maximum extent along the x axis can be computed as:

```
B.max[0] = max(m[0][0] * A.min[0], m[0][0] * A.max[0])
         + max(m[0][1] * A.min[1], m[0][1] * A.max[1])
         + max(m[0][2] * A.min[2], m[0][2] * A.max[2]) + t[0];
```

Computing an encompassing bounding box for a rotated AABB using the min-max representation can therefore be implemented as follows:

```
// Transform AABB a by the matrix m and translation t,
// find maximum extents, and store result into AABB b.
void UpdateAABB(AABB a, float m[3][3], float t[3], AABB &b)
{
    // For all three axes
    for (int i = 0; i < 3; i++) {
        // Start by adding in translation
        b.min[i] = b.max[i] = t[i];
        // Form extent by summing smaller and larger terms respectively
```

```
        for (int j = 0; j < 3; j++) {
            float e = m[i][j] * a.min[j];
            float f = m[i][j] * a.max[j];
            if (e < f) {
                b.min[i] += e;
                b.max[i] += f;
            } else {
                b.min[i] += f;
                b.max[i] += e;
            }
        }
    }
}
```

Correspondingly, the code for the center-radius AABB representation becomes [Arvo90]:

```
// Transform AABB a by the matrix m and translation t,
// find maximum extents, and store result into AABB b.
void UpdateAABB(AABB a, float m[3][3], float t[3], AABB &b)
{
    for (int i = 0; i < 3; i++) {
        b.c[i] = t[i];
        b.r[i] = 0.0f;
        for (int j = 0; j < 3; j++) {
            b.c[i] += m[i][j] * a.c[j];
            b.r[i] += Abs(m[i][j]) * a.r[j];
        }
    }
}
```

Note that computing an AABB from a rotated AABB is equivalent to computing it from a freely oriented bounding box. Oriented bounding boxes and their intersection tests will be described in more detail ahead. However, classed between the methods presented here and those to be presented would be the method of storing oriented bounding boxes with the objects but still intersecting them as reconstructed AABBs (as done here). Doing so would require extra memory for storing the orientation matrix. It would also involve an extra matrix-matrix multiplication for combining the rotation matrix of the oriented bounding box with the transformation matrix **M**. The benefit of this solution is that the reconstructed axis-aligned box would be much tighter, starting with an oriented box. The axis-aligned test is also much cheaper than the full-blown test for oriented boxes.

4.3 **Spheres**

The sphere is another very common bounding volume, rivaling the axis-aligned bounding box in popularity. Like AABBs, spheres have an inexpensive intersection test. Spheres also have the benefit of being rotationally invariant, which means that they are trivial to transform: they simply have to be translated to their new position. Spheres are defined in terms of a center position and a radius:

```
// Region R = { (x, y, z) | (x-c.x)^2 + (y-c.y)^2 + (z-c.z)^2 <= r^2 }
struct Sphere {
    Point c;  // Sphere center
    float r;  // Sphere radius
};
```

At just four components, the bounding sphere is the most memory-efficient bounding volume. Often a preexisting object center or origin can be adjusted to coincide with the sphere center, and only a single component, the radius, need be stored. Computing an optimal bounding sphere is not as easy as computing an optimal axis-aligned bounding box. Several methods of computing bounding spheres are examined in the following sections, in order of increasing accuracy, concluding with an algorithm for computing the minimum bounding sphere. The methods explored for the nonoptimal approximation algorithms remain relevant in that they can be applied to other bounding volumes.

4.3.1 **Sphere-sphere Intersection**

The overlap test between two spheres is very simple. The Euclidean distance between the sphere centers is computed and compared against the sum of the sphere radii. To avoid an often expensive square root operation, the squared distances are compared. The test looks like this:

```
int TestSphereSphere(Sphere a, Sphere b)
{
    // Calculate squared distance between centers
    Vector d = a.c - b.c;
    float dist2 = Dot(d, d);
    // Spheres intersect if squared distance is less than squared sum of radii
    float radiusSum = a.r + b.r;
    return dist2 <= radiusSum * radiusSum;
}
```

Although the sphere test has a few more arithmetic operations than the AABB test, it also has fewer branches and requires fewer data to be fetched. In modern architectures, the sphere test is probably barely faster than the AABB test. However, the speed of these simple tests should not be a guiding factor in choosing between the two. Tightness to the actual data is a far more important consideration.

4.3.2 Computing a Bounding Sphere

A simple approximative bounding sphere can be obtained by first computing the AABB of all points. The midpoint of the AABB is then selected as the sphere center, and the sphere radius is set to be the distance to the point farthest away from this center point. Note that using the geometric center (the mean) of all points instead of the midpoint of the AABB can give extremely bad bounding spheres for nonuniformly distributed points (up to twice the needed radius). Although this is a fast method, its fit is generally not very good compared to the optimal method.

An alternative approach to computing a simple approximative bounding sphere is described in [Ritter90]. This algorithm tries to find a good initial almost-bounding sphere and then in a few steps improve it until it does bound all points. The algorithm progresses in two passes. In the first pass, six (not necessarily unique) extremal points along the coordinate system axes are found. Out of these six points, the pair of points farthest apart is selected. (Note that these two points do not necessarily correspond to the points defining the longest edge of the AABB of the point set.) The sphere center is now selected as the midpoint between these two points, and the radius is set to be half the distance between them. The code for this first pass is given in the functions **MostSeparatedPointsOnAABB()** and **SphereFromDistantPoints()** of the following:

```
// Compute indices to the two most separated points of the (up to) six points
// defining the AABB encompassing the point set. Return these as min and max.
void MostSeparatedPointsOnAABB(int &min, int &max, Point pt[], int numPts)
{
    // First find most extreme points along principal axes
    int minx = 0, maxx = 0, miny = 0, maxy = 0, minz = 0, maxz = 0;
    for (int i = 1; i < numPts; i++) {
        if (pt[i].x < pt[minx].x) minx = i;
        if (pt[i].x > pt[maxx].x) maxx = i;
        if (pt[i].y < pt[miny].y) miny = i;
        if (pt[i].y > pt[maxy].y) maxy = i;
        if (pt[i].z < pt[minz].z) minz = i;
        if (pt[i].z > pt[maxz].z) maxz = i;
    }
```

```
    // Compute the squared distances for the three pairs of points
    float dist2x = Dot(pt[maxx] - pt[minx], pt[maxx] - pt[minx]);
    float dist2y = Dot(pt[maxy] - pt[miny], pt[maxy] - pt[miny]);
    float dist2z = Dot(pt[maxz] - pt[minz], pt[maxz] - pt[minz]);
    // Pick the pair (min,max) of points most distant
    min = minx;
    max = maxx;
    if (dist2y > dist2x && dist2y > dist2z) {
        max = maxy;
        min = miny;
    }
    if (dist2z > dist2x && dist2z > dist2y) {
        max = maxz;
        min = minz;
    }
}

void SphereFromDistantPoints(Sphere &s, Point pt[], int numPts)
{
    // Find the most separated point pair defining the encompassing AABB
    int min, max;
    MostSeparatedPointsOnAABB(min, max, pt, numPts);

    // Set up sphere to just encompass these two points
    s.c = (pt[min] + pt[max]) * 0.5f;
    s.r = Dot(pt[max] - s.c, pt[max] - s.c);
    s.r = Sqrt(s.r);
}
```

In the second pass, all points are looped through again. For all points outside the current sphere, the sphere is updated to be the sphere just encompassing the old sphere and the outside point. In other words, the new sphere diameter spans from the outside point to the point on the backside of the old sphere opposite the outside point, with respect to the old sphere center.

```
    // Given Sphere s and Point p, update s (if needed) to just encompass p
    void SphereOfSphereAndPt(Sphere &s, Point &p)
    {
        // Compute squared distance between point and sphere center
        Vector d = p - s.c;
        float dist2 = Dot(d, d);
        // Only update s if point p is outside it
```

```
    if (dist2 > s.r * s.r) {
        float dist = Sqrt(dist2);
        float newRadius = (s.r + dist) * 0.5f;
        float k = (newRadius - s.r) / dist;
        s.r = newRadius;
        s.c += d * k;
    }
}
```

The full code for computing the approximate bounding sphere becomes:

```
void RitterSphere(Sphere &s, Point pt[], int numPts)
{
    // Get sphere encompassing two approximately most distant points
    SphereFromDistantPoints(s, pt, numPts);

    // Grow sphere to include all points
    for (int i = 0; i < numPts; i++)
        SphereOfSphereAndPt(s, pt[i]);
}
```

By starting with a better approximation of the true bounding sphere, the resulting sphere could be expected to be even tighter. Using a better starting approximation is explored in the next section.

4.3.3 Bounding Sphere from Direction of Maximum Spread

Instead of finding a pair of distant points using an AABB, as in the previous section, a suggested approach is to analyze the point cloud using statistical methods to find its direction of maximum spread [Wu92]. Given this direction, the two points farthest away from each other when projected onto this axis would be used to determine the center and radius of the starting sphere. Figure 4.8 indicates the difference in spread for two different axes for the same point cloud.

Just as the mean of a set of data values (that is, the sum of all values divided by the number of values) is a measure of the central tendency of the values, *variance* is a measure of their dispersion, or spread. The mean u and the variance σ^2 are given by

$$u = \frac{1}{n} \sum_{i=1}^{n} x_i,$$

$$\sigma^2 = \frac{1}{n} \sum_{i=1}^{n} (x_i - u)^2 = \frac{1}{n} \left(\sum_{i=1}^{n} x_i^2 \right) - u^2.$$

The square root of the variance is known as the *standard deviation*. For values spread along a single axis, the variance is easily computed as the average of the squared deviation of the values from the mean:

```
// Compute variance of a set of 1D values
float Variance(float x[], int n)
{
    float u = 0.0f;
    for (int i = 0; i < n; i++)
        u += x[i];
    u /= n;
    float s2 = 0.0f;
    for (int i = 0; i < n; i++)
        s2 += (x[i] - u) * (x[i] - u);
    return s2 / n;
}
```

Usually there is no obvious direct interpretation of variance and standard deviation. They are, however, important as comparative measures. For two variables, the *covariance* measures their tendency to vary together. It is computed as the average of products of deviation of the variable values from their means. For multiple variables, the covariance of the data is conventionally computed and expressed as a matrix, the *covariance matrix* (also referred to as the variance-covariance or dispersion matrix).

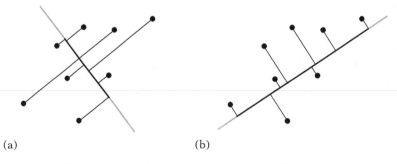

(a) (b)

Figure 4.8 The same point cloud projected onto two different axes. In (a) the spread on the axis is small. In (b) the spread is much larger. A bounding sphere can be determined from the axis for which the projected point set has the maximum spread.

The covariance matrix $\mathbf{C} = [c_{ij}]$ for a collection of n points P_1, P_2, \ldots, P_n is given by

$$c_{ij} = \frac{1}{n} \sum_{k=1}^{n} (P_{k,i} - u_i)(P_{k,j} - u_j),$$

or equivalently by

$$c_{ij} = \frac{1}{n} \left(\sum_{k=1}^{n} P_{k,i} P_{k,j} \right) - u_i u_j.$$

The u_i (and u_j) term is the mean of the i-th coordinate value of the points, given by

$$u_i = \frac{1}{n} \sum_{k=1}^{n} P_{k,i}.$$

Informally, to see how covariance works, consider the first covariance formula. When two variables tend to deviate in the same direction from their respective means, the product,

$$(P_{k,i} - u_i)(P_{k,j} - u_j),$$

will be positive more often than negative. If the variables tend to deviate in different directions, the product will be negative more often than positive. The sum of these products identifies how the variables co-vary. When implemented using single-precision floats, the former of the two covariance formulas tends to produce results that are more accurate by retaining more bits of precision. Using double precision, there is typically little or no difference in the results. The following code implements the first formula:

```
void CovarianceMatrix(Matrix33 &cov, Point pt[], int numPts)
{
    float oon = 1.0f / (float)numPts;
    Point c = Point(0.0f, 0.0f, 0.0f);
    float e00, e11, e22, e01, e02, e12;

    // Compute the center of mass (centroid) of the points
    for (int i = 0; i < numPts; i++)
```

```
        c += pt[i];
    c *= oon;

    // Compute covariance elements
    e00 = e11 = e22 = e01 = e02 = e12 = 0.0f;
    for (int i = 0; i < numPts; i++) {
        // Translate points so center of mass is at origin
        Point p = pt[i] - c;
        // Compute covariance of translated points
        e00 += p.x * p.x;
        e11 += p.y * p.y;
        e22 += p.z * p.z;
        e01 += p.x * p.y;
        e02 += p.x * p.z;
        e12 += p.y * p.z;
    }
    // Fill in the covariance matrix elements
    cov[0][0] = e00 * oon;
    cov[1][1] = e11 * oon;
    cov[2][2] = e22 * oon;
    cov[0][1] = cov[1][0] = e01 * oon;
    cov[0][2] = cov[2][0] = e02 * oon;
    cov[1][2] = cov[2][1] = e12 * oon;
}
```

Once the covariance matrix has been computed, it can be decomposed in a manner that reveals more about the principal directions of the variance. This decomposition is performed by computing the eigenvalues and eigenvectors of the matrix. The relationship between these is such that the eigenvector associated with the largest magnitude eigenvalue corresponds to the axis along which the point data has the largest variance. Similarly, the eigenvector associated with the smallest magnitude eigenvalue is the axis along which the data has the least variance. Robustly finding the eigenvalues and eigenvectors of a matrix is a nontrivial task in general. Typically, they are found using some (iterative) numerical technique (for which a good source is [Golub96]).

By definition, the covariance matrix is always symmetric. As a result, it decomposes into real (rather than complex) eigenvalues and an orthonormal basis of eigenvectors. For symmetric matrices, a simpler decomposition approach can be used. For a moderate-size matrix, as here, the Jacobi method works quite well. The intricate details of the Jacobi method are beyond the scope of this book. Briefly, however, the algorithm performs a number of transformation steps to the given input matrix. Each step consists of applying a rotation to the matrix, bringing the matrix closer and closer to a diagonal matrix (all elements zero, except along the diagonal). When the matrix is diagonal, the elements on the diagonal are the eigenvalues. While this is

done, all rotations are also concatenated into another matrix. Upon exit, this matrix will contain the eigenvectors. Ideally, this decomposition should be performed in double-precision arithmetic to minimize numerical errors. The following code for the Jacobi method is based on the presentation in [Golub96]. First is a subroutine for assisting in computing the rotation matrix.

```
// 2-by-2 Symmetric Schur decomposition. Given an n-by-n symmetric matrix
// and indices p, q such that 1 <= p < q <= n, computes a sine-cosine pair
// (s, c) that will serve to form a Jacobi rotation matrix.
//
// See Golub, Van Loan, Matrix Computations, 3rd ed, p428
void SymSchur2(Matrix33 &a, int p, int q, float &c, float &s)
{
    if (Abs(a[p][q]) > 0.0001f) {
        float r = (a[q][q] - a[p][p]) / (2.0f * a[p][q]);
        float t;
        if (r >= 0.0f)
            t = 1.0f / (r + Sqrt(1.0f + r*r));
        else
            t = -1.0f / (-r + Sqrt(1.0f + r*r));
        c = 1.0f / Sqrt(1.0f + t*t);
        s = t * c;
    } else {
        c = 1.0f;
        s = 0.0f;
    }
}
```

Given this support function, the full Jacobi method is now implemented as:

```
// Computes the eigenvectors and eigenvalues of the symmetric matrix A using
// the classic Jacobi method of iteratively updating A as A = J^T * A * J,
// where J = J(p, q, theta) is the Jacobi rotation matrix.
//
// On exit, v will contain the eigenvectors, and the diagonal elements
// of a are the corresponding eigenvalues.
//
// See Golub, Van Loan, Matrix Computations, 3rd ed, p428
void Jacobi(Matrix33 &a, Matrix33 &v)
{
    int i, j, n, p, q;
```

```
float prevoff, c, s;
Matrix33 J, b, t;

// Initialize v to identify matrix
for (i = 0; i < 3; i++) {
    v[i][0] = v[i][1] = v[i][2] = 0.0f;
    v[i][i] = 1.0f;
}

// Repeat for some maximum number of iterations
const int MAX_ITERATIONS = 50;
for (n = 0; n < MAX_ITERATIONS; n++) {
    // Find largest off-diagonal absolute element a[p][q]
    p = 0; q = 1;
    for (i = 0; i < 3; i++) {
        for (j = 0; j < 3; j++) {
            if (i == j) continue;
            if (Abs(a[i][j]) > Abs(a[p][q])) {
                p = i;
                q = j;
            }
        }
    }

    // Compute the Jacobi rotation matrix J(p, q, theta)
    // (This code can be optimized for the three different cases of rotation)
    SymSchur2(a, p, q, c, s);
    for (i = 0; i < 3; i++) {
        J[i][0] = J[i][1] = J[i][2] = 0.0f;
        J[i][i] = 1.0f;
    }
    J[p][p] =  c; J[p][q] = s;
    J[q][p] = -s; J[q][q] = c;

    // Cumulate rotations into what will contain the eigenvectors
    v = v * J;

    // Make 'a' more diagonal, until just eigenvalues remain on diagonal
    a = (J.Transpose() * a) * J;

    // Compute "norm" of off-diagonal elements
    float off = 0.0f;
```

```
    for (i = 0; i < 3; i++) {
        for (j = 0; j < 3; j++) {
            if (i == j) continue;
            off += a[i][j] * a[i][j];
        }
    }
    /* off = sqrt(off); not needed for norm comparison */

    // Stop when norm no longer decreasing
    if (n > 2 && off >= prevoff)
        return;

    prevoff = off;
    }
}
```

For the particular 3 × 3 matrix used here, instead of applying a general approach
such as the Jacobi method the eigenvalues could be directly computed from a simple
cubic equation. The eigenvectors could then easily be found through, for example,
Gaussian elimination. Such an approach is described in [Cromwell94]. Given the
previously defined functions, computing a sphere from the two most distant points
(according to spread) now looks like:

```
void EigenSphere(Sphere &eigSphere, Point pt[], int numPts)
{
    Matrix33 m, v;

    // Compute the covariance matrix m
    CovarianceMatrix(m, pt, numPts);
    // Decompose it into eigenvectors (in v) and eigenvalues (in m)
    Jacobi(m, v);

    // Find the component with largest magnitude eigenvalue (largest spread)
    Vector e;
    int maxc = 0;
    float maxf, maxe = Abs(m[0][0]);
    if ((maxf = Abs(m[1][1])) > maxe) maxc = 1, maxe = maxf;
    if ((maxf = Abs(m[2][2])) > maxe) maxc = 2, maxe = maxf;
    e[0] = v[0][maxc];
    e[1] = v[1][maxc];
    e[2] = v[2][maxc];

    // Find the most extreme points along direction 'e'
```

```
    int imin, imax;
    ExtremePointsAlongDirection(e, pt, numPts, &imin, &imax);
    Point minpt = pt[imin];
    Point maxpt = pt[imax];

    float dist = Sqrt(Dot(maxpt - minpt, maxpt - minpt));
    eigSphere.r = dist * 0.5f;
    eigSphere.c = (minpt + maxpt) * 0.5f;
}
```

The modified full code for computing the approximate bounding sphere becomes:

```
void RitterEigenSphere(Sphere &s, Point pt[], int numPts)
{
    // Start with sphere from maximum spread
    EigenSphere(s, pt, numPts);

    // Grow sphere to include all points
    for (int i = 0; i < numPts; i++)
        SphereOfSphereAndPt(s, pt[i]);
}
```

The type of covariance analysis performed here is commonly used for dimension reduction and statistical analysis of data, and is known as *principal component analysis* (PCA). Further information on PCA can be found in [Jolliffe02]. The eigenvectors of the covariance matrix can also be used to orient an oriented bounding box, as described in Section 4.4.3.

4.3.4 Bounding Sphere Through Iterative Refinement

The primary idea behind the algorithm described in Section 4.3.2 is to start with a quite good, slightly underestimated, approximation to the actual smallest sphere and then grow it until it encompasses all points. Given a better initial sphere, the final sphere can be expected to be better as well. Consequently, it is hardly surprising that the output of the algorithm can very effectively be used to feed itself in an iterative manner. The resulting sphere of one iteration is simply shrunk by a small amount to make it an underestimate for the next iterative call.

```
void RitterIterative(Sphere &s, Point pt[], int numPts)
{
    const int NUM_ITER = 8;
```

```
    RitterSphere(s, pt, numPts);
    Sphere s2 = s;
    for (int k = 0; k < NUM_ITER; k++) {
        // Shrink sphere somewhat to make it an underestimate (not bound)
        s2.r = s2.r * 0.95f;

        // Make sphere bound data again
        for (int i = 0; i < numPts; i++) {
            // Swap pt[i] with pt[j], where j randomly from interval [i+1,numPts-1]
            DoRandomSwap();
            SphereOfSphereAndPt(s2, pt[i]);
        }

        // Update s whenever a tighter sphere is found
        if (s2.r < s.r) s = s2;
    }
}
```

To further improve the results, the points are considered at random, rather than in the same order from iteration to iteration. The resulting sphere is usually much better than that produced by Wu's method (described in the previous section), at the cost of a few extra iterations over the input data. If the same iterative approach is applied to Wu's algorithm, the results are comparable. As with all iterative hill-climbing algorithms of this type (such as gradient descent methods, simulated annealing, or TABU search), the search can get stuck in local minima, and an optimal result is not guaranteed. The returned result is often very nearly optimal, however. The result is also very robust.

4.3.5 **The Minimum Bounding Sphere**

A sphere is uniquely defined by four (non co-planar) points. Thus, a brute-force algorithm for computing the minimum bounding sphere for a set of points is to consider all possible combinations of four (then three, then two) points, computing the smallest sphere through these points and keeping the sphere if it contains all other points. The kept sphere with the smallest radius is then the minimum bounding sphere. This brute-force algorithm has a complexity of $O(n^5)$ and is therefore not practical. Fortunately, the problem of computing the minimum bounding sphere for a set of points has been well studied in the field of computational geometry, and a randomized algorithm that runs in expected linear time has been given by [Welzl91].

Assume a minimum bounding sphere S has been computed for a point set P. If a new point Q is added to P, then only if Q lies outside S does S need to be recomputed. It is not difficult to see that Q must lie on the boundary of the new minimum bounding

sphere for the point set $P \cup \{Q\}$. Welzl's algorithm is based on this observation, resulting in a recursive algorithm. It proceeds by maintaining both the set of input points and a *set of support*, which contains the points from the input set that must lie on the boundary of the minimum sphere. The following code fragment outlines Welzl's algorithm:

```
Sphere WelzlSphere(Point pt[], unsigned int numPts, Point sos[], unsigned int numSos)
{
    // if no input points, the recursion has bottomed out. Now compute an
    // exact sphere based on points in set of support (zero through four points)
    if (numPts == 0) {
        switch (numSos) {
        case 0: return Sphere();
        case 1: return Sphere(sos[0]);
        case 2: return Sphere(sos[0], sos[1]);
        case 3: return Sphere(sos[0], sos[1], sos[2]);
        case 4: return Sphere(sos[0], sos[1], sos[2], sos[3]);
        }
    }
    // Pick a point at "random" (here just the last point of the input set)
    int index = numPts - 1;
    // Recursively compute the smallest bounding sphere of the remaining points
    Sphere smallestSphere = WelzlSphere(pt, numPts - 1, sos, numSos);  // (*)
    // If the selected point lies inside this sphere, it is indeed the smallest
    if(PointInsideSphere(pt[index], smallestSphere))
        return smallestSphere;
    // Otherwise, update set of support to additionally contain the new point
    sos[numSos] = pt[index];
    // Recursively compute the smallest sphere of remaining points with new s.o.s.
    return WelzlSphere(pt, numPts - 1, sos, numSos + 1);
}
```

Although the two recursive calls inside the function make the function appear expensive, Welzl showed that assuming points are removed from the input set at random the algorithm runs in expected linear time. Note that, as presented, the first recursive call (marked with an asterisk in the code) is likely to cause stack overflow for inputs of more than a few thousand points. Slight changes to the code avoid this problem, as outlined in [Gärtner99]. A full implementation is given in [Capens01]. Also available on the Internet is a more intricate implementation, part of the Computational Geometry Algorithms Library (CGAL). Writing a robust implementation of Welzl's algorithm requires that the four support functions for computing exact spheres from one through four points must correctly deal with degenerate input, such as collinear points.

Welzl's algorithm can be applied to computing both bounding circles and higher dimensional balls. It does not, however, directly extend to computing the minimum sphere bounding a set of spheres. An algorithm for the latter problem is given in [Fischer03]. Having covered spheres in detail, we now turn our attention to bounding boxes of arbitrary orientation.

4.4 Oriented Bounding Boxes (OBBs)

An oriented bounding box (OBB) is a rectangular block, much like an AABB but with an arbitrary orientation. There are many possible representations for an OBB: as a collection of eight vertices, a collection of six planes, a collection of three slabs (a pair of parallel planes), a corner vertex plus three mutually orthogonal edge vectors, or a center point plus an orientation matrix and three halfedge lengths. The latter is commonly the preferred representation for OBBs, as it allows for a much cheaper OBB-OBB intersection test than do the other representations. This test is based on the separating axis theorem, which is discussed in more detail in Chapter 5.

```
// Region R = { x | x = c+r*u[0]+s*u[1]+t*u[2] }, |r|<=e[0], |s|<=e[1], |t|<=e[2]
struct OBB {
    Point c;        // OBB center point
    Vector u[3];    // Local x-, y-, and z-axes
    Vector e;       // Positive halfwidth extents of OBB along each axis
};
```

At 15 floats, or 60 bytes for IEEE single-precision floats, the OBB is quite an expensive bounding volume in terms of memory usage. The memory requirements could be lowered by storing the orientation not as a matrix but as Euler angles or as a quaternion, using three to four floating-point components instead of nine. Unfortunately, for an OBB-OBB intersection test these representations must be converted back to a matrix for use in the effective separating axis test, which is a very expensive operation. A good compromise therefore may be to store just two of the rotation matrix axes and compute the third from a cross product of the other two at test time. This relatively cheap CPU operation saves three floating-point components, resulting in a 20% memory saving.

4.4.1 OBB-OBB Intersection

Unlike the previous bounding volume intersection tests, the test for overlap between two oriented bounding boxes is surprisingly complicated. At first, it seems a test to see if either box that is fully outside a face of the other would suffice. In its simplest form,

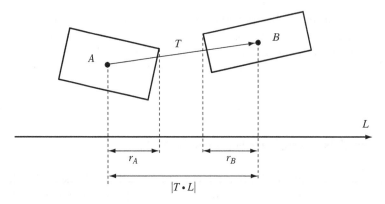

Figure 4.9 Two OBBs are separated if for some axis L the sum of their projected radii is less than the distance between their projected centers.

this test could be performed by checking if the vertices of box A are all on the outside of the planes defined by the faces of box B, and vice versa. However, although this test works in 2D it does not work correctly in 3D. It fails to deal with, for example, the case in which A and B are almost meeting edge to edge, the edges perpendicular to each other. Here, neither box is fully outside any one face of the other. Consequently, the simple test reports them as intersecting even though they are not. Even so, the simple test may still be useful. Although it is not always correct, it is conservative in that it never fails to detect a collision. Only in some cases does it incorrectly report separated boxes as overlapping. As such, it can serve as a pretest for a more expensive exact test.

An exact test for OBB-OBB intersection can be implemented in terms of what is known as the separating axis test. This test is discussed in detail in Chapter 5, but here it is sufficient to note that two OBBs are separated if, with respect to some axis L, the sum of their projected radii is less than the distance between the projection of their center points (as illustrated in Figure 4.9). That is, if

$$|T \cdot L| > r_A + r_B.$$

For OBBs it is possible to show that at most 15 of these separating axes must be tested to correctly determine the OBB overlap status. These axes correspond to the three coordinate axes of A, the three coordinate axes of B, and the nine axes perpendicular to an axis from each. If the boxes fail to overlap on any of the 15 axes, they are not intersecting. If no axis provides this early out, it follows that the boxes must be overlapping.

The number of operations in the test can be reduced by expressing B in the coordinate frame of A. If \mathbf{t} is the translation vector from A to B and $\mathbf{R} = [r_{ij}]$ (the rotation

Table 4.1 The 15 separating axis tests needed to determine OBB-OBB intersection. Superscripts indicate which OBB the value comes from.

L	$\lvert T \cdot L \rvert$	r_A	r_B
\mathbf{u}_0^A	$\lvert t_0 \rvert$	\mathbf{e}_0^A	$\mathbf{e}_0^B \lvert r_{00} \rvert + \mathbf{e}_1^B \lvert r_{01} \rvert + \mathbf{e}_2^B \lvert r_{02} \rvert$
\mathbf{u}_1^A	$\lvert t_1 \rvert$	\mathbf{e}_1^A	$\mathbf{e}_0^B \lvert r_{10} \rvert + \mathbf{e}_1^B \lvert r_{11} \rvert + \mathbf{e}_2^B \lvert r_{12} \rvert$
\mathbf{u}_2^A	$\lvert t_2 \rvert$	\mathbf{e}_2^A	$\mathbf{e}_0^B \lvert r_{20} \rvert + \mathbf{e}_1^B \lvert r_{21} \rvert + \mathbf{e}_2^B \lvert r_{22} \rvert$
\mathbf{u}_0^B	$\lvert t_0 r_{00} + t_1 r_{10} + t_2 r_{20} \rvert$	$\mathbf{e}_0^A \lvert r_{00} \rvert + \mathbf{e}_1^A \lvert r_{10} \rvert + \mathbf{e}_2^A \lvert r_{20} \rvert$	\mathbf{e}_0^B
\mathbf{u}_1^B	$\lvert t_0 r_{01} + t_1 r_{11} + t_2 r_{21} \rvert$	$\mathbf{e}_0^A \lvert r_{01} \rvert + \mathbf{e}_1^A \lvert r_{11} \rvert + \mathbf{e}_2^A \lvert r_{21} \rvert$	\mathbf{e}_1^B
\mathbf{u}_2^B	$\lvert t_0 r_{02} + t_1 r_{12} + t_2 r_{22} \rvert$	$\mathbf{e}_0^A \lvert r_{02} \rvert + \mathbf{e}_1^A \lvert r_{12} \rvert + \mathbf{e}_2^A \lvert r_{22} \rvert$	\mathbf{e}_2^B
$\mathbf{u}_0^A \times \mathbf{u}_0^B$	$\lvert t_2 r_{10} - t_1 r_{20} \rvert$	$\mathbf{e}_1^A \lvert r_{20} \rvert + \mathbf{e}_2^A \lvert r_{10} \rvert$	$\mathbf{e}_1^B \lvert r_{02} \rvert + \mathbf{e}_2^B \lvert r_{01} \rvert$
$\mathbf{u}_0^A \times \mathbf{u}_1^B$	$\lvert t_2 r_{11} - t_1 r_{21} \rvert$	$\mathbf{e}_1^A \lvert r_{21} \rvert + \mathbf{e}_2^A \lvert r_{11} \rvert$	$\mathbf{e}_0^B \lvert r_{02} \rvert + \mathbf{e}_2^B \lvert r_{00} \rvert$
$\mathbf{u}_0^A \times \mathbf{u}_2^B$	$\lvert t_2 r_{12} - t_1 r_{22} \rvert$	$\mathbf{e}_1^A \lvert r_{22} \rvert + \mathbf{e}_2^A \lvert r_{12} \rvert$	$\mathbf{e}_0^B \lvert r_{01} \rvert + \mathbf{e}_1^B \lvert r_{00} \rvert$
$\mathbf{u}_1^A \times \mathbf{u}_0^B$	$\lvert t_0 r_{20} - t_2 r_{00} \rvert$	$\mathbf{e}_0^A \lvert r_{20} \rvert + \mathbf{e}_2^A \lvert r_{00} \rvert$	$\mathbf{e}_1^B \lvert r_{12} \rvert + \mathbf{e}_2^B \lvert r_{11} \rvert$
$\mathbf{u}_1^A \times \mathbf{u}_1^B$	$\lvert t_0 r_{21} - t_2 r_{01} \rvert$	$\mathbf{e}_0^A \lvert r_{21} \rvert + \mathbf{e}_2^A \lvert r_{01} \rvert$	$\mathbf{e}_0^B \lvert r_{12} \rvert + \mathbf{e}_2^B \lvert r_{10} \rvert$
$\mathbf{u}_1^A \times \mathbf{u}_2^B$	$\lvert t_0 r_{22} - t_2 r_{02} \rvert$	$\mathbf{e}_0^A \lvert r_{22} \rvert + \mathbf{e}_2^A \lvert r_{02} \rvert$	$\mathbf{e}_0^B \lvert r_{11} \rvert + \mathbf{e}_1^B \lvert r_{10} \rvert$
$\mathbf{u}_2^A \times \mathbf{u}_0^B$	$\lvert t_1 r_{00} - t_0 r_{10} \rvert$	$\mathbf{e}_0^A \lvert r_{10} \rvert + \mathbf{e}_1^A \lvert r_{00} \rvert$	$\mathbf{e}_1^B \lvert r_{22} \rvert + \mathbf{e}_2^B \lvert r_{21} \rvert$
$\mathbf{u}_2^A \times \mathbf{u}_1^B$	$\lvert t_1 r_{01} - t_0 r_{11} \rvert$	$\mathbf{e}_0^A \lvert r_{11} \rvert + \mathbf{e}_1^A \lvert r_{01} \rvert$	$\mathbf{e}_0^B \lvert r_{22} \rvert + \mathbf{e}_2^B \lvert r_{20} \rvert$
$\mathbf{u}_2^A \times \mathbf{u}_2^B$	$\lvert t_1 r_{02} - t_0 r_{12} \rvert$	$\mathbf{e}_0^A \lvert r_{12} \rvert + \mathbf{e}_1^A \lvert r_{02} \rvert$	$\mathbf{e}_0^B \lvert r_{21} \rvert + \mathbf{e}_1^B \lvert r_{20} \rvert$

matrix bringing B into A's coordinate frame), the tests that must be performed for the different axes L are summarized in Table 4.1.

This test can be implemented as follows:

```
int TestOBBOBB(OBB &a, OBB &b)
{
    float ra, rb;
    Matrix33 R, AbsR;

    // Compute rotation matrix expressing b in a's coordinate frame
    for (int i = 0; i < 3; i++)
        for (int j = 0; j < 3; j++)
            R[i][j] = Dot(a.u[i], b.u[j]);
```

```
// Compute translation vector t
Vector t = b.c - a.c;
// Bring translation into a's coordinate frame
t = Vector(Dot(t, a.u[0]), Dot(t, a.u[1]), Dot(t, a.u[2]));

// Compute common subexpressions. Add in an epsilon term to
// counteract arithmetic errors when two edges are parallel and
// their cross product is (near) null (see text for details)
for (int i = 0; i < 3; i++)
    for (int j = 0; j < 3; j++)
        AbsR[i][j] = Abs(R[i][j]) + EPSILON;

// Test axes L = A0, L = A1, L = A2
for (int i = 0; i < 3; i++) {
    ra = a.e[i];
    rb = b.e[0] * AbsR[i][0] + b.e[1] * AbsR[i][1] + b.e[2] * AbsR[i][2];
    if (Abs(t[i]) > ra + rb) return 0;
}

// Test axes L = B0, L = B1, L = B2
for (int i = 0; i < 3; i++) {
    ra = a.e[0] * AbsR[0][i] + a.e[1] * AbsR[1][i] + a.e[2] * AbsR[2][i];
    rb = b.e[i];
    if (Abs(t[0] * R[0][i] + t[1] * R[1][i] + t[2] * R[2][i]) > ra + rb) return 0;
}

// Test axis L = A0 x B0
ra = a.e[1] * AbsR[2][0] + a.e[2] * AbsR[1][0];
rb = b.e[1] * AbsR[0][2] + b.e[2] * AbsR[0][1];
if (Abs(t[2] * R[1][0] - t[1] * R[2][0]) > ra + rb) return 0;

// Test axis L = A0 x B1
ra = a.e[1] * AbsR[2][1] + a.e[2] * AbsR[1][1];
rb = b.e[0] * AbsR[0][2] + b.e[2] * AbsR[0][0];
if (Abs(t[2] * R[1][1] - t[1] * R[2][1]) > ra + rb) return 0;

// Test axis L = A0 x B2
ra = a.e[1] * AbsR[2][2] + a.e[2] * AbsR[1][2];
rb = b.e[0] * AbsR[0][1] + b.e[1] * AbsR[0][0];
if (Abs(t[2] * R[1][2] - t[1] * R[2][2]) > ra + rb) return 0;

// Test axis L = A1 x B0
ra = a.e[0] * AbsR[2][0] + a.e[2] * AbsR[0][0];
rb = b.e[1] * AbsR[1][2] + b.e[2] * AbsR[1][1];
```

```
    if (Abs(t[0] * R[2][0] - t[2] * R[0][0]) > ra + rb) return 0;

    // Test axis L = A1 x B1
    ra = a.e[0] * AbsR[2][1] + a.e[2] * AbsR[0][1];
    rb = b.e[0] * AbsR[1][2] + b.e[2] * AbsR[1][0];
    if (Abs(t[0] * R[2][1] - t[2] * R[0][1]) > ra + rb) return 0;

    // Test axis L = A1 x B2
    ra = a.e[0] * AbsR[2][2] + a.e[2] * AbsR[0][2];
    rb = b.e[0] * AbsR[1][1] + b.e[1] * AbsR[1][0];
    if (Abs(t[0] * R[2][2] - t[2] * R[0][2]) > ra + rb) return 0;

    // Test axis L = A2 x B0
    ra = a.e[0] * AbsR[1][0] + a.e[1] * AbsR[0][0];
    rb = b.e[1] * AbsR[2][2] + b.e[2] * AbsR[2][1];
    if (Abs(t[1] * R[0][0] - t[0] * R[1][0]) > ra + rb) return 0;

    // Test axis L = A2 x B1
    ra = a.e[0] * AbsR[1][1] + a.e[1] * AbsR[0][1];
    rb = b.e[0] * AbsR[2][2] + b.e[2] * AbsR[2][0];
    if (Abs(t[1] * R[0][1] - t[0] * R[1][1]) > ra + rb) return 0;

    // Test axis L = A2 x B2
    ra = a.e[0] * AbsR[1][2] + a.e[1] * AbsR[0][2];
    rb = b.e[0] * AbsR[2][1] + b.e[1] * AbsR[2][0];
    if (Abs(t[1] * R[0][2] - t[0] * R[1][2]) > ra + rb) return 0;

    // Since no separating axis is found, the OBBs must be intersecting
    return 1;
}
```

To make the OBB-OBB test as efficient as possible, it is important that the axes are tested in the order given in Table 4.1. The first reason for using this order is that by testing three orthogonal axes first there is little spatial redundancy in the tests, and the entire space is quickly covered. Second, with the setup given here, where *A* is transformed to the origin and aligned with the coordinate system axes, testing the axes of *A* is about half the cost of testing the axes of *B*. Although it is not done here, the calculations of **R** and **AbsR** should be interleaved with the first three tests, so that they are not unnecessarily performed in their entirety when the OBB test exits in one of the first few *if* statements.

If OBBs are used in applications in which they often tend to have one axis aligned with the current world up, for instance, when traveling on ground, it is worthwhile special-casing these "vertically aligned" OBBs. This simplification allows for a much

faster intersection test that only involves testing four separating axes in addition to a cheap test in the vertical direction.

In some cases, performing just the first 6 of the 15 axis tests may result in faster results overall. In empirical tests, [Bergen97] found that the last 9 tests in the OBB overlap code determine nonintersection about 15% of the time. As perhaps half of all queries are positive to start with, omitting these 9 tests results in false positives about 6 to 7% of the time. When the OBB test is performed as a pretest for an exact test on the bounded geometry, this still leaves the test conservative and no collisions are missed.

4.4.2 Making the Separating-axis Test Robust

A very important issue overlooked in several popular treatments of the separating-axis theorem is the robustness of the test. Unfortunately, any code implementing this test must be very carefully crafted to work as intended. When a separating axis is formed by taking the cross product of an edge from each bounding box there is a possibility these edges are parallel. As a result, their cross product is the null vector, all projections onto this null vector are zero, and the sum of products on each side of the axis inequality vanishes. Remaining is the comparison $0 > 0$. In the perfect world of exact arithmetic mathematics, this expression would trivially evaluate to false. In reality, any computer implementation must deal with inaccuracies introduced by the use of floating-point arithmetic.

For the optimized inequalities presented earlier, the case of parallel edges corresponds to only the zero elements of the rotation matrix \mathbf{R} being referenced. Theoretically, this still results in the comparison $0 > 0$. In practice, however, due to accumulation of errors the rotation matrix will not be perfectly orthonormal and its zero elements will not be exactly zero. Thus, the sum of products on both sides of the inequality will also not be zero, but some small error quantity. As this accumulation of errors can cause either side of the inequality to change sign or shift in magnitude, the result will be quite random. Consequently, if the inequality tests are not very carefully performed these arithmetic errors could lead to the (near) null vector incorrectly being interpreted as a separating axis. Two overlapping OBBs therefore could be incorrectly reported as nonintersecting.

As the right-hand side of the inequalities should be larger when two OBBs are interpenetrating, a simple solution to the problem is to add a small epsilon value to the absolute values of the matrix elements occurring on the right-hand side of the inequalities. For near-zero terms, this epsilon term will be dominating and axis tests corresponding to (near) parallel edges are thus made disproportionately conservative. For other, nonzero cases, the small epsilon term will simply disappear. Note that as the absolute values of the components of a rotation matrix are bounded to the range [0, 1] using a fixed-magnitude epsilon works fine regardless of the sizes of the boxes involved. The robustness of the separating-axis test is revisited in Chapter 5.

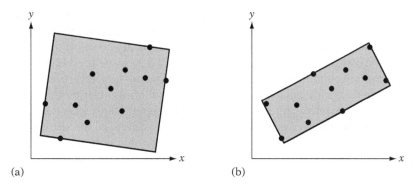

Figure 4.10 (a) A poorly aligned and (b) a well-aligned OBB.

4.4.3 **Computing a Tight OBB**

Computing tight-fitting oriented bounding boxes is a difficult problem, made worse by the fact that the volume difference between a poorly aligned and a well-aligned OBB can be quite large (Figure 4.10). There exists an algorithm for calculating the minimum volume bounding box of a polyhedron, presented in [O'Rourke85]. The key observation behind the algorithm is that given a polyhedron either one face and one edge or three edges of the polyhedron will be on different faces of its bounding box. Thus, these edge and face configurations can be searched in a systematic fashion, resulting in an $O(n^3)$ algorithm. Although it is an interesting theoretical result, unfortunately the algorithm is both too complicated and too slow to be of much practical value.

Two other theoretical algorithms for computing near approximations of the minimum-volume bounding box are presented in [Barequet99]. However, the authors admit that these algorithms are probably too difficult to implement and would be impractical even so, due to the large constant-factor overhead in the algorithms. Thus, with the currently available theoretical algorithms of little practical use OBBs must be computed using either approximation or brute-force methods.

A simpler algorithm offered in [Barequet99] provides a coarse approximation of the optimal OBB for a point set by first computing the minimum AABB of the set. From the point set, a pair of points on the two parallel box sides farthest apart are selected to determine the length direction of the OBB. The set of points is then projected onto the plane perpendicular to the OBB length direction. The same procedure is now applied again, only this time computing the minimum axis-aligned rectangle, with points on the two parallel sides farthest apart determining a second axis for the OBB. The third OBB axis is the perpendicular to the first two axes. Although this algorithm is very easy to code, in practice bounding boxes much closer to optimal can be obtained through other algorithms of similar complexity, as described in the following.

For long and thin objects, an OBB axis should be aligned with the direction of the objects. For a flat object, an OBB axis should be aligned with the normal of the flat object. These directions correspond to the principal directions of the objects, and the principal component analysis used in Section 4.3.3 can be used here.

Computing bounding boxes based on covariance of model vertices generally works satisfactorily for models whose vertices are uniformly distributed over the model space. Unfortunately, the influence of internal points often bias the covariance and can make the OBB take on any orientation regardless of the extremal points. For this reason, all methods for computing bounding volumes based on weighting vertex positions should ideally be avoided. It is sufficient to note that the defining features (center, dimensions, and orientation) of a minimum bounding volume are all independent of clustering of object vertices. This can easily be seen by considering adding (or taking away) extra vertices off-center, inside or on the boundary, of a bounding volume. These actions do not affect the defining features of the volume and therefore should not affect its calculation. However, adding extra points in this manner changes the covariance matrix of the points, and consequently any OBB features directly computed from the matrix. The situation can be improved by considering just extremal points, using only those points on the convex hull of the model. This eliminates the internal points, which can no longer misalign the OBB. However, even though all remaining points are extremal the resulting OBB can still be arbitrarily bad due to point distribution. A clustering of points will still bias an axis toward the cluster. In other words, using vertices alone simply cannot produce reliable covariance matrices.

A suggested solution is to use a continuous formulation of covariance, computing the covariance across the entire face of the primitives [Gottschalk00]. The convex hull should still be used for the calculation. If not, small outlying geometry would extend the bounding box, but not contribute enough significance to align the box properly. In addition, interior geometry would still bias the covariance. If the convex hull is already available, this algorithm is $O(n)$. If the convex hull must be computed, it is $O(n \log n)$.

Given n triangles (p_k, q_k, r_k), $0 \leq k < n$, in the convex hull, the covariance matrix is given by

$$C_{ij} = \left(\frac{1}{a_H} \sum_{0 \leq k < n} \frac{a_k}{12} \left(9 m_{k,i} m_{k,j} + p_{k,i} p_{k,j} + q_{k,i} q_{k,j} + r_{k,i} r_{k,j} \right) \right) - m_{H,i} m_{H,j},$$

where $a_k = \| (q_k - p_k) \times (r_k - p_k) \| / 2$ is the area and $m_k = (p_k + q_k + r_k)/3$ is the centroid of triangle k.

The total area of the convex hull is given by

$$a_H = \sum_{0 \leq k < n} a_k,$$

and the centroid of the convex hull,

$$m_H = \frac{1}{a_H} \sum_{0 \le k < n} a_k m_k,$$

is computed as the mean of the triangle centroids weighted by their area. The i and j subscripts indicate which coordinate component is taken (that is, x, y, or z). Code for this calculation can be found in the publicly available collision detection package RAPID. A slightly different formulation of this covariance matrix is given in [Eberly01], and code is available on the companion CD-ROM for this book.

The method just described treats the polyhedron as a hollow body, computing the covariance matrix from the surface areas. A related method treating the polyhedron as a solid body is described in [Mirtich96a]. Given an assumed uniform density polyhedron, Mirtich's polyhedral mass property algorithm integrates over the volume of the polyhedron, computing its 3×3 inertia tensor (also known as the inertia or mass matrix). The eigenvectors of this symmetric matrix are called the principal axes of inertia, and the eigenvalues the principal moments of inertia. Just as with the covariance matrices before, the Jacobi method can be used to extract these axes, which in turn can then serve as the orientation matrix of an OBB. Detailed pseudocode for computing the inertia matrix is given in Mirtich's article. A public domain implementation in C is also available for download on the Internet. Mirtich's article is revisited in [Eberly03], in which a more computationally efficient approach is derived and for which pseudocode is provided.

Note that neither covariance-aligned nor inertia-aligned oriented bounding boxes are optimal. Consider an object A and its associated OBB B. Let A be expanded by adding some geometry to it, but staying within the bounds of B. For both methods, this would in general result in a different OBB B' for the new object A'. By construction, B and B' both cover the two objects A and A'. However, as the dimensions of the two OBBs are in the general case different, one OBB must be suboptimal.

4.4.4 Optimizing PCA-based OBBs

As covariance-aligned OBBs are not optimal, it is reasonable to suspect they could be improved through slight modification. For instance, perhaps the OBB could be rotated about one of its axes to find the orientation for which its volume is smallest. One improved approach to OBB fitting is to align the box along just one principal component. The remaining two directions are determined from the computed minimum-area bounding rectangle of the projection of all vertices onto the perpendicular plane to the selected axis. Effectively, this method determines the best rotation about the given axis for producing the smallest-volume OBB.

This approach was suggested in [Barequet96], in which three different methods were investigated.

- All-principal-components box
- Max-principal-component box
- Min-principal-component box

The all-principal-components box uses all three principal components to align the OBB, and is equivalent to the method presented in the previous section. For the max-principal-component box, the eigenvector corresponding to the largest eigenvalue is selected as the length of the OBB. Then all points are projected onto a plane perpendicular to that direction. The projection is followed by computing the minimum-area bounding rectangle of the projected points, determining the remaining two directions of the OBB. Finally, the min-principal-component box selects the shortest principal component as the initial direction of the OBB, and then proceeds as in the previous method. Based on empirical results, [Barequet96] conclude that the min-principal-component method performs best. A compelling reason max-principal-component does not do better is also given: as the maximum principal component is the direction with the maximum variance, it will contribute the longest possible edge and is therefore likely to produce a larger volume.

A local minimum volume can be reached by iterating this method on a given starting OBB. The procedure would project all vertices onto the plane perpendicular to one of the directions of the OBB, updating the OBB to align with the minimum-area bounding rectangle of the projection. The iterations would be repeated until no projection (along any direction of the OBB) gives an improvement, at which point the local minimum has been found. This method serves as an excellent optimization of boxes computed through other methods, such as Mirtich's, when performed as a preprocessing step.

Remaining is the problem of computing the minimum-area bounding rectangle of a set of points in the plane. The key insight here is a result from the field of computational geometry. It states that a minimum-area bounding rectangle of a convex polygon has (at least) one side collinear with an edge of the polygon [Freeman75].

Therefore, the minimum rectangle can trivially be computed by a simple algorithm. First, the convex hull of the point set is computed, resulting in a convex polygon. Then, an edge at a time of the polygon is considered as one direction of the bounding box. The perpendicular to this direction is obtained, and all polygon vertices are projected onto these two axes and the rectangle area is computed. When all polygon edges have been tested, the edge (and its perpendicular) giving the smallest area determines the directions of the minimum-area bounding rectangle. For each edge considered, the rectangle area is computed in $O(n)$ time, for a total complexity

of $O(n^2)$ for the algorithm as a whole. This algorithm can be implemented as follows:

```
// Compute the center point, 'c', and axis orientation, u[0] and u[1], of
// the minimum area rectangle in the xy plane containing the points pt[].
float MinAreaRect(Point2D pt[], int numPts, Point2D &c, Vector2D u[2])
{
    float minArea = FLT_MAX;

    // Loop through all edges; j trails i by 1, modulo numPts
    for (int i = 0, j = numPts - 1; i < numPts; j = i, i++) {
        // Get current edge e0 (e0x,e0y), normalized
        Vector2D e0 = pt[i] - pt[j];
        e0 /= Length(e0);

        // Get an axis e1 orthogonal to edge e0
        Vector2D e1 = Vector2D(-e0.y, e0.x);  // = Perp2D(e0)

        // Loop through all points to get maximum extents
        float min0 = 0.0f, min1 = 0.0f, max0 = 0.0f, max1 = 0.0f;
        for (int k = 0; k < numPts; k++) {
            // Project points onto axes e0 and e1 and keep track
            // of minimum and maximum values along both axes
            Vector2D d = pt[k] - pt[j];
            float dot = Dot2D(d, e0);
            if (dot < min0) min0 = dot;
            if (dot > max0) max0 = dot;
            dot = Dot2D(d, e1);
            if (dot < min1) min1 = dot;
            if (dot > max1) max1 = dot;
        }
        float area = (max0 - min0) * (max1 - min1);

        // If best so far, remember area, center, and axes
        if (area < minArea) {
            minArea = area;
            c = pt[j] + 0.5f * ((min0 + max0) * e0 + (min1 + max1) * e1);
            u[0] = e0; u[1] = e1;
        }
    }
    return minArea;
}
```

The minimum-area bounding rectangle of a convex polygon can also be computed in $O(n \log n)$ time, using the method of *rotating calipers* [Toussaint83]. The rotating calipers algorithm starts out bounding the polygon by four lines through extreme points of the polygon such that the lines determine a rectangle. At least one line is chosen to be coincident with an edge of the polygon. For each iteration of the algorithm, the lines are simultaneously rotated clockwise about their supporting points until a line coincides with an edge of the polygon. The lines now form a new bounding rectangle around the polygon. The process is repeated until the lines have been rotated by an angle of 90 degrees from their original orientation. The minimum-area bounding rectangle corresponds to the smallest-area rectangle determined by the lines over all iterations. The time complexity of the algorithm is bounded by the cost of computing the convex hull. If the convex hull is already available, the rotating calipers algorithm is $O(n)$.

4.4.5 Brute-force OBB Fitting

The last approach to OBB fitting considered here is simply to compute the OBB in a brute-force manner. One way to perform brute-force fitting is to parameterize the orientation of the OBB in some manner. The space of orientations is sampled at regular intervals over the parameterization and the best OBB over all sampled rotations is kept. The OBB orientation is then refined by sampling the interval in which the best OBB was found at a higher subinterval resolution. This hill-climbing approach is repeated with smaller and smaller interval resolutions until there is little or no change in orientation for the best OBB.

For each tested coordinate system, computing the candidate OBB requires the transformation of all vertices into the coordinate system. Because this transformation is expensive, the search should exit as soon as the candidate OBB becomes worse than the currently best OBB. In that it is cheap to compute and has a relatively good fit, a PCA-fitted OBB provides a good initial guess, increasing the chances of an early out during point transformation [Miettinen02a]. To further increase the chance of an early out, the (up to) six extreme points determining the previous OBB should be the first vertices transformed. In [Miettinen02b] it is reported that over 90% of the tests are early-exited using this optimization. Brute-force fitting of OBBs generally results in much tighter OBBs than those obtained through PCA-based fitting.

The hill-climbing approach just described considers many sample points in the space of orientation before updating the currently best OBB. The optimization-based OBB-fitting method described in [Lahanas00] hill climbs the search space one sample at a time, but employs a multisample technique to aid the optimizer escape from local minima.

4.5 Sphere-swept Volumes

After spheres and boxes, it is natural to consider cylinders as bounding volumes. Unfortunately, when the mathematics is worked out it turns out that the overlap test

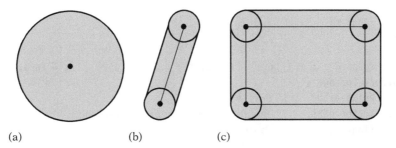

(a) (b) (c)

Figure 4.11 (a) A sphere-swept point (SSP). (b) A sphere-swept line (SSL). (c) A sphere-swept rectangle (SSR).

for cylinders is quite expensive, making them less attractive as bounding volumes. However, if a cylinder is fitted with spherical end caps the resulting capped cylinder volume becomes a more attractive bounding volume. Let the cylinder be described by the points A and B (forming its medial axis) and a radius r. The capped cylinder would be the resulting volume from sweeping a sphere of radius r along the line segment AB. This volume is part of a family of volumes, extensions of the basic sphere.

Recall that the test between two spheres computes the distance between the two center points, comparing the result against the sum of the radii (squaring the quantities to avoid an expensive square root). By replacing the sphere center points with arbitrary inner primitives or medial structures, new bounding volumes can be obtained. The resultant volumes are equivalent to sweeping the inner primitive with a sphere of radius r (or, technically, forming the Minkowski sum of the sphere and the primitive). As such, this entire family of bounding volumes is therefore collectively referred to as *sphere-swept volumes* (SSVs). All points within a distance r from the inner medial structure belong to the SSV. Three types of sphere-swept volumes are illustrated in Figure 4.11.

Following the sphere overlap test, the intersection test for two SSVs simply becomes calculating the (squared) distance between the two inner primitives and comparing it against the (squared) sum of their combined radii. The cost of sphere-swept tests is completely determined by the cost of the distance function. To make the distance test as inexpensive as possible, the inner primitives are usually limited to points, line segments, or rectangles. The resulting SSVs — sphere-swept points (SSPs), sphere-swept lines (SSLs), and sphere-swept rectangles (SSRs) — are commonly referred to, respectively, as *spheres*, *capsules*, and *lozenges*. The latter looks like an OBB with rounded corners and edges. Capsules are also referred to as *capped cylinders* or *spherocylinders*. The data structures for capsules and lozenges can be defined as follows:

```
// Region R = { x | (x - [a + (b - a)*t])^2 <= r }, 0 <= t <= 1
struct Capsule {
    Point a;        // Medial line segment start point
    Point b;        // Medial line segment endpoint
```

```
        float r;          // Radius
};

// Region R = { x | (x - [a + u[0]*s + u[1]*t])^2 <= r }, 0 <= s,t <= 1
struct Lozenge {
    Point a;          // Origin
    Vector u[2];      // The two edges axes of the rectangle
    float r;          // Radius
};
```

Due to similarity in shape, lozenges can be a viable substitute for OBBs. In situations of close proximity, the lozenge distance computation becomes less expensive than the OBB separating-axis test.

4.5.1 Sphere-swept Volume Intersection

By construction, all sphere-swept volume tests can be formulated in the same way. First, the distance between the inner structures is computed. Then this distance is compared against the sum of the radii. The only difference between any two types of sphere-swept tests is in the calculation used to compute the distance between the inner structures of the two volumes. A useful property of sphere-swept volumes is that the distance computation between the inner structures does not rely on the inner structures being of the same type. Mixed-type or hybrid tests can therefore easily be constructed. Two tests are presented in the following: the sphere-capsule and capsule-capsule tests.

```
int TestSphereCapsule(Sphere s, Capsule capsule)
{
    // Compute (squared) distance between sphere center and capsule line segment
    float dist2 = SqDistPointSegment(capsule.a, capsule.b, s.c);
    // If (squared) distance smaller than (squared) sum of radii, they collide
    float radius = s.r + capsule.r;
    return dist2 <= radius * radius;
}

int TestCapsuleCapsule(Capsule capsule1, Capsule capsule2)
{
    // Compute (squared) distance between the inner structures of the capsules
    float s, t;
    Point c1, c2;
    float dist2 = ClosestPtSegmentSegment(capsule1.a, capsule1.b,
                                capsule2.a, capsule2.b, s, t, c1, c2);
```

```
// If (squared) distance smaller than (squared) sum of radii, they collide
float radius = capsule1.r + capsule2.r;
return dist2 <= radius * radius;
}
```

The functions `SqDistPointSegment()` and `ClosestPtSegmentSegment()` used here are found in Chapter 5 (Sections 5.1.2.1 and 5.1.9, respectively). A distance test for SSRs (and thus, by reduction, also for SSLs and SSPs) based on halfspace tests is given in [Larsen99] and [Larsen00].

4.5.2 Computing Sphere-swept Bounding Volumes

The machinery needed for computing SSVs has been described in previous sections. For instance, by computing the principal axes a capsule can be fitted by using the longest axis as the capsule length. The next longest axis determines the radius. Alternatively, the length can also be fit using a least-square approach for fitting a line to a set of points. For SSRs, all three axes would be used, with the shortest axis forming the rectangle face normal. See [Eberly01], [Larsen99], and [Larsen00] for further detail.

4.6 Halfspace Intersection Volumes

With the notable exception of spheres, most bounding volumes are convex polyhedra. All of these polyhedral bounding volumes are representable as the intersection of a set of halfspaces, wherein the halfspace dividing planes coincides with the sides of the bounding volume. For instance, AABBs and OBBs are both the intersection of six halfspaces. A tetrahedron is the intersection of four halfspaces — the smallest number of halfspaces needed to form a closed volume. Generally, the more halfspaces used the better the resulting intersection volume can fit an object. If the bounded object is polyhedral, the tightest possible convex bounding volume is the convex hull of the object. In this case, the number of faces on the hull serves as a practical upper limit on how many halfspaces are needed to form the bounding volume. Convex hulls are important bounding volumes, and an in-depth treatment of collision detection algorithms for convex hulls is given in Chapter 9.

Although convex hulls form the tightest bounding volumes, they are not necessarily the best choice of bounding volume. Some drawbacks of convex hulls include their being expensive and difficult to compute, taking large amounts of memory to represent, and potentially being costly to operate upon. By limiting the number of halfspaces used in the intersection volume, several simpler alternative bounding volumes can be formed. A few variants are described in the sections that follow.

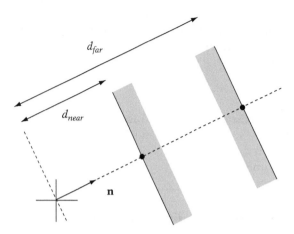

Figure 4.12 A slab is the infinite region of space between two planes, defined by a normal **n** and two signed distances from the origin.

4.6.1 Kay–Kajiya Slab-based Volumes

First introduced by Kay and Kajiya for speeding up ray-object intersection tests, Kay–Kajiya volumes are a family of many-sided parallelepipedal bounding volumes based on the intersection of slabs [Kay86]. A slab is the infinite region of space between two parallel planes (Figure 4.12). This plane set is represented by a unit vector **n** (the plane-set normal) and two scalar values giving the signed distance from the origin (along **n**) for both planes.

```
// Region R = { (x, y, z) | dNear <= a*x + b*y + c*z <= dFar }
struct Slab {
    float n[3];    // Normal n = (a, b, c)
    float dNear;   // Signed distance from origin for near plane (dNear)
    float dFar;    // Signed distance from origin for far plane (dFar)
};
```

To form a bounding volume, a number of normals are chosen. Then, for each normal, pairs of planes are positioned so that they bound the object on both its sides along the direction of the normal. For polygonal objects, the positions of the planes can be found by computing the dot product of the normal and each object vertex. The minimum and maximum values are then the required scalar values defining the plane positions.

To form a closed 3D volume, at least three slabs are required. Both AABBs and OBBs are examples of volumes formed as the intersection of three slabs. By increasing the

number of slabs, slab-based bounding volumes can be made to fit the convex hulls of objects arbitrarily tightly.

For the original application of ray intersection, a quick test can be based on the fact that a parameterized ray intersects a slab if and only if it is simultaneously inside all (three) slabs for some interval, or equivalently if the intersection of the intervals for ray-slab overlap is nonzero. With pairs of planes sharing the same normal, calculations can be shared between the two ray-plane intersection tests, improving test performance.

Although slab-based volumes allow for fast ray intersection tests, they cannot easily be used as-is in object-object intersection testing. However, by sharing normals across all objects it is possible to perform fast object-object tests (explored in the next section).

4.6.2 Discrete-orientation Polytopes (*k*-DOPs)

Based on the same idea as the Kay–Kajiya slab-based volumes are the volumes known as *discrete-orientation polytopes* (*k*-DOPs) or *fixed-direction hulls* (FDHs), suggested by [Konečný97] and [Klosowski98]. (Although the latter is perhaps a more descriptive term, the former is more commonly used and is adopted here.) These *k*-DOPs are convex polytopes, almost identical to the slab-based volumes except that the normals are defined as a fixed set of axes shared among all *k*-DOP bounding volumes. The normal components are typically limited to the set $\{-1, 0, 1\}$, and the normals are not normalized. These normals make computation of *k*-DOPs cheaper, which is important because *k*-DOPs must be dynamically realigned. By sharing the normals among all objects, *k*-DOP storage is very cheap. Only the min-max intervals for each axis must be stored. For instance, an 8-DOP becomes:

```
struct DOP8 {
    float min[4];  // Minimum distance (from origin) along axes 0 to 3
    float max[4];  // Maximum distance (from origin) along axes 0 to 3
};
```

A 6-DOP commonly refers to polytopes with faces aligned along the six directions $(\pm 1, 0, 0)$, $(0, \pm 1, 0)$, and $(0, 0, \pm 1)$. This 6-DOP is of course an AABB, but the AABB is just a special-case 6-DOP; any oriented bounding box could also be described as a 6-DOP. An 8-DOP has faces aligned with the eight directions $(\pm 1, \pm 1, \pm 1)$ and a 12-DOP with the 12 directions $(\pm 1, \pm 1, 0)$, $(\pm 1, 0, \pm 1)$, and $(0, \pm 1, \pm 1)$. An example of a 2D 8-DOP is shown in Figure 4.13.

A 14-DOP is defined using the combined directions of the 6-DOP and 8-DOP. The 18-DOP, 20-DOP, and 26-DOP are formed in a similar way. The 14-DOP corresponds to an axis-aligned box with the eight corners cut off. The 18-DOP is an AABB wherein the 12 edges have been cut off. The 18-DOP is also referred to as a *tribox* [Crosnier99].

Figure 4.13 8-DOP for triangle (3, 1), (5, 4), (1, 5) is {1, 1, 4, −4, 5, 5, 9, 2} for axes (1, 0), (0, 1), (1, 1), (1, −1).

Note that the k-DOP is not just any intersection of slabs, but the tightest slabs that form the body. For example, the triangle (0, 0), (1, 0), (0, 1) can be expressed as several slab intersections, but there is only one k-DOP describing it. If and only if the slab planes have a common point with the volume formed by the intersection of the slabs are the slabs defining a k-DOP. This tightness criterion is important, as the overlap test for k-DOPs does not work on the intersection volume but solely on the slab definitions. Without the given restriction, the overlap test would be quite ineffective.

Compared to oriented bounding boxes, the overlap test for k-DOPs is much faster (about an order of magnitude), even for large-numbered DOPs, thanks to the fixed-direction planes. In terms of storage, the same amount of memory required for an OBB roughly corresponds to a 14-DOP. k-DOPs have a (probable) tighter fit than OBBs, certainly as k grows and the k-DOP resembles the convex hull. For geometry that does not align well with the axes of the k-DOP, OBBs can still be tighter. OBBs will also perform better in situations of close proximity.

The largest drawback to k-DOPs is that even if the volumes are rarely colliding the k-DOPs must still be updated, or "tumbled." As this operation is expensive, whenever possible the tumbling operation should be avoided. This is usually done by pretesting the objects using bounding spheres (not performing the k-DOP test if the sphere test fails). In general, k-DOPs perform best when there are few dynamic objects being tested against many static objects (few k-DOPs have to update) or when the same object is involved in several tests (the cost of updating the k-DOP is amortized over the tests).

A slightly different k-DOP is examined in [Zachmann00]. Here, the k-DOP axes are selected using a simulated annealing process in which k points are randomly distributed on a unit sphere, with the provision that for each point P, $-P$ is also in the set. A repelling force among points is used as the annealing temperature.

4.6.3 *k*-DOP–*k*-DOP Overlap Test

Due to the fixed set of axes being shared among all objects, intersection detection for k-DOPs is similar to and no more difficult than testing two AABBs for overlap.

The test simply checks the $k/2$ intervals for overlap. If any pair of intervals do not overlap, the k-DOPs do not intersect. Only if all pairs of intervals are overlapping are the k-DOPs intersecting.

```
int TestKDOPKDOP(KDOP &a, KDOP &b, int k)
{
    // Check if any intervals are non-overlapping, return if so
    for (int i = 0; i < k / 2; i++)
        if (a.min[i] > b.max[i] || a.max[i] < b.min[i])
            return 0;

    // All intervals are overlapping, so k-DOPs must intersect
    return 1;
}
```

As with oriented bounding boxes, the order in which axes are tested is likely to have an effect on performance. As intervals along "near" directions are likely to have similar overlap status, consecutive interval tests preferably should be performed on largely different (perpendicular) directions. One way to achieve this is to preprocess the order of the global axes using a simple greedy algorithm. Starting with any axis to test first, it would order all axes so that the successor to the current axis is the one whose dot product with the current axis is as close to zero as possible.

4.6.4 Computing and Realigning k-DOPs

Computing the k-DOP for an object can be seen as a generalization of the method for computing an AABB, much as the overlap test for two k-DOPs is really a generalization of the AABB-AABB overlap test. As such, a k-DOP is simply computed from the projection spread of the object vertices along the defining axes of the k-DOP. Compared to the AABB calculation, the only differences are that the vertices have to be projected onto the axes and there are more axes to consider. The restriction to keep axis components in the set $\{-1, 0, 1\}$ makes a hardcoded function for computing the k-DOP less expensive than a general function for arbitrary directions, as the projection of vertices onto these axes now involves at most three additions. For example, an 8-DOP is computed as follows:

```
// Compute 8-DOP for object vertices v[] in world space
// using the axes (1,1,1), (1,1,-1), (1,-1,1) and (-1,1,1)
void ComputeDOP8(Point v[], int numPts, DOP8 &dop8)
{
    // Initialize 8-DOP to an empty volume
```

```
        dop8.min[0] = dop8.min[1] = dop8.min[2] = dop8.min[3] = FLT_MAX;
        dop8.max[0] = dop8.max[1] = dop8.max[2] = dop8.max[3] = -FLT_MAX;

        // For each point, update 8-DOP bounds if necessary
        float value;
        for (int i = 0; i < numPts; i++) {
            // Axis 0 = (1,1,1)
            value = v[i].x + v[i].y + v[i].z;
            if (value < dop8.min[0]) dop8.min[0] = value;
            else if (value > dop8.max[0]) dop8.max[0] = value;

            // Axis 1 = (1,1,-1)
            value = v[i].x + v[i].y - v[i].z;
            if (value < dop8.min[1]) dop8.min[1] = value;
            else if (value > dop8.max[1]) dop8.max[1] = value;

            // Axis 2 = (1,-1,1)
            value = v[i].x - v[i].y + v[i].z;
            if (value < dop8.min[2]) dop8.min[2] = value;
            else if (value > dop8.max[2]) dop8.max[2] = value;

            // Axis 3 = (-1,1,1)
            value = -v[i].x + v[i].y + v[i].z;
            if (value < dop8.min[3]) dop8.min[3] = value;
            else if (value > dop8.max[3]) dop8.max[3] = value;
        }
    }
```

Although k-DOPs are invariant under translation, a rotation leaves the volume unaligned with the predefined axes. As with AABBs, k-DOPs must therefore be realigned whenever the volume rotates. A simple solution is to recompute the k-DOP from scratch, as described. However, because recomputing the k-DOP involves transforming the object vertices into the new space this becomes expensive when the number of object vertices is large. A more effective realignment approach is to use a hill-climbing method similar to that described in Section 4.2.5 for computing AABBs. The only difference is that instead of keeping track of six references to vertices of the convex hull the hill climber would for a k-DOP now keep track of k vertex references, one for each facial direction of the k-DOP. If frame-to-frame coherency is high and objects rotate by small amounts between frames, tracking vertices is a good approach. However, the worst-case complexity of this method is $O(n^2)$ and it can perform poorly when coherency is low. Hill climbing results in a tight bounding volume.

Another, approximative, approach is based on computing and storing the vertices of each k-DOP for its initial local orientation at preprocess time. Then at runtime

the k-DOP is recomputed from these vertices and transformed into world space by the current orientation matrix. This is equivalent to the AABB method described in Section 4.2.6.

The vertex set of the k-DOP in its initial orientation can be computed with the help of a duality transformation mapping. Here the dual mapping of a plane $ax + by + cz = 1$ is the point (a, b, c) and vice versa. Let the defining planes of the k-DOP be expressed as plane equations. Then by computing the convex hull of the dual of these planes the faces (edges and vertices) of the convex hull maps into the vertices (edges and faces) of the intersection of the original planes when transformed back under the duality mapping. For this duality procedure to work, the k-DOP must be translated to contain the origin, if it is not already contained in the k-DOP. For volumes formed by the intersection of halfspaces, a point in the volume interior can be obtained through linear programming (see Section 9.4.1). Another, simpler, option is to compute an interior point using the *method of alternating projection* (MAP). This method starts with an arbitrary point in space. Looping over all halfspaces, in arbitrary order, the point is updated by projecting it to the bounding hyperplane of the current halfspace whenever it lies outside the halfspace. Guaranteed to converge, the loop over all halfspaces is repeated until the point lies inside all halfspaces. If the starting point lies outside the intersection volume, as is likely, the resulting point will lie on the boundary of the intersection volume, and specifically on one of the bounding hyperplanes. (If the point lies inside the volume, the point itself is returned by the method.) A point interior to the volume is obtained by repeating the method of alternating projections with different starting points until a second point, on a different bounding hyperplane, is obtained. The interior point is then simply the midpoint of the two boundary points. MAP may converge very slowly for certain inputs. However, for the volumes typically used as bounding volumes, slow convergence is usually not a problem. For more information on MAP, see [Deutsch01]. For more information on duality (or polarity) transformations see, for example, [Preparata85], [O'Rourke98], or [Berg00].

A simpler way of computing the initial vertex set is to consider all combinations of three non co-planar planes from the input set of k-DOP boundary planes. Each such set of three planes intersects in a point (Section 5.4.5 describes how this point is computed). After all intersection points have been computed, those that lie in front of one or more of the k-DOP boundary planes are discarded. The remaining points are then the vertices of the k-DOP.

k-DOPs can also be realigned using methods based on linear programming, as described in [Konečný97] and [Konečný98]. A more elaborate realignment strategy is presented in [Fünfzig03]. Linear programming is described in Section 9.4.

4.6.5 Approximate Convex Hull Intersection Tests

It is easy to test separation between two convex polygons (for example, using the rotating calipers method mentioned in Section 4.4.4). Unfortunately, the problem is not as simple for polytopes. Accurate methods for this problem are discussed in

Chapter 9. In many situations, however, fully accurate polytope collision detection might be neither necessary nor desired. By relaxing the test to allow approximate solutions, it is possible to obtain both simpler and faster methods.

One such approach maintains both the defining planes and vertices of each convex hull. To test two hulls against each other, the vertices of each hull are tested against the planes of the other to see if they lie fully outside any one plane. If they do, the hulls are not intersecting. If neither set of vertices is outside any face of the other hull, the hulls are conservatively considered overlapping. In terms of the separating-axis test, this corresponds to testing separation on the face normals of both hulls, but not the edge-edge combinations of both.

Another approach is simply to replace the vertex set with a set of spheres. The spheres are chosen so that their union approximates the convex hull. Now the test proceeds by testing spheres (instead of vertices) against the planes. The idea is that compared to vertex tests fewer sphere tests must be performed. Although this test is faster, it is also less accurate. To improve accuracy while keeping the set size down, the set of spheres is often hand optimized.

As with k-DOPs, testing can be sped up by ordering the stored planes to make successive planes as perpendicular to each other as possible. Similarly, to avoid degenerate behavior due to clustering the vertices (or spheres) can be randomly ordered. Bounding the vertex set with a sphere and testing the sphere against the plane before testing all vertices often allow for early outs.

Compared to other bounding volume tests, these tests are still relatively expensive and are typically preceded by a cheaper bounding volume test (such as a sphere-sphere test) to avoid hull-testing objects that are sufficiently far apart to not be intersecting. The coherency methods presented in Chapter 9 are also useful for minimizing the number of hull tests that have to be performed.

4.7 **Other Bounding Volumes**

In addition to the bounding volumes covered here, many other types of volumes have been suggested as bounding volumes. These include cones [Held97], [Eberly02], cylinders [Held97], [Eberly00], [Schömer00], spherical shells [Krishnan98], ellipsoids [Rimon92], [Wang01], [Choi02], [Wang02], [Chien03], and zonotopes [Guibas03]. Cones, cylinders, and ellipsoids are self-explanatory. Spherical shells are the intersection of the volume between two concentric spheres and a cone with its apex at the sphere center. Zonotopes are centrally symmetric polytopes of certain properties. These shapes have not found widespread use as bounding volumes, in part due to having expensive intersection tests. For this reason, they are not covered here further.

It should be noted that whereas ellipsoid-ellipsoid is an expensive intersection test, tests of ellipsoids against triangles and other polygons can be transformed into testing a sphere against a skewed triangle by applying a nonuniform scaling to the coordinate space. Thus, ellipsoids are feasible bounding volumes for certain sets of tests.

4.8 **Summary**

Bounding volumes are simple geometric shapes used to encapsulate one or more objects of greater geometrical complexity. Most frequently, spheres and boxes are used as bounding volumes. If a really tight fit is required, slab volumes or convex hulls may be used. Bounding volumes are used as early overlap rejection tests, before more expensive tests are performed on the geometry enclosed within them. As discussed in Section 4.1, there are trade-offs involved in the selection of bounding volume shapes. By using bounding volumes of tighter fit, the chance of early rejection increases, but at the same time the bounding volume test becomes more expensive and the storage requirement for the bounding volume increases. Typically, bounding volumes are computed in a preprocessing step and, as necessary, transformed with the bounded objects at runtime to match the objects' movements.

In addition to detailing the most common bounding volumes and how to compute them, this chapter described how to perform homogeneous intersection tests (between volumes of the same type). These tests were meant as a teaser toward Chapter 5, which in considerable detail covers (heterogeneous) intersection tests and distance calculations between primitive geometrical shapes, such as lines and line segments, spheres, boxes, triangles, polygons, and polyhedra.

Chapter 5

Basic Primitive Tests

After a high-level system has ruled out as many objects as possible from further collision tests, all collision systems must perform low-level tests between primitives or bounding volumes to determine intersection status. In some cases, a simple indication whether there is an intersection is sufficient. In other cases, the actual point of intersection is required. This chapter describes how these low-level tests can be efficiently performed. In addition, the goal is to provide enough specific mathematical detail to allow derivation of tests that go beyond the scope of this presentation, using the mathematical ideas examined here.

Note that some of the mathematical expressions presented herein may be subject to numerical accuracy problems when implemented in floating-point arithmetic. These problems are only briefly touched on here. A deeper discussion of the robustness issues due to numerical accuracy problems is found in Chapter 11.

5.1 Closest-point Computations

Closest-point queries are some of the most powerful of collision queries. Given the closest points between two objects, the distance between the objects is obtained. If the combined maximum movement of two objects is less than the distance between them, a collision can be ruled out. In a hierarchical representation, closest-point computations allow parts of the hierarchy that will never come close enough to collide to be pruned from further consideration.

Obtaining the closest points between two objects can be seen as a minimization problem. One approach is to formulate the minimization problem and solve it using methods of calculus (such as the method of Lagrange multipliers). In this text a more geometric approach is preferred, and the following subsections illustrate how the closest points can be obtained for various geometric objects.

Note that closest points between two objects can sometimes be maintained incrementally at low cost, facilitating fast collision testing. Incremental computation of closest points is further explored in Chapter 9, in the context of collision between convex objects.

5.1.1 **Closest Point on Plane to Point**

Given a plane π, defined by a point P and a normal \mathbf{n}, all points X on the plane satisfy the equation $\mathbf{n} \cdot (X - P) = 0$ (that is, the vector from P to X is perpendicular to \mathbf{n}). Now let Q be an arbitrary point in space. The closest point R on the plane to Q is the orthogonal projection of Q onto the plane, obtained by moving Q perpendicularly (with respect to \mathbf{n}) toward the plane. That is, $R = Q - t\mathbf{n}$ for some value of t, as illustrated in Figure 5.1. Inserting this expression for R into the plane equation and solving for t gives:

$$\mathbf{n} \cdot ((Q - t\mathbf{n}) - P) = 0 \Leftrightarrow \qquad \textit{(inserting R for X in plane equation)}$$

$$\mathbf{n} \cdot Q - t(\mathbf{n} \cdot \mathbf{n}) - \mathbf{n} \cdot P = 0 \Leftrightarrow \qquad \textit{(expanding dot product)}$$

$$\mathbf{n} \cdot (Q - P) = t(\mathbf{n} \cdot \mathbf{n}) \Leftrightarrow \qquad \textit{(gathering similar terms and moving t expression to RHS)}$$

$$t = \mathbf{n} \cdot (Q - P)/(\mathbf{n} \cdot \mathbf{n}) \qquad \textit{(dividing both sides by } \mathbf{n} \cdot \mathbf{n})$$

Substituting this expression for t in $R = Q - t\mathbf{n}$ gives the projection point R as

$$R = Q - (\mathbf{n} \cdot (Q - P)/(\mathbf{n} \cdot \mathbf{n}))\mathbf{n}.$$

When \mathbf{n} is of unit length, t simplifies to $t = \mathbf{n} \cdot (Q - P)$, giving R as simply $R = Q - (\mathbf{n} \cdot (Q - P))\mathbf{n}$. From this equation it is easy to see that for an arbitrary point Q, $t = \mathbf{n} \cdot (Q - P)$ corresponds to the signed distance of Q from the plane in units of the length of \mathbf{n}. If t is positive, Q is in front of the plane (and if negative, Q is behind the plane).

When the plane is given in the four-component form $\mathbf{n} \cdot X = d$, the corresponding expression for t is $t = ((\mathbf{n} \cdot Q) - d)/(\mathbf{n} \cdot \mathbf{n})$. The code for computing the closest point on the plane to a point therefore becomes:

```
Point ClosestPtPointPlane(Point q, Plane p)
{
    float t = (Dot(p.n, q) - p.d) / Dot(p.n, p.n);
    return q - t * p.n;
}
```

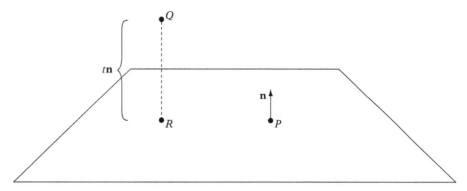

Figure 5.1 Plane π given by P and **n**. Orthogonal projection of Q onto π gives R, the closest point on π to Q.

If the plane equation is known to be normalized, this simplifies to $t = (\mathbf{n} \cdot Q) - d$, giving:

```
Point ClosestPtPointPlane(Point q, Plane p)
{
    float t = Dot(p.n, q) - p.d;
    return q - t * p.n;
}
```

The signed distance of Q to the plane is given by just returning the computed value of t:

```
float DistPointPlane(Point q, Plane p)
{
    // return Dot(q, p.n) - p.d; if plane equation normalized (||p.n||==1)
    return (Dot(p.n, q) - p.d) / Dot(p.n, p.n);
}
```

5.1.2 Closest Point on Line Segment to Point

Let AB be a line segment specified by the endpoints A and B. Given an arbitrary point C, the problem is to determine the point D on AB closest to C. As shown in Figure 5.2, projecting C onto the extended line through AB provides the solution. If the projection point P lies within the segment, P itself is the correct answer. If P lies

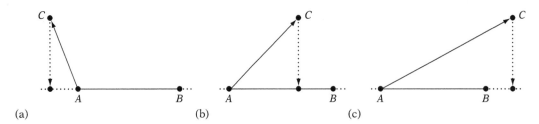

(a) (b) (c)

Figure 5.2 The three cases of *C* projecting onto *AB*: (a) outside *AB* on side of *A*, (b) inside *AB*, and (c) outside *AB* on side of *B*.

outside the segment, it is instead the segment endpoint closest to *C* that is the closest point.

Any point on the line through *AB* can be expressed parametrically as $P(t) = A + t(B - A)$. Using the projective properties of the dot product, the *t* corresponding to the projection of *C* onto the line is given by $t = (C - A) \cdot \mathbf{n}/\|B - A\|$, where $\mathbf{n} = (B - A)/\|B - A\|$ is a unit vector in the direction of *AB*.

Because the closest point on the line segment is required, *t* must be clamped to the interval $0 \le t \le 1$, after which *D* can be obtained by substituting *t* into the parametric equation. Implemented, this becomes:

```
// Given segment ab and point c, computes closest point d on ab.
// Also returns t for the position of d, d(t) = a + t*(b - a)
void ClosestPtPointSegment(Point c, Point a, Point b, float &t, Point &d)
{
    Vector ab = b - a;
    // Project c onto ab, computing parameterized position d(t) = a + t*(b - a)
    t = Dot(c - a, ab) / Dot(ab, ab);
    // If outside segment, clamp t (and therefore d) to the closest endpoint
    if (t < 0.0f) t = 0.0f;
    if (t > 1.0f) t = 1.0f;
    // Compute projected position from the clamped t
    d = a + t * ab;
}
```

If divisions are expensive, the division operation can be postponed by multiplying both sides of the comparisons by the denominator, which as a square term is guaranteed to be nonnegative. Optimized in this fashion, the code becomes:

```
// Given segment ab and point c, computes closest point d on ab.
// Also returns t for the parametric position of d, d(t) = a + t*(b - a)
```

```
void ClosestPtPointSegment(Point c, Point a, Point b, float &t, Point &d)
{
    Vector ab = b - a;
    // Project c onto ab, but deferring divide by Dot(ab, ab)
    t = Dot(c - a, ab);
    if (t <= 0.0f) {
        // c projects outside the [a,b] interval, on the a side; clamp to a
        t = 0.0f;
        d = a;
    } else {
        float denom = Dot(ab, ab);  // Always nonnegative since denom = ||ab||^2
        if (t >= denom) {
            // c projects outside the [a,b] interval, on the b side; clamp to b
            t = 1.0f;
            d = b;
        } else {
            // c projects inside the [a,b] interval; must do deferred divide now
            t = t / denom;
            d = a + t * ab;
        }
    }
}
```

The same basic method can be used for finding the closest point on a ray or the closest point on a line. For a ray, it is necessary to clamp t only when it goes negative. For a line, there is no need to clamp t at all.

5.1.2.1 Distance of Point to Segment

The squared distance between a point C and a segment AB can be directly computed without explicitly computing the point D on AB closest to C. As in the preceding section, there are three cases to consider. When $AC \cdot AB \leq 0$, A is closest to C and the squared distance is given by $AC \cdot AC$. When $AC \cdot AB \geq AB \cdot AB$, B is closest to C and the squared distance is $BC \cdot BC$. In the remaining case, $0 < AC \cdot AB < AB \cdot AB$, the squared distance is given by $CD \cdot CD$, where

$$D = A + \frac{AC \cdot AB}{AB \cdot AB} AB.$$

However, because the expression $CD \cdot CD$ simplifies to

$$AC \cdot AC - \frac{(AC \cdot AB)^2}{AB \cdot AB},$$

computing D is not required. Because several subterms recur, the implementation can be efficiently written as follows:

```
// Returns the squared distance between point c and segment ab
float SqDistPointSegment(Point a, Point b, Point c)
{
    Vector ab = b - a, ac = c - a, bc = c - b;
    float e = Dot(ac, ab);
    // Handle cases where c projects outside ab
    if (e <= 0.0f) return Dot(ac, ac);
    float f = Dot(ab, ab);
    if (e >= f) return Dot(bc, bc);
    // Handle cases where c projects onto ab
    return Dot(ac, ac) - e * e / f;
}
```

5.1.3 Closest Point on AABB to Point

Let B be an axis-aligned bounding box and P an arbitrary point in space. The point Q on (or in) B closest to P is obtained by clamping P to the bounds of B on a componentwise basis. There are four cases to consider for verifying that clamping gives the desired result. If P is inside B, the clamped point is P itself, which is also the point in B closest to P. If P is in a face Voronoi region of B, the clamping operation will bring P to that face of B. (Voronoi regions were introduced in Chapter 3.) The clamping corresponds to an orthogonal projection of P onto B and must therefore result in the closest point on B. When P is in a vertex Voronoi region of B, clamping P gives the vertex as a result, which again is the closest point on B. Finally, when P is in an edge Voronoi region, clamping P corresponds to an orthogonal projection onto the edge, which also must be the closest point on B to P. This procedure works in both two and three dimensions. The clamping procedure for a 2D box is illustrated in Figure 5.3, for the point P lying in an edge Voronoi region (a) and in a vertex Voronoi region (b).

The following code implements the closest-point operation:

```
// Given point p, return the point q on or in AABB b that is closest to p
void ClosestPtPointAABB(Point p, AABB b, Point &q)
{
    // For each coordinate axis, if the point coordinate value is
    // outside box, clamp it to the box, else keep it as is
```

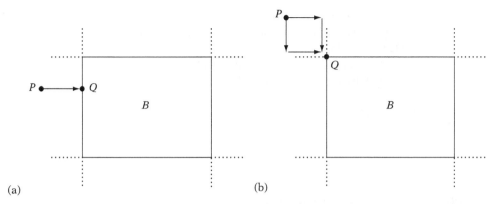

Figure 5.3 Clamping *P* to the bounds of *B* gives the closest point *Q* on *B* to *P*: (a) for an edge Voronoi region, (b) for a vertex Voronoi region.

```
for (int i = 0; i < 3; i++) {
    float v = p[i];
    if (v < b.min[i]) v = b.min[i];  // v = max(v, b.min[i])
    if (v > b.max[i]) v = b.max[i];  // v = min(v, b.max[i])
    q[i] = v;
  }
}
```

In CPU architectures supporting SIMD instructions this function can often be implemented in just two instructions: a *max* instruction followed by a *min* instruction!

5.1.3.1 Distance of Point to AABB

When the point *Q* on an AABB *B* closest to a given point *P* is computed only to determine the distance between *P* and *Q*, the distance can be calculated without explicitly obtaining *Q*. This is illustrated by the following code. To simplify the calculation and to avoid an expensive square root call, the squared distance is computed.

```
// Computes the square distance between a point p and an AABB b
float SqDistPointAABB(Point p, AABB b)
{
    float sqDist = 0.0f;
```

```
    for (int i = 0; i < 3; i++) {
        // For each axis count any excess distance outside box extents
        float v = p[i];
        if (v < b.min[i]) sqDist += (b.min[i] - v) * (b.min[i] - v);
        if (v > b.max[i]) sqDist += (v - b.max[i]) * (v - b.max[i]);
    }
    return sqDist;
}
```

5.1.4 Closest Point on OBB to Point

Let B be an OBB given by a center point C; three orthogonal unit vectors \mathbf{u}_0, \mathbf{u}_1, and \mathbf{u}_2 specifying the orientation of the x, y, and z axes of B; and three scalar values e_0, e_1, and e_2 specifying the box halfwidths along each axis (Figure 5.4). In this representation, all points S contained by B can be written as $S = C + a\mathbf{u}_0 + b\mathbf{u}_1 + c\mathbf{u}_2$, where $|a| \leq e_0$, $|b| \leq e_1$, and $|c| \leq e_2$.

A point P in world space relates to its corresponding point $Q = (x, y, z)$ in the coordinate system of the OBB B as $P = C + x\mathbf{u}_0 + y\mathbf{u}_1 + z\mathbf{u}_2$. Given P, the OBB-space coordinates can be solved for as follows. Only the derivation of the x

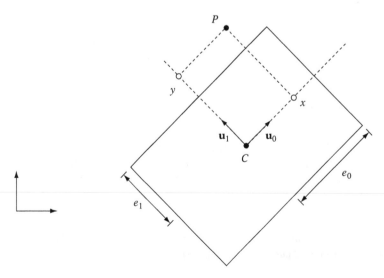

Figure 5.4 The point P, in world space, can be expressed as the point (x, y) in the coordinate system of this 2D OBB.

coordinate is shown here. The other coordinates can be solved for in a similar manner.

$$P = C + x\mathbf{u}_0 + y\mathbf{u}_1 + z\mathbf{u}_2 \Leftrightarrow \qquad \textit{(original expression)}$$

$$P - C = x\mathbf{u}_0 + y\mathbf{u}_1 + z\mathbf{u}_2 \Leftrightarrow \qquad \textit{(moving C to left side)}$$

$$(P - C) \cdot \mathbf{u}_0 = (x\mathbf{u}_0 + y\mathbf{u}_1 + z\mathbf{u}_2) \cdot \mathbf{u}_0 \Leftrightarrow \qquad \textit{(taking dot product with } \mathbf{u}_0 \textit{ on both sides)}$$

$$(P - C) \cdot \mathbf{u}_0 = x(\mathbf{u}_0 \cdot \mathbf{u}_0) + y(\mathbf{u}_1 \cdot \mathbf{u}_0) + z(\mathbf{u}_2 \cdot \mathbf{u}_0) \Leftrightarrow \qquad \textit{(expanding dot product expression)}$$

$$(P - C) \cdot \mathbf{u}_0 = x \qquad \textit{(simplifying using } \mathbf{u}_0 \cdot \mathbf{u}_0 = 1,$$
$$\mathbf{u}_1 \cdot \mathbf{u}_0 = \mathbf{u}_2 \cdot \mathbf{u}_0 = 0)$$

The full set of OBB coordinates are thus given by $x = (P - C) \cdot \mathbf{u}_0$, $y = (P - C) \cdot \mathbf{u}_1$, and $z = (P - C) \cdot \mathbf{u}_2$.

To compute the point R on (or in) B closest to P, the same approach as used for an AABB can be applied by expressing P in the OBB coordinate system as Q, clamping Q to the extents e_0, e_1, and e_2, and reexpressing Q in world coordinates. The code for this follows.

```
// Given point p, return point q on (or in) OBB b, closest to p
void ClosestPtPointOBB(Point p, OBB b, Point &q)
{
    Vector d = p - b.c;
    // Start result at center of box; make steps from there
    q = b.c;
    // For each OBB axis...
    for (int i = 0; i < 3; i++) {
        // ...project d onto that axis to get the distance
        // along the axis of d from the box center
        float dist = Dot(d, b.u[i]);
        // If distance farther than the box extents, clamp to the box
        if (dist > b.e[i]) dist = b.e[i];
        if (dist < -b.e[i]) dist = -b.e[i];
        // Step that distance along the axis to get world coordinate
        q += dist * b.u[i];
    }
}
```

Mathematically, the described method is equivalent to transforming the point P into the local coordinate system of the OBB, computing the point on the OBB (now effectively an AABB) closest to the transformed point, and transforming the resulting point back into world coordinates.

5.1.4.1 Distance of Point to OBB

To obtain the squared distance between the point P and the closest point on OBB B, the previous function could be called in this way:

```
// Computes the square distance between point p and OBB b
float SqDistPointOBB(Point p, OBB b)
{
    Point closest;
    ClosestPtPointOBB(p, b, closest);
    float sqDist = Dot(closest - p, closest - p);
    return sqDist;
}
```

If only the squared distance and not the closest point is needed, this code can be further simplified. By projecting the vector **v** from the center of B to P onto each of the three OBB axes, the distance d from P to the box center along that axis is obtained. Because the axes are orthogonal, any excess amount that d is beyond the extent of the box for a given axis can be computed, squared, and added to the total squared distance of P independently of the other two axes.

```
// Computes the square distance between point p and OBB b
float SqDistPointOBB(Point p, OBB b)
{
    Vector v = p - b.c;
    float sqDist = 0.0f;
    for (int i = 0; i < 3; i++) {
        // Project vector from box center to p on each axis, getting the distance
        // of p along that axis, and count any excess distance outside box extents
        float d = Dot(v, b.u[i]), excess = 0.0f;
        if (d < -b.e[i])
            excess = d + b.e[i];
        else if (d > b.e[i])
            excess = d - b.e[i];
        sqDist += excess * excess;
    }
    return sqDist;
}
```

5.1.4.2 Closest Point on 3D Rectangle to Point

Determining the point Q on a 3D rectangle R closest to a given point P is virtually equivalent to the problem of finding the closest point on an OBB, in that a 3D rectangle can be seen as an OBB with zero extent along the z axis.

As such, a rectangle is defined by a center point C, two orthogonal unit vectors \mathbf{u}_0 and \mathbf{u}_1 specifying the orientation of the x and y axes of R, and two scalar values e_0 and e_1 specifying the rectangle halfwidth extents along each axis. In this representation, all points S contained by R are given by $S = C + a\mathbf{u}_0 + b\mathbf{u}_1$, where $|a| \le e_0$ and $|b| \le e_1$. Expressed as code, this rectangle structure becomes:

```
struct Rect {
    Point c;       // center point of rectangle
    Vector u[2];   // unit vectors determining local x and y axes for the rectangle
    float e[2];    // the halfwidth extents of the rectangle along the axes
};
```

Rewriting the **ClosestPtPointOBB()** code to account for a zero-extent z axis results in the following code for finding the closest point on a 3D rectangle.

```
// Given point p, return point q on (or in) Rect r, closest to p
void ClosestPtPointRect(Point p, Rect r, Point &q)
{
    Vector d = p - r.c;
    // Start result at center of rect; make steps from there
    q = r.c;
    // For each rect axis...
    for (int i = 0; i < 2; i++) {
        // ...project d onto that axis to get the distance
        // along the axis of d from the rect center
        float dist = Dot(d, r.u[i]);
        // If distance farther than the rect extents, clamp to the rect
        if (dist > r.e[i]) dist = r.e[i];
        if (dist < -r.e[i]) dist = -r.e[i];
        // Step that distance along the axis to get world coordinate
        q += dist * r.u[i];
    }
}
```

A 3D rectangle R can also be given by three points (A, B, and C) such that the vectors $B - A$ and $C - A$ span the rectangle. All points S in R are now given by

$S = A + u(B - A) + v(C - A)$, $0 \leq u \leq 1$, and $0 \leq v \leq 1$. In this scenario, a similar projection approach can be used (but adjusting for the new clamping intervals). Optimizing the implementation for this case results in the following code.

```
// Return point q on (or in) rect (specified by a, b, and c), closest to given point p
void ClosestPtPointRect(Point p, Point a, Point b, Point c, Point &q)
{
    Vector ab = b - a;  // vector across rect
    Vector ac = c - a;  // vector down rect
    Vector d = p - a;
    // Start result at top-left corner of rect; make steps from there
    q = a;
    // Clamp p' (projection of p to plane of r) to rectangle in the across direction
    float dist = Dot(d, ab);
    float maxdist = Dot(ab, ab);
    if (dist >= maxdist)
        q += ab;
    else if (dist > 0.0f)
        q += (dist / maxdist) * ab;
    // Clamp p' (projection of p to plane of r) to rectangle in the down direction
    dist = Dot(d, ac);
    maxdist = Dot(ac, ac);
    if (dist >= maxdist)
        q += ac;
    else if (dist > 0.0f)
        q += (dist / maxdist) * ac;
}
```

This is slightly more expensive than the initial approach, as it is not benefitting from normalization of the rectangle's across and down vectors during a precalculation step.

5.1.5 Closest Point on Triangle to Point

Given a triangle *ABC* and a point *P*, let *Q* describe the point on *ABC* closest to *P*. One way of obtaining *Q* is to rely on the fact that if *P* orthogonally projects inside *ABC* the projection point is the closest point *Q*. If *P* projects outside *ABC*, the closest point must instead lie on one of its edges. In this case, *Q* can be obtained by computing the closest point to *P* for each of the line segments *AB*, *BC*, and *CA* and returning the computed point closest to *P*. Although this works, it is not a very efficient approach. A better solution is to compute which of the triangle's Voronoi feature regions *P* is in.

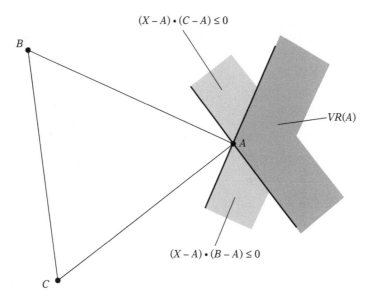

$(X - A) \cdot (C - A) \le 0$

$VR(A)$

$(X - A) \cdot (B - A) \le 0$

Figure 5.5 The Voronoi region of vertex A, $VR(A)$, is the intersection of the negative halfspaces of the two planes $(X - A) \cdot (B - A) = 0$ and $(X - A) \cdot (C - A) = 0$.

Once determined, only the orthogonal projection of P onto the corresponding feature must be computed to obtain Q.

To see how P can be determined to be in a vertex Voronoi region, consider the vertex Voronoi region of A. This region is determined as the intersection of the negative halfspaces of two planes through A, one with a normal of $B - A$ and the other with the normal $C - A$ (as illustrated in Figure 5.5).

Determining if P lies in one of the edge Voronoi regions can be done in a number of ways. It turns out that an efficient test is to effectively compute the barycentric coordinates of the orthogonal projection R of P onto ABC. Recall from Section 3.4 that the barycentric coordinates of R are given as the ratios of (anything proportional to) the signed areas of triangles RAB, RBC, and RCA to the signed area of ABC. Let \mathbf{n} be the normal of ABC and let $R = P - t\mathbf{n}$ for some t. The barycentric coordinates (u, v, w) of R, $R = uA + vB + wC$, can then be computed from the quantities

```
Vector n = Cross(b - a, c - a);
float rab = Dot(n, Cross(a - r, b - r));  // proportional to signed area of RAB
float rbc = Dot(n, Cross(b - r, c - r));  // proportional to signed area of RBC
float rca = Dot(n, Cross(c - r, a - r));  // proportional to signed area of RCA
float abc = rab + rbc + rca;              // proportional to signed area of ABC
```

as $u = rbc/abc$, $v = rca/abc$, and $w = rab/abc$. However, a little vector arithmetic shows that these expressions simplify. For example, the expression for *rab* simplifies as follows:

$\mathbf{n} \cdot ((A - R) \times (B - R)) =$ *(original expression)*

$\mathbf{n} \cdot (A \times (B - R) - R \times (B - R)) =$ *(expanding cross product)*

$\mathbf{n} \cdot (A \times B - A \times R - R \times B) =$ *(expanding cross products; removing $\mathbf{n} \cdot (R \times R) = 0$ term)*

$\mathbf{n} \cdot (A \times B - A \times (P - t\mathbf{n}) - (P - t\mathbf{n}) \times B) =$ *(substituting $R = P - t\mathbf{n}$ for R)*

$\mathbf{n} \cdot (A \times B - A \times P + tA \times \mathbf{n} - P \times B + t\mathbf{n} \times B) =$ *(expanding cross products)*

$\mathbf{n} \cdot (A \times B - A \times P - P \times B + t\mathbf{n} \times (B - A)) =$ *(gathering similar terms)*

$\mathbf{n} \cdot (A \times B - A \times P - P \times B) =$ *(removing $\mathbf{n} \cdot (t\mathbf{n} \times (B - A)) = 0$ term)*

$\mathbf{n} \cdot ((A - P) \times (B - P))$ *(contracting cross product after adding $\mathbf{n} \cdot (P \times P) = 0$ term)*

In other words, the barycentric coordinates of R can be obtained directly from P without computing R.

For P to lie in an edge Voronoi region — for example, the one corresponding to edge AB — P would have to lie outside or on AB, signified by $rab \leq 0$, as well as within the positive halfspaces of the planes $(X - A) \cdot (B - A) = 0$ and $(X - B) \cdot (A - B) = 0$. Note that it is *not* sufficient just to test if P is outside AB, in that for a triangle with an obtuse angle at A, P could be outside AB and actually be located in the Voronoi region of edge CA (Figure 5.6). (Similarly, it is a common mistake to assume, for example, that A is the closest point to P if P lies outside AB and $(P - A) \cdot (B - A) < 0$.) If P is not found to be in any of the vertex or edge Voronoi regions, Q must lie inside ABC

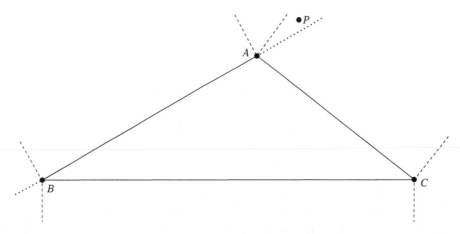

Figure 5.6 When the angle at A is obtuse, P may lie in the Voronoi region of edge CA even though P lies outside AB and not in the vertex Voronoi regions of either A or B.

and, in fact, be the orthogonal projection R, which can now be easily computed per the preceding. This information is now enough to produce a code solution.

```
Point ClosestPtPointTriangle(Point p, Point a, Point b, Point c)
{
    Vector ab = b - a;
    Vector ac = c - a;
    Vector bc = c - b;

    // Compute parametric position s for projection P' of P on AB,
    // P' = A + s*AB, s = snom/(snom+sdenom)
    float snom = Dot(p - a, ab), sdenom = Dot(p - b, a - b);

    // Compute parametric position t for projection P' of P on AC,
    // P' = A + t*AC, s = tnom/(tnom+tdenom)
    float tnom = Dot(p - a, ac), tdenom = Dot(p - c, a - c);

    if (snom <= 0.0f && tnom <= 0.0f) return a;  // Vertex region early out

    // Compute parametric position u for projection P' of P on BC,
    // P' = B + u*BC, u = unom/(unom+udenom)
    float unom = Dot(p - b, bc), udenom = Dot(p - c, b - c);

    if (sdenom <= 0.0f && unom <= 0.0f) return b;  // Vertex region early out
    if (tdenom <= 0.0f && udenom <= 0.0f) return c;  // Vertex region early out

    // P is outside (or on) AB if the triple scalar product [N PA PB] <= 0
    Vector n = Cross(b - a, c - a);
    float vc = Dot(n, Cross(a - p, b - p));
    // If P outside AB and within feature region of AB,
    // return projection of P onto AB
    if (vc <= 0.0f && snom >= 0.0f && sdenom >= 0.0f)
        return a + snom / (snom + sdenom) * ab;

    // P is outside (or on) BC if the triple scalar product [N PB PC] <= 0
    float va = Dot(n, Cross(b - p, c - p));
    // If P outside BC and within feature region of BC,
    // return projection of P onto BC
    if (va <= 0.0f && unom >= 0.0f && udenom >= 0.0f)
        return b + unom / (unom + udenom) * bc;

    // P is outside (or on) CA if the triple scalar product [N PC PA] <= 0
    float vb = Dot(n, Cross(c - p, a - p));
```

```
    // If P outside CA and within feature region of CA,
    // return projection of P onto CA
    if (vb <= 0.0f && tnom >= 0.0f && tdenom >= 0.0f)
        return a + tnom / (tnom + tdenom) * ac;

    // P must project inside face region. Compute Q using barycentric coordinates
    float u = va / (va + vb + vc);
    float v = vb / (va + vb + vc);
    float w = 1.0f - u - v;   // = vc / (va + vb + vc)
    return u * a + v * b + w * c;
}
```

As presented, this code contains four cross-product calls. Because cross products are often more expensive to calculate than dot products, it is worthwhile exploring whether these can be replaced by more economical expressions. It turns out that the Lagrange identity

$$(\mathbf{a} \times \mathbf{b}) \cdot (\mathbf{c} \times \mathbf{d}) = (\mathbf{a} \cdot \mathbf{c})(\mathbf{b} \cdot \mathbf{d}) - (\mathbf{a} \cdot \mathbf{d})(\mathbf{b} \cdot \mathbf{c})$$

can be used to express the three scalar triple products

```
    Vector n = Cross(b - a, c - a);
    float va = Dot(n, Cross(b - p, c - p));
    float vb = Dot(n, Cross(c - p, a - p));
    float vc = Dot(n, Cross(a - p, b - p));
```

in terms of the six dot products

```
    float d1 = Dot(b - a, p - a);
    float d2 = Dot(c - a, p - a);
    float d3 = Dot(b - a, p - b);
    float d4 = Dot(c - a, p - b);
    float d5 = Dot(b - a, p - c);
    float d6 = Dot(c - a, p - c);
```

as

```
    float va = d3*d6 - d5*d4;
    float vb = d5*d2 - d1*d6;
    float vc = d1*d4 - d3*d2;
```

In fact, these six dot products, **d1** to **d6**, can be used to compute the **snom**, **sdenom**, **tnom**, **tdenom**, **unom**, and **udenom** terms as well:

```
float snom = d1;
float sdenom = -d3;
float tnom = d2;
float tdenom = -d6;
float unom = d4 - d3;
float udenom = d5 - d6;
```

The vector **n** is no longer needed. This allows the code to be optimized to the final version.

```
Point ClosestPtPointTriangle(Point p, Point a, Point b, Point c)
{
    // Check if P in vertex region outside A
    Vector ab = b - a;
    Vector ac = c - a;
    Vector ap = p - a;
    float d1 = Dot(ab, ap);
    float d2 = Dot(ac, ap);
    if (d1 <= 0.0f && d2 <= 0.0f) return a; // barycentric coordinates (1,0,0)

    // Check if P in vertex region outside B
    Vector bp = p - b;
    float d3 = Dot(ab, bp);
    float d4 = Dot(ac, bp);
    if (d3 >= 0.0f && d4 <= d3) return b; // barycentric coordinates (0,1,0)

    // Check if P in edge region of AB, if so return projection of P onto AB
    float vc = d1*d4 - d3*d2;
    if (vc <= 0.0f && d1 >= 0.0f && d3 <= 0.0f) {
        float v = d1 / (d1 - d3);
        return a + v * ab; // barycentric coordinates (1-v,v,0)
    }

    // Check if P in vertex region outside C
    Vector cp = p - c;
    float d5 = Dot(ab, cp);
    float d6 = Dot(ac, cp);
    if (d6 >= 0.0f && d5 <= d6) return c; // barycentric coordinates (0,0,1)
```

```
// Check if P in edge region of AC, if so return projection of P onto AC
float vb = d5*d2 - d1*d6;
if (vb <= 0.0f && d2 >= 0.0f && d6 <= 0.0f) {
    float w = d2 / (d2 - d6);
    return a + w * ac;  // barycentric coordinates (1-w,0,w)
}

// Check if P in edge region of BC, if so return projection of P onto BC
float va = d3*d6 - d5*d4;
if (va <= 0.0f && (d4 - d3) >= 0.0f && (d5 - d6) >= 0.0f) {
    float w = (d4 - d3) / ((d4 - d3) + (d5 - d6));
    return b + w * (c - b);  // barycentric coordinates (0,1-w,w)
}

// P inside face region. Compute Q through its barycentric coordinates (u,v,w)
float denom = 1.0f / (va + vb + vc);
float v = vb * denom;
float w = vc * denom;
return a + ab * v + ac * w;  // = u*a + v*b + w*c, u = va * denom = 1.0f - v - w
}
```

A third way of obtaining the closest point is to use a vector calculus approach, as suggested in [Eberly01]. Briefly, the triangle ABC is parameterized as $T(s,t) = A + s(B - A) + t(C - A)$, where $s \geq 0$, $t \geq 0$, and $s + t \leq 1$. The closest point to a given point P now corresponds to the minimum of the squared distance function $d(s,t) = \|T(s,t) - P\|^2$, which is a quadratic expression in s and t. The minimum of this function must occur in one of three cases: at a vertex, on an edge, or in the interior of the triangle. By first differentiating $d(s,t)$ with respect to these different cases (that is, substituting $s = 0$, $t = 0$, or $t = 1 - s$ as necessary), setting the derivatives to zero and solving, and then comparing the resulting s and t values to the triangle bounds, it is possible to find out which case corresponds to the minimum.

For this particular application, the vector calculus solution becomes more complicated than just described. However, the general approach of viewing the problem as a quadratic minimization problem is valuable, and the same idea can be used to determine the distance between, say, a line or line segment and a triangle. Additional information on the vector calculus approach, including pseudocode, is given in [Eberly01].

5.1.6 **Closest Point on Tetrahedron to Point**

Given a point P, the problem is determining the point Q on (or in) a tetrahedron $ABCD$ closest to P (as illustrated in Figure 5.7). A straightforward solution is to compute Q

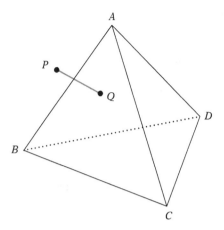

Figure 5.7 The point *Q* on the tetrahedron *ABCD* closest to *P*.

by calling the **ClosestPtPointTriangle()** function (defined in the previous section) once for each face plane of the tetrahedron *P*. Of all computed points, the one closest to *P* is returned as *Q*. Separately from the distance tests, a different test is made to see if *P* lies inside all face planes. When it does, *P* itself is the closest point.

Assuming the tetrahedron *ABCD* has been defined so that its faces *ABC*, *ACD*, *ADB*, and *BDC* all are arranged counterclockwise when viewed from outside the tetrahedron, this solution can be implemented as follows.

```
Point ClosestPtPointTetrahedron(Point p, Point a, Point b, Point c, Point d)
{
    // Start out assuming point inside all halfspaces, so closest to itself
    Point closestPt = p;
    float bestSqDist = FLT_MAX;
    // If point outside face abc then compute closest point on abc
    if (PointOutsideOfPlane(p, a, b, c)) {
        Point q = ClosestPtPointTriangle(p, a, b, c);
        float sqDist = Dot(q - p, q - p);
        // Update best closest point if (squared) distance is less than current best
        if (sqDist < bestSqDist) bestSqDist = sqDist, closestPt = q;
    }
    // Repeat test for face acd
    if (PointOutsideOfPlane(p, a, c, d)) {
        Point q = ClosestPtPointTriangle(p, a, c, d);
        float sqDist = Dot(q - p, q - p);
        if (sqDist < bestSqDist) bestSqDist = sqDist, closestPt = q;
    }
```

```
    // Repeat test for face adb
    if (PointOutsideOfPlane(p, a, d, b)) {
        Point q = ClosestPtPointTriangle(p, a, d, b);
        float sqDist = Dot(q - p, q - p);
        if (sqDist < bestSqDist) bestSqDist = sqDist, closestPt = q;
    }
    // Repeat test for face bdc
    if (PointOutsideOfPlane(p, b, d, c)) {
        Point q = ClosestPtPointTriangle(p, b, d, c);
        float sqDist = Dot(q - p, q - p);
        if (sqDist < bestSqDist) bestSqDist = sqDist, closestPt = q;
    }
    return closestPt;
}
```

Here the value of **PointOutsideOfPlane(P, A, B, C)** corresponds to the sign of the scalar triple product of the vectors $P - A$, $B - A$, and $C - A$.

```
// Test if point p lies outside plane through abc
int PointOutsideOfPlane(Point p, Point a, Point b, Point c)
{
    return Dot(p - a, Cross(b - a, c - a)) >= 0.0f; // [AP AB AC] >= 0
}
```

Often the winding of the tetrahedron vertices is not known beforehand, meaning it cannot be assumed, say, that face *ABC* is counterclockwise when viewed from outside the tetrahedron. In this case, the solution is to additionally pass the fourth tetrahedron vertex to **PointOutsideOfPlane()** and make sure it and the tested point lie on opposite sides of the tested tetrahedron face. In other words, the function then becomes:

```
// Test if point p and d lie on opposite sides of plane through abc
int PointOutsideOfPlane(Point p, Point a, Point b, Point c, Point d)
{
    float signp = Dot(p - a, Cross(b - a, c - a)); // [AP AB AC]
    float signd = Dot(d - a, Cross(b - a, c - a)); // [AD AB AC]
    // Points on opposite sides if expression signs are opposite
    return signp * signd < 0.0f;
}
```

This overall approach works well and is simple to implement. However, it is possible to derive a more efficient solution by applying the same basic method used for finding the closest point on a triangle. First, the Voronoi feature region in which the point P is located is determined. Once the feature has been obtained, Q is given by the orthogonal projection of P onto this feature. For a tetrahedron there are 14 overall Voronoi feature regions that must be considered: four vertex regions, six edge regions, and four face regions. If P does not lie in one of the feature regions, P must by default be contained in the tetrahedron. The tests for containment in a feature region are similar to those made earlier for the triangle. For example, P is now determined to lie in the vertex Voronoi region of A if the following expressions are satisfied.

$$(P - A) \cdot (B - A) \leq 0$$
$$(P - A) \cdot (C - A) \leq 0$$
$$(P - A) \cdot (D - A) \leq 0$$

For P to lie in the Voronoi region associated with edge AB, the following tests would have to be satisfied (again assuming a known counterclockwise winding of the faces).

$$(P - A) \cdot (B - A) \geq 0$$
$$(P - B) \cdot (A - B) \geq 0$$
$$(P - A) \cdot ((B - A) \times \mathbf{n}_{ABC}) \geq 0, \text{ where } \mathbf{n}_{ABC} = (B - A) \times (C - A)$$
$$(P - A) \cdot (\mathbf{n}_{ADB} \times (B - A)) \geq 0, \text{ where } \mathbf{n}_{ADB} = (D - A) \times (B - A)$$

Analogous sets of expressions can be defined for testing containment in the remaining regions. At first glance, this may not seem like an improvement over the earlier test. However, many of the computed quantities are shared between different Voronoi regions and need not be recomputed. It is also possible to simplify the expressions involved in testing the Voronoi regions using the Lagrange identity, similar to the optimization done for the closest-point-on-triangle test. In this case, it turns out that all tests can be composed in terms of just 10 different dot products.

5.1.7 Closest Point on Convex Polyhedron to Point

Several approaches are available for locating the point on a convex polyhedron H closest to a point P in space. A simple-to-implement $O(n)$ method is to compute the point on each polyhedron face closest to P and return the one closest to P. A concurrently run test determines if P lies inside all faces of H, in which case P is interior to H. To speed up the test, the face distance calculation would have to be run only when P lies in front of the face.

For larger polyhedra, a faster approach is to construct, as a precomputation, a hierarchy over the parts of the polyhedron. Utilizing a preconstructed hierarchy allows the closest point to be located in logarithmic time. An example of such a hierarchy is the Dobkin–Kirkpatrick hierarchy, described in Chapter 9. Chapter 9 also describes other approaches that can efficiently locate the closest point on the polyhedra (such as the GJK algorithm).

5.1.8 Closest Points of Two Lines

Whereas a pair of lines in two dimensions always intersect unless they are parallel, a pair of lines in three dimensions almost never intersect. Furthermore, even if two 3D lines intersect in exact real arithmetic, under floating-point arithmetic they are quite likely not to, due to rounding errors. Thus, to be able to robustly test the intersection of two 3D lines it is best to assume that the lines might not intersect but only come sufficiently close to each other. The intersection test then becomes determining the distance between the lines and checking whether this distance is less than a given threshold value.

The closest points of two lines can be determined as follows. Let the lines L_1 and L_2 be specified parametrically by the points P_1 and Q_1 and P_2 and Q_2:

$$L_1(s) = P_1 + s\mathbf{d}_1, \mathbf{d}_1 = Q_1 - P_1$$
$$L_2(t) = P_2 + t\mathbf{d}_2, \mathbf{d}_2 = Q_2 - P_2$$

For some pair of values for s and t, $L_1(s)$ and $L_2(t)$ correspond to the closest points on the lines, and $\mathbf{v}(s, t) = L_1(s) - L_2(t)$ describes a vector between them (Figure 5.8). The points are at their closest when \mathbf{v} is of minimum length. The key realization is that this happens when \mathbf{v} is perpendicular to both L_1 and L_2. To see this, consider that the shortest distance between a point P and a line L is the length of a straight line

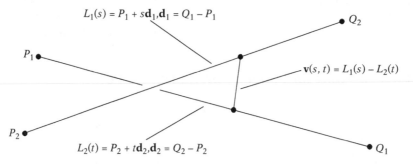

Figure 5.8 The vector $\mathbf{v}(s, t)$ connecting the two closest points of two lines, $L_1(s)$ and $L_2(t)$, is always perpendicular to both lines.

between P and the point Q corresponding to the orthogonal projection of P onto L. Consequently, the line PQ is orthogonal to L. Because this reasoning holds for both $L_1(s)$ with respect to L_2 and $L_2(t)$ with respect to L_1, \mathbf{v} must be perpendicular to both lines. For nonparallel lines, \mathbf{v} is unique.

The problem is now finding values for s and t satisfying these two perpendicularity constraints:

$$\mathbf{d}_1 \cdot \mathbf{v}(s, t) = 0$$
$$\mathbf{d}_2 \cdot \mathbf{v}(s, t) = 0.$$

Substituting the parametric equation for $\mathbf{v}(s, t)$ gives:

$$\mathbf{d}_1 \cdot (L_1(s) - L_2(t)) = \mathbf{d}_1 \cdot ((P_1 - P_2) + s\mathbf{d}_1 - t\mathbf{d}_2) = 0$$
$$\mathbf{d}_2 \cdot (L_1(s) - L_2(t)) = \mathbf{d}_2 \cdot ((P_1 - P_2) + s\mathbf{d}_1 - t\mathbf{d}_2) = 0.$$

This can be expressed as the 2×2 system of linear equations

$$(\mathbf{d}_1 \cdot \mathbf{d}_1)s - (\mathbf{d}_1 \cdot \mathbf{d}_2)t = -(\mathbf{d}_1 \cdot \mathbf{r})$$
$$(\mathbf{d}_2 \cdot \mathbf{d}_1)s - (\mathbf{d}_2 \cdot \mathbf{d}_2)t = -(\mathbf{d}_2 \cdot \mathbf{r}),$$

where $\mathbf{r} = P_1 - P_2$.

Written symbolically, in matrix notation, this corresponds to

$$\begin{bmatrix} a & -b \\ b & -e \end{bmatrix} \begin{bmatrix} s \\ t \end{bmatrix} = \begin{bmatrix} -c \\ -f \end{bmatrix},$$

where $a = \mathbf{d}_1 \cdot \mathbf{d}_1$, $b = \mathbf{d}_1 \cdot \mathbf{d}_2$, $c = \mathbf{d}_1 \cdot \mathbf{r}$, $e = \mathbf{d}_2 \cdot \mathbf{d}_2$, and $f = \mathbf{d}_2 \cdot \mathbf{r}$. This system of equations is solved, for example, using Cramer's rule to give

$$s = (bf - ce)/d$$
$$t = (af - bc)/d,$$

where $d = ae - b^2$. Note that $d \geq 0$, in that $d = \|\mathbf{d}_1\|^2 \|\mathbf{d}_2\|^2 - (\|\mathbf{d}_1\| \|\mathbf{d}_2\| \cos(\theta))^2 = (\|\mathbf{d}_1\| \|\mathbf{d}_2\| \sin(\theta))^2$. When $d = 0$, the two lines are parallel, which must be handled separately. In this case, any point P can be selected on the one line. On the other line, the point closest to P is selected using the projection method described in Section 5.1.2.

5.1.9 **Closest Points of Two Line Segments**

The problem of determining the closest points of two line segments S_1 and S_2,

$$S_1(s) = P_1 + s\mathbf{d}_1, \ \mathbf{d}_1 = Q_1 - P_1, \ 0 \le s \le 1$$
$$S_2(t) = P_2 + t\mathbf{d}_2, \ \mathbf{d}_2 = Q_2 - P_2, \ 0 \le t \le 1,$$

is more complicated than computing the closest points of the lines L_1 and L_2 of which the segments are a part. Only when the closest points of L_1 and L_2 happen to lie on the segments does the method for closest points between lines apply. For the case in which the closest points between L_1 and L_2 lie outside one or both segments, a common misconception is that it is sufficient to clamp the outside points to the nearest segment endpoint. However, as cases (b) and (c) of Figure 5.9 illustrate, this is not a valid assumption.

It can be shown that if just one of the closest points between the lines is outside its corresponding segment that point can be clamped to the appropriate endpoint of the segment and the point on the other segment closest to the endpoint is computed [Lumelsky85]. This corresponds to case (b) in Figure 5.9, in which the closest point on L_1 is clamped to endpoint Q_1 on segment S_1. The closest point R on L_2 to Q_1 is then computed and found to be on segment S_2, leaving the closest points as Q_1 and R.

If both points are outside their respective segments, the same clamping procedure must be repeated twice, as illustrated by case (c) in Figure 5.9. Again the closest point on L_1 gets clamped to endpoint Q_1 on S_1. The closest point R on L_2 to Q_1 is computed. Because R is found to be outside segment S_2, it is clamped to the nearest segment endpoint, Q_2. The closest point S on L_1 to Q_2 is then computed and now found to be on segment S_1, leaving the closest points as Q_2 and S.

Given a point $S_2(t) = P_2 + t\mathbf{d}_2$ on the second segment, the closest point $L_1(s)$ on L_1 is given by

$$s = (S_2(t) - P_1) \cdot \mathbf{d}_1 / \mathbf{d}_1 \cdot \mathbf{d}_1 = (P_2 + t\mathbf{d}_2 - P_1) \cdot \mathbf{d}_1 / \mathbf{d}_1 \cdot \mathbf{d}_1.$$

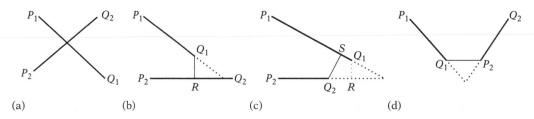

Figure 5.9 Closest points (a) inside both segments, (b) and (c) inside one segment endpoint of other, (d) endpoints of both segments (after [Lumelsky85]).

Similarly, given the point $S_1(s) = P_1 + s\mathbf{d}_1$ on S_1, the closest point $L_2(t)$ on L_2 is computed as

$$t = (S_1(s) - P_2) \cdot \mathbf{d}_2/\mathbf{d}_2 \cdot \mathbf{d}_2 = (P_1 + s\mathbf{d}_1 - P_2) \cdot \mathbf{d}_2/\mathbf{d}_2 \cdot \mathbf{d}_2.$$

Alternatively, Gaussian elimination can be used on the 2×2 system of linear equations to solve for the one unknown in terms of the other. In either case, the expressions for s and t simplify to

$$s = (bt - c)/a$$
$$t = (bs + f)/e,$$

with $a = \mathbf{d}_1 \cdot \mathbf{d}_1$, $b = \mathbf{d}_1 \cdot \mathbf{d}_2$, $c = \mathbf{d}_1 \cdot \mathbf{r}$, $e = \mathbf{d}_2 \cdot \mathbf{d}_2$, and $f = \mathbf{d}_2 \cdot \mathbf{r}$.

Code implementing this function follows.

```
// Clamp n to lie within the range [min, max]
float Clamp(float n, float min, float max) {
    if (n < min) return min;
    if (n > max) return max;
    return n;
}

// Computes closest points C1 and C2 of S1(s)=P1+s*(Q1-P1) and
// S2(t)=P2+t*(Q2-P2), returning s and t. Function result is squared
// distance between between S1(s) and S2(t)
float ClosestPtSegmentSegment(Point p1, Point q1, Point p2, Point q2,
                              float &s, float &t, Point &c1, Point &c2)
{
    Vector d1 = q1 - p1; // Direction vector of segment S1
    Vector d2 = q2 - p2; // Direction vector of segment S2
    Vector r = p1 - p2;
    float a = Dot(d1, d1); // Squared length of segment S1, always nonnegative
    float e = Dot(d2, d2); // Squared length of segment S2, always nonnegative
    float f = Dot(d2, r);

    // Check if either or both segments degenerate into points
    if (a <= EPSILON && e <= EPSILON) {
        // Both segments degenerate into points
        s = t = 0.0f;
        c1 = p1;
        c2 = p2;
```

```
        return Dot(c1 - c2, c1 - c2);
    }
    if (a <= EPSILON) {
        // First segment degenerates into a point
        s = 0.0f;
        t = f / e; // s = 0 => t = (b*s + f) / e = f / e
        t = Clamp(t, 0.0f, 1.0f);
    } else {
        float c = Dot(d1, r);
        if (e <= EPSILON) {
            // Second segment degenerates into a point
            t = 0.0f;
            s = Clamp(-c / a, 0.0f, 1.0f); // t = 0 => s = (b*t - c) / a = -c / a
        } else {
            // The general nondegenerate case starts here
            float b = Dot(d1, d2);
            float denom = a*e-b*b; // Always nonnegative

            // If segments not parallel, compute closest point on L1 to L2 and
            // clamp to segment S1. Else pick arbitrary s (here 0)
            if (denom != 0.0f) {
                s = Clamp((b*f - c*e) / denom, 0.0f, 1.0f);
            } else s = 0.0f;
            // Compute point on L2 closest to S1(s) using
            // t = Dot((P1 + D1*s) - P2,D2) / Dot(D2,D2) = (b*s + f) / e
            t = (b*s + f) / e;

            // If t in [0,1] done. Else clamp t, recompute s for the new value
            // of t using s = Dot((P2 + D2*t) - P1,D1) / Dot(D1,D1)= (t*b - c) / a
            // and clamp s to [0, 1]
            if (t < 0.0f) {
                t = 0.0f;
                s = Clamp(-c / a, 0.0f, 1.0f);
            } else if (t > 1.0f) {
                t = 1.0f;
                s = Clamp((b - c) / a, 0.0f, 1.0f);
            }
        }
    }

    c1 = p1 + d1 * s;
    c2 = p2 + d2 * t;
    return Dot(c1 - c2, c1 - c2);
}
```

As an optimization, the division by e can be deferred until t is known to be in the range [0, 1], making the code at the end of the large *else* statement read:

```
...
float tnom = b*s + f;
if (tnom < 0.0f) {
    t = 0.0f;
    s = Clamp(-c / a, 0.0f, 1.0f);
} else if (tnom > e) {
    t = 1.0f;
    s = Clamp((b - c) / a, 0.0f, 1.0f);
} else {
    t = tnom / e;
}
```

This deferral saves one, often expensive, division operation in the general case.

5.1.9.1 2D Segment Intersection

Testing whether two 2D segments AB and CD intersect can be done by first computing the intersection point of their extended lines and then verifying that the intersection point lies within the bounding box of each segment. Refer to Figures 5.10a and b for examples. The case of the lines being parallel has to be handled separately.

The intersection between the extended lines can be computed by writing the first line in explicit form, $L_1(t) = A + t(B - A)$, and the second line in implicit form, $\mathbf{n} \cdot (X - C) = 0$, where $\mathbf{n} = (D - C)^\perp$ is a perpendicular to CD. Substituting the first line equation for the unknown point in the second equation and solving for t then gives:

$$\mathbf{n} \cdot (A + t(B - A) - C) = 0 \Leftrightarrow \qquad \text{(substituting } A + t(B - A) \text{ for X)}$$

$$\mathbf{n} \cdot (A - C) + t(\mathbf{n} \cdot (B - A)) = 0 \Leftrightarrow \qquad \text{(expanding the dot product; gathering similar terms)}$$

$$t(\mathbf{n} \cdot (B - A)) = -\mathbf{n} \cdot (A - C) \Leftrightarrow \qquad \text{(isolating t term on LHS)}$$

$$t(\mathbf{n} \cdot (B - A)) = \mathbf{n} \cdot (C - A) \Leftrightarrow \qquad \text{(removing negation on RHS by inverting vector)}$$

$$t = \mathbf{n} \cdot (C - A)/\mathbf{n} \cdot (B - A) \qquad \text{(dividing both sides by } \mathbf{n} \cdot (B - A))$$

The actual intersection point $P = L_1(t)$ can now be obtained by substituting t into the explicit equation. An alternative to testing if P lies within the bounding box of AB is to verify that $0 \le t \le 1$.

An alternative overlap test for 2D segments can be based on the insight that the segments overlap only if the endpoints of either segment are located on different sides

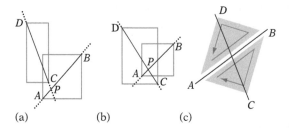

(a) (b) (c)

Figure 5.10 (a) Segments *AB* and *CD* do not intersect because the intersection point *P* of their extended lines lies outside the bounding box of *CD*. (b) Segments *AB* and *CD* intersect because *P* lies inside the bounding boxes of both *AB* and *CD*. (c) Segment *CD* intersects the line through *AB* because the triangles *ABD* and *ABC* have opposite winding.

of the extended line through the other segment. That is, for *AB* and *CD* to overlap, *A* and *B* must be on different sides of *CD* and *C* and *D* must be on different sides of *AB*.

Testing whether the endpoints *C* and *D* are on different sides of *AB* can be done by verifying that the triangles *ABD* and *ABC* wind in different directions (illustrated in Figure 5.10c). To determine the winding, the signed triangle area can be computed. Recall that the signed area is positive if the triangle winds counterclockwise, negative if it winds clockwise, and zero if the triangle is degenerate (collinear or coincident points).

```
// Returns 2 times the signed triangle area. The result is positive if
// abc is ccw, negative if abc is cw, zero if abc is degenerate.
float Signed2DTriArea(Point a, Point b, Point c)
{
    return (a.x - c.x) * (b.y - c.y) - (a.y - c.y) * (b.x - c.x);
}
```

In the case in which the segments are intersecting, it turns out that the signed areas computed to detect this can also be used to compute the intersection point. The computation and its derivation are given in the following implementation.

```
// Test if segments ab and cd overlap. If they do, compute and return
// intersection t value along ab and intersection position p
int Test2DSegmentSegment(Point a, Point b, Point c, Point d, float &t, Point &p)
{
    // Sign of areas correspond to which side of ab points c and d are
    float a1 = Signed2DTriArea(a, b, d); // Compute winding of abd (+ or -)
    float a2 = Signed2DTriArea(a, b, c); // To intersect, must have sign opposite of a1
```

```
      // If c and d are on different sides of ab, areas have different signs
      if (a1 * a2 < 0.0f) {
          // Compute signs for a and b with respect to segment cd
          float a3 = Signed2DTriArea(c, d, a);  // Compute winding of cda (+ or -)
          // Since area is constant a1 - a2 = a3 - a4, or a4 = a3 + a2 - a1
//        float a4 = Signed2DTriArea(c, d, b); // Must have opposite sign of a3
          float a4 = a3 + a2 - a1;
          // Points a and b on different sides of cd if areas have different signs
          if (a3 * a4 < 0.0f) {
              // Segments intersect. Find intersection point along L(t) = a + t * (b - a).
              // Given height h1 of an over cd and height h2 of b over cd,
              // t = h1 / (h1 - h2) = (b*h1/2) / (b*h1/2 - b*h2/2) = a3 / (a3 - a4),
              // where b (the base of the triangles cda and cdb, i.e., the length
              // of cd) cancels out.
              t = a3 / (a3 - a4);
              p = a + t * (b - a);
              return 1;
          }
      }
      // Segments not intersecting (or collinear)
      return 0;
  }
```

Here, the expression **a1 * a2 < 0.0f** is used to test if **a1** and **a2** have different signs (and similarly for **a3** and **a4**). When working with signed integers, a better alternative is to use exclusive-or instead of multiplication, **a1 ^ a2 < 0**, thereby avoiding potential problems with overflow. In the presence of collinear points, either or both of **a1** and **a2** may be zero. To detect proper intersections in these cases, the test would have to be written along the lines of:

```
if (a1 != 0.0f && a2 != 0.0f && a1*a2 < 0.0f) ... // for floating-point variables
if ((a1 | a2) != 0 && a1 ^ a2 < 0) ... // for integer variables
```

Finally, note that for some applications it is worthwhile to test if the bounding boxes of *AB* and *CD* overlap before proceeding with one of these segment intersection tests. This is especially true for determining intersection of line segments in 3D, for which the involved computations are more expensive.

5.1.10 Closest Points of a Line Segment and a Triangle

The closest pair of points between a line segment *PQ* and a triangle *ABC* is not necessarily unique. When the segment is parallel to the plane of the triangle, there

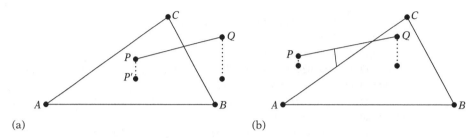

Figure 5.11 The closest pair of points between a line segment and a triangle can always be found either (a) between an endpoint of the segment and the triangle interior or (b) between the segment and an edge of the triangle.

may be an infinite number of pairs equally close. However, regardless of whether the segment is parallel to the plane or not it is always possible to locate points such that the minimum distance occurs either (a) between an endpoint of the segment and the interior of the triangle or (b) between the segment and an edge of the triangle. These two cases are illustrated in Figure 5.11.

Case (a) can occur only if the projection of a segment endpoint onto the supporting plane of the triangle lies inside the triangle. However, even when a segment endpoint projects inside the triangle an edge of the triangle may provide a closer point to the segment. Thus, the closest pair of points can be found by computing the closest pairs of points between the entities

segment *PQ* and triangle edge *AB*,

segment *PQ* and triangle edge *BC*,

segment *PQ* and triangle edge *CA*,

segment endpoint *P* and plane of triangle (when *P* projects inside *ABC*), and

segment endpoint *Q* and plane of triangle (when *Q* projects inside *ABC*)

and returning the pair with the overall smallest minimum separating distance as the result.

The number of tests required can be reduced in some cases. For example, when both endpoints project inside the triangle no segment-edge tests are necessary, because either endpoint projection must correspond to a closest point. When one endpoint projects inside the triangle, only one segment-edge test is required. When both endpoints project outside the triangle, one of the segment-edge tests is not needed. For the latter two cases, the necessary segment-edge tests can be determined by examining which Voronoi regions the segment endpoints lie in.

A remaining case is when the segment intersects the triangle. For a transverse intersection, the intersection point corresponds to the closest points. When the segment

lies in the plane of the triangle, any point on the segment in intersection with the triangle realizes the closest points. An alternative method for determining the closest points between a segment and a triangle, based on a vector calculus approach, is outlined in [Eberly01] and [Schneider02].

5.1.11 Closest Points of Two Triangles

As for the case of determining the closest pair of points between a segment and a triangle, there may be an infinite number of equally close points between two triangles. However, the closest points between two triangles T_1 and T_2 can always be realized in such a way that one point lies on the boundary of one of the triangles. Consequently, a pair of closest points between two triangles can be found by computing the closest points between segment and triangle for all six possible combinations of an edge from one triangle tested against the other triangle. The pair of points having the least (squared) distance then corresponds to the closest pair of points of minimum global distance.

Segment-triangle distance tests are fairly expensive, and thus a better realization is that the closest pair of points between T_1 and T_2 can be found to occur either on an edge from each triangle (Figure 5.12a) or as a vertex of one triangle and a point interior to the other triangle (Figure 5.12b). The problem now becomes that of computing the closest points among all pairs of edges, one from each triangle, and the closest point on the opposite triangle for each vertex of each triangle (when said vertex projects interior to the other triangle). In all, six vertex-triangle tests and nine edge-edge tests are required. Out of all pairs of closest points, the one with the overall smallest distance corresponds to the globally closest pair of points between the triangles.

If the triangles are not known a priori to be disjoint, an additional test is required to rule out the intersection of the two triangles. When intersecting, the distance between

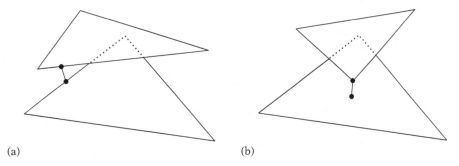

(a) (b)

Figure 5.12 The closest pair of points between two triangles can be realized (a) as lying on an edge from either triangle or (b) as a vertex of one triangle and a point interior to the other triangle.

the triangles is trivially zero, but the closest points are not likely to be well defined because there may be infinitely many (for example, if the triangles are parallel and overlapping).

5.2 **Testing Primitives**

The *testing* of primitives is less general than the computation of distance between them. Generally, a test will indicate only that the primitives are intersecting, not determine where or how they are intersecting. Therefore, these intersection tests are often much faster than tests returning additional information.

5.2.1 **Separating-axis Test**

An extremely useful tool for implementing various intersection tests is the *separating-axis test*. It follows from the *separating hyperplane theorem*, a fundamental result of convex analysis. This theorem states that given two convex sets A and B, either the two sets are intersecting or there exists a separating hyperplane P such that A is on one side of P and B is on the other.

The separating-axis test follows intuitively from the theorem, because two convex objects cannot "curve" around each other. Thus, when they are not intersecting there will be a gap between them into which a plane can be inserted to separate the two objects. When either or both objects are concave, a plane would in general no longer be sufficient to separate the nonintersecting objects. Instead, a curved surface would be required to separate the objects. When the objects are intersecting, no surface — curved or not — can be inserted between the objects to separate them.

Given a hyperplane P separating A and B, a *separating axis* is a line L perpendicular to P. It is called a separating axis because the orthogonal projections of A and B onto L result in two nonoverlapping intervals (Figure 5.13). Because the two intervals do not overlap, the conclusion is that the geometries must be disjoint. Because a separating axis exists if and only if a separating hyperplane exists, either can be tested for. However, in practice it turns out to be better to test for separation on an axis, in that it results in a less expensive test.

For performing a separating-axis test, it is worth noting that many collision primitives — such as segments, AABBs, OBBs, k-DOPs, and spheres — are symmetrical in the sense that they have a center point C, which always projects into the middle of the projection interval of their projection onto an axis. Given a potentially separating axis L, an efficient separation test of two symmetrical objects A and B is therefore to compute the halfwidth, or radii, of their projection intervals and compare the sum of them against the distance between their center projections. If the sum is less than the distance between the center projections, the objects must be disjoint. An example is given in Figure 5.14, in which A and B correspond to a circle and an

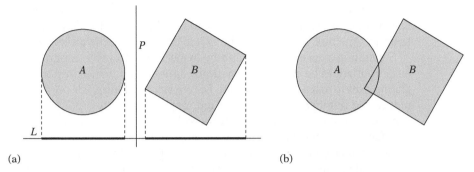

(a) (b)

Figure 5.13 (a) Two convex objects, A and B, separated by a hyperplane P (one of many possible hyperplanes). Stated equivalently, A and B are nonoverlapping in their projection onto the separating axis L (which is perpendicular to P). (b) The same convex objects are in an intersecting situation and therefore not separable by any hyperplane.

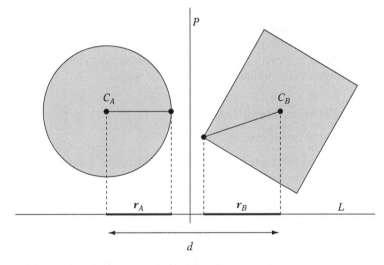

Figure 5.14 Two objects are separated if the sum of the radius (halfwidth) of their projections is less than the distance between their center projections.

oriented rectangle (or, equivalently, a sphere and an OBB, as seen from the side). First, for each object, a supporting point along L is obtained; that is, a point most distant from the object center along either direction of L (in that the projections are symmetrical, the direction does not matter; there will be a point equally distant in both directions). The two object radii, r_A and r_B, are then obtained by computing the distance between the projections onto L of the object centers and their respective most distant points. The distance d between the center projections is also computed. Given these computed quantities, the objects are now separated if $r_A + r_B < d$.

The separating-axis test applies even when an object is not symmetric — as in the case of an arbitrary convex hull, for instance — but the test would have to be modified to project the hull vertices onto the axis in order to find the projection intervals.

Separating axes are easy to find by inspection. However, for an implementation it is important to be able to automatically limit an infinite number of potentially separating axes to just a few axes tested. For convex polyhedra, it is possible to drastically reduce the number of axes to test. Ignoring ordering, two polyhedral objects may come into contact in six different ways with respect to their features. They can meet face-face, face-edge, face-vertex, edge-edge, edge-vertex, or vertex-vertex. Because vertices can be considered part of the edges, the combinations involving vertices are subsumed by the same situations involving edges. This reduces the contact situations to three essentially different combinations: face-face, face-edge, and edge-edge.

For the face-face and face-edge cases, it is sufficient to test the face normals of both objects as potential separating axes. For the edge-edge case, the potential separating axis to be tested corresponds to the cross product of the two edges. The reason the cross product is used for the separating-axis test in the edge-edge case can be justified by considering what happens when two objects come into contact edge to edge. The points on the edges closest to each other form the feet of a perpendicular between the two edges. Because this perpendicular is the cross product of the edges, it is the correct candidate to test as a separating axis. In summary, to test the separability of two polyhedral objects the following axes must be tested.

- Axes parallel to face normals of object A
- Axes parallel to face normals of object B
- Axes parallel to the vectors resulting from the cross products of all edges in A with all edges in B

As soon as a separating axis is found, a test can immediately exit with "no intersection." If all axes are tested, with no separating axis found, the objects must be intersecting.

For two general polytopes with the same number of faces (F) and edges (E) there are $2F + E^2$ potential separating axes. Because the number of separating axes is quadratic in the number of edges, a separating-axis test may be infeasible for objects of moderate to high complexity. However, it is possible to speed up a separating-axis test by caching the last successful separating axis and testing it first on a subsequent query, in the hope of getting an early nonintersection exit thanks to spatial and temporal coherency of the objects between queries.

When two polytopes are colliding, the separating-axis test can also assist in computing contact information. Instead of exiting early when an overlap is detected on an axis, all axes are tested for overlap. After all axes have been tested, the axis with the least (normalized) overlap can be used as the contact normal, and the overlap can be used to estimate the penetration depth. With some extra work, contact points can also be computed with the help of the separating axis. For those interested in reading

further, the separating-axis test was suggested for the collision detection of oriented bounding boxes by [Larcombe95].

5.2.1.1 Robustness of the Separating-axis Test

A potential problem with the separating-axis test is robustness in the case of a separating axis being formed by the cross product of an edge from each object. When these two edges become parallel, the result is the zero vector and all projections onto this axis, and sums of these projections, are therefore zero. Thus, if the test is not carefully crafted, a zero vector may incorrectly be interpreted as a separating axis. Due to the use of floating-point arithmetic, this problem may occur even in the case of a near-zero vector for two near-parallel edges. In fact, the robustness problem of the separating-axis test was encountered in Section 4.4.2 in the context of the OBB-OBB intersection test, and a solution for the problem in that particular context can be found there.

When possible, it is best to analyze the robustness problem in the context in which it will occur. A generic solution to the problem is to test if the resulting cross-product vector is a (near) zero vector, and if so attempt to deal with the problem either by producing another axis that is perpendicular to the two vectors or by ignoring the axis if separation on the axis can be ruled out.

The following code fragment outlines how a more robust separating-axis test for edges *AB* and *CD* could be implemented.

```
// Compute a tentative separating axis for ab and cd
Vector m = Cross(ab, cd);
if (!IsZeroVector(m)) {
    // Edges ab and cd not parallel, continue with m as a potential separating axis
    ...
} else {
    // Edges ab and cd must be (near) parallel, and therefore lie in some plane P.
    // Thus, as a separating axis try an axis perpendicular to ab and lying in P
    Vector n = Cross(ab, c - a);
    m = Cross(ab, n);
    if (!IsZeroVector(m)) {
        // Continue with m as a potential separating axis
        ...
    }
    // ab and ac are parallel too, so edges must be on a line. Ignore testing
    // the axis for this combination of edges as it won't be a separating axis.
    // (Alternatively, test if edges overlap on this line, in which case the
    // objects are overlapping.)
    ...
}
```

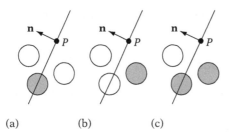

Figure 5.15 Illustrating the three sphere-plane tests. (a) Spheres intersecting the plane. (b) Spheres fully behind the plane. (c) Spheres intersecting the negative halfspace of the plane. Spheres testing true are shown in gray.

The **IsZeroVector()** function tests if its argument is a vector with a magnitude sufficiently close to zero (according to some tolerance value; see Section 11.3.1). Widening the tolerance intervals and treating near-parallel edges as parallel may result in near-intersections being interpreted as intersections. Overall, this is much more attractive than the alternative: two intersecting objects falsely reported as nonintersecting due to the projection onto a zero-vector separating axis, for example.

A related source of robustness errors is when the vectors used in the cross product have a large magnitude, which may result in additional loss of precision in the calculations involving the cross product. If a bound on the magnitude of the input vectors it not known, it is prudent to normalize them before computing the cross product to maintain precision.

5.2.2 Testing Sphere Against Plane

It is possible to test a sphere against a plane in several ways. This section describes three such tests: testing if the sphere intersects the plane, if the sphere lies fully behind the plane, and if the sphere intersects the negative halfspace of the plane. Figure 5.15 illustrates these three scenarios.

Let a sphere S be specified by a center position C and a radius r, and let a plane π be specified by $(\mathbf{n} \cdot X) = d$, where \mathbf{n} is a unit vector; that is, $\|\mathbf{n}\| = 1$. To determine if the sphere is intersected by the plane, the plane equation can be evaluated for the sphere center. Because \mathbf{n} is unit, the resulting value corresponds to the signed distance of the sphere center from the plane. If the absolute value of the distance is within the sphere radius, the plane intersects the sphere:

```
// Determine whether plane p intersects sphere s
int TestSpherePlane(Sphere s, Plane p)
{
    // For a normalized plane (|p.n| = 1), evaluating the plane equation
```

```
    // for a point gives the signed distance of the point to the plane
    float dist = Dot(s.c, p.n) - p.d;
    // If sphere center within +/-radius from plane, plane intersects sphere
    return Abs(dist) <= s.r;
}
```

To determine if the sphere lies fully behind (inside the negative halfspace of) plane π, the test changes to:

```
// Determine whether sphere s is fully behind (inside negative halfspace of) plane p
int InsideSpherePlane(Sphere s, Plane p)
{
    float dist = Dot(s.c, p.n) - p.d;
    return dist < -s.r;
}
```

If instead the negative halfspace of the plane is to be considered solid for the test with the sphere, the test changes to:

```
    // Determine whether sphere s intersects negative halfspace of plane p
    int TestSphereHalfspace(Sphere s, Plane p)
    {
        float dist = Dot(s.c, p.n) - p.d;
        return dist <= s.r;
    }
```

5.2.3 **Testing Box Against Plane**

Let a plane P be given by $(\mathbf{n} \cdot X) = d$. Testing if a box B intersects P can also be accomplished with the separating-axis test. Here, only the axis parallel to the plane normal \mathbf{n} need be tested. Because the plane extends indefinitely, there are no edges with which to form edge-edge axis combinations. Axes corresponding to the face normals of the box can be eliminated from testing because the infinite extent of the plane means the plane will never sit fully outside one of the box faces unless it is parallel to the face, a case already handled by the plane normal axis.

Consider first the case of B being an OBB, given by the usual representation of a center C; local coordinate axes \mathbf{u}_0, \mathbf{u}_1, and \mathbf{u}_2; and three scalars e_0, e_1, and e_2 (making the OBB sides $2e_i$ wide for $0 \leq i \leq 2$). Points R in the OBB are given by $R = C \pm a_0\mathbf{u}_0 \pm a_1\mathbf{u}_1 \pm a_2\mathbf{u}_2$, where $|a_i| \leq e_i$. Similarly, the eight vertices V_i, $0 \leq i \leq 7$, of the OBB are given by $V_i = C \pm e_0\mathbf{u}_0 \pm e_1\mathbf{u}_1 \pm e_2\mathbf{u}_2$.

In that any line L parallel to \mathbf{n} serves as a separating axis, a good choice is to have L go through the box center, giving L as $L(t) = C + t\mathbf{n}$. The box center C projects onto L at $t = 0$. Because the OBB is symmetrical about its center, the projection onto L results in a symmetric interval of projection $[C - r\,\mathbf{n}, C + r\,\mathbf{n}]$, centered at C, with a halfwidth (or radius) of r. Testing if B intersects P now amounts to computing the radius r of the projection interval and checking if the distance of the center point of B to P is less than r.

Because points of the OBB farthest away from its center are the vertices of the OBB, the overall maximum projection radius onto any vector \mathbf{n} will be realized by one of the vertices. Thus, it is sufficient to consider only these when computing the radius r. The projection radii r_i of the eight vertices are given by

$$r_i = (V_i - C) \cdot \mathbf{n} = (C \pm e_0\mathbf{u}_0 \pm e_1\mathbf{u}_1 \pm e_2\mathbf{u}_2 - C) \cdot \mathbf{n} = (\pm e_0\mathbf{u}_0 \pm e_1\mathbf{u}_1 \pm e_2\mathbf{u}_2) \cdot \mathbf{n}.$$

Due to the distributive properties of the dot product, this expression can be written as

$$r_i = \pm(e_0\mathbf{u}_0 \cdot \mathbf{n}) \pm (e_1\mathbf{u}_1 \cdot \mathbf{n}) \pm (e_2\mathbf{u}_2 \cdot \mathbf{n}).$$

The maximum positive radius r is obtained when all involved terms are positive, corresponding to only positive steps along \mathbf{n}, which is achieved by taking the absolute value of the terms before adding them up:

$$r = |e_0\mathbf{u}_0 \cdot \mathbf{n}| + |e_1\mathbf{u}_1 \cdot \mathbf{n}| + |e_2\mathbf{u}_2 \cdot \mathbf{n}| .$$

Because the extents are assumed positive, r can be written as

$$r = e_0 |\mathbf{u}_0 \cdot \mathbf{n}| + e_1 |\mathbf{u}_1 \cdot \mathbf{n}| + e_2 |\mathbf{u}_2 \cdot \mathbf{n}| .$$

When the separating-axis vector \mathbf{n} is *not* a unit vector, r instead becomes

$$r = (e_0 |\mathbf{u}_0 \cdot \mathbf{n}| + e_1 |\mathbf{u}_1 \cdot \mathbf{n}| + e_2 |\mathbf{u}_2 \cdot \mathbf{n}|) \big/ \|\mathbf{n}\| .$$

The signed distance s of C from P is obtained by evaluating the plane equation for C, giving $s = \mathbf{n} \cdot C - d$. Another way of obtaining s is to compute the distance u of P from C, $s = -u$. Recall that P is $\mathbf{n} \cdot X = d$, where $d = Q \cdot \mathbf{n}$ for some point Q on the plane. As all points on P project to a single point on L, it is sufficient to work with the projection of Q onto L. The distance u can therefore be computed as $u = (Q - C) \cdot \mathbf{n} = Q \cdot \mathbf{n} - C \cdot \mathbf{n} = d - C \cdot \mathbf{n}$, which up to a sign change is equivalent

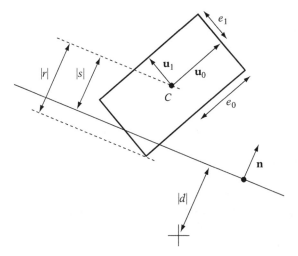

Figure 5.16 Testing intersection of an OBB against a plane.

to the evaluation of the plane equation for the box center. Figure 5.16 illustrates the quantities used in the test.

Because the intersection between the OBB B and the plane P occurs when $-r \leq s \leq r$, or equivalently when $|s| \leq r$, there is now sufficient information to implement the test.

```
// Test if OBB b intersects plane p
int TestOBBPlane(OBB b, Plane p)
{
    // Compute the projection interval radius of b onto L(t) = b.c + t * p.n
    float r = b.e[0]*Abs(Dot(p.n, b.u[0])) +
              b.e[1]*Abs(Dot(p.n, b.u[1])) +
              b.e[2]*Abs(Dot(p.n, b.u[2]));
    // Compute distance of box center from plane
    float s = Dot(p.n, b.c) - p.d;
    // Intersection occurs when distance s falls within [-r,+r] interval
    return Abs(s) <= r;
}
```

It is not necessary for \mathbf{n} to be normalized for the test to work. If \mathbf{n} is nonunit, both r and s will be a factor $\|\mathbf{n}\|$ larger, which does not affect the test.

Other tests can be easily implemented in a similar vein. For example, the OBB falls inside the negative halfspace of the plane if $s \leq -r$. If $r \leq s$, the OBB lies fully in the positive halfspace of the plane. For an OBB given as $B = C + k_0\mathbf{v}_0 + k_1\mathbf{v}_1 + k_2\mathbf{v}_2$,

$0 \leq k_0, k_1, k_2 \leq 1$, the radius r of the OBB is instead obtained by $r = (|\mathbf{v}_0 \cdot \mathbf{n}| + |\mathbf{v}_1 \cdot \mathbf{n}| + |\mathbf{v}_2 \cdot \mathbf{n}|)/2$. For an axis-aligned box B, the local axes \mathbf{u}_0, \mathbf{u}_1, and \mathbf{u}_2 are known in advance, and thus the code can be simplified accordingly.

```
// Test if AABB b intersects plane p
int TestAABBPlane(AABB b, Plane p)
{
    // These two lines not necessary with a (center, extents) AABB representation
    Point c = (b.max + b.min) * 0.5f;  // Compute AABB center
    Point e = b.max - c;  // Compute positive extents

    // Compute the projection interval radius of b onto L(t) = b.c + t * p.n
    float r = e[0]*Abs(p.n[0]) + e[1]*Abs(p.n[1]) + e[2]*Abs(p.n[2]);
    // Compute distance of box center from plane
    float s = Dot(p.n, c) - p.d;
    // Intersection occurs when distance s falls within [-r,+r] interval
    return Abs(s) <= r;
}
```

This test is equivalent to finding an AABB vertex most distant along the plane normal and making sure that vertex and the vertex diagonally opposite lie on opposite sides of the plane.

5.2.4 Testing Cone Against Plane

Let a plane be given by $(\mathbf{n} \cdot X) = d$, where $d = -P \cdot \mathbf{n}$ for a point P on the plane and \mathbf{n} is unit. Let a cone be specified by its tip T, normalized axis direction \mathbf{d}, height h, and a bottom radius r (Figure 5.17). The cone is intersecting the negative halfspace of the plane if any point of the cone lies inside the negative halfspace; that is, if there is a point X of the cone for which $(\mathbf{n} \cdot X) < d$. For a cone only two points must be tested for this condition.

- The tip T of the cone

- The point Q on the circular endcap of the cone, farthest in the direction of $-\mathbf{n}$

For the second test, Q must be located. Thanks to the format the cone is given in, Q is easily obtained by stepping from the tip along the direction vector to the circular bottom endcap and down the endcap toward the plane:

$$Q = T + h\mathbf{v} + r\mathbf{m}.$$

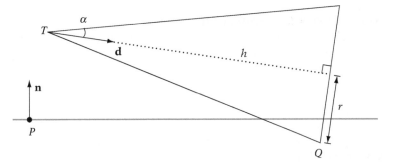

Figure 5.17 Illustrating the variables involved in the intersection test of a cone against a plane or halfspace.

The vector \mathbf{m} is given by $\mathbf{m} = (\mathbf{n} \times \mathbf{v}) \times \mathbf{v}$.

If $\mathbf{n} \times \mathbf{v}$ is zero, the cone axis is parallel to the plane normal, in which case, $Q = T + h\mathbf{v}$ is the correct point to test against the halfspace. However, in this case \mathbf{m} is also zero and thus it is not necessary to handle this case specially.

Often cones are specified by giving the halfangle α at the cone apex, rather than the bottom radius r. In that $\tan \alpha = r/h$, in these cases r is obtained as $r = h \tan \alpha$. Giving r rather than α is clearly a better representation for this test.

If the intersection test is against the plane itself and not a halfspace, the computation of Q must be changed to lie farthest in the direction of \mathbf{n} in the case T lies behind the plane. The test for intersection now becomes testing that T and Q lie on different sides of the plane, indicated by $(\mathbf{n} \cdot T) - d$ and $(\mathbf{n} \cdot Q) - d$ having different signs. Of these, $(\mathbf{n} \cdot T) - d$ has already been computed to determine which side of the plane T lies on.

5.2.5 Testing Sphere Against AABB

Testing whether a sphere intersects an axis-aligned bounding box is best done by computing the distance between the sphere center and the AABB (see Section 5.1.3.1) and comparing this distance with the sphere radius. If the distance is less than the radius, the sphere and AABB must be intersecting. To avoid expensive square root operations, both distance and radius can be squared before the comparison is made without changing the result of the test. Using the function **SqDistPointAABB()** defined in Section 5.1.3.1, the implementation becomes:

```
// Returns true if sphere s intersects AABB b, false otherwise
int TestSphereAABB(Sphere s, AABB b)
{
    // Compute squared distance between sphere center and AABB
```

```
    float sqDist = SqDistPointAABB(s.c, b);
    // Sphere and AABB intersect if the (squared) distance
    // between them is less than the (squared) sphere radius
    return sqDist <= s.r * s.r;
}
```

For collision handling, it is often useful to have the point on the AABB closest to the sphere center returned, in which case the test can be written using **ClosestPtPointAABB()** instead:

```
// Returns true if sphere s intersects AABB b, false otherwise.
// The point p on the AABB closest to the sphere center is also returned
int TestSphereAABB(Sphere s, AABB b, Point &p)
{
    // Find point p on AABB closest to sphere center
    ClosestPtPointAABB(s.c, b, p);

    // Sphere and AABB intersect if the (squared) distance from sphere
    // center to point p is less than the (squared) sphere radius
    Vector v = p - s.c;
    return Dot(v, v) <= s.r * s.r;
}
```

Note that testing whether the sphere is fully outside one or more faces of the AABB is not a sufficient test for determining intersection between the sphere and the AABB. For example, a sphere may be in a nonintersecting position just outside an edge of an AABB but not lie fully outside either of the two AABB faces meeting at the edge, as illustrated in Figure 5.18.

5.2.6 Testing Sphere Against OBB

Testing a sphere against an oriented bounding box is almost identical to testing against an axis-aligned bounding box, substituting the call to **ClosestPtPointAABB()** for a call to **ClosestPtPointOBB()**:

```
// Returns true if sphere s intersects OBB b, false otherwise.
// The point p on the OBB closest to the sphere center is also returned
int TestSphereOBB(Sphere s, OBB b, Point &p)
```

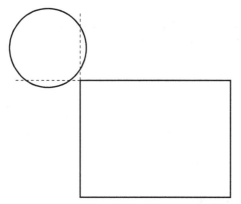

Figure 5.18 A sphere that does not lie fully outside any face plane of an AABB but nevertheless does not intersect the AABB.

```
{
    // Find point p on OBB closest to sphere center
    ClosestPtPointOBB(s.c, b, p);

    // Sphere and OBB intersect if the (squared) distance from sphere
    // center to point p is less than the (squared) sphere radius
    Vector v = p - s.c;
    return Dot(v, v) <= s.r * s.r;
}
```

5.2.7 Testing Sphere Against Triangle

The test for intersection between a sphere and a triangle follows the same pattern as testing a sphere against a box. First, the point P on the triangle closest to the sphere center is computed. The distance between P and the sphere center is then compared against the sphere radius to detect possible intersection:

```
// Returns true if sphere s intersects triangle ABC, false otherwise.
// The point p on abc closest to the sphere center is also returned
int TestSphereTriangle(Sphere s, Point a, Point b, Point c, Point &p)
{
    // Find point P on triangle ABC closest to sphere center
    p = ClosestPtPointTriangle(s.c, a, b, c);
```

```
    // Sphere and triangle intersect if the (squared) distance from sphere
    // center to point p is less than the (squared) sphere radius
    Vector v = p - s.c;
    return Dot(v, v) <= s.r * s.r;
}
```

To avoid an expensive square root operation, the squared distances are compared in the code.

5.2.8 Testing Sphere Against Polygon

Testing whether a sphere intersects a polygon could be done analogously to the last few tests: computing the closest point on the polygon to the sphere center and comparing the distance between these two points to the sphere radius. The closest point on a polygon to a given point P can be computed by triangulating the polygon and computing the closest point to P for each triangle, and returning the point closest to P as the result. This is not very efficient for large polygons, however, as $n - 2$ triangle tests would have to be performed for a polygon with n vertices.

An alternative method is to perform the following tests in turn:

1. Test if the sphere intersects the plane of the polygon. Exit with false if not.

2. Test each edge of the polygon to see if it pierces the sphere. Exit with true if so.

3. Project the sphere center onto the plane of the polygon. Perform a point-in-polygon test (see Section 5.4.1) to see if this point is inside the polygon. If so, exit with true. Otherwise, exit with false, as the sphere does not intersect the polygon.

The following code fragment illustrates how the test can be implemented.

```
// Test whether sphere s intersects polygon p
int TestSpherePolygon(Sphere s, Polygon p)
{
    // Compute normal for the plane of the polygon
    Vector n = Normalize(Cross(p.v[1] - p.v[0], p.v[2] - p.v[0]));
    // Compute the plane equation for p
    Plane m; m.n = n; m.d = -Dot(n, p.v[0]);
    // No intersection if sphere not intersecting plane of polygon
    if (!TestSpherePlane(s, m)) return 0;
    // Test to see if any one of the polygon edges pierces the sphere
```

```
    for (int k = p.numVerts, i = 0, j = k - 1; i < k; j = i, i++) {
        float t;
        Point q;
        // Test if edge (p.v[j], p.v[i]) intersects s
        if (IntersectRaySphere(p.v[j], p.v[i] - p.v[j], s, t, q) && t <= 1.0f)
            return 1;
    }
    // Test if the orthogonal projection q of the sphere center onto m is inside p
    Point q = ClosestPtPointPlane(s.c, m);
    return PointInPolygon(q, p);
}
```

As an optimization, for steps 2 and onward it is possible to project the sphere and polygon into the principal plane where the polygon has the largest area and treat the problem as the 2D test of a circle against a polygon. This reduces the overall number of arithmetic operations required for the test.

5.2.9 Testing AABB Against Triangle

The test of a triangle T intersecting a box B can be efficiently implemented using a separating-axis approach ([Eberly01], [Akenine-Möller01]). There are 13 axes that must be considered for projection:

1. Three face normals from the AABB

2. One face normal from the triangle

3. Nine axes given by the cross products of combination of edges from both

As before, as soon as a separating axis is found the test can immediately exit with a "no intersection" result. If all axes are tested and no separating axis is found, the box and the triangle must be intersecting. It has been suggested that the most efficient order in which to perform these three sets of tests is 3-1-2 [Akenine-Möller01].

The same 13 axis tests apply to both OBBs and AABBs. However, for an AABB (because the local axes of the box are known) some optimizations can be made to speed up the runtime calculations required for the test. Here, only the AABB test is presented, but to better illustrate the similarities — as well as to facilitate the AABB-specific optimizations — the AABB is assumed to be given in a form commonly used for OBBs. That is, by a center C; local axes $\mathbf{u}_0 = (1, 0, 0)$, $\mathbf{u}_1 = (0, 1, 0)$, and $\mathbf{u}_2 = (0, 0, 1)$; and extents e_0, e_1, and e_2. The triangle it is tested against is given by points $V_0 = (v_{0x}, v_{0y}, v_{0z})$, $V_1 = (v_{1x}, v_{1y}, v_{1z})$, and $V_2 = (v_{2x}, v_{2y}, v_{2z})$.

The three face normals (\mathbf{u}_0, \mathbf{u}_1, \mathbf{u}_2) from the AABB are trivially tested by computing the AABB of the triangle and testing B and the AABB of the triangle for overlap. If the two AABBs do not intersect, neither do B and T. Testing the axis parallel to the triangle face normal corresponds to testing if the AABB intersects the plane of the triangle. As this test was described in Section 5.2.3, it is not further elaborated on here. Remaining is testing the nine axes corresponding to the cross products of the three edge directions from B and the three edge directions from T.

As with most separating-axis tests, the computations are simplified by moving one object (the symmetrical one, if present) to the origin. Here, the box center is moved to align with the origin, resulting in the following variable updates: $V_0 \leftarrow V_0 - C$, $V_1 \leftarrow V_1 - C$, $V_2 \leftarrow V_2 - C$, and $C \leftarrow (0, 0, 0)$. Let the triangle edges be given by $\mathbf{f}_0 = V_1 - V_0 = (f_{0x}, f_{0y}, f_{0z})$, $\mathbf{f}_1 = V_2 - V_1 = (f_{1x}, f_{1y}, f_{1z})$, and $\mathbf{f}_2 = V_0 - V_2 = (f_{2x}, f_{2y}, f_{2z})$. The nine axes considered as separating axes can then be specified as $\mathbf{a}_{ij} = \mathbf{u}_i \times \mathbf{f}_j$. Because \mathbf{u}_0, \mathbf{u}_1, and \mathbf{u}_2 have a simple form, these axes simplify as follows:

$$
\begin{aligned}
\mathbf{a}_{00} &= \mathbf{u}_0 \times \mathbf{f}_0 &= (1, 0, 0) \times \mathbf{f}_0 &= (0, -f_{0z}, f_{0y}) \\
\mathbf{a}_{01} &= \mathbf{u}_0 \times \mathbf{f}_1 &= (1, 0, 0) \times \mathbf{f}_1 &= (0, -f_{1z}, f_{1y}) \\
\mathbf{a}_{02} &= \mathbf{u}_0 \times \mathbf{f}_2 &= (1, 0, 0) \times \mathbf{f}_2 &= (0, -f_{2z}, f_{2y}) \\
\mathbf{a}_{10} &= \mathbf{u}_1 \times \mathbf{f}_0 &= (0, 1, 0) \times \mathbf{f}_0 &= (f_{0z}, 0, -f_{0x}) \\
\mathbf{a}_{11} &= \mathbf{u}_1 \times \mathbf{f}_1 &= (0, 1, 0) \times \mathbf{f}_1 &= (f_{1z}, 0, -f_{1x}) \\
\mathbf{a}_{12} &= \mathbf{u}_1 \times \mathbf{f}_2 &= (0, 1, 0) \times \mathbf{f}_2 &= (f_{2z}, 0, -f_{2x}) \\
\mathbf{a}_{20} &= \mathbf{u}_2 \times \mathbf{f}_0 &= (0, 0, 1) \times \mathbf{f}_0 &= (-f_{0y}, f_{0x}, 0) \\
\mathbf{a}_{21} &= \mathbf{u}_2 \times \mathbf{f}_1 &= (0, 0, 1) \times \mathbf{f}_1 &= (-f_{1y}, f_{1x}, 0) \\
\mathbf{a}_{22} &= \mathbf{u}_2 \times \mathbf{f}_2 &= (0, 0, 1) \times \mathbf{f}_2 &= (-f_{2y}, f_{2x}, 0)
\end{aligned}
$$

Recall that the projection radius of a box with respect to an axis \mathbf{n} is given by

$$
r = e_0 |\mathbf{u}_0 \cdot \mathbf{n}| + e_1 |\mathbf{u}_1 \cdot \mathbf{n}| + e_2 |\mathbf{u}_2 \cdot \mathbf{n}|.
$$

In the case of $\mathbf{n} = \mathbf{a}_{00}$, this simplifies to

$$
\begin{aligned}
r &= e_0 |\mathbf{u}_0 \cdot \mathbf{a}_{00}| + e_1 |\mathbf{u}_1 \cdot \mathbf{a}_{00}| + e_2 |\mathbf{u}_2 \cdot \mathbf{a}_{00}| \Leftrightarrow \\
r &= e_0 |0| + e_1 |-\mathbf{a}_{00z}| + e_2 |\mathbf{a}_{00y}| \Leftrightarrow \\
r &= e_1 |f_{0z}| + e_2 |f_{0y}|.
\end{aligned}
$$

Similarly, simple expressions for the AABB projection radius are easily obtained for the remaining \mathbf{a}_{ij} axes. In all cases, the projection interval of the box is simply $[-r, r]$.

Projecting T onto a given axis \mathbf{n} results in the projection interval $[\min(p_0,\ p_1, p_2), \max(p_0, p_1, p_2)]$, where p_0, p_1, and p_2 are the distances from the origin to the projections of the triangle vertices onto \mathbf{n}. For $\mathbf{n} = \mathbf{a}_{00}$ this gives:

$$p_0 = V_0 \cdot \mathbf{a}_{00} = V_0 \cdot (0, -f_{0z}, f_{0y}) = -v_{0y}f_{0z} + v_{0z}f_{0y} = -v_{0y}(v_{1z} - v_{0z}) + v_{0z}(v_{1y} - v_{0y})$$
$$= -v_{0y}v_{1z} + v_{0z}v_{1y}$$
$$p_1 = V_1 \cdot \mathbf{a}_{00} = V_1 \cdot (0, -f_{0z}, f_{0y}) = -v_{1y}f_{0z} + v_{1z}f_{0y} = -v_{1y}(v_{1z} - v_{0z}) + v_{1z}(v_{1y} - v_{0y})$$
$$= v_{1y}v_{0z} - v_{1z}v_{0y} = p_0$$
$$p_2 = V_2 \cdot \mathbf{a}_{00} = V_2 \cdot (0, -f_{0z}, f_{0y}) = -v_{2y}f_{0z} + v_{2z}f_{0y} = -v_{2y}(v_{1z} - v_{0z}) + v_{2z}(v_{1y} - v_{0y})$$

If the projection intervals $[-r, r]$ and $[\min(p_0, p_1, p_2), \max(p_0, p_1, p_2)]$ are disjoint for the given axis, the axis is a separating axis and the triangle and the AABB do not overlap.

For this axis, $\mathbf{n} = \mathbf{a}_{00}$, it holds that $p_0 = p_1$ and the projection interval for the triangle simplifies to $[\min(p_0, p_2), \max(p_0, p_2)]$. The triangle projection intervals simplify in the same manner for all nine projection axes, as they all contain one zero component. Here, the AABB and triangle projection intervals are therefore disjoint if $\max(p_0, p_2) < -r$ or $\min(p_0, p_2) > r$. If min() and max() operations are available as native floating-point instructions on the target architecture, an equivalent expression that avoids one (potentially expensive) comparison is $\max(-\max(p_0, p_2), \min(p_0, p_2)) > r$. The latter formulation is especially useful in an SIMD implementation (see Chapter 13 for more on SIMD implementations).

The following code fragment illustrates how this test can be implemented.

```
int TestTriangleAABB(Point v0, Point v1, Point v2, AABB b)
{
    float p0, p1, p2, r;

    // Compute box center and extents (if not already given in that format)
    Vector c = (b.min + b.max) * 0.5f;
    float e0 = (b.max.x - b.min.x) * 0.5f;
    float e1 = (b.max.y - b.min.y) * 0.5f;
    float e2 = (b.max.z - b.min.z) * 0.5f;

    // Translate triangle as conceptually moving AABB to origin
    v0 = v0 - c;
    v1 = v1 - c;
    v2 = v2 - c;

    // Compute edge vectors for triangle
```

```
Vector f0 = v1 - v0,  f1 = v2 - v1, f2 = v0 - v2;

// Test axes a00..a22 (category 3)
// Test axis a00
p0 = v0.z*v1.y - v0.y*v1.z;
p2 = v2.z*(v1.y - v0.y) - v2.y*(v1.z - v0.z);
r = e1 * Abs(f0.z) + e2 * Abs(f0.y);
if (Max(-Max(p0, p2), Min(p0, p2)) > r) return 0;  // Axis is a separating axis

// Repeat similar tests for remaining axes a01..a22
...

// Test the three axes corresponding to the face normals of AABB b (category 1).
// Exit if...
// ... [-e0, e0] and [min(v0.x,v1.x,v2.x), max(v0.x,v1.x,v2.x)] do not overlap
if (Max(v0.x, v1.x, v2.x) < -e0 || Min(v0.x, v1.x, v2.x) > e0) return 0;
// ... [-e1, e1] and [min(v0.y,v1.y,v2.y), max(v0.y,v1.y,v2.y)] do not overlap
if (Max(v0.y, v1.y, v2.y) < -e1 || Min(v0.y, v1.y, v2.y) > e1) return 0;
// ... [-e2, e2] and [min(v0.z,v1.z,v2.z), max(v0.z,v1.z,v2.z)] do not overlap
if (Max(v0.z, v1.z, v2.z) < -e2 || Min(v0.z, v1.z, v2.z) > e2) return 0;

// Test separating axis corresponding to triangle face normal (category 2)
Plane p;
p.n = Cross(f0, f1);
p.d = Dot(p.n, v0);
return TestAABBPlane(b, p);
}
```

Note that there are robustness issues related to the tests of categories 2 (in computing the face normal for a degenerate or oversized triangle) and 3 (the cross product of two parallel edges giving a zero vector). See Section 5.2.1.1 for a discussion of what has to be done to cover these cases in a fully robust implementation.

The topic of triangle-AABB overlap testing is discussed in [Voorhies92]. A test of arbitrary polygons against an AABB is given in [Green95].

5.2.10 Testing Triangle Against Triangle

Many algorithms have been suggested for detecting the intersection of two triangles *ABC* and *DEF*. The most straightforward test is based on the fact that in general when two triangles intersect either two edges of one triangle pierce the interior of the other or one edge from each triangle pierces the interior of the other triangle (Figure 5.19).

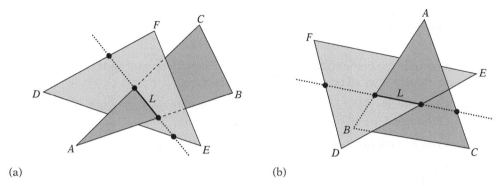

(a) (b)

Figure 5.19 In the general case, two triangles intersect (a) when two edges of one triangle pierce the interior of the other or (b) when one edge from each pierces the interior of the other.

A triangle-triangle test can therefore be implemented in terms of (up to) six edge-triangle tests. If an edge of one triangle intersects the other triangle, the triangles intersect. If all six tests fail, they are not intersecting.

The case in which the triangles are coplanar, or one or both triangles are degenerate (with two or more coincident vertices, turning the triangles into lines or points), is not handled correctly by this test. In fact, none of the suggested algorithms for triangle-triangle intersection handle these cases by default: they all rely on theirs being handled as special cases.

A second approach is to apply the separating-axis test. For intersecting two triangles, 11 separating axes must be tested: one axis parallel to the face normal for each of the two triangles, plus nine combinations of edges, with one edge from each triangle. For each axis, the triangles are projected onto the axis and the projection intervals are tested for overlap. If the projection intervals are found disjoint on any axis, the triangles are nonintersecting and the test can immediately exit. However, when the projection intervals overlap on all 11 axes the triangles must be intersecting.

A test similar in spirit to the separating-axis test is the *interval overlap method* suggested by [Möller97b]. However, it is much less expensive than the previous two tests. As a first step, it tests if the two face normals act as separating axes. This is done by testing, for both triangles, whether the vertices of one triangle lie fully on one side of the plane of the other triangle. If so, the triangles are nonintersecting. If not, at this point, the planes of the triangles must be intersecting in a line L, $L(t) = P + t\,\mathbf{d}$, where $\mathbf{d} = \mathbf{n}_1 \times \mathbf{n}_2$ is the cross product of the two triangle normals \mathbf{n}_1 and \mathbf{n}_2. Furthermore, this line must also be intersecting both triangles. The scalar intersection intervals between each triangle and L are now computed (these correspond to the intersection points marked with black dots in Figure 5.19). Now, only if these scalar intervals intersect do the triangles intersect. As an optimization, instead of directly computing the triangle intersection intervals with L the intervals are computed and intersected on

the principal coordinate axis most parallel with L. To summarize, the interval overlap method proceeds as follows.

1. Compute the plane equation of triangle 1. Exit with no intersection if the vertices of triangle 2 are all on the same side of this plane.

2. Compute the plane equation of triangle 2. Exit with no intersection if the vertices of triangle 1 are all on the same side of this plane.

3. Compute the line L of intersection between the two planes.

4. Determine which principal coordinate axis is most parallel with the intersection line L.

5. Compute scalar intersection intervals for each triangle with L, as projected onto this principal axis.

6. The triangles intersect if the intersection intervals overlap; otherwise, they do not.

C code for this test is publicly available for download on the Internet.

A test of roughly the same time complexity as the interval overlap method, but conceptually easier, is the penetration method used in the ERIT package of intersection tests [Held97]. It tests if the second triangle straddles the plane of the first triangle, exiting with "no intersection" if not. Otherwise, the line segment realizing this intersection is computed. This segment is then tested for intersection and containment against the first triangle, to determine the final intersection status of the two triangles. This penetration method can be summarized as follows.

1. Compute the plane equation of triangle 1. Exit with no intersection if the vertices of triangle 2 are all on the same side of this plane.

2. Compute the intersection between triangle 2 and the plane of triangle 1. This is a line segment in the plane of triangle 1.

3. Test if the line segment intersects or is contained in triangle 2. If so, the triangles intersect; otherwise, they do not.

As an optimization to step 3, Held suggests projecting the line segment and triangle 2 to the principal plane the triangle is most parallel with and solving the intersection as a 2D triangle/line-segment test.

The final method mentioned here, similar to the interval overlap method, is presented in [Devillers02]. The first two steps are identical, but then the Devillers method relies on bringing the two triangles into a canonical form to simplify the interval overlap test on the line L of intersection between the two planes. The canonical form is achieved by cyclical permutation of the triangle vertices so that the vertex that lies alone on one side of the plane of the other triangle is the first vertex of each triangle

(that is, vertices A and D). The remaining vertices are also swapped to ensure that A and D lie above the plane of the other triangle (viewing the other triangle in its counterclockwise order).

After the triangles have been brought into the canonical form, the edges incident to A and D (that is, AB and AC, and DE and DF, respectively) are now guaranteed to intersect the line L of intersection between the two planes. Furthermore, the overlap of the intersection intervals on L can now be determined through two scalar triple product tests on the vertices, without explicitly computing the intervals themselves.

Overall, the logic for Devillers' test is more involved than the other methods presented here, but if implemented correctly the authors suggest the resulting code becomes somewhat faster as well as more robust. Refer to the original presentation for full implementational details.

5.3 **Intersecting Lines, Rays, and (Directed) Segments**

Tests involving lines, rays, and segments are frequently used, for example, to simulate bullets fired or for testing line of sight. Line tests are sometimes used instead of more complicated queries. For example, the contact of a hand or foot of a player character against the environment or the contact of a vehicle wheel against the ground can often be efficiently modeled with a simple line test. The following sections explore efficient tests of lines, rays, and segments against various common collision primitives.

5.3.1 **Intersecting Segment Against Plane**

Let a plane P be given by $(\mathbf{n} \cdot X) = d$ and a segment by the parametric equation $S(t) = A + t\,(B - A)$ for $0 \le t \le 1$ (Figure 5.20). The t value of intersection of the segment with the plane is obtained by substituting the parametric equation for X in the plane equation and solving for t:

$$(\mathbf{n} \cdot (A + t\,(B - A))) = d \qquad \textit{(substituting } S(t) = A + t\,(B - A) \textit{ for } X \textit{ in } (\mathbf{n} \cdot X) = d)$$

$$\mathbf{n} \cdot A + t\,\mathbf{n} \cdot (B - A) = d \qquad \textit{(expanding the dot product)}$$

$$t\,\mathbf{n} \cdot (B - A) = d - \mathbf{n} \cdot A \qquad \textit{(moving scalar term to RHS)}$$

$$t = (d - \mathbf{n} \cdot A) / (\mathbf{n} \cdot (B - A)) \qquad \textit{(dividing both sides by } \mathbf{n} \cdot (B - A) \textit{ to isolate } t)$$

The expression for t can now be inserted into the parametric equation for the segment to find the actual intersection point Q:

$$Q = A + [(d - \mathbf{n} \cdot A) / (\mathbf{n} \cdot (B - A))](B - A).$$

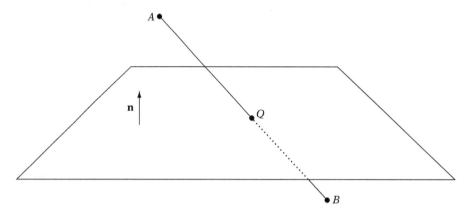

Figure 5.20 Intersecting the segment *AB* against a plane.

This can now be implemented as follows.

```
int IntersectSegmentPlane(Point a, Point b, Plane p, float &t, Point &q)
{
    // Compute the t value for the directed line ab intersecting the plane
    Vector ab = b - a;
    t = (p.d - Dot(p.n, a)) / Dot(p.n, ab);

    // If t in [0..1] compute and return intersection point
    if (t >= 0.0f && t <= 1.0f) {
        q = a + t * ab;
        return 1;
    }
    // Else no intersection
    return 0;
}
```

Note that this code does not explicitly handle division by zero. Assuming IEEE-754 floating-point arithmetic, it does still give the correct result in the case of the denominator being zero. Refer to Section 11.2.2 on infinity arithmetic for details of how to correctly deal with division-by-zero errors without having to explicitly test for them.

If the plane is not explicitly given, but only implicitly specified by three (non-collinear) points on the plane, the test can be written in the following manner instead.

```
// Intersect segment ab against plane of triangle def. If intersecting,
// return t value and position q of intersection
int IntersectSegmentPlane(Point a, Point b, Point d, Point e, Point f,
                          float &t, Point &q)
{
    Plane p;
    p.n = Cross(e - d, f - d);
    p.d = Dot(p.n, d);
    return IntersectSegmentPlane(a, b, p, t, q);
}
```

5.3.2 **Intersecting Ray or Segment Against Sphere**

Let a ray be given by $R(t) = P + t\mathbf{d}$, $t \geq 0$, where P is the ray origin and \mathbf{d} a normalized direction vector, $\|\mathbf{d}\| = 1$. If $R(t)$ describes a segment rather than a ray, then $0 \leq t \leq t_{max}$. Let the sphere boundary be defined by $(X - C) \cdot (X - C) = r^2$, where C is the sphere center and r its radius. To find the t value at which the ray intersects the surface of the sphere, $R(t)$ is substituted for X, giving

$$(P + t\mathbf{d} - C) \cdot (P + t\mathbf{d} - C) = r^2.$$

Let $\mathbf{m} = P - C$, then:

$$(\mathbf{m} + t\,\mathbf{d}) \cdot (\mathbf{m} + t\,\mathbf{d}) = r^2 \Leftrightarrow \qquad \text{(substituting } \mathbf{m} = P - C)$$

$$(\mathbf{d} \cdot \mathbf{d})t^2 + 2(\mathbf{m} \cdot \mathbf{d})t + (\mathbf{m} \cdot \mathbf{m}) = r^2 \Leftrightarrow \qquad \text{(expanding the dot product)}$$

$$t^2 + 2(\mathbf{m} \cdot \mathbf{d})t + (\mathbf{m} \cdot \mathbf{m}) - r^2 = 0 \qquad \text{(simplifying } \mathbf{d} \cdot \mathbf{d} = 1;$$

$$\text{canonical form for quadratic equation)}$$

This is a quadratic equation in t. For the quadratic formula $t^2 + 2bt + c = 0$, the solutions are given by $t = -b \pm \sqrt{b^2 - c}$. Here, $b = \mathbf{m} \cdot \mathbf{d}$ and $c = (\mathbf{m} \cdot \mathbf{m}) - r^2$.

Solving the quadratic has three outcomes, categorized by the discriminant $d = b^2 - c$. If $d < 0$, there are no real roots, which corresponds to the ray missing the sphere completely. If $d = 0$, there is one real (double) root, corresponding to the ray hitting the sphere tangentially in a point. If $d > 0$, there are two real roots and the ray intersects the sphere twice: once entering and once leaving the sphere boundary. In the latter case, the smaller intersection t value is the relevant one, given by $t = -b - \sqrt{b^2 - c}$. However, it is important to distinguish the false intersection case of the ray starting outside the sphere and pointing away from it, resulting in an

Figure 5.21 Different cases of ray-sphere intersection: (a) ray intersects sphere (twice) with $t > 0$, (b) false intersection with $t < 0$, (c) ray intersects sphere tangentially, (d) ray starts inside sphere, and (e) no intersection.

intersection value of $t < 0$. This case is illustrated in Figure 5.21, along with all other ray-sphere intersection relationships.

The following code implements the ray-sphere intersection test.

```
// Intersects ray r = p + td, |d| = 1, with sphere s and, if intersecting,
// returns t value of intersection and intersection point q
int IntersectRaySphere(Point p, Vector d, Sphere s, float &t, Point &q)
{
    Vector m = p - s.c;
    float b = Dot(m, d);
    float c = Dot(m, m) - s.r * s.r;
    // Exit if r's origin outside s (c > 0) and r pointing away from s (b > 0)
    if (c > 0.0f && b > 0.0f) return 0;
    float discr = b*b - c;
    // A negative discriminant corresponds to ray missing sphere
    if (discr < 0.0f) return 0;
    // Ray now found to intersect sphere, compute smallest t value of intersection
    t = -b - Sqrt(discr);
    // If t is negative, ray started inside sphere so clamp t to zero
    if (t < 0.0f) t = 0.0f;
    q = p + t * d;
    return 1;
}
```

For intersecting a directed segment AB against a sphere, the same code can be used by setting $P = A$ and $\mathbf{d} = (B - A)/\|B - A\|$. On intersection, it is important to verify that $t \le \|B - A\|$ so that the detected intersection does not lie beyond the end of the segment.

To just test if the ray intersects the sphere (but not when or where), the code can be optimized to not have to perform a potentially expensive square root operation.

Making early exits as soon as possible, the code becomes:

```
// Test if ray r = p + td intersects sphere s
int TestRaySphere(Point p, Vector d, Sphere s)
{
    Vector m = p - s.c;
    float c = Dot(m, m) - s.r * s.r;
    // If there is definitely at least one real root, there must be an intersection
    if (c <= 0.0f) return 1;
    float b = Dot(m, d);
    // Early exit if ray origin outside sphere and ray pointing away from sphere
    if (b > 0.0f) return 0;
    float disc = b*b - c;
    // A negative discriminant corresponds to ray missing sphere
    if (disc < 0.0f) return 0;
    // Now ray must hit sphere
    return 1;
}
```

If \mathbf{d} is not normalized, the quadratic equation to solve becomes $(\mathbf{d} \cdot \mathbf{d})t^2 + 2(\mathbf{m} \cdot \mathbf{d})t + (\mathbf{m} \cdot \mathbf{m}) - r^2 = 0$. For a quadratic equation such as this one, of the form $at^2 + 2bt + c = 0$, the solutions are given by

$$t = \frac{-b \pm \sqrt{b^2 - ac}}{a},$$

with the discriminant $d = b^2 - ac$.

5.3.3 Intersecting Ray or Segment Against Box

Recalling the definition of a *slab* as being the space between a pair of parallel planes, the volume of a rectangular box can be seen as the intersection of three such slabs at right angles to one another. Now, just as a point is inside the box if and only if it lies inside all three slabs a segment intersects the box if and only if the intersections between the segment and the slabs all overlap. If the intersections of the segment with the slabs do not overlap, the segment cannot lie inside the slabs at the same time, and therefore cannot be intersecting the volume formed by the intersection of the slabs. The same principle also applies for the intersection of a ray or a line with a box. The intersection and nonintersection of a ray against a 2D box, formed as the intersection of an x slab and a y slab, is illustrated in Figure 5.22.

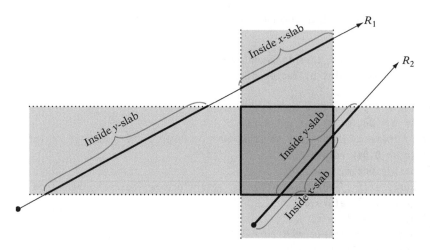

Figure 5.22 Ray R_1 does not intersect the box because its intersections with the x slab and the y slab do not overlap. Ray R_2 does intersect the box because the slab intersections overlap.

A test for intersecting a ray against a box therefore only needs to compute the intersection intervals of the ray with the planes of the slabs and perform some simple comparison operations to maintain the logical intersection of all intersection intervals along the ray. All that is required is to keep track of the farthest of all entries into a slab, and the nearest of all exits out of a slab. If the farthest entry ever becomes farther than the nearest exit, the ray cannot be intersecting the slab intersection volume and the test can exit early (with a result of nonintersection).

The intersection intervals of the ray with the slabs are obtained by inserting the parametric equation of the ray, $R(t) = P + t\,\mathbf{d}$, into the plane equations of the slab planes, $X \cdot \mathbf{n}_i = d_i$, and solving for t, giving $t = (d - P \cdot \mathbf{n}_i)/(\mathbf{d} \cdot \mathbf{n}_i)$. For an AABB, two components of the normal are zero, and thus given $P = (p_x, p_y, p_z)$ and $\mathbf{d} = (d_x, d_y, d_z)$ the expression simplifies to, for example, $t = (d - p_x)/d_x$ for a plane perpendicular to the x axis, where d simply corresponds to the position of the plane along the x axis. To avoid a division by zero when the ray is parallel to a slab, this case is best handled separately by substituting a test for the ray origin being contained in the slab. The following code is an implementation of the test of a ray against an AABB.

```
// Intersect ray R(t) = p + t*d against AABB a. When intersecting,
// return intersection distance tmin and point q of intersection
int IntersectRayAABB(Point p, Vector d, AABB a, float &tmin, Point &q)
{
    tmin = 0.0f;              // set to -FLT_MAX to get first hit on line
    float tmax = FLT_MAX;     // set to max distance ray can travel (for segment)
```

```
// For all three slabs
for (int i = 0; i < 3; i++) {
    if (Abs(d[i]) < EPSILON) {
        // Ray is parallel to slab. No hit if origin not within slab
        if (p[i] < a.min[i] || p[i] > a.max[i]) return 0;
    } else {
        // Compute intersection t value of ray with near and far plane of slab
        float ood = 1.0f / d[i];
        float t1 = (a.min[i] - p[i]) * ood;
        float t2 = (a.max[i] - p[i]) * ood;
        // Make t1 be intersection with near plane, t2 with far plane
        if (t1 > t2) Swap(t1, t2);
        // Compute the intersection of slab intersection intervals
        tmin = Max(tmin, t1);
        tmax = Min(tmax, t2);
        // Exit with no collision as soon as slab intersection becomes empty
        if (tmin > tmax) return 0;
    }
}
// Ray intersects all 3 slabs. Return point (q) and intersection t value (tmin)
q = p + d * tmin;
return 1;
}
```

If the same ray is being intersected against a large number of boxes, the three divisions involved can be precomputed once for the ray and then be reused for all tests. As a further optimization, the outcome of the statement if (t1 > t2) Swap(t1, t2) is also completely predetermined by the signs of the components of the ray direction vector. It could therefore be removed by determining in advance which one of eight (or four for a 2D test) alternative routines to call, in which the effects of the *if* statements have been folded into the surrounding code.

Note that the presented ray-box intersection test is a special case of the intersection test of a ray against the Kay–Kajiya slab volume, described in Section 4.6.1. Increasing the number of slabs allows an arbitrarily good fit of the convex hulls of objects to be achieved. The Kay–Kajiya test is, in turn, really just a specialization of the Cyrus–Beck clipping algorithm [Cyrus78]. A Cyrus–Beck-like clipping approach is also used in Section 5.3.8 for the intersection of a ray or segment against a convex polyhedron.

If the problem is just to test if the segment intersects with the box, without determining the intersection point an alternative solution is to use the separating-axis test. Without loss of generality, a coordinate system can be chosen in which the box is centered at the origin and oriented with the coordinate axes. For an AABB, the centering is accomplished by translating the segment along with the AABB to the origin. For an OBB, the segment endpoints can be transformed from world space into

the OBB space, after which both can be translated to the origin in the same way as for the AABB. Assuming the OBB is given by a center point C; a halfwidth extent vector $\mathbf{e} = (e_0, e_1, e_2)$; and local coordinate axes \mathbf{u}_0, \mathbf{u}_1, and \mathbf{u}_2; then a point P in world space can be expressed in the OBB coordinate system as the point (x, y, z), where $x = (P - C) \cdot \mathbf{u}_0$, $y = (P - C) \cdot \mathbf{u}_1$, and $z = (P - C) \cdot \mathbf{u}_2$.

Let the segment be described by a midpoint $M = (m_x, m_y, m_z)$ and endpoints $M - \mathbf{d}$ and $M + \mathbf{d}$, where $\mathbf{d} = (d_x, d_y, d_z)$ is a direction vector for the segment. The halflength of the segment is $\|\mathbf{d}\|$. Projecting the segment onto some separating axis $\mathbf{v} = (v_x, v_y, v_z)$ through the origin results in a projection interval centered at a signed distance $d_s = (M \cdot \mathbf{v}) / \|\mathbf{v}\|$ away from the origin (along \mathbf{v}), with a radius (or halflength) of $r_s = |\mathbf{d} \cdot \mathbf{v}| / \|\mathbf{v}\|$. Letting r_b denote the projection interval radius of the box onto the vector \mathbf{v}, \mathbf{v} acts as a separating axis if and only if $|d_s| > r_b + r_s$ (Figure 5.23).

For an OBB specified by three orthogonal unit vectors \mathbf{u}_0, \mathbf{u}_1, and \mathbf{u}_2 and three halflength extents e_0, e_1, and e_2, the projection interval radius r_b is given by

$$r_b = (e_0 |\mathbf{u}_0 \cdot \mathbf{v}| + e_1 |\mathbf{u}_1 \cdot \mathbf{v}| + e_2 |\mathbf{u}_2 \cdot \mathbf{v}|) / \|\mathbf{v}\|.$$

By substituting $\mathbf{u}_0 = (1, 0, 0)$, $\mathbf{u}_1 = (0, 1, 0)$, and $\mathbf{u}_2 = (0, 0, 1)$, the corresponding expression for an AABB is given by

$$r_b = (e_0 |v_x| + e_1 |v_y| + e_2 |v_z|) / \|\mathbf{v}\|.$$

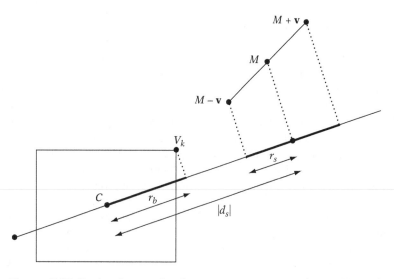

Figure 5.23 Testing intersection between a segment and an AABB using a separating-axis test.

Table 5.1 The six separating axes for testing intersection between a segment and an AABB.

v_i	d_s	r_b	r_s	$\lvert d_s\rvert > r_b + r_s$
$(1,0,0)$	m_x	e_0	$\lvert d_x\rvert$	$\lvert m_x\rvert > e_0 + \lvert d_x\rvert$
$(0,1,0)$	m_y	e_1	$\lvert d_y\rvert$	$\lvert m_y\rvert > e_1 + \lvert d_y\rvert$
$(0,0,1)$	m_z	e_2	$\lvert d_z\rvert$	$\lvert m_z\rvert > e_2 + \lvert d_z\rvert$
$\mathbf{d}\times(1,0,0)$	$(m_y d_z - m_z d_y)/\lVert\mathbf{d}\rVert$	$(e_1\lvert d_z\rvert + e_2\lvert d_y\rvert)/\lVert\mathbf{d}\rVert$	0	$\lvert m_y d_z - m_z d_y\rvert > e_1\lvert d_z\rvert + e_2\lvert d_y\rvert$
$\mathbf{d}\times(0,1,0)$	$(m_z d_x - m_x d_z)/\lVert\mathbf{d}\rVert$	$(e_0\lvert d_z\rvert + e_2\lvert d_x\rvert)/\lVert\mathbf{d}\rVert$	0	$\lvert m_z d_x - m_x d_z\rvert > e_0\lvert d_z\rvert + e_2\lvert d_x\rvert$
$\mathbf{d}\times(0,0,1)$	$(m_x d_y - m_y d_x)/\lVert\mathbf{d}\rVert$	$(e_0\lvert d_y\rvert + e_1\lvert d_x\rvert)/\lVert\mathbf{d}\rVert$	0	$\lvert m_x d_y - m_y d_x\rvert > e_0\lvert d_y\rvert + e_1\lvert d_x\rvert$

There are six axes that must be tested as separating axes: three corresponding to the AABB face normals ($\mathbf{v}_0 = (1,0,0)$, $\mathbf{v}_1 = (0,1,0)$, and $\mathbf{v}_2 = (0,0,1)$) and three corresponding to cross products between the segment direction vector and the face normals ($\mathbf{v}_3 = \mathbf{d}\times(1,0,0)$, $\mathbf{v}_4 = \mathbf{d}\times(0,1,0)$, and $\mathbf{v}_5 = \mathbf{d}\times(0,0,1)$). Table 5.1 gives the results of working out the expressions for d_s, r_b, r_s, and $\lvert d_s\rvert > r_b + r_s$ for these six axes.

The expressions for separation given in Table 5.1 directly translate into an efficient implementation.

```
// Test if segment specified by points p0 and p1 intersects AABB b
int TestSegmentAABB(Point p0, Point p1, AABB b)
{
    Point c = (b.min + b.max) * 0.5f;    // Box center-point
    Vector e = b.max - c;                // Box halflength extents
    Point m = (p0 + p1) * 0.5f;          // Segment midpoint
    Vector d = p1 - m;                   // Segment halflength vector
    m = m - c;                           // Translate box and segment to origin
    // Try world coordinate axes as separating axes
    float adx = Abs(d.x);
    if (Abs(m.x) > e.x + adx) return 0;
    float ady = Abs(d.y);
    if (Abs(m.y) > e.y + ady) return 0;
    float adz = Abs(d.z);
    if (Abs(m.z) > e.z + adz) return 0;

    // Add in an epsilon term to counteract arithmetic errors when segment is
    // (near) parallel to a coordinate axis (see text for detail)
    adx += EPSILON; ady += EPSILON; adz += EPSILON;
```

```
// Try cross products of segment direction vector with coordinate axes
if (Abs(m.y * d.z - m.z * d.y) > e.y * adz + e.z * ady) return 0;
if (Abs(m.z * d.x - m.x * d.z) > e.x * adz + e.z * adx) return 0;
if (Abs(m.x * d.y - m.y * d.x) > e.x * ady + e.y * adx) return 0;
// No separating axis found; segment must be overlapping AABB
return 1;
}
```

As written, the expressions for **e**, **d**, and **m** all have a factor 0.5 that can be removed, allowing the first five lines of initial setup code to be simplified to:

```
Vector e = b.max - b.min;
Vector d = p1 - p0;
Point m = p0 + p1 - b.min - b.max;
```

Remaining to address is the robustness of the code for when the segment direction vector **d** is parallel to one of the coordinate axes, making the three cross products give a zero vector result. If the segment does not intersect the AABB, the first three *if* tests will correctly detect this. If the segment does intersect, the latter three *if* statements correspond to 0 > 0 tests. To avoid rounding errors causing the axis to be incorrectly interpreted as separating, a small epsilon term can be added to the **adx**, **ady**, and **adz** values to bias the comparison, similar to what was done for the OBB-OBB test in Chapter 4.

5.3.4 **Intersecting Line Against Triangle**

The intersection of lines (as well as rays and segments) against triangles is a very common test. For this reason, this test is discussed in detail in this and the two following sections. Starting with the test involving lines, let a triangle ABC and a line through the points P and Q be given. The line PQ intersects ABC if the point R of intersection between the line and the plane of ABC lies inside the triangle (Figure 5.24). One solution to the intersection problem is therefore to compute R and perform a point-in-triangle test with it. Note that if ABC is arranged counterclockwise from a given viewing direction R is inside ABC if R lies to the left of the triangle edges AB, BC, and CA (where the edges are considered as directed line segments). Similarly, if ABC is arranged clockwise R is inside ABC if R is to the right of all triangle edges.

Instead of explicitly computing R for use in the sidedness test, the test can be performed directly with the line PQ against the triangle edges. Consider the scalar triple products:

$$u = [PQ \ PC \ PB]$$

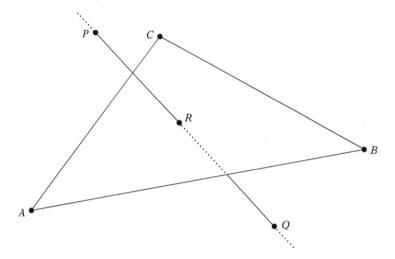

Figure 5.24 Intersecting the line through *P* and *Q* against the triangle *ABC*.

$$v = [PQ \ PA \ PC]$$
$$w = [PQ \ PB \ PA]$$

If *ABC* is counterclockwise, for *PQ* to pass to the left of the edges *BC*, *CA*, and *AB* the expressions $u \geq 0$, $v \geq 0$, and $w \geq 0$ (respectively) must be true. Similarly, when *ABC* is clockwise the scalar triple products must be nonpositive for *PQ* to pass to the right of the edges. For a double-sided triangle, which is both clockwise and counterclockwise depending on from which side it is viewed, *PQ* passes on the inside if all three scalar triple products have the same sign (ignoring zeroes).

For obtaining the intersection point with *ABC*, it can be shown that *u*, *v*, and *w* are proportional to u^*, v^*, and w^*:

$$u^* = ku = [PR \ PC \ PB]$$
$$v^* = kv = [PR \ PA \ PC]$$
$$w^* = kw = [PR \ PB \ PA],$$

where $k = \|PR\|/\|PQ\|$.

Here, u^*, v^*, and w^* are proportional to the volumes of the tetrahedra *RBCP*, *RCAP*, and *RABP*. As these tetrahedra all have the same height (as shown in Section 3.4 on barycentric coordinates), the volumes are accordingly proportional to the areas of their base triangles *RBC*, *RCA*, and *RAB*. It follows that u^*, v^*, and w^* (and more importantly, *u*, *v*, and *w*) therefore can be directly used to compute the barycentric

coordinates of *R*. It is now straightforward to derive the code for testing a line *PQ* against a counterclockwise triangle *ABC* and computing the barycentric coordinates of the intersection point, if any.

```
//Given line pq and ccw triangle abc, return whether line pierces triangle. If
//so, also return the barycentric coordinates (u,v,w) of the intersection point
int IntersectLineTriangle(Point p, Point q, Point a, Point b, Point c,
                          float &u, float &v, float &w)
{
    Vector pq = q - p;
    Vector pa = a - p;
    Vector pb = b - p;
    Vector pc = c - p;
    // Test if pq is inside the edges bc, ca and ab. Done by testing
    // that the signed tetrahedral volumes, computed using scalar triple
    // products, are all positive
    u = ScalarTriple(pq, pc, pb);
    if (u < 0.0f) return 0;
    v = ScalarTriple(pq, pa, pc);
    if (v < 0.0f) return 0;
    w = ScalarTriple(pq, pb, pa);
    if (w < 0.0f) return 0;

    // Compute the barycentric coordinates (u, v, w) determining the
    // intersection point r, r = u*a + v*b + w*c
    float denom = 1.0f / (u + v + w);
    u *= denom;
    v *= denom;
    w *= denom;      // w = 1.0f - u - v;
    return 1;
}
```

For robustness, the case in which *PQ* lies in the plane of *ABC* must be handled separately. *PQ* is in the plane of *ABC* when $u = v = w = 0$, which would result in a division-by-zero error if left unhandled.

The code can be optimized further by rearranging the terms in the triple scalar products' expressions so that a cross product is shared between two of them, turning the middle section of code into:

```
Vector m = Cross(pq, pc);
u = Dot(pb, m);  // ScalarTriple(pq, pc, pb);
if (u < 0.0f) return 0;
```

```
v = -Dot(pa, m);  // ScalarTriple(pq, pa, pc);
if (v < 0.0f) return 0;
w = ScalarTriple(pq, pb, pa);
if (w < 0.0f) return 0;
```

For a double-sided test the same code would instead read:

```
Vector m = Cross(pq, pc);
u = Dot(pb, m); // ScalarTriple(pq, pc, pb);
v = -Dot(pa, m); // ScalarTriple(pq, pa, pc);
if (!SameSign(u, v)) return 0;
w = ScalarTriple(pq, pb, pa);
if (!SameSign(u, w)) return 0;
```

It is also possible to recast the arithmetic of this test as

```
Vector m = Cross(pq, p);
u = Dot(pq, Cross(c, b)) + Dot(m, c - b);
v = Dot(pq, Cross(a, c)) + Dot(m, a - c);
w = Dot(pq, Cross(b, a)) + Dot(m, b - a);
```

or equivalently as

```
Vector m = Cross(pq, p);
float s = Dot(m, c - b);
float t = Dot(m, a - c);
u = Dot(pq, Cross(c, b)) + s;
v = Dot(pq, Cross(a, c)) + t;
w = Dot(pq, Cross(b, a)) - s - t;
```

The three cross products $C \times B$, $A \times C$, and $B \times A$ are constant for a given triangle, as are the vectors $\mathbf{e}_0 = C - B$ and $\mathbf{e}_1 = A - C$. If these are stored with the triangle, at runtime only one cross product and five dot products need to be evaluated. Because the remaining cross product only depends on values from the line, it only has to be evaluated once even if the line is tested against many triangles. This last formulation is equivalent to performing the intersection test with the line PQ and the triangle edges expressed as lines using *Plücker coordinates* [Amanatides97]. Brief but good introductions to Plücker coordinates are given in [Erickson97] and [Shoemake98]. Although a Plücker coordinate formulation results in slightly fewer floating-point operations (assuming no special dot or cross-product instructions are

available), in practice the extra memory accesses incurred are likely to make it slower than the scalar triple product solution. In addition, the higher memory overhead of the Plücker coordinate approach is unappealing. Finally, note that the triangle face normal $\mathbf{n} = (B - A) \times (C - A)$ can be recovered from the three stored cross products as $\mathbf{n} = -(C \times B) - (A \times C) - (B \times A)$.

This type of test can be extended into a segment test by explicitly computing the intersection t value of $L(t) = P + t(Q - P)$ with the plane of ABC once the line PQ has been found intersecting ABC, discarding an intersection unless $0 \leq t \leq 1$. An alternative approach for intersecting a segment against a triangle is given in Section 5.3.6.

Determining directly in 3D whether a line or a segment intersects with the interior of a triangle by computing the sidedness of the line against the triangle edges is overall the most robust way of performing a triangle intersection test. Section 11.3.3 discusses the reasons for this inherent robustness.

The approach of using triple scalar products to determine if the intersection takes place outside an edge can also be applied to arbitrary convex polygons, but for efficiency it is better to test the point of intersection between the line and the plane against the polygon interior. The triple scalar method does, however, extend nicely to intersection against quadrilaterals, as shown in the following section.

5.3.5 Intersecting Line Against Quadrilateral

The triple scalar method described in the previous section can be used almost unmodified for computing the intersection point R of a line with a quadrilateral $ABCD$. Assume $ABCD$ is convex and given counterclockwise. A point inside $ABCD$ must then be either inside the triangle ABC or inside the triangle DAC.

Because the edge CA is shared between both triangles, if this edge is tested first it can be used to effectively discriminate which triangle R must *not* lie inside. For example, if R lies to the left of CA, R cannot lie inside DAC, and thus only ABC has to be tested, with only two additional edges to test against. If instead R lies to the right of CA, only DAC must be tested, in that R cannot lie inside ABC. Again, only two additional edges must be tested. The case of R lying on CA can be arbitrarily assigned to either triangle. Whether R lies to the left or to the right of CA, in both cases only three edges are tested in all. In terms of floating-point operations, the cost of intersecting a line against a quadrilateral is therefore the same as that of intersecting against a triangle!

For this intersection test, it is not possible to return the barycentric coordinates of the intersection point directly. Additionally, to which one of the two triangles the coordinates relate would have to be specified or, alternatively, the coordinates would always have to be given with respect to, say, ABC, even if the intersection point lies inside DAC. In the following sample implementation, the intersection point is computed inside the function and returned instead of the point's barycentric coordinates.

```
// Given line pq and ccw quadrilateral abcd, return whether the line
// pierces the triangle. If so, also return the point r of intersection
int IntersectLineQuad(Point p, Point q, Point a, Point b, Point c, Point d, Point &r)
{
    Vector pq = q - p;
    Vector pa = a - p;
    Vector pb = b - p;
    Vector pc = c - p;
    // Determine which triangle to test against by testing against diagonal first
    Vector m = Cross(pc, pq);
    float v = Dot(pa, m);      // ScalarTriple(pq, pa, pc);
    if (v >= 0.0f) {
        // Test intersection against triangle abc
        float u = -Dot(pb, m);      // ScalarTriple(pq, pc, pb);
        if (u < 0.0f) return 0;
        float w = ScalarTriple(pq, pb, pa);
        if (w < 0.0f) return 0;
        // Compute r, r = u*a + v*b + w*c, from barycentric coordinates (u, v, w)
        float denom = 1.0f / (u + v + w);
        u *= denom;
        v *= denom;
        w *= denom;      // w = 1.0f - u - v;
        r = u*a + v*b + w*c;
    } else {
        // Test intersection against triangle dac
        Vector pd = d - p;
        float u = Dot(pd, m);      // ScalarTriple(pq, pd, pc);
        if (u < 0.0f) return 0;
        float w = ScalarTriple(pq, pa, pd);
        if (w < 0.0f) return 0;
        v = -v;
        // Compute r, r = u*a + v*d + w*c, from barycentric coordinates (u, v, w)
        float denom = 1.0f / (u + v + w);
        u *= denom;
        v *= denom;
        w *= denom;      // w = 1.0f - u - v;
        r = u*a + v*d + w*c;
    }
    return 1;
}
```

This particular intersection method can also be used for testing against a concave quadrilateral, assuming the diagonal fully interior to the quadrilateral is used for the

first test. One way of effectively accomplishing this is to determine the interior diagonal during preprocessing and outputting either of its end vertices as the first vertex, thus making the diagonal CA the interior diagonal. Self-intersecting quadrilaterals, however, cannot be directly tested with this method.

5.3.6 Intersecting Ray or Segment Against Triangle

Compared to the method presented in the previous section, a slightly different approach to intersecting a ray or line segment against a triangle is described in [Möller97a]. Recall that points (of the plane) of the triangle ABC are given by $T(u, v, w) = uA + vB + wC$, where (u, v, w) are the barycentric coordinates of the point such that $u + v + w = 1$. T is inside ABC if and only if its barycentric coordinates satisfy $0 \leq u, v, w \leq 1$. Alternatively, this may also be written as $T(v, w) = A + v(B - A) + w(C - A)$, with $u = 1 - v - w$. T is now inside ABC if $v \geq 0$, $w \geq 0$, and $v + w \leq 1$.

Let a directed line segment between the two points P and Q be defined parametrically as $R(t) = P + t(Q - P), 0 \leq t \leq 1$. By setting $T(v, w)$ equal to $R(t)$ it is possible to solve for t, v, and w to later verify if these are within the bounds required for an intersection:

$$T(v, w) = R(t) \Leftrightarrow \qquad\qquad\qquad\qquad \textit{(original expression)}$$

$$A + v(B - A) + w(C - A) = P + t(Q - P) \Leftrightarrow \quad \textit{(substituting parameterized expressions)}$$

$$(P - Q)t + (B - A)v + (C - A)w = P - A \qquad\qquad \textit{(rearranging terms)}$$

This is a 3×3 system of linear equations, and thus it can be written in matrix notation as

$$\begin{bmatrix} (P - Q) & (B - A) & (C - A) \end{bmatrix} \begin{bmatrix} t \\ v \\ w \end{bmatrix} = \begin{bmatrix} (P - A) \end{bmatrix},$$

where the vectors are given as column vectors. Now t, v, and w can be solved for using Cramer's rule:

$$t = \det \begin{bmatrix} (P - A) & (B - A) & (C - A) \end{bmatrix} / \det \begin{bmatrix} (P - Q) & (B - A) & (C - A) \end{bmatrix}$$

$$v = \det \begin{bmatrix} (P - Q) & (P - A) & (C - A) \end{bmatrix} / \det \begin{bmatrix} (P - Q) & (B - A) & (C - A) \end{bmatrix}$$

$$w = \det \begin{bmatrix} (P - Q) & (B - A) & (P - A) \end{bmatrix} / \det \begin{bmatrix} (P - Q) & (B - A) & (C - A) \end{bmatrix}$$

As det $\begin{bmatrix} \mathbf{a} & \mathbf{b} & \mathbf{c} \end{bmatrix} = \mathbf{a} \cdot (\mathbf{b} \times \mathbf{c})$, the algebraic identities for scalar triple products allow these expressions to be simplified to

$$t = (P - A) \cdot \mathbf{n}/d$$
$$v = (C - A) \cdot \mathbf{e}/d$$
$$w = -(B - A) \cdot \mathbf{e}/d,$$

where

$$\mathbf{n} = (B - A) \times (C - A)$$
$$d = (P - Q) \cdot \mathbf{n}$$
$$\mathbf{e} = (P - Q) \times (P - A).$$

Note that if $d < 0$ the segment points away from the triangle, and if $d = 0$ the segment runs parallel to the plane of the triangle.

The following code implements this variant of segment-triangle intersection.

```
// Given segment pq and triangle abc, returns whether segment intersects
// triangle and if so, also returns the barycentric coordinates (u,v,w)
// of the intersection point
int IntersectSegmentTriangle(Point p, Point q, Point a, Point b, Point c,
                             float &u, float &v, float &w, float &t)
{
    Vector ab = b - a;
    Vector ac = c - a;
    Vector qp = p - q;

    // Compute triangle normal. Can be precalculated or cached if
    // intersecting multiple segments against the same triangle
    Vector n = Cross(ab, ac);

    // Compute denominator d. If d <= 0, segment is parallel to or points
    // away from triangle, so exit early
    float d = Dot(qp, n);
    if (d <= 0.0f) return 0;

    // Compute intersection t value of pq with plane of triangle. A ray
    // intersects iff 0 <= t. Segment intersects iff 0 <= t <= 1. Delay
    // dividing by d until intersection has been found to pierce triangle
```

```
    Vector ap = p - a;
    t = Dot(ap, n);
    if (t < 0.0f) return 0;
    if (t > d) return 0;     // For segment; exclude this code line for a ray test

    // Compute barycentric coordinate components and test if within bounds
    Vector e = Cross(qp, ap);
    v = Dot(ac, e);
    if (v < 0.0f || v > d) return 0;
    w = -Dot(ab, e);
    if (w < 0.0f || v + w > d) return 0;

    // Segment/ray intersects triangle. Perform delayed division and
    // compute the last barycentric coordinate component
    float ood = 1.0f / d;
    t *= ood;
    v *= ood;
    w *= ood;
    u = 1.0f - v - w;
    return 1;
}
```

This formulation differs slightly from the one given in [Möller97a] because as a byproduct it computes the normal **n** of the triangle *ABC*, which is often useful to have.

Another way of looking at this test is as consisting of first computing the intersection point *S* between the segment and the plane of the triangle. This point is then tested for containment in the triangle through the computation of its barycentric coordinates with respect to the triangle (as described in Section 3.4). Some of the calculations in computing *S* and its barycentric coordinates can be shared, including those for the normal of the triangle plane. These calculations can also be precomputed and stored with the triangle.

When precomputation is allowed, the method can be further optimized by computing and storing plane equations for the plane of the triangle as well as for what could be considered the "edge planes" of the triangle (the three planes perpendicular to the triangle plane, through each of the edges, as shown in Figure 5.25). By scaling the edge plane equations so that they report a distance of one for the opposing triangle vertex (not on the edge plane), the evaluation of the edge plane equations for *S* directly give the barycentric coordinates of *S* (with respect to the opposing triangle vertex). Note that it is only necessary to store two of the three edge planes, as the third barycentric coordinate is directly obtained from the other two. The segment-triangle test can now be implemented in four plane equation evaluations (plus a few stray operations), exemplified by the following code.

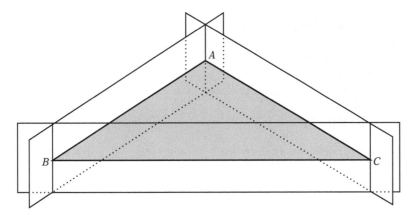

Figure 5.25 The "edge planes" of triangle *ABC* perpendicular to the plane of *ABC* and passing through *ABC*'s edges.

```
struct Triangle {
    Plane p;                 // Plane equation for triangle plane
    Plane edgePlaneBC;       // When evaluated gives barycentric weight u (for vertex A)
    Plane edgePlaneCA;       // When evaluated gives barycentric weight v (for vertex B)
};

// Given segment pq and precomputed triangle tri, returns whether segment intersects
// triangle. If so, also returns the barycentric coordinates (u,v,w) of the
// intersection point s, and the parameterized intersection t value
int IntersectSegmentTriangle(Point p, Point q, Triangle tri,
                    float &u, float &v, float &w, float &t, Point &s)
{
    // Compute distance of p to triangle plane. Exit if p lies behind plane
    float distp = Dot(p, tri.p.n) - tri.p.d;
    if (distp < 0.0f) return 0;

    // Compute distance of q to triangle plane. Exit if q lies in front of plane
    float distq = Dot(q, tri.p.n) - tri.p.d;
    if (distq >= 0.0f) return 0;

    // Compute t value and point s of intersection with triangle plane
    float denom = distp - distq;
    t = distp / denom;
    s = p + t * (q - p);

    // Compute the barycentric coordinate u; exit if outside 0..1 range
    u = Dot(s, tri.edgePlaneBC.n) - tri.edgePlaneBC.d;
```

```
      if (u < 0.0f || u > 1.0f) return 0;
      // Compute the barycentric coordinate v; exit if negative
      v = Dot(s, tri.edgePlaneCA.n) - tri.edgePlaneCA.d;
      if (v < 0.0f) return 0;
      // Compute the barycentric coordinate w; exit if negative
      w = 1.0f - u - v;
      if (w < 0.0f) return 0;

      // Segment intersects tri at distance t in position s (s = u*A + v*B + w*C)
      return 1;
}
```

By multiplying with **denom** throughout, it is possible to defer the (often expensive) division until the segment has been found actually intersecting the triangle.

For a triangle *ABC*, the triangle structure **tri** can be initialized as follows.

```
      Triangle tri;
      Vector n = Cross(b - a, c - a);
      tri.p = Plane(n, a);
      tri.edgePlaneBC = Plane(Cross(n, c - b), b);
      tri.edgePlaneCA = Plane(Cross(n, a - c), c);
```

To have the edge planes compute the barycentric coordinates of the point for which they are evaluated, they must be scaled to return a distance of one for the opposing triangle vertex (not on the plane).

```
      tri.edgePlaneBC *= 1.0f / (Dot(a, tri.edgePlaneBC.n) - tri.edgePlaneBC.d);
      tri.edgePlaneCA *= 1.0f / (Dot(b, tri.edgePlaneCA.n) - tri.edgePlaneCA.d);
```

The triangle record is now completely initialized and can be stored. Note that no triangle vertices are required for performing the intersection test. This triangle record requires 12 floating-point components, compared to the nine floating-point components required for storing the three vertices of the triangle as used by the initial method.

5.3.7 Intersecting Ray or Segment Against Cylinder

An infinite cylinder of any orientation can be specified by a line, defined by two points *P* and *Q* and by a radius *r*. If *X* denotes a point on the surface of the cylinder, the

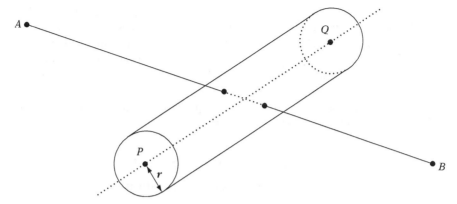

Figure 5.26 The line, ray, or segment specified by points A and B is intersected against the cylinder given by points P and Q and the radius r.

cylinder surface can be stated as satisfying the implicit equation

$$(\mathbf{v} - \mathbf{w}) \cdot (\mathbf{v} - \mathbf{w}) - r^2 = 0, \quad \text{where} \quad \mathbf{v} = X - P, \quad \mathbf{d} = Q - P, \quad \text{and} \quad \mathbf{w} = \frac{\mathbf{v} \cdot \mathbf{d}}{\mathbf{d} \cdot \mathbf{d}} \mathbf{d}.$$

This equation simply states that when taking the vector \mathbf{v} from P to a point X and subtracting \mathbf{w} (the component of \mathbf{v} parallel to \mathbf{d}) the resulting vector (which is perpendicular to \mathbf{d}, the direction of the cylinder) must have a length equal to r for X to be on the cylinder surface. The equation has been squared to avoid a square root term, which simplifies further processing.

The intersection of a line $L(t) = A + t(B - A)$, defined by the points A and B (Figure 5.26), with the cylinder can be found by substituting $L(t)$ for X in the previous equation and solving for t. Writing $\mathbf{v} = L(t) - P = (A - P) + t(B - A)$ as $\mathbf{v} = \mathbf{m} + t\mathbf{n}$, with $\mathbf{m} = A - P$ and $\mathbf{n} = B - A$, after some manipulation the equation turns into

$$\left(\mathbf{n} \cdot \mathbf{n} - \frac{(\mathbf{n} \cdot \mathbf{d})^2}{\mathbf{d} \cdot \mathbf{d}} \right) t^2 + 2 \left(\mathbf{m} \cdot \mathbf{n} - \frac{(\mathbf{n} \cdot \mathbf{d})(\mathbf{m} \cdot \mathbf{d})}{\mathbf{d} \cdot \mathbf{d}} \right) t + \mathbf{m} \cdot \mathbf{m} - \frac{(\mathbf{m} \cdot \mathbf{d})^2}{\mathbf{d} \cdot \mathbf{d}} - r^2 = 0.$$

The repeated division by $\mathbf{d} \cdot \mathbf{d}$ can be eliminated by multiplying both sides by $\mathbf{d} \cdot \mathbf{d}$, giving

$$\left((\mathbf{d} \cdot \mathbf{d})(\mathbf{n} \cdot \mathbf{n}) - (\mathbf{n} \cdot \mathbf{d})^2 \right) t^2 + 2 \left((\mathbf{d} \cdot \mathbf{d})(\mathbf{m} \cdot \mathbf{n}) - (\mathbf{n} \cdot \mathbf{d})(\mathbf{m} \cdot \mathbf{d}) \right) t + (\mathbf{d} \cdot \mathbf{d})((\mathbf{m} \cdot \mathbf{m}) - r^2)$$
$$- (\mathbf{m} \cdot \mathbf{d})^2 = 0.$$

Note that although multiplying the original quadratic equation by $\mathbf{d} \cdot \mathbf{d}$ removes the need for an often expensive division this may have undesirable effects on the overall robustness of the solution (due to the size of the intermediary terms). Ideally, the cylinder direction is given as a unit vector \mathbf{d}, in which case all $\mathbf{d} \cdot \mathbf{d}$ terms disappear. (In fact, if \mathbf{d} is unit the cylinder surface can be more succinctly defined as $(\mathbf{v} \times \mathbf{d}) \cdot (\mathbf{v} \times \mathbf{d}) = r^2$.)

In either case, both equations are quadratic equations in t on the form $at^2 + 2bt + c = 0$. For the latter formulation, the terms are:

$$a = (\mathbf{d} \cdot \mathbf{d})(\mathbf{n} \cdot \mathbf{n}) - (\mathbf{n} \cdot \mathbf{d})^2$$
$$b = (\mathbf{d} \cdot \mathbf{d})(\mathbf{m} \cdot \mathbf{n}) - (\mathbf{n} \cdot \mathbf{d})(\mathbf{m} \cdot \mathbf{d})$$
$$c = (\mathbf{d} \cdot \mathbf{d})((\mathbf{m} \cdot \mathbf{m}) - r^2) - (\mathbf{m} \cdot \mathbf{d})^2.$$

These terms can be rewritten using Lagrange's identity as

$$a = (\mathbf{d} \times \mathbf{n}) \cdot (\mathbf{d} \times \mathbf{n})$$
$$b = (\mathbf{d} \times \mathbf{m}) \cdot (\mathbf{d} \times \mathbf{n})$$
$$c = (\mathbf{d} \times \mathbf{m}) \cdot (\mathbf{d} \times \mathbf{m}) - r^2(\mathbf{d} \cdot \mathbf{d}),$$

thus revealing that $a = 0$ indicates that \mathbf{d} and \mathbf{n} are parallel and that a is always positive (although small errors may make it negative when working with floating-point arithmetic). The sign of c indicates whether A lies inside ($c < 0$) or outside ($c > 0$) the surface of the cylinder. Solving for t gives

$$t = \frac{-b \pm \sqrt{b^2 - ac}}{a}.$$

The sign of the discriminant $b^2 - ac$ determines how many real roots the quadratic has. If negative, there are no real roots, which corresponds to the line not intersecting the cylinder. If positive, there are two real roots, the smaller of which being the parameterized value at which the line enters and the larger when it exits the cylinder. When the discriminant is zero, there is a single root signifying that the line is touching the cylinder tangentially in a single point at parameterized value t.

To detect intersection against a finite cylinder rather than an infinite cylinder, intersections beyond the endcap planes through P and Q and perpendicular to \mathbf{d} must not be treated as intersections with the cylinder. Unless the (directed) line query points away from the endcap plane, an intersection test against the plane must be performed to detect a potential intersection with the side of the finite cylinder. Given a valid t, $L(t)$ lies outside the plane through P if $(L(t) - P) \cdot \mathbf{d} < 0$, or equivalently

if $(\mathbf{m} \cdot \mathbf{d}) + t(\mathbf{n} \cdot \mathbf{d}) < 0$. When $L(t)$ lies outside the cylinder, if $\mathbf{n} \cdot \mathbf{d} \leq 0$, L points away from or runs parallel to the P endcap. Only when $\mathbf{n} \cdot \mathbf{d} > 0$ must an intersection test against the P endcap be performed. Let the endcap plane through P be given by $(X - P) \cdot \mathbf{d} = 0$. Inserting $L(t)$ for X and solving gives the intersection with the plane occuring at $t = -(\mathbf{m} \cdot \mathbf{d})/(\mathbf{n} \cdot \mathbf{d})$. The intersection point lies within the endcap if $(L(t) - P) \cdot (L(t) - P) \leq r^2$.

Similarly, $L(t)$ lies outside the plane through Q if $(L(t) - P) \cdot \mathbf{d} > \mathbf{d} \cdot \mathbf{d}$, or if $(\mathbf{m} \cdot \mathbf{d}) + t(\mathbf{n} \cdot \mathbf{d}) > \mathbf{d} \cdot \mathbf{d}$. With $L(t)$ outside the cylinder on the Q side, an intersection test against the Q endcap must only be performed when $\mathbf{n} \cdot \mathbf{d} < 0$. When $\mathbf{n} \cdot \mathbf{d} \geq 0$ there is no intersection with the cylinder. The intersection with the endcap plane through Q, $(X - Q) \cdot \mathbf{d} = 0$, occurs at $t = ((\mathbf{d} \cdot \mathbf{d}) - (\mathbf{m} \cdot \mathbf{d}))/(\mathbf{n} \cdot \mathbf{d})$, and the intersection point with the plane lies within the endcap if $(L(t) - Q) \cdot (L(t) - Q) \leq r^2$. The following code sample illustrates how the preceding derivation can be used to implement the test of a segment against a finite cylinder.

```
// Intersect segment S(t)=sa+t(sb-sa), 0<=t<=1 against cylinder specified by p, q and r
int IntersectSegmentCylinder(Point sa, Point sb, Point p, Point q, float r, float &t)
{
    Vector d = q - p, m = sa - p, n = sb - sa;
    float md = Dot(m, d);
    float nd = Dot(n, d);
    float dd = Dot(d, d);
    // Test if segment fully outside either endcap of cylinder
    if (md < 0.0f && md + nd < 0.0f) return 0; // Segment outside 'p' side of cylinder
    if (md > dd && md + nd > dd) return 0;  // Segment outside 'q' side of cylinder
    float nn = Dot(n, n);
    float mn = Dot(m, n);
    float a = dd * nn - nd * nd;
    float k = Dot(m, m) - r * r;
    float c = dd * k - md * md;
    if (Abs(a) < EPSILON) {
        // Segment runs parallel to cylinder axis
        if (c > 0.0f) return 0;    // 'a' and thus the segment lie outside cylinder
        // Now known that segment intersects cylinder; figure out how it intersects
        if (md < 0.0f) t = -mn / nn;    // Intersect segment against 'p' endcap
        else if (md > dd) t = (nd - mn) / nn; // Intersect segment against 'q' endcap
        else t = 0.0f;    // 'a' lies inside cylinder
        return 1;
    }
    float b = dd * mn - nd * md;
    float discr = b * b - a * c;
    if (discr < 0.0f) return 0;    // No real roots; no intersection
```

```
    t = (-b - Sqrt(discr)) / a;
    if (t < 0.0f || t > 1.0f) return 0;      // Intersection lies outside segment
    if (md + t * nd < 0.0f) {
        // Intersection outside cylinder on 'p' side
        if (nd <= 0.0f) return 0;     // Segment pointing away from endcap
        t = -md / nd;
        // Keep intersection if Dot(S(t) - p, S(t) - p) <= r^2
        return k + 2 * t * (mn + t * nn) <= 0.0f;
    } else if (md + t * nd > dd) {
        // Intersection outside cylinder on 'q' side
        if (nd >= 0.0f) return 0; // Segment pointing away from endcap
        t = (dd - md) / nd;
        // Keep intersection if Dot(S(t) - q, S(t) - q) <= r^2
        return k + dd - 2 * md + t * (2 * (mn - nd) + t * nn) <= 0.0f;
    }
    // Segment intersects cylinder between the endcaps; t is correct
    return 1;
}
```

With minor adjustments, the same approach can be used to intersect a ray (not a segment) against the finite cylinder. The intersection against a capsule, rather than a cylinder, is performed in a comparable manner by replacing the intersection with the endcap planes with intersection against hemispherical endcaps. Tests for intersecting lines, rays, and segments with a cylinder have previously been described in [Shene94], [Cychosz94], and [Held97].

5.3.8 Intersecting Ray or Segment Against Convex Polyhedron

To intersect a segment $S(t) = A + t(B - A)$, $0 \le t \le 1$, against a convex polyhedron it turns out that a convenient representation for the polyhedron is to describe it as the intersection of a set of halfspaces [Haines91b]. For such a format, the segment intersects the polyhedron if there exists some value for t, $0 \le t \le 1$, for which $S(t)$ lies inside all halfspaces. An efficient way of determining if this is the case is simply to clip the segment against each halfspace, trimming away the portion of the segment that lies outside the halfspace. If during this clipping process the segment becomes zero length, the segment cannot intersect the polyhedron and the process can stop with a result of "no intersection." After the segment has been intersected against all halfspaces, what remains of the segment must be the intersection of the segment and the polyhedron.

The clipping process can be implemented as keeping track of the segment defined over the interval $t_{first} \le t \le t_{last}$, where t_{first} and t_{last} are initially set to 0 and 1, respectively, but are adjusted as the segment is intersected against the planes defining

the halfspaces. (To intersect a ray against the intersection volume, t_{last} would instead initially be set to $+\infty$. For a line, additionally t_{first} would be initially set to $-\infty$.)

Now recall that for a segment $S(t) = A + t(B - A)$, $0 \le t \le 1$, and a plane $\mathbf{n} \cdot X = d$ the intersection of the segment and the plane is given by $t = (d - \mathbf{n} \cdot A)/(\mathbf{n} \cdot (B - A))$. Thus, the plane faces the segment if the denominator $\mathbf{n} \cdot (B - A)$ is negative, and if the denominator is positive the plane faces away from the segment. When the denominator is zero, the segment is parallel to the plane. When the plane faces the segment, the computed t is the parameterized value corresponding to the point at which the segment is entering the halfspace. As a consequence, if t is *greater* than t_{first} the segment must be clipped by setting t_{first} to the current value of t. When the plane faces away from the segment, t corresponds to the parameterized value at the point the segment is exiting the halfspace. Therefore, if t is less than t_{last}, t_{last} must be set to the current value of t. If ever $t_{last} < t_{first}$, the segment has disappeared and there is no intersection.

The segment running parallel to the plane must be handled as a special case. If the segment lies outside the halfspace, parallel to the defining plane, the segment cannot be intersecting the polyhedron and the test can immediately return "no intersection." If the segment lies inside the halfspace, the plane can simply be ignored and processing may continue with the next plane. To determine whether the segment lies inside or outside the halfspace, either endpoint of the segment may be tested against the plane by insertion into the plane equation, the sign of the result determining the sidedness of the point.

Figure 5.27 gives a 2D illustration of how a ray is clipped against a number of halfspaces and how the logical intersection of the ray being clipped against each halfspace forms the part of the ray that overlaps the intersection volume. The following function implements the test just described.

```
// Intersect segment S(t)=A+t(B-A), 0<=t<=1 against convex polyhedron specified
// by the n halfspaces defined by the planes p[]. On exit tfirst and tlast
// define the intersection, if any
int IntersectSegmentPolyhedron(Point a, Point b, Plane p[], int n,
                               float &tfirst, float &tlast)
{
    // Compute direction vector for the segment
    Vector d = b - a;
    // Set initial interval to being the whole segment. For a ray, tlast should be
    // set to +FLT_MAX. For a line, additionally tfirst should be set to -FLT_MAX
    tfirst = 0.0f;
    tlast = 1.0f;
    // Intersect segment against each plane
    for (int i = 0; i < n; i++) {
        float denom = Dot(p[i].n, d);
        float dist = p[i].d - Dot(p[i].n, a);
        // Test if segment runs parallel to the plane
```

Figure 5.27 The intersection of a ray (or segment) against a convex polyhedron (defined as the intersection of a set of halfspaces) is the logical intersection of the ray clipped against all halfspaces. (Illustration after [Haines91b].)

```
    if (denom == 0.0f) {
        // If so, return "no intersection" if segment lies outside plane
        if (dist > 0.0f) return 0;
    } else {
        // Compute parameterized t value for intersection with current plane
        float t = dist / denom;
        if (denom < 0.0f) {
            // When entering halfspace, update tfirst if t is larger
            if (t > tfirst) tfirst = t;
        } else {
            // When exiting halfspace, update tlast if t is smaller
            if (t < tlast) tlast = t;
        }
        // Exit with "no intersection" if intersection becomes empty
        if (tfirst > tlast) return 0;
    }
}
// A nonzero logical intersection, so the segment intersects the polyhedron
return 1;
}
```

Overall, this problem is very similar to that of the intersecting of a segment against a box defined as the intersection of three slabs (as in Section 5.3.3). Because a box is just a special case of a convex polyhedron, this code could also be used for the segment-box test.

5.4 **Additional Tests**

This section describes a number of tests and computations that do not directly fit into the classifications of the earlier sections but are still either commonly encountered or illustrate a technique that can be applied to related problems.

5.4.1 **Testing Point in Polygon**

A large number of approaches exist for testing the containment of a point in a polygon. An excellent survey of point-in-polygon methods is given in [Haines94]. An additional method, based on quadrant testing, is presented in [Weiler94]. An approach based on a CSG representation of the polygon is described in [Walker99]. A good survey is also given in [Huang97].

Most point-in-polygon tests required in real-time collision detection applications can be limited to involve convex polygons only. Whereas the point containment for concave n-gons may require $O(n)$ time, the special structure of convex polygons allows a fast point-containment test to be performed in $O(\log n)$ time, through an interval-halving approach.

Assume a convex n-gon is given counterclockwise by the vertices $V_0, V_1, \ldots, V_{n-1}$. By testing whether the query point P is to the left or right of the directed line through V_0 and V_k, $k = \lfloor n/2 \rfloor$, half the polygon can be excluded from further tests. The procedure is repeated, with the value of k adjusted accordingly until P either has been found to lie outside the polygon (right of the directed line through V_0 and V_1, or left of the one through V_0 and V_{n-1}) or between the directed lines through V_0 and V_k and through V_0 and V_{k+1}. In the latter case, P is contained in the polygon if P also lies to the left of the directed line through V_k and V_{k+1}.

As an example, consider the eight-sided convex polygon of Figure 5.28. Initially, P is tested against the directed line A through V_0 and V_4, dividing the polygon in half vertex-wise. Because P lies to the left of A, the right polygon half is discarded and the left half is now processed in the same manner. Next, P is tested against the line B, followed by a test against C. At this point, P lies between the lines through two consecutive vertices, and thus a final test is performed against the directed line D through these two vertices, here confirming that P indeed lies inside the polygon.

By using the predicate `TriangleIsCCW()`, which determines if the triangle specified by three points is defined counterclockwise, this test can be efficiently implemented as follows.

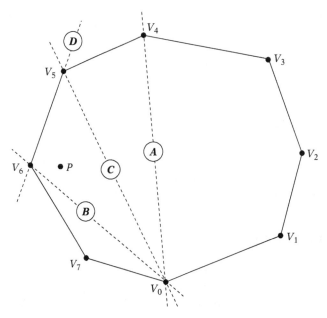

Figure 5.28 A binary search over the vertices of the convex **polygon** allows the containment test for *P* to be performed in *O*(log *n*) time (here using four sidedness tests, *A* through *D*).

```
// Test if point p lies inside ccw-specified convex n-gon given by vertices v[]
int PointInConvexPolygon(Point p, int n, Point v[])
{
    // Do binary search over polygon vertices to find the fan triangle
    // (v[0], v[low], v[high]) the point p lies within the near sides of
    int low = 0, high = n;
    do {
        int mid = (low + high) / 2;
        if (TriangleIsCCW(v[0], v[mid], p))
            low = mid;
        else
            high = mid;
    } while (low + 1 < high);

    // If point outside last (or first) edge, then it is not inside the n-gon
    if (low == 0 || high == n) return 0;

    // p is inside the polygon if it is left of
    // the directed edge from v[low] to v[high]
    return TriangleIsCCW(v[low], v[high], p);
}
```

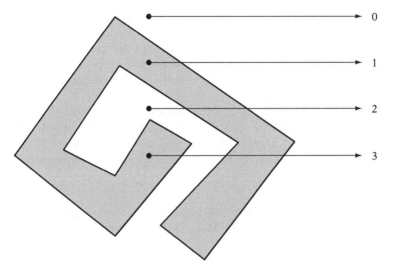

Figure 5.29 Shooting rays from four different query points. An odd number of boundary crossings indicates that the query point is inside the polygon.

This point containment test is similar in structure to the one presented in [Preparata85], where a point interior to the n-gon fills the role played here by the vertex V_0.

Another $O(n)$ test that works for concave polygons is based on shooting a ray from the point along some direction (commonly the positive x axis) and counting the number of times it crosses the polygon boundary. If the ray crosses the boundary once, the point must be inside the polygon. If it crosses twice, the point must be outside, with the ray first entering and then exiting the polygon. In general, the point will be inside the polygon for an odd number of crossings and outside for an even number of crossings. This test, commonly referred to as the *crossings test*, is illustrated in Figure 5.29.

Some care must be exercised to properly handle cases where the ray passes through a polygon vertex or coincides with an edge of the polygon. If not dealt with correctly, multiple crossings could be detected in these cases, giving an incorrect crossings count. In practice, this problem can be dealt with effectively by arranging the tests performed so as to treat vertices on the ray as lying infinitesimally above the ray. Several variations on the crossings test are presented in [Haines94].

5.4.2 Testing Point in Triangle

The case of testing whether a point is contained in a triangle comes up frequently enough that it is worth studying separately from point-in-polygon tests. Two effective solutions to the point-in-triangle problem have already been presented: one

for unprocessed triangles in Section 3.4 (on barycentric coordinates) and one for preprocessed triangles in Section 5.3.6.

A third solution is to take the triangle *ABC* and the query point *P* in the plane of the triangle and translate both so that *P* lies at the origin. The test now becomes that of checking if the origin is contained in the translated triangle (which will still be referred to as *ABC* throughout).

P lies inside *ABC* if and only if the triangles *PAB*, *PBC*, and *PCA* are all either clockwise or counterclockwise. Because *P* is at the origin, this is now equivalent to testing if the cross products $\mathbf{u} = B \times C$, $\mathbf{v} = C \times A$, and $\mathbf{w} = A \times B$ all point in the same direction; that is, if $\mathbf{u} \cdot \mathbf{v} \geq 0$ and $\mathbf{u} \cdot \mathbf{w} \geq 0$. Implemented, this test becomes:

```
// Test if point P lies inside the counterclockwise triangle ABC
int PointInTriangle(Point p, Point a, Point b, Point c)
{
    // Translate point and triangle so that point lies at origin
    a -= p; b -= p; c -= p;
    // Compute normal vectors for triangles pab and pbc
    Vector u = Cross(b, c);
    Vector v = Cross(c, a);
    // Make sure they are both pointing in the same direction
    if (Dot(u, v) < 0.0f) return 0;
    // Compute normal vector for triangle pca
    Vector w = Cross(a, b);
    // Make sure it points in the same direction as the first two
    if (Dot(u, w) < 0.0f) return 0;
    // Otherwise P must be in (or on) the triangle
    return 1;
}
```

If cross products are more expensive than dot products, Lagrange's identity allows this test to be written in terms of just five dot products.

```
// Test if point P lies inside the counterclockwise 3D triangle ABC
int PointInTriangle(Point p, Point a, Point b, Point c)
{
    // Translate point and triangle so that point lies at origin
    a -= p; b -= p; c -= p;
    float ab = Dot(a, b);
    float ac = Dot(a, c);
    float bc = Dot(b, c);
    float cc = Dot(c, c);
```

```
    // Make sure plane normals for pab and pbc point in the same direction
    if (bc * ac - cc * ab < 0.0f) return 0;
    // Make sure plane normals for pab and pca point in the same direction
    float bb = Dot(b, b);
    if (ab * bc - ac * bb < 0.0f) return 0;
    // Otherwise P must be in (or on) the triangle
    return 1;
}
```

Note the strong similarities between this function and the function **Barycentric()** of Section 3.4.

In 2D, this test becomes even simpler. Without loss of generality, assume the triangle ABC is defined counterclockwise. Then, the point P lies inside the triangle if and only if P lies to the left of the directed line segments AB, BC, and CA. These tests are easily performed with the help of the 2D pseudo cross product, as defined in Chapter 3. That is, given the function

```
// Compute the 2D pseudo cross product Dot(Perp(u), v)
float Cross2D(Vector2D u, Vector2D v)
{
    return u.y * v.x - u.x * v.y;
}
```

the test of P lying to the left of the segment AB becomes a call to this function with the arguments $P - A$ and $B - A$, followed by a test to see if the result is positive. The entire test then becomes:

```
// Test if 2D point P lies inside the counterclockwise 2D triangle ABC
int PointInTriangle(Point2D p, Point2D a, Point2D b, Point2D c)
{
    // If P to the right of AB then outside triangle
    if (Cross2D(p - a, b - a) < 0.0f) return 0;
    // If P to the right of BC then outside triangle
    if (Cross2D(p - b, c - b) < 0.0f) return 0;
    // If P to the right of CA then outside triangle
    if (Cross2D(p - c, a - c) < 0.0f) return 0;
    // Otherwise P must be in (or on) the triangle
    return 1;
}
```

If it is not known whether the triangle is clockwise or counterclockwise, the same approach can still be used. Containment of *P* in *ABC* is then indicated by *P* lying on the same side of all edges of the triangle. That is, either *P* lies to the left of all edges or to the right of all edges. If neither is true, *P* is not contained in the triangle. In terms of implementation, the code must be changed to test that the 2D pseudo cross products all have the same sign.

```
// Test if 2D point P lies inside 2D triangle ABC
int PointInTriangle2D(Point2D p, Point2D a, Point2D b, Point2D c)
{
    float pab = Cross2D(p - a, b - a);
    float pbc = Cross2D(p - b, c - b);
    // If P left of one of AB and BC and right of the other, not inside triangle
    if (!SameSign(pab, pbc)) return 0;
    float pca = Cross2D(p - c, a - c);
    // If P left of one of AB and CA and right of the other, not inside triangle
    if (!SameSign(pab, pca)) return 0;
    // P left or right of all edges, so must be in (or on) the triangle
    return 1;
}
```

Because the value returned by `Cross2D(p - a, b - a)` is twice the signed area of the triangle *PAB* (positive if *PAB* is counterclockwise, otherwise negative), yet another version of this test is to compute the areas of *PAB*, *PBC*, and *PCA* and see if their sum exceeds that of the area of *ABC*, in which case *P* lies outside *ABC*. To save on computations, the area of *ABC* could be stored with the triangle. As with the 3D test, this test can be optimized by storing plane equations for each edge that have been normalized to compute the barycentric coordinates of the query point.

5.4.3 Testing Point in Polyhedron

There are several available methods for testing if a point lies inside a given polyhedron. How the polyhedron is specified and whether it is convex or concave determine which methods are appropriate in a given situation. This section outlines a few different approaches, some of which are discussed in more detail in Chapters 8 and 9.

The simplest test is when the polyhedron is convex and given implicitly as the intersection volume of a number of halfspaces. In this case, the point lies inside the polyhedron if it lies inside each halfspace.

```
// Test if point p inside polyhedron given as the intersection volume of n halfspaces
int TestPointPolyhedron(Point p, Plane *h, int n)
```

```
{
    for (int i = 0; i < n; i++) {
        // Exit with 'no containment' if p ever found outside a halfspace
        if (DistPointPlane(p, h[i]) > 0.0f) return 0;
    }
    // p inside all halfspaces, so p must be inside intersection volume
    return 1;
}
```

If the polyhedron is given as a set of vertices without any connectivity information, the GJK method described in Chapter 9 serves as an efficient point containment approach. Only a convex polyhedron can be given in this format.

If the polyhedron is given as a closed mesh, one approach is to first build a solid-leaf BSP tree (see Chapter 8) from the mesh. Then, given this BSP tree if a point query on the tree ends up in a solid leaf the point is inside the polyhedron (otherwise, it is not). This method works for both convex and concave polyhedra.

A method that works with a polyhedron given either as a mesh or as an intersection of halfspaces is to shoot a ray from the tested point in any direction (typically along a major axis, such as the $+x$ axis) and count the number of faces intersected. If an odd number of faces is intersected, the point lies inside the polyhedron; otherwise, the point lies outside it. Due to floating-point classification errors, this method has robustness issues when a ray strikes (near) an edge or a vertex. To avoid dealing with the degeneracies of these cases, one effective approach is simply to recast the ray, although care must be taken not to hit an edge or vertex again. This method also works for both convex and concave polyhedra.

With a custom prebuilt data structure such as the Dobkin–Kirkpatrick hierarchical structure (see Section 9.3.1), a point containment query can be performed in $O(\log n)$ time.

5.4.4 **Intersection of Two Planes**

Let two planes, π_1 and π_2, be given by the plane equations $\mathbf{n}_1 \cdot X = d_1$ and $\mathbf{n}_2 \cdot X = d_2$. When the planes are not parallel, they intersect in a line L, $L = P + t\mathbf{d}$. As L lies in both planes, it must be perpendicular to the normals of both planes. Thus, the direction vector \mathbf{d} of L can be computed as the cross product of the two plane normals, $\mathbf{d} = \mathbf{n}_1 \times \mathbf{n}_2$ (Figure 5.30). If \mathbf{d} is the zero vector, the planes are parallel (and separated) or coincident; otherwise, they are intersecting.

For L to be fully determined, a point P on the line must also be given. One way of obtaining a point on the line is to express the point as being in a plane perpendicular to \mathbf{d}. Such a plane is spanned by \mathbf{n}_1 and \mathbf{n}_2, and thus P is given by $P = k_1\mathbf{n}_1 + k_2\mathbf{n}_2$ for some values of k_1 and k_2. Furthermore, P must lie on both π_1 and π_2, and thus it must satisfy both plane equations. Substituting this expression for P (in place of X)

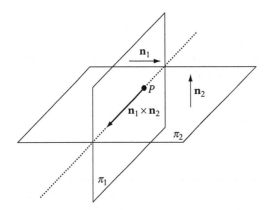

Figure 5.30 The intersection of two planes.

in the plane equations forms a 2×2 system of linear equations.

$$\mathbf{n}_1 \cdot (k_1 \mathbf{n}_1 + k_2 \mathbf{n}_2) = d_1$$
$$\mathbf{n}_2 \cdot (k_1 \mathbf{n}_1 + k_2 \mathbf{n}_2) = d_2.$$

By virtue of the linearity of the dot product, this is equivalent to

$$k_1 (\mathbf{n}_1 \cdot \mathbf{n}_1) + k_2 (\mathbf{n}_1 \cdot \mathbf{n}_2) = d_1$$
$$k_1 (\mathbf{n}_1 \cdot \mathbf{n}_2) + k_2 (\mathbf{n}_2 \cdot \mathbf{n}_2) = d_2,$$

which can be solved for k_1 and k_2 (by Cramer's rule, for example) to give the solution

$$k_1 = (d_1 (\mathbf{n}_2 \cdot \mathbf{n}_2) - d_2 (\mathbf{n}_1 \cdot \mathbf{n}_2)) / denom$$
$$k_2 = (d_2 (\mathbf{n}_1 \cdot \mathbf{n}_1) - d_1 (\mathbf{n}_1 \cdot \mathbf{n}_2)) / denom,$$

where

$$denom = (\mathbf{n}_1 \cdot \mathbf{n}_1)(\mathbf{n}_2 \cdot \mathbf{n}_2) - (\mathbf{n}_1 \cdot \mathbf{n}_2)^2.$$

A direct implementation of these expressions gives the following code.

```
// Given planes p1 and p2, compute line L = p+t*d of their intersection.
// Return 0 if no such line exists
```

```
int IntersectPlanes(Plane p1, Plane p2, Point &p, Vector &d)
{
    // Compute direction of intersection line
    d = Cross(p1.n, p2.n);

    // If d is zero, the planes are parallel (and separated)
    // or coincident, so they're not considered intersecting
    if (Dot(d, d) < EPSILON) return 0;

    float d11 = Dot(p1.n, p1.n);
    float d12 = Dot(p1.n, p2.n);
    float d22 = Dot(p2.n, p2.n);

    float denom = d11*d22 - d12*d12;
    float k1 = (p1.d*d22 - p2.d*d12) / denom;
    float k2 = (p2.d*d11 - p1.d*d12) / denom;
    p = k1*p1.n + k2*p2.n;
    return 1;
}
```

This code can be optimized by realizing that the denominator expression is really just the result of applying Lagrange's identity to $(\mathbf{n}_1 \times \mathbf{n}_2) \cdot (\mathbf{n}_1 \times \mathbf{n}_2)$. The denominator is therefore equivalent to

$$denom = \mathbf{d} \cdot \mathbf{d}.$$

Using the vector identity

$$\mathbf{u} \times (\mathbf{v} \times \mathbf{w}) = (\mathbf{u} \cdot \mathbf{w})\mathbf{v} - (\mathbf{v} \cdot \mathbf{w})\mathbf{u},$$

the expression for $P = k_1\mathbf{n}_1 + k_2\mathbf{n}_2$ can also be further simplified as follows.

$P = k_1\mathbf{n}_1 + k_2\mathbf{n}_2 \Leftrightarrow$ *(original expression)*

$P = [(d_1(\mathbf{n}_2 \cdot \mathbf{n}_2) - d_2(\mathbf{n}_1 \cdot \mathbf{n}_2))\mathbf{n}_1 + (d_2(\mathbf{n}_1 \cdot \mathbf{n}_1) - d_1(\mathbf{n}_1 \cdot \mathbf{n}_2))\mathbf{n}_2]/denom \Leftrightarrow$

(substituting k_1 and k_2)

$P\,denom = (d_1(\mathbf{n}_2 \cdot \mathbf{n}_2) - d_2(\mathbf{n}_1 \cdot \mathbf{n}_2))\mathbf{n}_1 + (d_2(\mathbf{n}_1 \cdot \mathbf{n}_1) - d_1(\mathbf{n}_1 \cdot \mathbf{n}_2))\mathbf{n}_2 \Leftrightarrow$

(multiplying both sides by denom)

$P\,denom = (d_1(\mathbf{n}_2 \cdot \mathbf{n}_2)\mathbf{n}_1 - d_2(\mathbf{n}_1 \cdot \mathbf{n}_2)\mathbf{n}_1) + (d_2(\mathbf{n}_1 \cdot \mathbf{n}_1)\mathbf{n}_2 - d_1(\mathbf{n}_1 \cdot \mathbf{n}_2)\mathbf{n}_2) \Leftrightarrow$

(distributing scalar multiply)

$$P \, denom = d_1((\mathbf{n}_2 \cdot \mathbf{n}_2)\mathbf{n}_1 - (\mathbf{n}_1 \cdot \mathbf{n}_2)\mathbf{n}_2) + d_2((\mathbf{n}_1 \cdot \mathbf{n}_1)\mathbf{n}_2 - (\mathbf{n}_1 \cdot \mathbf{n}_2)\mathbf{n}_1) \Leftrightarrow$$

(gathering similar terms)

$$P \, denom = d_1(\mathbf{n}_2 \times (\mathbf{n}_1 \times \mathbf{n}_2)) + d_2(\mathbf{n}_1 \times (\mathbf{n}_2 \times \mathbf{n}_1)) \Leftrightarrow$$

(rewriting using vector identity)

$$P \, denom = d_1(\mathbf{n}_2 \times (\mathbf{n}_1 \times \mathbf{n}_2)) - d_2(\mathbf{n}_1 \times (\mathbf{n}_1 \times \mathbf{n}_2)) \Leftrightarrow$$

(changing sign to make inner cross products equal)

$$P \, denom = (d_1\mathbf{n}_2 - d_2\mathbf{n}_1) \times (\mathbf{n}_1 \times \mathbf{n}_2) \Leftrightarrow \qquad \textit{(gathering similar terms)}$$

$$P = (d_1\mathbf{n}_2 - d_2\mathbf{n}_1) \times \mathbf{d}/denom$$

(substituting \mathbf{d} for $\mathbf{n}_1 \times \mathbf{n}_2$; dividing by denom on both sides)

The final terms in the expression of the line $L = P + t\mathbf{d}$ are therefore

$$P = (d_1\mathbf{n}_2 - d_2\mathbf{n}_1) \times \mathbf{d}/(\mathbf{d} \cdot \mathbf{d})$$

$$\mathbf{d} = \mathbf{n}_1 \times \mathbf{n}_2.$$

The implementation now becomes:

```
// Given planes p1 and p2, compute line L = p+t*d of their intersection.
// Return 0 if no such line exists
int IntersectPlanes(Plane p1, Plane p2, Point &p, Vector &d)
{
    // Compute direction of intersection line
    d = Cross(p1.n, p2.n);

    // If d is (near) zero, the planes are parallel (and separated)
    // or coincident, so they're not considered intersecting
    float denom = Dot(d, d);
    if (denom < EPSILON) return 0;

    // Compute point on intersection line
    p = Cross(p1.d*p2.n - p2.d*p1.n, d) / denom;
    return 1;
}
```

It should be noted that when it is known that the plane normals have been normalized (that is, $\|\mathbf{n}_1\| = \|\mathbf{n}_2\| = 1$), the division by the denominator is not required in either formulation.

5.4.5 **Intersection of Three Planes**

Given three planes π_1, π_2, and π_3, there are five essentially different intersection configurations possible, as illustrated in Figure 5.31.

1. All three planes are parallel (possibly coplanar) to one another.

2. Two planes are parallel and the last plane transversally cuts through the first two planes, forming two parallel intersection lines.

3. All three planes intersect in a single line.

4. The planes pairwise intersect in a line, forming three parallel lines of inter-section.

5. The three planes intersect in a point.

Let the planes be defined as $\pi_1{:}\mathbf{n}_1 \cdot X = d_1$, $\pi_2{:}\mathbf{n}_2 \cdot X = d_2$, and $\pi_3{:}\mathbf{n}_3 \cdot X = d_3$. The last case (5) can then be identified by $\mathbf{n}_1 \cdot (\mathbf{n}_2 \times \mathbf{n}_3) = 0$. Other cases can be identified in similar ways. When the planes intersect in a unique point $X = (x_1, x_2, x_3)$, this point can be solved for by considering the plane equations as a 3×3 system of linear equations:

$$\mathbf{n}_1 \cdot X = d_1$$

$$\mathbf{n}_2 \cdot X = d_2$$

$$\mathbf{n}_3 \cdot X = d_3.$$

This system can be solved either using Gaussian elimination or in terms of determinants and Cramer's rule. By letting $\mathbf{m}_1 = \begin{bmatrix} \mathbf{n}_1^x & \mathbf{n}_2^x & \mathbf{n}_3^x \end{bmatrix}^T$, $\mathbf{m}_2 = \begin{bmatrix} \mathbf{n}_1^y & \mathbf{n}_2^y & \mathbf{n}_3^y \end{bmatrix}^T$,

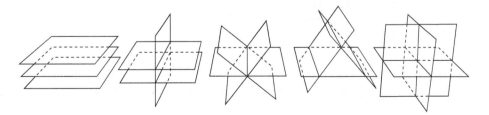

Figure 5.31 The five essentially different intersection configurations of three planes.

and $\mathbf{m}_3 = \begin{bmatrix} \mathbf{n}_1^z & \mathbf{n}_2^z & \mathbf{n}_3^z \end{bmatrix}^T$, Cramer's rule gives the solution as

$$x_1 = \begin{vmatrix} \mathbf{d} & \mathbf{m}_2 & \mathbf{m}_3 \end{vmatrix} \Big/ \begin{vmatrix} \mathbf{m}_1 & \mathbf{m}_2 & \mathbf{m}_3 \end{vmatrix}$$

$$x_2 = \begin{vmatrix} \mathbf{m}_1 & \mathbf{d} & \mathbf{m}_3 \end{vmatrix} \Big/ \begin{vmatrix} \mathbf{m}_1 & \mathbf{m}_2 & \mathbf{m}_3 \end{vmatrix}$$

$$x_3 = \begin{vmatrix} \mathbf{m}_1 & \mathbf{m}_2 & \mathbf{d} \end{vmatrix} \Big/ \begin{vmatrix} \mathbf{m}_1 & \mathbf{m}_2 & \mathbf{m}_3 \end{vmatrix},$$

where $\mathbf{d} = \begin{bmatrix} d_1 & d_2 & d_3 \end{bmatrix}^T$.

By selecting the most appropriate expressions for evaluation — in order to share as much computation as possible — the scalar triple products simplify to

$$x_1 = \mathbf{d} \cdot \mathbf{u}/denom$$

$$x_2 = \mathbf{m}_3 \cdot \mathbf{v}/denom$$

$$x_3 = -\mathbf{m}_2 \cdot \mathbf{v}/denom,$$

where $\mathbf{u} = \mathbf{m}_2 \times \mathbf{m}_3$, $\mathbf{v} = \mathbf{m}_1 \times \mathbf{d}$, and $denom = \mathbf{m}_1 \cdot \mathbf{u}$.

The following code implements this solution for three planes.

```
// Compute the point p at which the three planes p1, p2 and p3 intersect (if at all)
int IntersectPlanes(Plane p1, Plane p2, Plane p3, Point &p)
{
    Vector m1 = Vector(p1.n.x, p2.n.x, p3.n.x);
    Vector m2 = Vector(p1.n.y, p2.n.y, p3.n.y);
    Vector m3 = Vector(p1.n.z, p2.n.z, p3.n.z);

    Vector u = Cross(m2, m3);
    float denom = Dot(m1, u);
    if (Abs(denom) < EPSILON) return 0; // Planes do not intersect in a point
    Vector d(p1.d, p2.d, p3.d);
    Vector v = Cross(m1, d);
    float ood = 1.0f / denom;
    p.x = Dot(d, u) * ood;
    p.y = Dot(m3, v) * ood;
    p.z = -Dot(m2, v) * ood;
    return 1;
}
```

An alternative approach is to solve for X using the formula

$$X = \frac{d_1(\mathbf{n}_2 \times \mathbf{n}_3) + d_2(\mathbf{n}_3 \times \mathbf{n}_1) + d_3(\mathbf{n}_1 \times \mathbf{n}_2)}{\mathbf{n}_1 \cdot (\mathbf{n}_2 \times \mathbf{n}_3)},$$

as suggested by [Goldman90]. This formula can be obtained by realizing that X can be expressed as a linear combination of the directions of the lines of intersection of the planes,

$$X = a(\mathbf{n}_2 \times \mathbf{n}_3) + b(\mathbf{n}_3 \times \mathbf{n}_1) + c(\mathbf{n}_1 \times \mathbf{n}_2),$$

for some a, b, and c. Inserting this point in each of the three plane equations gives

$$\mathbf{n}_1 \cdot (a(\mathbf{n}_2 \times \mathbf{n}_3) + b(\mathbf{n}_3 \times \mathbf{n}_1) + c(\mathbf{n}_1 \times \mathbf{n}_2)) = d_1$$

$$\mathbf{n}_2 \cdot (a(\mathbf{n}_2 \times \mathbf{n}_3) + b(\mathbf{n}_3 \times \mathbf{n}_1) + c(\mathbf{n}_1 \times \mathbf{n}_2)) = d_2$$

$$\mathbf{n}_3 \cdot (a(\mathbf{n}_2 \times \mathbf{n}_3) + b(\mathbf{n}_3 \times \mathbf{n}_1) + c(\mathbf{n}_1 \times \mathbf{n}_2)) = d_3,$$

which simplify to

$$\mathbf{n}_1 \cdot a(\mathbf{n}_2 \times \mathbf{n}_3) = d_1$$

$$\mathbf{n}_2 \cdot b(\mathbf{n}_3 \times \mathbf{n}_1) = d_2$$

$$\mathbf{n}_3 \cdot c(\mathbf{n}_1 \times \mathbf{n}_2) = d_3,$$

from which a, b, and c are easily solved. Inserting the obtained values for a, b, and c gives the original formula. Some simple manipulation allows the formula for X to be further simplified to

$$X = \frac{d_1(\mathbf{n}_2 \times \mathbf{n}_3) + \mathbf{n}_1 \times (d_3\mathbf{n}_2 - d_2\mathbf{n}_3)}{\mathbf{n}_1 \cdot (\mathbf{n}_2 \times \mathbf{n}_3)},$$

which in code becomes:

```
// Compute the point p at which the three planes p1, p2 and p3 intersect (if at all)
int IntersectPlanes(Plane p1, Plane p2, Plane p3, Point &p)
{
    Vector u = Cross(p2.n, p3.n);
    float denom = Dot(p1.n, u);
    if (Abs(denom) < EPSILON) return 0; // Planes do not intersect in a point
```

```
    p = (p1.d * u + Cross(p1.n, p3.d * p2.n - p2.d * p3.n)) / denom;
    return 1;
}
```

The good news here is that both approaches presented are really generic solvers for 3×3 systems of linear equations. They are not limited to computing the intersection point of three nonparallel planes.

5.5 Dynamic Intersection Tests

So far, the described tests have involved what amounts to static objects: the intersection of two objects at a given point in time. A problem with static testing is that as the object movement increases between one point in time and the next so does the likelihood of an object simply jumping past another object. This unwanted phenomenon is called *tunneling*. Figure 5.32a illustrates this case with a moving sphere tunneling past a rectangular obstruction.

The ideal solution is to have the object move continuously along its path of motion, describing the motion parametrically over time, and solving for the point in time where the distance to some other object becomes zero. Figure 5.32b illustrates this *continuous swept test*. However, although solving the time of collision is feasible for simple motion and simple objects dealing with arbitrary motion and complex objects is a much more challenging problem. In fact, it is too expensive to address in most real-time applications.

A compromise is to *sample* the path of the object and perform several static object tests during a single object movement. Figure 5.32c shows how the movement of the sphere can be subdivided into smaller steps, performing a static object-object test at each sample point.

Tunneling can be avoided, in part, by making sure the moving object overlaps itself from one sample point to the next. However, as indicated by the black triangle in part (c) of the drawing there are still places where small or narrow objects may be tunneled past. To fully address the tunneling problem, the objects would also have to be extended in size so that all samples would together fully cover the volume formed by the continuously swept object.

The drawback with sampling is that, worst case, no collision occurs and all n sample points along the movement path have to be tested, resulting in an $O(n)$ time complexity. Note that for the sampling method it is not really the time that should be subdivided and sampled but the object motion. Subdividing the object motion to maintain object overlap is not a trivial problem for other than the simplest motions.

In many cases, objects can be assumed to be moving piecewise linearly; that is, only translating between positions, with immediate rotational changes at the start

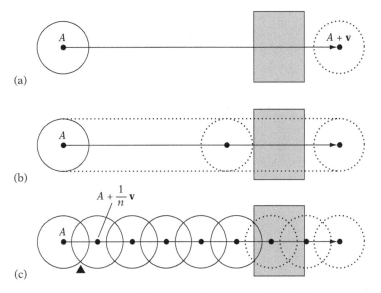

Figure 5.32 Dynamic collision tests. (a) Testing only at the start point and endpoint of an object's movement suffers from tunneling. (b) A swept test finds the exact point of collision, but may not be possible to compute for all objects and movements. (c) Sampled motion may require a lot of tests and still exhibit tunneling in the region indicated by the black triangle.

or end of a movement. Thus, for two objects A and B, the movement of object B can be subtracted from object A. Now object B is stationary and any intersection test needs to consider only a moving object (A) against a stationary object (B). That is, the test is effectively considering the objects' movement relative to each other. If an intersection point is computed, the movement of B must be added back into the computed intersection point to obtain actual world coordinates rather than object-relative coordinates. In the following sections, first two generic methods to dynamic tests are explored, followed by a number of specific methods addressing common intersection problems.

5.5.1 Interval Halving for Intersecting Moving Objects

Somewhere halfway between the sampling method and performing a continuous swept test lies a method based on performing a recursive binary search over the object movement to find the time of collision, if any. Consider again the problem of a sphere S moving at high speed past a stationary object. Let S be at position A, its movement described by the vector \mathbf{v}. Start by forming a bounding sphere that fully encloses the sphere at A and at $A + \mathbf{v}$ and test this sphere for collision against

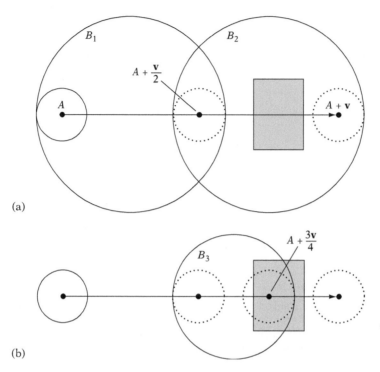

Figure 5.33 A few steps of determining the collision of a moving sphere against a stationary object using an interval-halving method.

other objects. If there is no collision, S can clearly move unobstructed to its end destination. However, if a collision is detected, halve the movement and recursively test the first half in the same manner, and if no collision is detected during the first half perform the same recursive test for the second half. If a collision has not been ruled out before the movement becomes less than some preset minimum motion, a collision can be assumed and the recursion is terminated.

Figure 5.33a illustrates the procedure of interval halving at the point where the initial sphere encompassing the complete movement has been found colliding with an object. At this point, the midpoint of the movement is computed, and a recursive call is issued for each half of the movement of S. In the first recursive call, the sphere B_1 bounding the motion of S from its starting point to the movement midpoint is found not to be colliding with any object, and the recursion terminates with no collision. The procedure continues with the second recursive call, finding that the sphere B_2 bounding the second half does intersect with an object. A new midpoint of the current half-interval is computed, and the two halves of the interval are again recursed over (Figure 5.33b). The sphere B_3 bounding the half corresponding to the first subinterval is also found colliding with an object, and thus again the movement

interval is recursed over. In this example, the recursion eventually terminates with an intersection. Interval halving for the case of a moving sphere against a stationary sphere can be implemented as follows.

```
// Intersect sphere s0 moving in direction d over time interval t0 <= t <= t1, against
// a stationary sphere s1. If found intersecting, return time t of collision
int TestMovingSphereSphere(Sphere s0, Vector d, float t0, float t1, Sphere s1, float &t)
{
    // Compute sphere bounding motion of s0 during time interval from t0 to t1
    Sphere b;
    float mid = (t0 + t1) * 0.5f;
    b.c = s0.c + d * mid;
    b.r = (mid - t0) * Length(d) + s0.r;
    // If bounding sphere not overlapping s1, then no collision in this interval
    if (!TestSphereSphere(b, s1)) return 0;

    // Cannot rule collision out: recurse for more accurate testing. To terminate the
    // recursion, collision is assumed when time interval becomes sufficiently small
    if (t1 - t0 < INTERVAL_EPSILON) {
        t = t0;
        return 1;
    }

    // Recursively test first half of interval; return collision if detected
    if (TestMovingSphereSphere(s0, d, t0, mid, s1, t)) return 1;

    // Recursively test second half of interval
    return TestMovingSphereSphere(s0, d, mid, t1, s1, t);
}
```

In general, this algorithm will terminate in $O(\log n)$ time. However, there are cases in which it will not. One worst-case scenario for this algorithm occurs when the sphere is moving parallel to a surface, just slightly farther away from it than the preset distance used to terminate the recursion. In this instance, both subintervals are recursed over at each step of the algorithm, causing the sphere movement to be subdivided in many small steps, with each step being tested for collision. A tighter bounding volume, such as an OBB, would exhibit better behavior in this situation. OBBs, however, can be quite expensive. In some scenes, architectural scenes in particular, an AABB may serve as a good substitute, as it aligns well with floors and walls, which tend to be aligned at 90 degrees to each other as well as being aligned to the world coordinate system.

The interval-halving method trivially adapts to handling complex objects with both objects under arbitrary motion. Let **MaximumObjectMovementOverTime()** be a

function taking an object and a time interval as arguments. As a result, it computes the maximum length of the paths taken by points on the surface of the object during its movement over the time interval. Furthermore, let `MinimumObjectDistanceAtTime()` be a function taking two objects and a time value as arguments. Its function result is the smallest distance between the surfaces of the objects at the given time. Given these two functions, the generic implementation of the interval-halving method now becomes:

```
// Test collision between objects a and b moving over the time interval
// [startTime, endTime]. When colliding, time of collision is returned in hitTime
int IntervalCollision(Object a, Object b, float startTime, float endTime, float &hitTime)
{
    // Compute the maximum distance objects a and b move over the time interval
    float maxMoveA = MaximumObjectMovementOverTime(a, startTime, endTime);
    float maxMoveB = MaximumObjectMovementOverTime(b, startTime, endTime);
    float maxMoveDistSum = maxMoveA + maxMoveB;
    // Exit if distance between a and b at start larger than sum of max movements
    float minDistStart = MinimumObjectDistanceAtTime(a, b, startTime);
    if (minDistStart > maxMoveDistSum) return 0;
    // Exit if distance between a and b at end larger than sum of max movements
    float minDistEnd = MinimumObjectDistanceAtTime(a, b, endTime);
    if (minDistEnd > maxMoveDistSum) return 0;

    // Cannot rule collision out: recurse for more accurate testing. To terminate the
    // recursion, collision is assumed when time interval becomes sufficiently small
    if (endTime - startTime < INTERVAL_EPSILON) {
        hitTime = startTime;
        return 1;
    }
    // Recursively test first half of interval; return collision if detected
    float midTime = (startTime + endTime) * 0.5f;
    if (IntervalCollision(a, b, startTime, midTime, hitTime)) return 1;
    // Recursively test second half of interval
    return IntervalCollision(a, b, midTime, endTime, hitTime);
}
```

For convex polygonal objects, after having located the closest time just before initial contact a subsequent separating-axis test can provide a collision normal to be used for collision response (given by the separating axis itself). The separating-axis test can also be used to determine the collision of moving convex objects directly, as explained in the next section.

5.5.2 **Separating-axis Test for Moving Convex Objects**

For nonrotating convex polygonal or polyhedral objects moving with constant velocity, a modification of the separating-axis test (as described in Section 5.2.1) can be used to determine the time of intersection of the objects, if any. First note that for two moving objects, A and B, the velocity of A can be subtracted off from B, thus effectively treating the problem as that of intersecting the stationary object A against the moving object B.

Now, if the objects are initially intersecting, the first time of contact is at time $t = 0$. Otherwise, the objects are disjoint. If disjoint, consider the intervals of projection of A and B onto some arbitrary line L. Clearly, collision may occur only if the projection interval of B moves toward the interval of A and eventually overlaps it.

Note that just immediately before a first time of contact between the A and B projection intervals A and B must be separated along some axis. Then, too, just immediately after a last time of contact they must again be separated along some axis. Thus, the first and last time of contact can be determined by projection onto the same separating axes as used for a stationary separating-axis test.

Consequently, to determine whether B intersects A it is sufficient to compute for each potential separating axis the times at which the projected intervals start and end intersection. The start and end times are computed using simple linear operations and correspond to the initial and final contact, respectively, of the objects. Because the objects can only overlap if they overlap simultaneously on all separating axes, the nonemptiness of the intersection of the time intervals determined by the first and last times of contact determines the collision result between the objects. Let t_{first} track the largest of all times corresponding to the first time of contact on a separating axis. Let t_{last} track the smallest of all times corresponding to the last time of contact on a separating axis. After all axes have been tested, the objects intersect if and only if $t_{first} \leq t_{last}$. If sometime during the test $t_{first} > t_{last}$, no intersection is possible and a result of "no intersection" can be immediately returned.

The technique of using the separating-axis test with moving objects was independently described by [Gomez99] for AABBs, and in more detail by [Levine00] for the general case. A concrete example of the described method is given in Section 5.5.8 for the intersection of moving AABBs.

5.5.3 **Intersecting Moving Sphere Against Plane**

Let a plane π be specified by $\mathbf{n} \cdot X = d$, where \mathbf{n} is a unit vector. Let a sphere S be specified by a center C and a radius r, and let \mathbf{v} be the direction vector for S such that the sphere center movement is given by $C(t) = C + t\mathbf{v}$ over the interval of motion $0 \leq t \leq 1$. The signed distance from the plane of a point R is $(\mathbf{n} \cdot R) - d$. Therefore, the sphere initially overlaps the plane if $\left| (\mathbf{n} \cdot C) - d \right| \leq r$.

The sphere's movement relative to the plane can be categorized by considering the sign of $\mathbf{n} \cdot \mathbf{v}$ and what side of the plane the sphere starts on. If $(\mathbf{n} \cdot \mathbf{v}) > 0$, the

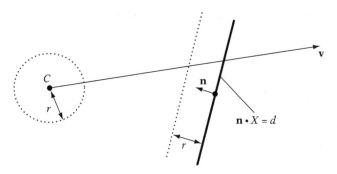

Figure 5.34 Intersecting the moving sphere specified by center C, radius r, and movement vector \mathbf{v} against the plane $\mathbf{n} \cdot X = d$ is equivalent to intersecting the segment $S(t) = C + t\mathbf{v}$ against the plane displaced by r along \mathbf{n} (here positive r, in that C lies in front of the plane).

sphere is moving away from the plane, assuming it lies in front of the plane. When the sphere lies behind the plane, it instead indicates the sphere moving toward the plane. Clearly, for $(\mathbf{n} \cdot \mathbf{v}) < 0$ the exact opposite holds. In that the sign of $(\mathbf{n} \cdot C) - d$ indicates what side of the plane the sphere is on, a more succinct statement is that the sphere is moving away from the plane when $(\mathbf{n} \cdot \mathbf{v})(\mathbf{n} \cdot C - d) > 0$ and toward it when $(\mathbf{n} \cdot \mathbf{v})(\mathbf{n} \cdot C - d) < 0$ (that is, when the signs of the two subexpressions agree and disagree, respectively). When $(\mathbf{n} \cdot \mathbf{v}) = 0$, the sphere is moving parallel to the plane.

Assume the sphere is moving toward the plane. To find the time t of first contact between them, a straightforward approach is to displace the plane toward the sphere center by the sphere radius r and then consider the problem as that of determining the intersection of the segment $S(t) = C + t\mathbf{v}$, $0 \le t \le 1$, with the displaced plane (Figure 5.34). Solving for t, if t is found to be within the segment interval t is the time at which the sphere collides with the plane.

Again, the sign of $(\mathbf{n} \cdot C) - d$ must be examined, now to see how the plane should be displaced. If the term is positive, the displaced plane is given by $(\mathbf{n} \cdot Q) = d + r$ and the first point on the sphere to touch the plane at time t of initial contact is $Q = C(t) - r\mathbf{n}$. If the term is negative, $(\mathbf{n} \cdot Q) = d - r$ describes the displaced plane and $Q = C(t) + r\mathbf{n}$ gives the first point of contact.

It is now possible to solve for t as follows:

$$(\mathbf{n} \cdot X) = d \pm r \Leftrightarrow \qquad \text{(plane equation for plane displaced either way)}$$

$$\mathbf{n} \cdot (C + t\mathbf{v}) = d \pm r \Leftrightarrow \qquad \text{(substituting } S(t) = C + t\mathbf{v} \text{ for X)}$$

$$(\mathbf{n} \cdot C) + t(\mathbf{n} \cdot \mathbf{v}) = d \pm r \Leftrightarrow \qquad \text{(expanding dot product)}$$

$$t = (\pm r - ((\mathbf{n} \cdot C) - d))/(\mathbf{n} \cdot \mathbf{v}) \qquad \text{(solving for t)}$$

When $0 \le t \le 1$, the sphere touches the plane at time t, with point of contact Q.

Note that the terms $(\mathbf{n} \cdot C) - d$ and $\mathbf{n} \cdot \mathbf{v}$, needed to determine if the sphere is moving toward the plane, reoccur in the expression for t and should not be recalculated in an implementation. This intersection test can now be implemented as follows.

```
// Intersect sphere s with movement vector v with plane p. If intersecting
// return time t of collision and point q at which sphere hits plane
int IntersectMovingSpherePlane(Sphere s, Vector v, Plane p, float &t, Point &q)
{
    // Compute distance of sphere center to plane
    float dist = Dot(p.n, s.c) - p.d;
    if (Abs(dist) <= s.r) {
        // The sphere is already overlapping the plane. Set time of
        // intersection to zero and q to sphere center
        t = 0.0f;
        q = s.c;
        return 1;
    } else {
        float denom = Dot(p.n, v);
        if (denom * dist >= 0.0f) {
            // No intersection as sphere moving parallel to or away from plane
            return 0;
        } else {
            // Sphere is moving towards the plane

            // Use +r in computations if sphere in front of plane, else -r
            float r = dist > 0.0f ? s.r : -s.r;
            t = (r - dist) / denom;
            q = s.c + t * v - r * p.n;
            return 1;
        }
    }
}
```

Here, the t value returned on a successful intersection may lie beyond the [0, 1] interval. When this happens, t corresponds to the future time at which the sphere would intersect the plane assuming the same motion. It is left to the caller to test t for inclusion in the [0, 1] interval.

Just testing whether a moving sphere intersects a plane without computing where the sphere strikes the plane is done with much less effort. The sphere intersects the plane if it starts and ends on different sides of the plane or if it overlaps the plane at its start or end positions. This test can be implemented as follows.

```
// Test if sphere with radius r moving from a to b intersects with plane p
int TestMovingSpherePlane(Point a, Point b, float r, Plane p)
{
    // Get the distance for both a and b from plane p
    float adist = Dot(a, p.n) - p.d;
    float bdist = Dot(b, p.n) - p.d;
    // Intersects if on different sides of plane (distances have different signs)
    if (adist * bdist < 0.0f) return 1;
    // Intersects if start or end position within radius from plane
    if (Abs(adist) <= r || Abs(bdist) <= r) return 1;
    // No intersection
    return 0;
}
```

This test also assumes the plane has been normalized; that is, $\|\mathbf{n}\| = 1$.

5.5.4 **Intersecting Moving AABB Against Plane**

Let a plane π be specified by $(\mathbf{n} \cdot X) = d$, where \mathbf{n} is a unit vector. Let an AABB B be specified by a center C; local axis vectors $\mathbf{u}_0 = (1, 0, 0)$, $\mathbf{u}_1 = (0, 1, 0)$, and $\mathbf{u}_2 = (0, 0, 1)$; and extents e_0, e_1, and e_2. Let \mathbf{v} be the direction vector for B such that the box center movement is given by $C(t) = C + t\mathbf{v}$ over the interval of motion $0 \le t \le 1$.

Consider the plane normal \mathbf{n} as a separating axis. The projection radius of B with respect to an axis \mathbf{n} is given by

$$r = e_0 |\mathbf{u}_0 \cdot \mathbf{n}| + e_1 |\mathbf{u}_1 \cdot \mathbf{n}| + e_2 |\mathbf{u}_2 \cdot \mathbf{n}| .$$

Because \mathbf{u}_0, \mathbf{u}_1, and \mathbf{u}_2 are fixed, this simplifies to

$$r = e_0 |\mathbf{n}_x| + e_1 |\mathbf{n}_y| + e_2 |\mathbf{n}_z| .$$

Note that the magnitude of the projected radius remains constant as B moves. The test now proceeds equivalently to the moving-sphere-against-plane test. The signed distance from the plane of a point R is $(\mathbf{n} \cdot R) - d$. Consequently, the AABB initially overlaps the plane if $|(\mathbf{n} \cdot C) - d| \le r$. If $(\mathbf{n} \cdot \mathbf{v}) > 0$, the AABB is moving away from the plane. When $(\mathbf{n} \cdot \mathbf{v}) = 0$, the AABB is moving parallel to the plane.

Displacing the plane toward the AABB by r changes the plane to $(\mathbf{n} \cdot X) = d + r$. When the AABB is moving toward the plane, the first point on the AABB to touch the plane is $Q = C(t) - r\mathbf{n}$, where $C(t)$ is the position of the AABB at the time it first

touches the plane. The condition for Q to be on the plane is $(\mathbf{n} \cdot Q) = d$. Solving for t gives $t = (r + d - (\mathbf{n} \cdot C))/(\mathbf{n} \cdot \mathbf{v})$. If $0 \le t \le 1$, the AABB touches the plane at time t, with point of contact Q. Unlike the moving-sphere-against-plane test, for an AABB there will not necessarily be a unique point of contact, as the contact region might be an edge or a face of the AABB. Due to the format used for the AABB in the preceding presentation, the test for an OBB is identical, except for the computation of r, which now involves the axes corresponding to the orientation of the OBB instead of the world axes.

5.5.5 Intersecting Moving Sphere Against Sphere

Let two spheres S_0 and S_1 be given with radii r_0 and r_1, respectively. Their corresponding movements are given by the two movement vectors \mathbf{v}_0 and \mathbf{v}_1. The parameterized movement of the sphere centers can therefore be described by the expressions $P_0(t) = C_0 + t\mathbf{v}_0$ and $P_1(t) = C_1 + t\mathbf{v}_1$ over the time interval $0 \le t \le 1$. The vector \mathbf{d} between the sphere centers at time t is given by

$$\mathbf{d}(t) = (C_0 + t\mathbf{v}_0) - (C_1 + t\mathbf{v}_1) = (C_0 - C_1) + t(\mathbf{v}_0 - \mathbf{v}_1).$$

Assuming the spheres do not initially touch, they first come in contact when the length of \mathbf{d} equals the sum of their radii: $(\mathbf{d}(t) \cdot \mathbf{d}(t))^{1/2} = r_0 + r_1$. To avoid the square root expression, both sides of the equivalence can be squared, giving $\mathbf{d}(t) \cdot \mathbf{d}(t) = (r_0 + r_1)^2$. To solve for t, let $\mathbf{s} = C_0 - C_1$, $\mathbf{v} = \mathbf{v}_0 - \mathbf{v}_1$, and $r = r_0 + r_1$, then:

$$\mathbf{d}(t) \cdot \mathbf{d}(t) = (r_0 + r_1)^2 \Leftrightarrow \qquad \textit{(original expression)}$$

$$(\mathbf{s} + t\,\mathbf{v}) \cdot (\mathbf{s} + t\,\mathbf{v}) = r^2 \Leftrightarrow \qquad \textit{(substituting } \mathbf{d}(t) = \mathbf{s} + t\,\mathbf{v}\textit{)}$$

$$(\mathbf{s} \cdot \mathbf{s}) + 2(\mathbf{v} \cdot \mathbf{s})t + (\mathbf{v} \cdot \mathbf{v})t^2 = r^2 \Leftrightarrow \qquad \textit{(expanding dot product)}$$

$$(\mathbf{v} \cdot \mathbf{v})t^2 + 2(\mathbf{v} \cdot \mathbf{s})t + (\mathbf{s} \cdot \mathbf{s} - r^2) = 0 \qquad \textit{(canonic form for quadratic equation)}$$

This is a quadratic equation in t. Writing the quadratic in the form $at^2 + 2bt + c = 0$, with $a = \mathbf{v} \cdot \mathbf{v}$, $b = \mathbf{v} \cdot \mathbf{s}$, and $c = \mathbf{s} \cdot \mathbf{s} - r^2$ gives the solutions for t as

$$t = \frac{-b \pm \sqrt{b^2 - ac}}{a}.$$

The discriminant $d = b^2 - ac$ determines how many real-valued roots the quadratic has. If $d < 0$, it has no real-valued roots, meaning the spheres will not intersect. If $d = 0$, there is one real root and the spheres become tangential at time t. If $d > 0$,

there are two real roots, with the spheres coming in first contact at the smaller time t then interpenetrating for awhile to stop penetrating at the larger time t. The first time of contact is for

$$t = \frac{-b - \sqrt{b^2 - ac}}{a}.$$

When implementing this test, it is necessary to verify that the spheres do not overlap at the start of the movement. Otherwise, it would fail to correctly deal with, say, a smaller sphere remaining fully inside a larger sphere, because the condition of the spheres coming into contact will never be satisfied in this case. One way of implementing this test is:

```
int TestMovingSphereSphere(Sphere s0, Sphere s1, Vector v0, Vector v1, float &t)
{
    Vector s = s1.c - s0.c;    // Vector between sphere centers
    Vector v = v1 - v0;        // Relative motion of s1 with respect to stationary s0
    float r = s1.r + s0.r;     // Sum of sphere radii
    float c = Dot(s, s) - r * r;
    if (c < 0.0f) {
        // Spheres initially overlapping so exit directly
        t = 0.0f;
        return 1;
    }
    float a = Dot(v, v);
    if (a < EPSILON) return 0; // Spheres not moving relative each other
    float b = Dot(v, s);
    if (b >= 0.0f) return 0;   // Spheres not moving towards each other
    float d = b * b - a * c;
    if (d < 0.0f) return 0;    // No real-valued root, spheres do not intersect

    t = (-b - Sqrt(d)) / a;
    return 1;
}
```

An alternative description of this particular approach can be found in [Gomez99].

Another approach to the problem is to express it in terms of one solved earlier. First, the problem (Figure 5.35a) is turned into that of a moving sphere versus a stationary sphere, by subtracting \mathbf{v}_1 off the movement of both (Figure 5.35b). Because the spheres first come in contact when $\mathbf{d}(t) = r_0 + r_1$, growing the radius of one while shrinking the radius of the other by the same amount does not affect the time of contact. It is therefore possible to turn the moving sphere into a point and the second stationary

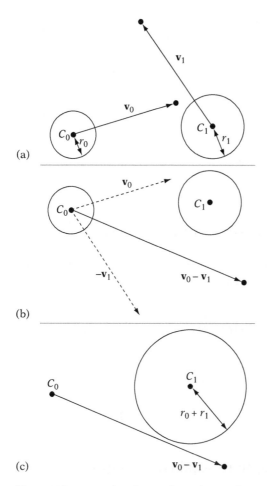

Figure 5.35 Recasting the moving sphere-sphere test as a ray intersection test. (a) The original problem of intersecting a moving sphere against a moving sphere. (b) Transforming problem into a moving sphere versus a **stationary** sphere. (c) Reduced to a ray test against a **stationary** sphere of larger radius.

sphere into one with a combined radius of $r_0 + r_1$ (Figure 5.35c). The problem now becomes that of intersecting a ray with a static sphere, for which a routine was given in Section 5.3.2. The implementation is now straightforward.

```
int TestMovingSphereSphere(Sphere s0, Sphere s1, Vector v0, Vector v1, float &t)
{
    // Expand sphere s1 by the radius of s0
    s1.r += s0.r;
```

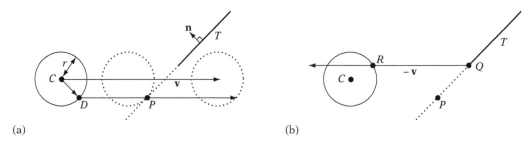

Figure 5.36 Illustrating Nettle's method for intersecting a moving sphere against a triangle.

```
// Subtract movement of s1 from both s0 and s1, making s1 stationary
Vector v = v0 - v1;
// Can now test directed segment s = s0.c + tv, v = (v0-v1)/||v0-v1|| against
// the expanded sphere for intersection
Point q;
float vlen = Length(v);
if (IntersectRaySphere(s0.c, v / vlen, s1, t, q)) {
    return t <= vlen;
}
return 0;
}
```

5.5.6 Intersecting Moving Sphere Against Triangle (and Polygon)

Let a sphere S be specified by a center C and a radius r, and let \mathbf{v} be the direction vector for S such that the sphere center movement is given by $C(t) = C + t\,\mathbf{v}$ over the interval of motion $0 \le t \le 1$. Let T be a triangle and \mathbf{n} be the unitized normal to this triangle.

A simple test, both conceptually and computationally, for intersecting the sphere against the triangle is suggested in [Nettle00]. Without loss of generality, assume the sphere is in front of the plane of triangle T, moving so as to end up behind the plane. In this situation, the first point on the sphere to come in contact with the plane is $D = C - r\mathbf{n}$. Now intersect the directed segment $D + t\,\mathbf{v}$, $0 \le t \le 1$, against the plane; let P be the intersection point. If P lies inside the triangle, then t is the desired time of intersection and P the point of contact (Figure 5.36a).

For the case in which P lies outside the triangle, let Q be the point on the triangle closest to P. If the moving sphere hits the triangle at all, then Q is the point it will hit

first (as the circular cross section of the sphere, as it moves through the plane, will be centered at P).

To determine whether the sphere hits Q, instead of moving the sphere toward the triangle a ray $Q - t\mathbf{v}$ can be cast "in reverse" from Q toward the sphere. If this ray does not hit the sphere or if t does not lie in the range of zero to one, then the sphere does not hit Q and there is no intersection. If the ray hits the sphere at some point R, with $0 \leq t \leq 1$, then the point R on the sphere will first come into contact with point Q of the triangle, at time t (Figure 5.36b).

Unfortunately, this test is not robust. When the sphere is moving parallel to the plane of the triangle, there is no intersection between the movement vector and the plane and the algorithm breaks.

However, this is not always a problem as, for example, when all triangles intersected against are part of a mesh such that all exposed triangle edges are always shared with another triangle. A moving sphere will then always hit a neighboring triangle before it has a chance to fail detecting intersection with a triangle it is moving parallel to. Of course, collision response relating to sliding in the plane of the triangle must also be adapted to handle this situation.

A more robust, but also more expensive, method is first to perform a sphere-against-plane test (either as just described, or as per Section 5.5.3). If there is an intersection, the point P of earliest contact is tested for containment in T, just as in Nettle's approach. If P lies inside T, the earliest intersection has been found and the test can exit. Otherwise, a test of the moving sphere against each triangle edge is performed. This is equivalent to testing the directed segment $C + t\mathbf{v}$, $0 \leq t \leq 1$, against the edges turned into cylinders of radius r (see Section 5.3.7). If one or more intersections against the curved surface (only) of the cylinders are detected, the closest one corresponds to the earliest intersection, which is returned.

Assuming that no intersection has been detected up to this point, the ray is intersected against the spheres of radius r centered on the vertices of the triangle. Again, if there are one or more intersections the closest one is returned. If no sphere is intersected, this corresponds to the original sphere not intersecting the triangle. Note that for the ray-cylinder tests no intersection against the endcaps is necessary: if there is an intersection between the sphere and the triangle, the ray will intersect the spheres at the vertices before it can strike an endcap. The last bit of the test, as given in Section 5.3.7, can therefore be omitted.

Overall, this approach is perhaps best seen conceptually as a ray test against the solid volume V resulting from sweeping T with S, forming the Minkowski sum $T \oplus S$ of T and S (as described in Section 3.11), but with the three individual component tests performed either as ray tests or as sphere tests (depending on what is more appropriate). The next section describes how to apply the Minkowski sum approach to the problem of intersecting a moving sphere against an AABB.

This second, more robust, method is suggested in [Schroeder01], with corrections in [Akenine-Möller02]. Both of the approaches described in this section generalize to intersections against arbitrary polygons in a straightforward way.

5.5.7 **Intersecting Moving Sphere Against AABB**

Let a sphere S be specified by a center C and a radius r, and let \mathbf{d} be the direction vector for S, such that the sphere center movement is given by $C(t) = C + t\,\mathbf{d}$ over the interval of motion $0 \le t \le 1$. Let B be an AABB. Intersecting the moving sphere S against the box B is equivalent to intersecting the segment $L(t) = C + t\,\mathbf{d}$, $0 \le t \le 1$, against the volume V that results after sweeping B with S (that is, against the Minkowski sum of B and S, $V = B \oplus S$), as illustrated in Figure 5.37. The latter test can be efficiently performed without forming V, as demonstrated next.

Let E be the AABB given by expanding the faces of B outward by a distance equivalent to the sphere radius r. This is the tightest AABB bounding V, differing from V only in the lack of spherically beveled edges. Now, intersect L against E. If L does not intersect E, then clearly S does not intersect B. Otherwise, let $P = L(t)$ denote the point where L intersects E at time t.

If P lies in a face Voronoi region of B, then nothing more is needed: S intersects B at time t when the sphere center is at point P. However, if P lies in an edge or vertex Voronoi region, further tests are required to determine whether L passes through the beveled region of V not present in E, thus missing V, or whether L intersects V on one of its beveled edges or vertices at some later time t', $t < t' \le 1$.

When P lies in an edge Voronoi region of B, L must additionally be intersected against the capsule of radius r determined by the edge. If and only if L intersects the capsule does S intersect B. The intersection of L and the capsule corresponds to the actual intersection of S and B.

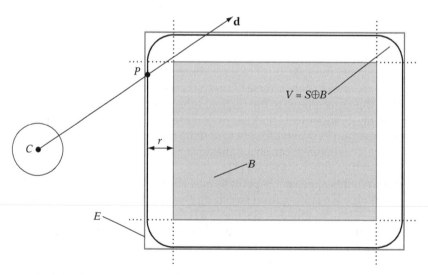

Figure 5.37 A 2D illustration of how the test of a moving sphere against an AABB is transformed into a test of a line segment against the volume resulting after sweeping the AABB with the sphere (forming the Minkowski sum of the sphere and the AABB).

The last consideration is when P lies in a vertex Voronoi region. In this case, L must additionally be intersected against all three capsules of radius r determined by the edges coincident to the vertex. If L does not intersect one of the capsules, S does not intersect B. Otherwise, the intersection of S with B occurs at the smallest time t at which L intersects one of the edge capsules. As a potential speedup, L can be tested against a sphere K of radius r centered at the vertex. If L intersects K, and the intersection point lies in the vertex Voronoi region, then this intersection point provides the answer and the capsules do not have to be tested against. However, if the intersection point between L and K lies outside the vertex Voronoi region (or if L does not intersect K at all), the sphere test was in vain and the three cylinders must be intersected anyway. The following code fragment illustrates how to efficiently determine which Voronoi region P is contained in and which edges must be tested for the edge and vertex region cases.

```
int IntersectMovingSphereAABB(Sphere s, Vector d, AABB b, float &t)
{
    // Compute the AABB resulting from expanding b by sphere radius r
    AABB e = b;
    e.min.x -= s.r; e.min.y -= s.r; e.min.z -= s.r;
    e.max.x += s.r; e.max.y += s.r; e.max.z += s.r;

    // Intersect ray against expanded AABB e. Exit with no intersection if ray
    // misses e, else get intersection point p and time t as result
    Point p;
    if (!IntersectRayAABB(s.c, d, e, t, p) || t > 1.0f)
        return 0;

    // Compute which min and max faces of b the intersection point p lies
    // outside of. Note, u and v cannot have the same bits set and
    // they must have at least one bit set among them
    int u = 0, v = 0;
    if (p.x < b.min.x) u |= 1;
    if (p.x > b.max.x) v |= 1;
    if (p.y < b.min.y) u |= 2;
    if (p.y > b.max.y) v |= 2;
    if (p.z < b.min.z) u |= 4;
    if (p.z > b.max.z) v |= 4;

    // 'Or' all set bits together into a bit mask (note: here u + v == u | v)
    int m = u + v;

    // Define line segment [c, c+d] specified by the sphere movement
    Segment seg(s.c, s.c + d);
```

```
        // If all 3 bits set (m == 7) then p is in a vertex region
        if (m == 7) {
            // Must now intersect segment [c, c+d] against the capsules of the three
            // edges meeting at the vertex and return the best time, if one or more hit
            float tmin = FLT_MAX;
            if (IntersectSegmentCapsule(seg, Corner(b, v), Corner(b, v ^ 1), s.r, &t))
                tmin = Min(t, tmin);
            if (IntersectSegmentCapsule(seg, Corner(b, v), Corner(b, v ^ 2), s.r, &t))
                tmin = Min(t, tmin);
            if (IntersectSegmentCapsule(seg, Corner(b, v), Corner(b, v ^ 4), s.r, &t))
                tmin = Min(t, tmin);
            if (tmin == FLT_MAX) return 0;    // No intersection
            t = tmin;
            return 1;    // Intersection at time t == tmin
        }
        // If only one bit set in m, then p is in a face region
        if ((m & (m - 1)) == 0) {
            // Do nothing. Time t from intersection with
            // expanded box is correct intersection time
            return 1;
        }
        // p is in an edge region. Intersect against the capsule at the edge
        return IntersectSegmentCapsule(seg, Corner(b, u ^ 7), Corner(b, v), s.r, &t);
    }

// Support function that returns the AABB vertex with index n
Point Corner(AABB b, int n)
{
    Point p;
    p.x = ((n & 1) ? b.max.x : b.min.x);
    p.y = ((n & 2) ? b.max.y : b.min.y);
    p.z = ((n & 4) ? b.max.z : b.min.z);
    return p;
}
```

This test also works for performing the same intersection against an OBB: by expressing the sphere center C and the movement vector \mathbf{d} in the local coordinate system of the OBB the problem is effectively reduced to that of a moving sphere against an AABB.

5.5.8 Intersecting Moving AABB Against AABB

Because an AABB is an instance of a convex polyhedron, the problem of determining intersection between two moving AABBs, A and B with corresponding velocities \mathbf{v}_A

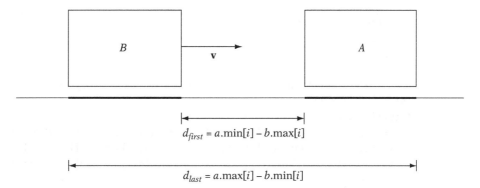

Figure 5.38 Illustrating the distances the projection of box B travels to reach first and last contact with the projection of the **stationary** box A when B is moving toward A.

and \mathbf{v}_B, can be solved using the moving version of the separating-axis test as described in Section 5.5.2.

The problem is first cast into that of a stationary box A and a moving box B by subtracting the velocity of A from B, giving the relative velocity $\mathbf{v} = \mathbf{v}_B - \mathbf{v}_A$. Figure 5.38 illustrates, given B moving toward A, the distances d_{first} and d_{last} that B must cover to reach first and last contact with A. The times to first and last contact, t_{first} and t_{last}, are then easily obtained by dividing these distances by the speed with which B is moving toward A. These times are obtained for all three principal axes, and the largest t_{first} and smallest t_{last} correspond to the intersection of the times the boxes overlap on the three axes, if at all. If the projections of the boxes are ever found to be nonintersecting and moving apart on an axis, the test can immediately exit with "no intersection." A full implementation of this test follows.

```
// Intersect AABBs 'a' and 'b' moving with constant velocities va and vb.
// On intersection, return time of first and last contact in tfirst and tlast
int IntersectMovingAABBAABB(AABB a, AABB b, Vector va, Vector vb,
                                          float &tfirst, float &tlast)
{
    // Exit early if 'a' and 'b' initially overlapping
    if (TestAABBAABB(a, b)) {
        tfirst = tlast = 0.0f;
        return 1;
    }

    // Use relative velocity; effectively treating 'a' as stationary
    Vector v = vb - va;
```

```
// Initialize times of first and last contact
tfirst = 0.0f;
tlast = 1.0f;

// For each axis, determine times of first and last contact, if any
for (int i = 0; i < 3; i++) {
    if (v[i] < 0.0f) {
        if (b.max[i] < a.min[i]) return 0;     // Nonintersecting and moving apart
        if (a.max[i] < b.min[i]) tfirst = Max((a.max[i] - b.min[i]) / v[i], tfirst);
        if (b.max[i] > a.min[i]) tlast  = Min((a.min[i] - b.max[i]) / v[i], tlast);
    }
    if (v[i] > 0.0f) {
        if (b.min[i] > a.max[i]) return 0;     // Nonintersecting and moving apart
        if (b.max[i] < a.min[i]) tfirst = Max((a.min[i] - b.max[i]) / v[i], tfirst);
        if (a.max[i] > b.min[i]) tlast = Min((a.max[i] - b.min[i]) / v[i], tlast);
    }

    // No overlap possible if time of first contact occurs after time of last contact
    if (tfirst > tlast) return 0;
}
return 1;
}
```

A solution similar to the one presented here is given in [Gomez99].

5.6 Summary

In this chapter, a large number of different tests and queries have been discussed in quite some detail. These include closest-point calculations (which directly allow the distance between the two query objects to be found); heterogeneous intersection tests (such as between a sphere and an OBB); intersections involving lines, rays, and line segments (against triangles, for example); and point containment tests (for both polygons and polytopes), to name a few. In addition to static intersection tests, methods for performing dynamic tests have also been described, including the powerful generalization of the separating-axis test.

Even though this chapter has covered a wide variety of tests, readers will inevitably make note of specific tests that were excluded from coverage. As mentioned at the start of the chapter, the intent behind the provided spectrum of tests and the mathematical detail given is to allow the readers themselves to derive these other tests using the ideas presented herein. Being able to derive tests from scratch is important because there are not many sources that cover intersection tests to a great extent, and even

those that do are unlikely to cover the particular tests the reader requires. One notable exception to the lack of comprehensive sources for intersection tests is [Schneider02], which is a treasure trove of geometrical tests of all types and an excellent supplement to this chapter. [Eberly01] and [Bergen03] are also good references, albeit not as comprehensive. Individual articles on specific tests can also be found in the five-volume book series *Graphic Gems* [Glassner90], [Arvo91], [Kirk92], [Heckbert94], and [Paeth95].

Chapter 6

Bounding Volume Hierarchies

Wrapping objects in bounding volumes and performing tests on the bounding volumes before testing the object geometry itself can result in significant performance improvements. However, although the tests themselves have been simplified, the same number of pairwise tests are still being performed. The asymptotic time complexity remains the same and the use of bounding volumes improves the situation by a constant factor. By arranging the bounding volumes into a tree hierarchy called a *bounding volume hierarchy* (BVH), the time complexity can be reduced to logarithmic in the number of tests performed.

The original set of bounding volumes forms the leaf nodes of the tree that is this bounding volume hierarchy. These nodes are then grouped as small sets and enclosed within larger bounding volumes. These, in turn, are also grouped and enclosed within other larger bounding volumes in a recursive fashion, eventually resulting in a tree structure with a single bounding volume at the top of the tree. Figure 6.1 shows a small AABB hierarchy constructed from five objects.

With a hierarchy in place, during collision testing children do not have to be examined if their parent volume is not intersected. The same bounding volume hierarchies are also used, for instance, in scene graphs and ray tracing and for view-frustum culling.

Comparing bounding volume hierarchies with spatial partitioning schemes (see Chapter 7), the main differences are that two or more volumes in a BVH can cover the same space and objects are generally only inserted in a single volume. In contrast, in a spatial partitioning scheme the partitions are disjoint and objects contained in the spatial partitioning are typically allowed to be represented in two or more partitions.

It is important to note that the bounding volume of a parent node does not necessarily need to enclose the bounding volumes of its child nodes. Although it is often easier to construct hierarchies in which this parent-child property holds true, the parent bounding volume needs to enclose only the object primitives contained in the subtrees of its children.

Figure 6.1 A bounding volume hierarchy of five simple objects. Here the bounding volumes used are AABBs.

One approach to creating hierarchies is to have designers or artists manually create them as part of their modeling hierarchies. However, creating trees manually is not ideal. First, designers tend to think functionally rather than spatially. Consequently, it is likely that, for instance, all nuts and bolts across a large mechanical design are grouped under the same node. Such a grouping is not good from a collision detection perspective. Second, the hierarchy is also likely to be either too shallow or too deep in the wrong places. The designer's modeling hierarchy has been — and arguably should be — constructed for easy editing and not to enable efficient intersection queries. Although designers could theoretically adjust their hierarchies to be more spatially oriented and better suited to collision queries, this is unlikely to be an effective use of their time. A better solution is to automate, where possible, the generation of hierarchies from the provided models. Such automation is not always a trivial process and there are many issues to consider, as the next section will show.

6.1 Hierarchy Design Issues

There are many ways to construct a bounding volume hierarchy. The next section outlines a number of desired characteristics for good hierarchies. A generic cost function to aid the cost comparison of queries for various hierarchical schemes is found in Section 6.1.2. Finally, Section 6.1.3 discusses the question of what tree degree might provide the best hierarchy.

6.1.1 Desired BVH Characteristics

Similar to bounding volumes, several desired properties for bounding volume hierarchies have been suggested [Kaplan85] [Kay86] [Hubbard96]:

- *The nodes contained in any given subtree should be near each other.* Without explicitly defining nearness, the lower down the tree the nodes are the nearer they should be to each other.

- *Each node in the hierarchy should be of minimal volume.*

- *The sum of all bounding volumes should be minimal.*

- *Greater attention should be paid to nodes near the root of the hierarchy.* Pruning a node near the root of the tree removes more objects from further consideration than removal of a deeper node would.

- *The volume of overlap of sibling nodes should be minimal.*

- *The hierarchy should be balanced with respect to both its node structure and its content.* Balancing allows as much of the hierarchy as possible to be pruned whenever a branch is not traversed into.

For real-time applications, games especially, an important addition to the previous list is the requirement that the worst-case time for queries not be much worse than the average-case query time. This requirement is particularly important for console games, for which a fixed frame rate is usually required (typically 60 fps).

Additionally, it is desired that the hierarchy can be automatically generated without user intervention. For real-time applications, most hierarchies are usually generated in a preprocessing step and not at runtime. For games, excessive waiting for precomputed structures to build can have a detrimental impact on level construction and design. Therefore, although precomputation makes the construction less time significant algorithms of quadratic complexity and above are still likely to be too slow even for preprocessing use. If a hierarchy is constructed at runtime, building the hierarchy should also pay for itself in that the time taken for construction should be less than the time saved by using the hierarchy.

Finally, a very important factor often glossed over in treatments of collision detection is the total memory requirement for the data structures used to represent the bounding volume hierarchy. For example, console games roughly allocate a tenth of the available memory for collision data. Whereas the built-in memory for next-generation console systems will increase for each generation, the ratio allocated for collision detection data is likely to remain roughly constant because the memory requirements for other systems (such as rendering, animation, and AI) also are likely to grow proportionally. These memory constraints set hard limits on all considered collision detection systems.

6.1.2 Cost Functions

Several people have come up with expressions to identify the various parts contributing to the expected cost of bounding volume hierarchy queries. A cost formula first presented in [Weghorst84] and adapted for bounding volume hierarchies by [Gottschalk96] and subsequently refined in [Klosowski98] and [He99] is

$$T = N_V C_V + N_P C_P + N_U C_U + C_O.$$

Here, T is the total cost of intersecting the two hierarchies, N_V is the number of BV pairs tested for overlap, C_V is the cost of testing a pair of BVs for overlap, N_P is the number of primitive pairs tested, C_P is the cost of testing a primitive pair, N_U is the number of nodes that need to be updated, C_U is the cost of updating each such node, and, where necessary, C_O is the cost of a one-time processing (such as a coordinate transformation between objects).

Of these variables, for instance, N_V and N_P are minimized by making the bounding volume fit the object as tightly as possible. By making the overlap tests as fast as possible, C_V and C_P are minimized. Unfortunately, making the bounding volume tighter typically increases the time to perform the overlap test. At the same time, a tighter bounding volume is likely to result in fewer intersection tests. In general, the values are so intrinsically linked that minimizing one value often causes another to increase. Finding a compromise among existing requirements is a challenge in all collision detection systems.

6.1.3 Tree Degree

An interesting question is that of what degree or branching factor to use in the tree representing the bounding volume hierarchy. What is better, a binary, ternary, d-ary (for some d), or a tree with any number of children at a node? A tree of a higher degree will be of smaller height, minimizing root-to-leaf traversal time. At the same time, more work has to be expended at each visited node to check its children for overlap. The opposite holds for a low-degree tree: although the tree will be of greater height, less work is spent at each node. In terms of size, a d-ary tree of n leaves has $(n-1)/(d-1)$ internal nodes for a total of $(nd-1)/(d-1)$ nodes in the tree. Clearly the larger the degree the fewer internal nodes are needed to form the tree.

The question of what degree to use is a difficult one and no definitive answer has been forthcoming. Looking at actual usage, it appears binary trees are by far the most common hierarchical representation. An important reason is that binary trees are easier to build and, to some extent, to represent and traverse than other trees. For instance, when building a tree top-down, to partition the set of objects into two subsets only a single splitting plane has to be found. Partitioning m objects into just two (nonempty) partitions can be done in $2^{m-1} - 1$ ways, and the corresponding expressions grow exponentially (and therefore prohibitively) with an increasing number of partitions.

Analytical arguments have also been put forth in support of the choice of binary trees [Klosowski98] [Konečný98]. The actual cost of a collision query depends on what descent rules are used when traversing the hierarchies. For instance, given a balanced d-ary tree of n leaves, the "descend A before B" and "descend A and B simultaneously" rules (both described later on) have costs proportional to $f(d) = d \log_d(n)$ and $f(d) = d^2 \log_d(n)$, respectively. The former minimizes for $d = 2.718$, and the latter for $d = 2$, suggesting the use of a binary or possibly ternary tree as optimal. Empirical results also appear to be in support of the choice $d = 2$, but

these are not conclusive — especially because few experiments seem to have been conducted with higher-degree trees.

Platform-architectural issues also play a significant role in what type of trees perform well. Ideally, trees should be laid out in memory so that nodes occur linearly in memory during traversal. The issue of cache-efficient tree structures is revisited in Chapter 13.

6.2 Building Strategies for Hierarchy Construction

As the number of possible trees grows exponentially in terms of the number of elements in the input set, an exhaustive search for the best tree is infeasible. This rules out finding an optimal tree. Instead, heuristic rules are used to guide the construction, examining a few alternatives at each decision-making step, picking the best alternative. Arriving at a suboptimal solution is not necessarily a problem, as there is usually a very large number of trees that are not too far from optimal.

There are three primary categories of tree construction methods: *top-down, bottom-up,* and *insertion* methods (Figure 6.2). Top-down (or divisive) methods proceed by partitioning the input set into two (or more) subsets, bounding them in the chosen bounding volume, then recursing over the bounded subsets. Thanks to the ease with which they can be implemented, top-down methods are by far the most popular. However, they do not generally result in the best possible trees.

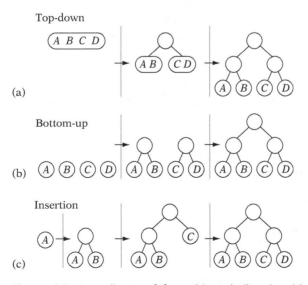

Figure 6.2 A small tree of four objects built using (a) top-down, (b) bottom-up, and (c) insertion construction.

Bottom-up (or agglomerative) methods start with the input set as the leaves of the tree and then group two or more of them to form a new (internal) node, proceeding in the same manner until everything has been grouped under a single node (the root of the tree). Although bottom-up methods are likely to produce better trees than the other methods, they are also more difficult to implement.

Insertion methods build the hierarchy incrementally by inserting objects one at a time into the tree. The insertion position is chosen so as to minimize some cost measurement for the resulting tree. Insertion methods are considered on-line methods, whereas both top-down and bottom-up methods are considered off-line methods in that they require all primitives to be available before construction starts. A benefit of on-line methods is that they allow updates to be performed at runtime. Very little research has been done on insertion methods for constructing collision detection hierarchies.

As noted earlier, even though most hierarchy construction takes place during a preprocessing stage, it is still important to find fast construction methods. Any algorithms of $O(n^2)$ complexity and above are likely to be too slow for building hierarchies from a larger number of primitives.

To simplify the presentation, in the following sections the discussion has primarily been limited to binary trees. The same methods typically also apply to n-ary or even general trees.

6.2.1 **Top-down Construction**

A top-down method can be described in terms of a recursive procedure. It starts out by bounding the input set of primitives (or objects) in a bounding volume. These primitives are then partitioned into two subsets. The procedure is now called recursively to form subhierarchies for the two subsets, which are then connected as children to the parent volume. The recursion stops when the input set consists of a single primitive (or, if elected, earlier than that), at which point the procedure just returns after creating the bounding volume for the primitive. The following code fragment illustrates how top-down construction can be implemented.

```
// Construct a top-down tree. Rearranges object[] array during construction
void TopDownBVTree(Node **tree, Object object[], int numObjects)
{
    assert(numObjects > 0);

    const int MIN_OBJECTS_PER_LEAF = 1;
    Node *pNode = new Node;
    *tree = pNode;
    // Compute a bounding volume for object[0], ..., object[numObjects - 1]
    pNode->BV = ComputeBoundingVolume(&object[0], numObjects);
```

```
if (numObjects <= MIN_OBJECTS_PER_LEAF) {
    pNode->type = LEAF;
    pNode->numObjects = numObjects;
    pNode->object = &object[0];  // Pointer to first object in leaf
} else {
    pNode->type = NODE;
    // Based on some partitioning strategy, arrange objects into
    // two partitions: object[0..k-1], and object[k..numObjects-1]
    int k = PartitionObjects(&object[0], numObjects);
    // Recursively construct left and right subtree from subarrays and
    // point the left and right fields of the current node at the subtrees
    TopDownBVTree(&(pNode->left), &object[0], k);
    TopDownBVTree(&(pNode->right), &object[k], numObjects - k);
}
}
```

Apart from the selection of what bounding volume to use, only a single guiding criterion controls the structure of the resulting tree: the choice of how the input set is partitioned into two subsets. As a set of n elements can be partitioned into two nonempty subsets in $2^{n-1} - 1$ ways, it is clear that only a small subset of all partitions can reasonably be considered.

To simplify the partitioning, the set is usually divided into subsets using a splitting hyperplane. As it is not possible to guarantee selecting a splitting plane that does not cut across any primitives, any straddling primitives must be dealt with when partitioning the set. One solution is to split the primitive into two, assigning the parts to their respective subsets. Splitting of primitives allows the child bounding volumes to be smaller, minimizing their overlap, possibly completely eliminating it. A drawback with splitting straddling primitives is that any split primitives can again become subject to splitting, potentially giving rise to a huge increase of primitives.

A perhaps more common solution is not to split the primitive but to let the position of its centroid with respect to the splitting plane determine which subset it goes in. Using the centroid to determine which subset to assign the primitive to attempts to minimize the overlap between the sibling bounding volumes. This way, the bounding volume will be extended in width by half the width of the primitive. If the primitive had instead been arbitrarily assigned to either subset, in the worst case the bounding volume for the subset could have been extended by the full width of the primitive.

6.2.1.1 Partitioning Strategies

A simple partitioning method is the *median-cut algorithm*. Here, the set is divided in two equal-size parts with respect to their projection along the selected axis, resulting

in a balanced tree. The median cut is just one possible strategy. Going back to the list of desired properties given earlier, other possible partition strategies are:

- *Minimize the sum of the volumes (or surface areas) of the child volumes.* The probability of an intersection between a bounding volume and either of the two child volumes can be expected to be proportional to their volume. Thus, minimizing the sum of the volumes effectively minimizes the likelihood of intersection. For a ray query, the probability of a ray striking a bounding volume is instead proportional to the bounding volume's surface area.

- *Minimize the maximum volume (surface area) of the child volumes.* Whereas the previous strategy can result in one volume much larger than the other, this approach attempts to make the volumes more equal in size by making the larger volume as small as possible. This results in a more balanced query, improving worst-case behavior.

- *Minimize the volume (surface area) of the intersection of the child volumes.* This strategy helps decrease the probability of both children being overlapped and traversed into. Depending on the bounding volume used, the intersection can be complex to construct and even to approximate.

- *Maximize the separation of child volumes.* Separating children, even when not overlapping, can further decrease the likelihood of both children being traversed into.

- *Divide primitives equally between the child volumes.* This strategy is the median-cut algorithm mentioned at the start of the section. Its strength lies in giving the most balanced hierarchy possible.

- *Combinations of the previous strategies.*

Partitioning stops and a node is considered a leaf when some particular stop criterion is reached. Common stop criteria are:

- *The node contains just a single primitive, or less than some* k *primitives.*
- *The volume of the bounding volume has fallen below a set cut-off limit.*
- *The depth of the node has reached a predefined cut-off depth.*

Partitioning can also fail early, before a stop criterion triggers, for instance when:

- *All primitives fall on one side of the split plane.*
- *One or both child volumes end up with as many (or nearly as many) primitives as the parent volume.*
- *Both child volumes are (almost) as large as the parent volume.*

These failure conditions can also be treated as stopping criteria. Before stopping, however, it is reasonable to try other partitioning criteria. For instance — for a box-based tree — after failing to split along the longest side, first the next longest side and then the shortest side can be tested. Only if all three fail would splitting stop. Stopping early with k rather than just one primitive per leaf node has the benefit of using less memory. Unfortunately, during leaf-leaf tests instead of a single primitive-primitive test now $O(k^2)$ tests must be performed.

The choice of a partitioning plane is usually further broken down in two steps. First an axis is selected, and then a position along this axis. These choices are covered next.

6.2.1.2 Choice of Partitioning Axis

Out of an infinite number of possible axes, somehow a single axis must be selected as the partitioning axis. Theoretically, it is possible to apply an iterative optimization method (for example, hill climbing) to locate the best possible axis. Practically, such an approach is usually too expensive even for a preprocessing step. Consequently, the search must be limited to a small number of axes from which the best one is picked. Common choices of axes for inclusion in this limited set are:

1. *Local x, y, and z coordinate axes.* These are usually included as they are easy to perform operations with. They also form an orthogonal set, guaranteed to cover widely different directions.

2. *Axes from the intended aligned bounding volume.* The local axes of item 1 correspond to the face normals of an AABB. Some bounding volumes, such as k-DOPs, have additional fixed axes that also form a natural choice for partitioning axes.

3. *Axes of the parent bounding volume.* If the hierarchy is built of OBBs, the defining axes of the bounding OBB of the current set under partitioning are good candidate axes. Even if the hierarchy is built from, say, spheres (which do not have any apparent associated axes), a temporary OBB could still be computed for the parent's data set, from which splitting axes candidates would be extracted.

4. *Axis through the two most distant points.* Partitioning along the axis that goes through the two most distant points in the input set corresponds to an attempt at minimizing the volume of the child volumes. A near-optimal approximation to the most distant points is given by the simple $O(n)$ heuristic implemented as the function **MostSeparatedPointsOnAABB()** in Section 4.3.2.

5. *Axis along which variance is greatest.* Splitting along the dimension in which the input data has the largest spread also serves to minimize the volume of the child volumes. In an OBB hierarchy in which OBBs are covariance fitted, the axis of largest variance simply corresponds to the axis defining the longest side of the parent OBB.

Even though a full optimization step is infeasible, once a partitioning axis has been selected a small number of hill-climbing steps can be performed to improve on the axis. One approach involves perturbing the direction of the axis, replacing the selected axis if the perturbed axis performs better, and repeating this for as many steps as can be afforded.

An interesting, but largely unexplored, option is to apply other statistical methods than principal component analysis to the problem of finding partitioning axes. These include the related methods of *projection pursuit, independent component analysis,* and *blind signal separation,* which are all techniques for recovering unobserved individual components from an observed mixed source. For instance, the method of projection pursuit as a simplification can be described as a way of obtaining a direction for which the entropy (rather than the variance) of the projected data is maximized. As entropy is a measure of information or "interestingness," and data clusters will have high entropy, this direction forms a good candidate axis for partitioning the data in two or more clusters. For an introduction to projection pursuit and independent component analysis see [Stone98]. For blind signal separation see [Cardoso98].

6.2.1.3 Choice of Split Point

The infeasibility of optimizing over all possible axes applies to the choice of split point as well. As there are infinitely many splitting points along the axis, again the selection must be restricted to a small set of choices, such as:

- *Median of the centroid coordinates (object median).* Splitting at the object median evenly distributes the primitives between the subsets, resulting in a balanced tree. The median is trivially found in $O(n \log n)$ time by sorting the points, or in $O(n)$ time using a more sophisticated method (see [Cormen01] for details).

- *Mean of the centroid coordinates (object mean).* Well-balanced trees do not necessarily give the best query times. Splitting along the local axis with largest variance, [Klosowski98] report that using the object mean outperforms using the object median. They report splitting at the mean consistently gives smaller volume trees, with a lower number of operations performed and better query times as a result. The object mean is found in $O(n)$ time.

- *Median of the bounding volume projection extents (spatial median).* Splitting at the spatial median (thus splitting the volume in two equal parts) is an attractive option, as the split point is found in constant time from examining just the bounding volume and not its contained data. This alternative is often used when the axis is selected from the parent volume (for example, using the longest-side rule).

- *Splitting at* k *evenly spaced points along the bounding volume projection extents.* Instead of spending time on what amounts to "intelligently guessing" a good

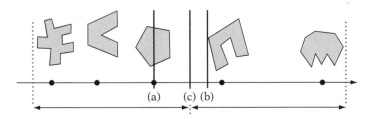

Figure 6.3 (a) Splitting at the object median. (b) Splitting at the object mean. (c) Splitting at the spatial median.

split position, this brute-force alternative simply tests some small number of evenly spaced points along the axis, picking the best one.

- *Splitting between (random subset of) the centroid coordinates.* Similar to the previous method, splitting between the projected centroids attempts to minimize the number of primitives straddling the splitting plane, at the expense of projecting and sorting the centroids.

Figure 6.3 illustrates some of these splitting choices. Instead of directly selecting a splitting point, the subsets can be built incrementally. For instance, [Zachmann98] splits along the axis through the two most distant points, a and b. Starting by adding the faces associated with a and b to the two different subsets, he assigns the remaining primitives to the subset whose bounding volume increases less with the primitive added. If both volumes increase by the same amount or do not increase at all (due to the primitive being fully inside the volume), the primitive is added to the set with fewer primitives.

Top-down construction is by far the most common approach to building bounding volume hierarchies. The advantages include ease of implementation and fast tree construction. The disadvantage is that as critical decisions are made early in the algorithm at a point where all information is not available the trees are typically not as good as possible.

6.2.2 Bottom-up Construction

In contrast to top-down methods, bottom-up methods are more complicated to implement and have a slower construction time but usually produce the best trees [Omohundro89]. To construct a tree hierarchy bottom up, the first step is to enclose each primitive within a bounding volume. These volumes form the leaf nodes of the tree. From the resulting set of volumes, two (or more) leaf nodes are selected based on some *merging criterion* (also called a *clustering rule*). These nodes are then bound within a bounding volume, which replaces the original nodes in the set. This pairing

procedure repeats until the set consists of a single bounding volume representing the root node of the constructed tree.

```
Node *BottomUpBVTree(Object object[], int numObjects)
{
    assert(numObjects != 0);

    int i, j;

    // Allocate temporary memory for holding node pointers to
    // the current set of active nodes (initially the leaves)
    NodePtr *pNodes = new NodePtr[numObjects];

    // Form the leaf nodes for the given input objects
    for (i = 0; i < numObjects; i++) {
        pNodes[i] = new Node;
        pNodes[i]->type = LEAF;
        pNodes[i]->object = &object[i];
    }
    // Merge pairs together until just the root object left
    while (numObjects > 1) {
        // Find indices of the two "nearest" nodes, based on some criterion
        FindNodesToMerge(&pNodes[0], numObjects, &i, &j);
        // Group nodes i and j together under a new internal node
        Node *pPair = new Node;
        pPair->type = NODE;
        pPair->left = pNodes[i];
        pPair->right = pNodes[j];
        // Compute a bounding volume for the two nodes
        pPair->BV = ComputeBoundingVolume(pNodes[i]->object, pNodes[j]->object);

        // Remove the two nodes from the active set and add in the new node.
        // Done by putting new node at index 'min' and copying last entry to 'max'
        int min = i, max = j;
        if (i > j) min = j, max = i;
        pNodes[min] = pPair;
        pNodes[max] = pNodes[numObjects - 1];
        numObjects--;
    }
    // Free temporary storage and return root of tree
    Node *pRoot = pNodes[0];
    delete pNodes;
    return pRoot;
}
```

Following the logic of earlier sections, one of the more meaningful merging criteria is to select the pair so that the volume of their bounding volume is minimized. A brute-force approach for finding which two nodes to merge is to examine all possible pairs, compute their bounding volume, and pick the pair with the smallest bounding volume. The brute-force approach requires $O(n^2)$ time. Repeated $n - 1$ times to form a full tree, the total construction time becomes $O(n^3)$.

6.2.2.1 Improved Bottom-up Construction

A more sophisticated implementation can improve on the performance of the brute-force approach substantially. Instead of constantly recomputing the preferred minimum volume pairings for each node, the nodes can keep track of their preferred pairing nodes and the new volume for the pair. Then, at any given time the node with the smallest stored volume and its stored pairing node would be the best pair of nodes to merge. These (*node, pairing node, volume*)-tuples can be effectively maintained in a data structure such as a priority queue (heap or binary search tree) sorted on volume, allowing fast access to the minimum volume entry.

Whenever a new pair is formed, most of the stored minimum volume pairings remain the same. Only the stored pairings involving either one of the two newly paired nodes are affected. More importantly, when they change, the stored volume for the pair can only increase. This allows the pairing node to be recomputed lazily, delaying the calculation to the time the pair is extracted from the priority queue.

In effect, the algorithm becomes an iteration wherein the currently best pair is removed from the queue. If the node has already been paired, the pair is simply discarded and the next best pair is extracted. If not, the best pairing node for the node is calculated. If it matches the stored pairing node, this pair must be the minimum volume pair and they can be merged. If it does not match, the pairing node must have been paired in an earlier step, so the node and the new pairing node are reinserted into the priority queue under a new volume priority value.

The missing piece is how to quickly calculate the pairing node that forms the smallest volume when paired with a given query node. Interestingly, a dynamic bounding volume tree (in particular, the top-down incremental insertion algorithm presented later on) is a suitable data structure for holding the bottom-up fragments of the tree as it is constructed! Given such a structure, the pairing node is located by searching from the top of the tree, descending into all children the query volume intersects. When the query volume is found in the hierarchy, the pairing node is the other child of the parent volume (that is, the sibling node). The following code fragment demonstates how the improved algorithm can be implemented.

```
Node *BottomUpBVTree(Object object[], int numObjects)
{
    PriorityQueue<Pair> q;
    InsertionBVTree t;
```

```
// Bound all objects in BV, forming leaf nodes. Insert leaf nodes into a
// dynamically changable insertion-built BV tree
InitializeInsertionBVTree(t, object, numObjects);

// For all nodes, form pair of references to the node and the node it pairs
// best with (resulting in the smallest bounding volume). Add all pairs to
// the priority queue, sorted on increasing volume order
InitializePriorityQueue(q, object, numObjects);

while (SizeOf(q) > 1) {
    // Fetch the smallest volume pair from the queue
    Pair *p = Dequeue(q);

    // Discard pair if the node has already been paired
    if (HasAlreadyBeenPaired(p->node)) continue;

    // Recompute the best pairing node for this node to see if
    // the stored pair node is still valid
    Node *bestpairnode = ComputeBestPairingNodeUsingTree(t, p->node);
    if (p->pairnode == bestpairnode) {
        // The store pair node is OK, pair the two nodes together;
        // link the nodes together under a new node
        Node *n = new Node;
        n->left = p->node;
        n->right = p->pairnode;

        // Add new node to BV tree; delete old nodes as not possible to pair with
        Delete(t, p->node);
        Delete(t, p->pairnode);
        Insert(t, n);

        // Compute a pairing node for the new node; insert it into queue
        Node *newbestpairnode = ComputeBestPairingNodeUsingTree(t, n);
        p = Pair(n, newbestpairnode);
    } else {
        // Best pair node changed since the pair was inserted;
        // update the pair, reinsert into queue and try again
        p = Pair(p->node, bestpairnode);
    }
    Enqueue(q, p, VolumeOfBVForPairedNodes(p));    // Queue, pair, priority
}
return Dequeue(q)->node;
}
```

A similar approach, specifically for building sphere trees, is presented in [Omo-hundro89].

6.2.2.2 Other Bottom-up Construction Strategies

When grouping two objects under a common node, the pair of objects resulting in the smallest bounding volume quite likely corresponds to the pair of objects nearest each other. As such, the merging criterion is often simplified to be the pairing of the query node with its nearest neighbor.

Locating the point (or object) out of a set of points closest to a given query point is known as the *nearest neighbor problem*. This problem has been well studied, and many different approaches have been suggested. For a small number of objects, a low-overhead brute-force solution is preferred. For larger numbers, solutions based on bucketing schemes or k-d trees are typically the most practical. A k-d tree solution is quite straightforward to implement (see Section 7.3.7 for details). The tree can be built top down in, on average, $O(n \log n)$ time, for example by splitting the current set of objects in half at the object median.

A nearest neighbor query is limited to the relevant parts of the k-d tree by keeping track of a bound for the nearest object found so far (see Section 7.3.7). Initially, this value is set to the distance from the query object to the root node object. As closer objects are found, the bound is decreased accordingly. Halfspaces farther away than the bound distance are pruned away, as they cannot possibly contain a nearer object. When neither halfspace can be discarded, the halfspace containing the query object is usually descended into first, as this is more likely to lead to the bound being lowered and the search sped up.

The k-nearest neighbor problem can be solved by the same basic method just by adding a priority queue of k objects that keeps track of the k-nearest objects seen so far, updating the bound distance from the last (farthest) element of the queue. On average, both search and insertion into a k-d tree can be performed in $O(\log n)$ time. k-d trees are discussed further in Chapters 7 and 13.

With the methods presented earlier, no guarantees were made as far as tree balance was concerned, and it is in fact easy to find input configurations that cause degenerate trees. Tree balance can be improved by forming not just one but several pairs of closest points during each iteration. For instance, when all possible $n/2$ pairs are formed at each iteration the resulting tree becomes balanced. This would also reduce the number of iterations needed to form the tree, from $O(n)$ to $O(\log n)$, improving construction time. As forming all possible pairs would result in a worse tree over just forming one pair, a good compromise is to form k pairs for some small value of k.

For forming larger clusters of objects, specific clustering algorithms can be used. One such approach is to treat the objects as vertices of a complete graph and compute a *minimum spanning tree* (MST) for the graph, with edge weights set to the distance between the two connected objects or some similar clustering measure. The MST is then broken into components by deleting edges that are "too long," and the remaining set of disjoint (but internally connected) components are the object clusters.

The MST can be computed using, for instance, *Prim's algorithm* or *Kruskal's algorithm*. Both of these are greedy algorithms, meaning that they always select to perform the locally best-looking alternative. Greedy algorithms often perform quite well on most problems, but they are not generally optimal. However, the MST problem is

optimally solved using either one of these two methods. Of the two, Prim's algorithm is probably both conceptually simpler and easier to implement. It starts with any vertex from the initial set and grows a tree from it by finding the lowest cost edge between an unconnected vertex and the tree. This edge and the vertex are then connected to the tree and the process is repeated until all vertices have been connected. For additional details on computing MSTs, including descriptions of both Prim's and Kruskal's algorithms, see [Cormen01] and the delightful book of [Skiena98].

6.2.2.3 Bottom-up *n*-ary Clustering Trees

One interesting method utilizing an MST calculation as a key step is the bottom-up clustering method presented in [Garcia99]. Given a set of *n* bounding spheres, this method begins by constructing the adjacency graph between the spheres. The edges of this graph contain grouping costs (described in material to follow) between pairs of spheres. From the graph, an MST is calculated, from which in turn a hierarchy of spheres is constructed.

As the number of edges in the complete adjacency graph is $O(n^2)$, which would severely impact the running time of the MST algorithm, Garcia et al. limit the number of connections each bounded object can have to some constant number k, reducing the complexity to $O(n)$. By using an appropriate space-partitioning strategy, the reduction could be limited to be approximately the k-nearest neighbors and still run in $O(n)$ time.

A clustering function is associated with the remaining edges. Given two spheres S_i and S_j — with radii r_i and r_j, respectively, and with a distance d_{ij} between their centers — Garcia et al. first define the attraction between S_i and S_j as $a_{ij} = r_i r_j / d_{ij}^2$. This attraction measure becomes larger the larger and closer the two spheres are, mimicking an intuitive perception of how clusters would form.

To avoid large clusters being created early in the build process, the final clustering function is defined as r_{ij}^3 / a_{ij}, where r_{ij} is the radius of the smallest bounding sphere encompassing S_i and S_j. This helps in penalizing the grouping of two spheres of high attraction when their resulting bounding sphere would be very large.

Once the adjacency graph with associated edge costs has been formed, the MST of the graph is computed. The edges of the MST are then sorted in ascending order of cost. From the sorted edges they construct what they call a binary clustering tree (BCT) by considering an edge at a time, combining the two nodes associated with the edge into a new cluster. If a node is already part of a cluster, the existing cluster is grouped into the new cluster instead of the node. As clusters are formed, they are bounded by the smallest bounding sphere containing the bounding spheres of the nodes. They are also assigned the cost of the connecting edge as a grouping cost. The construction of the BCT from the MST takes $O(n \log n)$ time.

At this point it would be possible to stop and use the resulting binary tree. However, as described, a final step of the algorithm converts the BCT into an *n*-ary tree by merging connected clusters that have similar grouping costs under a single node.

After the MST has been calculated and the edges sorted into a list in ascending order of weight, the weights are grouped into a set of families.

The first two weights in this list form the first family F_0. Defining u_i and s_i as the mean and standard deviation of the weights in family F_i, a subsequent weight w on the list is considered belonging to the family F_i if $w < u_i + 2s_i$. Whenever a weight is added to a family, the associated mean and standard deviation of the family are updated. When a weight is found not to belong to a family, it and the next weight on the list form a new family. This process repeats until all weights on the list have been assigned to a family. Finally, when all families have been determined the BCT is transformed into an n-ary tree by merging all adjacent clusters that belong to the same family.

6.2.3 Incremental (Insertion) Construction

The last type of construction approach is the *incremental* or *insertion* method. Here, the tree is built by inserting one object at a time, starting from an empty tree. Objects are inserted by finding the insertion location in the tree that causes the tree to grow as little as possible according to a cost metric. Normally the cost associated with inserting an object at a given position is taken to be the cost of its bounding volume plus the increase in volume its insertion causes in all ancestor volumes above it in the tree.

If the object being inserted is large compared to the existing nodes, it will tend to end up near the top of the hierarchy. Smaller objects are more likely to lie within existing bounding volumes and will instead end up near the bottom. When the new object is far away from existing objects it will also end up near the top. Overall, the resulting tree will therefore tend to reflect the actual clustering in the original set of objects.

Because the structure of a tree is dependent on the objects inserted into it and because insertion decisions are made based on the current structure, it follows that the order in which objects are inserted is significant. Using the objects in the order defined by the authoring tool can result in bad hierarchies that do not reflect the actual object clustering. Sorting the data suffers from the same problem, only more so. To avoid degenerate behavior, the best approach seems to be to randomly shuffle the objects before insertion.

A simple insertion method implementation would be to perform a single root-leaf traversal by consistently descending the child for which the insertion into would be cheaper. Then the insertion node would be selected from the visited nodes along the traced path such that the total tree volume would be minimized. As an $O(\log n)$ search is performed for each object inserted, the total complexity becomes $O(n \log n)$. A more advanced implementation would examine the entire tree, proceeding in a best-first manner by maintaining a search front using a priority queue, descending into the currently best node at all times. Both methods are described in [Omohundro89] in terms of creating sphere trees.

Insertion strategies can be as fast as or even faster than top-down methods and could produce better results. They are considered on-line methods in the sense that not all objects need be present when the process starts. That they are on-line methods also allows them to be used for updating an already existing tree, making them useful for dynamic systems. It is therefore somewhat surprising that very few collision detection systems report using incremental construction methods.

6.2.3.1 The Goldsmith–Salmon Incremental Construction Method

An interesting algorithm for constructing bounding volume hierarchies for use in ray tracing is described in [Goldsmith87], with improvements found in [Haines88]. As before, objects are inserted one at a time, at the position deemed most optimal. A single path from root to leaf is traversed by descending into the child with the smallest increase in bounding volume surface area, were the object to be inserted as a child of it.

The reason surface area is used follows from a result of projective geometry, stating that the average projected area of a convex 3D volume is one-fourth its surface area. Furthermore, the conditional probability that a random ray hits a confined bounding volume B if it hits a parent bounding volume A can therefore be shown to be proportional to the ratio of their surface areas. The root volume can conveniently be used as volume A throughout all computations, allowing the division to be avoided by directly comparing the conditional probabilities instead.

As surface areas are only used in ratios, they only have to be given within a constant factor, as the constant factor cancels out. For a bounding box of dimensions x, y, and z, the area can be computed as $x(y+z)+yz$, and for a sphere of radius r the area can be computed as r^2.

Now when a ray hits the root volume at least an additional k intersection tests must be performed, where k is the number of children of the root. This property also holds for any node, not just the root. Accounting for the conditional probability that a node is hit only if its parent is hit, the total average cost for hitting a node becomes k times the node's surface area divided by the surface area of the root node. Specifically, the cost of the root node is the number of children it has, and the cost of a leaf node is zero (as its cost was included in the cost of the parent). The total cost for a tree can now be calculated in $O(n)$ time as the sum of the cost of all nodes.

The tree cost can also be computed incrementally as the tree is built. This is implemented by passing on an incremental "inheritance cost" to the child nodes as the hierarchy is traversed during insertion. This cost corresponds to the increase in volume for ancestor volumes, due to the insertion of the object into the tree. To this is then added the cost of inserting the object at the current position according to the three different choices for insertion:

1. *The object and a leaf node are paired under a new node.* The incremental change to the inheritance cost for this case is $d = 2Area(\text{new node})$. This case also applies when pairing the object and the old root under a new root.

2. *The object is added as a new child to an existing node.* The cost of the existing old node is $c = k\,Area(\text{old node})$. The new node will have a cost of $c' = (k + 1)Area(\text{new node})$. The incremental cost is therefore $d = c' - c = k\,(Area(\text{new node}) - Area(\text{old node})) + Area(\text{new node})$.

3. *The object is added lower in the tree by means of recursing into a child volume.* In this case, the number of children remains the same for the currently examined node. However, the node may change in size as a result of inserting the object lower in the tree. The difference in cost becomes $d = k\,(Area(\text{new node}) - Area(\text{old node}))$.

After examining the increase in cost for all available insertion alternatives, the least expensive option is chosen at each step. It may happen that two or more subtrees have the same increase in cost. Typically, this occurs toward the end of the construction when objects lie fully within already existing bounding volumes. In this case, Goldsmith and Salmon suggest breaking ties by inserting the object into the bounding volume whose center it is closest to, or to use random selection.

Haines points out that a better selection rule is to apply insertion methods 1 and 2 to all available insertion alternatives and pick the one giving the best result. As a convincing example he considers a node with two children, one large (50% of the parent) and one quite small (1% of the parent). A new small object is added that would cause no increase to the larger child but triple the size of the smaller child to 3%. According to the original method, the new object would be inserted below the larger child. However, when the root node is intersected the larger child is hit 50% of the time, and therefore the new object must also be intersected half the time. In comparison, if the new object had been inserted below the smaller child the new object would only be intersection tested 3% of the time. By applying both methods 1 and 2 and picking the node corresponding to the smaller value of the different increases in cost, the better insertion position is selected.

6.3 Hierarchy Traversal

To determine the overlap status of two bounding volume hierarchies, some rule must be established for how to descend the trees when their top-level volumes overlap. Is the one hierarchy fully descended before the other one is? Are they both descended? This descent rule is at the heart of the overlap code, and several alternatives are explored ahead.

The two most fundamental tree-traversing methods are *breadth-first search* and *depth-first search* (Figure 6.4a and b). Breadth-first search (BFS) explores nodes at a given depth before proceeding deeper into the tree, whereas depth-first search (DFS) proceeds into the tree, searching deeper rather than wider, backtracking up the tree when it reaches the leaves. Pure breadth-first and depth-first traversals are

(a) (b) (c)

Figure 6.4 (a) Breadth-first search, (b) depth-first search, and (c) one possible best-first search ordering.

considered *uninformed* or *blind* search methods. Uninformed search methods do not examine and make traversal decisions based on the data contained in the traversed structure; they only look at the structure itself to determine what nodes to visit next.

In contrast to the uninformed methods is the group of *informed* search methods. These attempt to utilize known information about the domain being searched through heuristic rules. One such method is *best-first search* (Figure 6.4c). Best-first search is a greedy algorithm that always moves to the node that scores best on some search criterion (for example, distance to a set goal). It determines the best-scoring move by maintaining a priority queue of nodes, expanding the currently best node (first on the queue) and adding its children to the queue, repeating until the search fails (by running out of nodes) or the goal is found.

DFS seems to be the most popular choice for collision detection systems. DFS is often enhanced by a simple heuristic to guide the search along, improving on the basic blind DFS approach without the overhead of, say, a full best-first search.

Compared to DFS, BFS suffers from the fact that stacking all nodes during traversal requires a substantial amount of memory. For close-proximity queries, two binary trees with n leaves each can require stack space for as many as n^2 node-node pairs at one time. BFS is primarily used in interruptible collision detection systems for which it is important that if (or when) a query is interrupted a roughly equal amount of time has been spent in all parts of the hierarchy.

Similarly, BFS must be well tuned to give performance improvements over a heuristic-guided DFS-based traversal method. Any extra time spent on performing clever node reordering and managing a priority queue is time the depth-first method has already had in descending into child nodes.

6.3.1 Descent Rules

Returning to the issue of how the hierarchies are descended, given two hierarchies A and B there are several possible traversal alternatives. For instance, one can be fully traversed before the other, or they can be descended simultaneously. As an illustrative example (due to [Chung98]), consider a bird (hierarchy A) weaving through the mile-long pipes of an oil refinery (hierarchy B). Several possible descent rules present themselves.

- *Descend A before B is descended.* Fully descending into the leaves of *A* before starting to descend into *B* can be quite bad. In terms of the example, if the bird is somewhere in the middle of the oil refinery the leaves of the bird hierarchy will all overlap the top volume of the refinery. This descent rule is the worst possible choice, as hierarchy *B* will be recursed over as many times as there are leaves in hierarchy *A*. The hierarchy for *A* is clearly counterproductive here, resulting in more work than not having a hierarchy at all!

- *Descend B before A is descended.* Descending the larger refinery hierarchy before descending the hierarchy of the bird is slightly better. However, the refinery model could still contain many parts (such as nuts and bolts) quite a bit smaller than the bird, resulting in a similar situation as before, only reversed. Many leaves of *B* still end up being tested against the whole of *A*.

- *Descend the larger volume.* By dynamically determining which hierarchy is currently the larger one and descending into it, the problems with the two previous methods are circumvented. Initially, the refinery hierarchy is descended into, but when the small nuts and bolts parts are encountered the traversal switches over to descend the bird hierarchy, then back again when the bird parts become smaller than the nuts and bolts. This is one of the most effective descent rules in that it provides the largest reduction of total volume for subsequent bounding volume tests. As before, useful metrics for the size comparison include volume, surface area, and the maximum dimension length.

- *Descend A and B simultaneously.* Instead of just descending one hierarchy, both hierarchies can be descended into at the same time. Simultaneous descent has the benefit of more quickly traversing to the leaves, making fewer internal node-node (as well as node-leaf) overlap tests and involving no evaluation overhead for the descent criterion. However, in the bird-refinery example this rule will not prune the search space as effectively as the previous rule.

- *Descend A and B alternatingly.* The hierarchies can also be descended into in a lock-step fashion, in which first *A* is descended into, then *B*, then *A* again, and so on. This descent rule is very simple to implement, and just as with simultaneous traversal no descent criterion need be evaluated.

- *Descend based on overlap.* Another option is to prioritize descent to those parts in which the hierarchies overlap more before descending parts in which there is less overlap. The idea is that the more two bounding volumes overlap the more likely their objects are colliding.

- *Combinations of the previous or other complex rules based on traversal history.*

Which type of traversal is most effective depends entirely on the structure of the data, as indicated by the refinery example. The following sections explore framework implementations for the previous rules based on depth-first traversal. For very large

data sets, hybrid approaches such as a grid of trees is likely to be more effective than a single tree hierarchy. Hybrid approaches are discussed in Section 7.3.8.

6.3.2 **Generic Informed Depth-first Traversal**

Many descent rules can be handled by a simple procedure that recurses over the two hierarchies. First, if their top bounding volumes do not overlap the procedure just returns. If not, then if both supplied nodes are leaf nodes the low-level routine for colliding the contained geometry is called. Otherwise, the descent rule is evaluated and the code is recursively called for the child nodes of the hierarchy selected by the rule to descend into. Directly translated into code, this becomes:[1]

```
// Generic recursive BVH traversal code.
// Assumes that leaves too have BVs
void BVHCollision(CollisionResult *r, BVTree a, BVTree b)
{
    if (!BVOverlap(a, b)) return;
    if (IsLeaf(a) && IsLeaf(b)) {
        // At leaf nodes. Perform collision tests on leaf node contents
        CollidePrimitives(r, a, b);
    } else {
        if (DescendA(a, b)) {
            BVHCollision(a->left, b);
            BVHCollision(a->right, b);
        } else {
            BVHCollision(a, b->left);
            BVHCollision(a, b->right);
        }
    }
}
```

In the code, the function **BVOverlap()** determines the overlap between two bounding volumes. **IsLeaf()** returns true if its argument is a leaf node and not an internal node. **CollidePrimitives()** collides all contained primitives against one another, accumulating any reported collisions to the supplied **CollisionResult** structure.

DescendA() implements the descent rule, and returns true if object hierarchy *A* should be descended or false for object hierarchy *B*. It is important that this routine correctly deal with cases in which the leaves of *A* and *B* have been reached, so that an attempt to traverse into a leaf is not made. The descent rules of "descend *A*,"

1. The code format used here is inspired by [Gottschalk00].

"descend *B*," and "descend larger" can easily be implemented in this framework as follows.

```
// 'Descend A' descent rule
bool DescendA(BVTree a, BVTree b)
{
    return !IsLeaf(a);
}

// 'Descend B' descent rule
bool DescendA(BVTree a, BVTree b)
{
    return IsLeaf(b);
}

// 'Descend larger' descent rule
bool DescendA(BVTree a, BVTree b)
{
    return IsLeaf(b) || (!IsLeaf(a) && (SizeOfBV(a) >= SizeOfBV(b)));
}
```

Although the recursive version of the traversal code is quite easy to read and understand, it is not the most effective form of the code. An iterative version with explicit stacking of variables avoids the overhead of the recursive function calls. More importantly, it allows the code to exit early if just a single contact point is sought.

The iterative version follows. Note that to traverse the tree in the same order as the recursive version of the code, pushes to the stack must be given in reverse order.

```
// Non-recursive version
void BVHCollision(CollisionResult *r, BVTree a, BVTree b)
{
    Stack s = NULL;
    Push(s, a, b);
    while (!IsEmpty(s)) {
        Pop(s, a, b);

        if (!BVOverlap(a, b)) continue;
        if (IsLeaf(a) && IsLeaf(b)) {
            // At leaf nodes. Perform collision tests on leaf node contents
            CollidePrimitives(r, a, b);
            // Could have an exit rule here (eg. exit on first hit)
```

```
        } else {
            if (DescendA(a, b)) {
                Push(s, a->right, b);
                Push(s, a->left, b);
            } else {
                Push(s, a, b->right);
                Push(s, a, b->left);
            }
        }
    }
}
```

Here, the functions **Push()**, **Pop()**, and **IsEmpty()** implement an abstract stack data type. Studying the flow of the nonrecursive version, it soon becomes clear that unnecessary work is performed in pushing a new node pair onto the stack, only for it to be immediately popped off during the next iteration of the main loop. The redundant work can be avoided by slightly rearranging the code to allow the last stacked values to be assigned directly to the variables instead.

```
// Stack-use optimized, non-recursive version
void BVHCollision(CollisionResult *r, BVTree a, BVTree b)
{
    Stack s = NULL;
    while (1) {
        if (BVOverlap(a, b)) {
            if (IsLeaf(a) && IsLeaf(b)) {
                // At leaf nodes. Perform collision tests on leaf node contents
                CollidePrimitives(r, a, b);
                // Could have an exit rule here (eg. exit on first hit)
            } else {
                if (DescendA(a, b)) {
                    Push(s, a->right, b);
                    a = a->left;
                    continue;
                } else {
                    Push(s, a, b->right);
                    b = b->left;
                    continue;
                }
            }
        }
    }
```

```
        if (IsEmpty(s)) break;
        Pop(s, a, b);
    }
}
```

All recursive traversal functions can be transformed into iterative versions in the manner described here.

6.3.3 **Simultaneous Depth-first Traversal**

Simultaneous traversal cannot be directly handled by the previous framework. Because both bounding volumes are descended into at the same time, instead of two recursive calls there are now four for the node-node case. Code for simultaneous traversal follows.

```
// Recursive, simultaneous traversal
void BVHCollision(CollisionResult *r, BVTree a, BVTree b)
{
    if (!BVOverlap(a, b)) return;
    if (IsLeaf(a)) {
        if (IsLeaf(b)) {
            // At leaf nodes. Perform collision tests on leaf node contents
            CollidePrimitives(r, a, b);
            // Could have an exit rule here (eg. exit on first hit)
        } else {
            BVHCollision(a, b->left);
            BVHCollision(a, b->right);
        }
    } else {
        if (IsLeaf(b)) {
            BVHCollision(a->left, b);
            BVHCollision(a->right, b);
        } else {
            BVHCollision(a->left, b->left);
            BVHCollision(a->left, b->right);
            BVHCollision(a->right, b->left);
            BVHCollision(a->right, b->right);
        }
    }
}
```

It is interesting to compare the number of operations involved in the various types of traversals. As it would take two additional recursive calls for the previous methods to examine the same four node-node pairs the simultaneous traversal descends into, simultaneous traversal can be expected to require about two-thirds the work of the directed methods (which is strictly true only in the case in which all nodes are visited).

Specifically, consider the worst-case scenario in which two complete binary trees of n levels each are in a relative position such that all bounding volume leaves are overlapping but there is no collision. For this case it can be shown that a simultaneous traversal will perform $(2^{2(n-1)} - 1)/3$ internal node-node tests and $2^{2(n-1)}$ leaf-node, node-leaf, and leaf-leaf tests, totaling $(2^{2n} - 1)/3$ tests.

In comparison, the leaf-directed "descend A" and "descend B" rules perform $2^{n-1} - 1$ internal node-node tests and $(2^n - 1)2^{n-1}$ leaf-node, node-leaf, and leaf-leaf tests for a total of $2^{2n-1} - 1$ tests. The limit as n gets large between these two totals verifies the two-thirds ratio informally stated previously.

It is more difficult to provide any specific numbers for the informed traversal method, as the traversal pattern is completely dependent on the descent rule used. One thing that can be said for sure is that the total number of tests performed will be the same as for the leaf-directed traversals, as the code has the same structure and all possible traversal paths are formed. It is difficult to say whether using a simultaneous traversal saves anything over using a directed method such as "descend larger," which performs a more effective search by guiding it to where it is best needed.

6.3.4 Optimized Leaf-direct Depth-first Traversal

A drawback with simultaneous and heuristically guided methods is that collision tests involving the same leaves are likely to be spread out over time. If these tests involve some sort of transformation of the leaf data or the leaf bounding volumes (as is likely), these transformations have to be repeated each time the leaf is involved in a query. If these transformations are expensive, a caching mechanism can be implemented to hold the data after it has been initially transformed.

A compromise alternative to implementing a sophisticated caching scheme is the "descend A" rule. By traversing down to the leaves of hierarchy A before hierarchy B is descended into, it becomes very easy to transform the leaves of A just once. This compromise does not serve as a full replacement for a caching mechanism, as only the A hierarchy will effectively be cached this way. However, as it is so simple to implement it can serve as an indication of how much of an improvement a caching scheme would actually bring. A code fragment follows.

```
// This routine recurses over the first hierarchy, into its leaves.
// The leaves are transformed once, and then passed off along with
// second hierarchy to a support routine
```

```
void BVHCollision(CollisionResult *r, BVTree a, BVTree b)
{
    if (!BVOverlap(a, b)) return;
    if (!IsLeaf(a)) {
        BVHCollision(a->left, b);
        BVHCollision(a->right, b);
    } else {
        a2 = TransformLeafContentsOnce(a);
        BVHCollision2(r, a2, b);
    }
}

// The support routine takes what is known to be a leaf and a full
// hierarchy, recursing over the hierarchy, performing the low-level
// leaf-leaf collision tests once the hierarchy leaves are reached
void BVHCollision2(CollisionResult *r, BVTree a, BVTree b)
{
    if (!BVOverlap(a, b)) return;
    if (!IsLeaf(b)) {
        BVHCollision2(a, b->left);
        BVHCollision2(a, b->right);
    } else {
        // At leaf nodes. Perform collision tests on leaf node contents
        CollidePrimitives(r, a, b);
    }
}
```

6.4 Sample Bounding Volume Hierarchies

The hierarchy construction methods described earlier in this chapter are all generic in the sense that they apply to any type of bounding volume. To further illustrate how they can be used, this section elaborates on a few specific methods suggested in the literature and used in actual systems. These should not be interpreted as the final word on any one technique, merely as one way of implementing something.

6.4.1 OBB Trees

The OBB-tree hierarchy construction method presented in [Gottschalk96] proceeds in a top-down fashion. Initially a tight-fitting OBB is obtained for the original set of primitives. The OBB is fitted by aligning the box axes with the eigenvectors computed from the continuous formulation of covariance computed across the whole faces of the primitives, as described in Section 4.4.3. Given this box, the set is partitioned by

splitting along the longest axis of the OBB. Thanks to the covariance-fitted OBB, this axis corresponds to the axis of greatest spread. The object mean (computed from the projection of the primitive vertices onto the axis) is used as the splitting point.

Primitives straddling the splitting plane are assigned to the corresponding subset of the halfspace their centroids are in. If the longest axis fails to create two nonempty subsets, they instead try the other axes in decreasing order of length. If all axes fail, the set is considered indivisible. However, in the publicly available implementation (called RAPID) if the initial partitioning fails instead of trying alternative axes the set is simply partitioned into two equal parts based on the object median.

A strength of OBB trees is that they perform extremely well in situations of parallel close proximity between two surfaces; that is, when all points of the first surface are close to some point on the other surface. It can also be shown that hierarchies of OBBs converge quadratically to match the bounded geometry, whereas AABBs and spheres converge only linearly. In other words, if $O(m)$ OBBs are required to approximate some geometry within a given tolerance $O(m^2)$ AABBs or spheres would be required for the same task. Both N_V and N_P in the cost function tend to be smaller for OBB trees compared to AABB and sphere trees. However, the cost for the overlap test between two OBBs, C_V, is still about a magnitude slower than the overlap tests for AABBs and spheres.

6.4.2 **AABB Trees and BoxTrees**

In [Bergen97] the author describes constructing binary AABB trees using top-down recursive subdivision. At each step the set of primitives is tightly bounded with an AABB. The set is then partitioned into two parts by splitting the AABB orthogonally along its longest side. Primitives are assigned to the two subsets based on which side of the splitting plane the midpoint of the projection ends up on. This assignment method minimizes the overlap between the AABBs of the subsets, as no primitive can now extend beyond the splitting plane by more than half its length.

The recursive construction procedure is then repeated until the subset contains one primitive. The splitting point is chosen as the spatial median, splitting the AABB in half. van den Bergen reports better performance with this method than with splitting at the object median. In the rare case in which all primitives end up in one of the subsets the set is instead split based on the object median.

The informed traversal method is used along with the "descend larger" rule to traverse the trees. Instead of realigning the AABB trees as their objects rotate, the OBB test is used to compare the — after transformation — relatively oriented AABBs. As the same relative orientation is shared between all transformed AABB pairs, the transformation matrix needs to be computed just once per query, simplifying the OBB test.

van den Bergen also reports obtaining a speed increase from performing only the first 6 of the 15 axis tests for the rotated AABB tests. This is a trade-off that results in an overall cheaper test but also false hits that give rise to more (costly) primitive tests. The same optimization applied to OBB trees resulted in no change.

The *BoxTree* presented in [Zachmann95] is also a recursively constructed hierarchy of AABBs defined in the object's coordinate frame. Here, however, as a bounding box is cut into two (not necessarily equal size) parts by a splitting plane the resultant sub-boxes directly form the AABBs. Primitives fully inside either sub-box are assigned to the corresponding set. Any primitives straddling the splitting plane are sent to both boxes, resulting in a duplication of primitives. Overall, the construction is very similar to that of a *k*-d tree.

As primitives straddling the splitting plane are duplicated, the choice of splitting plane is made in an attempt to balance the tree and to minimize the number of straddling primitives. Before attempting to find this splitting plane, Zachmann first checks to see if there is a splitting plane that trims away a "large" (as large as possible) part of empty space from the AABB, making it fit the contained geometry better. Large is here defined by the ratio of the empty box to its parent being greater than a preset constant. All three AABB axes are tested during this operation and the one with the best result is used. In addition to stopping the recursion when a certain depth has been reached or the set of primitives is less than some particular limit, it is also stopped if one of the sub-boxes contains almost as many primitives as its parent box.

As the BoxTrees are constructed in model space, during testing they have to be transformed as the objects are transformed. However, as all AABBs share the same orientation as the top node, most calculations can be reused during the hierarchy traversal. To test the rotated AABBs (now OBBs), the separating-axis test can be used, now greatly simplified by the fact that the 15 axes remain the same throughout the test. Zachmann also describes an alternative clipping-based overlap test. For traversing the trees, Zachmann uses the simultaneous traversal method.

In a later presentation, Zachmann describes an alternative implementation in which instead of directly using the splitting plane to determine the boundary of the sub-boxes he determines the two planes that bound the straddling primitives on either side along the splitting axis. The "left" sub-box then becomes the left part of the parent AABB, split at the position of the rightmost of the two planes, and vice versa for the "right" sub-box. In other words, the child AABBs are identical to the parent AABB except for one side. In this representation both children are represented using just two (float) values, given the parent volume [Zachmann00].

Both van den Bergen's and Zachmann's methods work on arbitrary polyhedra or polygon soups. As such, they will only reliably detect surface collisions. They do not detect when one object is fully inside the other.

6.4.3 Sphere Tree Through Octree Subdivision

Thanks to its simplicity, a popular approach to building a sphere tree is to construct it from an octree subdivision of the object volume [Tzafestas96]. First, the object is enclosed in the smallest encompassing bounding cube. This cube is recursively subdivided into eight equal-size parts, or octants. Any octant that contains part of

the object is recursively divided until some preset tree depth is reached. During the construction, each occupied octree node is circumscribed with a sphere, forming the actual sphere tree. The octant center point is used as the sphere center. For a regular cube with side s, the sphere radius r is given by $r = s\sqrt{3}/2$. If the initial bounding volume is a general AABB instead of a cube, the radius for an octant with sides x, y, and z becomes $r = \sqrt{x^2 + y^2 + z^2}/2$.

To eliminate redundant spheres that do not contribute to the actual collision detection it is possible to stop recursing into any octree nodes that are occluded on all sides [O'Sullivan99]. This may cause collisions with interior parts to go undetected, however.

The sphere tree resulting from this approach has a fairly loose fit. Hubbard suggests using simulated annealing to tighten the spheres around the object, while still maintaining conservative coverage of the object [Hubbard95]. This involves making random changes to the spheres, accepting those producing a tighter sphere, sometimes accepting those that are worse to fight getting stuck in local minima. Unfortunately, as Hubbard points out, measuring the tightness of spheres around objects is difficult. The simulated annealing step is also quite slow and can produce very irregular distributions of spheres. The practical value of this technique is therefore somewhat limited.

6.4.4 Sphere Tree from Sphere-covered Surfaces

Using the basic top-down construction method, [Quinlan94] computes sphere trees from an input set of small spheres covering all surfaces of the original object. The surface covering is performed in a scan conversion-like process whereby each polygon in the input set is overlaid with a regular grid of spheres, with the sphere centers in the plane of the polygons. Each of these spheres, forming the leaf nodes of the final tree, is labeled with the polygon it was created to cover.

The hierarchy is built by dividing the full set of leaf spheres into two roughly equal-size parts. Two subtrees are constructed by recursively calling the algorithm with each of the subsets. These subtrees are then combined into a tree by adding them as children to a new parent node. At each step, the set of spheres is divided into two subsets by enclosing the sphere centers in an AABB. The AABB is split in half along its longest side and spheres are assigned to the subsets based on which AABB half their center is in.

Note that this approach assumes a surface representation based on (convex) polygons. It will not detect collisions with the interior of an object.

6.4.5 Generate-and-Prune Sphere Covering

An interesting method that does not construct a hierarchy as such but simply computes a collection of spheres, the union of which completely encloses a given object, was suggested by Greenspan and Burtnyk [Greenspan96]. Their algorithm consists

of two steps. First, a *generation* step is performed in which the object is fully covered by a large number of spheres. Then, in a second *pruning* step any and all redundant spheres are removed. Redundant here means that if the spheres were removed the object would still be fully covered by the remaining spheres.

The generation part is controlled by two parameters. The first parameter, *overshoot*, controls how far beyond the surface of the object a sphere is allowed to extend. The second parameter, *spacing*, specifies the minimum allowable distance between any two sphere centers. The algorithm proceeds by creating a tight uniform 3D grid around the object. The grid cell side is set to the spacing parameter. All cells are labeled *interior*, *exterior*, or *surface*, depending on whether they are fully inside the object, fully outside the object, or neither. Each cell is also assigned a value, initially zero. A sphere is then centered at every grid cell not marked exterior. Sphere radii are set so that spheres do not extend outside object boundaries by more than the overshoot parameter.

In the pruning step, spheres can be redundant either by being fully enclosed within a single (larger) sphere or by being enclosed by the union of a set of two or more spheres. In the first case, each sphere is simply compared to all other spheres to see if it is redundant, in which case it is removed. This process requires $O(n^2)$ sphere-sphere comparisons. To handle the second case, the remaining set of spheres is iterated over and for each cell fully contained within the sphere its associated value is incremented by one. After this is done, each grid cell labeled *surface* having a value of 1 must be contained in a single sphere. For the object to be fully enclosed, all such spheres must be included in the final set. These spheres are identified, removed, and added to the final set. The cell is labeled *processed*, indicating that it should not be considered henceforth.

When all such spheres have been added to the final set, and no more cells with a value of 1 exist, all remaining surface cells must be covered by two or more spheres. Conversely, each remaining sphere must be fully enclosed by two or more spheres. Thus, any sphere can be deleted from the candidate set while still maintaining full object coverage. As the sphere is deleted, the grid cells contained by it are decremented by one. Whenever this results in a grid cell with value 1, the corresponding sphere is added to the final set in the same way as before. Processing stops when no candidate spheres are remaining or, if desired, simply when all surface cells have been marked processed. Even though their algorithm does not proceed to build a hierarchy from the final sphere set, any of the previously described hierarchy construction methods could now be applied with the spheres as the input set to produce a sphere tree, if needed.

6.4.6 *k*-DOP Trees

In [Klosowski98] *k*-DOP trees were used for detection collisions between a flying object and a large static environment. Using top-down construction, they bound the input set of triangles in a *k*-DOP and then partition the input set in two parts, recursing over the parts. The recursion is stopped when the nodes contain a preset

threshold t of triangles. For the static hierarchy they used $t = 1$, and for the flying object $t = 40$. Query traversal was such that the environment was fully descended into before the object was descended.

Four different partitioning strategies were compared for the construction of the k-DOP trees. The choice of axis was limited to one of the x, y, or z coordinate axes based on the criteria of minimizing the sum of volumes, minimizing the maximum volume, using the axis with the largest variance, and splitting along the longest axis of the parent volume. The mean and the median of the axis-projected triangle centroid coordinates were both used to determine the splitting point.

Their results showed that splitting at the mean always produced a hierarchy with a smaller total volume than splitting at the median. The "minimize sum" strategy consistently produced the smallest total volume hierarchy, with "minimize maximum," "largest variance," and "longest axis" producing results roughly 7%, 10%, and 33% worse, respectively. They also examined using more than the three coordinate axes, specifically all $k/2$ defining directions for the k-DOPs, reporting it not really providing an improvement. Preprocessing time increased by about 30% on average, however.

To tumble the k-DOPs during updating, they used the more expensive hill-climbing method for the root node, as it and nearby nodes are most frequently visited. The approximate DOP-of-DOP method was used for all other nodes because of the (much) lower overhead.

Also working with k-DOPs, [Konečný98] instead uses the axis of largest variance among the set of $k/2$ fixed-direction axes for the k-DOPs (measured over the projected centroids). He then partitions the primitives in two sets of equal size.

[Klosowski98] compared 6-, 14-, 18-, and 26-DOPs and found 18-DOPs performing the best. As a contrast, [Zachmann98] compared 6-, 8-, and 14-DOPs, finding 6-DOPs (that is, AABBs) performing better than the other two. In a later work, using the nonstandard k-DOPs described in Chapter 4, Zachmann reports examining the full range $k = [6 \ldots 32]$. Although no k was optimal in all tests, $k = 24$ performed best overall [Zachmann00]. As these tests were performed under varying conditions, it is difficult to compare the results directly.

Using doubles (8 bytes) for vertex components and 4-byte integers for triangle vector indices, Klosowski et al. report they require $(16k + 108)n$ bytes to store all n triangles of the environment, including the hierarchy itself. For $k = 6, 14, 18$, and 26 this becomes 204, 332, 396, and 524 bytes per input triangle, respectively. This should be compared to the 412 bytes per input triangle claimed for the OBB-based collision detection package RAPID (also using doubles). What is worse, for a data set of 169,944 triangles they report a 26-DOP hierarchy being an obscene 69 MB in size!

6.5 **Merging Bounding Volumes**

When hierarchies are created top-down or incrementally, bounding volumes are typically created from scratch using the dimensions of the contained data.

During bottom-up construction an alternative to the rather costly operation of fitting the bounding volume directly to the data is to merge the child volumes themselves into a new bounding volume. This section presents such merging operations for AABBs, spheres, OBBs, and k-DOPs.

6.5.1 Merging Two AABBs

Computing the enclosing AABB for two given AABBs is trivial: the sides of the encompassing AABB are selected to coincide with the minimum and maximum sides of the two given volumes. For instance, for the min-max AABB representation, the enclosing AABB is computed by the following code.

```
// Computes the AABB a of AABBs a0 and a1
void AABBEnclosingAABBs(AABB &a, AABB a0, AABB a1)
{
    for (int i = 0; i < 2; i++) {
        a.min[i] = Min(a0.min[i], a1.min[i]);
        a.max[i] = Max(a0.max[i], a1.max[i]);
    }
}
```

Other AABB representations result in equally trivial implementations.

6.5.2 Merging Two Spheres

To compute the minimum sphere bounding two other spheres, the calculation is best split into two cases: where either sphere is fully enclosed by the other and where they are either partially overlapping or disjoint. To distinguish between the two cases, let the two spheres be S_0 and S_1, with centers C_0 and C_1 and radii r_0 and r_1, respectively (Figure 6.5). Let $d = \|C_1 - C_0\|$ be the distance between C_0 and C_1. Then, if $|r_1 - r_0| \geq d$, one sphere is fully inside the other. A simple geometric argument shows why this is so. Start with both spheres centered in the same location. Now $d = 0$, and the distance between the sphere surfaces is $|r_1 - r_0|$. However, clearly this is also the maximum distance by which the sphere centers can be separated (and d increased) before the inner sphere penetrates out through the surface of the outer sphere, and the result follows.

In the first case, in which one sphere is inside the other, no new sphere has to be calculated and the larger sphere can simply be returned. This avoids an expensive square root operation. For the second case, in which the spheres are either partially overlapping or are disjoint, the radius r of the new sphere is half the maximum

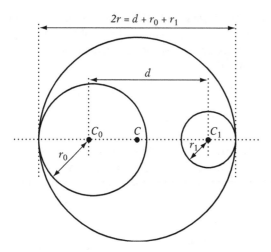

Figure 6.5 Merging spheres S_0 and S_1.

distance between the sphere surfaces; thus:

$$r = (d + r_0 + r_1)/2.$$

The sphere center C is computed by adjusting C_0 by r_0 units away from C_1 and then back toward C_1 by r units:

$$C = C_0 - r_0(C_1 - C_0)/\|C_1 - C_0\| + r(C_1 - C_0)/\|C_1 - C_0\|$$
$$= C_0 + (r - r_0)(C_1 - C_0)/\|C_1 - C_0\|.$$

The code for this follows.

```
// Computes the bounding sphere s of spheres s0 and s1
void SphereEnclosingSpheres(Sphere &s, Sphere s0, Sphere s1)
{
    // Compute the squared distance between the sphere centers
    Vector d = s1.c - s0.c;
    float dist2 = Dot(d, d);

    if (Sqr(s1.r - s0.r) >= dist2) {
        // The sphere with the larger radius encloses the other;
        // just set s to be the larger of the two spheres
```

```
        if (s1.r >= s0.r)
            s = s1;
        else
            s = s0;
    } else {
        // Spheres partially overlapping or disjoint
        float dist = Sqrt(dist2);
        s.r = (dist + s0.r + s1.r) * 0.5f;
        s.c = s0.c;
        if (dist > EPSILON)
            s.c += ((s.r - s0.r) / dist) * d;
    }
}
```

6.5.3 Merging Two OBBs

Computing an OBB from two OBBs is a bit more complicated. A straightforward solution is to use the techniques presented in Chapter 4. For instance, the 16 vertices of the two boxes can be passed directly to the **ComputeOBB()** function (which uses the eigenvectors of the covariance matrix for the points as the box axes). This could be further combined with the min-principal-component technique described in Section 4.4.4. The latter is used for the bottom-up construction in the BoxTree algorithm described in [Barequet96].

A drawback with these techniques is the cost of the iterative algorithms used to compute the eigenvectors, making them less suitable for real-time use. An alternative noniterative solution is presented in [Eberly00]. He suggests combining the rotations of the two OBBs by converting them into quaternions, interpolating halfway between them and then converting back to a rotation matrix, now determining the axes of the OBB. The extents are then established through projection onto these axes. Note that in the pseudocode presented in [Eberly00] the OBB center is determined before the OBB extents are calculated. In general, this will not fit the OBB as tightly as possible. To make the OBB tight with respect to the two OBBs, the center point should be calculated after the extents have been established.

6.5.4 Merging Two *k*-DOPs

Merging two *k*-DOPs is just as easy as merging two AABBs. For each *k*-DOP axis, the bounding *k*-DOP is defined by the smaller of the min values and the larger of the max values for the two DOPs to be bounded. Per definition, no planes can bound tighter than these do. The implementation is strikingly similar to the AABB merging code.

```
// Computes the KDOP d of KDOPs d0 and d1
void KDOPEnclosingKDOPs(KDOP &d, KDOP d0, KDOP d1, int k)
{
    for (int i = 0; i < k / 2; i++) {
        d.min[i] = Min(d0.min[i], d1.min[i]);
        d.max[i] = Max(d0.max[i], d1.max[i]);
    }
}
```

6.6 Efficient Tree Representation and Traversal

So far, hierarchy construction and traversal has been described in a fairly abstract manner. However, for an industrial-strength implementation it is important to optimize both the traversal code and the tree representation itself. As memory accesses and branch prediction misses tend to cause large penalties in modern architectures, two obvious optimizations are to minimize the size of the data structures involved and to arrange the data in a more cache-friendly way so that relevant information is encountered as soon as possible.

This section describes a few data representations and traversal optimizations that help speed up collision queries. However, always remember that due to difficult-to-predict cache behaviors some of these more advanced techniques might not always provide the expected speedups. If this is the case, consider that keeping the traversal code as short and straightforward as possible might in fact be a simple way of making it faster. Efficient tree representation is revisited in Chapter 13, in the context of memory optimization.

6.6.1 Array Representation

Assume a complete binary tree of n nodes is given as a collision hierarchy. This tree can be stored into an array of n elements by mapping its nodes in a breadth-first level-by-level manner.

```
// First level
array[0] = *(root);
// Second level
array[1] = *(root->left);
array[2] = *(root->right);
// Third level
array[3] = *(root->left->left);
...
```

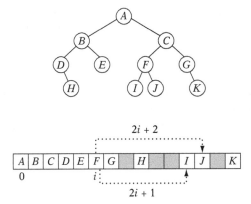

Figure 6.6 A binary tree (top) stored using a pointerless array representation (bottom). Children of node at array position i can be found at positions $2i + 1$ and $2i + 2$. Note wasted memory (shown in gray).

Given this setup, it is easy to verify that being at the node stored at **array[i]** the corresponding left child to the node will be found at **array[2*i+1]** and its right child at **array[2*i+2]**. Consequently, instead of representing the tree using nodes containing left and right pointers to the node's children it is possible to completely remove all pointers and store the pointerless nodes in an array in the manner just described (Figure 6.6). Knowing this child-indexing rule, the actual remapping can effectively be written as a simple recursive routine.

```
// Given a tree t, outputs its nodes in breadth-first traversal order
// into the node array n. Call with i = 0.
void BreadthFirstOrderOutput(Tree *t, Tree n[], int i)
{
    // Copy over contents from tree node to breadth-first tree
    n[i].nodeData = t->nodeData;
    // If tree has a left node, copy its subtree recursively
    if (t->left)
        BreadthFirstOrderOutput(t->left, n, 2 * i + 1);
    // Ditto if it has a right subtree
    if (t->right)
        BreadthFirstOrderOutput(t->right, n, 2 * i + 2);
}
```

When the tree is perfectly balanced (as the assumed complete tree would be), this saves memory space and pointer reads during tree traversal. Unfortunately, for

a nonbalanced tree, space still has to be allocated as if the tree were complemented with extra nodes to make it fully balanced. What is worse, even a single extra node added to a fully balanced tree will add one full extra level to the tree, doubling its storage space!

As such, this representation is most useful when the actual node data (its "payload") is small compared to the combined size of the child pointers, or when the tree really is fully balanced (or just a few nodes off on the short side from being fully balanced). For instance, when a hierarchy has been built using a median-based splitting criterion that guarantees some level of near balance, this could be a useful representation.

6.6.2 Preorder Traversal Order

Even when no guarantees can be made about the balance of the tree hierarchy, it is still possible to output the data in a more effective representation. If the tree nodes are output in preorder traversal order, the left child when present will always immediately follow its parent. This way, although a link is still needed to point at the right child only a single bit is needed to indicate whether there is a left child (immediately following the current node). Figure 6.7 illustrates a binary tree and its nodes output in preorder traversal order.

A routine taking an ordinary pointer-based tree and outputting it in preorder traversal order into an array is fairly straightforward to implement. The only complication is in updating the right-link pointers to point at a node location that is unknown at the time the parent node is written to memory. These can either be handled through a second pass through the tree or (better) through stacking and backpatching, as in the following code.

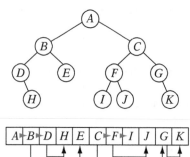

Figure 6.7 Same tree as in Figure 6.6 but with nodes output in preorder traversal order. Nodes now need a pointer to the right child (shown as an arrow). They also need a bit to indicate if the node has a left child (which when present **always immediately** follows the parent node). Here, this bit is indicated **by a gray triangle**.

```
// Given a tree t, outputs its nodes in preorder traversal order
// into the node array n. Call with i = 0.
int PreorderOutput(Tree *t, Tree n[], int i)
{
    // Implement a simple stack of parent nodes.
    // Note that the stack pointer 'sp' is automatically reset between calls
    const int STACK_SIZE = 100;
    static int parentStack[STACK_SIZE];
    static int sp = 0;

    // Copy over contents from tree node to PTO tree
    n[i].nodeData = t->nodeData;
    // Set the flag indicating whether there is a left child
    n[i].hasLeft = t->left != NULL;
    // If node has right child, push its index for backpatching
    if (t->right) {
        assert(sp < STACK_SIZE);
        parentStack[sp++] = i;
    }
    // Now recurse over left part of tree
    if (t->left)
        i = PreorderOutput(t->left, n, i + 1);
    if (t->right) {
        // Backpatch right-link of parent to point to this node
        int p = parentStack[--sp];
        n[p].rightPtr = &n[i + 1];
        // Recurse over right part of tree
        i = PreorderOutput(t->right, n, i + 1);
    }
    // Return the updated array index on exit
    return i;
}
```

In addition to reducing the needed number of child pointers by half, this representation also has the benefit of being quite cache friendly. The left child is very likely already in cache, having been fetched at the same time as its parent, making traversal more efficient.

6.6.3 Offsets Instead of Pointers

A typical tree implementation uses (32-bit) pointers to represent node child links. However, for most trees a pointer representation is overkill. More often than not, by

allocating the tree nodes from within an array a 16-bit index value from the start of the array can be used instead. This will work for both static and dynamic trees. If the tree is guaranteed to be static, even more range can be had by making the offsets relative from the parent node.

At the cost of some extra traversal overhead, it is also possible to combine the pointer and index representation. One extra reserved bit could indicate that the stored value should instead be used as an index into a separate array of either pointers or wider offset values.

6.6.4 Cache-friendlier Structures (Nonbinary Trees)

Execution time in modern architectures is often more limited by cache issues related to fetching data from memory than the number of instructions executed. It can therefore pay off to use nonconventional structures that although more complicated to traverse take up less memory and have a more cache-friendly access pattern.

One such possible representation is merging sets of three binary tree nodes (parent plus left and right child) into a "tri-node," a fused node containing all three nodes. The original set of three nodes has two internal links connecting the parent node with the children and four external links connected to the rest of the tree. The new node does not need any internal links, just the four external links.

For a four-level (15-node) complete binary tree, 14 internal links are needed. The corresponding tri-node tree has two levels (four nodes) and just four internal links (Figure 6.8). A six-level (63-node) binary tree has 62 internal links; the tri-node tree only 20. In general, the corresponding tri-node tree requires a third of the links of a complete binary tree, an even better reduction than with the preorder traversal order representation. In addition, tri-nodes can be output in a breadth-first fashion, potentially allowing the top n levels of the hierarchy to stay in cache.

The drawback is the additional processing required to traverse the tree. In addition, when a tree is not complete nodes go empty in the tri-node, wasting memory. A flag is also needed to indicate whether the node is used or empty. For this reason, tri-node trees are better suited for dense trees. For sparse trees, the preorder traversal order representation is preferable.

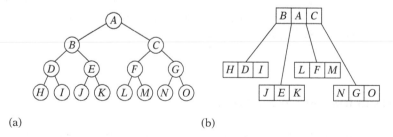

(a) (b)

Figure 6.8 (a) A four-level binary tree. (b) The corresponding two-level tri-node tree.

It is of course possible to combine this representation with previous methods. For instance, storing a tri-node tree in preorder traversal order with parent-relative offsets instead of child pointers would reduce the memory used for links to a minimum. A related technique is discussed in [Intel99], in which instead of a single sphere bounding volume the union of three spheres is used as the bounding volume, as three spheres fit nicely within a cache line.

6.6.5 Tree Node and Primitive Ordering

When, say, a simultaneous traversal is used four recursive calls are generated in the node-node part of the traversal algorithm. As the algorithm was presented in Section 6.3.3, the order in which these four calls were issued was completely determined by the relative ordering of the nodes within the two trees. If the current query is for testing rather than finding collision, or if distance pruning is used to cull away branches of the hierarchies, it is desired to find intersections as early as possible.

One possibility would be to attempt to figure out at runtime the best order in which to issue the recursive calls. This is not necessarily easy, as nothing is known about the structure further down the hierarchies at this point. A more feasible alternative (with no runtime overhead) is to rearrange the children of a parent node heuristically during construction, so that the child more likely to lead to an early intersection comes first. Following [Haines91a], a few possible ways to order the nodes (for not necessarily binary trees) include:

- *Arrange children so that leaves come before nodes.* If the collision status is determined at the primitive level, as all primitives are contained in the leaves, by having the leaves come before nonleaf nodes primitives are tested as early as possible.

- *Put the smallest subtrees first.* By considering the nodes as roots of hierarchy subtrees, the same argument applies. By having nodes with fewer descendants first, leaves should be reached earlier.

- *Sort children by their hits-to-tests ratio.* Based on actual usage, rearrange the hierarchy so that nodes actually involved in positive collision queries come first and those never or rarely involved come last.

- *Sort children from near to far along predominant query direction.* If tests are coming predominantly from a specific direction, such as from above for a hierarchy representing ground, it makes sense to sort children so that those corresponding to higher ground come first.

The same ordering principle applies to the primitives stored within a leaf, of course. When the leaf contains more than one primitive, the primitives can be sorted

according to similar rules. For instance, if different types of primitives are used, such as both triangles and quads as well as Bezier or NURBS surfaces, it makes sense to test the polygons first before performing the more expensive tests involving surface primitives.

It is also possible to arrange primitives to obtain extra culling information for free. Say an OBB tree is built from a set of polygons representing a static world that is collided with largely from above. The leaf OBBs of this tree are unlikely to have polygons extending all the way into their topmost corner. Let the polygons be rearranged so that the polygon with the highest vertex comes first in the list of polygons. Then rearrange this polygon's vertices so that the topmost vertex comes first in its set of vertices. Now the plane defined by the world *up* normal and the first vertex stored in the leaf (which is in a known position) can be used to quickly cull collisions with the OBB before other, more expensive, tests are performed.

Other possible arrangements include sorting vertices so that the two vertices forming the longest edge come first, and placing the vertex first, which together with the polygon centroid (which is easily computed from the stored vertices) forms the bounding sphere of the polygon (the centroid being the sphere center and the vertex defining the sphere radius).

6.6.6 On Recursion

Traversing of trees (binary or otherwise) is naturally expressed using recursion. However, as was pointed out in Section 6.3.2, recursion is not the most effective form in which to express the code. It suffers from a few other drawbacks. One problem is that exiting the recursion and immediately returning a value is not directly supported in most languages. Using a flag variable to tell the code to exit is not just an overly complicated and contrived solution but requires the recursion to "unwind" all the way to the top.

The ideal solution is to rewrite any recursive code using explicit stacking, in the manner described in Section 6.3.2. As the code is no longer recursive, it is possible to exit the function at any time. Further benefits include the ability to interrupt and resume the code at any point by simply saving away a few variable values. Having an explicit stack pointer makes it easy to detect bugs in the traversal code that might otherwise have caused an infinite recursion, and the code is overall easier to step through during debugging. An explicit stack pointer also implicitly provides a stack depth, making it easy to limit traversals to a specified maximum depth if so desired.

Not using recursion also avoids the overhead of recursive function calls. It is also likely to use less stack space, as only one stack frame for the local variables is ever created, reducing possible data cache trashing.

All of these considerations aside, during early development much can be said for the benefits of using easy-to-read recursive code for quick prototyping and testing. Fortunately, in both C and C++ there are alternatives to using nonrecursive code just

to be able to make an early exit out of a recursive test query. In C (and to a lesser extent in C++) another option is to use the library function **setjmp()** to exit a recursion. The test query version of the recursive generic informed depth-first traversal code can now be written as:

```c
#include <setjmp.h>
jmp_buf gJmpBuf;

int BVHTestCollision(BVTree a, BVTree b)
{
    int r = setjmp(gJmpBuf);
    if (r == 0) {
        BVHTestCollisionR(a, b);
        return 0;
    } else return r - 1;
}
// Generic recursive BVH traversal code
// assumes that leaves too have BVs
void BVHTestCollisionR(BVTree a, BVTree b)
{
    if (!BVOverlap(a, b))
        longjmp(gJmpBuf, 0 + 1);  /* false */
    if (IsLeaf(a) && IsLeaf(b)) {
        if (PrimitivesOverlap(a, b))
            longjmp(gJmpBuf, 1 + 1);  /* true */
    } else {
        if (DescendA(a, b)) {
            BVHTestCollisionR(a->left, b);
            BVHTestCollisionR(a->right, b);
        } else {
            BVHTestCollisionR(a, b->left);
            BVHTestCollisionR(a, b->right);
        }
    }
}
```

Note that as **longjmp()** cannot return a value of 0 it also cannot return a *bool* value of false. To work around this slight complication, a small value (here 1) must be added to the returned value, to be subtracted off in the main routine. In C++, instead of using **setjmp()** a more appropriate choice might be to use exception handling to accomplish the same thing.

6.6.7 **Grouping Queries**

In games it is not uncommon to have a number of test queries originating from the same general area. A common example is testing the wheels of a vehicle for collision with the ground. Ideally, these queries can be prearranged into a hierarchy, allowing any of the previously described traversal methods to be used. However, in some cases it may be impractical to precompute a hierarchy. In the vehicle example, this is true perhaps because the vehicle morphs between various drastically different shapes, with bits potentially blown off.

Now if the wheels are tested for collision independently, because the vehicle is small with respect to the world the query traversals through the topmost part of the world hierarchy will most likely be the same. As such, it is beneficial to move all queries together through the world hierarchy up until the point where they start branching out into different parts of the tree.

One approach is to compute a hierarchy dynamically for the query objects, which will automatically move the objects as one. For just a few objects, such as four wheels, this is probably overkill. Instead, the objects can simply be grouped within a single bounding volume. This volume is then "dropped down" the hierarchy it is tested against until it reaches a node where it would have to be dropped down both children. At this point in the tree the current node can effectively be used as an alternative root node for the individual collision queries of the objects with the world hierarchy. Assuming the original individual queries were spheres tested against a world hierarchy, this would appear as follows.

```
Sphere s[NUM_SPHERES];
...
for (int i = 0; i < NUM_SPHERES; i++)
    if (SphereTreeCollision(s[i], worldHierarchy))
        ...
```

A simple addition to the **SphereTreeCollision()** routine allows an alternative start node to be used for the test.

```
bool SphereTreeCollision(Sphere s, Tree *root)
{
    // If an alternative start node has been set, use it;
    // if not, use the provided start root node
    if (gStartNode != NULL) root = gStartNode;

    ...original code goes here...
}
```

Then, by providing functionality to set and reset the alternative start node

```
// Specifies an alternative starting node, or none (if null)
Tree *gStartNode = NULL;

// Set a new alternative start node
void BeginGroupedQueryTestVolume(Sphere *s, Tree *root)
{
    // Descend into the hierarchy as long as the given sphere
    // overlaps either child bounding sphere (but not both)
    while (root != NULL) {
        bool OverlapsLeft = root->left && SphereOverlapTest(s, root->left.bvSphere);
        bool OverlapsRight = root->right && SphereOverlapTest(s, root->right.bvSphere);
        if (OverlapsLeft && !OverlapsRight) root = root->left;
        else if (!OverlapsLeft && OverlapsRight) root = root->right;
        else break;
    }
    // Set this as the new alternative starting node
    gStartNode = root;
}

// Reset the alternative start node
void EndGroupedQueryTestVolume(void)
{
    gStartNode = NULL;
}
```

the original code can now very easily be transformed into a grouped query, with substantial savings in traversal time.

```
Sphere s[NUM_SPHERES];
...
// Compute a bounding sphere for the query spheres
Sphere bs = BoundingSphere(&s[0], NUM_SPHERES);
BeginGroupedQueryTestVolume(bs, worldHierarchy);
// Do the original queries just as before
for (int i = 0; i < NUM_SPHERES; i++)
    if (SphereTreeCollision(s[i], worldHierarchy))
        ...
// Reset everything back to not used a grouped query
EndGroupedQueryTestVolume();
...
```

Note that the original query code remains the same. It has only been bracketed by the grouped query code, making it easy to post-fit this type of optimization to existing code.

The type of optimization done here can be seen as a form of caching, and it would be possible to keep track of the alternative starting node from frame to frame, incrementally updating it by moving up and down the tree as the group of objects moved. The next section looks further at caching as a means of optimizing collision queries.

6.7 **Improved Queries Through Caching**

Caching serves as a very important means of optimizing collision queries. The basic idea is very simple. By keeping track of various information about the last collision query (or queries) an object was involved in, that information can often be used in a subsequent query to speed it up by "jump-starting" the calculations, thanks to the spatial and temporal coherence objects tend to exhibit.

The information cached can be classified in two types: *positive* (meaning it helps in more quickly detecting that the two objects are colliding) and *negative* (meaning it aids in determining the separation of the two objects). Specific pieces of information that can help quickly answer decision problems are referred to as *witnesses*.

In addition to caching witnesses and start nodes in hierarchies, caching can also be used for instance to keep track of both upper and lower distance bounds as an aid to excluding or including objects from further query processing. The caching ideas presented in the following sections are in no way intended as a full coverage but as a means of conveying through a few examples how caching can be used.

To facilitate caching it is helpful to associate an identity number with each unique query. This number can then serve as a key for a hash table in which the cached data is kept.

Something to keep in mind is that game restarts, object teleportation, activation or deactivation, and similar events can potentially wreak havoc on a caching system. It is important that cache structures are reset or invalidated whenever required by exception events such as the foregoing.

6.7.1 **Surface Caching: Caching Intersecting Primitives**

The most obvious caching scheme is to store one or more overlapping primitives from each object when the objects are found colliding. These primitives serve as witnesses of the collision. The next time the same two objects are tested for overlap these cached primitives can be tested first to see if they are still in collision. If so, a test query can immediately return without having to examine the full hierarchies, worst case. The drawback is that this type of caching method only works for test queries. If for instance all contacts are needed, no caching scheme of this type is able to provide a correct answer.

There are two possible cache organizations for holding the stored primitives: a shared or a distributed cache. A shared cache is a global cache that contains any number of pair entries. A distributed cache is a local cache wherein the primitives are stored within the objects themselves.

A shared cache is typically implemented as a hash table wherein the colliding primitives are registered under a key constructed from the two object IDs (such as their pointer addresses). The benefit with a shared cache is that the system easily handles an object being involved in any number of collisions. Drawbacks include the cost of performing a hash table lookup to see if there is a pair, and having to remove the pair when the objects are no longer in collision. The latter can be a quite difficult problem, and is typically handled using a lazy updating scheme in which the pair is deleted only when a subsequent query fails. Unfortunately, this solution keeps dead pairs in the cache for longer than necessary, filling the cache and potentially causing degenerate behavior.

The benefit of a distributed cache is that cached primitives are instantly available. However, if only a single primitive is cached per object the contact with multiple objects will cause the cache to be prematurely flushed, rendering it useless. For instance, assume there are three objects in a row: A, B, and C. A is in contact with B, which in turn is in contact with C. When A and B are first tested, a witness primitive from A is stored in A, and a witness primitive from B in B. Then B is tested against C, and a different witness primitive from B is stored in B, flushing the previously stored primitive. When A and B are tested again, the two cached primitives do not collide and a full collision pass has to be performed [Rundberg99].

This problem can be addressed by increasing the number of primitives that can be cached within an object. However, by allowing n primitives to be cached, up to n^2 tests will now have to be performed to determine if the objects are colliding. As such, n is limited to about two to six primitives for practical reasons. A shared or global collision cache could be implemented as in the following code fragment.

```
int ObjectsCollidingWithCache(Object a, Object b)
{
    // Check to see if this pair of objects is already in cache
    pair = FindObjectPairInCache(a, b);
    if (pair != NULL) {
        // Is so, see if the cached primitives overlap; if not,
        // lazily delete the pair from the collision cache
        if (PrimitivesOverlapping(pair->objAPrimitives, pair->ObjBPrimitives))
            return COLLIDING;
        else DeleteObjectPairFromCache(a, b);
    }
    // Do a full collision query, that caches the result
    return ObjectCollidingCachePrims(Object a, Object b);
}
```

```
int ObjectCollidingCachePrims(Object a, Object b)
{
    if (BVOverlap(a, b)) {
        if (IsLeaf(a) && IsLeaf(b)) {
            if (CollidePrimitives(a, b)) {
                // When two objects are found colliding, add the pair
                // along with the witness primitives to the shared cache
                AddObjectPairToCache(a, b);
                return COLLIDING;
            } else return NOT_COLLIDING;
        } else {
            ...
        }
    }
    ...
}
```

[Rundberg99] goes further than just testing the cached primitives. When the cached primitives do not overlap, he argues there is a chance that their neighboring primitives might be in collision and proceeds to test primitives around the cached primitives before eventually giving up and testing from the root. This of course assumes a representation in which neighboring primitives are easily accessible. Rundberg reports an average speedup of 1.1 to 2.0, with no slowdowns.

6.7.2 Front Tracking

A number of node-node comparisons are made when two object hierarchies are tested against each other. These node pairs can be seen as forming the nodes of a tree, the *collision tree*. For informed and alternating descent rules, the collision tree is binary; for the simultaneous descent rule, it is a 4-ary tree.

When the two objects are not colliding, as tree traversal stops when a node-node pair is not overlapping, all internal nodes of the collision tree correspond to colliding node-node pairs, and the leaves are the node-node pairs where noncollision was first determined.

Consequently, the collection of these leaf nodes, forming what is known as the *front* of the tree, serves as witness to the disjointedness of the two objects (Figure 6.9).

As objects typically move smoothly with respect to each other, this front can for the most part be expected to stay the same or just change locally. Therefore, instead of repeatedly building and traversing the collision tree from the root, this coherence can be utilized by keeping track of and reusing the front between queries, incrementally updating only the portions that change, if any.

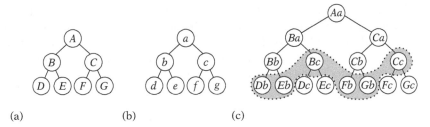

Figure 6.9 (a) The hierarchy for one object. (b) The hierarchy for another object. (c) The collision tree formed by an alternating traversal. The shaded area indicates a front in which the objects are (hypothetically) found noncolliding.

Following Li and Chen [Li98], assume the front contains n leaf nodes and that the collision tree is binary (implying that, for instance, "descend larger" is used as the descent rule). In a binary tree of n leaves, it is easy to show the number of internal nodes is $n - 1$. When a front is maintained, if the front moves down these internal nodes correspond to the work saved in using the front as a starting point as opposed to testing from the root.

If no front nodes move, which only happens when their parent nodes remain in collision, at least the $n/2$ parent nodes have to be checked for collision. The total number of nodes tested starting from the front is $n + n/2 = 3n/2$. Again, this results in a saving over the $2n$ nodes tested in traversing from the root.

When the front nodes move up, the number of nodes examined depends on how many levels they move. If they move just one level, the total number of nodes tested is therefore $n + n/2 + n/4 = 7n/4$. However, in this case traversing from the root is significantly cheaper, as only an order of n nodes is tested, or exactly $n/2 + (n/2 - 1) = n - 1$.

Given the probabilities p_D, p_S, and p_U — for a node to move down, stay the same, or move up — the expected number of nodes saved by maintaining a separation list is

$$s = p_D n + p_S(2n - 3n/2) + p_U(n - 7n/4)$$
$$= p_D n + p_S n/2 - p_U 3n/4.$$

Assume it is equally likely for a front node to move up, stay the same, or move down, that is $p_D = p_S = p_U = 1/3$. The saved number of nodes is then just $s = n/4$, which is not quite as effective as one might first think.

Clearly, the majority of the cost in updating the front lies in checking whether a node is staying put or moving up in the collision tree. In addition, to be able to test parent nodes for overlap parent pointers would have to be maintained in the data structure holding the front.

Here Li and Chen suggest a clever alternative approach. They simply examine the size of the front (measured in number of nodes) from one query to the next. If the

size increases, they predict the objects are getting closer and they keep the front for the next query. If instead the size stays the same, they predict the objects are moving away and the front is rebuilt from scratch in the next query. This way, parent nodes of the nodes in the front are never examined, and thus the major cost is avoided. An analysis similar to the previous gives the new cost function as

$$s = p_D n + p_S n - p_U 0,$$

which for $p_D = p_S = p_U = 1/3$ is $s = 2n/3$, a drastic improvement. More importantly, this function is nonnegative for any probability distribution and thus this method should never perform worse than a traversal from the root.

To avoid a full rebuild in volatile situations in which the front would move up only to immediately move down, they further propose deferring the rebuild by one query. In effect, the front is rebuilt from scratch if it has not grown for two consecutive queries. From their tests on a sphere tree, Li and Chen report an average speedup of 40% for the basic front-updating method. With deferred updating, they achieved an average speedup of 84%, not far from the optimal speedup of 100%. When updating was deferred for more than one query, performance degraded.

Overall, because the saving is proportional to the number of leaf nodes in the front maintaining a front is more useful for larger hierarchies. For small hierarchies in which only a few nodes can be skipped, the overhead is likely to exceed any savings.

6.8 **Summary**

Bounding volume hierarchies can be used to accelerate both broad- and narrow-phase processing. As a broad-phase method, BVHs are constructed to hold the objects in a scene and to cull groups of distant objects (when the groups' bounding volumes do not intersect the query object's bounding volume). As a narrow-phase method, BVHs are constructed over the parts of an (often complex) object, allowing pairwise tests to restrict primitive-primitive tests to those parts of the objects whose bounding volumes overlap.

This chapter looked at desired characteristics for BVHs. It also explored three classes of construction strategies for BVHs: top-down, bottom-up, and insertion-based construction methods. For top-down methods it becomes important to perform successive partitionings of objects into subgroups, and several partitioning strategies were suggested. Three types of traversal methods were also explored: breadth-first, depth-first, and best-first search orderings. When two BVHs are tested against each other it is meaningful to consider in what order the subtrees are visited, and in this regard several descent rules were stated.

The end of the chapter explored the efficiency of tree representations and traversals. These topics are revisited in Chapter 13.

Chapter 7

Spatial Partitioning

Recall from Chapter 2 that pairwise processing is expensive, and that the idea of broad-phase processing is to restrict pairwise tests to objects near enough that they could possibly intersect. *Spatial partitioning* techniques provide broad-phase processing by dividing space into regions and testing if objects overlap the same region of space. Because objects can only intersect if they overlap the same region of space, the number of pairwise tests is drastically reduced. This chapter explores three types of spatial partitioning methods: grids, trees, and spatial sorting.

7.1 Uniform Grids

A very effective space subdivision scheme is to overlay space with a regular grid. This grid divides space into a number of regions, or grid cells, of equal size. Each object is then associated with the cells it overlaps. As only objects overlapping a common cell could possibly be in contact, in-depth tests are only performed against those objects found sharing cells with the object tested for collision. The farther apart two objects are the less likely they overlap the same cells, and with an appropriately spaced grid only objects very likely to overlap would be subject to further pairwise tests.

Thanks to the uniformity of the grid, accessing a cell corresponding to a particular coordinate is both simple and fast: the world coordinate values are simply divided by the cell size to obtain the cell coordinates. Given the coordinates to a specific cell, neighboring cells are also trivial to locate. This conceptual as well as implementational simplicity has made grids both a good and popular choice for space subdivision. Grids are known by many other names, including regions, buckets, sectors, and zones.

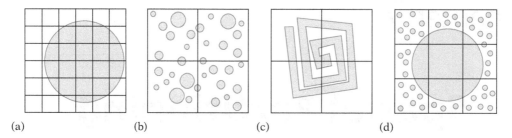

(a) (b) (c) (d)

Figure 7.1 Issues related to cell size. (a) A grid that is too fine. (b) A grid that is too coarse (with respect to object size). (c) A grid that is too coarse (with respect to object **complexity**). (d) A grid that is both too fine and too coarse.

7.1.1 Cell Size Issues

In terms of performance, one of the most important aspects of grid-based methods is choosing an appropriate cell size. There are four issues related to cell size that can hamper performance (Figure 7.1).

1. *The grid is too fine.* If the cells are too small, a large number of cells must be updated with associativity information for the object, which will take both extra time and space. The problem can be likened to fitting elephant-size objects into matchbox-size cells. Too fine of a grid can be especially bad for moving objects, due to the number of object links that must be both located and updated.

2. *The grid is too coarse (with respect to object size).* If the objects are small and the grid cells are large, there will be many objects in each cell. As all objects in a specific cell are pairwise tested against each other, a situation of this nature can deteriorate to a worst-case all-pairs test.

3. *The grid is too coarse (with respect to object complexity).* In this case, the grid cell matches the objects well in size. However, the object is much too complex, affecting the pairwise object comparison. The grid cells should be smaller and the objects should be broken up into smaller pieces, better matching the smaller grid cell size.

4. *The grid is both too fine and too coarse.* It is possible for a grid to be both too fine and too coarse at the same time. If the objects are of greatly varying sizes, the cells can be too large for the smaller objects while too small for the largest objects.

Case 4 is addressed in more detail in Section 7.2, on hierarchical grids. Taking the remaining cases into consideration, cell size is generally adjusted to be large enough (but not much larger) to fit the largest object at any rotation. This way, the number of cells an object overlaps is guaranteed to be no more than four cells (for a 2D grid; eight for a 3D grid). Having objects overlap only a small number of cells is important.

It limits the amount of work required to insert and update objects in the grid, and to perform the actual overlap tests.

Under the normal assumption of frame-to-frame noninterpenetration of objects, with cells and objects being almost the same size the maximum number of objects in a cell is bounded by a small constant. Consequently, resolving collisions within a cell using an all-pairs approach results in only a small number of pairwise object tests.

With cell size selected, grid dimensions are determined by dividing the diameter of the simulation space by the diameter of the cells. If memory use for storing the grid itself is a concern, the cell size can be increased at the cost of possible decreased performance. However, more grid cells do not necessarily have to translate into use of more memory (more on this in the following sections).

In ray tracing a popular method for determining the grid dimensions has been the $n^{1/3}$ rule: given n objects, divide space into a $k \times k \times k$ grid, with $k = n^{1/3}$. The ratio of cells to objects is referred to as the *grid density*. Recent results indicate that a density of 1 is not very good, and a much higher density is suggested [Havran99].

It is sometimes claimed that it is difficult to set a near-optimal cell size, and that if cell size is not correctly set grids become expensive in terms of performance or prohibitively memory intensive (see, for example, [Cohen95]). Practical experience suggests that this is not true. In fact, for most applications although it is easy to pick bad parameter values it is equally easy to pick good ones.

7.1.2 Grids as Arrays of Linked Lists

The natural way of storing objects in a grid is to allocate an array of corresponding dimension, mapping grid cells to array elements one-to-one. To handle the case of multiple objects ending up in a given cell, each array element would point to a linked list of objects, or be NULL if empty. If objects are inserted at the head of the list, insertion is trivially $O(1)$. For a single-linked list, updating and deletion of an arbitrary object is $O(n)$. However, updating and deletion can also be made $O(1)$ by using a double-linked list and having the objects maintain direct pointers to the linked-list entries of all cells the objects are in.

The easiest way of maintaining these linked lists is to embed the links within the objects themselves. When the maximum number of cells overlapped by an object has been limited by an appropriate choice of cell size, object-embedded links are a good solution that both improves data cache coherency and simplifies the code by avoiding the need for a specific system for allocation of link cells.

A drawback with using a dense array of this type is that for large grids just storing the list headers in each grid cell becomes prohibitive in terms of memory requirements. Making the grid cells larger is not a good solution, in that this will lower performance in areas in which objects are clustered — the most important case to handle. The next few sections present some alternative grid representations with lower memory requirements.

7.1.3 **Hashed Storage and Infinite Grids**

Perhaps the most effective alternative to using a dense array to store the grid is to map each cell into a hash table of a fixed set of n buckets (Figure 7.2). In this scheme, the buckets contain the linked lists of objects. The grid itself is conceptual and does not use any memory. An example of a simple multiplicative hash function, mapping a tuple consisting of the cell position coordinates into a bucket index, follows.

```
// Cell position
struct Cell {
    Cell(int32 px, int32 py, int32 pz) { x = px; y = py; z = pz; }
    int32 x, y, z;
};

#define NUM_BUCKETS 1024

// Computes hash bucket index in range [0, NUM_BUCKETS-1]
int32 ComputeHashBucketIndex(Cell cellPos)
{
    const int32 h1 = 0x8da6b343; // Large multiplicative constants;
    const int32 h2 = 0xd8163841; // here arbitrarily chosen primes
    const int32 h3 = 0xcb1ab31f;
    int32 n = h1 * cellPos.x + h2 * cellPos.y + h3 * cellPos.z;
    n = n % NUM_BUCKETS;
    if (n < 0) n += NUM_BUCKETS;
    return n;
}
```

Note that it is surprisingly easy to construct hash functions that although perhaps not bad, are just not very good (and there are no guarantees the previous hash function is particularly strong). For information on constructing more sophisticated hash functions see [Binstock96], [Jenkins97], or [Knuth98].

Performing a hash mapping of this type has the added benefit of allowing the grid to be unbounded in size. The mapping function wraps world coordinates into a finite number of cells (thereby making boundary checks for accessing neighboring cells unnecessary). Although the world may consist of an infinite amount of cells, only a finite number of them are overlapped by objects at a given time. Thus, the storage required for a hashed grid is related to the number of objects and is independent of the grid size.

To avoid having to perform a hash table lookup to find out that a cell is in fact empty and is not in the table, a dense bit array with 1 bit per cell in the grid can be used as a quick pretest indicator of whether a cell is empty or not. (Of course, this optimization is only possible by keeping the grid fixed in size.)

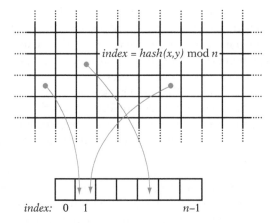

Figure 7.2 A (potentially infinite) 2D grid is mapped via a hash function into a small number of hash buckets.

To handle collisions (the mapping of two keys to the same bucket) in the hash table, two methods are traditionally used: *open hashing* and *closed hashing*. In open hashing (also known as *separate chaining*), each bucket is allowed to contain a linked list of records. When a new entry is added to the hash table, the bucket index is computed and the entry is added at the start of the linked list of the corresponding bucket. Each of the stored records contains a key along with associated data. In this case, the key would be the original cell coordinates and the data would be the head of a linked list of objects contained in that cell. As this representation ends up with buckets containing lists of lists, the code for updating the data structure as objects are added or deleted from a grid cell and its corresponding bucket becomes slightly more complicated than desired.

In contrast, closed hashing (or *open addressing*) stores records directly within the hash buckets themselves. When the computed bucket index of a new entry points at an occupied bucket, new bucket indices are computed (in a consistent manner) until an empty bucket is found and the record is inserted. The simplest such method, known as *linear probing*, simply tries subsequent buckets until one is found, wrapping around at the end of the hash table if necessary. Although linear probing has good cache behavior, it performs poorly as the hash table fills. Using linear probing, hash table utilization should not be much higher than 50% for good performance. Other, better but more complicated, probing approaches exist. See [Knuth98] for a detailed analysis of the behavior of linear probing and alternative probing methods.

A problem with closed hashing is that objects cannot be directly deleted from the hash table, but must be lazily deleted to avoid having subsequent searches fail. A lazy deletion involves marking the slot so that it is free for an insertion yet is not considered empty, which would (incorrectly) terminate a search of the hash table for some other object.

A third solution is to use the open hashing method but exclude the first-level linked list and have the buckets directly contain a list of objects. This results in very simple code with low overhead, but the lack of a stored key introduces two problems that must be addressed. First, when performing tests against the content of a specific cell it is now possible its bucket will contain both objects of interest as well as those from other cells, which happened to map to the same bucket. To avoid spending time peforming expensive narrow-phase tests on distant objects, in-depth tests must be preceded by a bounding volume test to cull irrelevant objects. Such culling is a good overall strategy anyway, in that nonoverlapping objects can share buckets regardless of hash table representation.

Second, a related problem occurs when several cells are tested by the same query. If two or more of the cells have been aliased to the same nonempty hash bucket, its content will be checked several times for the same query. Fortunately, this seemingly serious problem is easily solved by a time-stamping method in which hash buckets are labeled each time they are queried. The label consists of a unique identifier that changes for each query made. During a query, if a hash bucket is found labeled with the current identifier the bucket has already been examined and can be ignored. Time stamping is further described in Section 7.7.2.

A different approach to extending a grid when an object moves out of the region covered by the grid is described in [Reinhard00]. Separating the grid into both logical and physical parts, the logical grid is allowed to grow as the object moves outside the grid. However, the extra cells thus introduced are mapped onto the existing physical grid through a toroidal wrapping of logical cell coordinates modulo the size of the physical grid. The size of the logical grid now determines whether an object near the physical grid boundary must consider collisions against objects in its toroidal neighbor cells on the opposite side of the grid.

7.1.4 Storing Static Data

When grid data is static, such as when it represents world polygon data instead of dynamic objects, the need for a linked list can be removed altogether [Haines99]. Rather than storing the data in linked lists, the idea is to store all cell data in a single contiguous array. Figure 7.3 illustrates the same grid with the data stored using linked lists (a) and into an array (b).

The grid data can be assigned to an array in a two-pass process. In the first pass, the static data is iterated over, but instead of assigning the data to overlapped grid cells only a counter per cell is incremented when data would normally have been assigned to the cell. After all data is processed, counts have thereby been obtained for all n grid cells, with a_k indicating the number of objects in cell C_k. At this point an array of m elements

$$m = \sum_{0 \le i < n} a_i$$

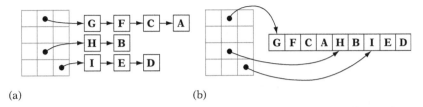

Figure 7.3 (a) A grid storing static data as lists. (b) The same grid with the static data stored into an array.

is allocated. Each cell is also associated with an index number b_k into this array, where

$$b_0 = 0$$
$$b_k = b_{k-1} + a_{k-1}.$$

The data is then in a second pass iterated over again. This time, the a_k objects overlapping cell C_k are stored with help from the associated index number into the array at indices b_k through $b_k + a_k - 1$. Because all data for each cell is stored contiguously in the array, and because no links are needed between the contiguous entries, the resulting array-based grid uses less memory and is more cache efficient than a representation based on linked lists.

7.1.5 Implicit Grids

An alternative to storing a grid explicitly is to store it implicitly, as the Cartesian product of two or more arrays. That is, the grid is now represented by two arrays (three in 3D), wherein one array corresponds to the grid rows and the other to the grid columns. As before, each array element points to a linked list of objects. An object is inserted into the grid by adding it to the lists of the grid cells it overlaps, for both the row and column array (Figure 7.4). Overlap testing for an object is now performed by checking to see if the object overlaps another object in *both* the row cells and the column cells it straddles.

Compared to the dense array representation, this scheme can result in either fewer or more list insertions. If the object is fully contained within a single grid cell of the implicit grid, it is inserted into two lists (one row and one column list), whereas in the previous scheme it would have been inserted in just one list. However, if the object were to overlap, say, 4×4 grid cells, it would be inserted into eight lists for the implicit grid (four row lists and four column lists) instead of 16, improving on the worst case. When objects overlap few cells the overlap test for this approach becomes more costly, not only because there are more objects in the lists that are being tested but because (many) more lists have to be checked.

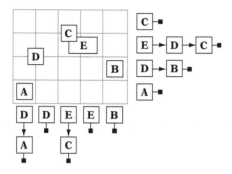

Figure 7.4 A 4 × 5 grid implicitly defined as the intersection of 9 (4 + 5) linked lists. Five objects have been inserted into the lists and their implied positions in the grid are indicated.

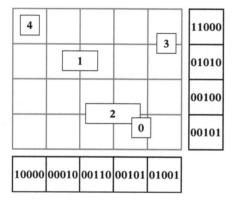

Figure 7.5 A 4 × 5 grid implicitly defined as the intersection of 9 (4 + 5) bit arrays. Five objects have been inserted into the grid. The bit position numbers of the bits set in a bit array indicate that the corresponding object is present in that row or column of the grid.

A more novel storage approach is to allocate, for each row and column of the grid, a bit array with 1 bit for each object in the world. Placing an object into the grid now simply involves setting the bit in the bit array in both the row and column bit arrays for the grid cell corresponding to the object (Figure 7.5).

An object exists in a grid cell if and only if the bit arrays of the row and column of the cell both have the bit corresponding to that object set. Testing for the presence of objects in a cell is therefore as simple as performing a bitwise AND operation on the two bit arrays.

When the query object overlaps several grid cells, the distributive properties of bitwise operators can be used to reduce the amount of computation needed. For example, assume an object overlaps rows r_i and r_{i+1} and columns c_j and c_{j+1}. The objects potentially intersected are given by the union of all bits set in the bitwise

intersection of each of the four grid cells (r_i, c_j), (r_i, c_{j+1}), (r_{i+1}, c_j), and (r_{i+1}, c_{j+1}). If **r[i]** and **c[j]** correspond to the bit masks of row cell i and column cell j, respectively, this method gives the resulting union **b** of bits as

```
b = (r[i] & c[j]) | (r[i] & c[j+1]) | (r[i+1] & c[j]) | (r[i+1] & c[j+1]);
```

However, the distributive properties of the bitwise operators allow this expression to be more efficiently computed as

```
b = (r[i] | r[i+1]) & (c[j] | c[j+1]);
```

This rewrite generalizes to an arbitrary number of cells overlapped, so that the bitwise OR of all overlapped row cells and of all column cells is first computed. Then the bitwise AND between the resulting bit fields gives the final result. This method is illustrated by the following code.

```
// Define the two global bit arrays
const int NUM_OBJECTS_DIV_32 = (NUM_OBJECTS + 31) / 32; // Round up
int32 rowBitArray[GRID_HEIGHT][NUM_OBJECTS_DIV_32];
int32 columnBitArray[GRID_WIDTH][NUM_OBJECTS_DIV_32];

void TestObjectAgainstGrid(Object *pObject)
{
    // Allocate temporary bit arrays for all objects and clear them
    int32 mergedRowArray[NUM_OBJECTS_DIV_32];
    int32 mergedColumnArray[NUM_OBJECTS_DIV_32];
    memset(mergedRowArray, 0, NUM_OBJECTS_DIV_32 * sizeof(int32));
    memset(mergedColumnArray, 0, NUM_OBJECTS_DIV_32 * sizeof(int32));

    // Compute the extent of grid cells the bounding sphere of A overlaps.
    // Test assumes objects have been inserted in all rows/columns overlapped
    float ooCellWidth = 1.0f / CELL_WIDTH;
    int x1 = (int)floorf((pObject->x - pObject->radius) * ooCellWidth);
    int x2 = (int)floorf((pObject->x + pObject->radius) * ooCellWidth);
    int y1 = (int)floorf((pObject->y - pObject->radius) * ooCellWidth);
    int y2 = (int)floorf((pObject->y + pObject->radius) * ooCellWidth);
    assert(x1 >= 0 && y1 >= 0 && x2 < GRID_WIDTH && y2 < GRID_HEIGHT);

    // Compute the merged (bitwise-or'ed) bit array of all overlapped grid rows.
    // Ditto for all overlapped grid columns
    for (int y = y1; y <= y2; y++)
```

```
        for (int i = 0; i < NUM_OBJECTS_DIV_32; i++)
            mergedRowArray[i] |= rowBitArray[y][i];
    for (int x = x1; x <= x2; x++)
        for (int i = 0; i < NUM_OBJECTS_DIV_32; i++)
            mergedColumnArray[i] |= columnBitArray[x][i];

    // Now go through the intersection of the merged bit arrays and collision test
    // those objects having their corresponding bit set
    for (int i = 0; i < NUM_OBJECTS_DIV_32; i++) {
        int32 objectsMask = mergedRowArray[i] & mergedColumnArray[i];
        while (objectsMask) {
            // Clears all but lowest bit set (eg. 01101010 -> 00000010)
            int32 objectMask = objectsMask & (objectsMask - 1);
            // Get index number of set bit, test against corresponding object
            // (GetBitIndex(v) returns log_2(v), i.e. n such that 2^n = v)
            int32 objectIndex = GetBitIndex(objectMask) + i * 32;
            TestCollisionAgainstObjectNumberN(objectIndex);
            // Mask out tested object, and continue with any remaining objects
            objectsMask ^= objectMask;
        }
    }
}
```

A simplified version of implicit grids using bit arrays can be used as a coarse broad-phase rejection method. Instead of having a bit array indicating exactly what objects are in each row and column of the grid, a single bit can be used to indicate the presence of an object in a row or column. If no bit is set for the rows and columns an object overlaps, the object cannot be in overlap and no further testing is necessary.

Table 7.1 illustrates memory use for three different grid representations: the implicit grid using bit arrays, a dense array (with double-linked lists), and a sparse array (also using double-linked lists). Up to roughly 1,000 objects and a grid size of 100 × 100, the implicit bit grid uses less memory than the other two representations. The implicit bit grid also uses memory in a cache-friendly way and is overall a very efficient spatial partitioning method.

7.1.6 **Uniform Grid Object-Object Test**

As mentioned earlier, grid cell sizes are usually constrained to be larger than the largest object. This way, an object is guaranteed to overlap at most the immediately neighboring cells, thereby greatly simplifying the overlap testing code. Still, a few key issues remain when it comes to assigning objects to cells and performing the

Table 7.1 Memory use (in bytes) for three different grid representations: implicit grid (with bit arrays), dense array (with double-linked list), and a sparse array (with double-linked list).

		Grid size ($m \times n$)		
	10×10	50×50	100×100	500×500
10	40	200	400	2,000
100	260	1,300	2,600	13,000
1,000	2,500	12,500	25,000	125,000
10,000	25,000	125,000	250,000	1,250,000
10	480	10,080	40,080	1,000,080
100	1,200	10,800	40,800	1,000,800
1,000	8,400	18,000	48,000	1,008,000
10,000	80,400	90,000	120,000	1,080,000
10	240	560	960	4,160
100	1,680	2,000	2,400	5,600
1,000	16,080	16,400	16,800	20,000
10,000	160,080	160,400	160,800	164,000

Objects in grid

Implicit grid (bit arrays):
$bytes = \lceil objects/8 \rceil (m + n)$

Dense array (double-linked list):
$bytes = 4mn + objects \cdot (4 + 4)$

Sparse array (double-linked list):
$bytes = 4(m + n) + objects \cdot (4 \cdot 2 + 4 \cdot 2)$

object-object tests. Should objects be placed in just one representative cell or all cells they overlap? If just one cell, what object feature should be used to determine which cell the object goes into? The next two sections look at these issues in the context of how the test queries are issued: if they are issued one at a time (allowing objects to move between successive tests) or if they are all issued simultaneously.

7.1.6.1 One Test at a Time

Consider the case in which objects are associated with a single cell only. When a given object is associated with its cell, in addition to testing against the objects associated with that cell additional neighboring cells must also be tested. Which cells have to be tested depends on how objects can overlap into other cells and what feature has been used to associate an object with its cell. The choice of feature generally stands between the object bounding sphere center and the minimum (top leftmost) corner of the axis-aligned bounding box.

If objects have been placed with respect to their centers, any object in the neighboring cells could overlap a cell boundary of this cell and be in collision with the current

object. Thus, regardless of which other cells (if any) the current object overlaps all neighboring cells and their contents must be tested for collision.

```
// Objects placed in single cell based on their bounding sphere center.
// Checking object's cell and all 8 neighboring grid cells:
check object's cell
check northwest neighbor cell
check north neighbor cell
check northeast neighbor cell
check west neighbor cell
check east neighbor cell
check southwest neighbor cell
check south neighbor cell
check southeast neighbor cell
```

This makes a total of nine cells tested (27 cells in 3D), which is not very promising. If instead the minimum corner of the axis-aligned bounding box has been used, most neighboring cells have to be tested only if the current object actually overlaps into them. The pseudocode for the 2D version of this test reads:

```
// Objects placed in single cell based on AABB minimum corner vertex.
// Checking object's "minimum corner" cell and up to all 8 neighboring grid cells:
check object's "minimum corner" cell
check north neighbor cell
check northwest neighbor cell
check west neighbor cell
if (object overlaps east cell border) {
    check northeast neighbor cell
    check east neighbor cell
}
if (object overlaps south cell border) {
    check southwest neighbor cell
    check south neighbor cell
    if (object overlaps east cell border)
        check southeast neighbor cell
}
```

At worst, all nine cells will still have to be checked, but at best only four cells have to be tested. This makes the minimum corner a much better feature for object placement than the center point. On the other hand, if objects have been placed in all cells they overlap the single object test would have to check only those exact cells

the AABB overlaps, as all colliding objects are guaranteed to be in those cells. The test would thus simply read:

```
// Objects placed in all cells overlapped by their AABB.
// Checking object's "minimum corner" cell and up to 3 neighboring grid cells:
check object's "minimum corner" cell
if (object overlaps east cell border)
    check east neighbor cell
if (object overlaps south cell border) {
    check south neighbor cell
    if (object overlaps east cell border)
        check southeast neighbor cell
}
```

Four tested cells is now the worst case, and a single cell the best case. Although this makes for the fastest test, it complicates the code for updating when objects move (having to update up to eight cells in a 3D grid) and is likely to use more memory than single-cell storage. In addition, collision between two objects can now be reported multiple times and thus pair collision status must be maintained (as discussed in Section 7.7.1).

7.1.6.2 All Tests at a Time

If instead of testing a single object at a time all objects are tested at the same time, the single-cell placement case can be optimized utilizing the fact that object pair checking is commutative. In other words, checking object A against object B is the same as checking object B against object A. For example, if objects in the current grid cell check for collision with the neighbor cell to the east, when the time comes for the east cell to check against its neighboring cells the cell to the west of it can safely be ignored. A consequence is that all objects that can be collided with must also test for collisions *against* other objects. In other words, this scheme does not allow checking just a single moving object in a static grid of objects. It is important that all possible overlap relationships between cells be covered by the performed tests. For instance, a common mistake is to assume that the NE-versus-SW cell relationship does not have to be tested. However, this is a flawed assumption because two objects assigned to cells A and B are colliding in a third cell C (Figure 7.6).

Returning to the case in which objects are placed on the center point, all neighbors now do not have to be checked. It is sufficient to check half the neighbors and let the remaining half of directionally opposing tests be covered by the commutativity relation. The test could therefore simply read:

```
// Objects placed in single cell based on their bounding sphere center.
// All objects are checked for collisions at the same time, so collisions
```

Figure 7.6 Objects *A* and *B* are assigned to a cell based on the location of their top left-hand corners. In this case, overlap **may** occur in a third cell. Thus, to detect intersection between objects cells must be tested against their NE or SW neighbor cells.

```
// in the opposite direction will be handled when checking the objects
// existing in those cells.
check object's cell
check east neighbor cell
check southwest neighbor cell
check south neighbor cell
check southeast neighbor cell
```

This approach requires that all objects are tested, and thus these five tests cannot be combined with any border overlap test (as was done earlier), because that would prevent some necessary tests from occurring. For example, say object *A* does not overlap into the east neighbor cell and that the neighbor cell is not tested against. However, there could still be an object *B* in the east cell that overlaps into the cell to its west (overlapping with object *A*), but because the east cell does not test against its west neighbor any overlap between *A* and *B* would go undetected. Furthermore, as some (but not all) collisions will be detected twice per frame this approach would require that overlap status be recorded (for instance in a collision-pair matrix).

The case in which objects are placed in a single cell based on the minimum corner point can be similarly simplified. Here, however, border overlap tests can be used to minimize the number of neighboring cells checked further. This test now reads:

```
// Objects placed in single cell based on AABB minimum corner vertex.
// All objects are checked for collisions at the same time, so collisions
// in the opposite direction will be handled when checking the objects
// existing in those cells.
check object's "minimum corner" cell
check southwest neighbor cell
if (object overlaps east cell border)
    check east neighbor cell
if (object overlaps south cell border) {
    check south neighbor cell
```

```
        if (object overlaps east cell border)
            check southeast neighbor cell
    }
```

When testing neighboring cells, range checking of grid coordinates can be avoided by placing a layer of sentinels (dummy cells) around the border of the grid.

7.1.7 **Additional Grid Considerations**

Some issues relevant to efficient implementations remain. First, the presentation given here has implied that grids are kept from frame to frame and are incrementally updated. Although this is a good approach in general, arguments can also be made for a simpler approach in which the grid is simply cleared and all objects are readded from scratch each frame. For example, if most or all objects move, the latter operation may turn out cheaper than trying to update the grid data structure. Rebuilding the grid each frame also typically requires simpler data structures, which tends to reduce memory requirements (such as single-linked lists instead of double-linked lists). Readding all objects each frame also means objects can be tested as they are added, avoiding the potential problem of getting both *A-collides-with-B* and *B-collides-with-A* reported.

A second thing to keep in mind is that not all objects have to be added to the grid at all times. When testing distinct collision groups against each other, the objects of the first group can be directly added to the grid. Then, when testing the objects of the second group against the grid they do not have to be added to the grid at all. They only have to be used as query objects. An example of such a scenario is a group of enemy objects and another group of player bullets.

Last, it is worthwhile considering grid cell volumes and cell orientations different from those explored here. For instance, assume the grid is primarily used for performing line segment queries against a given set of objects in the plane (as discussed further in Section 7.4.2). Because lines at an angle may pass through more cells than do horizontal or vertical lines, it would be possible to have two grids, both containing the same set of objects but one grid at a 45-degree relative orientation to the other. Based on the orientation of a given line segment, the appropriate grid can now be used for the intersection query to improve efficiency.

Similarly, compare the regular uniform grid and the staggered hexagonal-like grid cell arrangement shown in Figure 7.7. Assume the spherical objects *A* and *B* are at most half the size of the grid cell side, are assigned to a single cell, and are tested one at a time. In this scenario, if the objects are placed using their centers *A* must check collisions against nine cells whereas *B* would have to check against just seven cells. If instead *A* and *B* were boxes, assigned using the top left-hand corner, *A* would have to test against five cells (center, east, south, southeast, and either northwest or southwest) and *B* only four cells (center, east, southwest, and southeast).

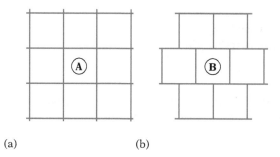

(a) (b)

Figure 7.7 (a) In a regular grid, grid cell *A* has eight neighbors. (b) In a **hexagonal-type** grid, grid cell *B* has just six neighbors.

7.2 **Hierarchical Grids**

The most significant problem with uniform grids is their inability to deal with objects of greatly varying sizes in a graceful way. When objects are much larger than the grid cell size and end up overlapping many cells, updating the position of a moving object becomes very expensive. If the cell size is adjusted to hold the larger objects, the grid becomes less spatially discriminatory as more small objects now end up in the same cell, with loss of performance as a result. Fortunately, this size problem can effectively be addressed by the use of *hierarchical grids* (or *hgrids*), a grid structure particularly well suited to holding dynamically moving objects.

The hierarchical grid, as described here, consists of a number of grids of varying cell sizes, all overlapping to cover the same space. Depending on use, these grids can be either 2D or 3D. Given a hierarchy containing n levels of grids and letting r_k represent the size of the grid cells at level k in the hierarchy, the grids are arranged in increasing cell size order, with $r_1 < r_2 < \ldots < r_n$. Level 1 is the lowest level, and level n is the highest level. The number of levels does not have to be fixed.

To facilitate fast insert and delete operations, objects are inserted into a single cell on just one of the levels. As the objects can still extend into other cells on that level, to minimize the number of neighboring cells that have to be tested for collisions objects are inserted into the hgrid at the level where the cells are large enough to contain the bounding volume of the object. Given an object P, this level L is denoted $L = Level(P)$. This way, the object is guaranteed to overlap at most four cells (or eight, for a 3D grid). At this point, the object is inserted into the cell in which its center (based on the object bounding sphere) or top left-hand position (based on the object AABB) is in. An example of an hgrid of this type is shown in Figure 7.8.

The grid cells can assume any relative size and should ideally be selected with respect to existing object sizes. In practice, a simple procedure for setting up the

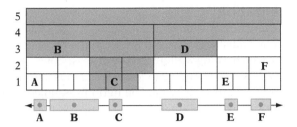

Figure 7.8 A small 1D hierarchical grid. Six objects, *A* through *F*, have each been inserted in the cell containing the object center point, on the appropriate grid level. The shaded cells are those that must be tested when performing a collision check for object *C*.

hierarchy works well. Let the cells at level 1 just encompass the smallest objects. Then successively double the cell size so that cells of level $k + 1$ are twice as wide as cells of level k. Repeat the doubling process until the highest-level cells are large enough to encompass the largest objects. In general, this setup serves well to minimize the number of cells an object overlaps. It is still possible to do better in specific instances, however. For instance, if there are only two object sizes clearly two grid levels suffice.

Testing whether an arbitrary object *A* is in collision with objects stored in the hgrid is done by traversing through all hgrid levels. At each level, *A* is tested against not only those grid cells its bounding volume overlaps but those neighboring cells that could have objects extending into the cells that are overlapped (as discussed in Section 7.1.6). Note that it is not sufficient to check just the immediately neighboring cells to the cell the object is in. A large object, when checked against the grid, would cover a lot of cells at the lowest level and not just the immediate neighborhood.

If not just a single object, but all *n* objects are tested at the same time, testing does not have to proceed over all hgrid levels. Instead, each object can start testing from its insertion level. This follows, as smaller objects will test against the grid levels of larger objects.

Overall, the hgrid structure is not much different from a tree structure, such as an octree, implemented using arrays. However, one key feature that sets it apart from the tree structures is the lack of a tree "top." That is, the hgrid corresponds to just the last few levels of the tree. The top levels of a tree rarely contain any objects and are simply traversed just to reach the lower levels at which the objects reside. Hgrids avoid these empty levels and gain extra speed in doing so.

To speed up the collision testing further, it is worthwhile keeping track of the total number of objects on each grid level. Levels that contain no objects can then be excluded from testing.

Hgrids can be very memory expensive when each grid level is allocated as a dense array. For this reason they are best implemented using hashed storage, as described in Section 7.1.3.

7.2.1 **Basic Hgrid Implementation**

This section outlines a simple and straightforward implementation of an hgrid. The hash table approach used is open hashing without the use of keys. Consequently, both bounding volume tests as well as time stamping (Section 7.7.2) must be used to avoid processing irrelevant and already processed data. The hgrid is assumed to have the following minimal structure:

```
struct HGrid {
  uint32 occupiedLevelsMask;          // Initially zero (Implies max 32 hgrid levels)
  int objectsAtLevel[HGRID_MAX_LEVELS]; // Initially all zero
  Object *objectBucket[NUM_BUCKETS];  // Initially all NULL
  int timeStamp[NUM_BUCKETS];         // Initially all zero
  int tick;
};
```

It is assumed that objects are inserted into the hgrid based on their bounding spheres. For the sake of simplicity, the given code links objects within a bucket using single-linked lists, with the list pointer embedded in the object. Use of a double-linked list would allow removal in $O(1)$ time, instead of $O(n)$ time. Associating each hgrid cell with an array (of object pointers) also allows removal in $O(1)$ time. The latter option requires some bookkeeping to handle the arrays overflowing, but is overall a faster and more cache-friendly option. Let the object representation contain the following variables.

```
struct Object {
    Object *pNextObject; // Embedded link to next hgrid object
    Point pos;           // x, y (and z) position for sphere (or top left AABB corner)
    float radius;        // Radius for bounding sphere (or width of AABB)
    int bucket;          // Index of hash bucket object is in
    int level;           // Grid level for the object
    ...                  // Object data
};
```

Cells are here assumed to be square (cubical for a 3D hgrid). The ratio of the diameter of the largest sphere that goes into a cell at a particular level with respect to the cell side size is given by:

```
const float SPHERE_TO_CELL_RATIO = 1.0f/4.0f; // Largest sphere in cell is 1/4*cell size
```

The smaller the ratio is, the fewer cells must be examined at a given level, on average. However, it also means that the average number of objects per cell increases. An appropriate ratio is application specific. When traversing from level to level, the grid cell side increases by the following factor:

```
const float CELL_TO_CELL_RATIO = 2.0f;  // Cells at next level are 2*side of current cell
```

Adding an object into the hgrid now can be done as follows.

```
void AddObjectToHGrid(HGrid *grid, Object *obj)
{
    // Find lowest level where object fully fits inside cell, taking RATIO into account
    int level;
    float size = MIN_CELL_SIZE, diameter = 2.0f * obj->radius;
    for (level = 0; size * SPHERE_TO_CELL_RATIO < diameter; level++)
        size *= CELL_TO_CELL_RATIO;

    // Assert if object is larger than largest grid cell
    assert(level < HGRID_MAX_LEVELS);

    // Add object to grid square, and remember cell and level numbers,
    // treating level as a third dimension coordinate
    Cell cellPos((int)(obj->pos.x / size), (int)(obj->pos.y / size), level);
    int bucket = ComputeHashBucketIndex(cellPos);
    obj->bucket= bucket;
    obj->level = level;
    obj->pNextObject = grid->objectBucket[bucket];
    grid->objectBucket[bucket] = obj;

    // Mark this level as having one more object. Also indicate level is in use
    grid->objectsAtLevel[level]++;
    grid->occupiedLevelsMask |= (1 << level);
}
```

Removing an object from the hgrid is done in a corresponding manner.

```
void RemoveObjectFromHGrid(HGrid *grid, Object *obj)
{
    // One less object on this grid level. Mark level as unused if no objects left
    if (--grid->objectsAtLevel[obj->level] == 0)
        grid->occupiedLevelsMask &= ~(1 << obj->level);
```

```
    // Now scan through list and unlink object 'obj'
    int bucket= obj->bucket;
    Object *p = grid->objectBucket[bucket];
    // Special-case updating list header when object is first in list
    if (p == obj) {
        grid->objectBucket[bucket] = obj->pNextObject;
        return;
    }
    // Traverse rest of list, unlinking 'obj' when found
    while (p) {
        // Keep q as trailing pointer to previous element
        Object *q = p;
        p = p->pNextObject;
        if (p == obj) {
            q->pNextObject = p->pNextObject;    // unlink by bypassing
            return;
        }
    }
    assert(0);    // No such object in hgrid
}
```

Checking an object for collision against objects in the hgrid can be done as follows. It is assumed that nothing is known about the number of objects tested at a time, and thus all grid levels are traversed (except when it can be concluded that there are no more objects to be found in the grid).

```
// Test collisions between object and all objects in hgrid
void CheckObjAgainstGrid(HGrid *grid, Object *obj,
                         void (*pCallbackFunc)(Object *pA, Object *pB))
{
    float size = MIN_CELL_SIZE;
    int startLevel = 0;
    uint32 occupiedLevelsMask = grid->occupiedLevelsMask;
    Point pos = obj->pos;

    // If all objects are tested at the same time, the appropriate starting
    // grid level can be computed as:
    // float diameter = 2.0f * obj->radius;
    // for ( ; size * SPHERE_TO_CELL_RATIO < diameter; startLevel++) {
    //     size *= CELL_TO_CELL_RATIO;
    //     occupiedLevelsMask >>= 1;
    // }
```

```
    // For each new query, increase time stamp counter
    grid->tick++;

    for (int level = startLevel; level < HGRID_MAX_LEVELS;
                 size *= CELL_TO_CELL_RATIO, occupiedLevelsMask >>= 1, level++) {
        // If no objects in rest of grid, stop now
        if (occupiedLevelsMask == 0) break;
        // If no objects at this level, go on to the next level
        if ((occupiedLevelsMask & 1) == 0) continue;

        // Compute ranges [x1..x2, y1..y2] of cells overlapped on this level. To
        // make sure objects in neighboring cells are tested, by increasing range by
        // the maximum object overlap: size * SPHERE_TO_CELL_RATIO
        float delta = obj->radius + size * SPHERE_TO_CELL_RATIO + EPSILON;
        float ooSize = 1.0f / size;
        int x1 = (int)floorf((pos.x - delta) * ooSize);
        int y1 = (int)floorf((pos.y - delta) * ooSize);
        int x2 = (int) ceilf((pos.x + delta) * ooSize);
        int y2 = (int) ceilf((pos.y + delta) * ooSize);

        // Check all the grid cells overlapped on current level
        for (int x = x1; x <= x2; x++) {
            for (int y = y1; y <= y2; y++) {
                // Treat level as a third dimension coordinate
                Cell cellPos(x, y, level);
                int bucket = ComputeHashBucketIndex(cellPos);

                // Has this hash bucket already been checked for this object?
                if (grid->timeStamp[bucket] == grid->tick) continue;
                grid->timeStamp[bucket] = grid->tick;

                // Loop through all objects in the bucket to find nearby objects
                Object *p = grid->objectBucket[bucket];
                while (p) {
                    if (p != obj) {
                        float dist2 = Sqr(pos.x - p->pos.x) + Sqr(pos.y - p->pos.y);
                        if (dist2 <= Sqr(obj->radius + p->radius + EPSILON))
                            pCallbackFunc(obj, p);  // Close, call callback function
                    }
                    p = p->pNextObject;
                }
            }
        }
    } // end for level
}
```

When, as here, a callback is used to call a function to handle two colliding objects it is important that the callback function not change the hgrid data structure itself. Because **CheckObjAgainstGrid()** is in the middle of operating on the data structure, such changes would cause reentrancy problems, leading to missed collisions at best and crashes at worst.

7.2.2 Alternative Hierarchical Grid Representations

Even though the hgrid is a great improvement over the basic nonhierarchical grid, a problem remains. When objects are tested one at a time, a large object could cover a lot of cells on the lowest levels, making for an expensive test in that it is intersected against the contents of all of these cells. Two hgrid schemes that address this problem are given in [Mirtich96b, Mirtich97], by whom the hgrid is referred to as a *hierarchical spatial hash table*.

The first scheme is to insert the objects in order of decreasing size, such that all objects going into grid level k are inserted before those that go into level $k - 1$. With this restriction, the newly inserted object has to be tested only against cells on the level at which it is being inserted and against cells on higher levels. Lower levels do not have to be tested because they are by order of insertion empty. To handle the dynamic addition and deletion of objects, a separate data structure would be necessary to maintain the sorted insertion and testing order of existing objects. An example of this scheme is shown in Figure 7.9.

For the second scheme, objects are no longer inserted in a single cell on just one level. Instead, the object is inserted in *all* cells it overlaps, starting at the lowest grid level at which the cells are large enough to contain the object, repeating for all overlapped grid cells of higher-level grids.

In the second scheme, given a pair (A, B) of objects in the grid, determining if they overlap can now be done by testing if they share a common cell at level $L = \max(Level(A), Level(B))$. In other words, the test is if they overlap on the larger of the two initial insertion levels for the objects. No other levels have to be tested.

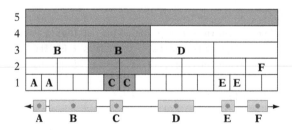

Figure 7.9 In Mirtich's (first) scheme, objects are inserted in all cells overlapped at the insertion level. As in Figure 7.8, the shaded cells indicate which cells must be tested when performing a collision check for object *C*.

In that this test relies on knowing which pairs to test, pair information has to be tracked separately. Whenever an object A is stored in a grid cell containing another object B, a counter corresponding to the pair (A, B) is incremented, and the pair is added to the tracking data structure. When either object moves out of one of their common cells, the counter is decremented. When the counter reaches zero, the pair is removed from the tracking data structure because they are no longer close. Only pairs in the tracking data structure undergo narrow-phase collision detection checking. The cost of moving an object is now much larger, but thanks to spatial coherence the larger grid cells have to be updated only infrequently. Overall, this scheme trades the cost of updating cells for the benefit of having to test fewer grid cells.

7.2.3 **Other Hierarchical Grids**

As presented, a drawback with the hierarchical grid is that it is not very appropriate for handling world geometry, which often consists of large amounts of unevenly distributed small static data. Representing the lowest-level grid as a dense grid will be extremely expensive is terms of storage. Similarly, a sparse representation using hashing is likely to cause slowdown when a large number of cells is intersected due to cache misses and the extra calculations involved. For this particular type of problem, other types of hierarchical grids are more suited. Many of these have their origins in ray tracing.

Of these, the most straightforward alternative is the *recursive grid* [Jevans89]. Here, a uniform grid is constructed over the initial set of primitives. For each grid cell containing more than some k primitives, a new, finer, uniform grid is recursively constructed for that cell. The process is stopped when a cell contains less than some m objects or when the depth is greater than n (usually 2 or 3). Compared to the original hgrid, the lowest-level grids no longer span the world and they will require less memory for a dense grid representation.

Two other grid alternatives are *hierarchy of uniform grids* [Cazals95] and *adaptive grids* [Klimaszewski97]. Both of these use object clustering methods to identify groups of primitives that should be contained within their own subgrids inside a larger uniform grid. More information and a thorough comparison of these two and other methods can be found in [Havran99].

7.3 **Trees**

Trees were discussed in the previous chapter in the context of bounding volume hierarchies. Trees also form good representations for spatial partitioning. This section explores two tree approaches to spatial partitioning: the octree and the k-d tree.

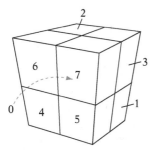

Figure 7.10 Numbering of the eight child nodes of the root of an octree.

7.3.1 **Octrees (and Quadtrees)**

The archetypal tree-based spatial partitioning method is the *octree*. It is an axis-aligned hierarchical partitioning of a volume of 3D world space. As the name suggests, each parent node in the octree has eight children. Additionally, each node also has a finite volume associated with it. The root node volume is generally taken to be the smallest axis-aligned cube fully enclosing the world. This volume is then subdivided into eight smaller equal-size subcubes (also called cells, octants, or cubelets) by simultaneously dividing the cube in half along each of the x, y, and z axes (Figure 7.10). These subcubes form the child nodes of the root node. The child nodes are, in turn, recursively subdivided in the same fashion. Typical criteria for stopping the recursive creation of the octree include the tree reaching a maximum depth or the cubes getting smaller than some preset minimum size. By virtue of construction, the associated volume of space for each node of the tree fully contains all descendant nodes.

Even though the geometric boundaries of a node can, for instance, be passed down and refined as the octree is traversed, the node structure is often enhanced to contain both node position and extent. This simplifies tree operations at the cost of extra memory. In addition, if the requirement for splitting into eight child volumes of equal size is relaxed to allow off-center splitting independently on all three axes, this volume information must be stored in the nodes.

```
// Octree node data structure
struct Node {
    Point center;         // Center point of octree node (not strictly needed)
    float halfWidth;      // Half the width of the node volume (not strictly needed)
    Node *pChild[8];      // Pointers to the eight children nodes
    Object *pObjList;     // Linked list of objects contained at this node
};
```

The analogous structure to the octree in two dimensions is known as a *quadtree*. The world is now enclosed in an axis-aligned bounding square, and is subdivided into four smaller squares at each recursive step.

Just as binary trees can be represented in a flat array without using pointers, so can both quadtrees and octrees. If the tree nodes are stored in the zero-based array **node[N]**, then being at some parent node **node[i]**, the children would for a quadtree be **node[4*i+1]** through **node[4*i+4]** and for an octree **node[8*i+1]** through **node[8*i+8]**. This representation requires the tree being stored as a complete tree.

Where a complete binary tree of n levels has $2^n - 1$ nodes, a complete d-ary tree of n levels has $(d^n - 1) / (d - 1)$ nodes. Using this type of representation, a complete seven-level octree would require just short of 300,000 nodes, limiting most trees to five or possibly six levels in practice.

As the tree must be preallocated to a specific depth and cannot easily grow further, the array representation is more suitable for static scenes and static octrees. The pointer-based representation is more useful for dynamic scenes in which the octree is constantly updated.

7.3.2 Octree Object Assignment

Octrees may be built to contain either static or dynamic data. In the former case, the data may be the primitives forming the world environment. In the latter case, the data is the moving entities in the world.

In the static scenario, it is straightforward to form the octree using top-down construction. Initially, all primitives in the world are associated with the root volume. As the root volume is split, the set of primitives is reassigned to the child cells it overlaps, duplicating the primitives when they overlap more than one cell. The procedure is repeated recursively, with the stopping criteria of not subdividing cells containing fewer than some fixed number of primitives or when primitives are assigned to all of the children (obviating further subdivision).

Determining to which child volumes to assign a primitive can be done by first dividing the primitives by the octree x-axis partitioning plane, splitting any straddling primitives into two parts, one for each side. Both sets are then similarly split for the y-axis partitioning plane, and the resulting four sets are split once more by the z-axis plane. The eight final sets are then assigned to the corresponding child node. Whether a primitive must be split by a given partitioning plane is determined by testing to see if it has vertices on both sides of the plane. Splitting of polygon primitives is discussed in detail in Section 8.3.4.

An alternative assignment approach is not to split the primitives. Instead, for each child volume and each primitive a full AABB-primitive overlap test is performed to see if the primitive should be assigned to that volume. Although perhaps a conceptually simpler method, this test is more expensive.

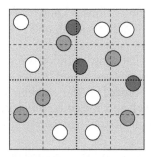

Figure 7.11 A quadtree node with the first level of subdivision shown in black dotted lines, and the following level of subdivision in **gray** dashed lines. Dark **gray** objects overlap the first-level dividing planes and become stuck at the current level. Medium **gray** objects propagate one level down before becoming stuck. Here, **only** the white objects descend two levels.

To avoid duplication of geometry between multiple octree nodes, the original set of primitives is stored in an array beforehand and a duplicate set of primitives is passed to the construction function. Each of the duplicate primitives is given a reference to the original primitive. When primitives are split, both parts retain the reference to the original primitive. As tree leaf nodes are generated, rather than storing the split-up duplicate geometry the references to the original set of primitives are stored. As the tree is static, this work is best done in a preprocessing step.

Duplicating the primitives across overlapped octants works great for a static environment. However, this approach is inefficient when the octree holds dynamic objects because the tree must be updated as objects move. For the dynamic scenario, a better approach is to restrict placement of objects to the lowest octree cell that contains the object in its interior. By associating the object with a single cell only, a minimum amount of pointer information must be updated when the object moves. A drawback of restricting objects to lie within a single octree cell is that objects may be higher in the tree than their size justifies. Specifically, any object straddling a partitioning plane will become "stuck" at that level, regardless of the relative size between the object and the node volume (Figure 7.11). This problem is addressed later. From here on, it is assumed the octree is of the dynamic variety.

The octree can begin as an empty tree grown on demand as objects are inserted. It can also be preallocated to alleviate the cost of dynamically growing it. Given the previous octree node definition, preallocating a pointer-based octree down to a specified depth can be done as:

```
// Preallocates an octree down to a specific depth
Node *BuildOctree(Point center, float halfWidth, int stopDepth)
{
    if (stopDepth < 0) return NULL;
```

```
    else {
        // Construct and fill in 'root' of this subtree
        Node *pNode = new Node;
        pNode->center = center;
        pNode->halfWidth = halfWidth;
        pNode->pObjList = NULL;

        // Recursively construct the eight children of the subtree
        Point offset;
        float step = halfWidth * 0.5f;
        for (int i = 0; i < 8; i++) {
            offset.x = ((i & 1) ? step : -step);
            offset.y = ((i & 2) ? step : -step);
            offset.z = ((i & 4) ? step : -step);
            pNode->pChild[i] = BuildOctree(center + offset, step, stopDepth - 1);
        }
        return pNode;
    }
}
```

Because objects have been restricted to reside in a single cell, the simplest linked-list solution for handling multiple objects in a cell is to embed the linked-list next pointer in the object. For the sample code given here, the object is assumed to be structured as follows.

```
struct Object {
    Point center;          // Center point for object
    float radius;          // Radius of object bounding sphere
    ...
    Object *pNextObject;   // Pointer to next object when linked into list
};
```

The code for inserting an object now becomes:

```
void InsertObject(Node *pTree, Object *pObject)
{
    int index = 0, straddle = 0;
    // Compute the octant number [0..7] the object sphere center is in
    // If straddling any of the dividing x, y, or z planes, exit directly
```

```
    for (int i = 0; i < 3; i++) {
        float delta = pObject->center[i] - pTree->center[i];
        if (Abs(delta) <= pObject->radius) {
            straddle = 1;
            break;
        }
        if (delta > 0.0f) index |= (1 << i); // ZYX
    }
    if (!straddle && pTree->pChild[index]) {
        // Fully contained in existing child node; insert in that subtree
        InsertObject(pTree->pChild[index], pObject);
    } else {
        // Straddling, or no child node to descend into, so
        // link object into linked list at this node
        pObject->pNextObject = pTree->pObjList;
        pTree->pObjList = pObject;
    }
}
```

`InsertObject()` can be changed so that whenever a child node pointer is NULL a new node is allocated and linked into the tree, with the object inserted into this new node.

```
if (!straddle) {
    if (pTree->pChild[index] == NULL) {
        pTree->pChild[index] = new Node;
        ...initialize node contents here...
    }
    InsertObject(pTree->pChild[index], pObject);
} else {
    ...same as before...
}
```

If nodes should be deleted in a corresponding manner whenever they no longer contain any objects, a pointer (or similar mechanism) is required in the node structure to be able to access the parent node for updating. The creation of new nodes can be delayed until a node contains *n* objects. When this happens, the node is split into eight child nodes, and the objects are reassigned among the children. When creating child nodes dynamically, all that is needed to build an octree incrementally is to create the initial root node; all other nodes are created as needed. Testing a dynamic octree

for collisions can be done as a recursive top-down procedure in which the objects of each nonempty node are checked against all objects in the subtree below the node.

```
// Tests all objects that could possibly overlap due to cell ancestry and coexistence
// in the same cell. Assumes objects exist in a single cell only, and fully inside it
void TestAllCollisions(Node *pTree)
{
    // Keep track of all ancestor object lists in a stack
    const int MAX_DEPTH = 40;
    static Node *ancestorStack[MAX_DEPTH];
    static int depth = 0; // 'Depth == 0' is invariant over calls

    // Check collision between all objects on this level and all
    // ancestor objects. The current level is included as its own
    // ancestor so all necessary pairwise tests are done
    ancestorStack[depth++] = pTree;
    for (int n = 0; n < depth; n++) {
        Object *pA, *pB;
        for (pA = ancestorStack[n]->pObjList; pA; pA = pA->pNextObject) {
            for (pB = pTree->pObjList; pB; pB = pB->pNextObject) {
                // Avoid testing both A->B and B->A
                if (pA == pB) break;
                // Now perform the collision test between pA and pB in some manner
                TestCollision(pA, pB);
            }
        }
    }

    // Recursively visit all existing children
    for (int i = 0; i < 8; i++)
        if (pTree->pChild[i])
            TestAllCollisions(pTree->pChild[i]);

    // Remove current node from ancestor stack before returning
    depth--;
}
```

7.3.3 Locational Codes and Finding the Octant for a Point

Consider a query point somewhere inside the space occupied by an octree. The leaf node octant in which the point lies can be found without having to perform direct

Figure 7.12 The cells of a 4 × 4 grid given in Morton order.

comparisons with the coordinates of the octree nodes. Let the point's coordinates be given as three floats x, y, and z. Remap each of these into binary fractions over the range $[0 \ldots 1]$. For instance, if the octree's x range spans $[10 \ldots 50]$, then an x coordinate of 25 would map into the fraction $(25 - 10)/(50 - 10) = 0.375 = 0.01100000$. Note that this does not require either all dimensions to be the same or that they be powers of 2. By virtue of construction, it should be clear that the most significant bit of the binary fraction for the x coordinate specifies whether the point lies to the left of the octree yz plane through the octree center point (when the bit is 0) or to the right of it (when the bit is 1). Taking the three most significant bits of the binary fractions for x, y, and z together as a unit, they form the index number (0–7) of the root's child node, in which the point lies. Similarly, the three next-most significant bits specify the subnode within that node in which the point lies, and so on until a leaf node has been reached.

The resulting binary string of interleaved bits of the three binary fractions can be seen as a key, a *locational code*, directly describing a node position within the tree. Nodes output in sorted order based on this locational code are said to be in *Morton order* (Figure 7.12).

Given the locational code for the parent node, a new locational code for one of its child nodes is easily constructed by left-shifting the parent key by 3 and adding (or ORing) in the parent's child index number (0–7) for the child node **childKey = (parentKey << 3) + childIndex**. Locational codes can be used in a very memory-efficient octree representation, explored next.

7.3.4 **Linear Octrees (Hash-based)**

Although the pointer-based representation is likely to save memory over the flat array-based representation for average trees, the former still requires up to eight child pointers to be stored in the octree nodes. These likely constitute a major part of the memory required to hold the tree.

A clever nonpointer-based representation alternative is the *linear octree*. A linear octree consists of just the octree nodes containing data, in which each node has

been enhanced to contain its own locational code. The locational codes for both the parent node and all children nodes can be computed from the stored locational code. As such, the octree nodes no longer need explicit pointers to the children, thereby becoming smaller.

```
// Octree node data structure (hashed)
struct Node {
    Point center;     // Center point of octree node (not strictly needed)
    int key;          // The location (Morton) code for this node
    int8 hasChildK;   // Bitmask indicating which eight children exist (optional)
    Object *pObjList; // Linked list of objects contained at this node
};
```

The size of a node can be explicitly stored or it can be derived from the "depth" of the locational code. In the latter case, a sentinel bit is required in the locational code to be able to distinguish between, say, 011 and 000000011, turning these into 1011 and 1000000011, respectively. The code for this follows.

```
int NodeDepth(unsigned int key)
{
    // Keep shifting off three bits at a time, increasing depth counter
    for (int d = 0; key; d++) {
        // If only sentinel bit remains, exit with node depth
        if (key == 1) return d;
        key >>= 3;
    }
    assert(0);    // Bad key
}
```

To be able to access the octree nodes quickly given just a locational code, the nodes are stored in a hash table using the node's locational code as the hash key. This hashed storage representation provides $O(1)$ access to any node, whereas locating an arbitrary node in a pointer-based tree takes $O(\log n)$ operations.

To avoid a failed hash table lookup, the node is often enhanced (as previously) with a bitmask indicating which of the eight children exist. The following code for visiting all existing nodes in a linear octree illustrates both how child nodes are computed and how the bitmask is used.

```
void VisitLinearOctree(Node *pTree)
{
    // For all eight possible children
```

```
for (int i = 0; i < 8; i++) {
    // See if the ith child exist
    if (pTree->hasChildK & (1 << i)) {
        // Compute new Morton key for the child
        int key = (pTree->key << 3) + i;
        // Using key, look child up in hash table and recursively visit subtree
        Node *pChild = HashTableLookup(gHashTable, key);
        VisitLinearOctree(pChild);
    }
  }
}
```

A hashed octree similar to this is described in [Warren93].

7.3.5 Computing the Morton Key

Given three integer values representing the *x*, *y*, and *z* coordinates of an octree leaf, the corresponding Morton key can be computed by the following function.

```
// Takes three 10-bit numbers and bit-interleaves them into one number
uint32 Morton3(uint32 x, uint32 y, uint32 z)
{
    // z--z--z--z--z--z--z--z--z--z-- : Part1By2(z) << 2
    // -y--y--y--y--y--y--y--y--y--y- : Part1By2(y) << 1
    // --x--x--x--x--x--x--x--x--x--x : Part1By2(x)
    // zyxzyxzyxzyxzyxzyxzyxzyxzyxzyx : Final result
    return (Part1By2(z) << 2) + (Part1By2(y) << 1) + Part1By2(x);
}
```

The support function **Part1By2()** splits up the bits of each coordinate value, inserting two zero bits between each original data bit. Interleaving the intermediate results is then done by shifting and adding the bits. The function **Part1By2()** can be implemented as:

```
// Separates low 10 bits of input by two bits
uint32 Part1By2(uint32 n)
{
    // n = ----------------------9876543210 : Bits initially
    // n = ------98----------------76543210 : After (1)
    // n = ------98--------7654--------3210 : After (2)
```

```
    // n = ------98----76----54----32----10 : After (3)
    // n = ----9--8--7--6--5--4--3--2--1--0 : After (4)
    n = (n ^ (n << 16)) & 0xff0000ff; // (1)
    n = (n ^ (n <<  8)) & 0x0300f00f; // (2)
    n = (n ^ (n <<  4)) & 0x030c30c3; // (3)
    n = (n ^ (n <<  2)) & 0x09249249; // (4)
    return n;
}
```

The equivalent code for interleaving 2D coordinates (for a quadtree) follows.

```
// Takes two 16-bit numbers and bit-interleaves them into one number
uint32 Morton2(uint32 x, uint32 y)
{
    return (Part1By1(y) << 1) + Part1By1(x);
}

// Separates low 16 bits of input by one bit
uint32 Part1By1(uint32 n)
{
    // n = ----------------fedcba9876543210 : Bits initially
    // n = --------fedcba98--------76543210 : After (1)
    // n = ----fedc----ba98----7654----3210 : After (2)
    // n = --fe--dc--ba--98--76--54--32--10 : After (3)
    // n = -f-e-d-c-b-a-9-8-7-6-5-4-3-2-1-0 : After (4)
    n = (n ^ (n << 8)) & 0x00ff00ff; // (1)
    n = (n ^ (n << 4)) & 0x0f0f0f0f; // (2)
    n = (n ^ (n << 2)) & 0x33333333; // (3)
    n = (n ^ (n << 1)) & 0x55555555; // (4)
    return n;
}
```

If sufficient bits are available in the CPU registers, the calls to the support function can be done in parallel. For example, using a modified **Part1By1()** function that operates on 32-bit numbers giving a 64-bit result, the **Morton2()** function presented previously can be written as:

```
uint32 Morton2(uint32 x, uint32 y)
{
    // Merge the two 16-bit inputs into one 32-bit value
    uint32 xy = (y << 16) + x;
```

```
        // Separate bits of 32-bit value by one, giving 64-bit value
        uint64 t = Part1By1_64BitOutput(xy);
        // Interleave the top bits (y) with the bottom bits (x)
        return (uint32)((t >> 31) + (t & 0x0ffffffff));
    }
```

In general, for the 2D case just presented, handling n-bit inputs would require $4n$-bit numbers being available in the intermediate calculations.

7.3.6 Loose Octrees

Consider again the problem of objects becoming stuck high up in a dynamic octree due to straddling of the partitioning planes. An effective way of dealing with this problem is to expand the node volumes by some amount to make them partially overlapping (Figure 7.13). The resulting relaxed octrees have been dubbed *loose octrees* [Ulrich00]. The loose nodes are commonly extended by half the side width in all six directions (but may be extended by any amount). This effectively makes their volume eight times larger.

Assuming spherical objects, the objects are propagated into the child node in which the sphere center is contained. Only when the sphere extends outside the loose cell would it remain at the current level.

With these larger nodes, objects now descend deeper into the tree, giving the partitioning more discriminatory power. Unfortunately positioned but otherwise pairwise distant objects that previously became stuck high up in the tree are less likely to have to be tested against other objects. Another benefit of the loose nodes is that the

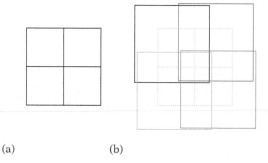

(a) (b)

Figure 7.13 (a) The cross section of a regular octree, shown as a quadtree. (b) Expanding the nodes of the octree, here by half the node width in all directions, turns the tree into a loose octree. (The loose nodes are offset and shown in different shades of gray to better show their boundaries. The original octree nodes are shown as dashed lines.)

depth at which an object will be inserted can be computed from the size of the object, allowing for $O(1)$ insertions.

This power does not come for free, however. The larger nodes overlap more neighboring nodes, and more nodes have to be examined to determine whether any two objects must be tested against each other. Still, in most cases the reduction in pairwise tests makes loose octrees attractive for collision detection purposes.

Loose octrees are similar in structure to hierarchical grids. The key difference is that octrees are rooted. This means that time is spent traversing the (largely) empty top of the tree to get at the lower-level nodes where the objects are, due to objects generally being much smaller than the world. In comparison, the hgrid is a shallower, rootless structure providing faster access to the nodes where the objects are stored.

In addition, hgrid levels can be dynamically deactivated so that no empty levels are processed and processing stops when no objects exist on the remaining levels. A linearized or array-based octree allows similar optimizations. The corresponding optimization for a pointer-based octree is to maintain a subtree object-occupancy count for each node. The cost of updating these occupancy counts is proportional to the height of the tree, whereas the hgrid level occupancy counters are updated in $O(1)$ time. Thanks to the automatic infinite tiling performed by the hash mapping, a hashed hgrid does not need to know the world size. The octree cannot easily accommodate an unbounded world without growing in height. Overall, hgrids seem to perform somewhat better than loose octrees for collision detection applications.

7.3.7 *k-d* Trees

A generalization of octrees and quadtrees can be found in the k-dimensional tree, or *k-d tree* [Bentley75], [Friedman77]. Here, k represents the number of dimensions subdivided, which does not have to match the dimensionality of the space used.

Instead of simultaneously dividing space in two (quadtree) or three (octree) dimensions, the k-d tree divides space along one dimension at a time. Traditionally, k-d trees are split along x, then y, then z, then x again, and so on, in a cyclic fashion. However, often the splitting axis is freely selected among the k dimensions. Because the split is allowed to be arbitrarily positioned along the axis, this results in both axis and splitting value being stored in the k-d tree nodes. An efficient way of storing the two bits needed to represent the splitting axis is presented in Section 13.4.1. One level of an octree can be seen as a three-level k-d tree split along x, then y, then z (all splits selected to divide the space in half). Figure 7.14 shows a 2D spatial k-d tree decomposition and the corresponding k-d tree layout.

Splitting along one axis at a time often accommodates simpler code for operating on the tree, in that only the intersection with a single plane must be considered. Furthermore, because this plane is axis aligned, tests against the plane are numerically robust.

For collision detection, k-d trees can be used wherever quadtrees or octrees are used. Other typical uses for k-d trees include *point location* (given a point, locate the

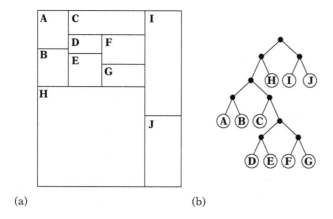

(a) (b)

Figure 7.14 A 2D *k*-d tree. (a) The spatial decomposition. (b) The *k*-d tree layout.

region it is in), *nearest neighbor* (find the point in a set of points the query point is closest to), and *range search* (locate all points within a given region) queries.

The following code illustrates how to visit all nodes of a *k*-d tree a given sphere overlaps. One interesting problem is correctly rejecting subtree volumes the sphere is outside of, even when the sphere straddles one or more of the supporting hyperplanes of the halfspaces forming the volume. The solution adopted here is to maintain the point inside the volume closest to the sphere center during traversal. Initially this variable, **volNearPt**, is set to the sphere center. As the traversal recurses the far side of the splitting plane (the side the sphere is not on), the point is clamped to the splitting plane to determine the closest point on the volume boundary. The distance between **volNearPt** and the query sphere center can now be used to cull subtrees.

```
struct KDNode {
    KDNode *child[2];    // 0 = near, 1 = far
    int splitType;       // Which axis split is along (0, 1, 2, ...)
    float splitValue;    // Position of split along axis
    ...
};

// Visit k-d tree nodes overlapped by sphere. Call with volNearPt = s->c
void VisitOverlappedNodes(KDNode *pNode, Sphere *s, Point &volNearPt)
{
    if (pNode == NULL) return;

    // Visiting current node, perform work here
    ...
```

```
// Figure out which child to recurse into first (0 = near, 1 = far)
int first = s->c[pNode->splitType] > pNode->splitValue;

// Always recurse into the subtree the sphere center is in
VisitOverlappedNodes(pNode->child[first], s, volNearPt);

// Update (by clamping) nearest point on volume when traversing far side.
// Keep old value on the local stack so it can be restored later
float oldValue = volNearPt[pNode->splitType];
volNearPt[pNode->splitType] = pNode->splitValue;

// If sphere overlaps the volume of the far node, recurse that subtree too
if (SqDistPointPoint(volNearPt, s->c) < s->r * s->r)
    VisitOverlappedNodes(pNode->child[first ^ 1], s, volNearPt);

// Restore component of nearest pt on volume when returning
volNearPt[pNode->splitType] = oldValue;
}
```

This code framework is easily extended to, for instance, locate the nearest neighbor object to the query sphere by starting with a sphere of unbounded size, shrinking the sphere as objects are encountered within the sphere. Note that the shape of the regions in a k-d tree will affect the number of nodes being visited. For example, if many narrow regions are next to each other, a wide query is likely to overlap all regions. To limit the number of nodes being visited, it is best to avoid regions narrow in one or more dimensions. Such nonnarrow regions are commonly referred to as *fat* regions.

The efficiency of k-d trees (in the context of ray tracing) is discussed in [MacDonald90]. An in-depth treatment of octrees, quadtrees, k-d trees, and similar spatial data structures is found in [Samet90a] and [Samet90b].

7.3.8 Hybrid Schemes

The previously described methods can also form the basis of various hybrid strategies. For instance, after having initially assigned objects or geometry primitives to a uniform grid, the data in each nonempty grid cell could be further organized in a tree structure. The grid now serves as a fast way of locating the appropriate trees (in a forest of trees) to perform further tests against (Figure 7.15a).

Grids can also be used as "acceleration structures" into a single tree hierarchy. Consider a uniform grid of tree node pointers in which each pointer has been directed to the tree node whose volume bounds the corresponding grid cell as tightly as possible (Figure 7.15b). Instead of traversing from the root to the node an object is in,

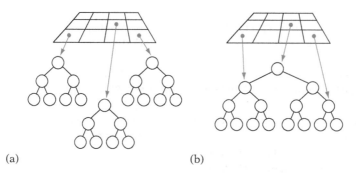

(a) (b)

Figure 7.15 (a) A grid of trees, each grid cell containing a separate tree. (b) A grid indexing into a single tree **hierarchy**, each grid cell pointing into the tree at which point traversal should start.

it suffices to locate the grid cell the object is inside and follow the pointer to the correct tree node. Using a grid in this manner can help bypass a large portion of the tree during queries.

To handle the case of going to the correct node when an object is on a grid cell boundary overlapping two or more cells, the grid cells can be made loose, similar to the nodes in a loose octree. The grid cell that encompasses the object is now used to find the entry point into the tree structure.

7.4 Ray and Directed Line Segment Traversals

Particularly common in many applications, games in particular, are *line pick* tests. These are queries involving rays or directed line segments. Typical uses include line-of-sight tests and tests for whether or not a fired bullet hits an enemy. They can also be used as the primary collision query. One such example could be performing line picks down from the wheels of a vehicle to attach the vehicle to the terrain below.

To accelerate these queries, hierarchical structures are used to minimize the number of objects that have to be intersected by the ray or segment. The key idea is to first spatially partition the world into a number of cells. The ray is then traced through those cells it pierces and intersected against any objects they might contain. The next two sections illustrate how ray queries are performed on k-d trees and uniform grids.

7.4.1 *k*-d Tree Intersection Test

The basic idea behind intersecting a ray or directed line segment with a k-d tree is straightforward. The segment $S(t) = A + t\,\mathbf{d}$ is intersected against the node's splitting plane, and the t value of intersection is computed. If t is within the interval of the

segment, $0 \leq t < tmax$, the segment straddles the plane and both children of the tree are recursively descended. If not, only the side containing the segment origin is recursively visited.

By first descending the side of the segment origin, overlapped k-d tree nodes are guaranteed to be traversed in order near to far. Thus, assuming the closest intersection point is sought, when a hit is detected among the node contents the test procedure can exit early, not having to test any other nodes.

```
// Visit all k-d tree nodes intersected by segment S = a + t * d, 0 <= t < tmax
void VisitNodes(KDNode *pNode, Point a, Vector d, float tmax)
{
    if (pNode == NULL) return;

    // Visiting current node, perform actual work here
    ...

    // Figure out which child to recurse into first (0 = near, 1 = far)
    int dim = pNode->splitType;
    int first = a[dim] > pNode->splitValue;

    if (d[dim] == 0.0f) {
        // Segment parallel to splitting plane, visit near side only
        VisitNodes(pNode->child[first], a, d, tmax);
    } else {
        // Find t value for intersection between segment and split plane
        float t = (pNode->splitValue - a[dim]) / d[dim];

        // Test if line segment straddles splitting plane
        if (0.0f <= t && t < tmax) {
            // Yes, traverse near side first, then far side
            VisitNodes(pNode->child[first], a, d, t);
            VisitNodes(pNode->child[first ^ 1], a + t * d, d, tmax - t);
        } else {
            // No, so just traverse near side
            VisitNodes(pNode->child[first], a, d, tmax);
        }
    }
}
```

This procedure can be rewritten to avoid explicit recursion, in the manner described in Chapter 6. Only small changes are required to accommodate traversals for octrees and BSP trees. It is also possible to directly link the faces of a leaf to the leaf nodes they border, allowing direct traversal from one leaf to the next. As a face

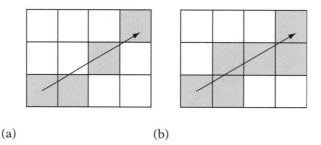

(a) (b)

Figure 7.16 Cell connectivity for a 2D line. (a) An 8-connected line. (b) A 4-connected line. In 3D, the corresponding lines would be 26-connected and 6-connected, respectively.

may border more than just one leaf node, a quadtree or k-d tree stored at the face is used to divide the face area and link each area with the correct neighboring leaf node.

7.4.2 **Uniform Grid Intersection Test**

Shooting a ray through a uniform grid is very similar to the rasterization steps performed by, say, the Bresenham line-drawing algorithm [Rogers98]. However, there is an important difference. In rasterization, the line may intersect cells that are not filled in (Figure 7.16a). For collision detection, this would be fatal; all pierced cells must be visited or some objects may not be tested. The traversal method used must enforce *6-connectivity* of the cells visited along the line. Cells in 3D are said to be 6-connected if they share faces only with other cells (in 2D, the same cells would be called 4-connected). If cells are also allowed to share edges, they are considered 18-connected. A cell is 26-connected if it can share a face, edge, or vertex with another cell (called 8-connected in 2D).

Bresenham-like methods are categorized by stepping along the major axis, taking a step along the minor axis (axes) when an error term has built up. It is possible to extend these methods to step through the missed cells when the step along the minor axis is performed. For a thorough derivation of how to do so see [Joy86].

In this section a slightly different method is presented, due to [Amanatides87] and [Cleary88]. This method is symmetric and does not use the concept of a major stepping axis. Cells are assumed to be square. In the following, the term *segment* means a directed line segment and the term *ray* will sometimes be used synonymously. To simplify the presentation, the grid is assumed to be 2D.

The key idea is that as a ray leaves a cell it pierces a cell boundary. Whether to step along the x axis or the y axis depends on whether a vertical or a horizontal boundary is pierced. This decision is made easy by maintaining two variables, tx and ty, containing the distance from the ray origin *along the ray* to the next vertical and

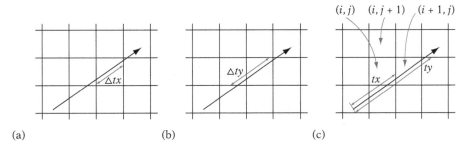

(a) (b) (c)

Figure 7.17 Illustrating the values of tx, ty, Δtx, and Δty. (a) Δtx is the distance between two vertical boundaries. (b) Δty is the distance between two horizontal boundaries. (c) For cell (i, j), the distance tx to the next horizontal **boundary** is less than the distance ty to the next horizontal **boundary**, and thus the next cell to visit is $(i + 1, j)$.

horizontal boundary. If tx is less than ty, a vertical boundary will be pierced before the next horizontal one is encountered, and the algorithm proceeds to step left or right along the x axis (depending on the direction of the ray) to the next cell.

As the step is made, tx is updated to represent the distance to the next vertical boundary. For uniform-size cells, the distance moved along the ray is constant from one vertical boundary to the next, and thus the change made to tx can be precomputed. This value is called Δtx (Figure 7.17a). The stepping value from one horizontal boundary to the next is similarly constant and kept as Δty (Figure 7.17b).

In Figure 7.17c, the current cell is denoted (i, j). Because tx (the distance from the ray origin to the next vertical boundary) is less than ty, the next cell visited is $(i + 1, j)$.

Assuming the cell side to be M units wide, Δtx is given by

$$\Delta tx = M \frac{\sqrt{dx^2 + dy^2}}{dx}.$$

For the line segment $(x_1, y_1) - (x_2, y_2)$, $dx = |x_2 - x_1|$ and $dy = |y_2 - y_1|$. The initial values of tx and ty are computed slightly differently depending on which direction the segment is pointing in. With the ray origin at (x_1, y_1), for the given x coordinate (x_1) the nearest vertical boundary to the left has a value of $minx = M \lfloor x_1/M \rfloor$. The nearest vertical boundary to the right has a value of $maxx = minx + M$. If the ray is directed to the right, the value of tx can therefore be computed as

$$tx = (maxx - x_1) \frac{\sqrt{dx^2 + dy^2}}{dx}.$$

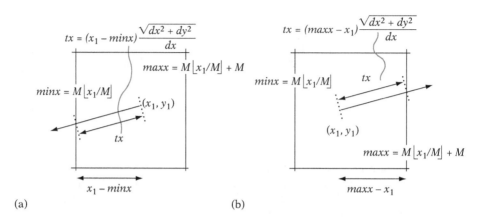

Figure 7.18 Computing the initial value of *tx* (done analogously for *ty*) (a) for a ray directed to the left and (b) for a ray directed to the right.

If instead the ray is directed to the left, the corresponding expression is

$$tx = (x_1 - minx)\frac{\sqrt{dx^2 + dy^2}}{dx}.$$

These derivations are illustrated in Figure 7.18. The initial value of *ty* is computed in an analogous fashion.

To keep track of which cell is currently visited, first the cell (i, j) that the ray or directed line segment originates in is found. A direction (di, dj) is then computed for the ray. For a ray directed up and to the right, the direction would be $(1, 1)$. For a ray going to the left, it would be $(-1, 0)$, and so on. Each time the ray passes through a cell boundary, a step of *di* or *dj* is made along the *x* axis or *y* axis respectively, depending on whether the boundary was vertical or horizontal. For a line segment, the coordinates of the ending cell are computed in advance to minimize the traversal cost.

The following code implements the full grid traversal. Note that because the term $\sqrt{dx^2 + dy^2}$ is constant and occurs in all four of the *tx*, *ty*, Δtx, and Δty terms it can be dropped, greatly simplifying the initialization calculations.

```
void VisitCellsOverlapped(float x1, float y1, float x2, float y2)
{
    // Side dimensions of the square cell
    const float CELL_SIDE = 30.0f;

    // Determine start grid cell coordinates (i, j)
    int i = (int)floorf(x1 / CELL_SIDE);
    int j = (int)floorf(y1 / CELL_SIDE);
```

```
    // Determine end grid cell coordinates (iend, jend)
    int iend = (int)floorf(x2 / CELL_SIDE);
    int jend = (int)floorf(y2 / CELL_SIDE);

    // Determine in which primary direction to step
    int di = ((x1 < x2) ? 1 : ((x1 > x2) ? -1 : 0));
    int dj = ((y1 < y2) ? 1 : ((y1 > y2) ? -1 : 0));

    // Determine tx and ty, the values of t at which the directed segment
    // (x1,y1)-(x2,y2) crosses the first horizontal and vertical cell
    // boundaries, respectively. Min(tx, ty) indicates how far one can
    // travel along the segment and still remain in the current cell
    float minx = CELL_SIDE * floorf(x1/CELL_SIDE), maxx = minx + CELL_SIDE;
    float tx = ((x1 > x2) ? (x1 - minx) : (maxx - x1)) / Abs(x2 - x1);
    float miny = CELL_SIDE * floorf(y1/CELL_SIDE), maxy = miny + CELL_SIDE;
    float ty = ((y1 > y2) ? (y1 - miny) : (maxy - y1)) / Abs(y2 - y1);

    // Determine deltax/deltay, how far (in units of t) one must step
    // along the directed line segment for the horizontal/vertical
    // movement (respectively) to equal the width/height of a cell
    float deltatx = CELL_SIDE / Abs(x2 - x1);
    float deltaty = CELL_SIDE / Abs(y2 - y1);

    // Main loop. Visits cells until last cell reached
    for (;;) {
        VisitCell(i, j);
        if (tx <= ty) {     // tx smallest, step in x
            if (i == iend) break;
            tx += deltatx;
            i += di;
        } else {            // ty smallest, step in y
            if (j == jend) break;
            ty += deltaty;
            j += dj;
        }
    }
}
```

Instead of using the *i* and *j* coordinates to index into some array **grid[i][j]**, it is possible to maintain a pointer to the current cell and step the pointer directly by adding appropriate values to the pointer instead of adding *di* and *dj* to a set of index variables.

The described algorithm can of course be implemented for the traversal of a 3D grid. In this case the structure of the main loop becomes:

```
for (;;) {
    VisitCell(i, j, k);
    if (tx <= ty && tx <= tz) {         // tx smallest, step in x
        if (i == iend) break;
        tx += deltatx;
        i += di;
    } else if (ty <= tx && ty <= tz) {  // ty smallest, step in y
        if (j == jend) break;
        ty += deltaty;
        j += dj;
    } else {                            // tz smallest, step in z
        if (k == kend) break;
        tz += deltatz;
        k += dk;
    }
}
```

It should be noted that as *tx* and *ty* are float variables it is possible that rounding errors may cause the cells visited during traversal to be different from those visited by an algorithm using exact arithmetic. If this is a concern, objects should be considered as extended by some small epsilon before being assigned to the grid. It is also possible to turn this algorithm into an all-integer algorithm by using integer-only inputs and multiplying through *tx*, *ty*, Δtx, and Δty by the denominators involved in the initialization code. An all-integer 4-connected line-drawing algorithm is described in [Barerra03].

If the objects stored in the grid can be concave, it is important to make sure that the intersection point of a detected intersection lies within the current cell. Otherwise, when a concave object straddles multiple cells the object could have been hit several cells away, and there might be a hit with a different object in any of the cells between. Section 7.7 presents methods for avoiding having to perform multiple intersection tests against the same objects in such situations as just described.

There are several possible optimizations that can be performed on ray queries on uniform grids. For example, note that a ray at an angle passes through more cells than an axis-aligned ray. Therefore, one possible optimization is to have several grids oriented differently and pick the most aligned one to trace a ray through. Another optimization is to apply a move-to-front reordering heuristic to objects in a cell. As intersected objects are likely to be intersected again on the next query, having an early upper bound on the distance to the nearest intersected object allows more distant objects within the same cell to be quickly culled using a quick distance test. Additional optimizations can be found in the ray-tracing literature [Glassner89], [Shirley00].

7.5 **Sort and Sweep Methods**

A drawback of inserting objects into the fixed spatial subdivisions that grids and octrees represent is having to deal with the added complications of objects straddling multiple partitions. An alternative approach is to instead maintain the objects in some sort of sorted spatial ordering. One way of spatially sorting the objects is the *sort and sweep* method [Baraff92] (referred to as *sweep and prune* in [Cohen95]).

First consider the case of detecting overlap among 1D bounding boxes. Each such box corresponds to an interval $[b, e]$ on the coordinate axis. Given n such intervals, all b and e values can be inserted into a sorted list (Figure 7.19). By sweeping the list, active intervals can be tracked by adding them to a list whenever their b values are encountered and removing them when their e values are encountered. Whenever a new interval is added to the list, it has also been found to overlap the already active intervals on the list.

By considering their projection intervals onto the x, y, and z axes, AABBs in 3D can be identified as three independent such intervals. Thus, for each coordinate axis a sorted linked list is maintained of the start and end values of the corresponding AABB projection intervals of all objects. The collisions for a single object can on average be found in near constant time by querying neighboring objects for overlap. Only those objects within the projection interval of the tested object have to be examined. Linked lists also allow for dynamic updating whenever an object moves.

After the lists have been sorted, as objects generally do not move very far between frames the lists will remain almost sorted from one frame to the next. To exploit temporal coherence effectively, the lists are kept from frame to frame and they are maintained sorted using a simple insertion sort, which has linear behavior for nearly ordered lists.

To allow for fast updates during the sorting pass, the lists need to be double linked. Start and end list sentinels help both to simplify (by removing special case tests such as testing for empty lists or reaching either end of the list) and speed up the code [Knuth98].

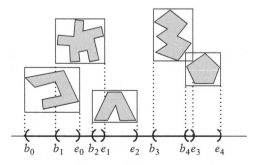

Figure 7.19 Projected AABB intervals on the x axis.

Figure 7.20 Objects clustered on the y axis (caused, for example, by falling objects settling on the ground). Even small object movements can now cause large positional changes in the list for the clustered axis.

In general, updating lists for n objects is expected time $O(n)$. However, coherence can break down due to clustering of objects. Specifically, sorting can deteriorate to $O(n^2)$ on the clustered axis because of small world movements causing large positional movements in the list. Unfortunately, such clustering is common. For instance, having all objects on a surface, such as a floor, will cause tight clustering on the vertical axis (Figure 7.20).

One solution to the global situation in which objects tend to cluster on, say, the y axis is to track only the x and z lists. In most situations, sorting on just two axes is likely to be sufficient, which also has the benefit of reducing the memory overhead of this scheme. In some cases, it might even be worthwhile to pick axes other than the normal x, y, and z ones to sort on. For instance, the $x = y$ axis could be considered in situations in which objects tend to cluster on x or y. Although this may lessen the clustering problem for specific applications, the problem still remains. Section 7.5.2 suggests an alternative implementation avoiding the worst-case $O(n^2)$ behavior.

7.5.1 Sorted Linked-list Implementation

To maintain the axis-sorted lists of projection interval extents, two types of structures are required: one that is the linked-list element corresponding to the minimum or maximum interval values and another one to link the two entries. A naive implementation would look as follows.

```
struct AABB {
    Elem *pMin[3]; // Pointers to the three minimum interval values (one for each axis)
    Elem *pMax[3]; // Pointers to the three maximum interval values (one for each axis)
    Object *pObj;  // Pointer to the actual object contained in the AABB
};

struct Elem {
    AABB *pAABB;   // Back pointer to AABB object (to find matching max/min element)
    Elem *pLeft;   // Pointer to the previous linked list element
```

```
    Elem *pRight;    // Pointer to the next linked list element
    float value;     // The actual min or max coordinate value
    int   minmax:1;  // A min value or a max value?
};
```

Here, the lists themselves would be represented by the three list headers:

```
Elem *gListHead[3];
```

By merging minimum and maximum values into one element each, space is conserved (as only a single back pointer to the AABB object is needed). In addition, the combined structure needs just one flag value, as its contained coordinate values are either min or max values. This results in the following structures.

```
struct AABB {
    Elem *pMin;      // Pointer to element containing the three minimum interval values
    Elem *pMax;      // Pointer to element containing the three minimum interval values
    Object *pObj;    // Pointer to the actual object contained in the AABB
};

struct Elem {
    AABB *pAABB;      // Back pointer to AABB object (to find matching max/min element)
    Elem *pLeft[3];   // Pointers to the previous linked list element (one for each axis)
    Elem *pRight[3];  // Pointers to the next linked list element (one for each axis)
    float value[3];   // All min or all max coordinate values (one for each axis)
    int   minmax:1;   // All min values or all max values?
};
```

Because the **Elem** structs do not move (only their contained pointers are being relinked), this representation can be refined further by placing the structs contiguously in memory. Given a pointer to either **Elem** struct, the corresponding min or max element can always be found either before or after (respectively) the current one.

As the AABB struct was only needed to link the **Elem** structs, the pair of **Elem** structs can effectively serve as the new AABB structure. Whereas previously **AABB** structs and **Elem** structs were allocated separately, now the **AABB** struct contains all required data and only a single structure need be allocated.

```
struct AABB {
    Elem min;        // Element containing the three minimum interval values
    Elem max;        // Element containing the three maximum interval values
```

```
    Object *pObj;        // Pointer to the actual object contained in the AABB
};

struct Elem {
    Elem *pLeft[3];      // Pointers to the previous linked list element (one for each axis)
    Elem *pRight[3];     // Pointers to the next linked list element (one for each axis)
    float value[3];      // All min or all max coordinate values (one for each axis)
    int   minmax:1;      // All min values or all max values?
};
```

Given a pointer to an **Elem** struct, the corresponding AABB is located in this way:

```
AABB *GetAABB(Elem *pElem)
{
    return (AABB *)(pElem->minmax ? (pElem - 1) : pElem);
}
```

Compared to the previous representation, this saves four pointers (16 bytes at 4 bytes per pointer) per AABB. By embedding the structure inside the objects themselves, the pointer to the object would no longer be needed and an additional 4 bytes would be saved. With a little trickery, the **minmax** bit fields could be moved from the **Elem** structs into the **AABB** struct to save some additional memory. They could, in fact, be embedded within one of the other structure fields and thus take up no extra space.

This is still quite an expensive structure at about 76 to 84 bytes per object, depending on implementation. Further savings can be had by turning the 32-bit pointers into 16-bit indices, assuming that at no time will there be more than 65,536 objects (which is a safe assumption for many applications).

In the following code it is assumed the three lists have been initialized to have both start and end sentinels. Sentinels can be set up as follows.

```
enum {
    MIN_ELEM = 0,       // Indicates AABB minx, miny, or minz element
    MAX_ELEM = 1        // Indicates AABB maxx, maxy, or maxz element
};

// Initialize the lists, with start and end sentinels
AABB *pSentinel = new AABB;
for (int i = 0; i < 3; i++) {
    pSentinel->min.pLeft[i] = NULL;     // not strictly needed
    pSentinel->min.pRight[i] = &pSentinel->max;
```

```
        pSentinel->max.pLeft[i] = &pSentinel->min;
        pSentinel->max.pRight[i] = NULL;     // not strictly needed
        pSentinel->min.value[i] = -FLT_MAX;
        pSentinel->max.value[i] = FLT_MAX;
        gListHead[i] = &pSentinel->min;
    }
    // Note backwardness of initializing these two
    pSentinel->min.minmax = MAX_ELEM;
    pSentinel->max.minmax = MIN_ELEM;
```

Inserting a new AABB into the sorted lists is done by scanning the lists for the appropriate insertion point. To simplify the presentation here, the overlap pair status is calculated in a separate pass after the new AABB has been inserted. To make the code more efficient, the overlap pair status could be updated at the same time objects are inserted by interleaving the routines. (Note that it is not possible to determine all overlapping pairs just by examining the **Elem** structs between the min and max element. The latter test would miss overlap with a larger AABB, completely encompassing the new AABB.)

To keep track of which collisions are active, the following code assumes the existence of two functions **AddCollisionPair()** and **DeleteCollisionPair()** that register and unregister, respectively, a pair of objects as being colliding.

```
void InsertAABBIntoList(AABB *pAABB)
{
    // For all three axes
    for (int i = 0; i < 3; i++) {
        // Search from start of list
        Elem *pElem = gListHead[i];

        // Insert min cell at position where pElem points to first larger element.
        // Assumes large sentinel value guards from falling off end of list
        while (pElem->value[i] < pAABB->min.value[i])
            pElem = pElem->pRight[i];
        pAABB->min.pLeft[i] = pElem->pLeft[i];
        pAABB->min.pRight[i] = pElem;
        pElem->pLeft[i]->pRight[i] = &pAABB->min;
        pElem->pLeft[i] = &pAABB->min;

        // Insert max cell in the same way. Can continue searching from last
        // position as list is sorted. Also assumes sentinel value present
        while (pElem->value[i] < pAABB->max.value[i])
            pElem = pElem->pRight[i];
```

```
            pAABB->max.pLeft[i] = pElem->pLeft[i];
            pAABB->max.pRight[i] = pElem;
            pElem->pLeft[i]->pRight[i] = &pAABB->max;
            pElem->pLeft[i] = &pAABB->max;
        }

        // Now scan through list and add overlap pairs for all objects that
        // this AABB intersects. This pair tracking could be incorporated into
        // the loops above, but is not done here to simplify the code
        for (Elem *pElem = gListHead[0]; ; ) {
            if (pElem->minmax == MIN_ELEM) {
                if (pElem->value[0] > pAABB->max.value[0])
                    break;
                if (AABBOverlap(pAABB, GetAABB(pElem)))
                    AddCollisionPair(pAABB, GetAABB(pElem));
            } else if (pElem->value[0] < pAABB->min.value[0])
                break;
        }
    }
```

After the position of an AABB has changed, the lists must be updated:

```
// This updating code assumes all other elements of list are sorted
void UpdateAABBPosition(AABB *pAABB)
{
    // For all three axes
    for (int i = 0; i < 3; i++) {
        Elem *pMin = &pAABB->min, *pMax = &pAABB->max, *t;

        // Try to move min element to the left. Move the roaming pointer t left
        // for as long as it points to elem with value larger than pMin's. While
        // doing so, keep track of the update status of any AABBs passed over
        for (t = pMin->pLeft[i]; pMin->value[i] < t->value[i]; t = t->pLeft[i])
            if (t->minmax == MAX_ELEM)
                if (AABBOverlap(pAABB, GetAABB(t)))
                    if (!HasCollisionPair(pAABB, GetAABB(t)))
                        AddCollisionPair(pAABB, GetAABB(t));
        // If t moves from its original position, move pMin into new place
        if (t != pMin->pLeft[i])
            MoveElement(i, pMin, t);
```

```
    // Similarly to above, try to move max element to the right
    for (t = pMax->pRight[i]; pMax->value[i] > t->value[i]; t = t->pRight[i])
        if (t->minmax == MIN_ELEM)
            if (AABBOverlap(pAABB, GetAABB(t)))
                if (!HasCollisionPair(pAABB, GetAABB(t)))
                    AddCollisionPair(pAABB, GetAABB(t));
    if (t != pMax->pRight[i])
        MoveElement(i, pMax, t->pLeft[i]);

    // Similarly to above, try to move min element to the right
    for (t = pMin->pRight[i]; pMin->value[i] > t->value[i]; t = t->pRight[i])
        if (t->minmax == MAX_ELEM)
            if (HasCollisionPair(pAABB, GetAABB(t)))
                DeleteCollisionPair(pAABB, GetAABB(t));
    if (t != pMin->pRight[i])
        MoveElement(i, pMin, t->pLeft[i]);

    // Similarly to above, try to move max element to the left
    for (t = pMax->pLeft[i]; pMax->value[i] < t->value[i]; t = t->pLeft[i])
        if (t->minmax == MIN_ELEM)
            if (HasCollisionPair(pAABB, GetAABB(t)))
                DeleteCollisionPair(pAABB, GetAABB(t));
    if (t != pMax->pLeft[i])
        MoveElement(i, pMax, t);

    }
}
```

The support function to move the AABB elements within the list is given by:

```
void MoveElement(int i, Elem *pElem, Elem *pDest)
{
    // Unlink element...
    pElem->pLeft[i]->pRight[i] = pElem->pRight[i];
    pElem->pRight[i]->pLeft[i] = pElem->pLeft[i];
    // ...and relink it _after_ the destination element
    pElem->pLeft[i] = pDest;
    pElem->pRight[i] = pDest->pRight[i];
    pDest->pRight[i]->pLeft[i] = pElem;
    pDest->pRight[i] = pElem;
}
```

The preceding code should be a sufficient framework for implementing the additional code required to complete the linked-list implementation of sort and sweep.

7.5.2 **Array-based Sorting**

The strength of the linked-list approach is twofold. First, it can handle a large number of objects, memory permitting. Second, when none or just a few objects move, little or no work is required to maintain the data structures from frame to frame. Unfortunately, the rather hefty memory overhead for each object AABB is a drawback. The worst-case $O(n^2)$ clustering behavior is equally serious.

An alternative is to implement axial extent sorting using arrays. Arrays are more inflexible when it comes to dynamically allowing more objects, but they use less memory. Using arrays, even if a single object moves the whole array might need updating, and thus a full sorting pass is required regardless. At the same time, the clustering problem is virtually removed and worst-case performance is determined by the sorting algorithm used [for example, $O(n \log n)$ for Quicksort or $O(kn)$ for radix sort]. Unlike lists, this remains constant even if all objects move, or if they move over large distances. Using arrays simplifies the code and provides cache-friendly accessing of memory. The following implementation operates on a single array of pointers, pointing to the object AABBs.

```
struct AABB {
    Point min;
    Point max;
    ...
};
AABB *gAABBArray[MAX_OBJECTS];
```

For each pass of the sort-and-sweep algorithm one of the coordinate axes is selected as the axis to sort along. (The selection is described later.) The selected axis is specified through a global variable.

```
int gSortAxis = 0; // Specifies axis (0/1/2) to sort on (here arbitrarily initialized)
```

Given a sorting axis, the pointers are sorted in ascending order based on the minimum value of the referenced AABB. To simplify the presentation, the following code uses *stdlib*'s **qsort()**. The required comparison function needed for **qsort()** to sort the AABBs is:

```
// Comparison function for qsort. Given two arguments A and B must return a
// value of less than zero if A < B, zero if A = B, and greater than zero if A > B
```

```
int cmpAABBs(const void *a, const void *b)
{
    // Sort on minimum value along either x, y, or z (specified in gSortAxis)
    float minA = (*(AABB **)a)->min[gSortAxis];
    float minB = (*(AABB **)b)->min[gSortAxis];
    if (minA < minB) return -1;
    if (minA > minB) return 1;
    return 0;
}
```

After the array has been sorted, it is scanned for overlapping boxes. To avoid keeping track of currently active intervals as the array is swept, this particular implementation scans the array forward for overlapping objects to the end of the currently tested box interval.

```
void SortAndSweepAABBArray(void)
{
    // Sort the array on currently selected sorting axis (gSortAxis)
    qsort(gAABBArray, MAX_OBJECTS, sizeof(AABB *), cmpAABBs);

    // Sweep the array for collisions
    float s[3] = { 0.0f, 0.0f, 0.0f }, s2[3] = { 0.0f, 0.0f, 0.0f }, v[3];
    for (int i = 0; i < MAX_OBJECTS; i++) {
        // Determine AABB center point
        Point p = 0.5f * (gAABBArray[i]->min + gAABBArray[i]->max);
        // Update sum and sum2 for computing variance of AABB centers
        for (int c = 0; c < 3; c++) {
            s[c] += p[c];
            s2[c] += p[c] * p[c];
        }
        // Test collisions against all possible overlapping AABBs following current one
        for (int j = i + 1; j < MAX_OBJECTS; j++) {
            // Stop when tested AABBs are beyond the end of current AABB
            if (gAABBArray[j]->min[gSortAxis] > gAABBArray[i]->max[gSortAxis])
                break;
            if (AABBOverlap(gAABBArray[i], gAABBArray[j]))
                TestCollision(gAABBArray[i], gAABBArray[j]);
        }
    }

    // Compute variance (less a, for comparison unnecessary, constant factor)
```

```
    for (int c = 0; c < 3; c++)
        v[c] = s2[c] - s[c] * s[c] / MAX_OBJECTS;

    // Update axis sorted to be the one with greatest AABB variance
    gSortAxis = 0;
    if (v[1] > v[0]) gSortAxis = 1;
    if (v[2] > v[gSortAxis]) gSortAxis = 2;
}
```

During the sweep pass, the variances of the AABB centers along each of the three axes are computed. After the pass is completed, the axis corresponding to the largest variance is selected for use the next time the routine is called. This method does not entirely avoid pathological cases. When objects are clustering in more than one dimension, worst-case $O(n^2)$ behavior could still arise.

Insertions are $O(1)$ by adding new AABBs after the position last used in the array. The sorting pass absorbs the cost of bringing the AABBs to their proper place. When an AABB is removed, its corresponding pointer also has to be removed from the array. Given an AABB, a binary search over the array locates the pointer in $O(\log n)$ time. The last pointer in the array replaces the pointer to be deleted. If removals are frequent, a back pointer inside the AABB structure to the array pointer could be filled in during the sweep pass, making deletions $O(1)$ as well.

7.6 Cells and Portals

Having an explicit spatial partitioning scheme just for collision detection is not always necessary. Sometimes it is sufficient to tie into a hierarchical organization already present for the efficient rendering of world geometry, such as a scene graph. An example of an organizational structure that lends itself well to being used with collision detection is the *cells-and-portals* method [Teller92], [Luebke95].

This method was developed for rendering architectural walkthrough systems. These are categorized by heavily occluded environments with high depth complexity. However, the amount of visible geometry in a typical architectural scene is low in comparison to the total geometry contained in the view frustum. The cells-and-portals method exploits the occluded nature of these scenes to reduce the amount of geometry that has to be rendered. The method proceeds by dividing the world into regions (cells) and the boundaries that connect them (portals). Rooms in the scene would correspond to cells, and doorways and windows to portals. The portals define connections between cells and both directly and indirectly determine which cells can be viewed from a given cell (Figure 7.21).

Rendering a scene partitioned into cells and portals starts with drawing the geometry for the cell containing the camera. After this cell has been rendered, the rendering

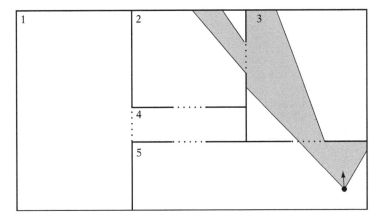

Figure 7.21 A simple portalized world with five cells (numbered) and five portals (dashed). The shaded region indicates what can be seen from a given viewpoint. Thus, here only cells 2, 3, and 5 must be rendered.

function is called recursively for adjoining cells whose portals are visible to the camera. During recursion, new portals encountered are clipped against the current portal, narrowing the view into the scene. Recursion stops when either the clipped portal becomes empty, indicating the new portal is not visible to the camera, or when no unvisited neighboring cells are available.

The portals are implemented as non-self-intersecting polygons. The cells themselves are traditionally defined by convex polyhedra. Being convex, the polygons in the cell can be rendered in any order without risk of overlap, thus obviating the need to sort polygons. (However, with the Z-buffer capabilities of modern hardware convex cells are no longer a requirement.) The following pseudocode illustrates an implementation of this rendering procedure.

```
RenderCell(ClipRegion r, Cell *c)
{
    // If the cell has not already been visited this frame...
    if (c->lastFrameVisited != currentFrameNumber) {
        // ...timestamp it to make sure it is not visited several
        // times due to multiple traversal paths through the cells
        c->lastFrameVisited = currentFrameNumber;
        // Recursively visit all connected cells with visible portals
        for (Portal *pl = c->pPortalList; pl != NULL; pl = pl->pNextPortal) {
            // Clip the portal region against the current clipping region
            ClipRegion visiblePart = ProjectAndIntersectRegion(r, pl->boundary);
```

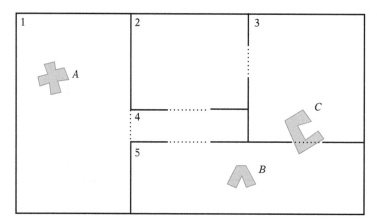

Figure 7.22 There are no objects in the cells overlapped by *A*, and thus object *A* does not need to test against **any** objects. Objects *B* and *C* must be tested against each other, as *C* crosses the portal between cells 3 and 5 and thus lies partly in the same cell as *B*.

```
         // If portal is not completely clipped its contents must be partially
         // visible, so recursively render other side through the reduced portal
         if (!EmptyRegion(visiblePart))
             RenderCell(visiblePart, pl->pAdjoiningCell);
     }
     // Now render all polygons (done last, for back-to-front rendering)
     for (Polygon *p = c.pPolygonList; p != NULL; p = p->pNextPolygon)
         RenderPolygon(p);
  }
}
```

The same cells-and-portals structure can be used to optimize collision detection queries. Initially, objects are associated with the cells containing their center point. As objects move, a ray test determines whether the object has moved out of the current cell. If it has, connected portals are tested against to find which neighboring cell the object moved into.

For object-object queries, given an object *A* only the objects in *A*'s assigned cell and those in adjoining cells whose portal *A* overlaps must now be checked against. Similarly, for object-world collisions only the polygons in the current cell and those of any overlapped cells must be checked against (Figure 7.22).

The BSP trees of Chapter 8 serve to divide the world into convex regions and the resulting spatial partitioning can be used for collision detection in a manner similar to the cells-and-portals method. In fact, BSP trees are often used in the automated generation of cells and portals.

7.7 **Avoiding Retesting**

A potential concern with partitioning schemes in which a single object may overlap multiple partitions is that the same two objects can be subject to testing against each other multiple times. This is clearly a problem when the pairwise test is expensive. If not handled correctly, it could also lead to collision-resolution code being run for the objects more than once. A similar problem occurs in ray-tracing applications, wherein shooting a ray through a uniform grid can result in the ray being tested multiple times against the same object located in several grid cells. In both cases, it would be wasteful to perform the same tests multiple times because the same objects are encountered again. Depending on the situation, a few alternative solutions are available.

7.7.1 **Bit Flags**

A straightforward solution to the retesting problem is to use a bit flag for indicating whether an intersection test has already been performed. In the case of shooting rays through a grid, there would be one bit per object. For object-object intersection tests, there would be a bit for every pair of objects. If the bit is set, the object (or pair of objects) in question has already been tested and any further testing can be skipped. If the bit is not set, the full test must be performed, after which the bit would be set to indicate the completion of the test.

In the object-object case, the bit flags are easily stored in an array indexed by the two object indices. In that the array entries (a, b) and (b, a) would represent the same pair, to avoid wasting memory only the upper triangular half above the diagonal would actually have to be stored. With a maximum of n objects, the array would then only have to hold $n(n-1)/2$ bits instead of n^2 bits. Given two object indices a and b, with $a < b$, the index of the corresponding bit is now computed as

$$bitindex = a(2n - a - 3)/2 + b - 1$$

instead of

$$bitindex = an + b.$$

The following code illustrates a possible implementation of a bit flag array for object-object intersection testing.

```
// Allocate enough words to hold a bit flag for each object pair
const int32 MAX_OBJECTS = 1000;
```

```
const int32 MAX_OBJECT_PAIRS = MAX_OBJECTS * (MAX_OBJECTS - 1) / 2;
int32 bitflags[(MAX_OBJECT_PAIRS + 31) / 32];
...
void TestObjectPair(int32 index0, int32 index1)
{
    assert(index0 != index1);
    // Find which object index is smaller and which is larger
    int32 min = index0, max = index1;
    if (index1 < index0) {
        min = index1;
        max = index0;
    }
    // Compute index of bit representing the object pair in the array
    int32 bitindex = min * (2 * MAX_OBJECTS - min - 3) / 2 + max - 1;
    // Look up the corresponding bit in the appropriate word
    int32 mask = 1L << (bitindex & 31);
    if ((bitflags[bitindex >> 5] & mask) == 0) {
        // Bit not set, so pair has not already been processed;
        // process object pair for intersection now
        ...
        // Finally mark object pair as processed
        bitflags[bitindex >> 5] |= mask;
    }
}
```

Although this works well for object-object testing, it is less than ideal in the ray-shooting case. In the object-object scenario, the array of bit flags would have to be reset once per frame, which is not too bad. For ray shooting, however, the array would have to be reset for each ray tested! In a typical game there might be tens or hundreds of ray-like tests performed each frame. Even for a modest number of objects, this operation now quickly becomes very expensive.

7.7.2 **Time Stamping**

An alternative way of keeping track of already-tested objects that works better for the ray-shooting scenario is to keep a running counter that increments for each ray query and assign the counter number, commonly referred to as a *time stamp*, to each object after it has been tested. Then, just before an object is to be tested the time stamp is checked to see if the object has already been tested in the current frame and can therefore be ignored.

Figure 7.23 illustrates how time stamping works. First, consider the interaction with object *A* only. In cell 1, the ray is tested against *A*. Because there is no intersection

Figure 7.23 Using time stamping avoids having to intersect the ray against object *A* twice, in both cells 1 and 2, as the ray is traced through the uniform grid. By storing the computed intersection with object *B* into a *mailbox*, the intersection can be reused in cell 3 without having to be recomputed.

between *A* and the ray, *A* is simply tagged with the time stamp of the ray and the ray processing continues to the next cell. In cell 2, the ray is again tested against *A*, but because it has already been time stamped with the current time object *A* can be safely ignored.

However, consider what happens with object *B*. It is also tested against in cell 1. There is an intersection between *B* and the ray, but the intersection point is in cell 3. Because the intersection point is not in the current cell, it is possible that there could be another intersection in the cells between (and in fact there is, with object *C* in cell 3). Thus, the ray processing must continue to subsequent cells. Before continuing to the next cell, the intersection with *B* must be compared to the best intersection stored so far to see if it constitutes a closer intersection. Because *B* happens to be the first object intersected, this is clearly the case and a pointer to *B* along with the parametric time at which the ray strikes *B* are saved as the currently best intersection. Before *B* is finally time stamped, it also makes sense to update the number of cells being traversed by the ray query. Because it is now known that there is an intersection in cell 3, there is no need to continue processing into cell 4. In cell 2, objects *A* and *B* have to be tested again, but both have been time stamped and are thus ignored, with processing continued to cell 3. In cell 3, *B* is again tested and ignored because of its time stamp. The ray is also tested against object *C*, which it intersects. As the intersection with *C* is found to be closer than the stored intersection with object *B*, the best intersection is updated to correspond to this new intersection. At this point, because there are no more objects to test in cell 3 and the ray processing was earlier set to stop in this cell the query can now return with the intersection with *C* as the result after having performed the intersection test with each object once only.

One slight problem remains. Regardless of the size used for the time stamp counter, eventually it will overflow. If enough bits have been assigned for the counter — which could well approach 64 bits for certain applications — the problem can safely be ignored as not happening during the uptime of the application. Assume for now that to conserve memory only an 8-bit counter was used. Every 256 ticks, the time stamp counter will now overflow and at that time all stored time stamps will have to be reset. If they are not, an object that has not been time stamped in 256 ticks

and is suddenly tested would incorrectly report that it has already been tested in the current time slice!

The time stamping technique described here has been described in the context of ray tracing as *mailboxes* [Amanatides87]. Another approach to eliminating multiple intersections and redundant calculations is the *residency masks* described in [Cychosz92].

In most applications, resetting the time stamp values will go unnoticed. However, for applications with a huge number of objects this operation could become expensive. For those applications, the solution is then to not reset all time stamp values at once. This solution is explored in the next section.

7.7.3 Amortized Time Stamp Clearing

The one-time overhead of resetting time stamp counters can be lessened using an amortized clearing scheme. Instead of clearing the counters all at once when the global counter overflows, the set of all time stamp counters can be divided into smaller blocks with a single block being reset each frame.

The best illustration of this amortized method is through a small example (see Table 7.2). Consider having some *n* objects, say 10, that are divided into three blocks (of three, three, and four objects each). Let the time stamp counters also count up to three. At start, all objects are initialized to have a time stamp of 0. On the first frame, the global time stamp counter is incremented to 1. After all objects have been updated, it is possible for each block to contain objects with time stamps of either 0 or 1. Before ending the first frame, block 0 is cleared to the *current* value of the global time stamp counter.

The same procedure is now repeated on each successive frame, with the next block of objects cleared, again to the current value of the global counter of that frame. Referring to Table 7.2, note that at the end of frame 4 there can no longer exist an object with a time stamp of value 1, which is the value the global counter will assume on frame 5. Similarly, at the end of frame 5 there is no object with a time stamp value of 2, and so on for all subsequent frames.

To further illustrate how the amortized clearing method works, the following code is an example of what an implementation of the method could look like. First, some required constant values are defined.

```
// Use 8 bits for the time stamp counter [0..255]
#define MAX_COUNTER_VALUE 255

// Divide up all time-stamped objects into as many blocks
#define NUM_BLOCKS MAX_COUNTER_VALUE
```

Table 7.2 Indicating possible time stamp values for objects in the three blocks at various points. At the point at which objects are about to be updated there is never an object with a time stamp equal to the current global time stamp. Thus, even though only a few objects are cleared each frame there is never a time stamp conflict.

Frame	Counter	Block 0	Block 1	Block 2	Comment
0	0	0	0	0	All object time stamps are cleared to 0 on startup
1	1	0/1	0/1	0/1	Incrementing global counter, updating objects
		1	0/1	0/1	Clearing (time stamps of objects in) block 0 to 1
2	2	1/2	0/1/2	0/1/2	Incrementing global counter, updating objects
		1/2	2	0/1/2	Clearing block 1 to 2
3	3	1/2/3	2/3	0/1/2/3	Incrementing global counter, updating objects
		1/2/3	2/3	3	Clearing block 2 to 3
4	0	0/1/2/3	0/2/3	0/3	Incrementing global counter, updating objects
		0	0/2/3	0/3	Clearing block 0 to 0; now no object with time stamp of 1
5	1	0/1	0/1/2/3	0/1/3	Incrementing global counter, updating objects
		0/1	1	0/1/3	Clearing block 1 to 1; now no object with time stamp of 2
6	2	0/1/2	1/2	0/1/2/3	Incrementing global counter, updating objects
		0/1/2	1/2	2	Clearing block 2 to 2; now no object with time stamp of 3

Once at initialization, all object time stamp counters are cleared to zero.

```
blockToClear = 0;
tickCounter = 0;
for (i = 0; i < MAX_OBJECTS; i++)
    object[i].timeStamp = tickCounter;
```

During each frame the time stamp counters are used as normal.

```
// Increment the global time stamp counter
tickCounter++;
// Do any and all object testing required for the frame
for (i = 0; i < MAX_OBJECTS; i++) {
    if (object[i].timeStamp == tickCounter) {
        // Already processed this object this frame, do nothing
        continue;
    } else {
        // Process object for intersection here
        ...
        // Mark object as processed
        object[i].timeStamp = tickCounter;
    }
}
```

At the end of each frame — or between rays in case of shooting rays — a subset of all stored time stamps is cleared by marking them with the *current* time stamp value (which has served its purpose for this frame).

```
// Reset the time stamp for all objects in the current block to be cleared
from = blockToClear * MAX_OBJECTS / MAX_COUNTER_VALUE;
to = (blockToClear + 1) * MAX_OBJECTS / MAX_COUNTER_VALUE;
for (i = from; i < to; i++)
    object[i].timeStamp = tickCounter;
// Indicate that the next block should be cleared the next frame
if (++blockToClear >= NUM_BLOCKS)
    blockToClear = 0;
// Wrap the global time stamp counter when it exceeds its maximum value
if (tickCounter >= MAX_COUNTER_VALUE - 1)
    tickCounter = 0;
```

The same technique can be applied for amortized clearing of other buffers. For example, by setting aside a few bits of the time stamp it could be used to spread the clearing of a (software) Z-buffer over a number of frames.

7.8 Summary

Spatial partitioning is an approach to accelerating broad-phase processing by dividing space into disjoint regions and associating scene objects with all regions they overlap.

Pairwise tests then must be performed only for those objects that share a region. In some cases objects are associated with just a single region, in which case neighboring regions also must be explored for potential collisions.

In this chapter, three types of spatial partitioning methods were explored: grids, trees, and spatial sorting. Grids are often uniform, meaning that they consist of grid cells of equal size. When large, grids may consume large amounts of memory. One way to reduce the memory requirements of grids is to use hashed storage, as described in Section 7.1.3, which has the benefit of allowing the grid to be of infinite extent. Grids can also be expressed implicitly. The implicit bit grid, in particular, is a very efficient spatial partitioning method. The hierarchical grid addresses the problem of objects being of greatly varying sizes, making it difficult to set a grid cell size for a uniform grid.

One of the tree representations described was the octree. It partitions space into eight uniform-size cells, then recursively partitions the cells in the same way. Thanks to their regular structure, octrees can be represented linearly, obviating the need to represent tree links using pointers, and thereby saving memory. The octree can also be made loose, meaning that its cells are expanded to overlap partially. Loose octrees address the problem of objects not being able to descend farther down the tree when they straddle a splitting plane (and are only allowed to be referenced from a single octree cell).

The k-d tree is a generalization of the octree in that it can represent the same spatial partitioning as the octree, but not vice versa. The k-d tree divides space into two, along one dimension at a time and at an arbitrary position. The simpler structure of the k-d tree makes queries on it easier.

Spatial sorting involves maintaining all objects in a sorted structure along one or more axes. The sorted structure is incrementally updated when objects move. Because the structure is sorted, object collisions are detected by examining neighboring objects without requiring a search.

Chapter 8 discusses one additional tree representation, which is a generalization of k-d trees. This representation can also be used as a spatial partitioning method.

Chapter 8

BSP Tree Hierarchies

Of the many spatial partitioning methods available, the BSP tree is the most versatile. It can perform the same tasks as the k-d tree, the quadtree, or the octree, but not vice versa. In addition to spatial partitioning, the BSP tree can be used as a boundary or solid representation of arbitrary polyhedral scenes. BSP trees are also powerful structures for collision detection, which this chapter explores.

8.1 BSP Trees

A *binary space-partitioning tree* (or *BSP tree* for short) is a binary tree structure that recursively partitions space into pairs of subspaces with respect to dividing planes of arbitrary position and orientation. If the space being partitioned is n-dimensional, the dividing planes are $(n-1)$-dimensional hyperplanes. In practice, the working space is usually 3D, and sometimes 2D. When the space being partitioned is 3D, the dividing hyperplane is a plane. In two dimensions, the dividing hyperplane is a line. The two partitions, or halfspaces, the space is divided into are commonly referred to as the *positive* and *negative* halfspaces. The positive halfspace lies in front of the dividing hyperplane and the negative halfspace behind it (see Section 3.6). Dividing planes are also referred to as splitting planes or partitioning planes.

As a simple example of a BSP tree, consider the illustrations of Figure 8.1. The square region defined by the gray outline is here the original space (note that this space does not have to be bounded; the square could easily be a plane). A first hyperplane, A, divides the original space into two regions, as illustrated in Figure 8.1a. Beneath the square is the corresponding BSP tree, with internal nodes shown as circles and the leaves as squares. Figure 8.1b shows a second hyperplane, B, dividing the negative halfspace of node A. Finally, a third hyperplane, C, is shown in Figure 8.1c, this time dividing the positive halfspace of node A. Note that the spatial regions corresponding to the leaves are always convex.

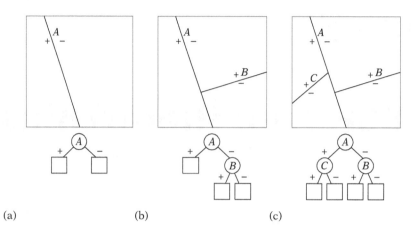

(a)　　　　　　　　　　(b)　　　　　　　　　　(c)

Figure 8.1 The successive division of a square into four convex subspaces and the corresponding BSP tree. (a) The initial split. (b) The first second-level split. (c) The second second-level split.

Originally, BSP trees were developed for addressing the hidden-surface problem [Fuchs80]. BSP trees solve this problem by allowing a scene to be view-independently decomposed in a preprocessing phase. The resulting tree can then be traversed at runtime to give the correct (back-to-front or front-to-back) sorting order of objects or individual polygons from an arbitrary viewpoint.

BSP trees have found uses in such varied applications as ray tracing, constructive solid geometry (CSG), and robot motion and path planning, to name a few. BSP trees are also very versatile when it comes to collision detection as they can serve *both* as a spatial partitioning (a nonboundary representation) and as a volume representation (a boundary representation, for a solid object). As a spatial partitioning scheme, BSP trees are very similar to quadtrees, octrees, and k-d trees, but BSP trees are more general as they can emulate these other spatial data structures. As a volume representation, BSP trees can be used to represent and distinguish the interiors of polygons and polyhedra from their exteriors.

Figure 8.2 illustrates the use of BSP trees for spatial partitioning and volume representation. Figure 8.2a shows how a space can be spatially partitioned to accelerate collision queries against the objects of the space. Thanks to the hierarchy formed by the BSP tree, with n objects in the tree only on the order of $O(\log n)$ objects are typically tested by a query, in that half of the remaining objects can be expected to be discarded by each successive test against a partitioning plane. (However, degenerate situations may cause all n objects to be tested — for example, if the query object is very large or if the tree is poorly built.)

Figure 8.2b shows how the dividing planes can be selected to coincide with the faces of a polygonal object, thus allowing the exterior of the shape to be partitioned from the interior of the shape. The spatial region associated with each leaf of this tree lies either fully inside or fully outside the original shape.

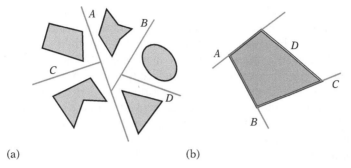

(a) (b)

Figure 8.2 The recursive division of space in half can be used as (a) a spatial partitioning over a number of objects. It can also be used as (b) a volume or **boundary** representation of an object.

When, as in the latter example, the dividing planes are selected to coincide with the faces of the input geometry, they are commonly called *autopartitioning* (and sometimes *polygon aligned*). Dividing planes coplanar to the *xy*, *xz*, or *yz* plane are called *axis aligned*. BSP trees using only axis-aligned dividing planes are commonly referred to as *k*-d trees (as described in Chapter 7). Dividing planes that have no restrictions put on them (nor on the partitionings they form) are here called *arbitrary* or *general*.

Constructing a BSP tree from scratch or recomputing parts of a tree is sufficiently expensive that they are rarely built or modified at runtime. For this reason, BSP trees are primarily used to hold static background geometry. Collision detection among moving objects is usually handled through some other method.

8.2 **Types of BSP Trees**

BSP trees can be categorized in many ways, such as how the dividing planes are oriented, if geometry is stored in the nodes or the leaves (if at all), and whether they are used for spatial partitioning or as a volume representation. In particular, three types of BSP trees are commonly identified, here called *node-storing*, *leaf-storing*, and *solid-leaf* (or just *solid*) BSP trees. These types are described in more detail in the following sections.

8.2.1 **Node-storing BSP Trees**

A node-storing (or node-based) BSP tree is autopartitioning, thus selecting supporting planes of faces from the geometry as the dividing planes used during construction. As the name suggests, the face whose supporting plane was selected as the dividing plane and all other faces coplanar with it are stored in the node. Remaining faces

are passed to the appropriate side of the plane in order to recursively construct the subtrees of the node, thus ending up stored in the nodes further down the tree. Any straddling faces are split against the dividing plane before the resulting pieces are passed down. Leaves of a node-storing tree may be empty (as all polygons can be stored in the nodes) or may contain a single face (plus any eventual faces coplanar with this face). Because faces are stored in the nodes, it is not strictly necessary to also store planes in the nodes (as they can be derived from the stored faces).

Traditionally, node-storing trees have mainly been used for software rendering of 3D environments, as keeping faces in the nodes results in fewer splits than with other BSP variants, in turn resulting in fewer faces to render. With the advent of 3D graphics hardware, using node-storing trees no longer makes sense in that they excessively divide the geometry into individual polygons. Effective use of 3D rendering hardware instead involves drawing long tri-strips or large patches of faces of the same material to minimize expensive state changes and to reduce the number of vertices transmitted to the graphics card. Such savings are not facilitated by the node-storing BSP tree.

Node-storing trees are not really suitable for collision detection either. Faces stored on the nodes have no spatial relationship to the position of a query object and are thus likely not to intersect the query object. However, these faces must still be tested against, as the query object traverses the dividing plane with which they are associated. In particular, architectural scenes — which tend to feature many coplanar faces — suffer from such overtesting.

Figure 8.3 illustrates the first step of building a node-storing BSP tree. The original 12-polygon input geometry is shown in Figure 8.3a. An initial dividing plane is selected to go through the plane of face *A* (Figure 8.3b). Because *G* also lies on this plane, both *A* and *G* are stored in the root node. Two faces, *D* and *J*, are straddling the divider plane and must be split, after which all faces lie entirely on one side of the dividing plane and can be uniquely assigned to the appropriate subtree. For the next ply of the tree, the plane through *B* is here selected as the dividing plane for the left subtree and the plane through *H* for the right subtree. Figure 8.3c shows the BSP tree after these splits have been performed. Construction proceeds in a similar manner until a termination criterion has been met.

The original BSP tree as described by [Fuchs83] is a node-storing BSP tree in which only the polygon whose supporting plane is selected as the dividing plane is stored in the node. Any other polygons coplanar to this plane are described as going arbitrarily to either side.

8.2.2 Leaf-storing BSP Trees

The term *leaf-storing* (or *leaf-based*) *BSP tree* refers to any BSP tree in which geometry is stored in the leaves of the tree rather than in the internal nodes. An internal tree node only contains the dividing plane and references to the child subtrees of the node. With no polygons on the internal nodes, queries on leaf-storing trees do not

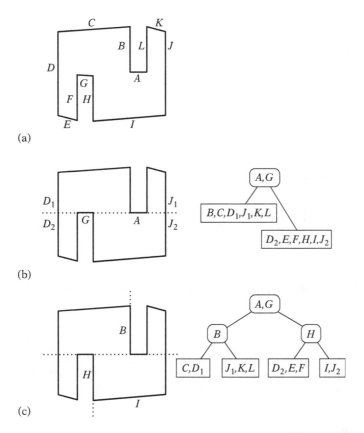

Figure 8.3 (a) The original 12-polygon input geometry. (b) The initial dividing plane is selected to pass through face A (and face G). (c) For the next ply of the tree dividing planes are selected to pass through faces B and H.

suffer from having to test unnecessary polygons when traversing a dividing plane. Collision queries on leaf-storing trees perform tests on all polygons contained in the leaves overlapped by the query object. Tests on the tree may exit early if a collision is detected.

The dividing planes of leaf-storing trees can be either general or autopartitioning. Regardless of which, any eventual faces coplanar with the selected dividing plane are not stored in the node but sent down either the front or back side child tree. When autopartitioning, all faces coplanar with a selected dividing plane should be marked so as to exclude them from consideration when selecting future dividing planes. If they are not excluded, theoretically a dividing plane could be reselected further down the tree, which does not make sense.

The construction of a leaf-storing tree is shown in Figure 8.4. Using arbitrary partitioning, the initially selected dividing plane divides the input set in half.

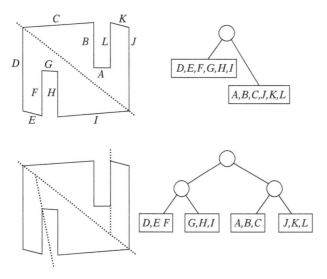

Figure 8.4 First steps of the construction of a leaf-storing BSP tree, using the same geometry as before.

These two halves are then divided again, at which point the construction is stopped, in that a reasonable partitioning has been obtained. Leaf-storing BSP trees (along with k-d trees, quadtrees, and octrees) are common collision geometry data structures, in particular when the collision geometry is given as a polygon soup.

8.2.3 Solid-leaf BSP Trees

Unlike the previous two BSP tree types, solid-leaf BSP trees are built to represent the solid volume occupied by the input geometry. That is, dividing planes are ultimately selected to separate the solid volume from the exterior of the object. A 2D example is shown in Figure 8.5, in which a solid-leaf BSP tree is constructed to represent the interior of a concave (dart-shaped) polygon.

Note that the supporting plane of every polygon in the input geometry must be selected as a dividing plane or the object's volume will not be correctly represented. Specifically, the dividing plane immediately before a leaf node always corresponds to a supporting plane. However, other internal tree nodes can use arbitrary dividing planes, allowing for a better balancing of the tree. In fact, for the object in Figure 8.5 a better BSP tree could be constructed by starting with a dividing plane through the concave vertex and its opposing vertex.

Note also that no geometry is stored in the tree. The leaf nodes only indicate whether the remaining area in front and behind of the dividing plane is empty or solid. In other words, a solid-leaf BSP tree can be seen as partitioning the input volume into a collection of convex polyhedra, which are then represented as the intersection volume of a number of halfspaces. The dividing planes of the BSP tree correspond to

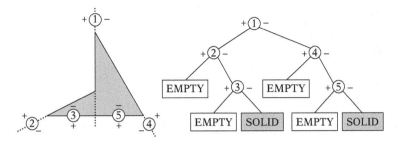

Figure 8.5 A solid figure cut by a number of dividing planes and the resulting solid-leaf BSP tree.

the partitioning planes, plus the boundary planes of the convex polyhedra. In terms of Figure 8.5, the initial dividing plane partitions the nonconvex shape into two (convex) triangles. The remaining dividing planes describe the boundary of these triangles.

Solid-leaf BSP trees have a number of valuable properties as far as collision detection goes. They allow trivial detection of robustness problems such as fall-throughs, in that intersection tests directly report whether an object lies in solid or empty space. Because the representation effectively encodes the boundary polygons of the input geometry, there is also no need to perform specific polygon tests (as no polygons are explicitly stored). The lack of special tests for polygons makes for very nice, uniform code.

It is also possible to create a hybrid between a solid-leaf and a leaf-storing BSP tree. An example of a hybrid tree is the *brush-storing* tree popularized through its use in the *Quake II* and *Quake III* games from id Software. This tree explicitly stores the planes that form the halfspace intersection volume that is the solid volume occupied by the leaf (where *brush* is the *Quake* terminology for this collection of planes). Additionally, the tree contains the beveling planes described in Section 8.4.3 to allow efficient AABB queries on the tree.

The various data formats used in the *Quake* games are well documented on the Internet. For example, the *Quake II* BSP file format is described in [McGuire00], as well as implicitly through the *Quake II* source code itself [idSoftware01]. The collision detection of *Quake III* is discussed in [Ostgard03].

8.3 **Building the BSP Tree**

Building a BSP tree involves three steps.

1. Selection of a partitioning plane.

2. Partitioning of the input geometry into two sets with respect to the plane; the geometry in front of the plane and the geometry behind it. Geometry that straddles

the plane is split to the plane before partitioning. (Polygons on the plane are treated differently depending on what type of tree is constructed.)

3. The forming of a tree by connecting with a new tree node the two subtrees created by recursively calling the construction algorithm with the two partitioned sets obtained in the previous step.

These steps translate directly into code as follows (here illustrated for the construction of a leaf-storing tree).

```
// Constructs BSP tree from an input vector of polygons. Pass 'depth' as 0 on entry
BSPNode *BuildBSPTree(std::vector<Polygon *> &polygons, int depth)
{
    // Return NULL tree if there are no polygons
    if (polygons.empty()) return NULL;

    // Get number of polygons in the input vector
    int numPolygons = polygons.size();

    // If criterion for a leaf is matched, create a leaf node from remaining polygons
    if (depth >= MAX_DEPTH || numPolygons <= MIN_LEAF_SIZE) || ...etc...)
        return new BSPNode(polygons);

    // Select best possible partitioning plane based on the input geometry
    Plane splitPlane = PickSplittingPlane(polygons);

    std::vector<Polygon *> frontList, backList;

    // Test each polygon against the dividing plane, adding them
    // to the front list, back list, or both, as appropriate
    for (int i = 0; i < numPolygons; i++) {
        Polygon *poly = polygons[i], *frontPart, *backPart;
        switch (ClassifyPolygonToPlane(poly, splitPlane)) {
        case COPLANAR_WITH_PLANE:
            // What's done in this case depends on what type of tree is being
            // built. For a node-storing tree, the polygon is stored inside
            // the node at this level (along with all other polygons coplanar
            // with the plane). Here, for a leaf-storing tree, coplanar polygons
            // are sent to either side of the plane. In this case, to the front
            // side, by falling through to the next case
        case IN_FRONT_OF_PLANE:
            frontList.push_back(poly);
            break;
```

```
    case BEHIND_PLANE:
        backList.push_back(poly);
        break;
    case STRADDLING_PLANE:
        // Split polygon to plane and send a part to each side of the plane
        SplitPolygon(*poly, splitPlane, &frontPart, &backPart);
        frontList.push_back(frontPart);
        backList.push_back(backPart);
        break;
    }
}

// Recursively build child subtrees and return new tree root combining them
BSPNode *frontTree = BuildBSPTree(frontList, depth + 1);
BSPNode *backTree = BuildBSPTree(backList, depth + 1);
return new BSPNode(frontTree, backTree);
}
```

For constructing leaf-storing or solid trees, polygons that lie on the partitioning plane are sent to either side of the plane (here, to the front side of the plane). For node-storing trees, coplanar polygons are instead stored in the node itself.

Although simple in structure, there are a few problems hidden in the helper functions called by this code. Specifically, having **PickSplittingPlane()** select a good partitioning plane is a nontrivial problem. Sections 8.3.1 and 8.3.2 cover this problem in more detail. There are also some subtle issues to do with robustness involved in classifying and splitting a polygon to a plane in the functions **ClassifyPolygonToPlane()** and **SplitPolygon()**, discussed further in Sections 8.3.3 through 8.3.5.

A third issue is determining when to stop the tree construction. This depends on the type of BSP tree being built. For a node-storing tree, the recursive construction proceeds until the set of remaining input polygons becomes empty. The same applies for a solid-leaf tree. The construction of a leaf-storing BSP tree is typically stopped when:

- The leaf contains less than some preset number of polygons.
- A fixed cutoff depth has been reached.
- A good dividing plane cannot be found.

The examples presented in this chapter use the same tree representation for construction of the tree and for runtime queries. However, it is important to stress

that a quality production system is likely to use two completely different representations for performance reasons. The BSP tree used during tree construction should be designed for easy manipulation using regular pointers to address child nodes, and it should have full-size uncompressed fields. In contrast, the BSP tree used at runtime should be designed to use little memory (using compressed nodes and pointers) and have its nodes output in a cache-efficient format (as discussed in Chapters 6 and 13).

8.3.1 Selecting Dividing Planes

The order in which dividing planes are selected during tree construction greatly affects the size and shape of the resulting tree, and therefore the effectiveness of the tree for querying. It also affects the tree's memory requirements. Due to the sheer number of possible plane orderings, computing an optimal BSP tree is an intractable problem. Fortunately, in practice good or even near-optimal solutions can be obtained by trying a number of candidate dividing planes at each level of the tree, proceeding with the one that scores best according to an evaluation function (as described in Section 8.3.2).

Because there are infinitely many arbitrary dividing planes, one approach of constraining the problem is limiting the set of possible dividing planes to a finite number by relying on autopartitioning. That is, the strategy is to restrict the search to the supporting planes of the faces in the input geometry.

Autopartitioning is simple to implement. It is also a natural choice for a node-storing tree. However, autopartitioning (alone) is not always ideal. In some cases — such as for a leaf-storing tree — relying on autopartitioning alone may lead to more splitting than is desired. To illustrate the point, Figure 8.6a shows a geometrical configuration in which all possible autopartitioned dividing planes end up splitting several faces. Figure 8.6b shows how, by using general dividing planes, the groups of polygons can be separated from each other, resulting in no splits at all. (However, it is important to note that if the three groups are moved closer to one another it will be impossible to find even a general dividing plane to separate the groups.)

For another drawback of using just autopartitioning, consider the problem of building a BSP tree from a polygon sphere. Because the sphere is a convex shape, all sphere faces will lie on just one side of a plane through any one of its faces. The resulting tree will in some sense therefore be maximally unbalanced, with a depth equal to the number of faces in the sphere (Figure 8.7a). Determining point containment — a typical worst-case query — is now an $O(n)$ operation. In contrast, if selected planes are instead allowed to cut across the sphere, roughly half the faces can be discarded for each plane tested, making the same worst-case query an $O(\log n)$ operation (Figure 8.7b).

If the BSP tree is computed as a boundary representation of the sphere, the supporting planes of the sphere faces at some point must be selected as dividing planes. One option is to perform general splits, dividing the geometry in half until only a

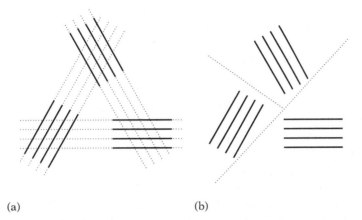

(a) (b)

Figure 8.6 (a) A configuration of 12 faces wherein all possible autopartitioned dividing planes end up splitting four faces. (b) Using **arbitrary** splits can allow the configuration to be partitioned in such a **way** that the problem disappears or is reduced.

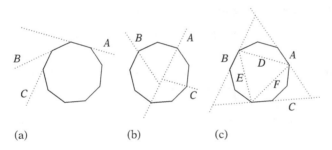

(a) (b) (c)

Figure 8.7 (a) An autopartitioned BSP tree for a **polygonal** sphere has worst-case $O(n)$ height. (b) Allowing **arbitrary** cuts across the sphere, tree height is reduced to $O(\log n)$. (c) Naylor's **hybrid** approach of alternating autopartitioning and general cuts also allows a **boundary** representation of the sphere to have $O(\log n)$ height, **additionally** providing early outs.

single polygon is left in the leaves, at which point its supporting plane is selected as the dividing plane. The drawback with this approach is that *all* leaves are now at an $O(\log n)$ depth, and thus there are no early outs for queries such as those well outside the sphere.

A better option is suggested by [Naylor93]. He proposes using a hybrid approach of alternating autopartitioning and general cuts to get both an $O(\log n)$ tree height and potential early outs. A set of autopartitioning planes is first selected to separate the sphere from the surrounding empty space, forming a tetrahedron surrounding

the sphere (illustrated in Figure 8.7c by the triangle formed by A, B, and C). The resulting volume is then separated into five disjoint parts through four planes interior to the sphere (illustrated by D, E, and F). One region corresponds to a solid tetrahedron interior to the sphere. The remaining four regions (three in the 2D illustration) are recursively subjected to the same separating procedure until all faces have been processed. The resulting tree can be seen as providing a sequence of approximations of the sphere through successive refinement, becoming more and more accurate with each additional level of the tree. There are strong similarities between this approach and the Dobkin–Kirkpatrick hierarchy described in Chapter 9.

Generalizing Naylor's approach to a full scene implies that an efficient way of dealing with highly detailed objects within a scene is to provide bounding volume approximations of the objects and autopartition through the faces of the bounding volumes before performing any splitting involving the geometry within the bounding volumes. Alternative candidate dividing planes — not autopartitioning — can be made to include, for example:

- Planes in a few predetermined directions (such as aligned with the coordinate axes) going through a polygon vertex.

- Planes in predetermined directions evenly distributed across the extents of the input geometry (forming a grid across the geometry).

- Planes through an edge of one polygon and a vertex of another.

Rather than relying exclusively on automatic selection of dividing planes, manually placed *hinting planes* can be used to guide the plane selection. These correspond to specially marked polygons that are not output as geometry but serve only to define planes considered dividing planes. Possible strategies for hint planes include:

- If a hint plane is present, pick a hint plane before anything else.

- Allow picking of any plane, with the caveat that a hint plane is not allowed to be split by a non-hint plane.

As an example, a good use of hint planes could be placing them aligned with the floors of a multi-story building. Such hint planes would quickly localize the proper floor within which search could then continue.

Finally, arbitrary planes can also be selected through a simple hill-climbing approach. That is, after an initial dividing plane has been found (through whatever means), a small neighborhood of similar planes obtained from slight offsetting and tilting is evaluated. If a better dividing plane is found, the new plane is kept and the hill climbing is repeated until a (local) maximum is found or a specified time limit is exceeded.

8.3.2 **Evaluating Dividing Planes**

Many general strategies have been suggested for evaluating splitting planes (see, for example, [James99]). A majority of these are based on the assumption of a node-storing tree, such as selecting the supporting plane of the face with the largest number of coplanar faces or of the face with the largest area. Storing these faces in the node would thus remove from further consideration a large number of faces (in the first case) or a face with a high likelihood of being split (in the second case).

Two strategies particularly relevant to collision detection are to pick planes so as to minimize splitting of geometry and to attempt to balance the geometry equally on both sides of the splitting plane. The former *least-crossed* strategy attempts to minimize the duplication of geometry due to splitting. Worst case, when starting with n polygons each split can introduce n additional polygons through splitting. Thus, it is possible to end up with $O(n^2)$ polygons in the final result. Because dividing planes with few straddling polygons are usually found at the periphery of a scene, used in isolation the least-crossed strategy is therefore likely to produce very unbalanced trees. On the other hand, balancing cuts — although they produce nicely structured trees — are likely to cause an excessive amount of split geometry because they tend to cut straight down the middle of a scene and its objects. A weighted linear combination of the two is therefore used in practice. Reducing splitting is often weighted much higher than balancing. Figure 8.8 illustrates a split intended to minimize straddling polygons, a split to achieve balance of the number of polygons on either side of the splitting plane, and a split intended as a compromise between minimizing straddling and balancing of polygons.

The following code fragment illustrates a very basic autopartitioning selection of a splitting plane. Here, all supporting planes of the set of polygons are considered for splitting. A weighted linear combination between the conflicting goals of trying to reduce splitting and attempting to increase balancing is used to evaluate the planes.

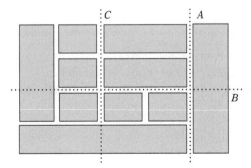

Figure 8.8 Part of a city grid split to minimize straddling polygons (*A*), balance the number of polygons on either side of the dividing plane (*B*), and compromise between minimizing straddling and balancing of polygons (*C*).

```
// Given a vector of polygons, attempts to compute a good splitting plane
Plane PickSplittingPlane(std::vector<Polygon *> &polygons)
{
    // Blend factor for optimizing for balance or splits (should be tweaked)
    const float K = 0.8f;
    // Variables for tracking best splitting plane seen so far
    Plane bestPlane;
    float bestScore = FLT_MAX;

    // Try the plane of each polygon as a dividing plane
    for (int i = 0; i < polygons.size(); i++) {
        int numInFront = 0, numBehind = 0, numStraddling = 0;
        Plane plane = GetPlaneFromPolygon(polygons[i]);
        // Test against all other polygons
        for (int j = 0; j < polygons.size(); j++) {
            // Ignore testing against self
            if (i == j) continue;
            // Keep standing count of the various poly-plane relationships
            switch (ClassifyPolygonToPlane(polygons[j], plane)) {
            case POLYGON_COPLANAR_WITH_PLANE:
                /* Coplanar polygons treated as being in front of plane */
            case POLYGON_IN_FRONT_OF_PLANE:
                numInFront++;
                break;
            case POLYGON_BEHIND_PLANE:
                numBehind++;
                break;
            case POLYGON_STRADDLING_PLANE:
                numStraddling++;
                break;
            }
        }
        // Compute score as a weighted combination (based on K, with K in range
        // 0..1) between balance and splits (lower score is better)
        float score = K * numStraddling + (1.0f - K) * Abs(numInFront - numBehind);
        if (score < bestScore) {
            bestScore = score;
            bestPlane = plane;
        }
    }
    return bestPlane;
}
```

Here, the variable **K** controlling the blending of the least-crossed and balancing strategies is given as a constant. In practice, it can be made to vary with the depth of the current node during construction.

Because most collision queries will only traverse tree nodes to visit the one (or a few) leaves of the tree overlapped by the query object, a well-balanced tree means that all leaves are roughly at the same depth and worst-case behavior is avoided. However, to improve average-case behavior dividing planes should not be selected for balancing but instead to provide short traversal paths to areas that have a high probability of being subject to query. As an illustration, consider the configuration shown in Figure 8.9. In illustration (a) a dividing plane splits the space in half, achieving perfect balance through an equal number of polygons on both sides of the plane. Assuming point queries uniformly distributed over the space, the expected number of polygons that would have to be tested is in this case $0.5 \cdot 5 + 0.5 \cdot 5 = 5$. In illustration (b), the plane has instead been selected to divide the space into a 2/3 ratio, with two polygons on one side and eight on the other. The expected number of polygons tested by the same uniform point query is now $2/3 \cdot 2 + 1/3 \cdot 8 = 4$, one less than before. Instead of just assuming a uniform distribution of queries, as was done here, statistics of query locations from actual runs could be used to determine accurate probability values in these calculations.

In general, research indicates that not very many splitting planes must be considered for good results. Fuchs et al. point out that for the least-crossed criterion near-minimal trees were obtained from just randomly selecting five candidate polygons at each level and testing these against the other polygons [Fuchs80]. This result is corroborated in [James99]. However, it should be noted that both results were obtained using autopartitioning and node-storing trees. (In fact, a majority of theoretical results on BSP trees are based on using autopartitioning and node-storing trees, thus differing greatly from typical practical use.)

More sophisticated evaluation methods have also been suggested, including *conflict minimization* [Fuchs80] and *conflict neutralization* [James00]. These approaches consider two or more consecutive dividing planes at a time, selecting the plane at the current level of the tree so as to reduce conflicts as much as possible (wherein a conflict is the splitting of one or more faces by a possible future dividing plane).

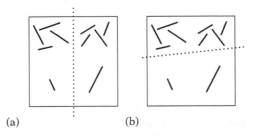

(a) (b)

Figure 8.9 (a) A balancing split. (b) A split to minimize expected query cost.

Again, these methods have largely been studied in conjunction with autopartitioning and not with general dividing planes.

Certain evaluation criteria, such as balancing, naturally tend to avoid the reselection of dividing planes. Even so, it may still be useful to include an explicit mechanism for avoiding reselection of a dividing plane that has already been used. When autopartitioning, reselection is easily avoided by tagging polygons as their supporting planes are selected and then not selecting supporting planes of marked polygons. In other cases, a history list of previously selected planes works as a simple solution.

8.3.3 Classifying Polygons with Respect to a Plane

As part of the BSP tree construction, after a dividing plane has been selected all polygons must be partitioned with respect to this plane into one of the following four categories.

- Polygons that lie in front of the dividing plane.

- Polygons that lie behind the dividing plane.

- Polygons straddling the dividing plane.

- Polygons coincident with the dividing plane.

Although theoretically straightforward, there is a problem with this classification when working with floating-point arithmetic. The problem is that points computed to lie on a given plane typically do not end up exactly on the plane but some small distance away from the plane. This slight deviation from the plane means that when a polygon is split by a dividing plane the resulting pieces do not necessarily classify as one lying in front of the dividing plane and one lying behind it. For example, inaccuracies in the computed intersection points could have both pieces straddling the dividing plane even though the splitting operation conceptually created the two pieces to lie on different sides of the plane. Addressing the floating-point issue is necessary for robust classification of polygons into these four categories.

A practical solution to this problem is to work with *thick* planes, meaning that all points within a small distance from the plane are considered lying on the plane. More specifically, instead of working with a plane defined as $\mathbf{n} \cdot (X - P) = 0$ points are considered on the plane if they satisfy $|\mathbf{n} \cdot (X - P)| < \varepsilon$ for some ε. The following function shows how the classification of a point to a thick plane can be implemented.

```
// Classify point p to a plane thickened by a given thickness epsilon
int ClassifyPointToPlane(Point p, Plane plane)
{
```

```
    // Compute signed distance of point from plane
    float dist = Dot(plane.n, p) - plane.d;
    // Classify p based on the signed distance
    if (dist > PLANE_THICKNESS_EPSILON)
        return POINT_IN_FRONT_OF_PLANE;
    if (dist < -PLANE_THICKNESS_EPSILON)
        return POINT_BEHIND_PLANE;
    return POINT_ON_PLANE;
}
```

Determining appropriate epsilon values is surprisingly nontrivial. Whereas the issue is glossed over here, Chapter 11 discusses this issue in detail.

As an example of classification of polygons to a thick plane, consider the four triangles of Figure 8.10. For triangle *ABC*, vertex *A* lies on the plane, and vertices *B* and *C* lie behind the plane. Because there is at least one vertex behind the plane and no vertices in front of the plane, *ABC* is classified as lying behind the plane. Triangle *DEF* has one vertex, *D*, in front of the plane and two vertices, *E* and *F*, on the plane. As there is at least one vertex in front of the plane and no vertices behind the plane, *DEF* is classified as lying in front of the plane. Note that *DEF* is considered in front of the plane even though *E* lies in the negative halfspace of the plane $\mathbf{n} \cdot (X - P) = 0$, as *E* is classified as being on the plane rather than behind it.

The triangle *GHI* is classified as straddling the dividing plane because there is at least one vertex in front of the plane and one behind the plane (*G* and *I*, respectively). Triangle *JKL* is classified as coplanar with the plane in that all of its vertices lie on the thickened plane. The following code illustrates how this approach extends to classifying an arbitrary polygon with respect to a dividing plane.

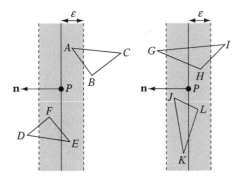

Figure 8.10 Triangle *ABC* lies behind the plane and triangle *DEF* lies in front of the plane. Triangle *GHI* straddles the plane and triangle *JKL* lies on the plane.

```
// Return value specifying whether the polygon 'poly' lies in front of,
// behind of, on, or straddles the plane 'plane'
int ClassifyPolygonToPlane(Polygon *poly, Plane plane)
{
    // Loop over all polygon vertices and count how many vertices
    // lie in front of and how many lie behind of the thickened plane
    int numInFront = 0, numBehind = 0;
    int numVerts = poly->NumVertices();
    for (int i = 0; i < numVerts; i++) {
        Point p = poly->GetVertex(i);
        switch (ClassifyPointToPlane(p, plane)) {
        case POINT_IN_FRONT_OF_PLANE:
            numInFront++;
            break;
        case POINT_BEHIND_PLANE:
            numBehind++;
            break;
        }
    }
    // If vertices on both sides of the plane, the polygon is straddling
    if (numBehind != 0 && numInFront != 0)
        return POLYGON_STRADDLING_PLANE;
    // If one or more vertices in front of the plane and no vertices behind
    // the plane, the polygon lies in front of the plane
    if (numInFront != 0)
        return POLYGON_IN_FRONT_OF_PLANE;
    // Ditto, the polygon lies behind the plane if no vertices in front of
    // the plane, and one or more vertices behind the plane
    if (numBehind != 0)
        return POLYGON_BEHIND_PLANE;
    // All vertices lie on the plane so the polygon is coplanar with the plane
    return POLYGON_COPLANAR_WITH_PLANE;
}
```

Because the introduction of an epsilon only moves the problem of correctly determining if points lie on the plane to correctly determining if points lie at epsilon distance from the plane, it may seem like nothing is gained by this procedure. However, two things are gained. First, polygon edges are guaranteed to have both endpoints at (roughly) epsilon distance or more from the plane. Having a minimum distance for the endpoints from the plane increases the angle of the edge to the plane, in turn increasing the accuracy in computing the intersection point between the edge and the plane. Second, with an appropriate epsilon the intersection point can be guaranteed to lie on the thick plane. Although points lying at (near) epsilon

distance from the plane are still misclassified, the misclassification no longer affects the robustness of polygon splitting, in that computed intersection points correctly classify as lying on the thick plane.

Traditional methods for splitting a polygon to a plane must be changed slightly to deal with a thick plane. These changes are discussed next.

8.3.4 Splitting Polygons Against a Plane

During BSP tree construction, when a polygon is found straddling a dividing plane it must be split in two. One piece is then sent down one side of the plane, and the other piece down the other side. To see why polygons must be split, consider the illustration in Figure 8.11. Here, two splits have been made, dividing the world into the three areas A, B, and C. The triangle T overlaps regions A and B, and thus should be referenced in those leaves. However, if T is not split the following happens. First, T is found straddling plane 1 and is sent down both sides. On the right side, T is now tested against plane 2 and again sent down both sides. At this point all leaves have been reached and T ends up in all of them!

When T is split against plane 1, only the small piece on the right side of the plane goes down the right side of the tree. This piece lies fully on one side of plane 2, and thus nothing goes into the leaf for region C. In other words, it is important to perform clipping of polygons during tree construction. Such clipping limits polygons from ending up in leaves whose associated spatial volume they did not intersect in the first place.

An alternative is to maintain the spatial volumes corresponding to the leaves and to perform polygon–convex-polyhedron tests to determine if a polygon should be added to a leaf. Maintaining such volumes is only practically feasible for axis-aligned BSP trees for which the leaf volumes are AABBs. In other cases, it is cheaper to split the polygons during construction.

The act of clipping the polygon against a plane is commonly performed using the Sutherland–Hodgman clipping algorithm [Sutherland74]. The algorithm proceeds

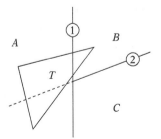

Figure 8.11 If T is not split by the first dividing plane, T straddles the second dividing plane and a copy ends up in the leaf for C, which otherwise would have remained empty.

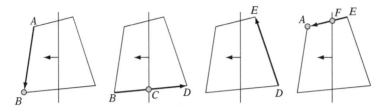

Figure 8.12 Clipping the polygon *ABDE* illustrates the four cases of the Sutherland–Hodgman polygon-clipping algorithm. The points of the output polygon *BCFA* are shown in gray in the cases in which they are output.

one polygon edge at a time and has four cases based on what sides of the clipping plane the edge startpoints and endpoints lie. The four cases are illustrated in Figure 8.12. In the first case, when both points lie in front of the plane the endpoint is output. The second case is the edge going from in front of the plane to behind the plane, for which the intersection point of the edge with the plane is output. The third case is when both points lie behind the plane, for which nothing is output. Finally, the forth case is when the edge goes from behind the plane to in front of the plane. In this case, both the intersection point and the endpoint are output.

With the Sutherland–Hodgman algorithm, only the portion of the polygon in front of the plane is retained. Because both pieces of the polygon must be retained for the BSP tree construction, the algorithm must be extended accordingly. In addition, because the clipping plane has been made thick one or more rules dealing with vertices lying on the plane must be added. One commonly used set of rules is outlined in Table 8.1, to which a fifth case has been added to the original four to deal with points on the plane.

One reason for working with thick planes was previously mentioned: inherent floating-point inaccuracies in computing the intersection point I means it will not lie exactly on the mathematical plane. Another related benefit of working with a thick

Table 8.1 Output rules for the modified Sutherland–Hodgman clipping algorithm dealing with a thickened plane and retaining both parts of the polygon. The rules are given in terms of the directed segment *AB*. *I* represents the intersection point of *AB* with the clipping plane.

A (previous vertex)	B (current vertex)	Front Polygon Output	Back Polygon Output
In front	In front	B	None
Behind	In front	I, B	I
In front	Behind	I	I, B
Behind	Behind	None	B
Any	On	B	B

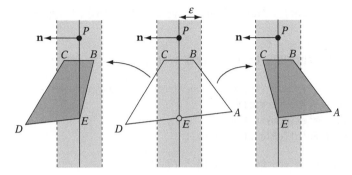

Figure 8.13 A potential problem with the modified clipping algorithm is that the resulting pieces (shown in dark gray) may overlap.

plane is that an intersection point is computed only for an edge with one endpoint in front of and the other endpoint behind the plane. Thanks to the thickness of the plane, a limit is therefore placed on how parallel to the plane the edge can become, which greatly increases the accuracy of the intersection point. Chapter 11 discusses these floating-point issues further.

For most applications, the set of rules presented in Table 8.1 works fine, but it is important to be aware that the two resulting polygon pieces may overlap in some cases. Consider the quad *ABCD* of Figure 8.13. When it is split against the plane, the subtriangle *BCE* will end up in both outputs.

For robust clipping of the polygon, so that no overlap exists between the generated pieces, a full set of all nine possible cases is necessary. Such a set is outlined in Table 8.2.

An implementation of these nine rules might look as follows.

Table 8.2 The final modified clipping algorithm for robustly clipping a polygon against a thick plane.

A (previous vertex)	B (current vertex)	Front Polygon Output	Back Polygon Output
In front	In front	B	None
On	In front	B	None
Behind	In front	I, B	I
In front	On	B	None
On	On	B	None
Behind	On	B	B
In front	Behind	I	I, B
On	Behind	None	A, B
Behind	Behind	None	B

```
void SplitPolygon(Polygon &poly, Plane plane, Polygon **frontPoly, Polygon **backPoly)
{
    int numFront = 0, numBack = 0;
    Point frontVerts[MAX_POINTS], backVerts[MAX_POINTS];

    // Test all edges (a, b) starting with edge from last to first vertex
    int numVerts = poly.NumVertices();
    Point a = poly.GetVertex(numVerts - 1);
    int aSide = ClassifyPointToPlane(a, plane);

    // Loop over all edges given by vertex pair (n - 1, n)
    for (int n = 0; n < numVerts; n++) {
        Point b = poly.GetVertex(n);
        int bSide = ClassifyPointToPlane(b, plane);
        if (bSide == POINT_IN_FRONT_OF_PLANE) {
            if (aSide == POINT_BEHIND_PLANE) {
                // Edge (a, b) straddles, output intersection point to both sides
                Point i = IntersectEdgeAgainstPlane(a, b, plane);
                assert(ClassifyPointToPlane(i, plane) == POINT_ON_PLANE);
                frontVerts[numFront++] = backVerts[numBack++] = i;
            }
            // In all three cases, output b to the front side
            frontVerts[numFront++] = b;
        } else if (bSide == POINT_BEHIND_PLANE) {
            if (aSide == POINT_IN_FRONT_OF_PLANE) {
                // Edge (a, b) straddles plane, output intersection point
                Point i = IntersectEdgeAgainstPlane(a, b, plane);
                assert(ClassifyPointToPlane(i, plane) == POINT_ON_PLANE);
                frontVerts[numFront++] = backVerts[numBack++] = i;
            } else if (aSide == POINT_ON_PLANE) {
                // Output a when edge (a, b) goes from 'on' to 'behind' plane
                backVerts[numBack++] = a;
            }
            // In all three cases, output b to the back side
            backVerts[numBack++] = b;
        } else {
            // b is on the plane. In all three cases output b to the front side
            frontVerts[numFront++] = b;
            // In one case, also output b to back side
            if (aSide == POINT_BEHIND_PLANE)
                backVerts[numBack++] = b;
        }
```

```
    // Keep b as the starting point of the next edge
    a = b;
    aSide = bSide;
  }

  // Create (and return) two new polygons from the two vertex lists
  *frontPoly = new Polygon(numFront, frontVerts);
  *backPoly = new Polygon(numBack, backVerts);
}
```

Note that calls to **assert()** have been added to verify that the computed intersection points really do lie on the thick plane. The call serves as a sanity check that the plane thickness has been well chosen with respect to the range of coordinate values present in the input data.

Figure 8.14 illustrates the result of splitting two polygons against a plane. The original polygons are given in outlines and the resulting pieces are shown in gray, slightly inset.

Although polygons are split during the construction of the tree, this does not necessarily mean that the polygon fragments ending up in the leaves must be the polygons output in the final tree.

For collision detection, it is better to store a reference to the original polygon with each fragment generated during splitting. In the leaves, the reference is output, rather than the fragment itself. Storing a reference to the original polygon avoids many robustness issues caused by clipping to planes, such as the introduction of

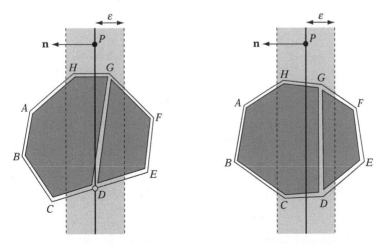

Figure 8.14 Two different polygons clipped to a thickened plane using the modified robust clipping algorithm. Resulting polygon pieces are shown in dark gray (slightly inset).

sliver polygons and T-junctions. Clipping also generates extra vertices, and thus not clipping saves memory as well. The drawback of not clipping is that it may now be important to make sure the intersection with a polygon takes place inside the volume of the leaf and not with the part of the polygon that lies outside the leaf volume. Without this test, a near-to-far traversal of the BSP tree could not be guaranteed to find the nearest point of intersection for a ray intersection test.

Most BSP tree presentations and resources on polygon clipping do not cover the use of thick planes for robustness. A notable exception is [Chin92], in discussion on robust polygon clipping.

8.3.5 More on Polygon Splitting Robustness

Although the previous section presented a thorough description of how to split a single polygon in a robust manner, there is one remaining issue that arises when clipping a shared edge of two neighboring polygons. Consider the two triangles ABC and CBD of Figure 8.15a, both with their vertices given in counterclockwise order. Splitting these triangles against the plane clips the shared edge BC twice: once for each triangle. There is a subtle yet crucial point here: the edge is defined as BC for triangle ABC and as CB for triangle CBD. Due to the differences between floating-point arithmetic and real arithmetic, intersecting BC against a plane P does not, in general, result in the same intersection point as intersecting CB with the same plane. Naive clipping code, which moves around the boundaries of the two triangles and clips the edges as they are encountered, will therefore introduce cracks between the two neighboring triangles (as the computed intersection points differ subtly).

Figure 8.15b illustrates the problem case. For triangle ABC, edges BC and CA are clipped against the plane. BC intersects the plane at F_{BC}. For triangle CBD, edges

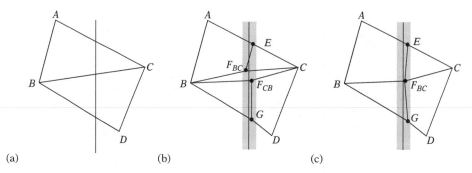

Figure 8.15 (a) Original geometry of two triangles intersecting a plane. (b) Inconsistent handling of the shared edge results in two different intersection points, which introduces cracking. (c) The correct result when the shared edge is handled **consistently**.

CB and *BD* must be clipped. *CB* intersects the plane at F_{CB}, subtly different from F_{BC} (the errors of the intersection points have been exaggerated to better illustrate the point). As can be seen from the illustration, this clearly introduces a crack between the clipped faces.

To robustly deal with this case, the clipping code must always intersect the given edge consistently as *either BC* or *CB*, but not *both*. Fortunately, the change is trivial: because an edge is only clipped when its endpoints lie on different sides of the plane, the edge can always be intersected as if it were ordered going from in front of the plane to behind the plane (or vice versa).

For the clipping code of the previous section, the only change required is thus swapping the edge endpoints for the arguments to the first call to **IntersectEdgeAgainstPlane()**, as follows.

```
...
if (bSide == POINT_IN_FRONT_OF_PLANE) {
    if (aSide == POINT_BEHIND_PLANE) {
        // Edge (a, b) straddles, output intersection point to both sides.
        // Consistently clip edge as ordered going from in front -> behind
        Point i = IntersectEdgeAgainstPlane(b, a, plane);
        ...
    }
    ...
```

Figure 8.15c illustrates the result of using a correct clipping procedure: the crack between the triangles exists no longer.

8.3.6 Tuning BSP Tree Performance

Tuning various BSP tree parameters to achieve best possible performance is a difficult problem. Is splitting strategy *A* better than strategy *B*? At what depth should tree construction stop? What is the most appropriate value of the variable **K** in the function **PickSplittingPlane()**?

To help evaluate different settings of various parameters, a good approach is to build a reference database of queries that occur at runtime, for example by player or enemies. These are logged during a normal run and saved along with the world collision geometry used. Because this database can be used to perform identical queries against different spatial partitionings of the collision geometry, it now becomes easy to compare different parameter settings, allowing the creation of a good spatial partitioning. If desired, tuning of the parameters themselves can be easily automated through a hill-climbing-like mechanism (such as simulated annealing or genetic algorithms).

8.4 Using the BSP Tree

As an example of the ease with which BSP trees handle certain problems, consider the problem of rendering the faces on the nodes of a node-storing BSP tree in back-to-front order. By construction, the geometry on each side of a dividing plane does not intersect. Consequently, if the camera lies on the front side of a dividing plane no geometry on the back side of the dividing plane can obscure the geometry on the front side (nor the geometry on the plane itself). Thus, all that is needed to render the tree back to front is to recursively render the far subtree of the current node, then the faces stored in the node, then recursively render the near subtree (the one corresponding to the side on which the camera lies). The implementation of back-to-front rendering of a BSP tree then becomes:

```
// Render node-storing BSP tree back-to-front w/ respect to cameraPos
void RenderBSP(BSPNode *node, Point cameraPos)
{
    // Get index of which child to visit first (0 = front, 1 = back)
    int index = ClassifyPointToPlane(cameraPos, node->plane) == POINT_IN_FRONT_OF_PLANE;

    // First visit the side the camera is NOT on
    if (node->child[index]) RenderBSP(node->child[index], cameraPos);
    // Render all polygons stored in the node
    DrawFrontfacingPolygons(node->pPolyList);
    // Then visit the other side (the one the camera is on)
    if (node->child[index ^ 1]) RenderBSP(node->child[index ^ 1], cameraPos);
}
```

The same recursive approach is used for all queries on BSP trees. In that leaf-storing BSP trees are really just another form of spatial partitioning, discussed in detail in Chapter 7, the following section focuses specifically on the implementation of basic collision queries on solid-leaf BSP trees.

8.4.1 Testing a Point Against a Solid-leaf BSP Tree

Testing if a point lies in empty or solid space of a solid-leaf BSP tree is a largely straightforward application. At each node, the point is evaluated with respect to the dividing plane at that node. If the point lies in front of the plane, the child node representing the front tree is visited, and vice versa. Traversal continues until a leaf node is reached, at which point the solidity of the leaf indicates the result.

The only complication lies in correctly determining if the query point lies on the boundary of the solid volume represented by the BSP tree. To handle the boundary case, both subtrees are traversed when the point lies on a dividing plane. If the

subtree results indicate the same result (solid or empty space), that is the result. Otherwise, the point lies in the boundary. The following code illustrates how this test may be implemented (using a thick plane for robustness).

```
int PointInSolidSpace(BSPNode *node, Point p)
{
    while (!node->IsLeaf()) {
        // Compute distance of point to dividing plane
        float dist = Dot(node->plane.n, p) - node->plane.d;
        if (dist > EPSILON) {
            // Point in front of plane, so traverse front of tree
            node = node->child[0];
        } else if (dist < -EPSILON) {
            // Point behind of plane, so traverse back of tree
            node = node->child[1];
        } else {
            // Point on dividing plane; must traverse both sides
            int front = PointInSolidSpace(node->child[0], p);
            int back = PointInSolidSpace(node->child[1], p);
            // If results agree, return that, else point is on boundary
            return (front == back) ? front : POINT_ON_BOUNDARY;
        }
    }
    // Now at a leaf, inside/outside status determined by solid flag
    return node->IsSolid() ? POINT_INSIDE : POINT_OUTSIDE;
}
```

If it is not necessary to categorize points as lying on the boundary and they can instead be considered inside the solid, this test can be simplified to visit the back side when the point is categorized as on the dividing plane. The code then becomes:

```
int PointInSolidSpace(BSPNode *node, Point p)
{
    while (!node->IsLeaf()) {
        // Compute distance of point to dividing plane
        float dist = Dot(node->plane.n, p) - node->plane.d;
        // Traverse front of tree when point in front of plane, else back of tree
        node = node->child[dist <= EPSILON];
    }
    // Now at a leaf, inside/outside status determined by solid flag
    return node->IsSolid() ? POINT_INSIDE : POINT_OUTSIDE;
}
```

8.4.2 **Intersecting a Ray Against a Solid-leaf BSP Tree**

A typical query on a BSP tree is the intersection of a ray or segment against the tree. One solution is to adapt the function **VisitNodes()**, discussed in Section 7.4.1, for traversing all nodes of a node-storing k-d tree intersected by a segment. Here, an alternative, nonrecursive, traversal routine is given.

One important difference between **VisitNodes()** and the discussed query is that the former computes the intersection point of the segment and a dividing plane. It then breaks the segment into two subsegments at this point. These subsegments are then subject to splitting in a similar manner as they are passed down the tree recursively. Due to accumulation of errors, this means that the computed intersection points are likely to drift off the original segment. The further down the tree a query traversal reaches the farther from the original segment the intersection points are expected to move. From a robustness standpoint, this is not very good.

The accumulation of error can be avoided by working exclusively with the intersection times of the ray with the dividing planes, without ever computing the intersection points. Use of thick planes hides the errors remaining in intersection time computations.

The routine to intersect the ray $R(t) = P + t\mathbf{d}$, $t_{min} \le t \le t_{max}$, against a solid-leaf BSP tree follows. The time t_{hit} of the first intersection with a solid leaf is returned when such an intersection exists.

```
// Intersect ray/segment R(t) = p + t*d, tmin <= t <= tmax, against bsp tree
// 'node', returning time thit of first intersection with a solid leaf, if any
int RayIntersect(BSPNode *node, Point p, Vector d, float tmin, float tmax, float *thit)
{
    std::stack<BSPNode *> nodeStack;
    std::stack<float> timeStack;

    assert(node != NULL);
    while (1) {
        if (!node->IsLeaf()) {
            float denom = Dot(node->plane.n, d);
            float dist = node->plane.d - Dot(node->plane.n, p);
            int nearIndex = dist > 0.0f;
            // If denom is zero, ray runs parallel to plane. In this case,
            // just fall through to visit the near side (the one p lies on)
            if (denom != 0.0f) {
                float t = dist / denom;
                if (0.0f <= t && t <= tmax) {
                    if (t >= tmin) {
                        // Straddling, push far side onto stack, then visit near side
                        nodeStack.push(node->child[1 ^ nearIndex]);
```

```
                    timeStack.push(tmax);
                    tmax = t;
                } else nearIndex = 1 ^ nearIndex; // 0 <= t < tmin, visit far side
            }
        }
    }
    node = node->child[nearIndex];
} else {
    // Now at a leaf. If it is solid, there's a hit at time tmin, so exit
    if (node->IsSolid()) {
        *thit = tmin;
        return 1;
    }
    // Exit if no more subtrees to visit, else pop off a node and continue
    if (nodeStack.empty()) break;
    tmin = tmax;
    node = nodeStack.top(); nodeStack.pop();
    tmax = timeStack.top(); timeStack.pop();
    }
}
// No hit
return 0;
}
```

Computing the intersection time t of the ray with a plane determines the sidedness of P with respect to the plane as a subcomputation. This information can be reused when determining which side(s) of the plane the ray should be sent down. It turns out that there are four cases that must be handled when considering the active section ($[t_{min}, t_{max}]$) of the ray against a dividing plane (illustrated in Figure 8.16). In the cases in which $t < 0$ and $t > t_{max}$, respectively, only the near side of the plane (where P lies) should be traversed. When $0 \leq t < t_{min}$, only the far side should be traversed. In the last case, where $t_{min} \leq t \leq t_{max}$, the near side should be traversed with the ray interval $[t_{min}, t]$ and the far side with the interval $[t, t_{max}]$.

To turn this into a test against thick planes, an epsilon term should be added to the plane comparisons to ensure that both sides are visited when the ray touches the thick plane. It is important that this epsilon term be larger than the thickness term used during construction of the tree.

If the ray is intersected against a leaf-storing tree rather than a solid-leaf tree, care must be taken when polygons have been sent down both sides of a dividing plane instead of being clipped to the plane. In this case, the same problem as when tracing a ray through a grid occurs: the ray might intersect a polygon at a point that lies outside the volume of the current leaf. Any intersection points outside the current leaf must be detected, allowing processing to continue unhindered.

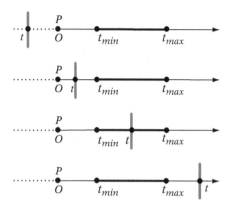

Figure 8.16 The four cases encountered when intersecting the active section of the ray against a plane (the plane shown in gray).

8.4.3 Polytope Queries on Solid-leaf BSP Trees

In addition to point and ray queries it is important to be able to perform volume queries against the BSP tree, such as an AABB test. A rather brute-force solution is to send each boundary polygon of the AABB down the BSP tree, splitting the polygons as they straddle dividing planes. If any part of a polygon ends up in a solid leaf, there is a collision. The implementation of this approach is straightforward and might look as follows.

```
// Intersect polygon 'p' against the solid-leaf BSP tree 'node'
int PolygonInSolidSpace(Polygon *p, BSPNode *node)
{
    Polygon *frontPart, *backPart;
    while (!node->IsLeaf()) {
        switch (ClassifyPolygonToPlane(p, node->plane)) {
        case POLYGON_IN_FRONT_OF_PLANE:
            node = node->child[0];
            break;
        case POLYGON_BEHIND_PLANE:
            node = node->child[1];
            break;
        case POLYGON_STRADDLING_PLANE:
            SplitPolygon(*p, node->plane, &frontPart, &backPart);
            if (PolygonInSolidSpace(frontPart, node->child[0])) return 1;
            if (PolygonInSolidSpace(backPart, node->child[1])) return 1;
```

```
            // No collision
            return 0;
        }
    }
    // Now at a leaf, inside/outside status determined by solid flag
    return node->IsSolid();
}
```

Unfortunately, there are (at least) two problems with this solution. First, as a boundary test this will not detect a collision if the AABB ends up fully encompassing some small free-floating part of the solid represented by the BSP tree. Second, this test is quite expensive, as it may have to perform up to six subqueries to determine the query result (and even more for general polytopes).

The first objection can be addressed by representing the query volume as a solid BSP tree and then testing if the intersection of the two trees is empty through the set operations on BSP trees described in [Thibault87]. However, intersecting BSP trees against each other does not really address the second objection.

A more interesting approach is to attempt to form a new BSP tree that represents the expanded volume corresponding to the Minkowski sum of the AABB and the original BSP tree [Melax00]. Testing a stationary AABB against the original BSP tree is now just a point query against the new *expanded* tree. (The expanded tree is sometimes also called a *bloated*, or *grown*, tree.) Similarly, the intersection of a moving AABB against the original tree becomes a ray test against the new tree. In both cases, the query on the tree now corresponds to a problem already solved.

The expanded volume can, in part, be formed by offsetting all planes in the original BSP tree outward along their normals by the radius r of the AABB (with respect to the plane normal). If the stored plane equation at a tree node is given by $\mathbf{n} \cdot X = d$, the offset plane is obtained by adding r to the d-term: $\mathbf{n} \cdot X = d + r$. The projected radius r itself is given by

$$r = e_0 |\mathbf{n}_x| + e_1 |\mathbf{n}_y| + e_2 |\mathbf{n}_z|,$$

where e_0, e_1, and e_2 are the half-extents of the AABB and $\mathbf{n} = (a, b, c)$ is the normal of the stored plane equation (see Section 5.2.3).

However, although offsetting the existing planes in the BSP tree is necessary it is not sufficient. As the rightmost drawing of Figure 8.17 illustrates, the resulting volume extends too far at the vertices (and, in 3D, at the edges), causing false collisions in these regions. To obtain the correct result, additional *beveling planes* must be added to the new tree so that when offset with the other planes they help form the Minkowski sum between the BSP tree and the AABB (Figure 8.18).

To see what additional planes are needed, note first that due to being the intersection of a number of halfspaces the volume described by a solid leaf of a solid BSP

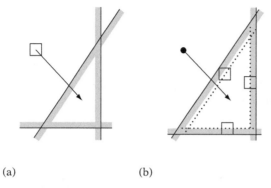

(a) (b)

Figure 8.17 (a) An AABB query against the original intersection volume. (b) To allow the AABB query to be replaced by a point query, the planes of the halfspace intersection volume are offset outward by the radius of the AABB (as projected onto their plane normals) to form an expanded volume. However, this alone does not form the proper Minkowski sum, as the offset shape extends too far at the corners, causing false collisions in these regions.

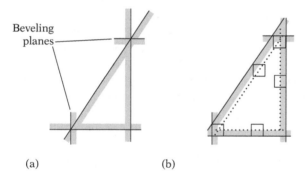

(a) (b)

Figure 8.18 (a) To form the Minkowski sum of the intersection volume and the AABB, additional beveling planes must be added to the BSP tree. (b) The planes after offsetting correspond to the shape formed by sweeping the AABB around the boundary of the intersection volume.

tree corresponds to a convex polyhedron. Therefore, the AABB query on the BSP tree can be seen as intersection tests between the AABB and the polytopes "stored" in the solid leaves.

For a given AABB polytope test, the separating-axis test specifies exactly which axes must be tested to determine if a collision has occurred. The planes of the polytope, as stored in the BSP tree, correspond to the separating axes of the polytope faces. The missing beveling planes are therefore those corresponding to the separating axes of the AABB faces and those corresponding to the cross product of edges from the AABB and edges from the polytope.

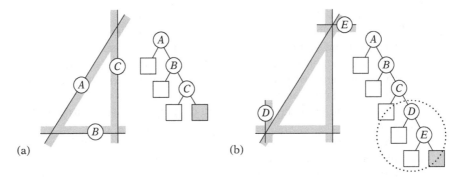

Figure 8.19 (a) The unbeveled tree for a triangle. (b) Beveling planes inserted between the solid leaf and its parent node.

Specifically, each supporting plane through the AABB faces is added at the polytope vertices most extreme in the direction of that plane normal (except in the case in which this plane is already present in the BSP tree). The planes corresponding to the edge-edge cross products are placed so as to pass through the edges of the leaf polytope.

Because the orientation of an AABB is fixed, if only AABB queries are performed on the solid BSP tree the additional beveling planes required can be precomputed and stored in the tree. They would be added between each solid leaf and the leaf's parent node, as illustrated in Figure 8.19.

When performing arbitrary polytope queries against the BSP tree, including OBB or sphere queries, the beveling planes cannot be precomputed but must instead be computed at runtime. This also holds when the BSP tree itself is not fixed but is allowed to rotate. To facilitate the computation of the required beveling planes using the separating-axis test, the solid BSP tree must be enhanced to contain an explicit boundary description of the solid leaf volumes of the tree.

Note that when performing a point or ray query against the expanded tree *all* dividing planes must be offset as the hierarchy is traversed, not just the planes corresponding to a boundary of the solid represented by the BSP tree. Otherwise, the query would not correctly end up in all of the leaves the original query volume would be overlapping.

8.5 **Summary**

In this chapter the BSP tree was presented as the most versatile spatial partitioning method, capable of performing the same tasks as quadtrees, octrees, and k-d trees, albeit at the cost of requiring more memory for storing full plane equations at each node of the tree. Additionally, it was shown how BSP trees can also be used as a boundary or solid representation of polyhedral objects.

Three types of BSP trees were described: node-storing, leaf-storing, and solid-leaf BSP trees. Recursive top-down construction of these trees was discussed, along with how to select and score dividing planes to form good trees.

For BSP trees (and similar structures), it is important to consider the robustness of inserting primitives and performing queries on the tree, to ensure that both primitives and queries end up in all nodes they overlap. It was shown how thick planes help in this respect, and both classification and clipping of polygons to a thick plane were described.

Point and ray queries were used to illustrate the basic recursive approach to performing BSP tree queries. Last, it was shown how polytope queries can be facilitated on BSP trees through the process of adding beveling planes and offsetting the dividing planes at query time to form an expanded tree. The expanded tree effectively forms the Minkowski sum of the polytope and the original BSP tree and therefore enables a simple ray query on the tree to substitute as the polytope query.

Chapter 9

Convexity-based Methods

It is not a coincidence that the bounding volume representations explored in this book have one feature in common: they are convex objects. Convex objects have certain properties that make them highly suitable for use in collision detection tests. One important property is the existence of a separating plane for nonintersecting convex objects (see Section 3.8). Another property of convex objects is that the distance between two points — one from each object — is at a local minimum. The distance is also a global minimum (Figure 9.1a). This property ensures that the global minimum distance between two convex objects can be found by simple hill climbing. That is, starting with any pair of points and moving each point gradually closer to the other (without moving outside the objects) a globally closest pair of points is eventually attained.

Concave objects do not share these characteristics. For example, for two concave objects a local minimum is not necessarily a global minimum (Figure 9.1b).

By exploiting the special properties of convex objects, it is possible to design efficient collision detection algorithms for them. This chapter discusses algorithms of this type. The algorithms deal largely with (convex) polyhedra, but some algorithms — notably the GJK algorithm of Section 9.5 — also deal with general convex objects. In the following, polyhedra are assumed convex unless otherwise stated.

9.1 Boundary-based Collision Detection

To establish a reference frame before looking at more advanced convexity-based methods, a simple solution to the collision detection problem for two polyhedra is to base the test on the boundary description of the objects. Let two polyhedra P and Q be given in a form allowing easy access to their vertices and faces (and therefore edges).

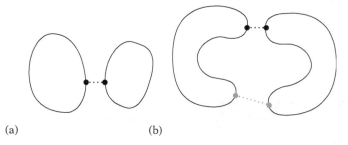

(a) (b)

Figure 9.1 (a) For two convex objects a local minimum distance between two points is always a global minimum. (b) For two concave objects the local minimum distance between two points (in gray) is not necessarily a global minimum (in black).

Assuming the polyhedra are both in the same frame of reference (accomplished by, for example, transforming Q into the space of P), their intersection can be determined as follows [Moore88].

1. Intersect each edge of P against polyhedron Q (for example, using the method described in Section 5.3.8). If an edge lies partly or fully inside Q, stop and report the polyhedra as intersecting.

2. Conversely, intersect each edge of Q against polyhedron P. If an edge lies partly or fully inside P, stop and report P and Q as intersecting.

3. Finally, to deal with the degenerate case of identical objects (such as cubes) passing through each other with their faces aligned, test the centroid of each face of Q against all faces of P. If a centroid is found contained in P, stop and return intersection.

4. Return nonintersection.

It may seem like the tests of steps 1 and 2 would subsume step 3. However, floating-point inaccuracies may cause the tests of the first two steps to fail in the situation described in step 3, thus making the centroid test necessary to handle this (infrequent) case. In that the edge tests of steps 1 and 2 are quite expensive, the test might be better expressed as follows.

1. Test each vertex of Q against all faces of P. If any vertex is found to lie inside all faces of P, stop and return the polyhedra as intersecting.

2. Repeat the previous step, but now testing each vertex of P against the faces of Q.

3. Intersect each edge of Q against polyhedron P (for example, using the method described in Section 5.3.8). If an edge intersects P, stop and report the polyhedra as intersecting.

4. To deal with the degenerate case of identical objects (such as cubes) passing through each other with their faces aligned, test the centroid of each face of Q against all faces of P. If a centroid is found contained in P, stop and return intersection as a result.

5. Return nonintersection.

Both algorithm formulations are $O(n^2)$ in the number of vertices or edges tested. In practice, even though the tests remain $O(n^2)$ worst case they can be improved by providing a bounding box for each polyhedron and restricting the testing to the vertices, edges, and faces intersecting the overlap volume of the two boxes. If the polyhedra are not intersecting, the bounding boxes typically overlap only a little (if at all) and most vertices, edges, and faces are culled from the expensive test. When the polyhedra are intersecting, the chance of detecting an intersection early — for example, by determining a vertex lying inside the other polyhedron — increases greatly. As a result, near linear behavior can be expected in most cases. However, linear behavior is still not as efficient as possible. By better exploiting the convexity of the objects, faster collision algorithms can be obtained. Such algorithms are explored ahead.

9.2 Closest-features Algorithms

In real-time simulations objects tend to move or rotate by small amounts from one frame to the next. For convex objects, this frame-to-frame coherence suggests that in general the closest points between two nonintersecting objects are located in the near vicinity of the closest points between the objects of the previous frame. However, although an accurate observation for strictly convex sets (informally, that curve everywhere) this it is not always true for polyhedra. For a polyhedron, even a minute change in orientation can cause the closest point to move from one side to the opposite side of one of its faces, which (depending on the size of the face) may be arbitrarily far away. Thus, for polyhedra, rather than tracking the closest points and using the closest points of the previous frame as a starting point a better approach is to track the *closest features* (vertices, edges, or faces) from frame to frame. A pair of features, one from each of two disjoint polyhedra, are said to be the closest features if they contain a pair of closest points for the polyhedra.

Perhaps the earliest and most well known collision detection algorithm based on the tracking of closest features is the *Lin–Canny algorithm* [Lin91]. A later, similar algorithm, addressing some serious flaws in the Lin–Canny algorithm, is the *Voronoi-Clip*, or *V-Clip algorithm* [Mirtich98]. The V-Clip algorithm is summarized in the next section.

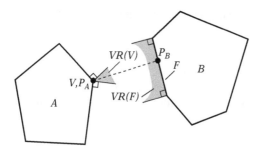

Figure 9.2 Two nonintersecting 2D polyhedra *A* and *B*. Indicated is the vertex-face feature pair *V* and *F*, constituting the closest pair of features and containing the closest pair of points, P_A and P_B, between the objects.

9.2.1 The V-Clip Algorithm

The V-Clip algorithm operates on a pair of polyhedra and is based on the following theorem, defining the closest points between the pair in terms of the closest features of the polyhedra.

Theorem: Let F_A and F_B be a pair of features from two disjoint convex polyhedra, *A* and *B*, and let $VR(F_A)$ and $VR(F_B)$ denote their Voronoi regions. Let $P_A \in F_A$ and $P_B \in F_B$ be a pair of closest points between the features. Then, if $P_A \in VR(F_B)$ and $P_B \in VR(F_A)$, F_A and F_B are a globally closest pair of features and P_A and P_B are a globally closest pair of points between *A* and *B* (albeit not necessarily unique).

Figure 9.2 illustrates a pair of (2D) polyhedra satisfying the conditions of this theorem.

V-Clip starts with two features, one from each input polyhedron. At each iteration of the algorithm, the features are tested to see if they meet the conditions of the theorem for being a closest pair of features. If so, the algorithm terminates, returning a result of nonintersection along with the pair of closest features. If the conditions are not met, V-Clip updates one of the features to a neighboring feature, where the neighbors of a feature are defined as follows.

- The neighbors of a vertex are the edges incident to the vertex.
- The neighbors of a face are the edges bounding the face.
- The neighbors of an edge are the two vertices and the two faces incident to the edge.

Figure 9.3 shows a chart of the possible feature pairs and legal transitions between them, according to the previously listed neighbor definitions. Solid arrows in the chart indicate that the interfeature distance is strictly decreased by a transition. Dashed

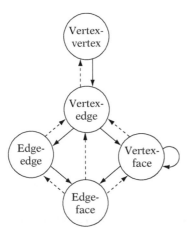

Figure 9.3 Feature pair transition chart in which solid arrows indicate strict decrease of interfeature distance and dashed arrows indicate no change.

arrows indicate no change in distance taking place. Because the chart does not contain a transition cycle of only dashed arrows, only a finite number of feature transitions can be performed before the feature distance is strictly decreased. In addition, there are no transitions that increase the interfeature distance. Therefore, convergence is assured and the algorithm eventually terminates with the closest pair of features (and thus, implicitly, with a closest pair of points).

One of the transitions in the chart of Figure 9.3 does not follow from the neighbor definitions: the (solid) arrow from the vertex-face state back to itself. This transition is present because it is possible for the V-Clip algorithm to become trapped in a local minimum in the vertex-face state. The problem occurs for objects in configurations similar to that shown in Figure 9.4, where the vertex V lies below the supporting plane of face F and at the same time lies inside all Voronoi planes of the Voronoi region, $VR(F)$, of F. In this situation there are no legal state transitions per the chart of Figure 9.3. Any attempted transition would either increase the interfeature distance or increase the dimension of a feature while the interfeature distance stayed the same, neither of which are allowed by the algorithm. When this problem situation is detected, an $O(n)$ brute-force test is performed of the vertex V against all face planes of object A. If V lies inside all face planes, the objects are intersecting and the algorithm stops and reports the objects as penetrating. Otherwise, F is updated to the face G of A that V has the largest positive signed distance from. This choice of a new face guarantees there is no possibility of descending into the same local minimum again, in that V is strictly closer to G than to F and is at least as close to G as to all other faces of A.

The test for the features being a closest pair of features is handled differently for each of the five possible feature pair types, the details of which are too elaborate to explore here. Unlike the Lin–Canny algorithm, V-Clip avoids explicitly computing

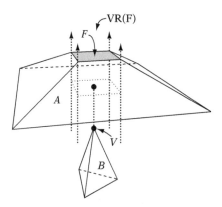

Figure 9.4 Two objects in a configuration for which the V-Clip algorithm becomes trapped in a local minimum (after [Mirtich98]).

the closest points between the features to perform the closest pair test, making V-Clip quite robust. Full implementational details on the V-Clip algorithm are given in [Mirtich98] and [Coutinho01], and a solid implementation is available on the Internet. It should be noted that the V-Clip algorithm is covered by U.S. patent 6,054,997.

9.3 Hierarchical Polyhedron Representations

Just as bounding volume hierarchies can accelerate queries on, say, polygon soups, hierarchical representations are also useful to accelerate many queries on polyhedra. BSP trees, as described in Chapter 8, constitute one possible representation. An alternative form of hierarchical representation is the forming of a sequence of polyhedra, nested inside each other like Russian dolls. Starting from the original polyhedron, each inscribed polyhedron of the sequence is a simplified version of its immediate outer parent. Given such a hierarchy, the idea is to perform queries starting at the simplest innermost polyhedron and moving up through the hierarchy to the original polyhedron. With just a small topological difference from one polyhedron to the next, only a small amount of work must be performed at each step, typically resulting in $O(\log n)$ queries.

Most well known of the nested polyhedron representations is the *Dobkin–Kirkpatrick hierarchy*, described in the following section. The Dobkin–Kirkpatrick hierarchy can be used for queries such as finding an extreme vertex in a given direction, locating the point on a polyhedron closest to a given point, or determining the intersection of two polyhedra. The Dobkin–Kirkpatrick hierarchy has inspired several other collision detection algorithms, such as the hybrid of the Dobkin–Kirkpatrick hierarchy and the Lin–Canny algorithm presented in [Guibas99] and the multiresolution representation presented in [Ehmann00]. The Dobkin–Kirkpatrick hierarchy is described in the next section.

9.3.1 **The Dobkin–Kirkpatrick Hierarchy**

The Dobkin–Kirkpatrick (DK) hierarchy of a d-dimensional polyhedron P is a sequence P_0, P_1, \ldots, P_k of nested increasingly smaller polytopal approximations of P, where $P = P_0$ and P_{i+1} is obtained from P_i by deletion of a subset of the vertices of P_i. The subset of vertices is selected to form a maximal set of independent vertices (that is, such that no two vertices in the set are adjacent to each other). The construction of the hierarchy stops with the innermost polyhedron P_k being a d-simplex (a tetrahedron, in 3D). [Edelsbrunner87] shows that every polyhedron allows the construction of a maximal set of independent vertices through a simple greedy algorithm. In pseudocode, the algorithm is as follows.

```
// Given a set s of vertices, compute a maximal set of independent vertices
Set IndependentSet(Set s)
{
    // Initialize i to the empty set
    Set i = EmptySet();
    // Loop over all vertices in the input set
    for (all vertices v in s) {
        // If unmarked and has 8 or fewer neighboring vertices...
        if (!Marked(v) && Degree(v) <= 8) {
            // Add v to the independent set and mark all of v's neighbors
            i.Add(v);
            s.MarkAllVerticesAdjacentToVertex(v);
        }
    }
    return i;
}
```

The independent set is guaranteed to be a constant fractional size of the current set of vertices, in turn guaranteeing a height of $O(\log n)$ for the DK hierarchy. Additionally, during the hierarchy construction pointers are added to connect deleted features of polyhedron P_i to new features of polyhedron P_{i+1}, and vice versa. These pointers help facilitate efficient queries on the hierarchy.

Figure 9.5 illustrates the construction of the Dobkin–Kirkpatrick hierarchy for a convex polygon P as specified by vertices V_0 through V_{11}. P_0 is set to be equivalent to P. P_1 is obtained from P_0 by deleting, say, the vertices V_1, V_3, V_5, V_7, V_9, and V_{11} (which form a maximal independent set). P_2 is similarly obtained from P_1 by deleting vertices V_2, V_6, and V_{10}. Because P_2 is a 2-simplex (a triangle), the hierarchy construction stops.

Given a DK hierarchy, many different queries can be answered in an efficient manner. For example, the point on P closest to a query point S can be located through a simple recursive procedure. As an illustration, consider the case of Figure 9.6.

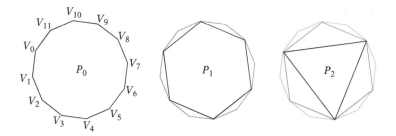

Figure 9.5 The Dobkin–Kirkpatrick hierarchy of the convex polygon $P = P_0$.

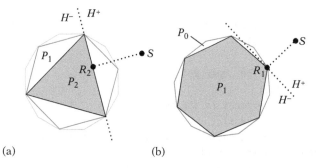

(a) (b)

Figure 9.6 The supporting plane H, for (a) P_2 and (b) P_1, through the point on the polyhedron closest to a query point S.

Starting at the innermost polyhedra P_i, $i = 2$, the closest point R_i on P_i to S is found through straightforward calculation (see Section 5.1.6). If $R_i = S$, then S is contained in P and the algorithm stops. Otherwise, knowing R_i, the closest point for P_{i-1} is found as follows. Let H be the supporting plane for P_i through R_i. P_{i-1} can now be described as consisting of the part in front of H and the part behind H:

$$P_{i-1} = \left(P_{i-1} \cap H^+\right) \cup \left(P_{i-1} \cap H^-\right).$$

The closest point R_{i-1} is therefore realized either between $P_{i-1} \cap H^+$ and S or between $P_{i-1} \cap H^-$ and S. The closest point between $P_{i-1} \cap H^-$ and S is directly given by R_i. Because $P_{i-1} \cap H^+$ (due to the construction of the hierarchy) is defined by one vertex and two edges, the closest point between $P_{i-1} \cap H^+$ and S is computed in constant time. Consequently, the point on P closest to the query point S is located in $O(\log n)$ steps and in $O(\log n)$ time.

A DK hierarchy can also be used to locate the extreme vertex in direction **d** through a relatively simple recursive procedure. First, the most extreme vertex V_k of the innermost polyhedron P_k is located by examining all four of its vertices. Knowing V_k, only

a few vertices in P_{k-1}, all of them neighbors of V_k, must be examined to find the most extreme vertex in P_{k-1}. By stepping up the hierarchy in this manner until P_0 is reached, the most extreme vertex of the original polyhedron is found in $O(\log n)$ steps. It can be shown that the tests at each step can be performed in constant time and consequently the extreme vertex is found in $O(\log n)$ time.

An accessible account of the DK hierarchy is given in [O'Rourke98]. Simultaneously traversing two hierarchical representations allows the intersection between two convex polygons to be determined in $O(\log n)$ time and between convex polyhedra in $O(\log^2 n)$ time [Dobkin90].

Specifically for the problem of finding extreme vertices of a polyhedron, the BSP tree-based acceleration structure presented in [Eberly04] is a worthy alternative to the DK hierarchy, in that the former is easier to implement and uses less memory.

9.4 **Linear and Quadratic Programming**

Although it is natural to view the problem of detecting collision between two convex polyhedra as a geometrical problem, it can also be treated as a mathematical optimization problem. Considering each polyhedron as the intersection volume of a number of halfspaces, the Boolean intersection test of the polyhedra is equivalent to what is known as the *feasibility problem* of linear programming. The latter is the problem of determining if there is a solution to a set of linear inequalities. In terms of the collision problem, this corresponds to determining if there exists a point interior to all halfspaces of both polyhedra (each halfspace being a linear inequality). Beyond just determining if the polyhedra intersect or not, determining the separation distance and the closest points between them in the case they do not intersect also can be treated as an optimization problem, specifically as a quadratic programming problem. Both linear and quadratic programming problems are optimization problems with respect to linear inequality constraints. In the linear programming problem, the goal is to optimize a linear function with respect to these constraints. The quadratic programming problem instead optimizes a quadratic function with respect to the constraints. The following sections describe in more detail how collision detection problems can be expressed as linear and quadratic programming problems. The following material also outlines methods for solving these problems.

9.4.1 **Linear Programming**

Let a *linear function* be a function of the form $f(x_1, x_2, \ldots, x_n) = c_1 x_1 + c_2 x_2 + \cdots + c_n x_n$, where the c_i terms are real number constants. Let a *linear constraint* be a linear equation or a linear inequality, where a *linear equation* is of the form $f(x_1, x_2, \ldots, x_n) = c$ and *linear inequalities* are of the form $f(x_1, x_2, \ldots, x_n) \le c$ or $f(x_1, x_2, \ldots, x_n) \ge c$. Then, the *linear programming problem* is the problem of optimizing (maximizing or

minimizing) a linear function with respect to a finite set of linear constraints. The linear function to be optimized is called the *objective function*. Without loss of generality, linear programming (LP) problems are here restricted to maximization of the objective function and to involve constraints of the form $f(x_1, x_2, \ldots, x_n) \leq c$ only (because $f(x_1, x_2, \ldots, x_n) \geq c$ can be written as $-f(x_1, x_2, \ldots, x_n) \leq -c$). Equality constraints, if needed, can be stated by requiring both $f(x_1, x_2, \ldots, x_n) \leq c$ and $f(x_1, x_2, \ldots, x_n) \geq c$.

Note that a linear inequality of n variables geometrically defines a halfspace in \mathbb{R}^n. The region of feasible solutions defined by a set of m inequalities therefore corresponds to the intersection of m halfspaces H_i, $1 \leq i \leq m$. In turn, this intersection corresponds to a convex polyhedron P, $P = H_1 \cap H_2 \cap \ldots \cap H_m$. Note also that the objective function can be seen as a dot product between the vectors $\mathbf{x} = (x_1, x_2, \ldots, x_n)$ and $\mathbf{c} = (c_1, c_2, \ldots, c_n)$. The LP problem is therefore geometrically equivalent to that of finding a supporting point \mathbf{x} of P in direction \mathbf{c}. (In fact, because P is a convex polyhedron the supporting point \mathbf{x} can always be made to correspond to a supporting vertex.)

In the literature, LP problems are often abstractly stated in terms of matrix-vector formulations, rather than as a geometric optimization over a convex polyhedron. In a matrix formulation the LP problem is to maximize (or minimize) the objective function $\mathbf{c}^T \mathbf{x}$, where \mathbf{c} is a (column) vector of d constants and $\mathbf{x} = (x_1, x_2, \ldots, x_d)^T$ satisfies the constraint inequalities $\mathbf{Ax} \leq \mathbf{b}$ (where \mathbf{A} is an $n \times d$ matrix of coefficients and \mathbf{b} is a column vector of n constants). The geometric interpretation is preferred in this book.

Given two convex polyhedra, A and B, each expressed as the intersection of halfspaces, the convex polyhedron C that is their intersection volume is described (perhaps redundantly) by the intersection of all halfspaces from both A and B. A and B are therefore in collision if and only if there is a solution to the LP problem with the defining halfspaces of A and B as the linear constraints. Because any point common to both polyhedra will serve as a witness to their collision, the objective function can be chosen arbitrarily, for example as $\mathbf{c} = (1, 0, \ldots, 0)$.

As an example of how polyhedral intersection can be treated as an LP problem, consider the two triangles, A and B, given in Figure 9.7. Triangle A is described by the halfspaces $-x + y \leq -1$, $-x - 4y \leq -1$, and $4x + y \leq 19$, and triangle B by the halfspaces $-4x + y \leq 0$, $x - 4y \leq 0$, and $x + y \leq 5$. The triangles are therefore intersecting if the following LP problem has a solution.

$$
\begin{aligned}
\text{Maximize} \quad & x \\
\text{subject to:} \quad & -x + y \leq -1 \\
& -x - 4y \leq -1 \\
& 4x + y \leq 19 \\
& -4x + y \leq 0
\end{aligned}
$$

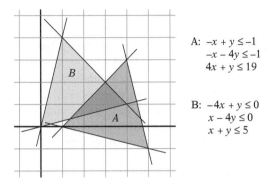

A: $-x + y \leq -1$
 $-x - 4y \leq -1$
 $4x + y \leq 19$

B: $-4x + y \leq 0$
 $x - 4y \leq 0$
 $x + y \leq 5$

Figure 9.7 The two triangles $A = (1, 0), (5, -1), (4, 3)$ and $B = (0, 0), (4, 1), (1, 4)$ defined as the intersection of three halfspaces each.

$$x - 4y \leq 0$$
$$x + y \leq 5$$

By inspection of Figure 9.7, this problem has a solution, with the maximum assumed for $x = 4$.

Alternatively, the intersection problem can be expressed as an LP problem in the following way. Let the two polyhedra be given in terms of their vertices. Now a linear programming problem can be set up to determine whether there exist coefficients for a plane such that it forms a separating plane for the two polyhedra. For example, for the setup of Figure 9.7 the problem can be restated to attempt to find a separating line $f(x, y) = ax + by + c$ for some $a, b,$ and c with the constraints that $f(A_i) \leq 0$ and $f(B_i) > 0$, where A_i and B_i are the vertices of the two polyhedra. Specifically, for the setup of Figure 9.7 the two triangles are nonintersecting if the following LP problem has a solution.

$$\text{Maximize} \qquad\qquad a$$
$$\text{subject to:} \qquad\qquad a + c \leq 0$$
$$5a - b + c \leq 0$$
$$4a + 3b + c \leq 0$$
$$c > 0$$
$$4a + b + c > 0$$
$$a + 4b + c > 0$$

In that it is already established that triangles A and B are intersecting, this particular LP problem does not have a solution.

The most famous method for solving linear programming problems is the *simplex method*, due to Danzig. A highly readable presentation of the simplex method is given in [Chvatal83]. When the LP problems are, as here, of low dimension and with few constraints, other (simpler) methods are often preferred. One such method, and the one presented here, is a randomized algorithm due to [Seidel90]. Before describing Seidel's algorithm, another even simpler algorithm is introduced. This algorithm, Fourier–Motzkin elimination, gives further insight into the problem of determining whether a set of inequality constraints provides a feasible solution. (Fourier–Motzkin elimination is also the method of choice for solving small systems by hand.)

9.4.1.1 Fourier–Motzkin Elimination

A simple approach for determining the consistency of a system of linear inequalities is the method known as *Fourier–Motzkin elimination*. It operates by successive rewrites of the system, eliminating one variable from the system on each rewrite. When only one variable is left, the system is trivially consistent if the largest lower bound for the variable is less than the smallest upper bound for the variable. More specifically, let the system be given as m constraints in n variables:

$$a_{11}x_1 + a_{12}x_2 + \ldots + a_{1n}x_n \leq b_1$$
$$a_{21}x_1 + a_{22}x_2 + \ldots + a_{2n}x_n \leq b_2$$
$$\vdots$$
$$a_{m1}x_1 + a_{m2}x_2 + \ldots + a_{mn}x_n \leq b_m$$

A variable x_k is selected for elimination and each inequality is "solved" for x_k, resulting in s lower and t upper bounds on x_k:

$$L_1(x_1, x_2, \ldots, x_{k-1}, x_{k+1}, \ldots, x_n) \leq x_k \qquad x_k \leq U_1(x_1, x_2, \ldots, x_{k-1}, x_{k+1}, \ldots, x_n)$$
$$L_2(x_1, x_2, \ldots, x_{k-1}, x_{k+1}, \ldots, x_n) \leq x_k \qquad x_k \leq U_2(x_1, x_2, \ldots, x_{k-1}, x_{k+1}, \ldots, x_n)$$
$$\vdots \qquad\qquad\qquad\qquad \vdots$$
$$L_s(x_1, x_2, \ldots, x_{k-1}, x_{k+1}, \ldots, x_n) \leq x_k \qquad x_k \leq U_t(x_1, x_2, \ldots, x_{k-1}, x_{k+1}, \ldots, x_n)$$

Because every lower bound on x_k must be less than or equal to every upper bound on x_k, it is possible to completely eliminate x_k by replacing the current set of inequalities with a new set of st inequalities formed by all pairwise combinations of lower and upper bounds for x_k. That is,

$$L_i(x_1, x_2, \ldots, x_{k-1}, x_{k+1}, \ldots, x_n) \leq U_j(x_1, x_2, \ldots, x_{k-1}, x_{k+1}, \ldots, x_n)$$

for all $1 \leq i \leq s$, $1 \leq j \leq t$.

The process is repeated, removing one variable for each iteration until just one variable remains and the consistency test can be trivially performed. To help illustrate the method, consider again the six inequalities for the two triangles of Figure 9.7. Rewritten to expose the variable x, the six inequalities become:

$$x \geq 1 + y \qquad\qquad\qquad x \geq y/4$$
$$x \geq 1 - 4y \qquad\qquad\qquad x \leq 4y$$
$$x \leq (19 - y)/4 \qquad\qquad\qquad x \leq 5 - y$$

Rearranging the order, these provide three lower bounds (left) and three upper bounds (right) for x:

$$y/4 \leq x \qquad\qquad\qquad x \leq 4y$$
$$1 + y \leq x \qquad\qquad\qquad x \leq 5 - y$$
$$1 - 4y \leq x \qquad\qquad\qquad x \leq (19 - y)/4$$

Because every lower bound on x must be less than or equal to every upper bound on x, it is possible to completely eliminate x by forming the following nine constraints from all pairwise combinations of lower and upper bounds for x.

$$y/4 \leq 4y \qquad\qquad 1 + y \leq 4y \qquad\qquad 1 - 4y \leq 4y$$
$$y/4 \leq 5 - y \qquad\qquad 1 + y \leq 5 - y \qquad\qquad 1 - 4y \leq 5 - y$$
$$y/4 \leq (19 - y)/4 \qquad\qquad 1 + y \leq (19 - y)/4 \qquad\qquad 1 - 4y \leq (19 - y)/4$$

When simplified, these give the following constraints on y:

$$-4/3 \leq -1 \leq 0 \leq 1/8 \leq 1/3 \leq y \leq 2 \leq 3 \leq 4 \leq 19/2$$

From these it is clear that y is most tightly bounded by

$$1/3 \leq y \leq 2.$$

This is a feasible bound, and thus the original system is consistent and the two triangles have one (or more) points in common. Note that the bound agrees with the illustration in Figure 9.7, and in fact provides the interval of projection of the

intersection volume onto the y axis. By picking a value for y from this interval and substituting it in the original set of inequalities, a similar bound will be given for x, from which a value for x can be chosen. The (x, y) pair of coordinates corresponds to a feasible point in the interior of the intersection volume. Here, arbitrarily setting $y = 2$ the bounds on x become

$$-7 \leq 1/2 \leq 3 \leq x \leq 3 \leq 17/4 \leq 8,$$

from which the only valid choice for x is $x = 3$. By inspection, Figure 9.7 has it that $(3, 2)$ is a vertex of the intersection volume.

Although Fourier–Motzkin elimination is both conceptually simple and straightforward to implement, a major drawback is the rapid increase of inequalities as variables are eliminated. Worst case, the number of inequalities is squared in each iteration, giving an exponential complexity. The situation can be improved somewhat through heuristic rules, such as eliminating the variable producing the least number of inequalities. In that most of the produced inequalities are redundant, removing these will also curb the exponential growth, as described in [Imbert93]. Despite the worst-case exponential complexity, Fourier–Motzkin elimination is still interesting (for small problems) in that the method is amenable to parallelization. Fourier–Motzkin elimination is closely related to a method for enumerating the vertices of a polyhedron, known as the *double description method* [Motzkin53].

9.4.1.2 Seidel's Algorithm

A simple method for solving linear programming problems in d variables and m inequality constraints is *Seidel's algorithm*. Seidel's algorithm has an expected running time of $O(d!m)$. Therefore, although the algorithm is not practical for large d it is quite efficient for small d; in particular for $d \leq 3$, which are the dimensions of interest for most collision detection problems. Before continuing to describe the algorithm, the LP problem is first restated for convenience. Given is a set $\{H_1, H_2, \ldots, H_m\}$ of m d-dimensional halfspaces. The intersection of these halfspaces forms a (possibly empty) polyhedron P, $P = H_1 \cap H_2 \cap \cdots \cap H_m$. Given is also an objective vector \mathbf{c} in \mathbb{R}^d. Wanted is a vertex \mathbf{v} of P such that \mathbf{v} is most extreme in direction \mathbf{c} (or an indication that the problem is infeasible when P is empty).

Seidel's algorithm is incremental in nature. It loops over the halfspaces and at each iteration computes the optimum vertex \mathbf{v}_i for the polyhedron $P_i = H_1 \cap H_2 \cap \cdots \cap H_i$ from \mathbf{v}_{i-1} of P_{i-1} of the previous iteration. There are two cases to consider each time a new halfspace H_i is introduced (Figure 9.8).

In the first case, when \mathbf{v}_{i-1} lies inside H_i, \mathbf{v}_{i-1} remains a feasible solution and nothing needs to be done (thus, $\mathbf{v}_i = \mathbf{v}_{i-1}$). On the other hand, in the case in which \mathbf{v}_{i-1} lies outside H_i, \mathbf{v}_{i-1} cannot be a feasible solution. In this case, however, \mathbf{v}_i must be contained in the bounding hyperplane π of H_i (because otherwise there would

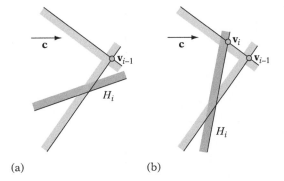

(a) (b)

Figure 9.8 (a) \mathbf{v}_{i-1} is contained in H_i, and thus $\mathbf{v}_i = \mathbf{v}_{i-1}$. (b) \mathbf{v}_{i-1} violates H_i, and thus \mathbf{v}_i must lie somewhere on the bounding hyperplane of H_i, specifically as indicated.

be some other feasible point on the segment between \mathbf{v}_i and \mathbf{v}_{i-1} more extreme in direction \mathbf{c} than \mathbf{v}_i, leading to a contradiction). \mathbf{v}_i therefore can be found by reducing the current LP problem to $d - 1$ dimensions as follows. Let \mathbf{c}' be the projection of \mathbf{c} into π. Let G_i be the intersection of H_j, $1 \le j < i$, with π. Then, \mathbf{v}_i is the solution to the $d - 1$-dimensional LP problem specified by the G_i constraints and the objective vector \mathbf{c}'. Thus, \mathbf{v}_i can be solved for recursively, with the recursion bottoming out when $d = 1$. In the 1D case, \mathbf{v}_i is trivially found as the largest or smallest value (depending on the direction of \mathbf{c}') satisfying all constraints. At this point, infeasibility of the LP problem is also trivially detected as a contradiction in the constraints.

To start the algorithm, an initial value for \mathbf{v}_0 is required. Its value is obtained by means of introducing a bounding box P_0 large enough to encapsulate the intersection volume P. Because an optimum vertex for P remains an optimum vertex for $P_0 \cap P$, the problem can be restated as computing, at each iteration, the optimum vertex \mathbf{v}_i for the polyhedron $P_i = P_0 \cap H_1 \cap H_2 \cap \cdots \cap H_i$ (from \mathbf{v}_{i-1} of P_{i-1} of the previous iteration). The initial value of \mathbf{v}_0 now simply corresponds to the vertex of P_0 most extreme in direction \mathbf{c} (trivially assigned based on the signs of the coordinate components of \mathbf{c}).

It is shown in [Seidel90] that the expected running time of this algorithm is $O(d!m)$. Seidel's algorithm is a *randomized algorithm* [Mulmuley94], here meaning that the underlying analysis behind the given time complexity relies on the halfspaces initially being put in *random* order. This randomization is also important for the practical performance of the algorithm.

Figure 9.9 graphically illustrates Seidel's algorithm applied to the triangles from Figure 9.7. The top left-hand illustration shows the six original halfspaces. The next seven illustrations show (in order, one illustration each) P_0 through H_6 being processed. At each step, the processed halfspace H_i is drawn in thick black, along with the \mathbf{v}_i for that iteration. With the given (random) ordering of the halfspaces, three recursive 1D calls are made: for halfspaces H_2, H_5, and H_6. For these, the 1D constraints in their respective bounding hyperplane are shown as arrows.

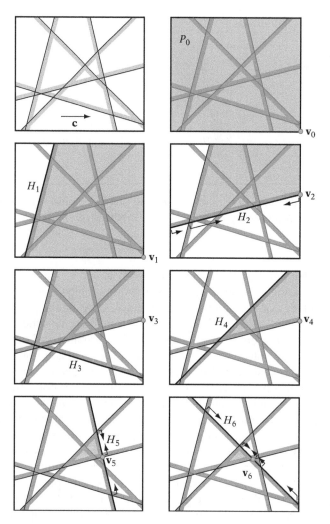

Figure 9.9 At top left, the six halfspaces from Figure 9.7. Remaining illustrations show Seidel's algorithm applied to these six halfspaces. The feasible region is shown in light gray and the current halfspace is shown in thick black. Arrows indicate the 1D constraints in the recursive call.

9.4.2 **Quadratic Programming**

Although linear programming is effective for determining if two polyhedra are intersecting, no other particular information is returned when the two polyhedra are not intersecting. In some cases it is desirable to have the closest points between the two polyhedra be returned, effectively giving the distance between the polyhedra. It turns

out that the polyhedron distance problem can be stated as a *quadratic programming problem*. Similar to LP problems, quadratic programming (QP) problems have linear constraints. However, the objective function is no longer linear but quadratic. One possible QP formulation of the polyhedron distance problem is to let the two disjoint polyhedra A and B each be defined as the convex hull of a finite set of points in \mathbb{R}^d:

$$A = CH(S_A), \qquad S_A = \{A_1, A_2, \ldots, A_m\}$$
$$B = CH(S_B), \qquad S_B = \{B_1, B_2, \ldots, B_n\}$$

The goal is now to find points P in A and Q in B such that the distance between P and Q, or equivalently that the length of the (column) vector $\mathbf{v} = P - Q$, is minimized. Let \mathbf{G} be the $d \times m$ matrix containing (as columns) the points of S_A. Let \mathbf{H} be the $d \times n$ matrix containing (as columns) the points of S_B. The polyhedron distance problem is now to solve the following QP problem in the variables $\mathbf{x} = (x_1, x_2, \ldots, x_m)^T$ and $\mathbf{y} = (y_1, y_2, \ldots, y_n)^T$.

$$
\begin{aligned}
\text{Minimize} \quad & \mathbf{v}^T \mathbf{v} \\
\text{subject to:} \quad & \mathbf{Gx} - \mathbf{Hy} = \mathbf{v} \\
& x_1 + x_2 + \ldots + x_m = 1 \\
& y_1 + y_2 + \ldots + y_n = 1 \\
& x_1, x_2, \ldots, x_m \geq 0 \\
& y_1, y_2, \ldots, y_n \geq 0
\end{aligned}
$$

Solving QP problems is, in general, more difficult than solving LP problems. Many algorithms have been suggested for solving QP problems. For the size of a problem typical of collision detection, two practical algorithms are given by Botkin [Botkin], [Botkin95] and Gärtner [Gärtner00]. Both algorithms share similarities with Seidel's algorithm for linear programming. Botkin's algorithm has an expected running time of $O(dd!n)$. No time complexity is given for Gärtner's algorithm.

9.5 The Gilbert–Johnson–Keerthi Algorithm

One of the most effective methods for determining intersection between two polyhedra is an iterative algorithm due to Gilbert, Johnson, and Keerthi, commonly referred to as the *GJK algorithm* [Gilbert88]. As originally described, GJK is a simplex-based descent algorithm that given two sets of vertices as inputs finds the Euclidean distance (and closest points) between the convex hulls of these sets. In a generalized form, the GJK algorithm can also be applied to arbitrary convex point sets, not just

polyhedra [Gilbert90]. Whereas the examples presented here are in terms of polytopes, the described algorithm is the generalized version that applies to nonpolygonal convex sets in a straightforward way.

Although the original presentation of the GJK algorithm is quite technical, neither the algorithm itself nor its implementation are very complicated in practice. However, understanding of the algorithm does require familiarity with some concepts from convex analysis and the theory of convex sets on which the algorithm relies.

An important point is that the GJK algorithm does not actually operate on the two input objects per se but on the Minkowski difference between the objects. This transformation of the problem reduces the problem from finding the distance between two convex sets to that of finding the distance between the origin and a single convex set. The GJK algorithm searches the Minkowski difference object iteratively a subvolume at a time, each such volume being a simplex. The Minkowski difference is not explicitly computed but sampled through a support mapping function on demand. These concepts (Minkowski difference, simplices, and support mapping functions) were described in Chapter 3, and in the following it is assumed the reader is familiar with them.

9.5.1 The Gilbert–Johnson–Keerthi Algorithm

As mentioned earlier, the GJK algorithm effectively determines intersection between polyhedra by computing the Euclidean distance between them. The algorithm is based on the fact that the separation distance between two polyhedra A and B is equivalent to the distance between their Minkowski difference C, $C = A \ominus B$, and the origin (Figure 9.10). Thus, the problem is reduced to that of finding the point on C closest to the origin. At the outset, this does not seem like much of an improvement, as the Minkowski difference is nontrivial to compute explicitly. However, a key point of the GJK algorithm is that it does not explicitly compute the Minkowski difference C. It only samples the Minkowski difference point set using a *support mapping*

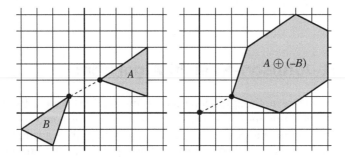

Figure 9.10 The distance between A and B is equivalent to the distance between their Minkowski difference and the origin.

of $C = A \ominus B$. Specifically, a support mapping is a function $s_A(\mathbf{d})$ that maps a given direction \mathbf{d} into a supporting point for the convex object A in that direction. Because the support mapping function is the maximum over a linear function, the support mapping for C, $s_{A\ominus B}(\mathbf{d})$, can be expressed in terms of the support mappings for A and B as $s_{A\ominus B}(\mathbf{d}) = s_A(\mathbf{d}) - s_B(-\mathbf{d})$. Thus, points from the Minkowski difference can be computed, on demand, from supporting points of the individual polyhedra A and B.

To search the Minkowski difference C for the point closest to the origin, the GJK algorithm utilizes a result known as *Carathéodory's theorem* [Rockafellar96]. The theorem says that for a convex body H of \mathbb{R}^d each point of H can be expressed as the convex combination of no more than $d + 1$ points from H. This allows the GJK algorithm to search the volume of the Minkowski difference C by maintaining a set Q of up to $d + 1$ points from C at each iteration. The convex hull of Q forms a simplex inside C. If the origin is contained in the current simplex, A and B are intersecting and the algorithm stops. Otherwise, the set Q is updated to form a new simplex, guaranteed to contain points closer to the origin than the current simplex. Eventually this process must terminate with a Q containing the closest point to the origin. In the nonintersecting case, the smallest distance between A and B is realized by the point of minimum norm in $CH(Q)$ (the convex hull of Q). The following step-by-step description of the GJK algorithm specifies in more detail how the set Q is updated.

1. Initialize the simplex set Q to one or more points (up to $d + 1$ points, where d is the dimension) from the Minkowski difference of A and B.

2. Compute the point P of minimum norm in $CH(Q)$.

3. If P is the origin itself, the origin is clearly contained in the Minkowski difference of A and B. Stop and return A and B as intersecting.

4. Reduce Q to the smallest subset Q' of Q such that $P \in CH(Q')$. That is, remove any points from Q not determining the subsimplex of Q in which P lies.

5. Let $V = s_{A\ominus B}(-P) = s_A(-P) - s_B(P)$ be a supporting point in direction $-P$.

6. If V is no more extremal in direction $-P$ than P itself, stop and return A and B as not intersecting. The length of the vector from the origin to P is the separation distance of A and B.

7. Add V to Q and go to 2.

Figure 9.11 illustrates how GJK iteratively finds the point on a polygon closest to the origin O for a 2D problem. The algorithm arbitrarily starts with the vertex A as the initial simplex set Q, $Q = \{A\}$. For a single-vertex simplex, the vertex itself is the closest point to the origin. Searching for the supporting vertex in direction $-A$ results in B. B is added to the simplex set, giving $Q = \{A, B\}$. The point on $CH(Q)$ closest to the origin is C. Because both A and B are needed to express C as a convex combination, both are kept in Q. D is the supporting vertex in direction $-C$ and it is

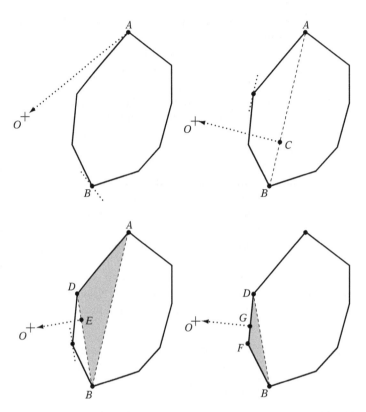

Figure 9.11 GJK finding the point on a **polygon** closest to the origin.

added to Q, giving $Q = \{A, B, D\}$. The closest point on $CH(Q)$ to the origin is now E. Because only B and D are needed to express E as a convex combination of vertices in Q, Q is updated to $Q = \{B, D\}$. The supporting vertex in direction $-E$ is F, which is added to Q. The point on $CH(Q)$ closest to the origin is now G. D and F is the smallest set of vertices in Q needed to express G as a convex combination, and thus Q is updated to $Q = \{D, F\}$. At this point, because no vertex is closer to the origin in direction $-G$ than G itself G must be the closest point to the origin, and the algorithm terminates.

Note that the GJK algorithm trivially deals with spherically extended polyhedra by comparing the computed distance between the inner polyhedron structures with the sum of the radii of their spherical extension. Note also that if the GJK algorithm is applied to the vertex sets of nonconvex polyhedra it will compute the smallest distance between the convex hulls of these nonconvex polyhedra.

Although presented here as a method operating on polyhedra only, the GJK algorithm can in fact be applied to arbitrary convex bodies [Gilbert90]. Because the input

bodies are always sampled through their support mappings, all that is required to allow the GJK algorithm to work with general convex objects is to supply appropriate support mappings (see Section 3.8).

The GJK algorithm terminates with the separation distance in a finite number of steps for polyhedra. However, it only asymptotically converges to the separation distance for arbitrary convex bodies. Therefore, a suitable tolerance should be added to the termination condition to allow the algorithm to terminate correctly when operating on nonpolyhedral objects.

Upon termination with nonintersection, in addition to returning the separation distance it is possible to have GJK compute the closest points between the input objects, computed from the points of objects A and B that formed the points in the last copy of simplex set Q. The steps of this computation are outlined in Section 9.5.3.

For an excellent in-depth description of the GJK algorithm, see [Bergen03]. A good presentation is also given in [Coutinho01]. A conversion to C of the original FORTRAN implementation of the GJK algorithm is available on the Internet [Ruspini].

9.5.2 Finding the Point of Minimum Norm in a Simplex

It remains to describe how to determine the point P of minimum norm in $CH(Q)$ for a simplex set $Q = \{Q_1, Q_2, \ldots, Q_k\}$, $1 \leq k \leq 4$. In the original presentation of GJK, this is done through a single procedure called the *distance subalgorithm* (or *Johnson's algorithm*). The distance subalgorithm reduces the problem to considering all subsets of Q separately. For example, for $k = 4$ there are 15 subsets corresponding to 4 vertices (Q_1, Q_2, Q_3, Q_4), 6 edges ($Q_1Q_2, Q_1Q_3, Q_1Q_4, Q_2Q_3, Q_2Q_4, Q_3Q_4$), 4 faces ($Q_1Q_2Q_3, Q_1Q_2Q_4, Q_1Q_3Q_4, Q_2Q_3Q_4$), and the interior of the simplex ($Q_1Q_2Q_3Q_4$). The subsets are searched one by one, in order of increasing size. The search stops when the origin is contained in the Voronoi region of the feature (vertex, edge, or face) specified by the examined subset (or, for the subset corresponding to the interior of the simplex when the origin is inside the simplex). Once a feature has been located, the point of minimum norm on this feature is given by the orthogonal projection of the origin onto the feature.

Consider again the case of $Q = \{Q_1, Q_2, Q_3, Q_4\}$. An arbitrary point P (specifically the origin) lies in the Voronoi region for, say, vertex Q_1 if and only if the following inequalities are satisfied:

$$(P - Q_1) \cdot (Q_2 - Q_1) \leq 0$$

$$(P - Q_1) \cdot (Q_3 - Q_1) \leq 0$$

$$(P - Q_1) \cdot (Q_4 - Q_1) \leq 0.$$

P lies in the Voronoi region associated with edge $Q_1 Q_2$ if and only if the following inequalities are satisfied:

$$(P - Q_1) \cdot (Q_2 - Q_1) \geq 0$$
$$(P - Q_2) \cdot (Q_1 - Q_2) \geq 0$$
$$(P - Q_1) \cdot ((Q_2 - Q_1) \times \mathbf{n}_{123}) \geq 0$$
$$(P - Q_1) \cdot (\mathbf{n}_{142} \times (Q_2 - Q_1)) \geq 0,$$

where

$$\mathbf{n}_{123} = (Q_2 - Q_1) \times (Q_3 - Q_1)$$
$$\mathbf{n}_{142} = (Q_4 - Q_1) \times (Q_2 - Q_1).$$

If P does not lie in a vertex or edge Voronoi region, face regions are tested by checking if P and the remaining point from Q lie on opposite sides of the plane through the three points from Q chosen to form the face. For example, P lies in the Voronoi region of $Q_1 Q_2 Q_3$ if and only if the following inequality holds:

$$((P - Q_1) \cdot \mathbf{n}_{123})((Q_4 - Q_1) \cdot \mathbf{n}_{123}) < 0,$$

where again

$$\mathbf{n}_{123} = (Q_2 - Q_1) \times (Q_3 - Q_1).$$

Analogous sets of inequalities can be defined for testing containment in the remaining vertex, edge, and face Voronoi regions. Note that most of the computed quantities are shared between different Voronoi region tests and need not be recomputed, resulting in an efficient test overall. Simplex sets of fewer than four points are handled in a corresponding way.

If what was just described seems familiar, it is because the routines given in Sections 5.1.2, 5.1.5, and 5.1.6 — for finding the point on a segment, on a triangle, and on a tetrahedron closest to a given point, respectively — utilize exactly the same approach. Indeed, the original implementation of the GJK algorithm also uses this optimized case-based approach to implementing the distance subalgorithm [Ruspini].

9.5.3 **GJK, Closest Points, and Contact Manifolds**

In addition to the separation distance, the GJK algorithm can provide a pair of closest points between the input objects. Upon termination with nonintersection, the set Q contains up to three points Q_i, forming a simplex from the Minkowski difference $C = A \ominus B$. Let k denote the number of points in Q and let P be the point of minimum norm in $CH(Q)$. Because Q contains the smallest number of vertices needed to express P as a convex combination, P can be expressed as

$$P = \sum_{1 \le i \le k} c_i Q_i, \quad \sum_{1 \le i \le k} c_i = 1, \quad c_i > 0,$$

where (c_1, c_2, \ldots, c_k) are the barycentric coordinates of P with respect to points Q_i. Given that each point Q_i is the difference of points A_i and B_i from input objects A and B, respectively, P can be rewritten as

$$P = \sum_{1 \le i \le k} c_i (A_i - B_i) = G - H, \quad \text{where} \quad G = \sum_{1 \le i \le k} c_i A_i, \quad H = \sum_{1 \le i \le k} c_i B_i.$$

Because P realizes the shortest distance between A and B, there must exist (not necessarily unique) points on the boundaries of A and B such that their difference is P. One such pair of points is G and H. Thus, by maintaining not just points Q_i but A_i and B_i a pair of closest points between A and B is directly obtained per the previous. Note that the calculations needed to determine P on the convex hull of Q amounts to computing the barycentric coordinates of P with respect to points Q_i, and thus the barycentric coordinates are effectively obtained for free.

In addition to the closest pair of points, it is possible to derive contact manifolds from the simplices at the termination of the GJK algorithm for two colliding (or near-colliding) polyhedra. See [Zhang95] and [Nagle02] for details.

9.5.4 **Hill Climbing for Extreme Vertices**

One of the most expensive steps of the GJK algorithm is finding an extreme vertex in a given direction. Trivially, extreme vertices can be located in $O(n)$ time by searching over all n vertices. A better approach relies on having a data structure listing all adjacent vertex neighbors for each vertex. Then an extreme vertex can be found through a simple hill-climbing algorithm, greedily visiting more and more extreme vertices until no vertex more extreme can be found. More specifically, from the current vertex V neighboring vertices V_i are examined until some vertex V_j is found being more extreme in the search direction than V. At this point, V_j is made the current vertex and the process repeats. Due to the convexity of the polyhedron, at the point where no

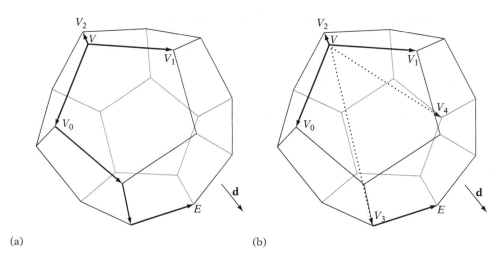

(a) (b)

Figure 9.12 (a) Hill climbing from *V* to the most extreme vertex *E* (in direction **d**) using adjacent vertices only. (b) Accelerated hill climbing using additional (artificial adjacency) information.

neighboring vertex is more extreme the current vertex is guaranteed to be an extreme vertex. This approach is very efficient, as it explores only a small corridor of vertices as it moves toward the extreme vertex.

Figure 9.12a illustrates the hill-climbing algorithm on a dodecahedron. Here, the current vertex V has three adjacent vertices V_0, V_1, and V_2. V_0 is more extreme than V in search direction **d** because $(V_0 - V) \cdot \mathbf{d} > 0$ and is thus made the new current vertex. Three additional steps are taken in the same way (indicated by thick arrows) until vertex E is finally reached. Because none of the neighbors of E are more extreme than E itself, E must be the most extreme vertex in direction **d**, and the search stops.

For larger polyhedra, the hill climbing can be sped up by adding one or more *artificial neighbors* to the adjacency list for a vertex. By linking to vertices at a greater distance away from the current vertex (measured in the smallest number of steps along edges between the two vertices), the hill-climbing algorithm is likely to make faster progress toward the most extreme vertex when moving through these artificial vertices. A simple approach is to assign artificial neighbors randomly. More intelligent algorithms can be employed to ensure artificial neighbors are at least some distance k away from the current vertex. To make sure the artificial neighbors are actually considered during hill climbing, it is a good idea to list them first on the list of neighboring vertices. Alternatively, a steepest descent rule can be employed: instead of moving to the first neighboring vertex more extreme, all neighbors are examined and the neighboring vertex most extreme is made the new current vertex. Figure 9.12b illustrates the hill-climbing algorithm with the addition of two artificial neighbors to the start vertex V and using a steepest descent rule. Now, E is reached in just two steps.

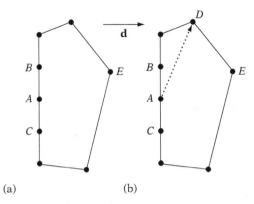

(a) (b)

Figure 9.13 (a) The vertex A is in a local minimum because hill climbing to either of its neighbors B and C does not move closer to the extreme vertex E. (b) Adding an artificial neighbor (here, D) not coplanar with the other neighbors avoids becoming stuck in the local minimum.

However, for a polyhedron this small the amount of work is roughly the same in that a larger number of neighbors must be examined at each step of the algorithm.

Adding artificial neighbors also addresses what is otherwise a problem for hill-climbing-like methods; namely, coplanar faces. Figure 9.13 illustrates how hill climbing can become stuck in a local minimum due to the presence of coplanar faces (or, as here, edges). In Figure 9.13a, vertex A is in a local minimum in that hill climbing to either of its neighbors B and C does not move closer to the extreme vertex E. If moving randomly to either neighbor, the next step might move back to A, causing infinite looping. In 2D, disallowing moving back to a previously visited vertex can prevent such cycling, but this does not hold in 3D (in which a vertex may end up with no remaining visitable neighbors during the search).

By adding an artificial neighbor N to each vertex V, where N is *not* coplanar with V and its real neighbors, local minima can effectively be avoided during hill climbing. Figure 9.13b shows how adding D as an artificial neighbor to A helps escape the local minimum. Note that a hierarchical representation such as the Dobkin–Kirkpatrick hierarchy could be used to locate an extreme vertex in logarithmic time.

9.5.5 Exploiting Coherence by Vertex Caching

The amount of effort spent hill climbing for an extreme vertex highly depends on the choice of the starting point P. In the best case, P itself is the extreme vertex and the search can terminate immediately. Worst case, P lies on the opposite side of where the extreme vertex is located. Because objects tend not to move much from frame to frame relative one another, a good choice for the initial point P would be the closest

point to the other object as found on the previous frame. An alternative is to keep the simplex from the previous frame. In both cases, an array or a hash table can effectively hold this information for each pair of objects from one frame to the next. When there is little frame-to-frame coherency, a better option might be to obtain the vector between the object centroids, compute supporting vertices on both objects with respect to the vector, and use these vertices as the starting points. This method can also be useful as a first-time initialization.

9.5.6 Rotated Objects Optimization

To be able to collide two objects, they must be in the same reference frame, such as both objects expressed in the coordinate system of the world space or one object given in the coordinate system of the other (the latter being a cheaper option because only one object must be transformed). However, for GJK rather than up-front transforming all vertices of one object into the space of the other a better approach is to simply transform the direction passed into the support mapping into the other reference frame. In the former case, all n vertices of one object (preferably the one with fewer vertices) must be transformed once. In the latter case, only a single vector must be transformed but a vector must be transformed k times, once per iteration of the algorithm. Generally k is much smaller than n, and thus the latter approach is therefore much more effective. In addition, the first approach requires extra storage to hold the transformed vertices, whereas the second alternative needs no additional vertex storage. In both cases, after the closest points have been found two more transformations may be needed to express these points in world space.

One scenario in which the latter approach may not be preferable is when a binary search over time is performed to find the time t at which an object moving under a linear translation intersects another object. The first approach still only requires n transformations (in that a translation does not change the object's rotation), whereas the latter now requires km transformations, where m is the number of steps of the binary search.

9.5.7 GJK for Moving Objects

Although the GJK algorithm is usually presented and thought of as operating on two convex polyhedra, it is more general than this. Given two point sets, it computes the minimum distance vector between the convex hulls of the point sets (an easy way of seeing this is to note that the support mapping function never returns a point interior to the hull). This is an important distinction, as it allows GJK to be used to determine collisions between convex objects under linear translational motion in a straightforward manner.

One approach to dealing with moving polyhedra is presented in [Xavier97]. Consider two polyhedra P and Q, with movements given by the vectors \mathbf{t}_1 and \mathbf{t}_2,

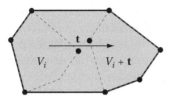

Figure 9.14 For a convex polyhedron under a translational movement **t**, the convex hull of the vertices V_i at the start and the vertices $V_i + $ **t** at the end of motion corresponds to the swept hull for the polyhedron.

respectively. To simplify the collision test, the problem is recast so that Q is stationary. The relative movement of P (with respect to Q) is now given by $\mathbf{t} = \mathbf{t}_1 - \mathbf{t}_2$. Let V_i be the vertices of P in its initial position. $V_i + \mathbf{t}$ describes the location of the vertices of P at the end of its translational motion.

It is not difficult to see that as P moves from start to end over its range of motion the volume swept out by P corresponds to the convex hull of the initial vertices V_i and the final vertices $V_i + \mathbf{t}$ (Figure 9.14). Determining if P collides with Q during its translational motion is therefore as simple as passing GJK the vertices of P at both the start and end of P's motion (in that this convex hull is what GJK effectively computes, given these two point sets). A drawback with this solution is that doubling the number of vertices for P increases the time to find a supporting vertex. A better approach, which does not suffer from this problem, is to consider the movement vector \mathbf{t} of P with respect to \mathbf{d}, the vector for which an extreme vertex is sought. From the definition of the extreme vertex it is easy to see that when \mathbf{t} is pointing away from \mathbf{d}, none of the vertices $V_i + \mathbf{t}$ can be more extreme than the vertices V_i. Thus, when $\mathbf{d} \cdot \mathbf{t} \leq 0$, an extreme vertex is guaranteed to be found among the vertices V_i (Figure 9.15a). Similarly, when $\mathbf{d} \cdot \mathbf{t} > 0$ only the vertices $V_i + \mathbf{t}$ need to be considered for locating an extreme vertex (Figure 9.15b).

The second of the two presented approaches is effectively implemented by changing the support mapping function such that the motion vector is added to the vertices

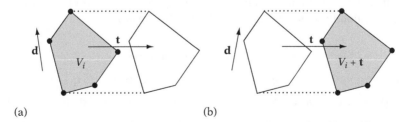

(a) (b)

Figure 9.15 (a) When $\mathbf{d} \cdot \mathbf{t} \leq 0$, the supporting vertex is found among the original vertices V_i and the vertices $V_i + \mathbf{t}$ do not have to be tested. (b) Similarly, when $\mathbf{d} \cdot \mathbf{t} > 0$ only the vertices $V_i + \mathbf{t}$ have to be considered.

during hill climbing. A drawback is that both presented methods only provide interference detection. However, interval halving can be effectively used to obtain the time of collision. Using an interval-halving approach, the simplices from the previous iteration are ideal candidates for starting the next iteration. Alternatively, the time of collision can be obtained iteratively using a root finder such as Brent's method, as described in [Vlack01].

A recent method that also returns the time of collision is presented in [Bergen04]. Described is an iterative GJK-based algorithm for performing a ray cast against a general convex object. This algorithm can trivially be used for detecting collision between two moving convex objects by forming the Minkowski sum of the objects and casting a ray against their sum, where the ray corresponds to the relative movement of one object with respect to the other. The time of collision is directly determined from the point along the ray at which intersection with the Minkowski sum occurs.

9.6 The Chung–Wang Separating-vector Algorithm

The last convexity-based algorithm explored here is an algorithm given by Chung and Wang [Chung96]. It is an original algorithm for intersection testing between polyhedra P and Q, which is fast and simple to implement. In fact, the Chung–Wang (CW) algorithm consists of two algorithms. The main algorithm starts from a candidate separating vector and, in the case of nonintersection of P and Q, iteratively updates the vector to one closer and closer to an actual separating vector. A supporting subalgorithm detects the case in which P and Q are in collision, for which the main algorithm would loop indefinitely.

Like the GJK algorithm, the CW algorithm operates on the vertices of the polyhedra. At each iteration i, the main algorithm computes the two vertices \mathbf{p}_i and \mathbf{q}_i ($\mathbf{p}_i \in P$, $\mathbf{q}_i \in Q$) most extreme with respect to the current candidate separating-vector \mathbf{s}_i. If this pair of vertices indicates object separation along \mathbf{s}_i, the algorithm exits with no intersection. Otherwise, the algorithm computes a new candidate separating-vector by reflecting \mathbf{s}_i about the perpendicular to the line through to \mathbf{p}_i and \mathbf{q}_i. More specifically, the main algorithm of the CW algorithm is given in the following five steps (the notation used here follows that in [Chung96]).

1. Start with some candidate separating vector \mathbf{s}_0 and let $i = 0$.

2. Find extreme vertices \mathbf{p}_i of P and \mathbf{q}_i of Q such that $\mathbf{p}_i \cdot \mathbf{s}_i$ and $\mathbf{q}_i \cdot -\mathbf{s}_i$ are maximized.

3. If $\mathbf{p}_i \cdot \mathbf{s}_i < \mathbf{q}_i \cdot -\mathbf{s}_i$, then \mathbf{s}_i is a separating axis. Exit reporting no intersection.

4. Otherwise, compute a new separating vector as $\mathbf{s}_{i+1} = \mathbf{s}_i - 2(\mathbf{r}_i \cdot \mathbf{s}_i)\mathbf{r}_i$, where $\mathbf{r}_i = (\mathbf{q}_i - \mathbf{p}_i) / \|\mathbf{q}_i - \mathbf{p}_i\|$.

5. Let $i = i + 1$ and go to 2.

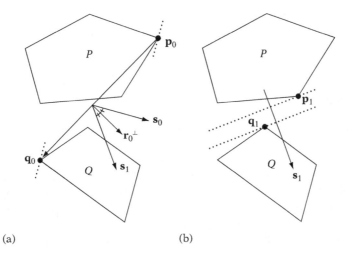

(a) (b)

Figure 9.16 (a) The first iteration of the CW algorithm for polygons P and Q. (b) A separating vector is found in the second iteration.

Figure 9.16 illustrates two steps of the main algorithm. In Figure 9.16a s_0 is the initial candidate vector for which the supporting vertices p_0 and q_0 are computed. These do not indicate that s_0 separates P and Q, and thus s_0 is reflected in the perpendicular r_0^\perp to the (unit) vector r_0 from p_0 to q_0 to give a new candidate vector s_1. In the next iteration of the algorithm, illustrated in Figure 9.16b, the supporting vertices p_1 and q_1 now show that s_1 is a separating vector and the algorithm terminates with nonintersection for the two polyhedra.

A subalgorithm is used to terminate the CW algorithm when the polyhedra intersect. It attempts to find a vector m such that $m \cdot r_i \geq 0$ for $0 \leq i \leq k$. If no such vector can be found, the origin must lie inside the Minkowski difference of P and Q, and the polyhedra intersect. The provided algorithm is $O(k)$, where k is the number of iterations performed. To reduce execution time, the subalgorithm can be executed on every n-th iteration rather than on every iteration.

The motivation for the update rule used (in step 4) is that for two spheres it provides a separating vector in one step. A proof of convergence for this rule is given in [Chung96]. It states that if v is any separating vector for P and Q then $s_{k+1} \cdot v > s_k \cdot v$, decreasing the angle between the candidate separating vector and the true separating vector on each iteration and thus showing convergence. However, [Bergen99] notes that the given proof is flawed and that it is only shown that $s_{k+1} \cdot v \geq s_k \cdot v$. Convergence for the CW algorithm is thus not quite proven. Even so, the CW algorithm appears to behave well in practice. By tracking the separating vector for two objects and using it as the initial candidate vector of a subsequent test, the CW algorithm runs in near constant time. In [Bergen99] the CW algorithm is reported twice as fast (on average) as a separating-axis-enhanced version of GJK. Experiments reported in

[Chung96] show that three iterations were sufficient to identify noncolliding objects in over 95% of cases when utilizing temporal coherence for the starting vector.

9.7 **Summary**

Collision systems work almost exclusively with convex objects because they have certain properties that make them highly suitable for intersection testing. One of these properties is the existence of a separating plane (or, equivalently, a separating axis) for two nonintersecting convex objects. Another property of convex objects is that when the distance between two points from two different convex objects are at a minimum they are at a global minimum. This allows closest pairs of points to be located using simple hill-climbing techniques.

One algorithm that utilizes hill climbing is the V-Clip algorithm. It tracks a pair of features, one from each input polytope, updating the features by walking across the surface of the polytopes so as to decrease the distance until the closest pair of features has been obtained. Closest-point queries on polytopes can also be accelerated using hierarchical representations, one example of which is the Dobkin–Kirkpatrick hierarchy.

Intersection queries on polytopes can also be answered using mathematical optimization methods. If a Boolean result is sufficient, linear programming can be used to determine the intersection status of two (or more) polytopes. However, linear programming cannot determine the closest points between two polytopes. For this problem, quadratic programming must be used instead.

Effectively a specialized quadratic programming method, the GJK algorithm is one of the most efficient methods for determining intersection between two polytopes, or in its generalized form between two arbitrary convex objects (as long as they can be described by a support mapping function). As was shown, the GJK algorithm also extends to handle objects moving under linear translational motion. Last, the CW separating-vector algorithm was presented as an efficient approach to finding a separating axis for two nonintersecting objects.

Chapter 10

GPU-assisted Collision Detection

Today, commodity graphics processing units (GPUs) have advanced to a state in which more raw processing power is inherent in GPUs than in main CPUs. This development is facilitated by GPUs working in a very restricted domain, allowing rendering tasks to be parallelized across many deeply pipelined, highly specialized computational units. This parallelism gives an overall speed advantage to GPUs, even though GPUs typically work at lower clock speeds than CPUs. Coupled with recent GPU improvements, such as increased programmability of vertex and pixel shaders and the introduction of floating-point textures, the computational power of GPUs has generated a lot of interest in mapping nonrendering-related, general-purpose computations — normally performed on the CPU — onto the GPU. For collision detection, there are two primary ways in which to utilize GPUs: for fast *image-space-based* intersection techniques or as a co-processor for accelerating mathematics or geometry calculations. Image-space-based intersection techniques rely on rasterizing the objects of a collision query into color, depth, or stencil buffers and from that determining whether the objects are in intersection.

Image-spaced-based techniques are generally easy to implement, work on any rasterizable primitives (including, for example, Bezier and NURBS patches), and do not require complex collision data structures in that they operate directly on the rendering geometry (and therefore also deal well with deformable nonstatic geometry). Because the testing is performed to the resolution of the buffer(s) to which the objects are rendered, all image-space collision detection methods are approximate. They can therefore report collision when two objects are actually separated; for example, when two objects separated by a small distance are far away from the rendering viewplane. They can also report no collision when objects are in fact colliding; for example, when the objects are so small or are so far away from the viewplane that no pixels are rasterized when rendering the objects. These issues can be largely ameliorated by rendering objects as close to the viewplane as possible (without incurring

413

clipping) and by picking a view direction to maximize on-screen projection. As will be discussed further on, image-spaced-based techniques also have problems with polygons edge-on to the viewer (in that these are not rasterized).

By carefully arranging data into textures, it is also possible to perform general-purpose computations on a GPU through programmable pixel shaders (or even through blending operations). For example, a static triangle mesh can be represented by a number of textures, encoding the component values of the vertices and (implicitly) the vertex-face connectivity. With an appropriate pixel shader program it is then possible to perform a ray intersection test against all encoded triangles in parallel. Using GPUs for general-purpose calculations is a new, highly active, area of research at present. For example, [Carr02] and [Purcell02] describe efforts aimed at accelerating ray-triangle intersection tests in the domain of ray tracing using GPUs.

This chapter looks at how image-spaced-based collision detection techniques can be used to determine the intersection between both convex and concave objects. An image-space collision-filtering algorithm is also described. Because the area of GPU-accelerated mathematics and geometry calculations is still young, it is not yet clear how useful or practical such techniques are for collision detection problems in general. Therefore, GPU-supported acceleration of calculations is not further explored here.

10.1 Interfacing with the GPU

Using GPUs as computation devices — a task they were not quite designed for — means that there are some practical issues to resolve. On the GPU input side, this means that data must be packeted in terms of vertex streams or as textures. Such packeting requires some care but is largely straightforward. The larger problem is that of moving results, computed on the GPU, back to main memory. On most current systems, reading data back from the GPU incurs a large performance penalty, in part caused by stalls and lost parallelism due to the readback. In some cases, buffer readbacks are unavoidable, but often algorithms can be structured to avoid these through the use of hardware-supported *occlusion queries*. Even when buffer readbacks are necessary, it is often possible through careful design to limit the amount of data read back. The next two sections discuss buffer readbacks in more detail, elaborating on how they can be reduced and even fully avoided.

10.1.1 Buffer Readbacks

Several algorithms have been proposed that in some fashion rely on reading back image buffers to main memory and analyzing their content to determine collisions (including [Boyles99] and [Dinerstein02]). For example, in OpenGL rectangular areas of a buffer can be read back using **glReadPixels()**, from the buffer specified

using **glReadBuffer()**. Unfortunately, reading buffers from GPU memory is usually a very slow operation, making buffer readbacks unappealing. There are several reasons these operations are slow. To read data back, all operations in the graphics pipeline must be completed, and no rendering to the read area can be allowed while the read is in progress. Effectively, the rendering pipeline stalls during the readback. In addition, because a GPU is primarily an output device bus transfer is usually optimized for sending data to the card (not for fetching data back). Finally, once the data arrives back in main memory the data might additionally need massaging by the driver to match the desired format specified in the read request. If buffer readbacks are used, it is therefore important to try to reduce both the number of readbacks issued and the amount of data read back.

Some have suggested using histogram queries to get data back from the GPU, such as through the OpenGL extension **EXT_histogram** [Boyles99]. Unfortunately, even when available histogram extensions are unlikely to be faster than buffer readbacks, in that they are typically implemented as buffer readbacks in the graphics card driver and are performed on the CPU (rather than being natively hardware accelerated).

Where available, one way of reducing the data readback is to trade fill rate for transfer bandwidth by downsampling the transfer area to quarter size using bilinear filtering. For example, assume the purpose of the readback is to detect the presence of white (255, 255, 255) 24-bit pixels on an otherwise black (0, 0, 0) background. After one round of downsampling, pixels can have values of (0, 0, 0), (64, 64, 64), (128, 128, 128), or (191, 191, 191), assuming rounding to nearest value. Any nonblack pixels indicate a white pixel present in the original image. In this scenario, the downsampling process can be performed four times before the ability to discern white pixels in the original image is lost (Figure 10.1). After four rounds of downsampling it is only necessary to read back 1/256 of the original image to main memory, thereby greatly reducing the time required to perform the transfer. Accumulating several downsampled buffers — concatenated into a single contiguous area — before reading data back to main memory also allows the number of readbacks to be reduced.

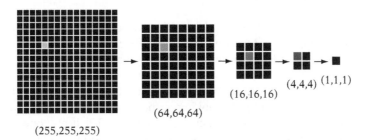

(255,255,255) (64,64,64) (16,16,16) (4,4,4) (1,1,1)

Figure 10.1 The presence of one or more white pixels on an otherwise black background remains detectable after (at most) four bilinear downsampling passes of an image. Numbers designate the RGB value of the nonblack pixel. Black pixels have an RGB value of (0,0,0).

10.1.2 **Occlusion Queries**

One way of completely avoiding buffer readbacks from the GPU is to recast algorithms to utilize the *occlusion query* feature available on most current commodity graphics hardware. When enabled, the occlusion query counts the number of pixels (or, technically, samples) of a triangle (or other rendering primitives) passing the current set of active tests (such as depth and stencil tests). Counter size varies among hardware implementations, from 1 bit upward. Counter overflows are usually saturated to the maximum value to ensure expected behavior.

Typical intended use for occlusion queries is for the application to render the major occluders of a scene first. After they have been rendered, for each (complex) detail object O_i an occlusion query is performed for a simple fully encompassing bounding volume of O_i before O_i itself is rendered. If the occlusion query says no part of the bounding volume is visible, O_i must be occluded and consequently can be culled rather than being rendered. When issuing an occlusion query, writes to color, depth, and stencil buffers are usually disabled to save processing time and to not interfere with the query (for example, in the case of multiple back-to-back queries).

In OpenGL, for example, an occlusion query core feature is provided as of version 1.5 [Segal03]. This feature supports a test that returns the number of samples of the occlusion-tested geometry passing stencil and depth tests. It also allows several outstanding occlusion queries, which greatly increases the opportunity for parallelism between CPU and GPU by minimizing stalls otherwise caused by waiting for an occlusion query to finish. In earlier versions of OpenGL, occlusion queries are supported through the vendor-specific extensions `HP_occlusion_test` and `NV_occlusion_query`.

In addition to helping to solve visibility problems, occlusion queries are effective for determining if two convex objects are intersecting. Such a test is explored in the next section.

10.2 **Testing Convex Objects**

Several treatments have been forwarded for GPU-assisted collision detection for convex objects; for example, by [Myszkowski95] and [Baciu99]. The basic idea behind these methods is to consider each render buffer pixel as a ray, perpendicular to the viewplane, cast toward the objects. When the ray intersects an object, the intersection can be described as an interval of first and last intersection with the ray. For a configuration of two convex objects, looking at the possible cases of intervals along a ray results in nine overall cases, illustrated in Figure 10.2. If any one of cases 5 through 8 occurs for a single pixel, the objects are in collision; otherwise, they are nonintersecting.

These early accounts rely on reading back the stencil buffer to perform the test. With modern graphics hardware, buffer readback is neither necessary nor indeed

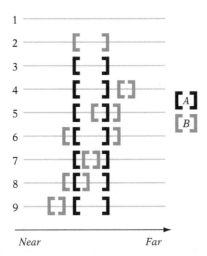

Figure 10.2 The nine cases in which a ray may intersect two convex objects, A and B.

desired. Instead, the test can be effectively performed on the GPU without buffer readbacks using occlusion queries. The modified test is quite simple, performed in two passes, with a fifty-fifty chance of early exit (with a result of nonintersection) after the first pass.

In the first pass, object A is rendered into the depth buffer, using a depth test of *less-equal*. The depth test is then changed to *greater-than*, depth buffer updates are disabled, and object B is rendered with occlusion querying enabled. If the occlusion query reports that no pixels of B are visible, B must lie fully in front of A, and the objects cannot be in collision. Otherwise, a second pass is performed, identical to the first, but with the roles of A and B reversed. At the start of both passes, the depth buffer is initialized to far Z. Color buffer updates are disabled throughout the test. It is not necessary to initialize the depth buffer on the second pass if the rendering at the start of each pass involves only the front faces of the object and the depth test is set to *always*. Similarly, the occlusion queries can be optimized by testing just the back faces.

Figure 10.3 illustrates this occlusion query collision test. Illustration (a) shows objects A and B, and the depth buffer initialized to far Z (as shown in gray). Drawing (b) shows the first pass, in which object A has been rendered to the depth buffer. In this case, a majority of the fragments of B pass the greater-than test, and thus a second pass is performed. In the second pass, illustrated in (c), object B is first rendered into the depth buffer. When object A is then tested, no fragments pass the greater-than test, and the conclusion is that A and B are separated. Note that this test does not require that objects A and B be polyhedral. They could equally well consist of, say, curved surfaces. For correct intersection determination the objects must be convex, however. A sample OpenGL implementation of this occlusion-based collision test is provided in Table 10.1.

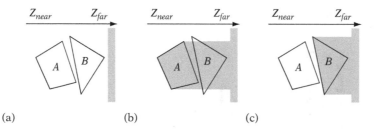

(a) (b) (c)

Figure 10.3 Occlusion queries can be used to determine if (convex) objects *A* and *B* are intersecting.

Table 10.1 Implementation of a collision test for two convex objects using OpenGL occlusion queries.

Pass	Code
0	```// Initialize depth buffer to far Z (1.0)``` ```glClearDepth(1.0f);``` ```glClear(GL_DEPTH_BUFFER_BIT);``` ```// Disable color buffer writes``` ```glColorMask(GL_FALSE, GL_FALSE, GL_FALSE, GL_FALSE);``` ```// Enable depth testing``` ```glEnable(GL_DEPTH_TEST);``` ```// Initialize occlusion queries``` ```Gluint query[1], numSamplesRendered;``` ```glGenQueries(1, query);```
1	```// Set pixels to always write depth``` ```glDepthFunc(GL_ALWAYS);``` ```glDepthMask(GL_TRUE);``` ```// Draw front faces of object A``` ```glCullFace(GL_BACK);``` ```RenderObject(A);``` ```// Pass pixels if depth is greater than current depth value``` ```glDepthFunc(GL_GREATER);``` ```// Disable depth buffer updates``` ```glDepthMask(GL_FALSE);``` ```// Render back faces of B with occlusion testing enabled``` ```glBeginQuery(GL_SAMPLES_PASSED, query[0]);``` ```glCullFace(GL_FRONT);``` ```RenderObject(B);``` ```glEndQuery(GL_SAMPLES_PASSED);```

(continued)

Table 10.1 *Continued.*

Pass	Code
	`// If occlusion test indicates no samples rendered, exit with no collision` `glGetQueryObjectuiv(query[0], GL_QUERY_RESULT, &numSamplesRendered);` `if (numSamplesRendered == 0) return NO_COLLISION;`
2	`// Set pixels to always write depth` `glDepthFunc(GL_ALWAYS);` `glDepthMask(GL_TRUE);` `// Draw front faces of object B` `glCullFace(GL_BACK);` `RenderObject(B);` `// Pass pixels if depth is greater than current depth value` `glDepthFunc(GL_GREATER);` `// Disable depth buffer updates` `glDepthMask(GL_FALSE);` `// Render back faces of A with occlusion testing enabled` `glBeginQuery(GL_SAMPLES_PASSED, query[0]);` `glCullFace(GL_FRONT);` `RenderObject(A);` `glEndQuery(GL_SAMPLES_PASSED);` `// If occlusion test indicates no pixels rendered, exit with no collision` `glGetQueryObjectuiv(query[0], GL_QUERY_RESULT, &numSamplesRendered);` `if (numSamplesRendered == 0) return NO_COLLISION;` `// Objects A and B must be intersecting` `return COLLISION;`

Better collision results than a simple Boolean result could be obtained through enhanced hardware occlusion query functionality. For example, in addition to the number of samples passed, hardware returning a screen-space bounding box and the closest and farthest z value of samples passed during the occlusion query would provide further information about where a collision occurs and the level of object penetration.

It is worth noting that the presented test also serves as a *conservative* test for concave objects A and B. If the test reports A and B as not intersecting, they are indeed not intersecting (within the accuracy of the rasterized approximation). However, if the test reports the concave objects as intersecting, they may or may not actually be intersecting in reality. Accurately dealing with concave geometry requires a different approach, as described in the next section.

10.3 **Testing Concave Objects**

A method that avoids the false positives on concave geometry returned by the algorithm of Section 10.2 is found in [Knott03a, Knott03b] and is described here. Recall that two objects *A* and *B* (whether convex or concave) are in collision if and only if they have a point in common. When *A* and *B* are polyhedral, they intersect if and only if part of an edge of one object lies inside the volume of the other object. Thus, if *A* and *B* intersect there exists a point on some edge of either object that belongs to both objects. A ray cast from this point — in any direction, but in particular toward the viewer — passes through the boundary of object *A* (or object *B*) an odd number of times (effectively exiting the solid object one more time than it is entering it). This scenario is illustrated in Figure 10.4. In (a), objects *A* and *B* are shown in perspective, with only the edges of object *B* drawn. Illustration (b) shows the objects from the side, here with four rays cast from different edges of *B* toward the viewer. Of the four rays, one passes through the boundary of object *A* an odd number of times, indicating that *A* and *B* must be intersecting. To ensure proper collision detection, a ray test must be performed for all points on all edges of object *B* against the volume of object *A*. If an intersection is not detected, the edges of object *A* must be tested against the volume of object *B* in a second pass.

Using graphics hardware, all required ray intersection tests of one pass can be effectively performed in parallel with the help of stencil buffer tests. Three major steps are involved.

0. Initialize:

- Disable color buffer writes.

- Initialize depth and stencil buffers.

- Enable depth buffer testing.

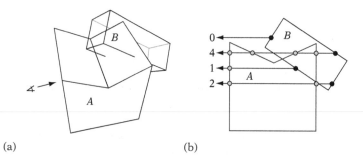

(a) (b)

Figure 10.4 Drawing the edges of *B* and then testing these against the faces of *A* using the described algorithm corresponds to performing a **point-in-polyhedron** query for all pixels rasterized by the edges of *B*, testing if **any ray** from a pixel toward the viewer intersects object *A* an odd number of times.

1. Render edges:

 - Enable depth buffer updates.

 - Set all pixels to pass always.

 - Draw all edges of object B, writing their depth into the depth buffer.

2. Render faces:

 - Disable depth buffer updates.

 - Set pixels to pass if they are nearer than the stored depth value.

 - Enable the stencil buffer test.

 - Render front faces of object A. Increment stencil buffer for pixels that pass.

 - Render back faces of object A. Decrement stencil buffer for pixels that pass.

After all three steps have been executed, the stencil buffer contains nonzero values if objects A and B are in collision. A sample OpenGL implementation of this collision test is provided in Table 10.2.

Rather than actually reading back the stencil buffer, nonzero values in the stencil buffer can be detected using an occlusion query for the screen-space bounding box of the smaller of the two objects. By passing query pixels that have a nonzero stencil value, the objects are intersecting if and only if the occlusion query reports pixels passing the stencil test.

It is important to note that the method described in this section is not without problems and may fail in certain situations. As an example, consider the case of Figure 10.5, in which two AABBs, A and B, are intersecting. Because those edges of A in intersection with object B are aimed straight into the screen, they are not rasterized. Thus, the only depth values written by A are those for the edges of the frontmost or backmost face. In that none of these edges interpenetrate B, and because no edges of B interpenetrate A, the result is that collision is not detected. Fortunately, in practice this situation can be made unlikely to happen by rendering the objects using perspective rather than orthographic projection. Although similar configurations can be constructed for perspective projection, the odds of shapes aligning into a similar situation in perspective projection are low. When alignment is still a concern, testing collision from multiple viewpoints would further reduce the odds of this type of failure.

The current test is not limited to detecting the intersection of only two objects. The intersections of multiple objects can be tested by changing the algorithm to first render all objects (rather than just one) in wireframe, followed by rendering all objects (rather

Table 10.2 Implementation outline of a concave object collision test using OpenGL.

Step	Code	
0	```// Disable color buffer writes``` ```glColorMask(GL_FALSE, GL_FALSE, GL_FALSE, GL_FALSE);``` ```// Clear depth and stencil buffers, initializing depth buffer to far Z (1.0)``` ```glClearDepth(1.0f);``` ```glClear(GL_DEPTH_BUFFER_BIT	GL_STENCIL_BUFFER_BIT);``` ```// Enable depth buffer testing``` ```glEnable(GL_DEPTH_TEST);```
1	```// Enable depth buffer updates. Set all pixels to pass always``` ```glDepthMask(GL_TRUE);``` ```glDepthFunc(GL_ALWAYS);``` ```// Draw edges of object B``` ```glPushAttrib(GL_POLYGON_BIT);``` ```glPolygonMode(GL_FRONT_AND_BACK, GL_LINE);``` ```DrawObject(B);``` ```glPopAttrib();```	
2	```// Disable depth buffer updates. Pass pixels if nearer than stored depth value``` ```glDepthMask(GL_FALSE);``` ```glDepthFunc(GL_LESS);``` ```// Increment stencil buffer for object A frontfaces``` ```glEnable(GL_STENCIL_TEST);``` ```glStencilOp(GL_KEEP, GL_KEEP, GL_INCR);``` ```glCullFace(GL_BACK);``` ```DrawObject(A);``` ```// Decrement stencil buffer for object A backfaces``` ```glStencilOp(GL_KEEP, GL_KEEP, GL_DECR);``` ```glCullFace(GL_FRONT);``` ```DrawObject(A);``` ```// Read back stencil buffer. Nonzero stencil values implies collision``` ```...```	

than just one) solidly. In order to know which two objects intersect when a collision is detected, object (and edge and face) IDs can be encoded in bits of the color buffer during rendering of both wireframe edges and solid faces. Where nonzero stencil buffer values indicate an object collision, the bits at the corresponding position in the color buffer now identify the objects (and edges and faces) in collision. Due to hardware rasterization issues, lines do not rasterize in the same way as polygons. Specifically, the edges of a polygon, rasterized as lines, do not necessarily occupy the same pixels at the same depths as the polygon edge pixels. Thus, when several

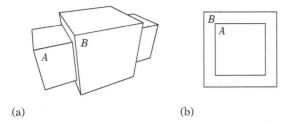

(a) (b)

Figure 10.5 Two AABBs in a configuration in which the algorithm fails to detect intersection, assuming orthographic projection. (a) Side view. (b) Front view.

objects are tested at once using this method edges must be offset away from the object volume during rendering by some appropriate amount in order to avoid object self-intersections. This test deals only with closed objects. As such, it is important that no objects undergo clipping during rendering, as this effectively renders the objects nonclosed.

The ray intersection parity test used here has strong similarities to the tests used in stencil-buffer shadow volumes [Everitt02] and [Lengyel02] and CSG rendering [Rossignac92], [Stewart02], and [Guha03]. As is the case for stencil-buffer shadow volumes, hardware stencil buffer support is not actually required to perform the ray intersection counting done here. For example, the equivalent of stencil operations can be implemented using additive and subtractive blending on any one of the RGBA channels of a color buffer [Röttger02].

If the concave objects A and B are given as CSG objects, GPU-based CSG rendering techniques (referenced previously) can also be used to determine collision between them. The objects are in collision if any pixels of the intersection of the two CSG trees are rendered.

10.4 **GPU-based Collision Filtering**

In addition to being used as a pairwise test, the test of Section 10.2 can, with minor changes, form the basis of a simple collision-filtering algorithm [Govindaraju03]. Recall that two objects are tested as nonintersecting if all fragments generated during rasterization of a second object lie closer to the viewer than the values present in the depth buffer from rendering a first object. For this case, the second object is said to be *fully visible* with respect to the first object. By rasterizing several objects into the depth buffer before the last object is tested, the test extends to multiple objects. If the last tested object is fully visible, it follows that it is not in intersection with any of the previous objects. The converse is not true, however. An object not in intersection with other objects is not necessarily fully visible with respect to those objects. The test is therefore conservative when applied to multiple objects.

Given a set of objects, it is now straightforward to implement a collision-filtering algorithm in terms of a number of repeated tests to see if an object from the set is fully visible with respect to the other objects. If so, this object is discarded as not intersecting any objects. Tests are repeated until no more objects can be discarded in this manner. Upon exit, the remaining set of objects — the *potentially colliding set* (PCS) — contains the objects that may be in collision. At this point, further pairwise tests can determine which exact objects of the set are intersecting, if desired.

Let $S = \{O_1, O_2, \ldots, O_n\}$ be a set of n objects. Testing whether object O_i is fully visible with respect to the rest of the objects, $O_1, O_2, \ldots, O_{i-1}, O_{i+1}, \ldots, O_n$, can be performed for all objects at once, using a simple two-pass approach in which objects are rendered and simultaneously tested for full visibility. In the first pass the objects are rendered and tested one by one in the order O_1, O_2, \ldots, O_n. The fully visible status of each object is recorded. In the second pass, the objects are rendered and tested in the reverse order, $O_n, O_{n-1}, \ldots, O_1$, and their status is again recorded. Now, for each object O_i if O_i is found fully visible with respect to $O_1, O_2, \ldots, O_{i-1}$ on the first pass and fully visible with respect to $O_n, O_{n-1}, \ldots, O_{i+1}$ on the second pass O_i is fully visible with respect to all other objects and therefore cannot be in collision. Thus, any object that was marked fully visible in both passes can be safely removed from the PCS. Additionally, if all of the last r rendered objects, $O_r, O_{r+1}, \ldots, O_n$, have been marked fully visible during the first pass (or all of the last s rendered objects, $O_s, O_{s-1}, \ldots, O_1$, during the second pass), they too can be removed from the PCS. The "fully visible" test for object O_i during each pass can be implemented in terms of an occlusion query as follows.

1. Disable depth buffer writes.

2. Enable depth testing, with pixels passing if their depth is greater than current value.

3. Perform an occlusion query on object O_i.

4. Enable depth buffer writes.

5. Set depth test to less-than or equal.

6. Render object O_i.

7. Get the result from the occlusion query. If no pixels passed the test, flag object O_i as fully visible during this pass.

These steps are repeated for all n objects. The test assumes the depth buffer is initially set to Z-far.

In a scene with n nonintersecting objects stacked n deep, the two-pass filtering algorithm is able to mark only the frontmost object as fully visible, leaving the remaining $n - 1$ objects in the PCS. It thus takes n repetitions to mark all objects as fully visible and to reduce the PCS to empty. The overall algorithm performance is therefore linearly dependent on the depth complexity of the scene. Because scenes rarely

have uniform depth complexity in all directions, the problem of high depth complexity can be alleviated by rendering the objects along different view directions from pass to pass. A simple alternative is to alternate between viewing down the three principal axes in a cyclic fashion. High depth complexity along one but not all axes is thus effectively handled. Although problem configurations are still possible, they are unlikely to occur in practice.

Figure 10.6 illustrates the algorithm on the set of objects $S = \{A, B, \ldots, H\}$. In the first pass of the filtering algorithm, objects are rendered in order A through H. After the first pass, objects A, B, C, D, G, and H have been marked fully visible (Figure 10.6a). In the second pass, objects are rendered in order H through A. At the end of the second pass, objects H, G, F, and B have been marked fully visible (Figure 10.6b). After the first round (of two passes), objects B, G, and H have been marked fully visible in both passes. These three objects can therefore safely be pruned from the PCS (Figure 10.6c). If a second round of filtering is performed, object C can be culled after the two passes. The remaining set of four objects (A, D, E, and F) cannot be pruned further using the same view axis. However, if a horizontal view axis is used object E can be pruned as well, ultimately leaving objects A, D, and F in the PCS (and thus as conservatively colliding).

The filtering algorithm can be applied directly to the objects (whether convex or concave). If the objects are of high complexity, it may be better to filter the objects

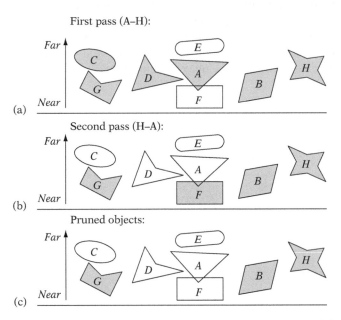

Figure 10.6 Objects, shown in gray, are those considered fully visible in (a) the first and (b) the second pass. (c) Objects B, G, and H are fully visible in both passes and can be pruned from the PCS.

on their bounding boxes first, before filtering on the objects themselves. Because the test does not rely on closed geometry, when a set of objects has been identified as potentially colliding the faces of the objects can be treated as individual objects. Reapplying the algorithm on the face sets returns the set of potentially colliding faces upon exit. Knowing these faces, exact intersection points can then be computed on the CPU if needed.

10.5 Summary

This chapter looked at utilizing the increasing processing power of GPUs for image-space-based intersection techniques. When the GPU is used for such purposes, it is important to restrict the communication between GPU and CPU because reading back data to the CPU is often slow. The main solution to overcoming this communication bottleneck relies on using hardware-supported occlusion queries to pass information back to the CPU. The tests presented in the chapter all use these occlusion queries. An alternative solution is to perform buffer readbacks of buffers that have been reduced in size through (possibly repeated) downsampling using bilinear filtering.

Image-space-based overlap tests for both convex and concave objects were presented, and inherent accuracy problems with image-space-based tests were noted. Last, a filtering method to cull a set of objects down to a small set of potentially colliding objects was discussed. This filtering method can be applied both as a broad-phase filtering method to the objects' bounding volumes or as a narrow-phase filtering method to the objects themselves.

Chapter 11

Numerical Robustness

An issue that has only had sporadic coverage so far is that of algorithm *robustness*. Formal definitions of robustness are possible. As briefly discussed in Chapter 2, in this book robustness is used simply to refer to a program's capacity to deal with numerical computations and geometrical configurations that are in some way difficult to handle. A robust program does not crash or get into infinite loops because of numerical errors. A robust algorithm returns consistent results for equivalent inputs and deals with degenerate situations in an expected way. A robust algorithm can still fail, but it fails gracefully, returning results consistent with the global state of the algorithm.

Collision detection code is particularly sensitive to robustness problems due to the numerical and geometrical nature of the algorithms involved. Specifically, solid objects simply must not pass through each other or randomly fall through the ground. Even so, there are still many reasons seemingly random fall-through may occur in practice. This chapter discusses the numerical origins of these problems and means of minimizing or even fully preventing them. Some geometrical sources of robustness problems are also discussed.

11.1 Robustness Problem Types

For the type of computations used in collision detection applications, there are two main categories of robustness problems: those due to *precision inaccuracies* and those due to *degeneracies*. Precision problems are caused by the fact that calculations on a computer are not performed with exact real arithmetic but limited-precision floating-point or integer arithmetic. Degeneracies, in short, are special-case values or conditions occurring during execution the algorithm in question was not designed to handle.

Often algorithms are designed under the assumptions that all computations are performed in exact real arithmetic and that no degeneracies exist in the

data operated on. Unfortunately, in reality these assumptions are wrong. First, computations — performed predominantly using floating-point arithmetic — are not exact, but suffer from, for example, rounding errors. Second, degenerate situations occur all the time, in many cases deliberately by design (for example, collinear points caused by aligning architectural designs to a grid).

The presence of problems from either category can give rise to, for example, conflicting results from different computations, outright incorrect answers, and even algorithms crashing or getting stuck in infinite loops. Numerical imprecision originates from several identifiable sources.

1. *Conversion and representation errors.* Many errors stem from decimal numbers, in general, not being exactly representable as binary numbers, which is the typical radix used in fixed-point or floating-point arithmetic. Irrational numbers, such as $\sqrt{2}$, are not representable in any (integral) number base, further compounding the problem.

2. *Overflow and underflow errors.* Numbers that become too large to be expressed in the given representation give rise to overflow errors (or underflow errors when the numbers are too small). These errors typically occur in multiplying two large (or small) numbers or dividing a large number by a small one (or vice versa).

3. *Round-off errors.* Consider the multiplication operation: in multiplying two real numbers the product $c = ab$ requires higher precision to represent than either a or b themselves. When the exact representation of c requires more than the n bits the representation allows, c must be rounded or truncated to n bits and consequently will be inexact in the last representable digit. Most operations cause round-off errors, not just multiplication.

4. *Digit-cancellation errors.* Cancellation errors occur when nearly equal values are subtracted or when a small value is added or subtracted from a large one.

5. *Input errors.* Errors may also stem from input data. These errors may be modeling errors, measurement errors, or errors due to previous inexact calculations.

Issues that would never arise in working with exact arithmetic must in finite-precision arithmetic be identified and dealt with properly. For example, the computed intersection point of a line with a triangle may actually lie slightly outside the triangle. Similarly, the midpoint of a line segment is unlikely to lie on the supporting line of the segment.

Degeneracies refer to special cases that in some way require special treatment. Degeneracies typically manifest themselves through predicate failures. A *predicate* is an elementary geometric query returning one of a small number of enumerated values. Failures occur when a predicate result is incorrectly computed or when it is not correctly handled by the calling code. In geometrical algorithms, predicates commonly return a result based on the sign of a polynomial expression. In

fact, the determinant predicates given in Chapter 3 are examples of this type of predicate. Consider, for example, the ORIENT2D(A, B, C) predicate. Recall that it returns whether the 2D point C is to the left, to the right, or on the directed line AB. When the three points lie on a line, the smallest errors in position for any one point can throw the result either way. If the predicate is evaluated using floating-point arithmetic, the predicate result is therefore likely completely unreliable. Similar robustness problems occur for all other determinant predicates presented in Chapter 3.

Many algorithms are formulated — explicitly or implicitly — in terms of predicates. When these predicates fail, the algorithm as a whole may fail, returning the wrong result (perhaps an impossible result) or may even get stuck in an infinite loop. Addressing degeneracy problems involves fixing the algorithms to deal gracefully with predicates that may return the incorrect result, adjusting the input so that troublesome cases do not appear or relying on extended or arbitrary precision arithmetic to evaluate the predicate expressions exactly.

To fully understand and ultimately address robustness problems in collision detection algorithms it is important to have a good understanding of the inherent peculiarities and restrictions of limited-precision computer arithmetic. The remainder of this chapter focuses particularly on the floating-point representation of real numbers and some measures that allow for robust usage of floating-point arithmetic.

11.2 Representing Real Numbers

Although there is an infinite number of real numbers, on a computer representations of real numbers must be finite in size. Consequently, a given representation will not be able to represent all real numbers exactly. Those real numbers not directly representable in the computer representation are approximated by the nearest representable number. The real numbers that are exactly expressible are called *machine representable numbers* (or just *machine numbers*).

When talking about computer representations of real numbers it is important to distinguish between the *precision* and the *accuracy* with which a number is given. Precision specifies how many digits (binary, decimal, or otherwise) there are in the representation. Accuracy concerns correctness and is related to how many digits of an approximation are correct. Thus, it is not unreasonable for an inaccurate value to be given precisely. For example, at 10 significant decimal digits, 3.123456789 is quite a precise but very inaccurate approximation (two correct digits) of π (3.14159...).

There are two common computer representations for real numbers: *fixed-point numbers* and *floating-point numbers*. Fixed-point numbers allocate a set number of digits for the integer and the fractional part of the real number. A 32-bit quantity, for example, may hold 16 bits for both the integer and fractional parts (a so-called 16.16 fixed-point number) or hold 8 bits for the integer part and 24 bits for the fractional part (an 8.24 fixed-point number). Given a real number r, the corresponding fixed-point number with n bits of fraction is normally represented as the integer part of $2^n r$.

Figure 11.1 Fixed-point numbers are equally spaced on the number line.

For example, 1/3 can be represented as the 16.16 fixed-point number 21846 ($2^{16}/3$) or the 8.24 fixed-point number 5592405 ($2^{24}/3$). As a consequence, fixed-point numbers are equally spaced on the number line (Figure 11.1). With fixed-point numbers there is a trade-off between the range over which the numbers may span and the precision with which the fractional part may be given. If numbers are known to be in a limited range around zero, fixed-point numbers allow high fractional precision (and thus potentially high accuracy).

In contrast, the decimal point of a floating-point number is not fixed at any given position but is allowed to "float" as needed. The floating of the decimal point is accomplished by expressing numbers in a *normalized* format similar to scientific notation. In scientific notation, decimal numbers are written as a number c (the coefficient), with an absolute value in the range $1 \leq |c| < 10$ multiplied by 10 to some (signed) integer power. For example:

$$8174.12 = 8.17412 \cdot 10^3$$

$$-12.345 = -1.2345 \cdot 10^1$$

$$0.0000724 = 7.24 \cdot 10^{-5}$$

Floating-point representations are generally not decimal but binary. Thus, (nonzero) numbers are instead typically given in the form $\pm(1.f) * 2^e$. Here, f corresponds to a number of fractional bits and e is called the *exponent*. For example, -8.75 would be represented as $-1.00011 * 2^3$. The $1.f$ part is referred to as the *mantissa* or *significand*. The f term alone is sometimes also called the *fraction*. For this format, the number 0 is handled as a special case (as discussed in the next section).

Floating-point values are normalized to derive several benefits. First, each number is guaranteed a unique representation and thus there is no confusion whether 100 should be represented as, say, $10 \cdot 10^1$, $1 \cdot 10^2$, or $0.1 \cdot 10^3$. Second, leading zeroes in a number such as 0.00001 do not have to be represented, giving more precision for small numbers. Third, as the leading bit before the fractional part is always 1, it does not have to be stored, giving an extra bit of mantissa for free.

Unlike fixed-point numbers, for floating-point numbers the density of representable numbers varies with the exponent, as all (normalized) numbers are represented using the same number of mantissa bits. On the number line, the spacing between representable numbers increases the farther away from zero a number is located (Figure 11.2). Specifically, for a binary floating-point representation the

0

Figure 11.2 Floating-point numbers are not evenly spaced on the number line. They are denser around zero (except for a normalization gap immediately surrounding zero) and become more and more sparse the farther from zero they are. The spacing between successive representable numbers doubles for each increase in the exponent.

number range corresponding to the exponent of $k + 1$ has a spacing twice that of the number range corresponding to the exponent of k. Consequently, the density of floating-point numbers is highest around zero. (The exception is a region immediately surrounding zero, where there is a gap. This gap is caused by the normalization fixing the leading bit to 1, in conjunction with the fixed range for the exponent.) As an example, for the IEEE single-precision format described in the next section there are as many numbers between 1.0 and 2.0 as there are between 256.0 and 512.0. There are also many more numbers between 10.0 and 11.0 than between 10000.0 and 10001.0 (1048575 and 1023, respectively).

Compared to fixed-point numbers, floating-point numbers allow a much larger range of values to be represented at the same time good precision is maintained for small near-zero numbers. The larger range makes floating-point numbers more convenient to work with than fixed-point numbers. It is still possible for numbers to become larger than can be expressed with a fixed-size exponent. When the floating-point number becomes too large it is said to have *overflowed*. Similarly, when the number becomes smaller than can be represented with a fixed-size exponent it is said to have *underflowed*. Because a fixed number of bits is always reserved for the exponent, floating-point numbers may be less precise than fixed-point numbers for certain number ranges. Today, with the exception of some handheld game consoles all home computers and game consoles have hardware-supported floating-point arithmetic, with speeds matching and often exceeding that of integer and fixed-point arithmetic.

As will be made clear in the next couple of sections, floating-point arithmetic does not have the same properties as has arithmetic on real numbers, which can be quite surprising to the uninitiated. To fully understand the issues associated with using floating-point arithmetic, it is important to be familiar with the representation and its properties. Today, virtually all platforms adhere (or nearly adhere) to the IEEE-754 floating-point standard, discussed next.

11.2.1 The IEEE-754 Floating-point Formats

The IEEE-754 standard, introduced in 1985, is today the de facto floating-point standard. It specifies two basic *binary* floating-point formats: *single-precision* and *double-precision* floating-point numbers.

Figure 11.3 The IEEE-754 single-precision (top) and double-precision (bottom) floating-point formats.

In the single-precision floating-point format, floating-point numbers are at the binary level 32-bit entities consisting of three parts: 1 sign bit (*S*), 8 bits of exponent (*E*), and 23 bits of fraction (*F*) (as illustrated in Figure 11.3). The leading bit of the mantissa, before the fractional part, is not stored because it is always 1. This bit is therefore referred to as the *hidden* or *implicit* bit. The exponent is also not stored directly as is. To represent both positive and negative exponents, a bias is added to the exponent before it is stored. For single-precision numbers this bias is +127. The stored exponents 0 (all zeroes) and 255 (all ones) are reserved to represent special values (discussed ahead). Therefore, the effective range for *E* becomes $-126 \le E \le 127$. All in all, the value *V* of a stored IEEE-754 single-precision number is therefore

$$V = (-1)^S * (1.F) * 2^{E-127}.$$

The IEEE-754 *double-precision* format is a 64-bit format. It consists of 1 sign bit, 11 bits of exponent, and 52 bits of fraction (Figure 11.3). The exponent is given with a bias of 1023. The value of a stored IEEE-754 double-precision number is therefore

$$V = (-1)^S * (1.F) * 2^{E-1023}.$$

With their 8-bit exponent, IEEE-754 single-precision numbers can represent numbers of absolute value in the range of approximately 10^{-38} to 10^{38}. The 24-bit significand means that these numbers have a precision of six to nine decimal digits. The double-precision format can represent numbers of absolute value between approximately 10^{-308} and 10^{308}, with a precision of 15 to 17 decimal digits. Table 11.1 outlines the representation for a few single-precision floating-point numbers.

Thanks to the bias, floating-point numbers have the useful property that comparing the bit patterns of two positive floating-point numbers as if they were two 32-bit integers will give the same Boolean result as a direct floating-point comparison. Positive floating-point numbers can therefore be correctly sorted on their integer representation. However, when negative floating-point numbers are involved a signed integer

1

Table 11.1 The integer representation (in hex), sign, exponent, and mantissa (in binary) of some IEEE-754 single-precision floating-point numbers.

Number	Bit Pattern	S	Exp	Mantissa (Binary)
0.0f	0x00000000	0	0	(0.)000 0000 0000 0000 0000 0000
0.1f	0x3dcccccd	0	123	(1.)100 1100 1100 1100 1100 1101
0.33333333f	0x3eaaaaab	0	125	(1.)010 1010 1010 1010 1010 1011
1.0f	0x3f800000	0	127	(1.)000 0000 0000 0000 0000 0000
2.0f	0x40000000	0	128	(1.)000 0000 0000 0000 0000 0000
100.0f	0x42c80000	0	133	(1.)100 1000 0000 0000 0000 0000
1000000.0f	0x49742400	0	146	(1.)111 0100 0010 0100 0000 0000
−10.0f	0xc1200000	1	130	(1.)010 0000 0000 0000 0000 0000
machine epsilon (2^{-23})	0x34000000	0	104	(1.)000 0000 0000 0000 0000 0000
smallest positive (2^{-126})	0x00800000	0	1	(1.)000 0000 0000 0000 0000 0000

comparison would order the numbers as follows:

$$-0.0 < -1.0 < -2.0 < \ldots < 0.0 < 1.0 < 2.0 < \ldots$$

If desired, this problem can be overcome by inverting the integer range corresponding to the negative floating-point numbers (by treating the float as an integer in some machine-specific manner) before ordering the numbers and afterward restoring the floating-point values through an inverse process.

Note that the number 0 cannot be directly represented by the expression $V = (-1)^S * (1.F) * 2^{E-127}$. In fact, certain bit strings have been set aside in the representation to correspond to specific values, such as zero. These special values are indicated by the exponent field being 0 or 255. The possible values are determined as described in Table 11.2.

Using the normalized numbers alone, there is a small gap around zero when looking at the possible representable numbers on the number line. To fill this gap, the IEEE standard includes *denormalized* (or *subnormal*) numbers, an extra range of small numbers used to represent values smaller than the smallest possible normalized number (Figure 11.4).

The IEEE standard also defines the special values plus infinity, minus infinity, and not-a-number (+*INF*, −*INF*, and *NaN*, respectively). These values are further discussed in Section 11.2.2. The signed zero (−0) fills a special role to allow, for example, the correct generation of +*INF* or −*INF* when dividing by zero. The signed zero compares equal to 0; that is −0 = +0 is true.

Table 11.2 The values assumed by IEEE-754 single-precision floating-point numbers based on the values of the exponent, fraction, and sign fields.

Exponent	Fraction	Sign	Value
$0 < E < 255$			$V = (-1)^S * (1.F) * 2^{E-127}$
$E = 0$	$F = 0$	$S = 0$	$V = 0$
$E = 0$	$F = 0$	$S = 1$	$V = -0$
$E = 0$	$F \neq 0$		$V = (-1)^S * (0.F) * 2^{-126}$ (denormalized numbers)
$E = 255$	$F = 0$	$S = 0$	$V = +INF$
$E = 255$	$F = 0$	$S = 1$	$V = -INF$
$E = 255$	$F \neq 0$		$V = NaN$ (signaling if top fraction bit is 0, else quiet *NaN*)

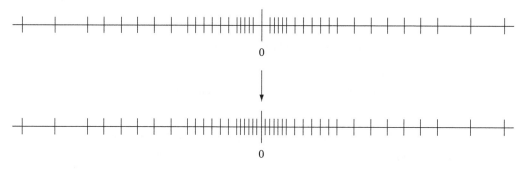

Figure 11.4 Denormalized (or subnormal) floating-point numbers fill in the gap immediately surrounding zero.

An important detail about the introduction and widespread acceptance of the IEEE standard is its strict accuracy requirements of the arithmetic operators. In short, the standard states that the floating-point operations must produce results that are correct in all bits. If the result is not *machine representable* (that is, directly representable in the IEEE format), the result must be correctly rounded (with minimal change in value) with respect to the currently set rounding rule to either of the two machine-representable numbers surrounding the real number.

For rounding to be performed correctly, the standard requires that three extra bits are used during floating-point calculations: two *guard bits* and one *sticky bit*. The two guard bits act as two extra bits of precision, effectively making the mantissa 26 rather than 24 bits. The sticky bit becomes set if one of the omitted bits beyond the guard bits would become nonzero, and is used to help determine the correctly rounded

Table 11.3 Numbers rounded to one decimal digit under the four rounding modes supported by the IEEE-754 standard.

Number	Toward Nearest	Toward −Infinity	Toward +Infinity	Toward Zero
−1.35	−1.4	−1.4	−1.3	−1.3
−1.25	−1.2	−1.3	−1.2	−1.2
1.25	1.2	1.2	1.3	1.2
1.35	1.4	1.3	1.4	1.3

result when the guard bits alone are not sufficient. The three extra bits are used only internally during computations and are not stored.

The standard describes four rounding modes: *round toward nearest* (rounding toward the nearest representable number, breaking ties by rounding to the even number), *round toward negative infinity* (always rounding down), *round toward positive infinity* (always rounding up), and *round toward zero* (truncating, or chopping, the extra bits). Table 11.3 presents examples of the rounding of some numbers under these rounding modes.

The error introduced by rounding is bounded by the value known as the *machine epsilon* (or *unit round-off error*). The machine epsilon is the smallest nonzero machine-representable number that added to 1 does not equal 1. Specifically, if $fl(x)$ denotes the mapping of the real number x to the nearest floating-point representation it can be shown that

$$fl(x) = x(1 + \varepsilon), \quad |\varepsilon| \le u,$$

where u is the machine epsilon. For single precision, machine epsilon is $2^{-23} \approx 1.1921 \cdot 10^{-7}$, and for double precision $2^{-52} \approx 2.2204 \cdot 10^{-16}$. These values are in C and C++ defined as the constants **FLT_EPSILON** and **DBL_EPSILON**, respectively. They can be found in **<float.h>** for C and in **<climits>** for C++. The machine epsilon can be used to estimate errors in floating-point calculations.

An in-depth presentation of floating-point numbers and related issues is given in [Goldberg91]. In the following, floating-point numbers are assumed IEEE-754 single-precision numbers unless otherwise noted.

11.2.2 Infinity Arithmetic

In addition to allowing representation of real numbers, the IEEE-754 standard also introduces the quasi-numbers *negative infinity*, *positive infinity*, and *NaN*

(*not-a-number*, sometimes also referred to as *indeterminate* or *indefinite*). Arithmetic on this extended domain is referred to as *infinity arithmetic*. Infinity arithmetic is noteworthy in that its use often obviates the need to test for and handle special-case exceptions such as division-by-zero errors. Relying on infinity arithmetic does, however, mean paying careful attention to details and making sure the code does exactly the right thing in every case.

Positive (+*INF*, or just *INF*) and negative (−*INF*) infinity originate either from a calculation overflow or as a result of an expression limit. Overflow is generated when a finite result is produced that is larger than the maximum number representable. For example, overflow can be generated by dividing a very large number by a very small number:

```
float a = 1.0e20;
float b = 1.0e-20;
float c = a / b; // gives c = +INF
float d = -a / b; // gives d = -INF
```

For an expression such as 1/0, the result can be made arbitrarily large by choosing a corresponding small (positive) number as the denominator. As the expression tends to infinity as the denominator tends to zero, the expression result is taken to be the limit *INF*. Similarly, 1/*INF* is zero, as the result can be made arbitrarily close to zero by choosing a sufficiently large value for the denominator. In some cases, such as for 0/0, no limit exists. In these cases, the result is indeterminate (*NaN*):

```
float a = 0.0f;
float b = a / a;  // gives b = NaN (and _not_ 1.0f)
```

NaN is also the result of operations such as $\sqrt{-1}$, (*INF* − *INF*), and 0 · *INF*. (There are in fact several distinct *NaN* codes returned for these different operations, but this is irrelevant to the discussion here.)

For comparisons, four mutually exclusive relations between IEEE-754 values are possible: less than, equal to, greater than, and unordered. For any pair of values exactly one of these relations is true. Both *INF* and −*INF* behave as expected with respect to comparison operations, and thus for instance *INF* = *INF*, −*INF* = −*INF*, −*INF* < *INF*, −*INF* < 0, and 0 < *INF* all evaluate to true. *NaN*, however, is considered unordered, which means that all comparisons involving *NaN* evaluate to false except for *NaN* ≠ *NaN* (which is true). For arithmetic operations, if one or both operands are *NaN* the result will also be *NaN*.

The introduction of *NaN*s is tricky in the sense that it leads to a trichotomy problem. Previously it could be assumed that (exactly) one of $a < b$, $a = b$, or $a > b$ was true.

However, the assumption that $a > b$ implies $\neg(a \leq b)$ does not hold for *NaNs*. Using infinity arithmetic, the statement

```
if (a > b) x; else y;
```

is *not* equivalent to

```
if (a <= b) y; else x;
```

NaNs can therefore slip through range checks of the type illustrated in the following code.

```
// Test if val is in the range [min..max]
int NumberInRange(float val, float min, float max)
{
    if (val < min || val > max) return 0;
    // Here val assumed to be in [min..max] range, but could actually be NaN
    ...
    return 1;
}
```

The safe way of writing this test is as follows.

```
// Test if val is in the range [min..max]
int NumberInRange(float val, float min, float max)
{
    if (val >= min && val <= max) {
        // Here val guaranteed to be in [min..max] range (and not be NaN)
        ...
        return 1;
    } else return 0;
}
```

As an example of how a division-by-zero check can be avoided through infinity arithmetic, consider the problem of intersecting a segment S with a plane P, as discussed in Section 5.3.1. Let P be given by $(\mathbf{n} \cdot X) = d$ and S by the parametric equation $S(t) = A + t(B - A)$ for $0 \leq t \leq 1$. The t value for intersection of the segment with the plane is given by

$$t = (d - \mathbf{n} \cdot A)/(\mathbf{n} \cdot (B - A)),$$

which when substituted for t in $S(t)$ gives the intersection point Q as

$$Q = A + [(d - \mathbf{n} \cdot A)/(\mathbf{n} \cdot (B - A))](B - A).$$

If the segment is parallel to the plane, the division denominator will be zero. Under IEEE-754 arithmetic, for a nonzero x, $x/0$ gives *INF* or $-INF$ (depending on the sign of x). If x is zero, the result is *NaN* instead. In all of these cases, the code should correctly return nonintersection as the result. This can be accomplished by making sure the test for t being in the range [0, 1] is performed correctly, as illustrated by the following code.

```
// Test if segment AB intersects plane p. If so, return 1, along with
// the intersection t value and the intersection point Q. If not, return 0
int IntersectSegmentPlane(Point a, Point b, Plane p, float &t, Point &q)
{
    // Compute t value at which the directed line ab intersects the plane
    Vector ab = b - a;
    t = (p.d - Dot(p.n, a)) / Dot(p.n, ab);
    // If t in [0..1] compute and return intersection point
    if (t >= 0.0f && t <= 1.0f) {
        q = a + t * ab;
        return 1;
    }
    // Else t is +INF, -INF, NaN, or not in [0..1], so no intersection
    return 0;
}
```

Under the IEEE-754 standard, *INF* and *NaN* exceptions are further supported by the concept of "sticky" exception flag bits. These global flags are set whenever an exception occurs, and remain set until cleared. They allow for implementing robust code by first performing a quick-and-dirty solution that does not test for overflows, division-by-zero errors, and so on. If after the computation no sticky bits are set, the result can be used as is. However, if one or more exceptions occurred with corresponding sticky bits set then a slower but more robust version of the code is called. Not all compilers and not all machines are fully compliant with respect to the IEEE rules of infinity arithmetic, and thus it is important to verify the correct behavior before relying on these features in an implementation.

11.2.3 Floating-point Error Sources

Although well defined, floating-point representations and arithmetic are inherently inexact. A first source of error is that certain numbers are not exactly representable in

some number bases. For example, in base 10, 1/3 is not exactly representable in a fixed number of digits; unlike, say, 0.1. However, in a binary floating-point representation 0.1 is no longer exactly representable but is instead given by the repeating fraction $(0.0001100110011\ldots)_2$. When this number is normalized and rounded off to 24 bits (including the one bit that is not stored) the mantissa bit pattern ends in $\ldots 11001101$, where the last least significant bit has been rounded up. The IEEE single-precision representation of 0.1 is therefore slightly larger than 0.1. As virtually all current CPUs use binary floating-point systems, the following code is thus extremely likely to print "Greater than" rather than anything else.

```
float tenth = 0.1f;
if (tenth * 10.0f > 1.0f)
    printf("Greater than\n");
else if (tenth * 10.0f < 1.0f)
    printf("Less than\n");
else if (tenth * 10.0f == 1.0f)
    printf("Equal\n");
else
    printf("Huh?\n");
```

That some numbers are not exactly representable also means that whereas replacing **x/2.0f** with **x*0.5f** is exact (as both 2.0 and 0.5 are exactly representable) replacing **x/10.0f** with **x*0.1f** is not. As multiplications are generally faster than divisions (up to about a magnitude, but the gap is closing on current architectures), the latter replacement is still frequently and deliberately performed for reasons of efficiency.

It is important to realize that floating-point arithmetic does not obey ordinary arithmetic rules. For example, round-off errors may cause a small but nonzero value added to or subtracted from a large value to have no effect. Therefore, mathematically equivalent expressions can produce completely different results when evaluated using floating-point arithmetic.

Consider the expression **1.5e3 + 4.5e-6**. In real arithmetic, this expression corresponds to $1500.0 + 0.0000045$, which equals 1500.0000045. Because single-precision floats can hold only about seven decimal digits, the result is truncated to 1500.0 and digits are lost. Thus, in floating-point arithmetic **a + b** can equal **a** even though **b** is nonzero and both **a** and **b** can be expressed exactly!

A consequence of the presence of truncation errors is that floating-point arithmetic is not associative. In other words, **(a + b) + c** is not necessarily the same as **a + (b + c)**. Consider the following three values of **a**, **b**, and **c**.

```
float a = 9876543.0f;
float b = -9876547.0f;
float c = 3.45f;
```

Inserting the values into the expressions gives

```
(a + b) + c = (9876543.0f + -9876547.0f) + 3.45f = -4.0f + 3.45f = -0.55f
a + (b + c) = 9876543.0f + (-9876547.0f + 3.45f) = 9876543.0f + -9876544.0f = -1.0f
```

illustrating the difference between the two expressions.

As a corollary, note that a compiler will not (or should not) turn **x + 2.0f + 0.5f** into **x + 2.5f**, as this could give a completely different result. The compiler will be able to fold floating-point constants only from the left for left-associative operators (which most operators are). That is, turning **2.0f + 0.5f + x** into **2.5f + x** at compile time is sound. A good coding rule is to place floating-point constants to the left of any variables (that is, unless something else specific is intended with the operation).

Repeated rounding errors cause numbers slowly to erode from the right, from the least significant digits. This leads to loss of precision, which can be a serious problem. Even worse is the problem of *cancellation*, which can lead to significant digits being lost at the front (left) of a number. This loss is usually the result of a single operation: the subtraction of two subexpressions nearly equal in value (or, equivalently, the addition of two numbers of near equal magnitude but of opposite sign).

As an example, consider computing the discriminator $b^2 - 4ac$ of a quadratic equation for $b = 3.456$, $a = 1.727$, and $c = 1.729$. The exact answer is $4 \cdot 10^{-6}$, but single-precision evaluation gives the result as $4.82387 \cdot 10^{-6}$, of which only the first single digit is correct! When, as here, errors become significant due to cancellation, the cancellation is referred to as *catastrophic*. Cancellation does not have to be catastrophic, however. For example, consider the subtraction $1.875 - 1.625 = 0.25$. Expressed in binary it reads $1.111 - 1.101 = 0.010$. Although significant digits have been lost in the subtraction, this time it is not a problem because all three quantities are exactly representable. In this case, the cancellation is *benign*.

In all, extreme care must be taken when working with floating-point arithmetic. Even something as seemingly simple as selecting between the two expressions $a(b-c)$ and $ab - ac$ is deceptively difficult. If b and c are close in magnitude, the first expression exhibits a cancellation problem. The second expression also has a cancellation problem when ab and ac are near equal. When $|a| > 1$, the difference between ab and ac increases more (compared to that between b and c) and the cancellation problem of the second expression is reduced. However, when $|a| < 1$ the terms ab and ac become smaller, amplifying the cancellation error, while at the same time the cancellation error in the first expression is scaled down. Selecting the best expression is therefore contingent on knowledge about the values taken by the involved variables. (Other factors should also be considered, such as overflow and underflow errors.)

In many cases rewriting an expression can help avoid a cancellation error. For example, the function

$$f(x) = 1 - \cos(x)$$

suffers from cancellation errors when x is near zero. By rewriting the function as

$$f(x) = 2\sin^2(x/2), \quad \text{or} \quad f(x) = \frac{\sin^2(x)}{1 + \cos x}$$

this problem is avoided. Similarly, the function

$$g(x) = \sqrt{x+1} - \sqrt{x}$$

has a cancellation error for large x. This error is removed by rewriting the function as

$$g(x) = \frac{1}{\sqrt{x+1} + \sqrt{x}}.$$

Many practical examples of avoiding errors in finite-precision calculations are provided in [Acton96].

11.3 **Robust Floating-point Usage**

Despite some apparent shortcomings, floating-point arithmetic often remains the most convenient number representation for real-time applications such as collision detection. With some care, the floating-point use in these applications frequently can be made robust. The most important tool for accomplishing this task is the use of tolerances. The following sections look at how tolerances are used with floating-point numbers and, as examples, discusses how simple intersection tests of lines against planes and triangles are made robust using tolerances. Another important device is to ensure consistency between related calculations by properly sharing common subexpressions between the calculations. This approach is again exemplified in terms of the intersection between lines and triangles.

11.3.1 **Tolerance Comparisons for Floating-point Values**

Working with floating-point arithmetic, it is important to be aware of the fact that direct comparisons of floating-point values are almost always the wrong thing to do, due to the accumulation of rounding and cancellation errors. For example, a test such as

```
if (x == 0.0f) ...
```

is likely to fail due to accumulated errors in x, making it perhaps very close to but never quite equal to zero. A better approach in this case is to use a tolerance and consider x zero when within some small range of values centered on zero. This is done by writing the test as

```
if (Abs(x) <= epsilon) ...
```

where *epsilon* is a small value chosen to match the desired tolerance. This epsilon could be as small as, say, 10^{-6}, but could also be upward of 0.1 or larger, all depending on the range for x and the computations performed. Comparing x against an arbitrary value y turns the test into its generalized form:

```
if (Abs(x - y) <= epsilon) ... // Absolute tolerance comparison
```

This described use of an epsilon tolerance value to compare two floating-point values for equality is referred to as *absolute tolerance*, as the epsilon value is fixed. The drawback with an absolute tolerance test is that it is difficult to find relevant epsilon values. The epsilon value depends on the range of values for the input data and on the floating-point format used. It is not possible to pick one epsilon value for the entire range of floating-point numbers. For very small (nonequal) values of x and y their difference may always be smaller, and for large values larger, than the epsilon value. Another way of looking at it is that as the tested numbers grow larger the absolute test requires that more and more digits agree. When the numbers are sufficiently larger than the fixed epsilon, the test will always fail unless the numbers are exactly equal, which is usually not intended. An absolute tolerance should therefore only be used when the orders of magnitude of the numbers are known in advance and the tolerance value can be set accordingly.

An alternative solution is to use a *relative tolerance*. Here, the basic idea is to divide the one number by the other and see how close the result is to 1. Assuming $|x| \leq |y|$, the test becomes

```
if (Abs(x / y - 1.0f) <= epsilon) ...
```

This expression can be written as

```
if (Abs((x - y) / y) <= epsilon) ...
```

To avoid the costly division operation and to guard against division-by-zero errors, multiplying by **Abs(y)** on both sides of the latter expression simplifies it to

```
if (Abs(x - y) <= epsilon * Abs(y)) ...
```

Removing the assumption of $|x| \le |y|$ turns the expression into its final form:

```
if (Abs(x - y) <= epsilon * Max(Abs(x), Abs(y))) ... // Relative tolerance comparison
```

Note that it is important for the comparison for the relative test to be less-equal and not less-than. Otherwise, the test fails when both numbers are exactly zero.

The relative test is also not without problems. Note that the test expression behaves as desired when **Abs(x)** and **Abs(y)** are greater than 1, but when they are less than 1 the effective epsilon is made smaller, and the smaller the numbers get the more digits of them are required to agree. A solution to the problems of both tests is therefore to combine the two tests, using the relative test when the magnitudes of the numbers are greater than 1 and the absolute test when they are smaller than 1:

```
if (Abs(x - y) <= epsilon * Max(Abs(x), Abs(y), 1.0f)) ... // Combined comparison
```

This expression can be expensive to compute if **Max()** is not available as a machine instruction. An approximate expression that is cheaper to compute is

```
if (Abs(x - y) <= epsilon * (Abs(x) + Abs(y) + 1.0f)) ... // Combined comparison
```

Because the relative tests are more complex than the absolute tolerance test, an absolute tolerance test is typically preferred whenever applicable.

The value of epsilon is often taken to be some small multiple of the machine epsilon. By setting epsilon to the square root of the machine epsilon, the numbers are required to agree to roughly half the number of positions available in the given machine representation.

Although the use of tolerances is often frowned upon in theoretical computational geometry papers, in which it is somewhat derogatorily referred to as "epsilon tweaking" and a "programming trick," it largely remains the only feasible practical approach to robustness for floating-point arithmetic in real-time applications. For collision detection applications, using tolerances works well in practice. With large enough tolerance values, error buildup can be ignored. However, using tolerances does assume an active understanding of the problems involved and is far from an automatic process. A good presentation of tolerances is given in [Knuth97].

It is worth noting that in using tolerances equality is no longer a transitive property. Thus, with A equaling B and B equaling C, under a tolerance comparison this no longer implies that A equals C. Without the transitive property, sorting (for example) breaks down and may give different results based on the order in which elements are given. When working with tolerances, it is therefore possible for inconsistencies to arise. Robust code must consider and deal with such inconsistencies.

11.3.2 **Robustness Through Thick Planes**

To illustrate the problems that may occur due to most real numbers not being exactly representable as floating-point numbers, consider computing the intersection point of two line segments *AB* and *CD*, as shown in Figure 11.5. The grid points correspond to machine-representable numbers. Because the exact intersection point *P* does not lie on the grid, it is snapped to some neighboring grid point *Q*, according to the active rounding rule. Imagine *CD* constitutes a 2D world boundary and *AB* the directed movement of a point object. Placing the point at position *Q* effectively moves it outside the world, likely causing the point to fall out of the world, not detecting any more collisions on future movements.

In 3D, a similar problem situation occurs when, for example, intersecting a segment *AB* against a plane *P*. Due to floating-point errors, the computed intersection point is unlikely to lie on either *AB* or *P*. Instead, it lies somewhere in the immediate vicinity of both, as illustrated in Figure 11.6a. Because the intersection point ends up behind the plane roughly half the time, a point object moving from *A* to *B* is again very likely to end up falling out of the world.

An effective way of dealing with the problem of intersection points not lying on the plane is to introduce a tolerance, treating the plane as having *thickness*. Let the maximum distance a computed intersection point can deviate from *P* be denoted by *e*. Then if the plane is treated as having a radius of r, $r > e$, the intersection point — wherever it is — must lie on this thick plane and fall-through is avoided (Figure 11.6b). Determining how large *e* can be, so that an appropriate *r* can be chosen, is not trivial and depends on many application-specific factors. A pragmatic solution is to determine *r* empirically by testing intersection points against the thick plane and increasing *r* until all intersection points (over the full range of input values) correctly classify as lying on the thick plane.

Introducing thick planes also helps increase the accuracy of the intersection point between the segment and the plane. If the segment is nearly perpendicular to the

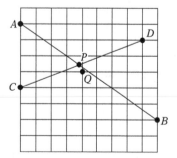

Figure 11.5 The intersection point *P* between two segments *AB* and *CD* is rarely exactly representable using floating-point numbers. It is approximated by snapping to a nearby machine-representable point *Q*.

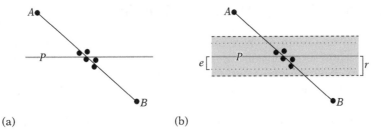

(a) (b)

Figure 11.6 (a) After accounting for errors and rounding to machine-representable numbers, the computed intersection point of the segment AB and the plane P is unlikely to lie on either line or plane. Instead, the point could lie in, say, any of the indicated positions. (b) By treating the plane as having a thickness, defined by a radius r, the point is guaranteed to be on the plane as long as $r > e$, where e is the maximum distance by which the intersection point can be shown to deviate from P.

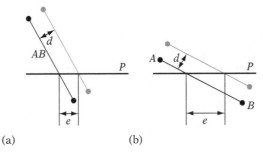

(a) (b)

Figure 11.7 (a) Let AB be a segment nearly perpendicular to a plane P. When AB is displaced by a small distance d, the error distance e between the two intersection points is small. (b) As the segment becomes more parallel to the plane, the error distance e grows larger for the same displacement d.

plane, a small displacement d in the position of the segment will correspond to a similar size displacement e of the intersection point (Figure 11.7a). However, as the segment becomes increasingly parallel to the plane the same displacement of the segment causes the error in the intersection point to grow disproportionately (Figure 11.7b). Assuming there is a fixed upper bound for the length of the segment (which holds for most practical applications), having a thick plane means that there is also a bound on how parallel to the plane the segment can become before actually lying in the plane. Because no intersection computation is required once the segment lies in the plane, the thick plane consequently enforces a limit on the displacement error for the intersection point. Thick planes allow, for example, the clipping of polygons to a plane to be performed robustly, as discussed in Sections 8.3.3 and 8.3.4.

11.3.3 **Robustness Through Sharing of Calculations**

To illustrate how failure to share calculations across related computations can cause robustness problems, consider a commonly suggested method of detecting intersection between a line (or segment) L and a triangle T. The test begins with computing the intersection point P between L and the supporting plane of T. Once P is obtained, it is tested for containment in T, for example by testing if P lies on the same side of all triangle edges when considered counterclockwise. (For efficiency, the point containment step is often performed by projecting T and P to the principal plane where T has the largest area. An inexpensive 2D point-triangle test then suffices for determining containment. This step is ignored here, as it does not affect the robustness problem discussed.)

Unfortunately, implemented using floating-point arithmetic this test is not robust. To illustrate the problem, consider the intersection of a line L against two triangles ABC and ADB (Figure 11.8). π_1 and π_2 are the supporting planes of ABC and ADB, respectively. Let L pass infinitesimally to the left of the middle of edge AB. Because edge AB is shared between the triangles, in real arithmetic L would intersect triangle ABC and not triangle ADB. However, using the previous intersection test inaccuracies caused by floating-point arithmetic may have that *neither* triangle is intersected by L. To see why, consider first the intersection of L with π_1, resulting in an intersection point P_1. However, floating-point errors may cause P_1 to lie slightly to the right of the edge AB and therefore outside triangle ABC. This case is shown (exaggerated) in Figure 11.9a. Next L is intersected against plane π_2, intersecting in some point P_2. Because π_1 and π_2 are different planes, represented by different plane equations whose components are subject to floating-point inaccuracies, P_1 and P_2 are highly

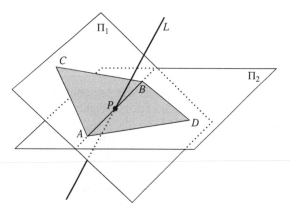

Figure 11.8 The line L is intersected against triangles ABC and ADB. Because L is passing through the edge AB common to both triangles, the intersection test is susceptible to inaccuracies due to floating-point errors. A **poorly** implemented test **may** fail to detect intersection with both triangles.

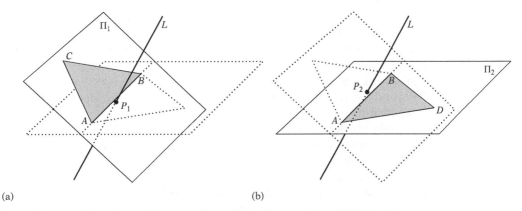

Figure 11.9 Floating-point inaccuracies may have (a) the intersection point P_1 between L and plane π_1 lie outside triangle ABC and (b) the intersection point P_2 between L and π_2 lie outside triangle ADB. Thus, **any** test based on first computing the intersection point with the plane of a triangle and then testing the point for containment in the triangle is **inherently** nonrobust.

unlikely to be the same point. It is therefore quite possible for P_2 to lie to the left of AB and thus outside triangle ADB (Figure 11.9b). Consequently, the test may fail to detect intersection against both triangles, even though real arithmetic guarantees an intersection.

There are two main reasons for the test failing.

1. *Information is discarded.* Precision is lost as P_1 and P_2 are computed and expressed in machine-representable numbers. The discarded information makes the triangle containment test unreliable.

2. *Information is not shared between successive, related tests.* P_1 and P_2 should be the same point P, but are not, as two subtly different calculations are used for computing the intersection point. Decisions that should be consistent between the tests — such as whether P lies to the left or right of AB — therefore will not be.

One robust method of intersecting a line against a triangle is the test presented in Section 5.3.4, based on computing scalar triple products to determine if L lies inside all edges of the triangle. Assuming L passes through points P and Q, the sign of the scalar triple product $[PQ\ PB\ PA]$ indicates on which side of edge AB the line L lies.

Floating-point errors can change the sign of the scalar triple product when it is near zero. However, because the same expression is computed for both triangles when testing L against AB, the sign test must indicate that L intersects either of the triangles. In other words, the shared calculation guarantees that L intersects one of the triangles even though it may not strictly be the same triangle given by

exact arithmetic. Because the line can no longer pass between the triangles in the presence of floating-point errors, the test is now robust.

It is important that the shared calculation be performed exactly the same from one triangle to the next. That is, the edge *AB* cannot also be treated as the edge *BA* in the neighboring triangle. Otherwise, the tested scalar triple products would involve [*PQ PB PA*] and [*PQ PA PB*], which although identical in reals are not identical under floating-point arithmetic.

For indexed vertices, treating shared edges as the same directed segments is easily done by ordering the edge vertices on their indices. Nonindexed vertices are ordered by listing the vertex with the smaller x component (then y, then z component) before the other vertex (lexicographical ordering).

Only after *L* has been determined to intersect one of the triangles is the intersection point *P* with the plane of that triangle computed. It is important to note that this point may lie outside the triangle. Any subsequent processing of the point must take this into account, which is nontrivial in itself. A solution that circumvents both problems is to forego line and segment tests completely and instead use fat objects for testing. This approach is discussed next.

11.3.4 Robustness of Fat Objects

As indicated in the previous, tests involving the intersection of lines and segments are extra sensitive to floating-point issues. Points have similar problems. One solution to the robustness problems with points, lines, and segments is to avoid them altogether and instead only rely on tests involving *fat* objects. For this discussion, an object is considered fat if it has a radius of at least *r* over all directions. For points, lines, and segments their fat counterparts are spheres, (infinite) cylinders, and capsules.

As shown in the previous section, subtle errors may cause a line to pass between the shared edge of two triangles even though the triangles correctly share the end vertices of this edge. However, by turning the line into a cylinder or capsule even an outright gap between the two triangles can be accommodated as long as the capsule radius *r* is greater than *e*/2, where *e* is the width of the largest gap in the geometry. In practice, *r* is much greater than *e*, dwarfing all errors due to floating-point arithmetic, making fat tests extremely robust. Figure 11.10 illustrates the difference between these two types of tests. A drawback with fat tests is that they are generally much more expensive than their "thin" counterparts, in that they effectively amount to a distance calculation rather than just an intersection test.

11.4 Interval Arithmetic

One way of tracking the error bounds of floating-point calculations is to perform the calculations using *interval arithmetic* (*interval analysis*) [Moore66]. In interval

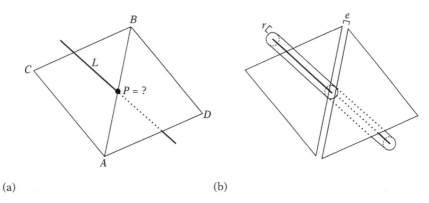

(a) (b)

Figure 11.10 (a) As seen in Section 11.3.3, floating-point errors can have line L pass between triangles ABC and ADB without intersecting either. (b) By testing using fat objects, such as a capsule, even outright gaps in the **geometry** can be accommodated as long as the radius r of the fat object is greater than $e/2$, where e is the width of the widest gap.

arithmetic, tolerance is built into the computations themselves by specifying each value as a range $[a, b]$ of possible values, symbolizing some value x such that $a \le x \le b$. Special operators are defined in order to perform arithmetic on these interval values, producing new interval values as results. Some common operators are defined as follows:

$$[a, b] + [c, d] = [a + c, b + d]$$

$$[a, b] - [c, d] = [a - d, b - c]$$

$$[a, b] * [c, d] = [\min(ac, ad, bc, bd), \max(ac, ad, bc, bd)]$$

$$[a, b]/[c, d] = [a, b] * [1/d, 1/c] \quad \text{for} \quad 0 \notin [c, d]$$

$$[a, b]^2 = \begin{cases} [0, \max(a^2, b^2)] & \text{if } 0 \in [a, b] \\ [\min(a^2, b^2), \max(a^2, b^2)] & \text{otherwise} \end{cases}$$

Unlike regular floating-point arithmetic, interval arithmetic provides bounds on rounding errors, and an interval arithmetic computation essentially amounts to a mathematical proof that the true value of an expression lies within the computed bounds. These bounds can then be compared against those of other entities in order to, for example, say with certainty that two objects are not intersecting if the bounds are distinct.

The next section presents a few simple examples of interval arithmetic. The section thereafter explores how interval arithmetic applies to collision detection problems.

11.4.1 **Interval Arithmetic Examples**

As an example of an interval arithmetic computation, consider the evaluation of $x(6 - x)$ for $x = [1, 3]$:

$$x(6 - x) = [1, 3]([6, 6] - [1, 3]) = [1, 3][3, 5] = [3, 15].$$

In this case, the true range of the expression for the given value of x is $[5, 9]$, which is contained in the interval $[3, 15]$ (as it must be). This example also illustrates the main weakness with interval arithmetic: the resulting intervals are often much larger than necessary. In complex nested expressions, this "error explosion" can quickly cause intervals to become unusable. The problem, known as the *dependency problem*, is that each time a variable occurs in an expression it is treated as a new variable, independent from earlier occurrences. However, in the earlier example the subexpressions to the multiplication, x and $6 - x$, are both dependent on x. The multiplication has no knowledge of this fact and thus the computation suffers from an unnecessary widening of the resulting interval. For this reason, if a variable occurs more than once in an expression the computed result may not tightly bound the true value range of the expression.

In many cases, it is possible to avoid, or at least limit, the dependency problem by rearranging an expression to eliminate dependencies. For example, for $x = [3.0, 3.1]$ the expression

$$f(x) = x/(x - 1),$$

evaluates as $f([3.0, 3.1]) = [3.0, 3.1]/[2.0, 2.1] = [1.4, 1.6]$. The equivalent expression

$$f(x) = 1 + 1/(x - 1),$$

in which x only occurs once, evaluates as $f([3.0, 3.1]) = 1 + 1/[2.0, 2.1] = 1 + [0.476, 0.5] = [1.476, 1.5]$, which is a tight bound. Similarly, the expressions

$$g(x, y) = \frac{x + y}{x - y} \quad \text{and} \quad h(x, y) = \frac{xy}{x + y}$$

can be tightly written as

$$g(x, y) = 1 - \frac{2}{1 - x/y} \quad \text{and} \quad h(x, y) = \frac{1}{1/x - 1/y}.$$

In addition, squaring a number using the special operator x^2 is tight, whereas using $x * x$ is not. Of course, rewriting an expression to remove multiple occurrences of a variable can introduce other problems, such as susceptibility to cancellation errors (which is not further addressed here). Overall, it is best to avoid long computation chains because they tend to exaggerate the dependency problem.

At some computational cost, tighter intervals can be obtained by splitting the input intervals into subintervals, evaluating the function for all subintervals and then taking the union of the partial results as the final function result. (The idea of splitting into subintervals is also used in the *interval Newton method*, a powerful method for robustly finding the roots of a function over a given interval [Hansen92].) As an example of how splitting into subintervals may give tighter bounds, consider again the evaluation of $x(6 - x)$, now for the two subintervals $x = [1, 2]$ and $x = [2, 3]$. The former interval gives

$$x(6 - x) = [1, 2]([6, 6] - [1, 2]) = [1, 2][4, 5] = [4, 10],$$

and the latter gives

$$x(6 - x) = [2, 3]([6, 6] - [2, 3]) = [2, 3][3, 4] = [6, 12].$$

The union of these two intervals is $[4, 12]$, tighter than the $[3, 15]$ bound obtained for $x = [1, 3]$.

The computer implementation of interval arithmetic using floating-point arithmetic is straightforward. Intervals are represented as pairs of values and operations take pairs as arguments and produce pairs as a result. The only caveat is that it is important to round the interval bounds of all results outward to maintain the correct answer within the bounds, in that the interval endpoints may not be machine representable. This additional rounding, coupled with the fact that two numbers rather than one are stored and operated on, makes software-implemented interval arithmetic operations up to a magnitude slower than corresponding native floating-point operations. However, interval arithmetic is parallelizable, and therefore amenable to SIMD optimizations.

The implementation of interval arithmetic operations in IEEE-754 floating-point arithmetic is covered in [Walster98] and [Hickey01]. Robust rounding of interval arithmetic operations is discussed in [Abrams98].

11.4.2 **Interval Arithmetic in Collision Detection**

Interval arithmetic has practical applications in collision detection. For example, consider the problem of detecting intersection between an implicit surface S and

an AABB. Let $f(x, y, z) = 0$ be the implicit function defining the surface. Now evaluate f using interval arithmetic for the AABB intervals for x, y, and z. Let $[r_1, r_2] = f([x_1, x_2], [y_1, y_2], [z_1, z_2])$ denote the interval resulting from this evaluation. Because all points outside S have $f(x, y, z) > 0$, if $r_1 > 0$, the conclusion is that the AABB and S cannot possibly be intersecting. If the bound has been tightly computed it is also possible to conclude that the AABB is intersecting the boundary of S if $r_1 \leq 0 \leq r_2$, and lies fully inside S if $r_2 < 0$. More concretely, consider the intersection of B, an AABB defined by the minimum and maximum points (a_x, a_y, a_z) and (b_x, b_y, b_z) against a sphere S given by the center point (c_x, c_y, c_z) and the radius r. The function $f(x, y, z)$ then becomes

$$f(x, y, z) = (x - [c_x, c_x])^2 + (y - [c_y, c_y])^2 + (z - [c_z, c_z])^2 - [r, r]^2.$$

Finally, compute $[r_1, r_2] = f([a_x, b_x], [a_y, b_y], [a_z, b_z])$. Because $[a_x, b_x]$, $[a_y, b_y]$, and $[a_z, b_z]$ only occur once, the computed bound will be tight if the n^2 terms are implemented optimally (that is, not as $n * n$). Thus, B lies outside S if $r_1 > 0$, intersects the boundary of S if $r_1 \leq 0 \leq r_2$, and lies fully inside S if $r_2 < 0$. For additional uses of interval arithmetic in collision detection, see [Mitchell90], [Duff92], [Snyder93], and [Redon02].

11.5 **Exact and Semi-exact Computation**

Although floating-point numbers are convenient to work with, they are quite susceptible to rounding problems, as has been illustrated. To avoid these problems, an alternative is to forego floating-point and instead work with *exact arithmetic*. Arithmetic is exact if all bits of all values are retained throughout all calculations, thus effectively avoiding robustness problems and facilitating exact decisions. However, for arbitrary computations to be exact the arithmetic must be performed with arbitrary precision. At best, the solution is to use an arbitrary-precision arithmetic library, but these are too slow for real-time use.

Fortunately, it turns out that arbitrary precision is not necessary. In many cases, computations are performed only to ultimately partake in the evaluation of Boolean expressions, or *predicates*. Examples of such predicates include the ORIENT2D(), ORIENT3D(), INCIRCLE2D(), and INSPHERE() determinant expressions of Section 3.1.6. Because the expression of a predicate is of fixed complexity, it is possible to set a limit on how many bits are required to evaluate the entire expression exactly. Thus, the involved arithmetic only needs extended (but nor arbitrary) precision, often no more than 64 or 128 bits of precision. For certain algorithms, use of exact predicates is all that is needed. For example, convex hulls can be computed exactly using exact ORIENT2D() and ORIENT3D() predicates. Evaluating predicates exactly using extended precision arithmetic has been

well studied in the field of computational geometry and a few reasonably efficient implementations have been presented, including those of [Priest91], [Fortune93], and [Shewchuk96a].

However, some applications rely on more than exact predicates. In particular, collision detection applications typically require that intersection points be computed, perhaps as a result of the intersection of a line segment and a plane. Representing such an intersection point generally requires higher precision than that needed for the endpoints of the segment or the plane equation coefficients. Further computations with the intersection point will require still higher precision in subsequent intersection calculations, and so on. To avoid requiring unbounded precision and to make the computation feasible for a real-time application, it is clear that the intersection point must be truncated or rounded in some fashion. Once this rounding takes place, however, the computation is no longer exact!

The first of the following two sections discusses some of the issues involved in performing exact computations using integers. The next section presents the scenario in which a segment is intersected against a plane, and discusses how to deal with the problem of truncating the intersection point to integer coordinates.

11.5.1 Exact Arithmetic Using Integers

As long as overflow does not take place, integer calculations using addition, subtraction, and multiplication are exact (division must be handled separately, as discussed later). These three integer operations are also associative, unlike their floating-point counterparts. Therefore, no special considerations are necessary to ensure, for example, that shared edges are always treated as the same directed line segment in intersection tests.

To avoid overflow, sufficient precision must be present in the integer type to which the result of an operation is assigned. For addition and subtraction of two n-bit numbers, representing the result requires $n + 1$ bits of precision, in general. The multiplication of two n-bit numbers produces a result of $2n$ bits. For example, consider exactly computing the dot product between two 3D vectors on a target CPU for which the widest integer arithmetic supported is 64-bits. For the dot product result to stay within 64 bits, the three products inside the dot product cannot exceed 62 bits, or adding them up could cause an overflow. For the products not to exceed 62 bits, the product terms cannot exceed 31 bits. Therefore, a 64-bit dot product will at most support 31-bit vector components as input. If two dot products are added as part of an expression, an additional bit disappears and the vector components can now at most be 30 bits wide, without risking overflow. Similar reasoning applies to other expressions.

Unless explicitly tested for, overflow will go undetected. A straightforward way of detecting overflow is to cast the operands to a larger integer type, perform the operation, and compare the result with the result in the lower precision. If they are

different, overflow occurred. (With some care, single- or double-precision floats could also be used to test for integer operation overflows.) If the type is already the largest supported native integer type, this will not work, however. As an illustration of how overflow can be tested for without going to a larger integer type, consider the addition of unsigned integers a and b. The overflow of $c = a + b$ can be detected by testing the input arguments in the manner

```
bool overflow = (a > ~b);
unsigned int c = a + b;
```

or by testing the result (where overflow occurs if the result is smaller than either argument):

```
unsigned int c = a + b;
bool overflow = (c < a);
```

For signed integers a and b, the overflow test becomes a little more complicated. An early test can be done by comparing the arguments against INT_MAX and INT_MIN based on sign as

```
bool overflow = (a > 0 ? (b > INT_MAX - a) : (b < INT_MIN - a));
signed int c = a + b;
```

or after the addition has taken place by detecting if a and b have the same sign and the result has opposite sign (however, note that testing after the fact relies on behavior unspecified by the language standard with respect to overflow):

```
signed int c = a + b;
bool overflow = ((a ^ b) >= 0 && (b ^ c) < 0);
```

Similar overflow tests can be devised for subtraction and multiplication.

Overflow (and therefore overflow testing) can be avoided by allotting enough bits to hold all intermediate and the final result of a calculation exactly. This often requires implementing extended-precision operations. Extended-precision addition and subtraction can often be efficiently implemented using native support in the CPU of a carry flag (or similar mechanism). Assuming the widest available integer type is 32 bits, a high-level implementation of unsigned 64-bit addition may be performed as follows.

```
typedef uint32 uint64[2];

void Uadd64(uint64 x, uint64 y, uint64 res)
{
    uint32 a = x[1] + y[1];  // Compute sum of higher 32 bits
    uint32 b = x[0] + y[0];  // Compute sum of lower 32 bits
    if (b < x[0]) a++;       // Carry if low sum overflowed
    res[0] = b;
    res[1] = a;
}
```

Extended-precision multiplication of two 32-bit values resulting in a 64-bit value can be performed as follows. Let x and y be the two 32-bit values. Write them as $x = x_h 2^{16} + x_l$ and $y = y_h 2^{16} + y_l$. Then the product xy is equivalent to

$$xy = (x_h 2^{16} + x_l)(y_h 2^{16} + y_l) = x_h y_h 2^{32} + (x_h y_l + x_l y_h) 2^{16} + x_l y_l.$$

The products $x_h y_h$, $x_h y_l$, $x_l y_h$, and $x_l y_l$ are all $16 \times 16 \rightarrow 32$-bit multiplications that in this scenario are assumed hardware supported. The code for $32 \times 32 \rightarrow 64$-bit multiplication then becomes:

```
void Umult32to64(uint32 x, uint32 y, uint64 res)
{
    uint16 xh = x >> 16, xl = x & 0xffff;
    uint16 yh = y >> 16, yl = y & 0xffff;
    uint32 a = xh * yh;
    uint32 b = xh * yl;
    uint32 c = xl * yh;
    uint32 d = xl * yl;
    d = d + (b << 16);
    if (d < (b << 16)) a++;
    d = d + (c << 16);
    if (d < (c << 16)) a++;
    a = a + (b >> 16) + (c >> 16);
    res[0] = d;
    res[1] = a;
}
```

Signed operations can be implemented analogously. Algorithms for implementing extended-precision arithmetic are well described in several sources; for example, in [Knuth97].

The need for extended-precision arithmetic can be greatly reduced by postponing the evaluation of expressions until absolutely needed, and then shifting the calculations to evaluate them centered on zero. As an example, consider the problem of determining if a point P lies inside a triangle T by testing if P lies to the left (or right) of all three triangle edges (see Section 5.3.4). The farther away from the origin P and T lie the larger the values used in the left-of tests and the greater the chance of the tests overflowing. Because P only lies in T if P also lies in the AABB of T, the tests can be postponed (or avoided completely) by first testing P against the AABB (Figure 11.11a). This early AABB test cannot cause overflows to occur because AABB tests do not involve any arithmetic operations, only compares.

If P and T pass the AABB test, both P and T are translated into a new coordinate system centered on the AABB of T (Figure 11.11b). Assuming the triangle is small with respect to the coordinate space, the coordinate components of T (and therefore of P, in that it lies inside the AABB of T) are small enough that the left-of tests can be performed without risk of overflow.

It should be noted that a single-precision floating-point number can represent integers in the range $[-2^{24}, 2^{24}]$ accurately. Thus, floating-point arithmetic on integer values is exact (for addition, subtraction, and multiplication) as long as the input and output values lie within this range. Similarly, double-precision floating-point numbers can represent integers in the range $[-2^{53}, 2^{53}]$ accurately. Doubles therefore allow the exact multiplication of 26-bit integers and can exactly compute a 3D dot product involving 25-bit integers.

Whereas additions, subtractions, and multiplications are easy to deal with, divisions remain a problem in working with integer arithmetic. Some approaches to dealing with division are outlined in the next section. A more involved example is presented in Section 11.5.3.

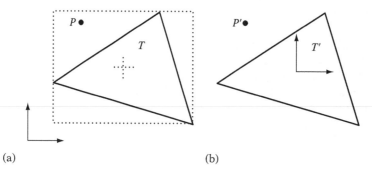

(a) (b)

Figure 11.11 (a) Reducing the amount of precision needed for a point-in-triangle test begins with testing the point P against the AABB of triangle T. (b) If P passes the test, P and T are tested for intersection in a new coordinate system centered on the AABB of T.

11.5.2 **Integer Division**

When trying to perform exact computations, the presence of integer divisions poses a serious problem. Consider yet again the problem of intersecting the line segment $S(t) = A + t(B - A)$, $0 \le t \le 1$, against a plane P given by $(\mathbf{n} \cdot X) = d$. Solving for t gives

$$t = (d - \mathbf{n} \cdot A)/(\mathbf{n} \cdot (B - A)) = t_{nom}/t_{denom}.$$

With integer division rounding the result toward zero, naively determining if S intersects P by direct evaluation of the expression and then verifying if $0 \le t \le 1$ leads to failure. For instance, if t evaluates to, say, −0.4 or 1.2 in the reals, then the integer evaluation gives 0 and 1, respectively, turning nonintersections into intersections. To correctly (exactly) determine if S intersects P requires eliminating the division. A division-free test can be obtained by multiplying all terms in the test expression $0 \le t \le 1$ by the denominator t_{denom}, giving:

$$\begin{cases} 0 \le t_{nom} \le t_{denom}, & \text{if } t_{denom} > 0 \\ 0 \le -t_{nom} \le -t_{denom}, & \text{if } t_{denom} < 0 \end{cases}$$

(If $t_{denom} = 0$ the segment is parallel to the plane, which may be treated as nonintersection, or as an intersection at $t = 0$ if and only if $t_{nom} = 0$. That is, this is the case when the segment lies in the plane.)

All divisions that ultimately end up in a subexpression of a test can be eliminated in a similar fashion. For example, using cross-multiplication the test $a/b > c/d$ can be turned into $ad > bc$ (possibly with a less-than test, based on the signs of the involved variables). The latter inequality is equivalent to $ad - bc > 0$, which in turn is equivalent to computing the sign of the determinant:

$$\begin{vmatrix} a & c \\ b & d \end{vmatrix}.$$

An alternative to explicitly computing the sign of this determinant using extended precision is to compute the sign using a *continued fractions expansion,* as suggested in [Michelucci96]. Michelucci notes that for rational numbers $0 < a < b$, $0 < c < d$, because

$$order\left(\frac{a}{b}, \frac{c}{d}\right) = order\left(\frac{d}{c}, \frac{b}{a}\right) = order\left(\left\lfloor \frac{d}{c} \right\rfloor + \frac{d \bmod c}{c}, \left\lfloor \frac{b}{a} \right\rfloor + \frac{b \bmod a}{a}\right),$$

the terms a/b and c/d compare as follows:

$$order\left(\frac{a}{b}, \frac{c}{d}\right) = \begin{cases} \text{Greater than} & , \left\lfloor \dfrac{d}{c} \right\rfloor > \left\lfloor \dfrac{b}{a} \right\rfloor \\[2ex] \text{Less than} & , \left\lfloor \dfrac{d}{c} \right\rfloor < \left\lfloor \dfrac{b}{a} \right\rfloor \\[2ex] order\left(\dfrac{d \bmod c}{c}, \dfrac{b \bmod a}{a}\right) & otherwise \end{cases}$$

Accounting for arbitrary values of a, b, c, and d, the ordering test can be implemented as follows.

```
// Compare rational numbers a/b and c/d
int Order(int a, int b, int c, int d)
{
    // Make c and d be nonnegative
    if (c < 0) b = -b, c = -c;
    if (d < 0) a = -a, d = -d;
    // Handle a and/or b being negative
    if (a < 0 && b < 0) {
        int olda = a, oldb = b;
        a = c; b = d; c = -olda; d = -oldb;
    }
    if (a < 0) return LESS_THAN;
    if (b < 0) return GREATER_THAN;

    // Make a <= b, exit if order becomes known
    if (a > b) {
        if (c < d) return GREATER_THAN;
        int olda = a, oldb = b;
        a = d; b = c; c = oldb; d = olda;
    }
    if (c > d) return LESS_THAN;

    // Do continued fraction expansion (given that 0<=a<=b, 0<=c<=d)
    while (a != 0 && c != 0) {
        int m = d / c;
        int n = b / a;
        if (m != n) {
            if (m < n) return LESS_THAN;
```

```
        if (m > n) return GREATER_THAN;
    }
    int olda = a, oldb = b;
    a = d % c; b = c; c = oldb % olda; d = olda;
    }
    if (a == 0) return c == 0 ? EQUAL : LESS_THAN;
    return GREATER_THAN;
}
```

A similar method is presented in [Avnaim95].

After eliminating all divisions present in tests, what remains is dealing with divisions in constructions, such as computing the intersection point between the segment S and the plane P. Handling these divisions is where the real problem occurs. Because the intersection point is not exactly representable, in general, it must be rounded or truncated to integer coordinates. The resulting point is unlikely to lie on the plane. Instead, it will typically lie either in front of or behind the plane. If S represents the movement of a particle from position A to position B, rounding the intersection point to lie behind the plane effectively places the particle outside the world, likely leading to errant behavior as the particle continues its movement from the rounded position.

Ensuring that a construction satisfies the criteria imposed by the collision detection system requires careful consideration and coding. An example is given in the next section, for the case of segment-plane intersection.

11.5.3 Segment Intersection Using Integer Arithmetic

Yet again the problem of intersecting the line segment $S(t) = A + t(B - A)$, $0 \le t \le 1$, against the plane P given by $(\mathbf{n} \cdot X) = d$ is revisited. It is assumed S represents the linear motion of a point object O from position A to position B over a time interval given by t. O intersects the plane at time t as

$$t = (d - \mathbf{n} \cdot A)/(\mathbf{n} \cdot (B - A)),$$

which substituted in $S(t)$ gives the intersection point Q as

$$Q = A + [(d - \mathbf{n} \cdot A)(B - A)]/\mathbf{n} \cdot (B - A).$$

Assume the segment straddles the plane, with A in front of the plane and B behind it. Because the coordinate components of Q are integers, Q is highly unlikely to lie

on the plane due to the rounding caused by the integer division. Therefore, Q must somehow be adjusted to guarantee that it lies on or in front of the plane. There are two problems to address when performing the adjustment. First, the adjustment must be large enough to ensure that the new point position lies in front of the plane. Second, the adjustment must not move Q to cause the segment AQ to intersect some other geometry.

To address the first problem, the following approach can be used. Assume, without loss of generality, that A lies in front of plane P. Then, Q must be adjusted to also lie in front of P to satisfy $(\mathbf{n} \cdot Q) \geq d$. A simple way of achieving this goal is to round each coordinate component of Q to maximize $\mathbf{n} \cdot Q$. That is, if $\mathbf{n}_x > 0$, Q_x is rounded upward, and if $\mathbf{n}_x < 0$, Q_x is rounded downward. Specifically, let $t_{nom} = (d - \mathbf{n} \cdot A)$ and $t_{denom} = \mathbf{n} \cdot (B - A)$. The adjusted Q_x is then given by

$$Q_x = A_x + (t_{nom}(B_x - A_x) + k)/t_{denom},$$

where $k = t_{denom} - 1$ to round up and $k = -t_{denom} + 1$ to round down. Q_y and Q_z are computed analogously. This procedure does not necessarily result in the smallest adjustment to Q, but for collision detection the actual position of Q is of less importance than Q lying on the correct side of plane P.

The following integer version of **TestSegmentPlane()** illustrates how the intersection point adjustment can be implemented. It is assumed that **Point**, **Vector**, and **Plane** are defined in terms of the 32-bit integer type **int32**.

```
// Test if segment ab intersects plane p. If so, return 1, along with
// an adjusted intersection point q. If not, return 0
int TestSegmentPlane(Point a, Point b, Plane p, Point &q)
{
    // Compute t value, t=tnom/tdenom, for directed segment ab intersecting plane p
    Vector ab = b - a;
    int64 tnom = p.d - Dot(p.n, a);
    int64 tdenom = Dot(p.n, ab);
    // Exit if segment is parallel to plane
    if (tdenom == 0) return 0;

    // Ensure denominator is positive so it can be multiplied through throughout
    if (tdenom < 0) {
        tnom = -tnom;
        tdenom = -tdenom;
    }

    // If t not in [0..1], no intersection
    if (tnom < 0 || tnom > tdenom) return 0;
```

```
// Line segment is definitely intersecting plane. Compute vector d to adjust
// the computation of q, biasing the result to lie on the side of point a
Vector d(0,0,0);
int64 k = tdenom - 1;
// If a lies behind plane p, round division other way
if (tdenom > 0) k = -k;
if (p.n.x > 0) d.x = k; else if (p.n.x < 0) d.x = -k;
if (p.n.y > 0) d.y = k; else if (p.n.y < 0) d.y = -k;
if (p.n.z > 0) d.z = k; else if (p.n.z < 0) d.z = -k;

// Compute and return adjusted intersection point
q = a + (tnom * ab + d) / tdenom;
return 1;
}
```

Assuming the calculations for **tnom** and **tdenom** involve 64-bit operations, the input values must not contain more than 30 bits of precision to avoid overflow. Additionally, the computation of \mathbf{q} must be performed using 64×32-bit precision multiplication and 96/32-bit precision division.

The second problem is that after adjusting Q, Q may inadvertently end up behind some other plane. A secondary intersection test is therefore required to determine if segment AQ intersects any world geometry. If so, a new Q is computed, which in turn may lie behind a third plane, and so on. Determining a Q that lies in front of m planes — that is, which satisfies $(\mathbf{n}_i \cdot Q) \geq d_i$, $1 \leq i \leq m$ — is a problem that belongs to the class of *integer linear programming problems* (see Section 9.4). These problems are notoriously difficult to solve. Thus, rather than attempting to solve for Q a pragmatic solution is simply to iterate, intersecting against one plane at a time and aborting if no good intersection point is found within n iterations (at which point A is returned as the intersection point).

As an example of computing the intersection point of a segment AB against a world consisting of polygons P_1 and P_2, consider the situation of Figure 11.12. Initially, AB is found straddling the supporting plane of both P_1 and P_2. Because AB passes through the interior of P_1 only (and not P_2), AB is intersected against P_1. The unadjusted intersection point Q_1 lies behind the plane of P_1, but through adjustment (per the previous) the resulting intersection point Q_2 lies in front of P_1. Segment AQ_2 must now be tested against the world. It is found intersecting P_2, resulting in the unadjusted intersection point Q_3, which adjusted becomes Q_4. Segment AQ_4 is not found intersecting anything, and thus Q_4 is returned as the intersection point.

Overall, this integer approach is more complicated than a floating-point approach using tolerances, explaining the more widespread use of floating-point in collision detection applications.

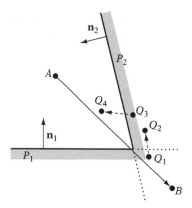

Figure 11.12 Intersecting segment AB against planes P_1 and P_2 (scale exaggerated).

11.6 **Further Suggestions for Improving Robustness**

In addition to the strategies covered in this chapter to this point, the following are some suggestions for further improving the robustness of numerical calculations and geometrical algorithms.

- Test critical algorithms by implementing a reference algorithm, using a different (perhaps brute-force) method. Run the two algorithms in parallel. If they do not agree to some k significant digits, find out why.

- Use defensive programming practices extensively. Add asserts to verify that computed intersection points actually lie on the (thick) plane or that a reflected velocity points away from the plane. However, beware (floating-point) inaccuracies in the assert statement itself!

- Make sure all possible special cases are covered by a routine. For example, most triangle-triangle intersection tests require special code to handle the two triangles lying in the same plane. Consider also how the triangle-triangle routine handles one or both triangles degenerating to a line segment or to a point. Pay special attention to how boundaries of objects are tested.

- It is possible to test how susceptible a calculation is to accumulated and amplified rounding errors by running the calculation in all rounding modes offered by the (IEEE-754) floating-point arithmetic. If the output varies more than is expected, the computation is unstable and should be reformulated.

- Avoid using several different formulas for computing the same value. Differences due to accumulated errors will introduce inconsistencies when the computed values are used as decision variables. (Compare the sharing of the scalar triple product, described in Section 11.3.3.)

- When working with floating-point formats, perform operations centered on the origin to avoid wasting the extra bit of precision offered by the sign bit. The same applies to signed integers.

11.7 **Summary**

Many parts of a collision detection system are sensitive to robustness issues. This chapter has discussed the sources of these issues, focusing on the sources of floating-point errors. To understand where the floating-point errors are coming from, it is important to understand how real numbers are represented as floating-point numbers. Today, the IEEE-754 floating-point formats are ubiquitous, and they were presented here.

The chapter further discussed how to perform robust computations using floating-point arithmetic. Three tactics were suggested. One is to work with tolerances that are large enough to effectively hide any error buildup. Commonly, tolerances are seen in the use of thick planes. Another tactic is to ensure sharing of calculations, ensuring values are not recomputed (in subtly different ways). A third tactic is to work exclusively with fat objects, allowing errors to be safely ignored.

Interval arithmetic was introduced as a failsafe approach to maintain bounds of the errors of computations. Last, the option of using exact arithmetic was explored. The next chapter also deals with robustness, discussing how to remove problematic features such as cracks and concave geometry from the input geometry before they cause problems at runtime.

Chapter 12

Geometrical Robustness

Just as it is important with numerical robustness, it is important for collision geometry on which tests are performed to be well formed. If not, the presence of small cracks between neighboring faces could cause objects to fall through what is intended to be solid. In fact, several geometrical features may cause problems for collision detection code, including the following.

- Redundant vertices, edges, and faces

- Degenerate faces, including nonconvex or self-intersecting faces and faces of zero or near-zero area

- Incorrect orientation of single-sided faces

- Unintended holes, cracks, gaps, and t-junctions between neighboring faces

- Nonplanar faces

In addition, interpenetrating faces may or may not present a problem, depending on the type of collision approach used. Overlapping faces may sometimes also be a problem, specifically if they have different surface properties assigned. A large list of the errors afflicting models in computer-aided design (CAD) is given in [Gu01]. Many of the errors listed also affect geometry for collision detection.

A lot of research is available on the cleanup and repair of geometry. Most of it is focused on boundary representations of solid models, as used in CAD (see, for example, [Barequet97] and [Murali97]). Unfortunately, although collision geometry is sometimes constructed as a solid model it is more frequently modeled as a mesh or a polygon soup. Unlike CAD geometry, such geometry cannot be expected to be either connected or manifold. That is, faces can be both disjoint and interpenetrating, and more than two faces may share an edge. The closed meshes of CAD geometry are not supposed to have holes, and the cleanup processing usually assumes that all

holes must be filled in. For an arbitrary mesh, no such a priori knowledge is available, and cracks must be distinguished from intentional holes.

There are many possible approaches to attempting to clean up arbitrary meshes. In this chapter, some of the key steps relevant to most approaches are described, specifically:

1. Welding of vertices

2. Fixing of cracks between neighboring faces

3. Merging co-planar faces into a single face

4. Decomposition into convex (possibly triangular) pieces

Figure 12.1 illustrates how these steps can be used to clean up a polygon soup model. In addition, this chapter describes methods for computing and holding adjacency information. This chapter ends with a discussion of some simple means of quickly detecting bad input geometry.

Cleaning up arbitrary input geometry can be quite difficult overall. An interesting account of the practical issues of mesh cleanup is found in [Erikson95].

12.1 **Vertex Welding**

Frequently, collision geometry suffers from being built from polygons whose vertices should have been joined but were not. These duplicate representations of a single vertex cause cracks between polygons. Although often invisible to the eye, these cracks still cause problems for collision detection systems. For example, they may cause collision queries, such as ray tests, to pass through what was supposed to be solid geometry. Additionally, duplicate vertices ruin the possibility of maintaining adjacency information between neighboring faces. Duplicate vertices also take up unnecessary space. For example, a triangle mesh with duplicate vertices may require nearly three times as much memory for storing the vertices as the same mesh without duplicate vertices.

Fixing the problem involves finding all pairs or sets of vertices "near" each other and joining them into a single vertex, a process known as *vertex welding* (also as *vertex shifting* or *vertex merging*). Vertices are considered near when they are within some preset distance of each other, called the *welding tolerance* or the *welding epsilon*. The space within the welding tolerance of a vertex is the *welding neighborhood* of the vertex.

Setting an appropriate welding distance is important. If the welding tolerance is too small, not all vertices that should be welded will be welded. If the distance is too large, vertices that should not be part of a welding operation may erroneously be included, causing collapsing of edges or faces of the geometry. Figure 12.2 illustrates both of these problems. User input is often required to set the welding distance, in that automatically determining it is a difficult problem.

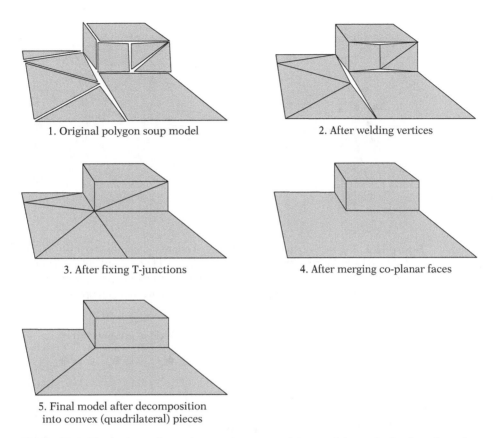

1. Original polygon soup model

2. After welding vertices

3. After fixing T-junctions

4. After merging co-planar faces

5. Final model after decomposition
into convex (quadrilateral) pieces

Figure 12.1 The key steps in turning a polygon soup into a well-formed robust mesh: vertex welding, t-junction removal, merging of co-planar faces, and decomposition into convex pieces.

A nontrivial problem is choosing the representative point that two or more vertices become after welding. To illustrate the issues arising, consider a number of vertices in a line, equidistantly spaced, with each pair of vertices being within the welding distance (Figure 12.3). Assume a process in which the set of vertices is iterated over and each vertex is compared against previously encountered vertices for welding. If no earlier vertex is within the welding distance, the vertex can be kept as is, but if a vertex is found within the welding distance some possible options include the following.

1. Replacing the current vertex with the previously kept vertex

2. Replacing the previously kept vertex with the current vertex

3. Replacing both vertices with one halfway between them

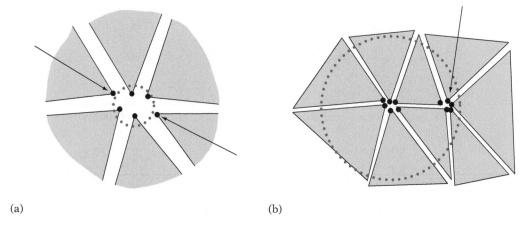

(a) (b)

Figure 12.2 The welding tolerance must be set **appropriately.** (a) Too small, and some vertices that should be included in the welding operation could be missed. (b) Too large, and vertices that should not be part of the welding operation could be **erroneously** included. Arrows indicate vertices **incorrectly** handled during the respective welding operations.

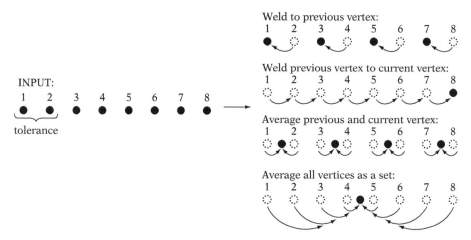

Figure 12.3 Different outcomes from alternative methods for welding a set of points mutually within the welding tolerance distance.

As shown in Figure 12.3, these alternatives give different results. The first option is attractive because it limits the *vertex drift* — the distance between a vertex's original and final position — to be the welding epsilon. Option 2 clearly has a worst-case vertex drift, proportional to n, where n is the number of vertices welded. Even though it is not illustrated here, option 3 also has a worst-case vertex drift proportional to n (consider the effects of doubling the welding epsilon given in Figure 12.3). If there

are no degenerate situations causing excessive vertex drift, averaging can be more consistent with an intuitive expectation of where the representative point should be.

Sequential processing implies an order dependency. Sequential methods must also address the issue of two or more previous vertices found within the welding distance of the current vertex. Should welding be performed with the closest one, or perhaps with all of them? Additionally, for all three approaches there are degenerate situations in which, although highly unlikely, two vertices arbitrarily close to each other may weld to two different positions.

The last issue, along with what to do when there are several previous vertices within the welding distance, can be avoided by using a simultaneous welding model. The simultaneous model identifies all sets of vertices such that each vertex of the set is within the tolerance distance of one or more other vertices of the set. For each set, all vertices within the set are averaged. This is also illustrated in Figure 12.3. This approach is more expensive to implement than sequential welding. It too suffers from degenerate cases (as illustrated), and thus the value of simultaneous welding is unclear.

A problem that remains is how to locate vertices within the welding distance of each other. A brute-force approach to vertex welding is simply to test each vertex A against every other vertex B. Although this method is quite simple to implement, its $O(n^2)$ complexity makes it too slow for large data sets. Fortunately, just about any space-partitioning data structure could be used to speed up the welding operation by, in effect, dividing the vertices into small distinct clusters so that only the vertices of one or a few clusters would have to be tested. In fact, vertex welding can be seen as a collision detection problem by thinking of the vertices and their welding neighborhood as small spheres or boxes to be tested for overlap. Thus, any fast collision method could be used for vertex welding.

A practical approach to the problem is to use the hashed uniform grid of Section 7.1.3. It is efficient, with an expected $O(n)$ complexity, which is optimal. Technically, its worst-case complexity is $O(n^2)$ — when all points fall within the same grid cell, but no welding takes place — but this worst-case scenario does not occur in practice. It is also an *on-line* algorithm, and thus vertices can be welded as they are added, instead of requiring all vertices to be present from the start.

The welding method employed in the following is a sequential processing of the vertices, welding the current vertex against previous vertices. The idea is to add vertices one at a time into the hashed grid. A test is then performed against grid cells that fall within the welding neighborhood of the current vertex V. If one of the cells contains some vertex W that V is within the welding distance of, W is returned as the welded vertex. If not, V is added to the grid cell it maps to, and V itself is returned as the welded vertex.

There are two key things to note. First, in order to limit the number of cells that must be tested **CELL_SIZE** should at least be larger than **2 * WELD_EPSILON**. Then the square welding neighborhood around V can at most overlap four neighboring grid cells (in 2D, eight cells for the cubic welding neighborhood in 3D). In practice, **CELL_SIZE** is usually selected to be a factor or two larger than the welding

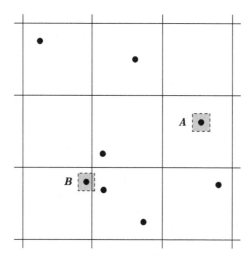

Figure 12.4 Only the grid cells intersected by the tolerance neighborhood of a vertex (here shown in **gray**) must be tested against during vertex welding. For vertex *A* this results in just one cell tested. For vertex *B*, two cells must be examined.

neighborhood. Because only the grid cells overlapped by the tolerance region surrounding *V* have to be examined, on average only the content of a single cell must be tested! Figure 12.4 illustrates how the approach works for two sample vertices.

Second, under the hash mapping two or more cell neighborhoods of vertices may map to the same hash bucket. This does not have any adverse effect on the method, in that a distance test is performed for all vertices within a tested cell. At worst, this results in a few extra vertices being tested during the welding test against the content of that hash bucket. The following is a sample 2D implementation of the hashed grid solution. First are some necessary constant values.

```
#define MAX_VERTICES 100000    // max number of vertices that can be welded at once
#define NUM_BUCKETS 128        // number of hash buckets to map grid cells into
#define CELL_SIZE 10.0f        // grid cell size; must be at least 2*WELD_EPSILON
#define WELD_EPSILON 0.5f      // radius around vertex defining welding neighborhood

// Maps unbounded grid cell coordinates (x, y) into an index
// into a fixed-size array of hash buckets
unsigned int GetGridCellBucket(int x, int y)
{
    const unsigned int magic1 = 0x8da6b343;   // Large multiplicative constants;
    const unsigned int magic2 = 0xd8163841;    // here arbitrarily chosen primes
    unsigned int index = magic1 * x + magic2 * y;
```

```
    // Bring index into [0, NUM_BUCKETS) range
    return index % NUM_BUCKETS;
}
```

The linked lists of vertices, one for each hash bucket, are implemented using three arrays. **first** holds the index of the first vertex in the bucket, **vertex** contains the vertices themselves, and **next** contains the index of the next vertex in the bucket.

```
int first[NUM_BUCKETS];       // start of linked list for each bucket
int next[MAX_VERTICES];       // links each vertex to next in linked list
Point vertex[MAX_VERTICES];   // unique vertices within tolerance
int numVertices;              // number of unique vertices currently stored
```

For a given hash bucket index **bucket** and a vertex **v**, **LocateVertexInBucket()** returns whether there was a vertex within **WELD_EPSILON** of **v**, and if so returns that vertex in **weldVertex**.

```
int LocateVertexInBucket(Point v, unsigned int bucket, Point **weldVertex)
{
    // Scan through linked list of vertices at this bucket
    for (int index = first[bucket]; index >= 0; index = next[index]) {
        // Weld this vertex to existing vertex if within given distance tolerance
        if (SqDistPointPoint(vertex[index], v) < WELD_EPSILON * WELD_EPSILON) {
            *weldVertex = &vertex[index];
            return 1;
        }
    }

    // No vertex found to weld to. Return v itself
    *weldVertex = &v;
    return 0;
}
```

When no vertex is found within the welding tolerance distance, **v** is added to a given bucket by linking it in at the head of the bucket list.

```
void AddVertexToBucket(Point v, unsigned int bucket)
{
    // Fill next available vertex buffer entry and link it into vertex list
    vertex[numVertices] = v;
```

```
        next[numVertices] = first[bucket];
        first[bucket] = numVertices++;
    }
```

When working with floating-point values, for large coordinates the addition of a small epsilon leaves the coordinate unchanged (see Chapter 11). In this case, the code would not correctly test against neighboring cells. Therefore, for the code to be robust it is important to make sure **WELD_EPSILON** is large enough for the coordinate values used. (A pragmatic solution is to add asserts to the code to detect this problem occuring. Should the assert trigger, the epsilon value is increased until the problem goes away.) The welding code is implemented by the following routine.

```
Point *WeldVertex(Point *v)
{
    // Make sure epsilon is not too small for the coordinates used!
    assert(v->x - WELD_EPSILON != v->x && v->x + WELD_EPSILON != v->x);
    assert(v->y - WELD_EPSILON != v->y && v->y + WELD_EPSILON != v->y);

    // Compute cell coordinates of bounding box of vertex epsilon neighborhood
    int top    = int((v->y - WELD_EPSILON) / CELL_SIZE);
    int left   = int((v->x - WELD_EPSILON) / CELL_SIZE);
    int right  = int((v->x + WELD_EPSILON) / CELL_SIZE);
    int bottom = int((v->y + WELD_EPSILON) / CELL_SIZE);

    // To lessen effects of worst-case behavior, track previously tested buckets
    unsigned int prevBucket[4];     // 4 in 2D, 8 in 3D
    int numPrevBuckets = 0;

    // Loop over all overlapped cells and test against their buckets
    for (int i = left; i <= right; i++) {
        for (int j = top; j <= bottom; j++) {
            unsigned int bucket = GetGridCellBucket(i, j);
            // If this bucket already tested, don't test it again
            for (int k = 0; k < numPrevBuckets; k++)
                if (bucket == prevBucket[k]) goto skipcell;
            // Add this bucket to visited list, then test against its contents
            prevBucket[numPrevBuckets++] = bucket;
            Point *weldVertex;
            // Call function to step through linked list of bucket, testing
            // if v is within the epsilon of one of the vertices in the bucket
            if (LocateVertexInBucket(*v, bucket, &weldVertex)) return weldVertex;
```

```
skipcell: ;
        }
    }

    // Couldn't locate vertex, so add it to grid, then return vertex itself
    int x = int(v->x / CELL_SIZE);
    int y = int(v->y / CELL_SIZE);
    AddVertexToBucket(*v, GetGridCellBucket(x, y));
    return v;
}
```

The **WeldVertex()** function can now be called repeatedly for all vertices subject to welding.

```
void WeldVertices(Point v[], int n)
{
    // Initialize the hash table of linked vertex lists
    for (int k = 0; k < NUM_BUCKETS; k++)
        first[k] = -1;
    numVertices = 0;

    // Loop over all vertices, doing something with the welded vertex
    for (int i = 0; i < n; i++) {
        Point *pVert = WeldVertex(&v[i]);
        if (pVert != &v[i])
            ...report v[i] was welded to pVert...
    }
}
```

After all vertices have been processed, the first **numVertices** entries of the **vertex** array contain all unique vertices. This makes it easy to, for example, output them to a data file.

```
fwrite(&numVertices, sizeof(numVertices), 1, stream);    // Output number of verts
fwrite(&vertex[0], sizeof(Point), numVertices, stream);  // Output verts themselves
```

Looping over all faces and welding the vertices of these faces automatically removes any unused vertices, in that only the vertices referenced by a face are being welded.

A less sophisticated welding method than the one just described is to sort all vertices (x_i, y_i, z_i) on the absolute component value sum, $|x_i| + |y_i| + |z_i|$. Given the

sorted vertices, a vertex V_i is welded by comparing it against the immediately following vertices V_j, $i < j$, for as long as

$$(|x_j| + |y_j| + |z_j|) - (|x_i| + |y_i| + |z_i|) \leq 3\varepsilon,$$

where ε is the weld epsilon. Although simple to implement, this is an off-line rather than on-line method, and thus all vertices must be welded in one go. It also has degenerate behavior when vertices are aligned to a regular grid, as all vertices on the diagonal lines $|x_i| + |y_i| + |z_i| = k$ (for all k) map to the same sum.

If nontriangulated geometry is welded, it is important to remember that the resulting geometry will likely contain nonplanar or nonconvex faces as well as collinear vertices. Nonconforming faces can be triangulated and made convex in a subsequent pass using the methods described in Section 12.5.

In general, after a pass of vertex welding no two vertices should be closer to each other than the distance used as the welding tolerance. This serves as a practical test for debugging a vertex welding system.

12.2 Computing Adjacency Information

For cleaning up model geometry — including the elimination of cracks and the merging of co-planar faces — it is important to have adjacency information describing how the faces, edges, and vertices of the model connect. Such adjacency information may not be available. Worst case, the data is just a polygon soup of individual faces. In this case, the adjacency information has to be computed.

A common geometry representation is the *face table* representation in which a table of faces (usually triangles, but sometimes quads) indexes into a table of vertices. Figure 12.5 presents a small example of a face table. The face/vertex table representation is fairly compact and allows any mesh to be represented.

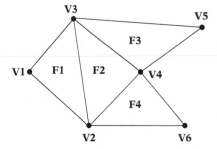

Face	Vertices (ccw)
F1	(V1,V2,V3)
F2	(V2,V4,V3)
F3	(V3,V4,V5)
F4	(V4,V2,V6)

Vertex	Coordinates
V1	(x1,y1,z1)
V2	(x2,y2,z2)
V3	(x3,y3,z3)
V4	(x4,y4,z4)
V5	(x5,y5,z5)
V6	(x6,y6,z6)

Figure 12.5 The face and vertex tables for a simple mesh.

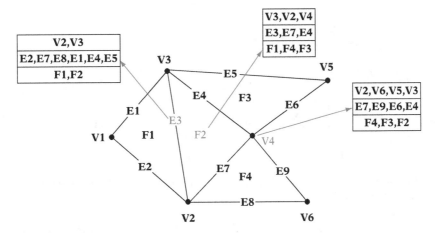

Figure 12.6 Adjacency information associated with each vertex, edge, and face facilitates instantaneous access to their adjacent vertices, edges, and faces.

Although it is possible to work directly on this basic representation, doing so would not be very efficient. To efficiently clean up the mesh geometry, removing degeneracies and other things that could cause problems for collision detection code, additional adjacency information must be computed.

Having full adjacency information allows retrieval of all adjacent vertices, edges, and faces of a given vertex, edge, or face in constant $O(1)$ time. Full adjacency information for some features of the mesh from the earlier example is provided in Figure 12.6.

However, storing a full set of adjacency information for every feature of a mesh is prohibitive in terms of memory requirements. A good compromise between fast adjacency queries and minimal storage is to store only some adjacency information, enough to allow other needed adjacency information to be derived in a fixed amount of time.

Several data structures, primarily for manifold solid models, have been suggested for storing partial adjacency information. The *winged-edge* [Baumgart75], *half-edge* [Mäntylä88], and *winged-triangle* [Paoluzzi89] data structures are examples of such representations (Figure 12.7).

The winged-edge and half-edge data structures are "edge-based." In the winged-edge representation, references to the vertices of the edge, the two faces connected to the edge, and the next and previous edges for both connected faces are stored for each edge. In the half-edge representation, each edge is treated as consisting of two half-edges: directed edges between the same two vertices, pointing in opposite directions. Each half-edge holds references to its "twin" half-edge, the face the half-edge is part of, the next half-edge of that face in counterclockwise order, and the vertex the half-edge originates from. In both schemes, vertices and faces have references to an incident (half-)edge.

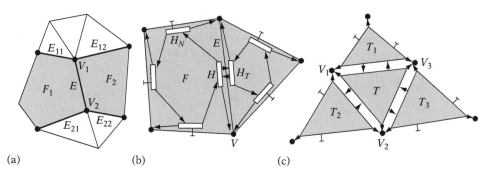

(a) (b) (c)

Figure 12.7 Data associated with (a) the winged-edge E, (b) the half-edge H, and (c) the winged-triangle T.

The winged-triangle data structure is "face-based." Each triangle references the vertices defining the triangle, as well as the three triangles sharing its edges. Vertices have a reference to an incident triangle. Edges are not explicitly stored in the winged-triangle representation. The definitions of these three data structures are as follows.

```
// Basic representation of an edge in the winged-edge representation
struct WingedEdge {
    Vertex *v1, *v2;            // The two vertices of the represented edge (E)
    Face *f1, *f2;              // The two faces connected to the edge
    Edge *e11, *e12, *e21, *e22; // The next edges CW and CCW for each face
};

// Basic representation of a half-edge in the half-edge representation
struct HalfEdge {
    HalfEdge *ht; // The matching "twin" half-edge of the opposing face
    HalfEdge *hn; // The next half-edge counter clockwise
    Face *f;      // The face connected to this half-edge
    Vertex *v;    // The vertex constituting the origin of this half-edge
};

// Basic representation of a triangle in the winged-triangle representation
struct WingedTriangle {
    Vertex *v1, *v2, *v3;         // The 3 vertices defining this triangle
    WingedTriangle *t1, *t2, *t3; // The 3 triangles this triangle connects to

    // Fields specifying to which edge (0-2) of these triangles the connection
    // is made are not strictly required, but they improve performance and can
    // be stored "for free" inside the triangle pointers
    int edge1:2, edge2:2, edge3:2;
};
```

Another popular representation is the *quad-edge* data structure. See [Guibas85] for details.

Data structures designed for nonmanifold geometry have also been suggested, such as the *radial-edge* [Weiler88] and *star-edge* [Karasick89] representations. However, because nonmanifold geometry may have any number of faces connected to an edge such data structures are more complicated than those for manifold geometry.

To fill in an adjacency structure when the original data is given as face and vertex tables, adjacency information must first be derived from the face and vertex tables. A naive approach is to compare each face against every other face and write adjacency information when two faces are found to share vertices. However, with an $O(n^2)$ time complexity this approach can handle only moderate-size meshes. The following two sections show how adjacency information can be computed in $O(n)$ time, which is asymptotically optimal for the problem. The immediately following section describes how to build a table for finding all faces incident to a given vertex. Section 12.2.2 shows how to compute an edge table, for looking up all faces sharing a given edge. The same principles used in both sections can be applied to any similar table computation, such as looking up all edges incident to a given vertex.

12.2.1 Computing a Vertex-to-Face Table

When a face/vertex table is given as input, the vertices of a given face can be immediately located. However, locating the faces a given vertex is part of would require an $O(n)$ pass over all faces. To make this operation equally fast, a *reverse table* can be computed: a table that for each vertex allows the immediate location of all faces incident to the vertex. To simplify the presentation, it is here assumed that all faces are triangles. The basic approach, however, is easily adapted to deal with arbitrary faces. Given as input is a number of triangles, **numTris**, contained in a face table (an array of type **Triangle**).

```
int numTris;     // The number of triangles
Triangle *tri;   // Pointer to face table array containing all the triangles
```

The **Triangle** structure is defined as:

```
struct Triangle {
    int vertexIndex[3];   // Indices into vertex table array
};
```

Because each vertex might be part of a large number of triangles, the reverse vertex table must maintain a dynamic, growable data structure associated with each vertex.

Here, a linked list of indices into the triangle array is maintained for each vertex in the data set. The element in the linked list is defined as such.

```
//Linked-list element to keep track of all triangles a vertex is part of
struct TriList {
    int triIndex;    // Index to some triangle the vertex is part of
    TriList *pNext;  // Pointer to the next triangle in the linked list
};
```

The maximum number of vertices, **MAX_VERTICES**, is at most three times the number of triangles. An array, **triListHead**, of many list-element pointers is allocated to hold the pointer to the head of each list. A second array, **triListEntry**, of equally many elements is reserved as a pool to allocate a list element from each time a triangle is associated with a given vertex list.

```
// If all vertices are unique, there are at most 3 * MAX_TRIANGLES vertices
const int MAX_VERTICES = 3 * MAX_TRIANGLES;

TriList *triListHead[MAX_VERTICES]; // The head of the list maintained for each vertex
TriList triListEntry[MAX_VERTICES]; // Entries of the linked list
```

Given these structures, the main code can now loop over all triangles and insert an index to the triangle into the linked list for each vertex of the triangle.

```
// Reset the list of triangles associated with each vertex
for (int i = 0; i < MAX_VERTICES; i++) triListHead[i] = NULL;
// Reset the triangle list entry counter
int cnt = 0;
// Loop over all triangles and all three of their vertices
for (int i = 0; i < numTris; i++) {
    for (int j = 0; j < 3; j++) {
        // Get the vertex index number
        int vi = tri[i].vertexIndex[j];
        // Fill in a new triangle entry for this vertex
        triListEntry[cnt].triIndex = i;
        // Link new entry first in list and bump triangle entry counter
        triListEntry[cnt].pNext = triListHead[vi];
        triListHead[vi] = &triListEntry[cnt++];
    }
}
```

All triangles sharing a vertex specified by the index **i** can now be accessed as in the following code.

```
for (TriList *pEntry = triListHead[i]; pEntry; pEntry = pEntry->pNext) {
    /* do something with triangle tri[pEntry->triIndex] here */
}
```

A reverse vertex table of this type is often practical to have. One possible use is for determining the neighboring triangles of a triangle T by computing the union of the lists associated with the three vertices of T. However, for this particular application a more efficient approach is to compute a table that directly associates with an edge the faces connected to the edge. Then, given a triangle the neighboring triangles could be immediately located by looking up the connected faces through the edge table. The next section illustrates how to compute this type of table.

12.2.2 Computing an Edge-to-Face Table

As before, the input is assumed to be a face table indexing into a vertex table. This time, the problem is to compute a table that associates an edge with the faces connected to the edge. Again, to simplify the presentation the faces are assumed to be triangles. Another simplifying assumption made here is that the input mesh is a (bounded) manifold. Thus, no edge will be connected to more than two triangles. Both assumptions can be lifted without much further work.

Because triangles, and faces in general, are given with their vertices in a consistent ordering (conventionally counterclockwise when viewed face-on), an edge from some vertex A to another vertex B that is part of two triangles will occur both as (A, B) for one triangle and (B, A) for the other triangle. To view both (A, B) and (B, A) as the same edge, it is necessary to enforce an ordering of A and B. Because the vertices are indices, the representative edge can simply be chosen to be the one that lists the vertex with the smaller index value first; that is, the edge $(\min(A, B), \max(B, A))$.

In a case in which vertices are given as a triplet of coordinates instead of an index, the vertices can still be consistently ordered by ordering the one with the smallest x, then y, then z component first. This is the *lexicographic ordering* of the vertices as implemented by the following code.

```
// Compare vertices lexicographically and return index (0 or 1) corresponding
// to which vertex is smaller. If equal, consider v0 as the smaller vertex
int SmallerVertex(Vertex v0, Vertex v1)
{
    if (v0.x != v1.x) return v1.x > v0.x;
    if (v0.y != v1.y) return v1.y > v0.y;
    return v1.z > v0.z;
}
```

Because edges are represented as a pair of vertex indices and this pair must be used to index into a table, an open hash table (see Chapter 6) is employed instead of a straight array. The hash key is computed from the two vertex indices. With each key is associated a data block, containing the two vertex indices and the two triangle edges the edge is connected to. This data block is realized by the following structure.

```
struct EdgeEntry {
    int vertexIndex[2];      // The two vertices this edge connects to
    int triangleIndex[2];    // The two triangles this edge connects to
    int edgeNumber[2];       // Which edge of that triangle this triangle connects to
    EdgeEntry *pNext;        // Pointer to the next edge in the current hash bucket
};
```

Assuming all edges are unique, the maximum number of edges, **MAX_EDGES**, is at most three times the number of triangles. The array **edgeListHead** is defined to contain that many list-element pointers, corresponding to the pointers to the head of each edge list. The hash key indexes into this array of list pointers. Again a second array, **edgeListEntry**, of equally many elements is allocated as a pool, this time from which to grab a list element each time a triangle is associated with a given edge list.

```
// If all edges are unique, there are at most 3 * MAX_TRIANGLES edges
const int MAX_EDGES = 3 * MAX_TRIANGLES;

// Hash table over edges, with a linked list for each hash bucket
EdgeEntry *edgeListHead[MAX_EDGES];
EdgeEntry edgeListEntry[MAX_EDGES]; // Entries of the linked list
```

To build the edge table, the main code loops over all triangles and all edges of each triangle. If the edge does not already exist in the linked list of the computed hash bucket, a new edge entry is linked into the bucket, specifying the triangle from which the edge was taken, and the two endpoint vertices of the edge. If the edge already exists in the hash bucket list, it has already been seen once and thus the second triangle entry can be filled in with the index of the current triangle. Here, it is assumed the function **ComputeHashKey()** implements the function computing a hash key value that maps into the **edgeListHead** array. The main code follows.

```
// Reset the hash table
for (int i = 0; i < MAX_EDGES; i++) {
```

```
        edgeListHead[i] = NULL;
}
// Reset the edge list entry counter
int cnt = 0;
// Loop over all triangles and their three edges
for (int i = 0; i < numTris; i++) {
    for (int j = 2, k = 0; k < 2; j = k, k++) {
        // Get the vertex indices
        int vj = tri[i].vertexIndex[j];
        int vk = tri[i].vertexIndex[k];
        // Treat edges (vj, vk) and (vk, vj) as equal by
        // flipping the indices so vj <= vk (if necessary)
        if (vj > vk) Swap(vj, vk);
        // Form a hash key from the pair (vj, vk) in range 0 <= x < MAX_EDGES
        int hashKey = ComputeHashKey(vj, vk);
        // Check linked list to see if edge already present
        for (EdgeEntry *pEdge = edgeListHead[hashKey]; ; pEdge = Edge->pNext) {
            // Edge is not in the list of this hash bucket; create new edge entry
            if (pEdge == NULL) {
                // Create new edge entry for this bucket
                edgeListEntry[cnt].vertexIndex[0] = vj;
                edgeListEntry[cnt].vertexIndex[1] = vk;
                edgeListEntry[cnt].triangleIndex[0] = i;
                edgeListEntry[cnt].edgeNumber[0] = j;
                // Link new entry first in list and bump edge entry counter
                edgeListEntry[cnt].pNext = edgeListHead[hashKey];
                edgeListHead[hashKey] = &edgeListEntry[cnt++];
                break;
            }
            // Edge is in this bucket, fill in the second edge
            if (pEdge->vertexIndex[0] == vj && pEdge->vertexIndex[1] == vk) {
                pEdge->triangleIndex[1] = i;
                pEdge->edgeNumber[1] = j;
                break;
            }
        }
    }
}
```

This code can easily be merged with the code given in Section 12.2.1 so that in addition to having the vertex table have each vertex index all of its incident faces

each vertex can reference one (or all) of its incident edges. This addition would allow all adjacency information to be accessed in $O(1)$ time using any feature (vertex, edge, or face) as the indexing element.

12.2.3 Testing Connectedness

As an example of what can be accomplished using adjacency information, consider the problem of determining whether all faces in the face table are connected through an edge to another face. If the faces are not all connected, the number of connected components and a face of each component should be output. The example is presented for triangles only.

To be able to know which connected component a triangle is part of, a **label** field is added to each triangle data structure for holding the component number. Initially triangles are labeled as not being part of any component. Then, all triangles are looped over and for each unmarked triangle encountered the running component number is increased by one, the triangle is tagged with this component number and all neighboring triangles of the triangle are recursively visited and marked with the same component number.

If all components are connected, the recursive procedure will end up visiting and marking all triangles with the initial component number. When returning to the outer loop, no unmarked faces will be found and the procedure will exit, saying there is only one component. If there are multiple components, the recursive routine will fail to visit some faces, which are eventually encountered by the outer loop, which in turn increments the component count before recursively visiting the faces of the next connected component, and so on. The following piece of code implements this procedure.

```
// Unlabel all triangles
for (i = 0; i < numTris; i++)
    tri[i].label = 0;
// Loop over all triangles, identifying and marking all components
int componentNumber = 0;
for (i = 0; i < numTris; i++) {
    // Skip triangles already labeled
    if (tri[i].label != 0) continue;
    // Mark this triangle with the current component number
    tri[i].label = ++componentNumber;
    printf("Component %d starts at triangle %d\n", componentNumber, i);
    // Recursively visit all neighboring triangles and mark them with the same number
    MarkAllNeighbors(i, componentNumber);
}
```

After this code has executed, **componentNumber** contains the number of components in the mesh. The code relies on a recursive subroutine, which visits all neighboring triangles of a given face.

```
void MarkAllNeighbors(int triIndex, int componentNumber)
{
    int neighborIndex;
    // Visit neighboring triangles of all three edges (if present)
    for (int i = 0; i < 3; i++) {
        neighborIndex = GetTriangleNeighbor(triIndex, i);
        // If there is a neighboring triangle not already marked...
        if (neighborIndex >= 0 && tri[neighborIndex].label != componentNumber) {
            // ...mark it, and visit it recursively
            tri[neighborIndex].label = componentNumber;
            MarkAllNeighbors(neighborIndex, componentNumber);
        }
    }
}
```

The recursive procedure in turn relies on a subroutine, which given a triangle index and an edge number queries the edge table for the other triangle sharing that edge, returning the index of said triangle (or –1 if no such triangle).

```
int GetTriangleNeighbor(int triIndex, int edgeNum)
{
    // Get vertex indices for the edge and compute corresponding hash key
    int vi = tri[triIndex].vertexIndex[edgeNum];
    int vj = tri[triIndex].vertexIndex[(edgeNum + 1) % 3];
    if (vi > vj) Swap(vi, vj);
    int hashKey = ComputeHashKey(vi, vj);
    // Search hash bucket list for a matching edge
    for (EdgeEntry *pEdge = edgeListHead[hashKey]; pEdge != NULL; pEdge = pEdge->pNext) {
        // ...
        if (pEdge->vertexIndex[0] == vi && pEdge->vertexIndex[1] == vj) {
            // Get index of the OTHER triangle of this edge
            int whichEdgeTri = (pEdge->triangleIndex[0] == triIndex);
            return pEdge->triangleIndex[whichEdgeTri];
        }
    }
    // The input edge was a boundary edge, not connected to any other triangle
    return -1;
}
```

Here, the function **MarkAllNeighbors()** is given recursively, for brevity. In practice, the function should be written to use an explicit stack because the program stack is unlikely to cope with a recursive routine working on a mesh of several thousand faces (see Chapter 6 for a description on how to turn recursion into the use of an explicit stack). An explicit stack would also better facilitate writing the code so as to not unnecessarily visit the face the code just came from. Additionally, an explicit stack also provides more options for controlling what and how much data is being stacked.

12.3 Holes, Cracks, Gaps, and T-junctions

A hole in a mesh is signified by a set of vertices, connected by a closed chain of edges in which no faces have been defined to connect all of these vertices and edges. Unlike intentional holes, which tend to be large, unintentional holes are usually narrow slits between two or more faces that were supposed to be connected (Figure 12.8). Unintentional holes are often referred to as *cracks* or *seams*.

The term *crack* is also used to refer to narrow wedge-like slots between two partially connected geometries. Narrow voids between two completely unconnected geometries will be referred to as *gaps*. Cracks can be found and addressed through local inspection; gaps can be detected only through global means.

Many cracks of a mesh are caused by duplicated vertices. These cracks are effectively resolved by welding the vertices of the mesh. Left are the cracks consisting of vertices that lie on the interior of some opposing edge of the edge-chain forming the crack. Situations in which an endpoint of one edge lying on the interior of another edge — the vertex usually displaced off the line by some small amount — are referred to as a *t-junctions* or *t-joints* (so named because the two edges often meet in the form of a letter T). The endpoint is called the *t-vertex*. In other words, a t-vertex is a vertex belonging to one or more polygons, falling on an edge of a polygon to which it does not belong. A t-junction may be formed either as part of a crack or a gap, depending on what the surrounding geometry looks like. Figure 12.9 illustrates all three problem situations: a (nonhole) crack, a gap, and a t-junction.

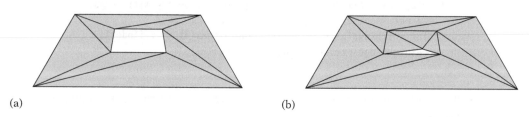

(a) (b)

Figure 12.8 (a) A mesh with an intentional hole. (b) A mesh with an unintentional hole — a crack (exaggerated).

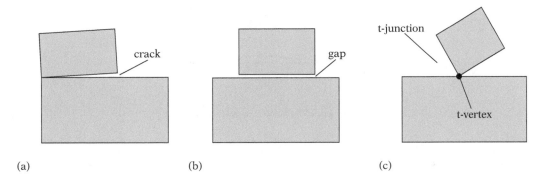

(a) (b) (c)

Figure 12.9 (a) A (nonhole) crack. (b) A gap. (c) A t-junction (and its corresponding t-vertex).

Several methods can be employed for detecting the presence of t-junctions. A straightforward approach is to loop over all vertices of the mesh and for each vertex test its connected edges, pairwise, for (near) collinearity. If two collinear edges are found, the edges are part of a crack. The crack can be resolved by merging the endpoint of one edge onto the other edge. Because vertices may be visited in any order, for this approach to correctly resolve cracks that involve an arbitrary number of vertices it is important that the endpoint vertices of the two merged edges be recursively revisited after the merge to locate all vertices on the edge-chain of the crack. If the mesh under repair is known to be 2-manifold, it is possible to limit the process to examining only those edges that have exactly one face connected to them. This method is simple to implement and it deals with all cracks correctly. However, it does not address gaps, in that gaps by definition cannot be found by a local examination of the geometry.

Resolving gaps correctly requires a more sophisticated, global method. Given an edge, this method must be able to find all mesh vertices lying on or nearly on the edge. Alternatively, given a vertex the method must be able to locate all edges the vertex is near. A practical solution is to insert all mesh edges into a hierarchical structure like an hgrid or a loose octree, which can then be queried for each vertex of the mesh.

As crack- or gap-induced t-junctions are found, they must be resolved. There are three main approaches to resolving t-junctions (illustrated in Figure 12.10).

- *Vertex collapse.* The t-vertex is displaced along the edge opposing it, toward either endpoint of the edge, and collapsed with that endpoint.

- *Edge cracking.* A more general solution is to split the edge opposing the t-vertex in half and connect the two new endpoints to the t-vertex. This increases the vertex count of all faces connected to the opposing edge by one.

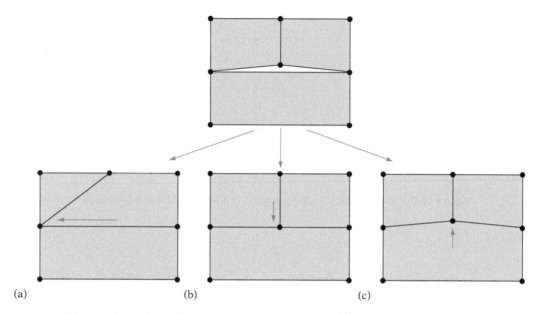

Figure 12.10 Three alternative methods for resolving a t-junction. (a) Collapsing the t-vertex with a neighboring vertex on the opposing edge. (b) Cracking the opposing edge in two, connecting the two new edge endpoints to the t-vertex. (c) Snapping the vertex onto the opposing edge and inserting it, by edge cracking, into the edge.

- *Vertex snapping.* Similar to edge cracking, this approach first snaps the t-vertex to lie on the opposing edge, after which the edge is cracked as in the previous alternative.

Vertex collapsing is not applicable in all situations, but when it is it is often preferable because it reduces the vertex count by one. It also effectively removes one edge from one of the faces connected to the t-vertex and the vertex into which the t-vertex is collapsed. When this face is a triangle, it becomes degenerate and can be removed. Note that all three approaches can create nonplanar or nonconvex faces. Subsequent triangulation of the involved faces may therefore be required.

When working with nonmanifold geometry, gaps may also appear as one face sits slightly above another face; for example, a small face upright in the middle of a large horizontal face (as shown in Figure 12.11). To resolve this, the second larger face must be split up to incorporate the edge of the first face. This *face cracking* can be handled by the same hierarchical data structure used for edge cracking if mesh faces instead of mesh edges are inserted into the data structure.

For some intersection queries, such as ray-versus-mesh tests, interpenetrating surfaces do not pose a problem to the queries. If this is the case, the face cracking

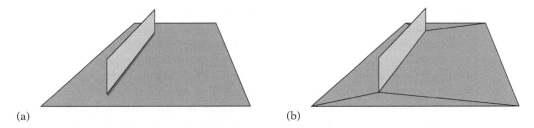

Figure 12.11 (a) A face meeting another face edge-on, forming a gap. (b) The gap resolved by face cracking.

does not have to be performed when the vertices of the edge lie in the negative halfspace of the supporting plane of the other face.

12.4 **Merging Co-planar Faces**

Edge and face cracking may introduce a fair number of extra faces to the collision. Because collision detection speed decreases as the number of faces increases, it is worthwhile incorporating an optimization step into the generation of robust collision geometry to help reduce the number of faces.

Many methods have been suggested for model simplification. Thorough reviews of the field are given in [Luebke02] and [Puppo97]. For collision detection, it is very important to preserve both shape and volume to prevent the collision geometry from "shrinking" inside the visual representation, allowing objects to interpenetrate visually even though they may not actually be touching in a collision sense. Out of the huge library of simplification methods, one approach particularly suitable for collision detection geometry is that of merging (near) co-planar faces. Face merging also helps to remove sliver-like and other degenerate faces, which are usually a source of robustness problems (see Chapter 11).

In addition to two faces being co-planar up to some given tolerance, some other criteria generally must be fulfilled for two faces to be mergeable. Specifically, the faces must:

- both be either double or single sided, and face in the same general direction when single sided,

- have the same associated surface properties (footstep sounds, friction attributes, or similar attributes), and

- share one or more boundary edges.

In this text, when two or more faces are said to be co-planar it is assumed that the faces are mergeable under these criteria.

Because the result of preprocessing is likely a triangle or quad mesh, one alternative is to merge two or more co-planar faces as long as the resulting face is a triangle or a quad. This straightforward approach is simple to implement. However, for it to produce a near-optimal result large clusters of faces would have to be considered for simultaneous merging. For example, for the spiral-like mesh given in Figure 12.12 no combination of faces other than all nine faces together form a convex face. Thus, a combinatorial number of face combinations would have to be tested for merging in the worst case, which is impractical.

A more involved method, but which promises much better results, is to merge *all* co-planar neighboring faces into a single (concave) polygon in a first pass. In a subsequent second pass, these polygons are then triangulated or otherwise decomposed into the type of convex pieces desired for the end result.

If adjacency information is available, it is straightforward to merge neighboring co-planar faces simply by visiting neighboring faces through the provided adjacency links. For example, given an edge-face table the merging process is linear in the number of edges, proceeding by looping over the edges and merging the faces connected to the edge if co-planar. If no adjacency information is available, instead of first computing adjacency information and then proceeding as described previously an alternative option is to find nearly co-planar faces through a scheme similar to environment cube mapping [Akenine-Möller02].

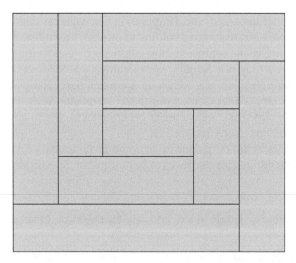

Figure 12.12 If two (or more) faces are only considered for merging when the resulting face is convex, no merging can be done for this spiral-like mesh. If concave faces are allowed during merging, this mesh can be merged into a single (quadrilateral) face.

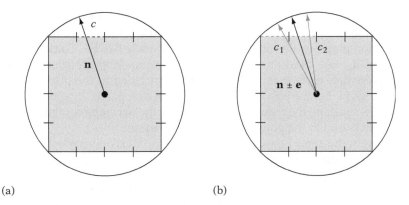

(a) (b)

Figure 12.13 (a) The normal **n** hits cell c (dashed) on the top face of the cube inscribed in the unit sphere. (b) The perturbed normal $\mathbf{n} \pm \mathbf{e}$ hits cells c_1 and c_2. The contents of these cells must be tested for co-planarity with the polygon having the normal **n**.

Each polygon normal can be seen as describing a position of the surface of the unit sphere. Let a cube be inscribed in the unit sphere, each cube face divided into a number of cells of a fixed uniform size. Each polygon normal will intersect some cube face cell (Figure 12.13a). Let polygons be associated with the face cell their normals intersect.

Near co-planar polygons will now largely map to the same cell, allowing them to be further processed after their co-planarity has been verified. However, due to the arbitrary discretization into cells, two plane normals arbitrarily close may still end up in different cells. A simple solution to this problem is to test all eight neighboring face cells of the cell the polygon normal intersected. Some care must be taken near the cube edges to make sure the correct cells are visited.

To cut down on the number of neighboring cells to test, the polygon normal **n** can be perturbed slightly in the plane of the intersected face, giving a rectangular region in the face, describing the area for which normals would be considered coplanar to **n**. All cells overlapped by the rectangular region would then be tested, similar to before (Figure 12.13b). Typically, the number of cells overlapped by this region would be smaller than eight. Again, care must be taken to visit the correct cells when the rectangular region extends over a cube edge.

The presented method has an expected complexity of $O(n)$. An alternative but less efficient $O(n \log n)$ tree-based sorting method is given in [Salesin92]. Alternative solutions to the problem of merging (near) co-planar faces are presented in [Hinker93] and [Kalvin96].

12.4.1 Testing Co-planarity of Two Polygons

One approach to testing if two polygons are co-planar is to compute the angle between their plane normals. If the angle is less than some given tolerance, the

polygons are considered co-planar and can be merged. This method works for many applications, such as general model simplification [Hinker93]. However, for collision detection purposes this approach is fundamentally flawed. Consider two polygons, A_1 and B_1, at a fixed angle θ to each other, requiring a plane thickness of d_1 of a representative plane for all vertices to be included in the plane, as illustrated in Figure 12.14. Let the polygons be scaled up in size, giving A_2 and B_2. Even though θ remains constant, the required thickness d_2 of the new representative plane increases without bound as the polygons are scaled up in size.

Clearly, the angle between the polygon normals is only a *relative* measurement of the co-planarity of the polygons. For an *absolute* error measurement, the thickness of the representative plane must be considered. A better solution to testing two polygons for co-planarity is therefore to perform the merging of the two polygons, conceptually, and see if the resulting polygon is considered planar by a polygon planarity test (presented in the next section). This approach directly extends to the merging of an arbitrary number of polygons.

To use a relative measurement of co-planarity for controlling merging of polygons for use with a collision detection system, the vertices of the merged polygons must be snapped to the representative plane of the merged polygon. This bounds the deviation of the polygon vertices from the plane, allowing the distance error to remain less than the tolerance value used to enforce thickness of the polygon for robust intersection tests.

However, with welded vertices snapping the vertices of one or more polygons to a representative plane inevitably introduces nonplanarity errors in faces sharing vertices with these polygons. Trying to address this would likely cause a ripple effect involving all vertices of the object. A reasonable solution is to let a subsequent triangulation pass take care of triangulating any faces that have been made more nonplanar than the given tolerance allows. Unfortunately, nothing guarantees that there are not more faces created during this triangulation than are removed through the initial merging process!

Figure 12.14 Testing the angle between the normals of the planes of two polygons is a *relative* measurement of their co-planarity, unaffected by scaling up the polygons. Testing the thickness required for the best-fit plane to contain all polygon vertices is an *absolute* measurement of the co-planarity of the polygons.

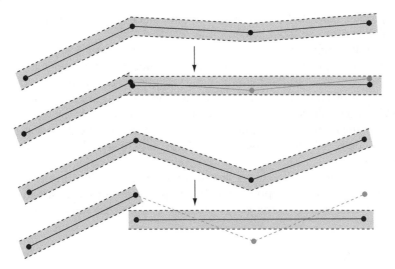

Figure 12.15 The upper illustration shows how an absolute merging tolerance smaller than the plane thickness tolerance (in gray) avoids cracks from appearing between neighboring faces. The lower illustration shows how a crack may appear when the merging tolerance exceeds the plane thickness tolerance.

Worse, if vertices are unwelded and are allowed to move during merging cracks can appear at the edges between neighboring faces unless the absolute merging tolerance is kept smaller than the plane thickness tolerance. Figure 12.15 illustrates how a crack may appear between a face and a merged face when the merging tolerance exceeds the plane thickness tolerance. To avoid tolerance issues that would cause robustness problems and to guarantee the reduction of faces due to merging, it is important to use an absolute error measurement for merging geometry for use with collision detection.

12.4.2 Testing Polygon Planarity

A polygon is defined by a set of vertices in the plane. Testing the polygon for planarity then involves making sure all defining vertices lie in a plane. This can be done by computing a plane equation for the supporting plane of the polygon and then testing all vertices to make sure they are within some tolerance of the plane. The plane equation for the supporting plane is obtained through computing a polygon normal and selecting a reference point on the polygon.

This sounds simple enough, but there is a hidden subtlety: how to compute the polygon normal $\mathbf{n} = (n_x, n_y, n_z)$. A first approach to computing the polygon normal might involve computing the cross product of two coincident polygon edges. However, this is not robust because the edges may be (near) collinear, causing the

cross product result to be the zero vector (and making the computation suffer large cancellation errors well before becoming zero).

Even if the angle between the edges is large, there is still a problem. Assume all vertices lie on a plane, except for the vertex V shared by the two edges. Let V deviate from the plane by some distance d. If the polygon is scaled up in the plane, V will remain at a distance d from the plane and the absolute planarity of the polygon should not be affected. However, because the cross product of those two edges was chosen as the representative plane normal, all vertices but the three coincident with the two edges will move arbitrarily far from the chosen plane as the polygon is scaled up.

It seems clear that all vertices should somehow be involved in the normal computation. One common approach is to compute the normal \mathbf{n}_i at each vertex V_i (as the cross product of the edges incident at the vertex) and then average the normals:

$$\mathbf{n} = \frac{1}{n} \sum_{0 \le i < n} \mathbf{n}_i, \quad \text{where} \quad \mathbf{n}_i = (V_{i+1} - V_i) \times (V_{i-1} - V_i).$$

It is here assumed that $V_n = V_0$ and $V_{-1} = V_{n-1}$. Because the magnitude of \mathbf{n} is unimportant, the normals can be summed rather than averaged.

Although this works well for convex polygons, it is unfortunately flawed for nonconvex polygons. Normals computed at concave vertices will point in the opposite direction of those computed at convex vertices. For example, consider the class of star-shaped polygons shown in Figure 12.16. The normals at the even-numbered vertices point out of the page, whereas the normals of the odd-numbered vertices point into the page.

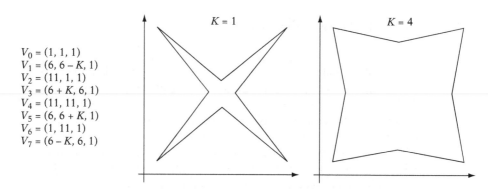

$V_0 = (1, 1, 1)$
$V_1 = (6, 6 - K, 1)$
$V_2 = (11, 1, 1)$
$V_3 = (6 + K, 6, 1)$
$V_4 = (11, 11, 1)$
$V_5 = (6, 6 + K, 1)$
$V_6 = (1, 11, 1)$
$V_7 = (6 - K, 6, 1)$

Figure 12.16 A class of star-shaped polygons, parameterized by K, $0 < K < 5$.

When normals of opposing direction are summed, the result may point in either direction, depending on the relative magnitudes of the inputs. Specifically, in this case the following (unnormalized) normals are obtained for a few different values of K:

K	\mathbf{n}
1	$(0, 0, -124)$
2	$(0, 0, -56)$
3	$(0, 0, 4)$
4	$(0, 0, 56)$

As the table indicates, the normal changes direction between $K = 2$ and $K = 3$. In fact, at about $K = 2.928932$ the normal becomes the zero vector and the method fails catastrophically!

It turns out that a much better and robust approach to computing normals is one commonly known as *Newell's method* [Tampieri92]. Newell's method uses the fact that the components of a polygon normal are proportional to the signed areas of the projections of the polygon onto the yz, xz, and xy planes. \mathbf{n} can therefore be computed as:

$$n_x = \sum_{0 \le i < n} (V_{i,y} - V_{i+1,y})(V_{i,z} + V_{i+1,z})$$

$$n_y = \sum_{0 \le i < n} (V_{i,z} - V_{i+1,z})(V_{i,x} + V_{i+1,x})$$

$$n_z = \sum_{0 \le i < n} (V_{i,x} - V_{i+1,x})(V_{i,y} + V_{i+1,y})$$

The terms being summed correspond to twice the signed area of the trapezoids formed, in each principal plane, by the current polygon edge and its projection onto the corresponding axis. The first term is the width of the trapezoid; the second term is twice its height. By rearranging terms, it can be seen that Newell's method is equivalent to computing the normal through the sum:

$$\mathbf{n} = \sum_{0 \le i < n} \mathbf{m}_i, \quad \text{where} \quad \mathbf{m}_i = V_i \times V_{i+1}.$$

For the star-shaped polygon used earlier, Newell's method consistently produces the expected normal (pointing out of the page):

K	\mathbf{n}
1	$(0, 0, 40)$
2	$(0, 0, 80)$
3	$(0, 0, 120)$
4	$(0, 0, 160)$

The following code illustrates how Newell's method can be implemented to compute a robust representative plane for a polygon. Here, the polygon centroid — that is, the average of all vertices — is used as the representative point on the plane when computing the plane equation.

```
// Given n-gon specified by points v[], compute a good representative plane p
void NewellPlane(int n, Point v[], Plane *p)
{
    // Compute normal as being proportional to projected areas of polygon onto the yz,
    // xz, and xy planes. Also compute centroid as representative point on the plane
    Vector centroid(0.0f, 0.0f, 0.0f), normal(0.0f, 0.0f, 0.0f);
    for (int i = n - 1, j = 0; j < n; i = j, j++) {
        normal.x += (v[i].y - v[j].y) * (v[i].z + v[j].z); // projection on yz
        normal.y += (v[i].z - v[j].z) * (v[i].x + v[j].x); // projection on xz
        normal.z += (v[i].x - v[j].x) * (v[i].y + v[j].y); // projection on xy
        centroid += v[j];
    }
    // Normalize normal and fill in the plane equation fields
    p->n = Normalize(normal);
    p->d = Dot(centroid, p->n) / n; // "centroid / n" is the true centroid point
}
```

Newell's method can be seen as computing a "best-fit" plane, using all vertices. Yet another alternative approach is to fit a plane to the polygon vertices using the method of *least-squares fit* (see [Eberly01] for details).

Computing plane equations using Newell's method is clearly more expensive than just taking the cross product of two coincident edges. Storing plane equations with the polygons is one option, but this is unattractive memory-wise. A compromise is still computing normals and plane equations at runtime using a cross product, but after having made sure the polygon is output so that the first three stored vertices of

the polygon give the best representative result. It is also possible to simplify Newell's method for specific primitives. For example, given a quadrilateral $ABCD$ the normal obtained by Newell's method can be reduced to that of computing the cross product of the two diagonals AC and DB because

$$2(AC \times DB) = (AB \times AD) + (BC \times BA) + (CD \times CB) + (DA \times DC).$$

The right-hand side of the expression corresponds to the summing of the cross product normals at each vertex. Interestingly, it is thus actually cheaper to compute a robust normal for a quadrilateral than it is to do the same for a triangle!

After having computed a good representative plane for a polygon, it is finally possible to test the planarity of the polygon by putting each of its vertices, in turn, through the computed plane equation to see by how much each vertex deviates from the plane. If they are all within a preset tolerance distance from the plane, the polygon is considered planar. An implementation of this test follows.

```
// Test if n-gon specified by vertices v[] is planar
int IsPlanar(int n, Point v[])
{
    // Compute a representative plane for the polygon
    Plane p;
    NewellPlane(n, v, &p);
    // Test each vertex to see if it is farther from plane than allowed max distance
    for (int i = 0; i < n; i++) {
        float dist = Dot(p.n, v[i]) - p.d;
        if (Abs(dist) > PLANARITY_EPSILON) return 0;
    }
    // All points passed distance test, so polygon is considered planar
    return 1;
}
```

In [Sunday02], the author addresses how to reduce the number of arithmetic operations needed to compute Newell normals and polygon areas.

12.5 Triangulation and Convex Partitioning

Although it would be possible to perform collision detection directly against the merged faces, tests involving convex faces only are often simpler, faster, and more robust. It therefore makes sense to decompose nonconvex faces into two or more convex pieces, a process known as *convex partitioning*. One alternative is simply to

triangulate nonconvex faces: decomposing them into a set of triangles. All faces can be triangulated, often in many different ways. Another alternative is to partition the faces into as few convex pieces as possible, thus reducing the number of faces to be tested.

The following sections describe two methods: one for triangulation of nonconvex faces and one for decomposition of nonconvex faces into a small number of convex pieces. Last, the problem of decomposing nonconvex polyhedra into convex pieces is discussed.

12.5.1 **Triangulation by Ear Cutting**

Various algorithms have been invented for the triangulation of polygons, ranging from slow but easy-to-implement algorithms to algorithms that although theoretically optimal are so complicated they are unimplementable in practice! One popular and quite straightforward triangulation algorithm proceeds by a process known as *ear cutting* (or *ear clipping*).

The triangle formed by a polygon vertex V_i and its immediate predecessor and successor vertices V_{i-1} and V_{i+1} is said to be an *ear* if the diagonal between V_{i-1} and V_{i+1} is contained in its entirety in the polygon. The vertex V_i is said to be the *ear tip*. The ear is commonly referred to by the ear tip vertex alone. It can be shown that every simple nontriangle polygon has at least two nonoverlapping ears [Meisters75]. Thus, all such polygons can be triangulated by the repeated identification and removal (or cutting) of ears. It follows that a triangulation of a simple polygon with n vertices consists of exactly $n - 2$ triangles. Figure 12.17 shows a simple polygon with two ears and one possible triangulation of the polygon.

For a simple polygon an equivalent test for three consecutive vertices V_{i-1}, V_i, and V_{i+1} forming an ear E is to make sure V_i is convex and that no other polygon vertex lies inside E. V_i is convex if E has the same winding as the polygon itself. Specifically, for a counterclockwise polygon V_i is convex if E is counterclockwise.

Now consider the process of triangulation by repeated ear cutting. Initially, a polygon will have some number n of ears, $n \geq 2$. As an ear is cut, n may decrease, increase, or stay the same. The change in number of ears depends on the ear tip-ness of the vertices V_{i-1} and V_{i+1} after the cutting. In other words, the change of ear-ness only happens locally to the vertices where the ear is cut.

A polygon can therefore be triangulated by looping counterclockwise (say) around the polygon boundary, visiting the vertices sequentially one after one, testing them for ear-ness. As ears are encountered, they are cut. To make sure both vertices where an ear is cut are revisited, the vertex previous to the (removed) ear tip vertex is set as the next vertex to visit after a cut.

Figure 12.18 illustrates the first steps of a triangulation using this method. Starting at V_0, vertex V_5 is found to be inside the ear triangle during ear verification, and thus V_0 is not an ear. The algorithm therefore proceeds to the next vertex V_1. V_1 is also

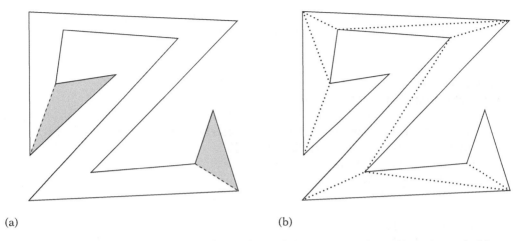

(a) (b)

Figure 12.17 (a) A simple polygon that only has two ears (ears shown in gray). (b) One possible triangulation of the polygon.

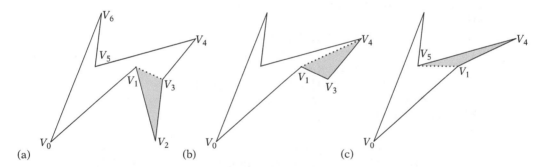

(a) (b) (c)

Figure 12.18 The first steps of triangulation by ear cutting. (a) Identifying V_2 as an ear. (b) Identifying V_3 as an ear after cutting V_2. (c) Identifying V_4 as an ear after cutting V_3.

not an ear because V_1 is not convex, in that the triangle (V_0, V_1, V_2) is clockwise. The algorithm proceeds to V_2. Because V_2 is convex and no polygon vertices lie in the triangle (V_1, V_2, V_3), V_2 is an ear and is clipped. Now a step back is taken, to revisit V_1 because its ear-ness status might have changed. However, V_1 is still concave, and thus the algorithm proceeds to its successor vertex, which is now V_3. It is found to be an ear and is cut, and thus the algorithm again revisits V_1. Yet again V_1 is concave. Next is vertex V_4, which is an ear. V_1 is now revisited once more, this time found to be an ear. After V_1 is cut, what remains is a triangle and the algorithm stops.

Testing if a vertex is an ear may require testing all other vertices for containment in the ear, and is therefore $O(n)$. The outer loop may end up performing up to the

order of 2*n* such tests. The overall complexity of the algorithm thus becomes $O(n^2)$. The following code fragment implements this triangulation algorithm.

```
// Triangulate the CCW n-gon specified by the vertices v[]
void Triangulate(Point v[], int n)
{
    // Set up previous and next links to effectively form a double-linked vertex list
    int prev[MAX_VERTICES], next[MAX_VERTICES];
    for (int i = 0; i < n; i++) {
        prev[i] = i - 1;
        next[i] = i + 1;
    }
    prev[0] = n - 1;
    next[n - 1] = 0;

    // Start at vertex 0
    int i = 0;
    // Keep removing vertices until just a triangle left
    while (n > 3) {
        // Test if current vertex, v[i], is an ear
        int isEar = 1;
        // An ear must be convex (here counterclockwise)
        if (TriangleIsCCW(v[prev[i]], v[i], v[next[i]])) {
            // Loop over all vertices not part of the tentative ear
            int k = next[next[i]];
            do {
                // If vertex k is inside the ear triangle, then this is not an ear
                if (TestPointTriangle(v[k], v[prev[i]], v[i], v[next[i]])) {
                    isEar = 0;
                    break;
                }
                k = next[k];
            } while (k != prev[i]);
        } else {
            // The 'ear' triangle is clockwise so v[i] is not an ear
            isEar = 0;
        }

        // If current vertex v[i] is an ear, delete it and visit the previous vertex
        if (isEar) {
            // Triangle (v[i], v[prev[i]], v[next[i]]) is an ear
            ...output triangle here...
```

```
        // 'Delete' vertex v[i] by redirecting next and previous links
        // of neighboring verts past it. Decrement vertex count
        next[prev[i]] = next[i];
        prev[next[i]] = prev[i];
        n--;
        // Visit the previous vertex next
        i = prev[i];
    } else {
        // Current vertex is not an ear; visit the next vertex
        i = next[i];
    }
  }
}
```

In some cases it is desirable to support polygons with holes. One way of handling such polygons is described next.

12.5.1.1 Triangulating Polygons with Holes

To be able to triangulate polygons with holes, a reasonable representation must first be established. A common representation is as a counterclockwise outer polygon boundary plus one or more clockwise inner hole boundaries. The drawing on the left in Figure 12.19 illustrates a polygon with one hole.

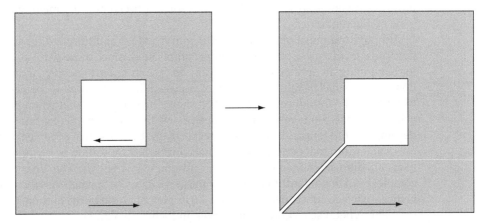

Figure 12.19 Handling holes by cutting a zero-width "channel" from the outer (CCW) boundary to the (CW) hole boundary. (The endpoint vertices of the channel coincide, but are shown slightly separated to better illustrate the channel formation.)

To be able to triangulate the polygon, the outer and inner boundaries must be merged into a single continuous chain of edges. This can be done by cutting a zero-width"channel"from the outer boundary to each inner boundary. Cutting this channel consists of breaking both the inner and outer boundary loops at a vertex each and then connecting the two vertices with two coincident edges in opposite directions such that the outer boundary and the hole boundary form a single counterclockwise continuous polygon boundary. Figure 12.19 shows how a hole is effectively resolved by this procedure. Multiple holes are handled by repeating the cutting procedure for each hole.

Sometimes the boundaries are given with arbitrary orientation and it is not known which boundary is the outer boundary and which are the hole boundaries. In these cases, the outer boundary can be assumed to be the one defining the polygon with the largest area and the remaining boundaries correspond to the holes. Once the outer boundary has been determined, a counterclockwise ordering for it, and clockwise ordering for the holes, is easily enforced by reversing the vertex order, if necessary.

Several triangulation programs are publicly available on the Internet. The perhaps best, most robust, program is due to Jonathan Shewchuk. Its implementation is discussed in [Shewchuk96b]. A good discussion of robust triangulation is also given in [Held01].

12.5.2 **Convex Decomposition of Polygons**

As shown in Chapter 5, an intersection test between a ray and a quadrilateral is no more expensive than against a triangle. Allowing collision geometry to consist not just of triangles but quadrilaterals or even arbitrary convex polygons can therefore provide a potential speedup at the cost of some extra complexity maintaining polygons of different order.

Although triangulation of a simple polygon is quite straightforward, its decomposition into a set of convex polygons is more complicated, much more so for an algorithm for computing an optimal decomposition. In fact, in order to achieve a decomposition into the smallest number of convex pieces additional vertices — *Steiner points* — may have to be introduced. Figure 12.20 shows two polygons that when partitioned using diagonals alone result in at best five and three convex pieces, but which can decompose into four and two pieces, respectively, by introducing Steiner points.

An algorithm that performs a minimal convex decomposition of a simple polygon (without the use of Steiner points) is presented in [Keil02]. The time and space complexity of this algorithm is $O(n + r^2 \min(r^2, n)) = O(n^3)$, where n is the number of vertices of which r are concave vertices. An implementation by the authors is available on the Internet. Pseudocode is also given in [Schneider02].

A simpler algorithm for convex decomposition is due to Hertel and Mehlhorn [Hertel83]. Starting with a triangulation of the simple polygon, the Hertel–Mehlhorn algorithm considers each diagonal one at a time. If the diagonal can be removed

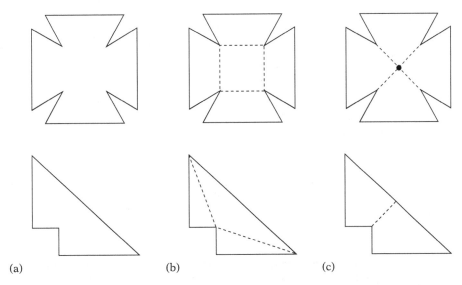

(a) (b) (c)

Figure 12.20 (a) Original polygons. (b) Optimum convex decomposition without the use of additional vertices, known as Steiner points. (c) Optimum convex decomposition using Steiner points.

without creating a concave vertex, it is removed. If not, processing proceeds with the next diagonal until all diagonals have been examined, making the complexity $O(n)$. The triangulation dominates the process, and the overall complexity is therefore $O(n^2)$. An example of convex decomposition using the Hertel–Mehlhorn algorithm is shown in Figure 12.21. In pseudocode, the Hertel–Mehlhorn algorithm becomes:

```
Mesh HertelMehlhorn(Polygon p)
{
    // Produce a triangulated mesh from the original polygon
    Mesh m = TriangulatePolygon(p);
    // Loop over all diagonals of the triangulated polygon
    int numDiagonals = GetNumberOfDiagonals(m);
    for (int i = 0; i < numDiagonals; i++) {
        // Test if the i-th diagonal can be removed without creating
        // a concave vertex; if so, remove the diagonal from the mesh
        if (DiagonalCanBeRemoved(m, i))
            RemoveDiagonal(m, i);
    }
```

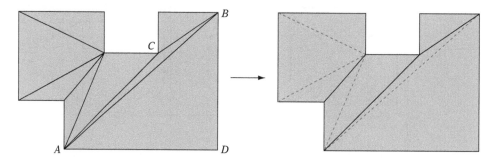

Figure 12.21 The Hertel–Mehlhorn algorithm turns a polygon triangulation into a convex decomposition by deletion of as many diagonals as possible.

```
    // The mesh is now a convex decomposition of the polygon. Return it
    return m;
}
```

Instead of having a separate second pass in which diagonals are deleted, this deletion can be incorporated into the actual triangulation process. As an ear is clipped, it is tested against the previously cut polygon. If merging the cut triangle with the previous polygon would form a convex polygon, the merge is performed. Otherwise, the previously cut polygon is output, and the just cut ear is kept as the new "previous polygon." The test itself can be performed in constant time by testing the convexity of the vertices where the triangle would attach to the previous polygon.

It can be shown that any convex partitioning that does not contain unnecessary edges will have at most four times the minimum number of convex pieces. Typically, for real-world cases the Hertel–Mehlhorn algorithm produces partitions not far from optimal.

It is possible to change the triangulation algorithm slightly to generate even better partitions, in general. The improvement consists of making the algorithm prefer creating diagonals that connect to at least one concave vertex to those that connect two convex vertices. For example, in Figure 12.21 replacing the diagonal between the convex vertices A and B with one from C to D would result in a convex decomposition into three instead of four pieces, which here is the optimum.

12.5.3 Convex Decomposition of Polyhedra

Just as intersection tests with convex polygons are faster than tests with arbitrary polygons, intersection tests on polyhedra are much more efficient if the polyhedra are convex. Nonconvex polyhedra are therefore best broken into convex pieces, allowing

the efficient algorithms of Chapter 9 to be used for collision detection. Overall, the decomposition of a polyhedron into convex pieces is a difficult problem. It is not made easier by the fact that some objects do not decompose well, or at all. For example, the inside of a bowl is concave everywhere; it can therefore not be broken into convex pieces (or, for a polygonal bowl, other than in the trivial sense of one piece per face). A torus is another example of a shape problematic to decompose.

A first idea for decomposition is to apply something similar to triangulation to the polyhedra. The equivalent of triangulation for polyhedra is *tetrahedralization*: the partitioning of a polyhedron into tetrahedra. Although all polygons can be triangulated, it turns out not all polyhedra are tetrahedralizable. Perhaps the most well-known example of a nontetrahedralizable polyhedron is *Schönhardt's polyhedron*, discovered as early as 1928. It is constructed from a triangular prism by twisting one of the triangles relative to the other so that each of the three rectangular faces of the prism "folds" into two triangles with a concave edge between them (Figure 12.22). When any four vertices of this polyhedron are considered, two of them must lie on opposite sides on one of these concave edges. Because no four vertices form a tetrahedron, tetrahedralization is therefore impossible.

However, the Schönhardt polyhedron is tetrahedralizable with the addition of a point internal to the polyhedron, a Steiner point. Some polyhedra of n vertices may, in fact, require on the order of $O(n^2)$ Steiner points to allow a tetrahedralization (one example is known as Chazelle's polyhedron). It has been shown that deciding whether a polyhedron is tetrahedralizable without the addition of Steiner points belongs to the class of NP-complete problems. In practical terms, this means that attempting to use a 3D equivalent to the Hertel–Mehlhorn algorithm for decomposing a polyhedron into convex pieces is not feasible. It should be noted that convex polyhedra are always tetrahedralizable. Finding a minimal tetrahedralization of a convex polyhedron is an NP-hard problem, however.

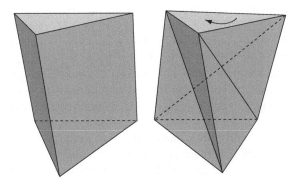

Figure 12.22 The Schönhardt polyhedron is obtained by twisting one of the triangles of a triangular prism relative to the other, creating three diagonal concave edges when the vertical sides of the prism are triangulated.

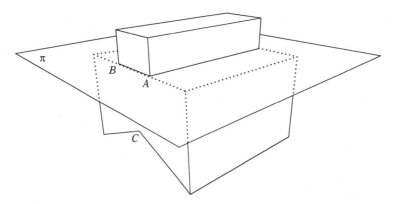

Figure 12.23 A good heuristic is to resolve two or more concave edges with a single cut. Here the cutting plane π passes through the concave edges A and B, leaving just one concave edge C (going into the drawing).

A more feasible approach to convex decomposition is to recursively split the polyhedron in two with a cutting plane through one or more concave edges. In that such a split reduces the number of concave edges by one, the procedure will eventually terminate, returning a set of convex pieces (which lack concave edges).

If the goal is to produce as few convex pieces as possible, a good rule is to attempt to resolve as many concave edges as possible with the same cut. This means that fewer cuts are needed, generally resulting in fewer pieces overall. Figure 12.23 illustrates a cut resolving two concave edges.

Where only one concave edge can be resolved, one degree of freedom remains to determine the cutting plane fully: the angle of rotation about the concave edge. In these cases, two reasonable options are to either find some other (convex) edge with which to form a cutting plane or to select the cutting plane to be the supporting plane of one of the faces incident to the concave edge. Both alternatives are illustrated in Figure 12.24. The former option is not always available because there may not be an edge that forms a plane with the concave edge. It also requires search for the second edge. The latter option requires no search and can always be performed. However, cutting planes that are aligned or nearly aligned with polygon faces are sources of robustness problems, similar to the line-plane intersection problem described in Section 11.3.2.

Splitting a nonconvex polyhedron by a plane can result in many pieces, not just two. The decomposition procedure is recursively called with each piece. To limit the number of pieces generated, not the entire of the polyhedron should be split to the cutting plane. Consider Figure 12.25, which illustrates the problem. Here, the cutting plane has been selected to cut off the part labeled A from the rest of the polyhedron. However, if the cut is applied globally across the polyhedron part B will also be cut off.

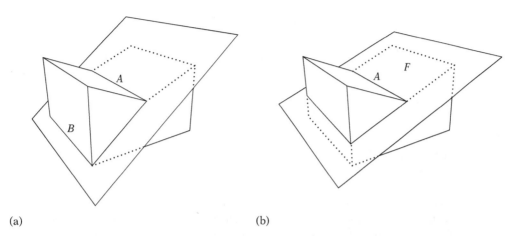

(a) (b)

Figure 12.24 Two alternatives to resolving a single concave edge A. (a) Cutting to the plane through A and some other edge B. (b) Cutting to the supporting plane of one of its neighboring faces F.

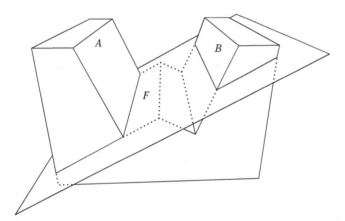

Figure 12.25 Cutting (here to the supporting plane π of face F, neighboring the selected concave edge) with the intent of cutting off part A can have the unintended global effect of also cutting off part B.

The polygons straddling the cutting plane form two disjoint "contours": one local to the A part, one local to the B part. By limiting the cutting to occur at the contour having connectivity to the original concave edge, the correct behavior is obtained (which here is cutting off part A only). After the cut, the geometry both in front and behind the planes will have open holes (in the shape of the contours) that must be filled in. These holes are closed by creating a polygon in the shape of the contour and connecting it to the rest of the geometry.

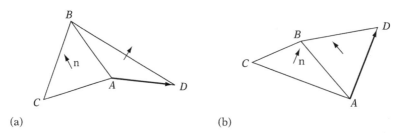

(a) (b)

Figure 12.26 (a) The edge AB is convex, as $\mathbf{n} \cdot (D - A) < 0$. (b) The edge AB is concave, as $\mathbf{n} \cdot (D - A) > 0$.

To determine if an edge is concave, the following approach can be used. Let F_1 and F_2 be the two faces meeting at an edge E. Then, the edge E is concave if some vertex of F_2 not on E lies in front of the plane through F_1. Specifically, for the two triangles ABC and ADB given in Figure 12.26 the edge AB is concave if $\mathbf{n} \cdot (D - A) > 0$, where $\mathbf{n} = (B - A) \times (C - A)$.

An algorithm for convex decomposition is given in [Belov02]. Cutting is discussed in [Yong00] and [Ribelles01]. The latter paper also covers hole filling. Convex decomposition using BSP trees is discussed in [Joshi03].

12.5.4 Dealing with "Nondecomposable" Concave Geometry

As mentioned at the start of the previous section, not all concave geometry can be feasibly decomposed into convex pieces. Consider a hemispherical bowl, modeled with polygons. Because the inside of the bowl is concave everywhere, decomposing the bowl into convex pieces would require cutting apart all faces of the inside the bowl. One solution, then, is to treat the bowl geometry as a polygon soup and collide against its boundary geometry as a collection of individual faces. This allows almost any of the collision methods described to this point to be applied to the problem. Unfortunately, a drawback of this solution is that volume information is lost. This means it is no longer possible to (easily) detect if an object is positioned fully inside the bowl geometry itself.

Another solution is to model the bowl as a CSG object. For example, a simple CSG representation of a bowl, D, is the intersection of an AABB A and the difference between two spheres B and C, $D = A \cap (B - C)$, as illustrated in Figure 12.27.

The collision status of an object M with the bowl can then be determined by the logical code expression

```
bool collides = PartiallyInside(A,M) && PartiallyInside(B,M) && PartiallyOutside(C,M);
```

where **PartiallyInside(X,Y)** is true if some part of **Y** lies inside **X** and **Partially Outside(X,Y)** is true if some part of **Y** lies outside **X**. The **PartiallyInside()**

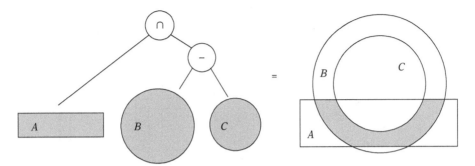

Figure 12.27 A hemispherical bowl modeled as a CSG object in terms of the intersection between the AABB *A* and the difference between the spheres *B* and *C*.

predicate is, of course, just a normal intersection test, as discussed in detail in Chapter 5. **PartiallyOutside()** is a new type of collision predicate not discussed earlier. However, its implementation is generally straightforward. For example, for the particular test needed here a sufficient condition for a line segment, triangle, polygon, or polyhedron to test as partially outside a sphere is if one or more vertices of the tested object lie outside the sphere.

12.6 Consistency Testing Using Euler's Formula

Badly formed geometry can also be detected through tests of the topology of the geometry. First, to set the stage two solid bodies are deemed topologically equivalent, or *homeomorphic*, to each other if their surface boundaries can be deformed into each other without cutting or gluing in trying to match them up. Polyhedra homeomorphic to a sphere are called *simple polyhedra*. A tetrahedron and a cube are both examples of simple polyhedra, as are all convex polyhedra.

The mathematical relationship between the number of vertices (V), faces (F), and edges (E) of a simple polyhedron is succinctly stated in *Euler's formula*:

$$V + F - E = 2.$$

For example, the polyhedron in Figure 12.28a satisfies the formula because $V = 9$, $F = 9$, and $E = 16$ give $V + F - E = 9 + 9 - 16 = 2$.

When a polyhedron has one or more holes in it, it is no longer simple but belongs to the class of *nonsimple polyhedra*. The number of holes is referred to as the *genus* of the polyhedron. Any polyhedron of zero genus (no holes) is topologically equivalent to a sphere, of genus one to a torus, of genus two to a solid figure eight, and so on. Another way of looking at it is that all polyhedra are topologically equivalent to a

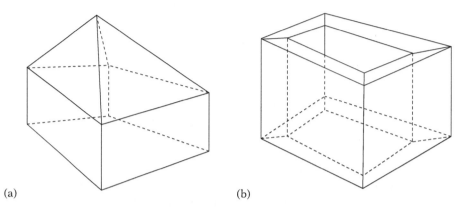

Figure 12.28 (a) A simple polyhedron. (b) A nonsimple polyhedron (of genus one).

sphere with zero or more handles, with the number of handles determined by the genus. An extended version of Euler's formula, which holds for polyhedra of any genus (*G*), is the *Euler–Poincaré formula*:

$$V + F - E = 2\,(1 - G)\,.$$

For the nonsimple polyhedron in Figure 12.28b, $V = 16$, $F = 16$, $E = 32$, and $G = 1$. It therefore satisfies the Euler–Poincaré formula. For the Euler–Poincaré formula to apply, all polyhedral faces must be bounded by a single loop of connected vertices; that is, be homeomorphic to disks. The faces cannot be rings or otherwise have holes in them. In addition, both formulas only apply to manifold geometry, and thus it is assumed that each edge is shared by exactly two faces, that each edge is connected to exactly two vertices, and that at least three edges join at each vertex.

Because the flattening of a polyhedron into the plane does not change the number of vertices, faces, or edges, Euler's formula also applies to planar graphs in general, and polygon meshes in particular. Note, however, that when flattening, for example, a cube into the plane one face of the cube corresponds to the unbounded surface outside the flattened figure. Therefore, when working with planar graphs either the unbounded face must be included in the face count or the formula has to be adjusted to account for one less face.

Several useful expressions can be derived from Euler's formula. Consider first a closed all-triangle mesh. For such a mesh, the relationship $E = 3F/2$ holds because there are three edges per face, but an edge is also part of two faces. For an arbitrary closed mesh, each face is bounded by at least three edges that all are part of two faces and the expression thus becomes $E \geq 3F/2$. Solving Euler's formula for E and F, respectively, and substituting in this expression gives that $F \leq 2V - 4$ and $E \leq 3V - 6$ for arbitrary closed meshes. If the closed mesh consists solely of triangles, the number

Table 12.1 Relationships between the number of edges, vertices, and faces of a closed mesh derived from Euler's formula.

For a *closed* (manifold) mesh consisting of a number of ...	the number of edges (E) and vertices (V) and faces relate as ...
triangles (T)	$2E = 3T, T = 2V - 4, E = 3V - 6$
quads (Q)	$2E = 4Q, Q = V - 2, E = 2V - 4$
triangles (T) and quads (Q)	$2E = 3T + 4Q, T = 2V - 2Q - 4$
arbitrary convex faces (F)	$2E \geq 3F, F \leq 2V - 4, E \leq 3V - 6$

of edges relate to the number of triangles (T) as $2E = 3T$ and the corresponding formulas become $T = 2V - 4$ and $E = 3V - 6$. If the mesh instead consists of a number of quads only, edges relate to the number of quads (Q) as $2E = 4Q$ and the formulas become $Q = V - 2$ and $E = 2V - 4$. For a closed mesh that may consist of both triangles and quads, $2E = 3T + 4Q$, and therefore $T = 2V - 2Q - 4$. These relationships between the number of edges, vertices, and faces are summarized in Table 12.1.

Euler's formula, and the formulas derived from it, can all be used to help check if a mesh is well formed. It is important to note that these formulas can only serve as necessary but not sufficient validity conditions in that a malformed mesh could by chance meet the restrictions of the formulas. The formulas should therefore be used in conjunction with other constraint checks for full validity checking.

As an example of how the formulas can be used in validity checking, consider the two cubes in Figure 12.29. Both cubes have been somewhat inefficiently modeled using nine vertices. The cube in Figure 12.29a is correctly modeled, with six quads and two triangles. The cube in Figure 12.29b, however, has been incorrectly modeled, with a t-junction on the top face (the resulting crack shown in gray). This cube consists of five quads and three triangles.

If the edge counts are known, 15 for the left cube and 16 for the right, Euler's formula gives $9 + (6 + 2) - 15 = 2$ for the left cube and $9 + (5 + 3) - 16 = 1$ for the right cube. Thus, the left cube satisfies the formula, whereas the right one does not. However, in many cases the representation used does not directly give the edge counts, only the face and vertex counts. In this case, because the cubes consist of triangles and quads only the number of edges can be computed using the formula $E = (3T + 4Q)/2$ derived earlier. For the left cube, this gives 15 edges, and for the right cube 14.5 edges. Because the number of edges must be integral, again something is wrong with the right cube. Consequently, whether edge counts are available or not, in both cases the conclusion must be that the right cube cannot have been correctly modeled.

Another way of detecting the problem is to note that for a closed manifold triangle mesh the number of triangles must be even, as $T = 2V - 4$ is always an even number.

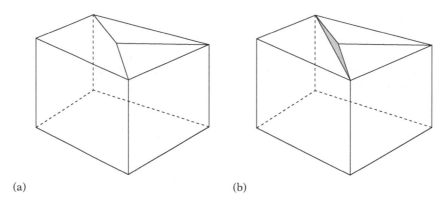

(a) (b)

Figure 12.29 The number of edges in a closed manifold mesh consisting of triangles and quads only is $E = (3T + 4Q)/2$. For the cube on the left, consisting of two triangles and six quads, this gives 15 edges. The cube on the right consists of three triangles and five quads, for which the formula gives 14.5 edges. Because this is not an integral number, the cube on the right cannot be **correctly** formed (and indeed, there is a t-junction on the top face).

The number of triangles in a closed manifold mesh consisting of triangles and quads must also be even, in that $T = 2V - 2Q - 4$ is always an even number as well.

12.7 **Summary**

It is important for collision detection systems to be given well-formed geometry as their input. If they are not, the presence of duplicated vertices, nonplanar polygons, t-junctions, and similar sources of robustness problems can easily cause severe failures such as objects falling through seemingly solid geometry.

This chapter presented solutions enabling taking an unstructured collection of polygons — a polygon soup — as input, and turning it into a well-formed mesh. The tools required for this cleanup process are generic and applicable to many other situations.

Discussed was how to weld duplicate vertices. The chapter also described how to compute adjacency information for vertices, edges, and faces, allowing the repair of cracks and t-junctions between neighboring faces. It discussed how to merge co-planar faces into a single face, and how to test for planarity and co-planarity in the first place. Because most collision systems work best with convex inputs methods for decomposing concave objects and faces into convex (or triangular) pieces were discussed. Suggestions were also given for how to deal with "nondecomposable" concave objects, such as the inside of a bowl, which is concave everywhere. Last, Euler's formula was presented as an inexpensive way to test the validity of closed meshes.

Chapter 13

Optimization

It is widely acknowledged that the most important optimizations to be made are high-level algorithmic changes. However, selecting the most appropriate algorithms for a task is but one thing. Algorithms rely on good underlying data structures whose efficiencies, in turn, are dependent on the target machine architecture. To complete the coverage of efficient data structures and algorithms, this chapter deals with a number of remaining issues related to tuning for target architectures, vital to making a production-quality collision detection system.

Recently, program efficiency could be effectively measured by counting the number of arithmetic operations performed and multiplying these by the execution time of each operator. Nonalgorithmic code optimizations therefore tended to focus on reducing the number of instructions executed or replacing instructions with equivalent but faster instructions. Although these optimizations still have some value, today two entirely different types of optimizations clearly stand out from the rest: *memory optimization* and optimizations utilizing *parallelism*.

Over the last several generations of CPUs, processor speeds have increased faster than memory access times have decreased. It is expected that this trend will continue. As such, if processes are not already, the likelihood of their becoming memory access bound is increasing at a rapid pace.

To help reduce this problem, CPU manufacturers are incorporating one or more levels of fast cache memory to sit between main memory and the CPU. These effectively implement a memory hierarchy in which higher but slower levels are only accessed if data cannot be found in the faster but smaller lower levels.

The introduction of cache memory greatly improves the situation, but alone does not serve to fully bridge the speed gap; it is still important that performance-sensitive code be written specifically to take advantage of this memory hierarchy. Because compilers have no or limited knowledge of the memory hierarchy, it is up to programmers to take advantage of it by explicitly implementing memory optimizations.

These memory optimizations can be divided into two categories: *hardware caching* and *software caching*.

Hardware caching is handled through data and instruction caches built into the CPU. Such caching happens automatically, but changes to how code and data are laid out in memory have a drastic effect on its efficiency. Optimizing at this level involves having a thorough understanding of how the CPU caches work and adapting code and data structures accordingly.

Software caching takes place at the user level and must be explicitly implemented and managed in the application, taking into account domain-specific knowledge. Software caching can be used, for example, to restructure data at runtime to make the data more spatially coherent or to uncompress data on demand.

A second important optimization is that of utilizing parallelism for both code and data. Today, many CPUs provide SIMD instructions that operate on several data streams in parallel. Most CPUs are also *superscalar* and can fetch and issue multiple instructions in a single cycle, assuming no interdependencies between instructions. Code written specifically to take advantage of parallelism can be made to run many times faster than code in which parallelism is not exploited.

Starting from the basics of CPU cache architecture, this chapter provides a thorough introduction to memory optimization. It explains how to improve low-level caching through code and data changes and how prefetching and preloading of data can further improve performance. Practical examples of cache-optimized data structures are given, and the notion of software caching as an optimization is explored. The concept of aliasing is introduced and it is explained how aliasing can cause major performance bottlenecks in performance-sensitive code. Several ways of reducing aliasing are discussed in detail. The chapter also discusses how taking advantage of SIMD parallelism can improve the performance of collision code, in particular that of low-level primitive tests. Last, the (potentially) detrimental effects of branch instructions on modern CPU instruction pipelines are covered at the end of the chapter, with suggestions for resolving the problem.

Before proceeding, it is important to stress that optimization should not be performed indiscriminately. Prior to implementing the optimizations described herein, alternative algorithm approaches should be explored. In general, a change of algorithm can provide much more improvement than fine-tuning. Do not try to intuit where optimization is needed; always use a code profiler to guide the optimization. Only when bottlenecks have been identified and appropriate algorithms and data structures have been selected should fine-tuning be performed. Because the suggested optimizations might not be relevant to a particular architecture, it also makes sense to measure the efficiency of an optimization through profiling.

Unless routines are written in assembly code, when implementing memory optimizations it is important to have an intuitive feel for what assembly code is generated for a given piece of high-level code. A compiler might handle memory accesses in a way that will invalidate fine-tuned optimizations. Subtle changes in the high-level code can also cause drastic changes in the assembly code. Make it a habit to study the assembly code at regular intervals.

13.1 **CPU Caches**

Today's CPUs are much faster at executing instructions than both instructions and data can be fetched from main memory. To work around the latencies in accessing main memory, small high-speed memories, *caches*, executing at virtually the same speed as the CPU are introduced. These caches contain copies of parts of main memory and sit between the CPU and main memory. There is typically an *instruction cache* for holding instructions and a *data cache* for holding data.

Whenever the CPU needs to fetch the next instruction or the data required for the currently executing instruction, it first looks to see if the data at the requested memory location is in the corresponding cache. If so, the data is directly fetched from the cache. If not, a *cache miss* results and the CPU must go to main memory, fetch the data, and store it in the cache. The latter alternative can be on the order of 50 to 500 times slower than the first one! Worst case, no other data is available for the CPU to work on while it is waiting for data to be fetched, causing the CPU to *stall* or come to a full halt. The CPU may also stall if instructions are executed that refer to values that have still to load. If data cannot be guaranteed to reside in cache, computations should be scheduled to occur as late as possible with respect to when data was read.

Each cache is broken into a number of sections of typically 32 or 64 bytes, called *cache lines*. Data transfer between main memory and cache is performed in section units. The cost associated with reading data from memory should therefore not be measured in the number of bytes read but in the number of cache lines accessed.

Main memory is usually mapped to the cache memory using a *direct-mapped* strategy. Direct mapping means that for a cache of M KB the bytes of each consecutive M KB area of main memory map one-to-one with cache memory. Two bytes M KB apart would consequently map to the same position in cache memory. To distinguish data in a cache line, each cache line also contains a *tag identifier*, specifying from which address in main memory the contained data originated.

Because two memory areas M KB apart map to the same cache lines, touching the memory areas alternatingly would cause the cache lines to be constantly flushed and reloaded. To lessen the impact of this problem, known as cache line *thrashing*, caches are often made *set associative* (multiway associative). For an n-way associative cache memory, each logical cache line corresponds to n physical cache lines, all of which are checked (by means of the tag identifier) to see if they hold the data requested. If not, the cache line with the oldest content is flushed and reused. In an n-way set associative cache, n different areas of memory M KB apart can be touched at the same time without causing cache thrashing. Commonly caches are designed to be 2-, 4-, or 8-way associative. Figure 13.1 illustrates the mapping of a 2-way set associative cache.

Many, if not most, CPUs have more than one level of cache between the CPU and main memory. The caches discussed to this point — level-1 caches, or *L1 caches* — are about as fast as the CPU itself. Because of cost, however, they are just a few kilobytes each (in the range of about 8 to 32 KB at the time this text is written), and thus cache

Main memory

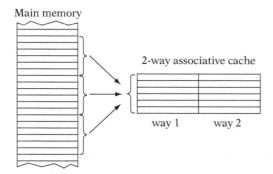

Figure 13.1 Illustrating how main memory is mapped into a 2-way associative cache.

misses are frequent. A level-2 cache, when present, sits between the level-1 cache and main memory. When an L1 cache miss occurs, the L2 cache is checked, and only if it too results in a miss is main memory accessed.

The L2 cache is not as fast as the L1 cache but is quite a bit faster than main memory. Because the L2 cache is cheaper to manufacture than an L1 cache, its capacity is larger, usually about 128 KB to 1 MB but potentially higher. A smaller number of CPUs include a third level of cache memory in their memory hierarchy.

Optimizing for cache utilization means staying on cache as much as possible and minimizing the number of cache line misses. Cache misses, whether code or data related, can be categorized into the following three types [Hill89].

- *Capacity misses.* These are caused by there not being enough space in the cache to hold all active data at the same time. They can be avoided by use of data compression, rearranging data to be less spread out, and by hot/cold removal of infrequently accessed data (as discussed in Section 13.3.1, on structure optimization).

- *Conflict misses.* These correspond to the cache thrashing caused by the number of accessed memory blocks mapping to the same cache line being greater than the associativity of the cache. Conflict misses can be avoided by compressing or rearranging data to not map to the same cache lines.

- *Compulsory misses.* These correspond to the unavoidable misses that take place when a block of memory is read for the first time. They can be minimized through increased cache line utilization by putting simultaneously accessed data together on the same cache line and by using less data or making it smaller.

Additional information on the organization of caches and memory hierarchies can be found in most introductory books on computer architecture, such as [Hennessy02].

13.2 **Instruction Cache Optimizations**

Optimizing the utilization of a cache has two key parts. The first is reducing the size of the data it holds. The second is increasing data locality so that data accessed at the same time is stored together. When writing assembly code, the programmer has direct control over both parameters. However, when using high-level languages such as C and C++ the programmer is somewhat at the mercy of the compiler to produce tight machine code. Still, a number of things can be done to help the compiler produce more code-cache-efficient code. For example, the following suggestions can help reduce code size.

- *Be careful with inlining of code.* Inlining tends to bloat code. Try to inline only those functions that are small enough that the inlined code would be as small as the code generated to call the function. Only functions meant to be inlined should be defined in *.h* files. In addition, beware aliasing issues, as discussed in Section 13.6.

- *Break loops up into cache-size chunks.* When the body of a loop is too large to fit in the instruction cache, break the code into several smaller loops. For example,

```
for (i = 0; i < N; i++) {
    ...A...;
    ...B...;
    ...C...;
}
```

where **A**, **B**, and **C** correspond to large chunks of (independent) code, can instead be written as

```
for (i = 0; i < N; i++)
    ...A...;
for (i = 0; i < N; i++)
    ...B...;
for (i = 0; i < N; i++)
    ...C...;
```

where **A**, **B**, and **C** each fit in cache. The latter code allows **A**, **B**, and **C** to remain in cache during the execution of the three smaller loops, rather than forcing each other out of cache, as in the former code. Keeping the code in cache outweighs the small cost added by the additional loop overhead. For loop bodies that do not quite fit into the instruction cache, an opposite strategy can be employed. Now try to reduce the code size to make the code fit in cache. Merge similar loops using loop fusion; explicitly apply common-subexpression elimination to repeated terms, rather than relying on the compiler being able to do so; and

substitute simpler, more easily implemented, algorithms (of similar efficiency) over more complicated ones.

- *Do not unroll loops unnecessarily.* Only unroll short innermost loops and only to the point where there is enough code in the loop body to fill any stalls due to instruction latencies, but not further.

- *Compile for size, not speed.* Rather than compiling at the highest optimization setting, try compiling with a compiler option that attempts to minimize code size (such as *-Os* provided by the *gcc* compiler) and see what effect it has.

- *Avoid creeping featurism.* Keep the functionality of a routine as simple as possible. If a function handles several cases, but only one occurs at a time, provide multiple functions, one for each case.

- *Use assembly language where beneficial to do so.* For a few time-critical applications, writing assembly code can be a good option. Contrary to popular opinion, good low-level programmers can frequently write better assembly code than a compiler can generate.

Although it might conflict with common software engineering practices, an effective way of improving locality is to adopt a more monolithic approach to code writing. Writing all code in a single function might be overkill, but writing larger functions helps. It also helps bringing functions closer to frequent call sites, to fit within the same cache page as the caller. Functions can be brought closer by manually moving them from one file to another to be defined just before or after the function they are called in. On some systems, functions can be moved automatically during linking by defining multiple code segments, corresponding to contiguous areas of code space. Compiler extensions then allow functions to be explicitly tagged with the code segment they should be placed in (for example, the *gcc* compiler provides this functionality through the **__attribute__ ((section ("xxx")))** extension). If a function is commonly used in several places, it can be worthwhile providing multiple copies of the function, associating one with each call site. Some code profilers can aid in this reorganization by providing a suggested function ordering.

Within functions, large *if* statements disrupt locality when either branch of the statement is skipped. In some cases, the two branch paths can be merged into one, reducing code size and therefore improving locality. As an example, consider the following code, part of a large function.

```
if (m > n) {
    for (int i = a; i < b; i++)
        c[i] = (big expression involving i) * d[i] + (second big expression
                involving i);
} else {
    for (int i = e; i < f; i++)
```

```
        g[i] = (big expression involving i) * h[i] + (second big expression
            involving i);
}
```

Extracting the two big expressions as separate functions may not necessarily be a good approach, as calling separate functions from within the large function could cause cache thrashing. A better approach is to rewrite the code as:

```
if (m > n) {
    lo = a; hi = b; out = c; in = d;
} else {
    lo = e; hi = f; out = g; in = h;
}
for (int i = lo; i < hi; i++)
    out[i] = (big expression involving i) * in[i] + (second big expression involving i);
```

This change effectively cuts the code size in half.

Many architectures provide one or more cache control instructions that can also help improve instruction cache use. Specifically, they can be used to instruct the CPU to fetch one or more cache lines worth of code into the instruction cache. By issuing cache instruction calls to the address of a function well in advance, the function can be in cache when it is called. However, in practice it can be difficult to put these instructions to effective use. Careful profiling can help gauge what improvements are made. To utilize the instruction cache effectively, it is quite important to study the machine code generated by the compiler to see how efficient it is, and to gain a sense of how changes in the high-level code can affect the generated code.

13.3 Data Cache Optimizations

The utilization of a data cache is also improved by reducing the size and increasing both the spatial and temporal locality of the data processed. Although size reduction can be seen as a form of compression, it rarely involves using a traditional coding method such as, say, Huffman, Lempel–Ziv, or arithmetic coding [Sayood00]. These are great when working with larger sets of data from high-latency sources such as secondary storage devices or network connections. When working with just a few bytes of data at a time from main and cached memory, the decompression time for these methods costs more than the savings. Instead, size reduction involves reassessing the stored data to see if it really has to be stored

in the first place, that it is not being stored redundantly, and whether it can be stored using a smaller data type. Simple run-length encoding schemes may also be effective.

Data locality can be improved by redesigning algorithms and data structures to allow data to be accessed in a more predictable, often linear or partially linear, fashion. Improving data locality may also involve a process often referred to as *blocking*: breaking large data into smaller chunks that each fit into cache.

At a lower level, the idea is to touch as few cache lines as possible, and therefore to arrange data such that all or most words on touched cache lines are being used at the same time. An example would be the separation of collision detection data from rendering data to avoid having RGB colors, texture coordinates, and other data irrelevant to collision detection reduce data locality by being interleaved with vertices and other relevant data. The following subsections discuss these issues in more detail.

13.3.1 Structure Optimizations

A starting point for improving data cache use is to look at how structures and classes can be optimized in this respect. Three options present themselves.

- *Decrease the overall size of the structure.* By not using more bits than necessary to represent member fields, more data fit into a cache line and the number of memory fetches required to access structure fields is reduced.

- *Reorder fields within the structure.* Fields within a structure are usually grouped conceptually, but should really be grouped on access patterns so that those typically accessed together are stored together.

- *Split structures into hot and cold parts.* Often a few structure fields are being accessed much more frequently than the other fields. By moving the infrequently accessed fields (the cold part) into a separate structure, cache coherency increases among the frequently accessed ones (the hot part), in particular when the structure is part of an array or some similar conglomerate data structure.

Alignment requirements on many platforms enforce compilers to pad structures so that any N-byte fields are N-byte aligned (for example, 32-bit integers aligned to memory addresses evenly divisible by four). The structures are padded to align their size to be a multiple of their largest N-byte field, wasting even more memory. Sorting the member variables by decreasing size reduces the memory waste due to padding. To aid in detecting space waste, some compilers can provide warnings whenever a class or structure is padded (in *gcc*, for example, through the *-Wpadded* option).

Platforms based on the MIPS architecture, for instance, have the alignment restrictions mentioned above. On them, given the following structure definitions

```
struct X {              struct Y {                  struct Z {
    int8 a;                 int8 a, pad_a[7];           int64 b;
    int64 b;                int64 b;                    int64 e;
    int8 c;                 int8 c, pad_c[1];           float f;
    int16 d;                int16 d, pad_d[2];          int16 d;
    int64 e;                int64 e;                    int8 a;
    float f;                float f,pad_f[1];           int8 c;
};                      };                          };
```

most compilers will have **sizeof(X) == 40**, **sizeof(Y) == 40**, and **sizeof(Z) == 24** (assuming 4-byte floats). The padding added to structure **X** (as indicated by structure **Y**) constitutes 40% of its memory requirements, compared to the identical, but size-sorted, **Z** structure. Other ways of decreasing the size of a structure include the following.

- *Do not store data that can be easily computed from already stored values.* For example, if the three vertices of a triangle have already been fetched from memory, it may actually be more efficient to derive a normal or a plane equation directly from the vertices instead of potentially incurring additional cache line fetches by reading additional data from the triangle's data structure.

- *Use smaller integers where possible.* Instead of always using the default-size integers (frequently of 32 bits or more), consider whether the data will fit in just 16 or perhaps even 8 bits. For example, if the player health is given as an integral percentage in the range 0 to 100, store it as an 8-bit byte and not a 32-bit integer.

- *Use bit fields instead of Booleans.* Instead of declaring flags as **bool** variables, pack all flags together as bits in a bit field. The size of a **bool** is machine dependent, but is at least a byte and can be as much as the size of a long integer. Storing flags as bits will therefore reduce the memory required for them by at least a factor of 8 and often up to a factor of 32 or more.

- *Use offsets instead of pointers to index data structures.* Whereas pointers are always a fixed size of usually 4 (or more) bytes, the size of an offset can be changed depending on how many items must be indexed. For example, a 2-byte offset can index an array of 2^{16} objects (or even more if the offset is taken relative to the current object). Few situations require indexing of that many objects.

With data cache misses being very expensive, more elaborate schemes to compress and uncompress data can also prove worthwhile. Some data compression examples are given in Sections 13.3.2 and 13.4.

It is important to point out that some of these suggestions might have extra CPU costs associated with them in certain architectures. For example, extra instructions might be required to operate on a smaller integer or on a bit of a bit field. With more instructions to execute, the pressure on the instruction cache would increase for the benefit of the data cache. As such, it is always a good idea to profile the code — ideally both before and after any changes — to see what improvements can be made.

Field reordering can be difficult to do properly. In a few cases, it is clear that certain fields should be stored within the same cache line, such as when the fields are always accessed together. For example, the fields of position, velocity, and acceleration are frequently accessed simultaneously and could benefit from being stored together. In most cases, however, it is far from trivial to determine what is the best field arrangement. Ideally, a compiler should take profile data from a previous run to perform the reordering automatically on a subsequent compile, but language standards may not allow field reordering and few (if any) compilers currently support such optimization. One way of getting a better idea of how to best reorder the fields is to access all structure fields indirectly through accessor functions. It is then possible to (temporarily) instrument these functions so as to measure which fields are frequently accessed and which are accessed together, whereupon you can then manually reorder the fields based on the access statistics. Note that adding padding in some cases improves performance by making two frequently accessed and neighboring fields fall within one cache line instead of across two.

The concept of hot/cold splitting of structures entails splitting the structure into two different parts: one containing the frequently accessed fields (the hot part) and the other the infrequently accessed fields (the cold part). These pieces are allocated and stored separately, and a link pointer to the corresponding cold part is embedded in each hot part (Figure 13.2). Although infrequently accessed fields now require a level of indirection to be accessed, thus incurring an extra cost, the main (hot) structure can now become smaller and the data cache is used more efficiently. Depending on how the structures are being accessed, the link pointer might not be necessary and, for instance, a single index could be used to access both an array of hot parts and another array of cold parts.

As a simple example of structure splitting, in which no link pointer is required, consider the following code for searching through an array of structures and incrementing the **count** field of the element that has the largest value **value** field.

```
struct S {
    int32 value;
    int32 count;
    ...
} elem[1000];

// Find the index of the element with largest value
int index = 0;
```

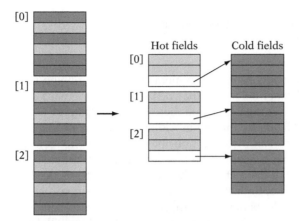

Figure 13.2 Given an array of three structure instances (with frequently accessed "hot" fields in light gray), hot/cold splitting rearranges the data so that cold fields are stored separately and the array structure only contains hot fields (plus a link to where the cold fields are located).

```
for (int i = 0; i < 1000; i++)
    if (elem[i].value > elem[index].value) index = i;
// Increment the count field of that element
elem[index].count++;
```

If this search is the predominant operation on this array of structures, it would make sense to split the structure **S** into a hot part (**S1**) and a cold part (**S2**) and rewrite the code as follows:

```
// Hot fields of S
struct S1 {
    int32 value;
} elem1[1000];

// Cold fields of S
struct S2 {
    int32 count;

    ...
} elem2[1000];

// Find the index of the element with largest value
int index = 0;
for (int i = 0; i < 1000; i++)
    if (elem1[i].value > elem1[index].value) index = i;
```

```
// Increment the count field of that element
elem2[index].count++;
```

All **value** fields are now consecutive in memory instead of being interleaved by the **count** field and all other fields that may be part of the original **S** structure. The search to find the largest **value** field could therefore be sped up by a factor of 2 (or more, if additional cold fields are present in addition to the **count** field).

Compilers and linkers can also use principles similar to hot/cold splitting for reordering of code, so that functions and parts of functions that are not frequently called are moved, reducing instruction cache thrashing due to reduced caller–callee cache conflicts. One such optimization is based on the concept of *cache line coloring* and involves arranging code (or data) such that frequently accessed items map to different cache lines (each of a distinct hypothetical color) [Hashemi97]. Unfortunately, very few compilers currently implement cache line coloring. Although the process can be applied by hand, it is a laborious procedure that has to be redone whenever the code is changed. Cache-conscious placement of data is also discussed in [Chilimbi99a]. Splitting and field reordering is discussed in [Chilimbi99b].

13.3.2 Quantized and Compressed Vertex Data

In addition to the data structures themselves, for collision detection code it is also important to consider how vertices are represented because they constitute a large part of the data. Although the x, y, and z values of vertices are frequently stored as three floats, it is often possible to quantize them to, for example, three 16-bit integer values. This quantization effectively snaps the vertices to a grid, so care must be taken so as not to cause quads and other larger collision primitives to become nonplanar.

In some cases it might even be possible to quantize a vertex further. For example, for smaller worlds a vertex could be encoded as a 32-bit integer with, say, 11 bits reserved for each of x and y, and 10 bits for z (Figure 13.3).

By expressing vertices in terms of a displacement from a previous vertex, even less space might be required to represent a vertex. One alternative is to compute the AABB of the vertices, use its center as a fixed origin, and compute the displacement of vertices from this point. At the cost of representing one extra point (the origin itself) at full precision, the other vertices can be expressed in fewer bits, on average.

For example, consider the five spatially coherent, but otherwise random, 16-bit integer vertices $A = (30086, 15857, 9385)$, $B = (30189, 15969, 9285)$,

Figure 13.3 Vertex quantized to a 32-bit integer with 11 bits of X and Y and 10 bits of Z.

$C = (30192, 15771, 9030)$, $D = (29971, 15764, 9498)$, and $E = (30304, 15888, 9133)$. These could be represented as $(-52, -9, 121)$, $(51, 103, 21)$, $(54, -95, -234)$, $(-167, -102, 234)$, and $(166, 22, -131)$ with a common 16-bit offset of $(30138, 15866, 9264)$. Here, the quantized vertices could be stored using (signed) 9-bit values, a considerable saving over the original format.

Even more space can be saved by allowing the origin to float from one vertex to the next. That is, the displacement is computed from the previous vertex, thus effectively implementing a delta compression scheme. Such a scheme works best when the vertices represent an indexed mesh so that their order can be shuffled to facilitate a better compression ratio. Rearranging the vertices A through E in the order D, A, B, E, C gives the first vertex as $(29971, 15764, 9498)$ and the following vertices as $(115, 93, -113)$, $(103, 112, -100)$, $(115, -81, -122)$, and $(-112, -117, -73)$. The vertex components can now be represented using (signed) 8-bit values.

Spatial partitioning methods can be combined with storing the data in the leaves in a quantized format because the range of the data in a leaf will generally only span a small part of the entire world. Quantization of localized data saves memory yet allows a full range of coordinate values. If the leaves are cached after decompression, the extra cost associated with decompression is generally counteracted by amortization. Having leaf contents stored relative to an origin corresponding to the spatial position of the parent node can help increase robustness because computations are now performed near that origin, maintaining more precision in the calculations.

13.3.3 Prefetching and Preloading

Because stalls caused by load accesses to uncached memory cause severe slowdowns, most modern CPUs provide mechanisms for helping avoid these stalls. One such mechanism is the *prefetch* instruction, which allows the programmer to direct the CPU to load a given cache line into cache while the CPU continues to execute as normal. By issuing a prefetch instruction in advance, the data so loaded will be in cache by the time the program needs it, allowing the CPU to execute at full speed without stalling. The risk is that if the prefetch instruction is issued too early then by the time the CPU is ready for the data it might have been flushed from cache. Conversely, if it is issued too late then there is little benefit to the prefetch. Ideally, the prefetch instruction should be issued early enough to account for the memory latency of a load, but not more.

For linear structures, prefetch instructions are both effective and easy to use. For example, a simple processing loop such as

```
// Loop through and process all 4n elements
for (int i = 0; i < 4 * n; i++)
    Process(elem[i]);
```

can be rewritten to use prefetching, with the help of a little code unrolling. Assuming a cache line fits four consecutive **elem** values, a better structure of the loop might be:

```
const int kLookAhead = 4;        // Experiment to find which fixed distance works best
Prefetch(&elem[0]);              // Prefetch first four elements
for (int i = 0; i < 4 * n; i += 4) { // Unrolled. Process and step 4 elements at a time
    Prefetch(&elem[i + kLookAhead]); // Prefetch cache line a few elements ahead
    Process(elem[i + 0]);        // Process the elements that have already
    Process(elem[i + 1]);        // been fetched into memory on the
    Process(elem[i + 2]);        // previous iteration
    Process(elem[i + 3]);
}
```

If the **Process()** function takes at least a quarter of the time of a memory stall, the next cache line of **elem** values should be in memory on the next iteration. (If it is faster than so, it might be better to prefetch data two cache lines ahead.)

For nonlinear structures prefetching becomes trickier. The most straightforward approach is to greedily prefetch all possible branches and hope for the best. For example, the preorder traversal of a binary tree could be greedily prefetched as in the following code.

```
void PreorderTraversal(Node *pNode)
{
    Prefetch(pNode->left);          // Greedily prefetch left traversal path
    Process(pNode);                 // Process the current node
    Prefetch(pNode->right);         // Greedily prefetch right traversal path
    PreorderTraversal(pNode->left); // Recursively visit left subtree
    PreorderTraversal(pNode->right); // then recursively visit right subtree
}
```

Greedy prefetching is simple to implement, but it is not very efficient. It is not unlikely that the prefetched areas have been flushed out of cache by the processing function before the code has returned to visit that part of the tree. Prefetching can be more effective when used together with linearization (described in Section 13.5).

Another CPU architecture mechanism for addressing the high latency of memory fetches is the use of nonblocking loads. Nonblocking loads allow the CPU to continue executing instructions after a cache miss, only stalling if the register that memory is being loaded into is accessed before the data is ready. Unless more than one outstanding load is allowed by the hardware, the CPU would also stall if another load is issued while the first one is pending, thus causing a second cache miss. While a load is outstanding, *hit-under-miss* execution of loads is usually allowed. That is, a subsequent load referring to data already in cache does not cause the CPU to stall.

On a CPU with nonblocking hit-under-miss loads, the earlier loop would be better written in an interleaved fashion to have processing go on while the next cache line is being fetched.

```
Elem a = elem[0];          // Load the cache line of the first four array elements
for (int i = 0; i < 4 * n; i += 4) {
    Elem e = elem[i + 4];  // Cache miss. Fetches next cache line using nonblocking load
    Elem b = elem[i + 1];  // These following three values are in cache and...
    Elem c = elem[i + 2];  // ...are loaded as hit-under-miss; no stalls
    Elem d = elem[i + 3];
    Process(a);            // Process the data from the cache line that...
    Process(b);            // ...was fetched in the previous iteration
    Process(c);
    Process(d);
    a = e;                 // e now in cache, and so is b, c, and d of next iteration
}
```

This particular code fetches one element beyond the end of the **elem** array, although the element is not actually processed. When reading data beyond the end of the array is a problem, the data access can be avoided by unrolling the last loop iteration and handling that iteration separately.

13.4 **Cache-aware Data Structures and Algorithms**

It is wise to design with best cache utilization in mind. Algorithms and data structures so designed, targeted for a given platform configuration, are referred to as *cache aware* or *cache conscious*.

To illustrate how cache awareness influences the code design, the following subsections include code examples of the ideas presented. First is a compact and cache-efficient representation for *k*-d trees. After that a compact representation of an AABB tree is presented, showing how quantization can be used to reduce storage requirements.

For code that must perform well across several different architectures, an alternative to constructing multiple cache-aware versions is to implement *cache oblivious* code. Such code promises to be reasonably cache efficient on any traditional cache setup. Cache obliviousness is discussed in Section 13.4.3.

13.4.1 **A Compact Static *k*-d Tree**

A node in a *k*-d tree must hold a type specifying whether the node is an internal node or a leaf node. If the node is internal, it must also contain two more

values: one specifying the axis the split was along and the other the coordinate value of the splitting point along that axis. If instead the node is a leaf node, it must contain a pointer or an index into an array of the data contained in the leaf. For ease of use, the splitting value is assumed to be given as a single-precision float.

At this point, a key insight is that changing the low-order bit(s) of the 23-bit floating-point mantissa will only ever so slightly change the value of the number. For the splitting plane of a k-d tree, this slight movement would be completely insignificant. Thus, without any ill effects the two low-order bits of the mantissa can be appropriated to store some other data. Specifically, the two low bits can be used to indicate the type of the node, with binary values 00, 01, and 10 specifying the x, y, or z axis, respectively, as the splitting axis for an internal k-d tree node. The binary value 11 is used to indicate that the k-d tree node is a leaf node. When the node is a leaf node, the remaining 30 bits contain an index referring to the actual leaf contents stored elsewhere. Taking these ideas into account, a k-d tree node can be expressed as:

```
union KDNode {
    float splitVal_type;  // nonleaf, type 00 = x, 01 = y, 10 = z-split
    int32 leafIndex_type; // leaf, type 11
};
```

By having the type bits be the low two bits of the float, it is possible to directly use **splitVal_type** as a float without stripping off the type bits. As argued, leaving them intact simply moves the splitting plane by a minuscule and insignificant amount. Overall, a k-d tree node can therefore be efficiently represented as a 32-bit value.

Assuming a cache line width of 64 bytes, a single cache line can hold a complete four-level k-d tree of 15 nodes output in breadth-first order (thus the children for a node at a 0-based index n can directly be located at positions $2n + 1$ and $2n + 2$). See Figure 13.4 for an illustration of the overall format.

A complete tree could now be stored by cutting the tree every four levels deep and outputting the resulting subtrees of 15 nodes in breadth-first order. Given a pointer, **pNode**, to a **KDNode**, pointers to the children can quickly be determined without further memory accesses.

```
// Align tree root to start of cache line (64-byte aligned)
void ComputeChildPointers(KDNode *pRoot, KDNode *pNode, KDNode **pLeft, KDNode **pRight)
{
    int32 nodeAddress = (int32)pNode;
    int32 nodeIndex = (nodeAddress & 0x3f) >> 2; // node index within cache line (0-14)
    int32 leftAddress, rightAddress;
    if (nodeIndex < 7) {
        // Three out of four, children are at 2n+1 and 2n+2 within current cache line
```

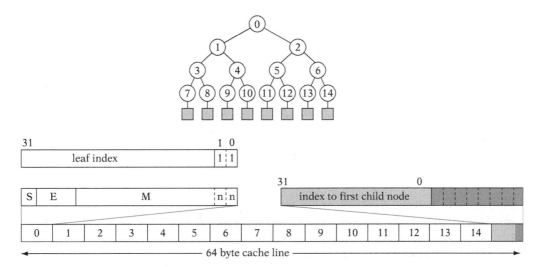

Figure 13.4 An efficient representation of a k-d tree. A **64-byte** cache line holds a four-level k-d tree, with 15 nodes in the first 60 **bytes**. The last 4 **bytes** of the cache line indicate which eight child subtree pairs exist and where **they** can be located.

```
        leftAddress = nodeAddress + (nodeAddress & 0x3f) + 4;
        rightAddress = leftAddress + 4;
    } else {
        // The children are roots of subtrees at some other cache lines
        int32 rootAddress = (int32)pRoot;
        int32 cacheLineFromStart = (nodeAddress - rootAddress) >> 6;
        int32 leftCacheLine = 16 * cacheLineFromStart + 1;
        int32 bitIndex = nodeIndex - 7; // (0-7)
        leftAddress = rootAddress + leftCacheLine * 64 + bitIndex * 2 * 64;
        rightAddress = leftAddress + 64; // at next consecutive cache line
    }
    *pLeft = (KDNode *)leftAddress;
    *pRight = (KDNode *)rightAddress;
}
```

A single root-leaf traversal of a tree of depth d would now only read $d/4$ cache lines compared to the worst-case d cache lines of, for example, a preorder traversal order output.

Even with just 4 bytes per node, storing a complete tree is still very expensive. Instead of requiring each subtree to have 16 children for the full depth of the tree, ideally only those subtrees actually present should be stored.

The remaining last 4 bytes on the cache line can be used to facilitate a compact representation of linkage to other subtrees. Let the first 3 bytes form an index into the array of existing subtrees, specifying where the first child subtree starts. Then let the 8 bits of the last byte specify which of the eight pairs of children are present, in that a subtree node at the fourth level will either have two or no children. To find the actual offset from the 3-byte index, at which point a given pair of child subtrees can be located, the bits corresponding to the preceding trees can then be added and multiplied by 128, the size of two cache lines. The following code illustrates how to compute pointers to the left and right subtrees of a k-d tree node using the described representation.

```
// Align tree root to start of cache line (64-byte aligned)
void ComputeChildPointers(KDNode *pRoot, KDNode *pNode, KDNode **pLeft, KDNode **pRight)
{
    int32 nodeAddress = (int32)pNode;
    int32 nodeIndex = (nodeAddress & 0x3f) >> 2; // node index within cache line (0-14)
    int32 leftAddress, rightAddress;
    if (nodeIndex < 7) {
        // Three out of four children are at 2n+1 and 2n+2 within current cache line
        leftAddress = nodeAddress + (nodeAddress & 0x3f) + 4;
        rightAddress = leftAddress + 4;
    } else {
        // The children are roots of subtrees at some other cache lines
        int32 rootAddress = (int32)pRoot;
        int32 bitIndex = nodeIndex - 7; // (0-7)
        // Last word on cache line specifies linking of subtrees
        int32 linkWord = *((int32 *)(nodeAddress | 0x3c));
        assert(linkWord & (1 << bitIndex)); // must be set
        int32 offset = PopCount8(linkWord & ((1 << bitIndex) - 1));
        leftAddress = rootAddress + ((linkWord >> 8) + offset * 2) * 64;
        rightAddress = leftAddress + 64; // at next consecutive cache line
    }
    *pLeft = (KDNode *)leftAddress;
    *pRight = (KDNode *)rightAddress;
}
```

The function **PopCount8()** computes the number of bits set in a byte. It can be implemented as a repeated parallel process in which first all odd bits are masked out and added to the even bits to form partial sums (of consecutive pairs of odd and even bit values) in each pair of two bits. These partial sums can then be masked and added in the same fashion until the final result is obtained.

```
inline int32 PopCount8(int32 n)
{
    n = n - ((n & 0xaa) >> 1);          // Form partial sums of two bits each
    n = (n & 0x33) + ((n >> 2) & 0x33); // Form partial sums of four bits each
    return (n + (n >> 4)) & 0x0f;       // Add four-bit sums together and mask result
}
```

Alternatively, **PopCount8()** can be implemented using a small (4- or 8-bit-wide) lookup table. The cost for computing the address of the children increases somewhat under this method compared to storing a full complete tree, but it still compares favorably to the cost of the incurred cache misses of most other schemes.

With appropriate changes, the same overall design principle applies to other cache line widths. For example, with a 32-byte cache line the nodes would have to be reduced to contain a three-level tree instead of the four-level tree presented here.

The k-d tree structure presented here was first presented in [Ericson03]. A similar approach to efficiently representing k-d trees is presented in [Szécsi03].

13.4.2 A Compact AABB Tree

AABB trees can be expressed in a compact format with the help of a simple observation: because the six sides of a parent AABB will all come from either or both children AABBs, at most six additional faces are required to be able to reconstruct the two child AABBs from the bounds of the parent AABB. That is, the minimum x value of the parent AABB must be either the minimum x value of the left child AABB or the minimum x value of the right child AABB. Additionally, 6 bits are needed to specify which child inherits a given side from the parent and which child gets its side determined by one of the six additional faces given.

Instead of expressing the new face values as floats, the memory requirements can be reduced further by quantizing them to a byte each, defining them in terms of a ratio of the parent sides [Gomez01]. The following code illustrates the node layout and how the children AABBs are reconstructed from the parent AABB and a compressed AABB node.

```
// Uncompressed AABB
struct AABB {
    float & operator [](int n) { return ((float *)this)[n]; }
    Point min;              // The minimum point defining the AABB
    Point max;              // The maximum point defining the AABB
};
```

```
// Compressed AABB node
struct PackedAABBNode {
    uint8 flags;        // Bits determining if new extent belong to left or right child
    uint8 newExtent[6]; // New extents, quantized within the parent volume
    ...                 // Potential links to children nodes
};

void ComputeChildAABBs(AABB &parent, PackedAABBNode &node, AABB *left, AABB *right)
{
    for (int i = 0; i < 6; i++) {
        int xyz = i & 3;
        // Compute the actual side value from the quantized newExtent[] value
        float min = parent.min[xyz], max = parent.max[xyz];
        float val = min + (max - min) * (float)node.newExtent[i] / 255.0f;
        // Test bits to see which child gets parent side value and which gets new value
        if (node.flags & (1 << i)) {
            (*left)[i] = parent[i];  // Left child gets parent's bound
            (*right)[i] = val;       // ...right child gets computed bound
        } else {
            (*left)[i] = val;        // Left child gets computed bound
            (*right)[i] = parent[i]; // ...right child gets parent's bound
        }
    }
}
```

The two remaining bits of the flag field can, for example, be used to indicate whether the node is a leaf or an internal node. In the presentation in [Gomez01], pointers to children nodes are given as two 16-bit indices, bringing the total node size to 11 bytes. For a static tree, one or both pointers could be omitted, making the node size even smaller. It is very important that extent values be rounded correctly upon packing, so that the quantized child AABB volumes are conservative and encompass the original child volumes.

13.4.3 Cache Obliviousness

An alternative to cache-aware algorithms and data structures is the class of *cache-oblivious* algorithms and data structures [Frigo99]. Rather than optimized for a given architecture, these are designed so as to perform well on arbitrary targets with different cache setups. They are conjectured to be no worse than a factor $O(\log n)$ slower than cache-aware methods [Prokop99].

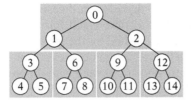

Figure 13.5 The van Emde Boas layout for a complete binary tree of height four. Numbers designate node position in a linearized array representation.

The idea behind cache-oblivious algorithms and data structures is to optimize for an ideal cache model with a cache line size L and a memory size Z, where both L and Z are unknown. Because L and Z can take on any value, the algorithm or data structure is optimized for all cache levels within the memory hierarchy and therefore also for widely differing CPU setups.

Several cache-oblivious algorithms, for example, the funnelsort algorithm, are presented in [Prokop99]. Prokop also outlines how a binary tree can be output in a cache-oblivious way, also referred to as the *van Emde Boas layout* [StøltingBrodal01]. Relevant not only to collision detection structures but to games in general, this interesting tree layout is recursively defined. Given a tree T of height h, the tree is split halfway across its height so T_0 represents the tree of all nodes in T with height less than $\lceil h/2 \rceil$. T_1 through T_k represent the subtrees of T rooted in the leaf nodes of T_0, ordered left to right. The van Emde Boas representation of T is then the van Emde Boas layout of T_0 followed by the van Emde Boas layouts of T_1 through T_k. Figure 13.5 illustrates the procedure for a binary tree of height four.

Although cache-aware methods are likely to perform better than cache-oblivious ones in practice, cache-oblivious algorithms and data structures are especially interesting in situations in which code is expected to run well on several different platforms.

13.5 Software Caching

For further improvements to the utilization of the low-level CPU data cache, it is useful to implement custom software caches in applications. In this context, an especially important concept is the idea of relying on caching for *data linearization*. Here, linearization means the rearrangement of concurrently accessed but dispersed data into contiguous blocks to improve performance by increasing spatial locality. By performing on-demand linearization and caching the result, it is possible to bring together data at runtime that cannot practically be stored together otherwise. An example would be the cached linearization of all leaves of a tree structure overlapped by a coarse query volume to speed up subsequent queries within the initial volume.

Software caching also works well with keeping collision data compressed. For example, the leaves of a tree can be stored in a compressed format in the main data structure. A software cache can now be established for the leaf nodes such that whenever a leaf is visited it is checked whether a cached node exists for the leaf. If it does not, the compressed data is uncompressed and cached with the leaf *id* as the key. This particular application is outlined in more detail in the following section.

Memory can also be saved in a different sense using software caching. Normally, to avoid runtime computations a lot of data is stored that could be computed at runtime from other data already present. Redundant data might include the AABB bounds of the content of a tree leaf node or face normals stored alongside the collision faces. Using software caching, these items could be omitted from the stored data and, for example, face normals could instead be computed on the fly from the vertex data and stored during the caching step. This type of caching could also be used to remember certain expensive calculations, such as freezing any required transformations of collision primitives.

Thanks to the spatial and temporal coherence exhibited by most collision queries, the cost of decompressing or rederiving data and then caching it becomes amortized over a number of queries, making the per-query overhead of caching largely negligible. Because only those leaves at which queries are taking place are being cached, spatial coherence implies that only a small number of cache entries is needed.

Another benefit of using software caching is that it allows the data format used in the cache to serve as a unified format all code can work against. New data structures can now be added to the system by providing a means to cache its data into the unified format. A unified format allows the low-level primitive tests to be written just once, better facilitating heavy optimization without risking having data format changes invalidating the code.

Depending on how high-level cache systems are implemented, it might be useful to provide the user with the option to enable or disable the software cache on a call-by-call basis, so that time is not spent on caching for a query the user knows would not benefit from it. Another potentially useful design option is to consider having the cache exist in "soft" memory. That is, the cache exists in the unused part of the memory manager heap and parts of the cache are invalidated when that memory is reclaimed through an allocation from the memory manager. Usually software caches are implemented through hashing into an array of fixed-size elements. For more detail on hashing see [Knuth98]. The usefulness of software caching in a game context is discussed in [Sauer01].

13.5.1 Cached Linearization Example

Software caching can help linearize data structures by following any indices and removing all indirection by retrieving and caching all referenced data into a consecutive area of memory. The increased level of data locality improves the CPU data

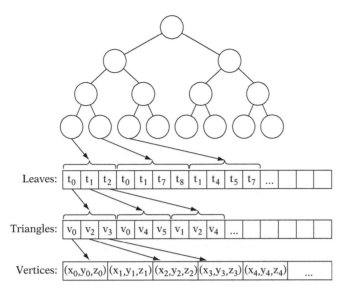

Figure 13.6 A tree structure stored in a compact format, with a lot of indirection, starting with indices from the leaves to the triangles contained in the leaves.

cache hit rate drastically and therefore also overall performance. Linearized data is also easier to prefetch or preload (as described in Section 13.3.3).

To illustrate data structure linearization through software caching, consider a tree-type data structure in which the leaf nodes contain a number of triangles. To reduce space, the leaf triangles have been stored as 16-bit indices into an array of the actual triangles. The triangles have in turn each been stored as three 16-bit indices into an array of vertices. The data format is illustrated in Figure 13.6, and through the following code.

```
// Array of all vertices, to avoid repeating vertices between triangles
Point vertex[NUM_VERTICES];

// Array of all triangles, to avoid repeating triangles between leaves
struct IndexedTriangle {
    int16 i0, i1, i2;
} triangle[NUM_TRIANGLES];

// Variable-size leaf node structure, containing indices into triangle array
struct Leaf {
    int16 numTris; // number of triangles in leaf node
    int16 tri[1];  // first element of variable-size array, with one or more triangles
};
```

To remove the indirection inherent in this leaf structure, leaves can be cached into a leaf node structure that contains all information as a consecutive block of data.

```
// Explicitly declared triangle, no indirection
struct Triangle {
    Point p0, p1, p2;
};

#define NUM_LEAFCACHE_ENTRIES (128-1)          // 2^N-1 for fast hash key masking w/ '&'

// Cached leaf node, no indirection
struct CachedLeaf {
    Leaf *pLeaf;                               // hash key corresponding to leaf id
    int16 numTris;                             // number of triangles in leaf node
    Triangle triangle[MAX_TRIANGLES_PER_LEAF]; // the cached triangles
} leafCache[NUM_LEAFCACHE_ENTRIES];
```

Figure 13.7 illustrates how the leaves of the previous tree structure are associated with a cache entry containing the linearized data, allowing triangles to be processed without any indirection at all.

The code that processes a leaf node can now be written to see if the node is already in cache, cache it if it is not, and then operate on the cached leaf node data.

```
// Compute direct-mapped hash table index from pLeaf pointer (given as input)
int32 hashIndex = ((int32)pLeaf >> 2) & NUM_LEAFCACHE_ENTRIES;
```

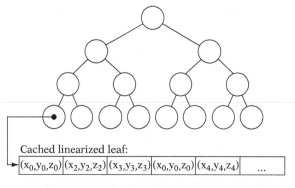

Figure 13.7 The same structure as in Figure 13.6, now linearized through a caching scheme so that vertices can be directly accessed with no indirection.

```
// If leaf not in cache at this address, cache it
CachedLeaf *pCachedLeaf = &leafCache[hashIndex];
if (pCachedLeaf->pLeaf != pLeaf) {
    // Set cache key to be pLeaf pointer
    pCachedLeaf->pLeaf = pLeaf;
    // Fetch all triangles and store in cached leaf (linearized)
    int numTris = pLeaf->numTris;
    pCachedLeaf->numTris = numTris;
    for (int i = 0; i < numTris; i++) {
        Triangle *pCachedTri = &pCachedLeaf->triangle[i];
        IndexedTriangle *pTri = &triangle[pLeaf->tri[i]];
        pCachedTri->p0 = vertex[pTri->i0];
        pCachedTri->p1 = vertex[pTri->i1];
        pCachedTri->p2 = vertex[pTri->i2];
    }
}

// Leaf now in cache so use cached leaf node data for processing leaf node
int numTris = pCachedLeaf->numTris;
for (int i = 0; i < numTris; i++) {
    Triangle *pCachedTri = &pCachedLeaf->triangle[i];
    DoSomethingWithTriangle(pCachedTri->p0, pCachedTri->p1, pCachedTri->p2);
}
...
```

For a 64-byte cache line, the original uncached code might in the worst case touch 10 cache lines for a single triangle: two cache lines for the leaf structure, two for the indexed triangle structure, and two for each of the vertices. Even if each individual piece of data has been padded to align to a cache line, the worst case is still upward of five cache line accesses. With the leaf in cache, the cached code would touch at most two cache lines per triangle and often just one cache line.

13.5.2 Amortized Predictive Linearization Caching

The linearization concept can also be used in more advanced caching schemes. As an example, consider a static tree hierarchy representing the world geometry. Let a collision query be issued for, say, a spherical volume surrounding the immediate neighborhood of a player character. By caching all polygon data within this volume into a linearized format, as long as the player remains within the sphere only the cached data has to be tested and the main hierarchy does not have to be traversed or tested against.

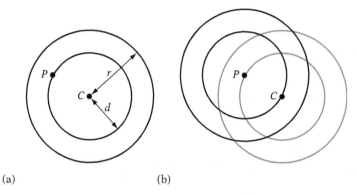

(a) (b)

Figure 13.8 (a) Sphere with center *C* and radius *r* for which all contained **geometry** is cached. A smaller sphere with the same center and a radius of *d* is also maintained. (b) When the **player** leaves the smaller sphere at some point *P*, the amortized caching of all **geometry** contained in the sphere centered at *P* with radius *r* begins. This caching must be guaranteed complete within the time it takes to travel the distance *r* − *d* to ensure that the new set of **geometry** can be made current when the outer sphere of the initial sphere pair is exited **by** the **player**.

To reduce the cost of linearizing the collision primitives within the sphere into the cache, this computation can be amortized. When the player has moved some distance away from the origin of the currently cached spherical volume, a new caching query is initiated from the current player position and completed by computing it in parts over a few frames (Figure 13.8). When the second set of cached data is fully computed, whichever set corresponding to the sphere whose center the player is closest to is made the current collision set, and the other set is cleared and recomputed in the same manner when the player again has moved some specific distance away from the new sphere origin.

This approach is best for applications in which the player character travels with moderate speed. It might not be suitable if instant teleportation from one location to another is possible.

13.6 Aliasing

In both C and C++ it is not uncommon to have two pointers pointing to the same location in memory. When two pointers point to the same memory location they are said to *alias* each other. For example, in following code the pointers **p1** and **p2** are both aliases to the memory of the integer variable **n**:

```
int n;
int *p1 = &n;   // *p1 references the location of n
int *p2 = &n;   // *p2 also references the location of n
```

Aliasing presents quite a problem for C/C++ compilers. When compilers are unable to deduce that two pointers cannot alias each other, they must conservatively assume aliasing is present. This assumption can impede certain optimizations, leaving code with unnecessary load and store instructions that bloat both code and slots in function stack frames, thus indirectly impacting on code and data cache efficiency. These loads and stores also hinder instruction reordering and loop unrolling, causing instruction stalling.

In contrast, a language such as FORTRAN 77 specifies that no two identifiers will be considered as aliasing each other unless they are declared as such in an **EQUIVALENCE** declaration. It therefore does not suffer from this aliasing problem at all. To illustrate the problem, consider the following code for transforming a point by a 3 × 3 matrix.

```
void TransformPoint(Point *pOut, Matrix &m, Point &in)
{
    pOut->x = m[0][0] * in.x + m[0][1] * in.y + m[0][2] * in.z;
    pOut->y = m[1][0] * in.x + m[1][1] * in.y + m[1][2] * in.z;
    pOut->z = m[2][0] * in.x + m[2][1] * in.y + m[2][2] * in.z;
}
```

The compiler has no higher-level knowledge of the intended function of the code. It therefore does not know that the programmer must have intended for **pOut** and **in** not to alias each other (or the code would not correctly be implementing a transformation, in that **pOut** is written to before **in** is fully used). As such, the compiler must assume **pOut** and **in** might reference the same structure.

Faced with the previous code, most compilers generate code that loads **in.x**, **in.y**, and **in.z** three times each, for a total of nine times. A really clever compiler using type-based alias analysis (as discussed later) would know that **pOut->x** could only alias **in.x** and **pOut->y** only **in.y**, and therefore only have to perform two reloads, for a total of five loads. Ideally though, the fields of **in** should be loaded once each.

In general, unless the compiler can prove that aliasing is not possible, it must assume it is present. Unfortunately, proving that aliasing is not taking place is difficult. For the compiler to assume aliasing is present when in fact it is not is bad. It causes variables to be fetched from memory when they are already present in a register, or stored to memory when holding the value in a register would have sufficed. Worse, failure to remove an unnecessary store can have a cascading effect. It may make it seem like other aliasing is present, thereby stopping the compiler from removing unnecessary memory accesses, which in turn can stop it from removing other ones, and so on.

It should be pointed out that declaring the input variables as **const** is not a solution to the aliasing problem. For example, declaring **m** as **const Matrix &m** just says that the memory area occupied by **m** is constant with respect to accesses through **m**, not that the memory area is constant in general. Thus, the memory area could still be

written to through **pOut**. Overall, **const** declarations promise almost nothing and do little to help the compiler optimize code. Instead, their primary use is to help detect programming errors.

That said, for the code given earlier, one way of solving the problem is to rewrite the code to read:

```
void TransformPoint(Point *pOut, Matrix &m, Point &in)
{
    float tmpx, tmpy, tmpz;
    tmpx = m[0][0] * in.x + m[0][1] * in.y + m[0][2] * in.z;
    tmpy = m[1][0] * in.x + m[1][1] * in.y + m[1][2] * in.z;
    tmpz = m[2][0] * in.x + m[2][1] * in.y + m[2][2] * in.z;
    pOut->x = tmpx; pOut->y = tmpy; pOut->z = tmpz;
}
```

Inputs are now used before memory is written to, and the same variable can be given as both input and output arguments without causing aliasing problems. Good compilers should now be able to optimize the code properly. Some architectures benefit more from ensuring that inputs are consumed before output is generated. In particular, RISC-like architectures with enough general-purpose registers to hold all the inputs usually benefit.

Whenever possible it is good practice to help the compiler in this way (using local variables to hold global variables, referenced values, and temporary results), thereby explicitly helping the compiler recognize that no aliasing is present. Unfortunately, it is not always easy to perform this rewrite manually. For example, with the higher level of data encapsulation and abstraction provided by the class and template concepts of C++, code is often broken up into smaller generic subunits, with the intent of hiding internal structure and operations. Thus, something as simple as making a local variable copy of a buffer pointer during a data structure traversal, or moving invariant expressions out of a loop, cannot always be made without exposing the data structure or by unfolding template instantiations.

The problem of higher levels of abstraction having a negative impact on optimization, especially with respect to aliasing, is known as the *abstraction penalty problem*. Further information is provided in [Stepanov], [Robison96a], and [Robison96b]. Some of the C++ abstraction penalty performance issues, especially relating to overhead in vector and matrix expressions, can be successfully addressed by the expression template technique as pioneered by [Veldhuizen95], albeit at a high development cost.

13.6.1 **Type-based Alias Analysis**

Some modern C/C++ compilers use *type-based alias analysis* to help address the problem of aliasing. The compiler uses the fact that the language standard states that only

two objects of the same compatible type may alias each other and that each area of memory can only be associated with one type during its lifetime.

For example, under the standard rules floats and integers are not compatible types. To allow block moves and similar operations to be performed, signed and unsigned chars are compatible with all types. Thanks to these compatibility rules, more sophisticated compilers enhanced with type-based alias analysis can deduce that there is no aliasing between **v[i]** and ***n** in the code

```
void Foo(float *v, int *n)
{
    for (int i = 0; i < *n; i++)
        v[i] += 1.0f;
}
```

and optimize it as if it was written as:

```
void Foo(float *v, int *n)
{
    int t = *n;
    for (int i = 0; i < t; i++)
        v[i] += 1.0f;
}
```

The difference is small, but important. In the former code, without type-based alias analysis the value of ***n** would have to be fetched from memory as many times as the loop iterates. In the second version, the value of ***n** has been moved out of the loop and is therefore fetched only once. It is important to note that according to the C/C++ language standards it is illegal to write code similar to the following *type-punning* operation.

```
uint32 i;
float f;
i = *((int32 *)&f);  // Illegal way of getting the integer representation of the float f
```

This operation is treating the memory holding **f** as having two different types. A compiler that applies type-based alias analysis on this code is therefore free to generate code that does not behave as intended. Because compilers have built-in knowledge about the deliberate aliasing of unions, many compilers allow access through a union to be a legal way to perform the following operation:

```
union {
    uint32 i;
```

```
     float f;
   } u;
   u.f = f;
   uint32 i = u.i;
```

However, to guarantee compliance with the language standard and thus generation of correct code, the float would have to be accessed by a **char** array, with the **uint32** assembled from its elements.

13.6.2 **Restricted Pointers**

The 1999 ANSI/ISO C standard defines a new qualifier keyword, **restrict**, which allows programmers to at least partly help compilers resolve some of the aliasing issues in a program. As a result, the compilers are able to more aggressively optimize the code. Some C++ compilers also provide the **restrict** keyword as a language extension. Declaring a pointer (or reference) with the **restrict** qualifier is basically a promise to the compiler that for the scope of the pointer the target of the pointer will only be accessed through that pointer (and pointers copied from it). Using restricted pointers and references, the earlier transformation code can be written to read:

```
void TransformPoint(Point * restrict pOut, Matrix & restrict m, Point & restrict in)
{
    pOut->x = m[0][0] * in.x + m[0][1] * in.y + m[0][2] * in.z;
    pOut->y = m[1][0] * in.x + m[1][1] * in.y + m[1][2] * in.z;
    pOut->z = m[2][0] * in.x + m[2][1] * in.y + m[2][2] * in.z;
}
```

A good compiler should now be able to produce optimal code for the function as it now knows that writing to **pOut** cannot possibly affect any of the inputs. Before relying on the use of restricted pointers, it is a good idea to verify that the target compiler is in fact using it as a hint to improve optimization, as even ignoring the keyword conforms to the language standard. As another example of the benefits of using restricted pointers, consider computing the product of two complex numbers, $(a + bi)(c + di) = (ac - bd) + (ad + bc)i$, as naively implemented by the following code.

```
void ComplexMult(float *a, float *b, float *c)
{
    a[0] = b[0]*c[0] - b[1]*c[1];   // real part in a[0] (b[0] and c[0])
    a[1] = b[0]*c[1] + b[1]*c[0];   // imaginary part in a[1] (b[1] and c[1])
}
```

Because this code could be called as in either one of the three calls

```
float f[3];
ComplexMult(&f[0], &f[0], &f[0]);   // a[0] aliases b[0], c[0]; a[1] aliases b[1], c[1]
ComplexMult(&f[1], &f[0], &f[0]);   // a[0] aliases b[1], c[1]
ComplexMult(&f[0], &f[1], &f[1]);   // a[1] aliases b[0], c[0]
```

it is clear that **a[0]** and **a[1]** might alias any of **b[0]**, **b[1]**, **c[0]**, and **c[1]**. The assignment to **a[0]** therefore means that all four input values must be fetched again in the second code line. To better illustrate the issue, the following compiler-generated code (here compiled with a version of *gcc* producing MIPS assembly code) shows that this is indeed the case.

```
ComplexMult(float *, float *, float *)
lwc1    f3,0x0000(a2)    ; f3 = c[0]
lwc1    f2,0x0004(a2)    ; f2 = c[1]
lwc1    f1,0x0000(a1)    ; f1 = b[0]
lwc1    f0,0x0004(a1)    ; f0 = b[1]
mul.s   f1,f1,f3         ; f1 = f1 * f3
mul.s   f0,f0,f2         ; f0 = f0 * f2
sub.s   f1,f1,f0         ; f1 = f1 - f0
swc1    f1,0x0000(a0)    ; a[0] = f1
lwc1    f2,0x0004(a1)    ; f2 = b[1] (reloaded)
lwc1    f3,0x0000(a2)    ; f3 = c[0] (reloaded)
lwc1    f0,0x0000(a1)    ; f0 = b[0] (reloaded)
lwc1    f1,0x0004(a2)    ; f1 = c[1] (reloaded)
mul.s   f2,f2,f3         ; f2 = f2 * f3
mul.s   f0,f0,f1         ; f0 = f0 * f1
add.s   f0,f0,f2         ; f0 = f0 + f2
jr      ra
swc1    f0,0x0004(a0)    ; a[1] = f0
```

However, by restrict-qualifying **a** (and to help the compiler with its alias analysis, also **b** and **c**; see the next section for the explanation), the compiler is effectively informed that neither **b** nor **c** can be aliased by **a**.

```
void ComplexMult(float * restrict a, float * restrict b, float * restrict c)
{
    a[0] = b[0]*c[0] - b[1]*c[1];   // real part
    a[1] = b[0]*c[1] + b[1]*c[0];   // imaginary part
}
```

The four input values should now only have to be fetched once each. Examining the compiler output for the function confirms this.

```
ComplexMult(float *, float *, float *)
lwc1    f2,0x0004(a1)   ; f2 = b[1]
lwc1    f0,0x0004(a2)   ; f0 = c[1]
lwc1    f1,0x0000(a1)   ; f1 = b[0]
mul.s   f4,f2,f0        ; f4 = f2 * f0
lwc1    f3,0x0000(a2)   ; f3 = c[0]
mul.s   f0,f1,f0        ; f0 = f1 * f0
mul.s   f2,f2,f3        ; f2 = f2 * f3
mul.s   f1,f1,f3        ; f1 = f1 * f3
add.s   f0,f0,f2        ; f0 = f0 + f2
sub.s   f1,f1,f4        ; f1 = f1 - f4
swc1    f0,0x0004(a0)   ; a[1] = f0
jr      ra
swc1    f1,0x0000(a0)   ; a[0] = f1
```

Furthermore, this code shows how the compiler is now free to rearrange the code, interleaving the instructions for the two calculations. Because instruction results are not always immediately available due to instruction latencies, instruction reordering helps reduce latency stalls between dependent instructions.

13.6.3 Avoiding Aliasing

Because aliasing can negatively affect the performance of a program, it is worthwhile considering what code and code style changes can be made to reduce aliasing in a program. Some good guidelines follow.

- *Cache global variables and formal pointer and reference function arguments in local variables.* In C++, even class members benefit from caching into local variables because they are subject to aliasing through the **this** pointer. From an optimization standpoint, class members behave much as global variables (but with a restricted scope) and should be treated as such.

- *Do not take the address of local variables (with &) unless necessary.* If their address is never taken, no pointers can point to them and aliasing of them is therefore impossible.

- *Avoid passing small values by pointer or reference if they can be passed by value.* Small values here refer to those that comfortably fit in a machine register. In some cases it might even be preferable to pass certain structures by value (usually smaller ones, of just one or a few fields).

- *Declare pointers and references as* **restrict**. In theory it is sufficient to restrict output pointers only. In practice, because pointers can be freely assigned to other pointers through complex expressions sometimes the compiler might not be able to track the pointer and must consider it lost. In these cases the compiler has to conservatively assume that two pointers may alias the same target unless both are qualified with **restrict**. Thus, restrict-qualifying all pointers simplifies the alias analysis and is likely to give the best result. It is, however, important to do so only if there really is no aliasing possible or the compiled code will not work correctly.

- *Declare variables as close to actual use as possible (that is, as late as possible).* With less code between declaration point and use, there is less code between to cause aliasing issues and for the compiler aliasing analysis to fail on. Define new temporary variables locally instead of reusing earlier temporary variables that happen to be in scope.

- *Inline small functions, especially if they take arguments by reference.*

- *Wherever possible, manually extract common subexpressions from* if *statements and loops (including the loop condition part).* The compiler might not be able to do so, due to hidden aliasing.

- *Minimize the abstraction penalty by not over-abstracting and overly generalizing code.*

Very little easily digestable information is available on the issues of aliasing, the abstraction penalty problem, restricted pointers, and similar topics. Two notable exceptions are [Robison99] and [Mitchell00].

13.7 **Parallelism Through SIMD Optimizations**

Today virtually all CPUs have multiple processing units. Commonly a CPU contains both an arithmetical logical unit (ALU), which performs integer operations, and a floating-point unit (FPU), which performs floating-point arithmetic. These units tend to operate in parallel so that the ALU can execute integer instructions at the same time the FPU is executing floating-point instructions. Some CPUs are n-*way superscalar*, meaning that they have n parallel execution units (generally ALUs) and can start processing of up to n instructions on each cycle.

Additionally, many current microprocessor architectures offer some type of *SIMD extensions* (single instruction, multiple data) to their basic instruction set. These SIMD instructions are defined on wide registers — holding 4, 8, or even 16 scalar integer or floating-point values — performing a single operation on these values in parallel. As such, the use of SIMD instructions promises a potential 4-fold (or 8- or 16-fold) performance increase for code that can take advantage of this instruction set.

Currently available SIMD extensions include SSE and SSE2 from Intel, 3DNow! from AMD, and AltiVec from Motorola and IBM. Sony's PlayStation 2 takes parallelism to a new level by offering both multimedia extensions on its MIPS CPU core (featuring two ALUs and one FPU) and two separate vector co-processors running parallel to the main CPU, both with parallel instruction streams. Overall, the PlayStation 2 is capable of executing up to seven different instructions at the same time! New game consoles like the PlayStation 3 and the Xbox 2 will offer even more parallelism. The following will focus on the use of SIMD instructions, which can be used to optimize sequential code in two different ways.

- *Instruction-level parallelism.* Existing algorithms can be optimized by identifying similar operations and computing these in parallel. For example, the multiplications in a dot product could be computed in parallel using a single SIMD multiplication. Because there are serial aspects to most computations, some parts of a process cannot be optimized using instruction-level parallelism, such as the summation of the partial products within the dot product.

- *Data-level parallelism.* SIMD can also be used to operate on completely different data in parallel. For example, a typical use could be to compute four dot products in parallel. Data-level parallelism is the natural operating use of SIMD instructions, as the SIMD name implies.

An example of a successful application of SIMD optimization is the acceleration of ray intersections in an interactive ray-tracing application, by testing four rays in parallel against a triangle using SIMD instructions [Wald01]. To feed the test, four rays (arranged in a 2×2 cluster) are simultaneously traversed through a k-d tree. The traversal decision is also made in parallel using SIMD instructions. A subtree is visited if at least one ray intersects its defining volume. Although some overhead is caused by this traversal decision, because the 2×2 cluster of rays is highly coherent little extra work is performed in reality. However, this query clustering is not as applicable to collision detection in general, in which a group of ray queries tend to span a much wider field. For the SIMD triangle test, a 3.5 to 3.7 time speedup compared to the non-SIMD C code was reported. The clustered traversal of four rays in parallel provided an additional speedup of about 2.

Compilers in general remain rather underdeveloped in their support of SIMD instructions. The support largely consists of providing intrinsic functions (built-in functions corresponding more or less one-to-one to the assembly instructions). Effective use of SIMD instructions still largely relies on hand coding in assembly language.

To illustrate how effective the use of SIMD instructions can be in collision detection tests, the next three sections outline possible implementations of four simultaneous sphere-sphere, sphere-AABB, and AABB-AABB tests. It is here assumed the SIMD architecture can hold four (floating-point) values in the same register and operate on them simultaneously in a single instruction. SIMD intersection tests for ray-box

and ray-triangle are not given here, but outlines can be found in [Knittel00] and [Bonnedal02], respectively.

Note that data-level parallelism can be utilized even on machines lacking SIMD extensions. The **PopCount8()** function in Section 13.4.1 is an example of how to implement data parallelism within a normal register variable.

13.7.1 Four Spheres Versus Four Spheres SIMD Test

Given eight spheres S_i, $1 \leq i \leq 8$, each defined by a 4-tuple (x_i, y_i, z_i, r_i) — where (x_i, y_i, z_i) is the sphere center and r_i its radius — the four sphere-sphere tests

$$(x_i - x_j)^2 + (y_i - y_j)^2 + (z_i - z_j)^2 \leq (r_i + r_j)^2$$

with $1 \leq i \leq 4$, $j = i + 4$, can be performed in parallel using SIMD instruction as follows. First let these eight SIMD registers be defined, where the notation is such that the register symbolically called **PX** contains the four values x_1, x_2, x_3, and x_4, and similarly for the remaining seven registers:

```
PX = x1 | x2 | x3 | x4          QX = x5 | x6 | x7 | x8
PY = y1 | y2 | y3 | y4          QY = y5 | y6 | y7 | y8
PZ = z1 | z2 | z3 | z4          QZ = z5 | z6 | z7 | z8
PR = r1 | r2 | r3 | r4          QR = r5 | r6 | r7 | r8
```

The four sphere-sphere tests can then be performed in parallel by the following SIMD assembly pseudocode.

```
SUB T1,PX,QX       ; T1 = PX - QX
SUB T2,PY,QY       ; T2 = PY - QY
SUB T3,PZ,QZ       ; T3 = PZ - QZ (T1-3 is difference between sphere centers)
ADD T4,PR,QR       ; T4 = PR + QR (T4 is sum of radii)
MUL T1,T1,T1       ; T1 = T1 * T1
MUL T2,T2,T2       ; T2 = T2 * T2
MUL T3,T3,T3       ; T3 = T3 * T3 (T1-3 is squared distance between sphere centers)
MUL R2,T4,T4       ; R2 = T4 * T4 (R2 is square of sum of radii)
ADD T1,T1,T2       ; T1 = T1 + T2
SUB T2,R2,T3       ; T2 = R2 - T3
LEQ Result,T1,T2   ; Result = T1 <= T2
```

The resulting code is just 11 instructions. With an instruction throughput/latency of 1/4 cycles, the final result is obtained in 16/19 cycles, making the effective throughput of the code just four cycles for one sphere-sphere test.

13.7.2 **Four Spheres Versus Four AABBs SIMD Test**

A sphere-AABB test can be implemented in a similar manner. As before, let the four spheres be given by the 4-tuples (x_i, y_i, z_i, r_i). Let the four AABBs be given by the opposing minimum and maximum corners $(min[i]x, min[i]y, min[i]z)$ and $(max[i]x, max[i]y, max[i]z)$. By first defining the symbolic SIMD registers

```
MINX = min1x | min2x | min3x | min4x        SX = x1 | x2 | x3 | x4
MINY = min1y | min2y | min3y | min4y        SY = y1 | y2 | y3 | y4
MINZ = min1z | min2z | min3z | min4z        SZ = z1 | z2 | z3 | z4
MAXX = max1x | max2x | max3x | max4x        SR = r1 | r2 | r3 | r4
MAXY = max1y | max2y | max3y | max4y
MAXZ = max1z | max2z | max3z | max4z
```

the test is then implemented by the following pseudocode:

```
MAX TX,SX,MINX      ; TX = Max(SX,MINX)   Find point T = (TX, TY, TZ) on/in AABB, closest
MAX TY,SY,MINY      ; TY = Max(SY,MINY)   to sphere center S. Computed by clamping sphere
MAX TZ,SZ,MINZ      ; TZ = Max(SZ,MINZ)   center to AABB extents.
MIN TX,TX,MAXX      ; TX = Min(TX,MAXX)
MIN TY,TY,MAXY      ; TY = Min(TY,MAXY)
MIN TZ,TZ,MAXZ      ; TZ = Min(TZ,MAXZ)
SUB DX,SX,TX        ; DX = SX - TX        D = S - T is vector between S and clamped center T
SUB DY,SY,TY        ; DY = SY - TY
SUB DZ,SZ,TZ        ; DZ = SZ - TZ
MUL R2,SR,SR        ; R2 = SR * SR        Finally compute Result = Dot(D, D) <= SR^2,
MUL DX,DX,DX        ; DX = DX * DX        where SR is sphere radius. (To reduce the latency
MUL DY,DY,DY        ; DY = DY * DY        of having two sequential additions in the dot
MUL DZ,DZ,DZ        ; DZ = DZ * DZ        product, move DZ^2 term over to right-hand side
ADD T1,DX,DY        ; T1 = DX + DY        of comparison and subtract it off SR^2 instead.)
SUB T2,R2,DZ        ; T2 = R2 - DZ
LEQ Result,T1,T2    ; Result = T1 <= T2
```

This code is 16 instructions long and an instruction throughput/latency of 1/4 cycles gives the final result in 23/26 cycles.

13.7.3 **Four AABBs Versus Four AABBs SIMD Test**

For performing four AABB-AABB tests in parallel, let eight AABBs be given by opposing minimum and maximum corners $(min[i]x, min[i]y, min[i]z)$

and *(max[i]x, max[i]y, max[i]z)*, for $1 \le i \le 8$. Defining the symbolic SIMD registers

```
MIN1X = min1x | min2x | min3x | min4x        MIN2X = min5x | min6x | min7x | min8x
MIN1Y = min1y | min2y | min3y | min4y        MIN2Y = min5y | min6y | min7y | min8y
MIN1Z = min1z | min2z | min3z | min4z        MIN2Z = min5z | min6z | min7z | min8z
MAX1X = max1x | max2x | max3x | max4x        MAX2X = max5x | max6x | max7x | max8x
MAX1Y = max1y | max2y | max3y | max4y        MAX2Y = max5y | max6y | max7y | max8y
MAX1Z = max1z | max2z | max3z | max4z        MAX2Z = max5z | max6z | max7z | max8z
```

allows the tests to be performed by the following pseudocode.

```
MAX AX,MIN1X,MIN2X   ; AX = Max(MIN1X,MIN2X)    Compute the intersection volume of the
MIN BX,MAX1X,MAX2X   ; BX = Min(MAX1X,MAX2X)    two bounding boxes by taking the maximum
MAX AY,MIN1Y,MIN2Y   ; AY = Max(MIN1Y,MIN2Y)    value of the minimum extents and the
MIN BY,MAX1Y,MAX2Y   ; BY = Min(MAX1Y,MAX2Y)    minimum value of the maximum extents.
MAX AZ,MIN1Z,MIN2Z   ; AZ = Max(MIN1Z,MIN2Z)
MIN BZ,MAX1Z,MAX2Z   ; BZ = Min(MAX1Z,MAX2Z)
LEQ T1,AX,BX         ; T1 = AX <= BX           If the intersection volume is valid (if
LEQ T2,AY,BY         ; T2 = AY <= BY           the two AABBs are overlapping) the
LEQ T3,AZ,BZ         ; T3 = AZ <= BZ           resulting minimum extents must be smaller
AND T4,T1,T2         ; T4 = T1 && T2           than the resulting maximum extents.
AND Result,T3,T4     ; Result = T3 && T4
```

This code is 11 instructions long and an instruction throughput/latency of 1/4 cycles gives the final result in 16/19 cycles.

13.8 Branching

Branching can be a performance issue for modern CPUs. An instruction, when executed by the CPU, is not executed all at once, but rather in several stages. The reason is parallelism. To see why, consider an abstract architecture with four stages.

1. *Fetch.* During this stage, the instruction is fetched from memory.

2. *Decode.* At this point, the bits of the instruction are examined and control is routed to the place of actual execution of the instruction.

3. *Execute.* The actual operation specified by the instruction is performed.

4. *Store.* The result of the instruction is committed to a register or to memory.

Clock cycle

	1	2	3	4	5	6	7	8
Fetch	I1				I2			
Decode		I1				I2		
Execute			I1				I2	
Store				I1				I2

◄—1 instruction—►

Clock cycle

	1	2	3	4	5	6	7	8
Fetch	I1	I2	I3	I4	I5	I6	I7	I8
Decode	...	I1	I2	I3	I4	I5	I6	I7
Execute	I1	I2	I3	I4	I5	I6
Store	I1	I2	I3	I4	I5

◄4 instructions►

Figure 13.9 Nonpipelined instruction execution (top). Pipelined instruction execution (bottom).

Each stage takes one clock cycle to execute, and thus one instruction completes execution in four clock cycles. If the next instruction is started first when the previous instruction is completed, an instruction would be executed every four clock cycles. However, by having stages of execution instruction processing can be *pipelined* to have their execution overlapping. Effectively, pipelining means a new instruction is now started on every clock cycle. Figure 13.9 illustrates nonpipelined and pipelined execution of a number of instructions (I1 through I8). In the same time it takes the nonpipelined processor to execute one instruction, the pipelined processor executes four instructions.

Clearly, by breaking the instruction processing into more, smaller and faster, stages the pipelined processor will process even more instructions at a faster rate. Because of the speed increases pipelining allows, some CPUs of current PCs have pipelines consisting of upward of 20 stages.

Branches, however, pose a problem for pipelined CPU architectures. As illustrated in Figure 13.10, because the instruction (I2) following a branch (I1) is not necessarily the branch target execution of successive instructions must be stopped until the branch has been fully executed and the branch target (I3) is known. Halting execution until the branch instruction has completed causes "bubbles" of inactivity in the pipeline. As a result, pipeline throughput decreases.

To keep the pipeline going, CPUs speculatively assume a branch target (based on previous branching history at the particular branch, tracked through a branch-specific cache) and hope the branch will behave as expected. If the guess is right, everything is fine. However, if the guess is wrong the pipeline is flushed (throwing

Clock cycle	1	2	3	4	5	6	7	8
Fetch	I1	I2	—	—	I3	I4	I5	I6
Decode	...	I1				I3	I4	I5
Execute	I1				I3	I4
Store	I1				I3

Figure 13.10 Illustrating the pipeline stalls caused by cancelling the execution of instruction I2 when the branch instruction I1 is encountered.

out all speculative work) and restarted. For a pipeline with 20 stages, it will take about 20 instructions before all stages of the pipeline are filled and the pipeline is working at full capacity again.

Avoiding pipeline flushes can greatly improve performance in the worst case. The best solution is to rewrite code so as to avoid branches in the first place. Improvements can also be had by rearranging code (*if* statements and other conditionals, in particular) so that control flow becomes more predictable.

Rewriting code to avoid branches often involves using various bit-shifting "tricks" to compute and operate on Boolean values. It can also involve coercing a compiler to emit special *predicated* CPU instructions that are or are not executed depending on the status of previously computed control flags. Most modern CPUs have predicated instructions in their instruction sets. Use of predicated instructions differs from compiler to compiler, and thus examining the generated code is necessary to understand under what circumstances they are emitted.

A full treatment of the topic of branch elimination is outside the scope of this book. To provide one example of how branches can be eliminated, consider the following routine for testing if a value is one of the first five prime numbers.

```
uint32 SmallPrime(uint32 x)
 {
    if ((x == 2) || (x == 3) || (x == 5) || (x == 7) || (x == 11))
        return 1;
    return 0;
}
```

For this code, most compilers will generate code containing about five branches. For example, Microsoft Visual C for the PC compiles the function to the following assembly code.

```
00401150    mov        eax,dword ptr [esp+4]    ; fetch x
00401154    cmp        eax,2                    ; if (x == 2) goto RETURN_1
```

```
00401157    je          00401170
00401159    cmp         eax,3                       ; if (x == 3) goto RETURN_1
0040115C    je          00401170
0040115E    cmp         eax,5                       ; if (x == 5) goto RETURN_1
00401161    je          00401170
00401163    cmp         eax,7                       ; if (x == 7) goto RETURN_1
00401166    je          00401170
00401168    cmp         eax,11                      ; if (x == 11) goto RETURN_1
0040116B    je          00401170
0040116D    xor         eax,eax                     ; return 0
0040116F    ret
00401170    mov         eax,1                       ; RETURN_1: return 1
00401175    ret
```

With almost every other instruction for a branch, this code is not pipeline friendly. The branches can be removed by replacing the shortcut OR operations (||) with bitwise OR operations (|) However, the resulting compiled code becomes quite long, and thus bitwise ORs do not constitute an ideal solution. A better solution is a small bitwise lookup table held in a constant. By setting bits 2, 3, 5, 7, and 11 of this constant, the bit corresponding to **x** holds the correct return result. When coded in C/C++, the only complication is that the bit-shift operators are undefined for right-hand operands larger than the number of bits in the left-hand operand. Taking this problem into account gives the following branch-optimized code.

```
uint32 SmallPrime(uint32 x)
{
    const uint32 PRIME_BITS = (1 << 2) | (1 << 3) | (1 << 5) | (1 << 7) | (1 << 11);
    uint32 mask = (x < 32);
    return (PRIME_BITS >> x) & mask;
}
```

The new function compiles to the following.

```
00401180    mov         ecx,dword ptr [esp+4]   ; fetch x
00401184    mov         edx,8Ach                ; PRIME_BITS = ...
00401189    cmp         ecx,32                  ; x < 32
0040118C    sbb         eax,eax
0040118E    shr         edx,cl                  ; edx = PRIME_BITS >> "x"
00401190    neg         eax                     ; eax = mask
00401192    and         eax,edx
00401194    ret                                 ; return (PRIME_BITS >> x) & mask
```

Not only is this code shorter than the original routine, it is also much more pipeline friendly, having no branches. Most branches in time-critical code can be removed through various approaches, such as the one presented here.

13.9 **Summary**

A majority of the chapters in this book have talked about the efficient implementation of data structures and algorithms as they apply to collision detection (as well as many other fields). However, beyond data structures and algorithms large performance increases can be had by directly targeting and tuning for the hardware architecture of the platform for which the collision system is intended. Another way of putting it is that constant factors matter! This chapter has focused on two major performance considerations for modern architectures: memory optimization and optimizations utilizing parallelism.

Because CPUs are so much faster at processing data (and code) than data can be delivered to the CPU from main memory, small but fast cache memory units sit between the CPU and memory to help deliver frequently used data to the CPU. Properly utilizing these caches is important because there can be one to three magnitudes difference in speed between data being in cache versus not being in cache. Several ways of optimizing for both code and data cache were discussed, from rearranging code and data through using cache-aware data structures and algorithms. It was also discussed how the presence of aliasing in C and C++ code is one of the major contributors to inhibited optimizations, leaving unnecessary memory accesses in the compiled code. What can be done to reduce the presence of aliasing was also explored.

The discussion of optimizations utilizing parallelism focused on SIMD extensions. Most CPUs today feature SIMD extensions, whereby instructions can operate on 4, 8, or even 16 data items in parallel. Leveraging these instructions for, say, primitive-primitive intersection tests can result in close to 4-, 8-, or 16-fold increases in performance for such tests.

The third and last performance consideration discussed here was branching. With some CPU pipelines being over 20 stages long, mispredicted branches become very expensive. Performance-critical code should avoid branches in inner loops, which can be accomplished through various bit tricks.

References

[Abrams98] Abrams, Stephen. Wonjoon Cho. Chun-Yi Hu. Takashi Maekawa. Nicholas Patrikalakis. Evan Sherbrooke. Xiuzi Ye. "Efficient and Reliable Methods for Rounded Interval Arithmetic," MIT Design Laboratory Memorandum 97-9. 1998.

[Acton96] Acton, Forman. *Real Computing Made Real*. Princeton University Press, 1996.

[Akenine-Möller01] Akenine-Möller, Tomas. "Fast 3D Triangle-box Overlap Testing," *Journal of Graphics Tools*, vol. 6, no. 1, pp. 29–33, 2001. See also http://www.ce.chalmers.se/staff/tomasm/pubs/tribox.pdf

[Akenine-Möller02] Akenine-Möller, Tomas. Eric Haines. *Real-Time Rendering* (2d ed.) A K Peters, 2002. http://www.realtimerendering.com/

[Amanatides87] Amanatides, John. Andrew Woo. "A Fast Voxel Traversal Algorithm for Ray Tracing." *Proceedings of Eurographics 1987*, pp. 3–10, 1987. http://www.cs.yorku.ca/~amana/research/grid.pdf

[Amanatides97] Amanatides, John. Kia Choi. "Ray Tracing Triangular Meshes." *Proceedings of the Eighth Western Computer Graphics Symposium*, pp. 43–52, April 1997. http://www.cs.yorku.ca/~amana/research/mesh.pdf

[Andrew79] Andrew, Alex. "Another Efficient Algorithm for Convex Hulls in Two Dimensions." *Information Processing Letters*, vol. 9, no. 5, pp. 216–219, 1979. http://dx.doi.org/10.1016/0020-0190(79)90072-3

[Anton00] Anton, Howard. *Elementary Linear Algebra* (8th ed.). John Wiley & Sons, 2000.

[Arvo90] Arvo, James. "Transforming Axis-aligned Bounding Boxes," in Andrew Glassner (ed.), *Graphics Gems*, Academic Press, pp. 548–550, 1990. http://www.graphicsgems.org/

[Arvo91] Arvo, James (ed.). *Graphics Gems II*, Academic Press, 1991. http://www.graphicsgems.org/

[Avnaim95] Avnaim, Francis. Jean-Daniel Boissonnat. Olivier Devillers. Franco Preparata. Mariette Yvinec. "Evaluation of a New Method to Compute Signs of Determinants," *Proceedings of the Eleventh Annual Symposium on Computational Geometry*, pp. 416–417, 1995. ftp://ftp-sop.inria.fr/geometrica/publis/abdpy-enmcs-95.pdf

[Baciu99] Baciu, George. Wingo Wong. Hanqiu Sun. "RECODE: An Image-based Collision Detection Algorithm," *Journal of Visualization and Computer Animation*, vol. 10, no. 4, pp. 181–192, 1999.

[Baraff92] Baraff, David. "Dynamic Simulation of Non-penetrating Rigid Bodies," Ph.D. thesis, Technical Report 92-1275, Computer Science Department, Cornell University, 1992. http://www.pixar.com/companyinfo/research/deb/

[Barber96] Barber, C. Bradford. David Dobkin. Hannu Huhdanpaa. "The Quickhull Algorithm for Convex Hulls," *ACM Transactions on Mathematical Software*, vol. 22, no. 4, pp. 469–483, 1996.
http://www.acm.org/pubs/citations/journals/toms/1996-22-4/p469-barber/

[Barequet96] Barequet, Gill. Bernard Chazelle. Leonid Guibas. Joseph Mitchell. Ayellet Tal. "BOXTREE: A Hierarchical Representation for Surfaces in 3D," *Computer Graphics Forum*, vol. 15, no. 3, pp. 387–396, 1996.
ftp://ftp.ams.sunysb.edu/pub/geometry/boxtree.ps.gz

[Barequet97] Barequet, Gill. Subodh Kumar. "Repairing CAD Models," *Proceedings of the 8th Conference on Visualization 1997 (VIS 97)*, pp. 363–370, October 1997. ftp://ftp.cs.technion.ac.il/pub/barequet/papers/unv-vis97.ps.gz

[Barequet99] Barequet, Gill. Sariel Har-Peled. "Efficiently Approximating the Minimum-volume Bounding Box of a Point Set in Three Dimensions," *Proceedings of the Tenth Annual ACM-SIAM Symposium on Discrete Algorithms*, pp. 82–91, 1999. http://valis.cs.uiuc.edu/~sariel/research/papers/98/bbox.pdf

[Barrera03] Barrera, Tony. Anders Hast. Ewert Bengtsson. "A Fast and Simple All-integer Parametric Line," in Jeff Lander (ed.), *Graphics Programming Methods*. Charles River Media, 2003.

[Baumgart72] Baumgart, Bruce. "Winged Edge Polyhedron Representation," *Artificial Intelligence Project Memo AIM-179 (CS-TR-72-320)*, Computer Science Department, Stanford University, 1972.
ftp://reports.stanford.edu/pub/cstr/reports/cs/tr/72/320/CS-TR-72-320.pdf

[Bekker01] Bekker, Henk. Jos Roerdink. "An Efficient Algorithm to Calculate the Minkowski Sum of Convex 3D Polyhedra," in *Computational Science - ICCS 2001, Lecture Notes in Computer Science 2073*, Springer-Verlag, pp. 619–628, 2001. http://www.cs.rug.nl/~roe/publications/ccs3.ps.gz

[Belov02] Belov, Gleb. "A Modified Algorithm for Convex Decomposition of 3D Polyhedra," Technical report MATH-NM-03-2002, Institut für Numerische Mathematik, Technische Universität, Dresden. March 2002.
http://www.math.tu-dresden.de/~belov/cd3/cd3.ps

[Bentley75] Bentley, Jon. "Multidimensional Binary Search Trees Used for Associative Searching," *Communications of the ACM*, vol. 18, no. 9, pp. 509–517,

1975. `http://www.acm.org/pubs/articles/journals/cacm/1975-18-9/p509-bentley/p509-bentley.pdf`

[Berg00] de Berg, Mark. Marc van Kreveld. Mark Overmars. Otfried Schwarzkopf. *Computational Geometry* (2d ed.). Springer Verlag, 2000.

[Bergen97] van den Bergen, Gino. "Efficient Collision Detection of Complex Deformable Models Using AABB Trees," *Journal of Graphics Tools*, vol. 2, no. 4, pp. 1–14, 1997. `http://www.win.tue.nl/~gino/solid/jgt98deform.pdf`

[Bergen99] van den Bergen, Gino. "Collision Detection in Interactive 3D Computer Animation," Ph.D. thesis, Eindhoven University of Technology, Eindhoven, 1999.

[Bergen03] van den Bergen, Gino. *Collision Detection in Interactive 3D Environments*. Morgan Kaufmann Publishers, 2003.

[Bergen04] van den Bergen, Gino. "Ray Casting against General Convex Objects with Application to Continuous Collision Detection." Submitted to *Journal of Graphics Tools*, 2004. `http://www.dtecta.com/papers/jgt04raycast.pdf`

[Binstock96] Binstock, Andrew. "Hashing Rehashed," *Doctor Dobbs Journal*, April 1996.

[Bonnedal02] Bonnedal, Rasmus. Magnus Pettersson. "SIMD Accelerated Ray Tracing," Master's thesis, Department of Computer Engineering, Chalmers University of Technology, Gothenburg, 2002.

[Botkin] Botkin, Nikolai. "Randomized Algorithm for Solving Quadratic Programs." `http://citeseer.ist.psu.edu/108615.html`

[Botkin95] Botkin, Nikolai. "Randomized Algorithms for the Separation of Point Sets and for Solving Quadratic Programs," *Applied Mathematics and Optimization*, vol. 32, pp. 195–210, 1995. `http://citeseer.ist.psu.edu/87315.html`

[Boyd04] Boyd, Stephen. Lieven Vandenberghe. *Convex Optimization*. Cambridge University Press, 2004. `http://www.stanford.edu/~boyd/cvxbook.html`

[Boyles99] Boyles, Michael. Shiaofen Fang. "Slicing-based Volumetric Collision Detection," *Journal of Graphics Tools*, vol. 4, no. 4, pp. 23–32, 1999. `http://www.avl.iu.edu/~mjboyles/papers/vcd.ps`

[Capens01] Capens, Nicolas. "Smallest Enclosing Spheres," *Flipcode Code of the Day Forum*, June 29, 2001. `http://www.flipcode.com/cgi-bin/msg.cgi?showThread=COTD-SmallestEnclosingSpheres&forum=cotd&id=-1` and `ftp://ftp.flipcode.com/cotd/MiniBall.zip`

[Cardoso98] Cardoso, Jean-François. "Blind Signal Separation: Statistical Principles," *Proceedings of IEEE*, vol. 86, no. 10, pp. 2009–2025, 1998.
`http://citeseer.ist.psu.edu/cardoso98blind.html`

[Carr02] Carr, Nathan. Jesse Hall. John Hart. "The Ray Engine," *Proceedings of the ACM SIGGRAPH/EUROGRAPHICS Conference on Graphics Hardware*, pp. 37–46, 2002.
`http://graphics.cs.uiuc.edu/~jch/papers/rt2/RayEngine-gh02.pdf`

[Cazals95] Cazals, Frédéric. George Drettakis. Claude Puech. "Filtering, Clustering, and Hierarchy Construction: A New Solution for Ray Tracing Very Complex Environments," *Computer Graphics Forum (Eurographics 1995 Proceedings)*, vol. 14, no. 3, pp. 371–382, 1995.
`http://w3imagis.imag.fr/Publications/1995/CDP95/index.fr.html`

[Chien03] Chien, Yu-Ren. Jing Sin Liu. "Improvements to Ellipsoidal Fit Based Collision Detection," Technical Report TR-IIS-03-001, Institute of Information Science, Academia Sinica, Taiwan, 2003.
`http://www.iis.sinica.edu.tw/LIB/TechReport/tr2003/tr03001.pdf`

[Chilimbi99a] Chilimbi, Trishul. Mark Hill. James Larus. "Cache-conscious Structure Layout," *Proceedings of the ACM SIGPLAN 1999 Conference on Programming Language Design and Implementation (PLDI 99)*, pp. 1–12, May 1999.
`http://research.microsoft.com/~trishulc/papers/layout_distr.pdf`

[Chilimbi99b] Chilimbi, Trishul. Bob Davidson. James Larus. "Cache-conscious Structure Definition," *Proceedings of the ACM SIGPLAN 1999 Conference on Programming Language Design and Implementation (PLDI 99)*, pp. 13–24, May 1999.
`http://research.microsoft.com/~trishulc/papers/definition_distr.pdf`

[Chin92] Chin, Norman. "Partitioning a 3-D Convex Polygon with an Arbitrary Plane," in David Kirk (ed.), *Graphics Gems III*, Academic Press, pp. 219–222, 1992.
`http://www.graphicsgems.org/`

[Choi02] Choi, Yi-King. Wenping Wang. Myung-Soo Kim. "Exact Collision Detection of Two Moving Ellipsoids Under Rational Motions," Technical Report TR-2002-15, Department of Computer Science and Information Systems, Hong Kong University, 2002.
`http://www.csis.hku.hk/research/techreps/document/TR-2002-15.pdf`

[Chung96] Chung, Kelvin. Wenping Wang. "Quick Collision Detection of Polytopes in Virtual Environments," *Proceedings of the ACM Symposium on Virtual Reality Software and Technology (VRST 96)*, Mark Green (ed.), pp. 125–131, 1996.
`http://www.geocities.com/kelchung220/download/exactcol.tar.gz`

[Chung98] Chung, Adrian. "Re: OBB Trees," *comp.graphics.algorithms* usenet newsgroup article, Message-ID <6le9nu$ef9$1@magpie.doc.ic.ac.uk>, June 7, 1998.
`http://groups.google.com/groups?selm=6le9nu$ef9$1@magpie.doc.ic.ac.uk`

[Chvatal83] Chvatal, Vasek. *Linear Programming*. W. H. Freeman & Co, 1983.

[Cleary88] Cleary, John. Geoff Wyvill. "Analysis of an Algorithm for Fast Ray Tracing Using Uniform Space Subdivision," *The Visual Computer*, vol. 4, no. 2, pp. 65–83, July 1988. See also Technical report 1987-282-30, Department of Computer Science, University of Calgary. `http://pharos.cpsc.ucalgary.ca/Dienst/Repository/2.0/Body/ncstrl.ucalgary_cs/1987-282-30/pdf`

[Cohen95] Cohen, Jonathan. Ming Lin. Dinesh Manocha. Madhav Ponamgi. "I-COLLIDE: An Interactive and Exact Collision Detection System for Large-scale Environments," *Proceedings of the 1995 Symposium on Interactive 3D Graphics*, pp. 189–196, 1995. `http://www.cs.jhu.edu/~cohen/Publications/icollide.pdf`

[Coutinho01] Coutinho, Murilo. *Dynamic Simulations of Multibody Systems*, Springer-Verlag, 2001.

[Cormen01] Cormen, Thomas. Charles Leiserson. Ronald Rivest. *Introduction to Algorithms*, (2d ed.). MIT Press, 2001.

[Cromwell94] Cromwell, Robert. "Efficient Eigenvalues for Visualization," in Paul Heckbert (ed.), *Graphics Gems IV*, Academic Press, pp. 193–198, 1994. `http://www.graphicsgems.org/`

[Crosnier99] Crosnier, André. Jarek Rossignac. "Tribox Bounds for Three-dimensional Objects," *Computers & Graphics*, vol. 23, no. 3, pp. 429–437, 1999. `http://www.gvu.gatech.edu/~jarek/papers/Tribox.pdf`

[Cychosz92] Cychosz, Joseph. "Use of Residency Masks and Object Space Partitioning to Eliminate Ray-Object Intersection Calculations," in David Kirk (ed.), *Graphics Gems III*, Academic Press, pp. 284–287, 1992.

[Cychosz94] Cychosz, Joseph. Warren Waggenspack Jr. "Intersecting a Ray with a Cylinder," in Paul Heckbert (ed.), *Graphics Gems IV*, Academic Press, pp. 356–365, 1994. `http://www.graphicsgems.org/`

[Cyrus78] Cyrus, Mike. Jay Beck. "Generalized Two- and Three-dimensional Clipping," *Computers and Graphics*, vol. 3, no. 1, pp. 23–28, 1978.

[Deutsch01] Deutsch, Frank. *Best Approximation in Inner Product Spaces*. Springer-Verlag, 2001.

[Devillers02] Devillers, Olivier. Philippe Guigue. "Faster Triangle-Triangle Intersection Tests," Technical Report 4488, INRIA, June 2002. `http://www.inria.fr/rrrt/rr-4488.html`

[Dinerstein02] Dinerstein, Jonathan. Parris Egbert. "Practical Collision Detection in Rendering Hardware for Two Complex 3D Polygon Objects," *Proceedings of the 20th Eurographics UK Conference*, pp. 129–135, 2002.

[Dobkin90] Dobkin, David. David Kirkpatrick. "Determining the Separation of Preprocessed Polyhedra: A Unified Approach," *Proceedings of the 17th International Colloquium on Automata, Languages and Programming*, vol. 443 of *Lecture Notes in Computer Science*, Springer-Verlag, pp. 400–413, 1990.
http://citeseer.ist.psu.edu/58807.html

[Duff92] Duff, Tom. "Interval Arithmetic and Recursive Subdivision for Implicit Functions and Constructive Solid Geometry," *Computer Graphics (SIGGRAPH 1992 Proceedings)*, vol. 26, no. 2, pp. 131–138, July 1992.
http://doi.acm.org/10.1145/133994.134027

[Eberly00] Eberly, David. "Intersection of Cylinders," Technical Report, Magic Software, November 21, 2000.
http://www.geometrictools.com/Documentation/IntersectionOfCylinders.pdf

[Eberly01] Eberly, David. *3D Game Engine Design*. Morgan Kaufmann Publishers, 2001.

[Eberly02] Eberly, David. "Intersection of a Sphere and a Cone," Technical Report, Magic Software, March 8, 2002.
http://www.geometrictools.com/Documentation/IntersectionSphereCone.pdf

[Eberly03] Eberly, David. "Polyhedral Mass Properties (Revisited)," Technical Report, Magic Software, January 25, 2003.
http://www.geometrictools.com/Documentation/PolyhedralMassProperties.pdf

[Eberly04] Eberly, David. *Game Physics*. Morgan Kaufmann Publishers, 2004.

[Edelsbrunner87] Edelsbrunner, Herbert. *Algorithms in Combinatorial Geometry*. Springer-Verlag, 1987.

[Ehmann00] Ehmann, Stephen. Ming Lin. "SWIFT: Accelerated Proximity Queries Between Convex Polyhedra by Multi-Level Voronoi Marching," Technical Report, Department of Computer Science, University of North Carolina at Chapel Hill, 2000.
http://www.cs.unc.edu/~geom/SWIFT/EhmannLinTR00.pdf

[Erickson97] Erickson, Jeff. "Plücker Coordinates," *Ray Tracing News*, vol. 10, no. 3, December 1997.
http://www.acm.org/tog/resources/RTNews/html/rtnv10n3.html#art11

[Ericson03] Ericson, Christer. "Memory Optimization," Presentation at Game Developer's Conference, San José, CA, 2003.
http://www.gdconf.com/archives/2003/Ericson_Christer.ppt

[Erikson95] Erikson, Carl. "Error Correction of a Large Architectural Model: The Henderson County Courthouse," Technical Report TR95-013, Department of Computer Science, University of North Carolina at Chapel Hill, 1995.
http://www.cs.unc.edu/~walk/papers/eriksonc/courthouse.ps.gz

[Everitt02] Everitt, Cass. Mark Kilgard. "Practical and Robust Stenciled Shadow Volumes for Hardware-accelerated Rendering," White paper, NVIDIA Corporation, March 2002.
http://arxiv.org/ftp/cs/papers/0301/0301002.pdf

[Fischer03] Fischer, Kaspar. Bernd Gärtner. "The Smallest Enclosing Ball of Balls: Combinatorial Structure and Algorithms," *Proceedings of 19th Annual ACM Symposium on Computational Geometry (SCG)*, pp. 292–301, 2003.
http://www.inf.ethz.ch/personal/gaertner/texts/own_work/ballsofballs.pdf

[Floater04] Floater, Michael. Kai Hormann. Géza Kós. "A General Construction of Barycentric Coordinates over Convex Polygons," to appear in *Advances in Computational Mathematics*, 2004.
http://heim.ifi.uio.no/~michaelf/papers/coordinates.pdf

[Fortune93] Fortune, Steven. Christopher Van Wyk. "Efficient Exact Arithmetic for Computational Geometry," *Proceedings of the 9th ACM Symposium on Computational Geometry*, pp. 163–172, May 1993.
http://cm.bell-labs.com/cm/cs/who/sjf/eeacg.ps.gz

[Freeman75] Freeman, Herbert. Ruth Shapira. "Determining the Minimum-area Encasing Rectangle for an Arbitrarily Closed Curve," *Communications of the ACM*, vol. 18, no. 7, pp. 409–413, 1975.

[Friedman77] Friedman, Jerome. Jon Bentley. Raphael Finkel. "An Algorithm for Finding Best Matches in Logarithmic Expected Time," *ACM Transactions on Mathematical Software*, vol. 3, no. 3, pp. 209–226, September 1977.
See also ftp://reports.stanford.edu/pub/cstr/reports/cs/tr/75/482/CS-TR-75-482.pdf

[Frigo99] Frigo, Matteo. Charles Leiserson. Harald Prokop. Sridhar Ramachandran. "Cache-oblivious Algorithms," *Proceedings of the 40th Annual Symposium on Foundations of Computer Science (FOCS 99)*, pp. 285–297, October 1999. ftp://theory.lcs.mit.edu/pub/cilk/FrigoLePr99.ps.gz

[Fuchs80] Fuchs, Henry. Zvi Kedem. Bruce Naylor. "On Visible Surface Generation by a Priori Tree Structures," *Computer Graphics (SIGGRAPH 1980 Proceedings)*, vol. 14, no. 3, pp. 124–133, July 1980.
http://portal.acm.org/citation.cfm?id=807481

[Fuchs83] Fuchs, Henry. Gregory Abram. Eric Grant. "Near Real-time Shaded Display of Rigid Objects," *Computer Graphics (SIGGRAPH 1983 Proceedings)*, vol. 17, no. 3, pp. 65–72, 1983. http://portal.acm.org/citation.cfm?id=801134

[Fünfzig03] Fünfzig, Christoph. Dieter Fellner. "Easy Realignment of k-DOP Bounding Volumes," *Proceedings of Graphics Interface 2003*, pp. 257–264, 2003. http://www.graphicsinterface.org/cgi-bin/DownloadPaper?name=2003/117/paper117.pdf

[Garcia99] Garcia, Miguel Angel. Angel Domingo Sappa. Luis Basañez. "Efficient Generation of Object Hierarchies from 3D Scenes," *IEEE International Conference on Robotics and Automation*, Detroit, USA, pp. 1359–1364, May 1999. `http://www.etse.urv.es/recerca/rivi/pub/3d/icra99.pdf`

[Gärtner99] Gärtner, Bernd. "Fast and Robust Smallest Enclosing Balls," *Proceedings 7th Annual European Symposium on Algorithms (ESA99)*, Lecture Notes in Computer Science vol. 1643, Springer-Verlag, pp. 325–338, 1999. `http://www.inf.ethz.ch/personal/gaertner/texts/own_work/esa99_final.pdf`

[Gärtner00] Gärtner, Bernd. Sven Schönherr. "An Efficient, Exact, and Generic Quadratic Programming Solver for Geometric Optimization," *Proceedings 16th Annual ACM Symposium on Computational Geometry (SCG)*, pp. 110–118, 2000. `http://www2.inf.ethz.ch/~gaertner/cv/publications.html`

[Gilbert88] Gilbert, Elmer. Daniel Johnson. S. Sathiya Keerthi. "A Fast Procedure for Computing the Distance Between Complex Objects in Three-dimensional Space," *IEEE Journal of Robotics and Automation*, vol. 4, no. 2, pp. 193–203, 1988.

[Gilbert90] Gilbert, Elmer. Chek-Peng Foo. "Computing the Distance Between General Convex Objects in Three-dimensional Space," *IEEE Transactions on Robotics and Automation*, vol. 6, no. 1, pp. 53–61, 1990.

[Glassner89] Glassner, Andrew (ed.). *An Introduction to Ray Tracing*. Academic Press, 1989.

[Glassner90] Glassner, Andrew (ed.). *Graphics Gems*. Academic Press, 1990. `http://www.graphicsgems.org/`

[Goldberg91] Goldberg, David. "What Every Computer Scientist Should Know About Floating-point Arithmetic," *ACM Computing Surveys*, March 1991.

[Goldman90] Goldman, Ronald. "Intersection of Three Planes," in Andrew Glassner (ed.), *Graphics Gems*, Academic Press, p. 305, 1990.

[Goldsmith87] Goldsmith, Jeffrey. John Salmon. "Automatic Creation of Object Hierarchies for Ray Tracing," *IEEE Computer Graphics and Applications*, vol. 7, no. 5, pp. 14–20, May 1987.

[Golub96] Golub, Gene. Charles van Loan. *Matrix Computations* (3d ed.). Johns Hopkins University Press, 1996.

[Gomez99] Gomez, Miguel. "Simple Intersection Tests for Games," *Gamasutra*, October 1999. `http://www.gamasutra.com/features/19991018/Gomez_1.htm`

[Gomez01] Gomez, Miguel. "Compressed Axis-aligned Bounding Box Trees," in Mark DeLoura (ed.), *Game Programming Gems 2*. Charles River Media, pp. 388–393, 2001.

[Gottschalk96] Gottschalk, Stefan. Ming Lin. Dinesh Manocha. "OBB-Tree: A Hierarchical Structure for Rapid Interference Detection," *Computer Graphics (SIGGRAPH 1996 Proceedings)*, pp. 171–180, 1996.
http://www.cs.unc.edu/~walk/papers/gottscha/sig96.pdf

[Gottschalk00] Gottschalk, Stefan. "Collision Queries Using Oriented Bounding Boxes," Ph.D. thesis, Department of Computer Science, University of North Carolina, Chapel Hill, 2000.
http://www.cs.unc.edu/~geom/theses/gottschalk/main.pdf

[Govindaraju03] Govindaraju, Naga. Stephane Redon. Ming Lin. Dinesh Manocha. "CULLIDE: Interactive Collision Detection Between Complex Models in Large Environments Using Graphics Hardware," *Proceedings of the ACM SIGGRAPH/EUROGRAPHICS Conference on Graphics Hardware*, San Diego, CA, pp. 25–32, 2003. http://gamma.cs.unc.edu/CULLIDE/

[Green95] Green, Daniel. Don Hatch. "Fast Polygon-Cube Intersection Testing," in Alan Paeth (ed.), *Graphics Gems V*, Academic Press, pp. 375–379, 1995.
http://www.graphicsgems.org/

[Greenspan96] Greenspan, Michael. Nestor Burtnyk. "Obstacle Count Independent Real-Time Collision Avoidance." *Proceedings of the 1996 IEEE International Conference on Robotics and Automation (ICRA 96)*, pp. 1073–1080, April 1996. http://www.ece.queensu.ca/hpages/faculty/greenspan/MyWebPage/papers/grebur96.pdf

[Gu01] Gu, Hong. Thomas Chase. Douglas Cheney. Thomas Bailey. Douglas Johnson. "Identifying, Correcting, and Avoiding Errors in Computer-aided Design Models Which Affect Interoperability," *Journal of Computing and Information Science in Engineering*, vol. 1, no. 2, pp. 156–166, June 2001.
http://dx.doi.org/10.1115/1.1384887

[Guha03] Guha, Sudipto. Shankar Krishnan. Kamesh Munagala. Suresh Venkatasubramanian. "The Power of a Two-sided Depth Test and Its Application to CSG Rendering and Depth Extraction," *Proceedings of ACM Siggraph Symposium on Interactive 3D Graphics* (to appear), 2003.
http://www.research.att.com/~krishnas/MY_PAPERS/i3d03_csg.pdf

[Guibas85] Guibas, Leonidas. Jorge Stolfi. "Primitives for the Manipulation of General Subdivisions and the Computation of Voronoi Diagrams," *ACM Transactions on Graphics*, vol. 4, no. 2, pp. 74–123, April 1985.
http://doi.acm.org/10.1145/282918.282923

[Guibas99] Guibas, Leonidas. David Hsu. Li Zhang. "H-Walk: Hierarchical Distance Computation for Moving Convex Bodies," *Proceedings of the Fifteenth Annual Symposium on Computational Geometry*, pp. 265–273, 1999.
http://citeseer.ist.psu.edu/guibas99hwalk.html

[Guibas03] Guibas, Leonidas. An Nguyen. Li Zhang. "Zonotopes as Bounding Volumes." *Proceedings of 14th Annual ACM-SIAM Symposium on Discrete Algorithms*, pp. 803–812, 2003. http://graphics.stanford.edu/projects/lgl/papers/gnz-zbv-2003/gnz-zbv-2003.pdf

[Haines88] Haines, Eric. "Automatic Creation of Object Hierarchies for Ray Tracing," *Ray Tracing News*, vol. 1, no. 6, April 1988. http://www.acm.org/tog/resources/RTNews/html/rtnews3a.html#art6

[Haines91a] Haines, Eric. "Efficiency Improvements for Hierarchy Traversal in Ray Tracing." in James Arvo (ed.), *Graphics Gems II*, Academic Press, pp. 267–272, 1991.

[Haines91b] Haines, Eric. "Fast Ray-convex Polyhedron Intersection," in James Arvo (ed.), *Graphics Gems II*, Academic Press, pp. 247–250, 1991. http://www.graphicsgems.org/

[Haines94] Haines, Eric. "Point in Polygon Strategies," in Paul Heckbert (ed.), *Graphics Gems IV*, Academic Press, pp. 24–46, 1994. See also http://www.erichaines.com/ptinpoly/

[Haines99] Haines, Eric. "Quicker Grid Generation via Memory Allocation," *Ray Tracing News*, vol. 12, no. 1, June 1999. http://www.acm.org/pubs/tog/resources/RTNews/html/rtnv12n1.html#art6

[Hansen92] Hansen, Eldon. *Global Optimization Using Interval Analysis*. Marcel Dekker, 1992.

[Hashemi97] Hashemi, Amir. David Kaeli. Brad Calder. "Efficient Procedure Mapping Using Cache Line Coloring," *Proceedings of the SIGPLAN Conference on Programming Language Design and Implementation*, pp. 171–182, June 1997. http://www.cs.ucsd.edu/users/calder/papers/PLDI97-Color.pdf

[Hausner98] Hausner, Melvin. *A Vector Space Approach to Geometry*. Dover Publications, 1998.

[Havran99] Havran, Vlastimil. Filip Sixta. "Comparison of Hierarchical Grids," *Ray Tracing News*, vol. 12, no. 1, June 1999. http://www.acm.org/tog/resources/RTNews/html/rtnv12n1.html#art3

[He99] He, Taosong. "Fast Collision Detection Using QuOSPO Trees," *Proceedings of the 1999 Symposium on Interactive 3D Graphics*, pp. 55–62, 1999. http://citeseer.ist.psu.edu/262510.html

[Heckbert94] Heckbert, Paul (ed.). *Graphics Gems IV*. Academic Press, 1994. http://www.graphicsgems.org/

[Held97] Held, Martin. "ERIT: A Collection of Efficient and Reliable Intersection Tests," *Journal of Graphics Tools*, vol. 2, no. 4, pp. 25–44, 1997. http://www.cosy.sbg.ac.at/~held/papers/jgt98.ps.gz

[Held01] Held, Martin. "FIST: Fast Industrial-strength Triangulation of Polygons," *Algorithmica*, vol. 30, no. 4, pp. 563–596, August 2001.
`http://citeseer.ist.psu.edu/held00fist.html`

[Hennessy02] Hennessy, John. David Patterson. David Goldberg. *Computer Architecture: A Quantitative Approach* (3d ed.). Morgan Kaufmann Publishers, 2002.

[Hertel83] Hertel, Stefan. Kurt Mehlhorn. "Fast Triangulation of Simple Polygons," *Proceedings of the 1983 International FCT Conference on Fundamentals of Computation Theory*, pp. 207–218, 1983.

[Hickey01] Hickey, Timothy. Qun Ju. Maarten van Emden. "Interval Arithmetic: From Principles to Implementation," *Journal of the ACM*, vol. 48, no. 5, pp. 1038–1068, September 2001.
`http://csr.uvic.ca/~vanemden/Publications/hickeyJuvE.ps`

[Hill89] Hill, Mark. Alan Smith. "Evaluating Associativity in CPU Caches," *IEEE Transactions on Computers*, vol. 38, no. 12, pp. 1612–1630, December 1989.

[Hinker93] Hinker, Paul. Charles Hansen. "Geometric Optimization," *Proceedings of the 4th Conference on Visualization 1993*, pp. 189–195, October 1993.
`http://www.ccs.lanl.gov/ccs1/projects/Viz/pdfs/93-vis.pdf`

[Huang97] Huang, Chong-Wei. Tian-Yuan Shih. "On the Complexity of Point-in-Polygon Algorithms," *Computers & Geosciences*, vol. 23, no. 1, pp. 109–118, 1997.

[Hubbard95] Hubbard Philip. "Collision Detection for Interactive Graphics Applications," *IEEE Transactions on Visualization and Computer Graphics*, vol. 1, no. 3, pp. 218–230, September 1995. See also: Technical Report CS-95-08, Department of Computer Science, Brown University.
`http://www.cs.brown.edu/publications/techreports/reports/CS-95-08.html`

[idSoftware01] id Software. Quake II source code. `ftp://ftp.idsoftware.com/idstuff/source/q2source-3.21.zip`

[Imbert93] Imbert, Jean-Louis. "Fourier's Elimination: Which to Choose?" in *Principles and Practice of Constraint Programming (PPCP)*, pp. 117–129, Newport, RI, 1993.

[Intel99] Intel. "Applying Streaming SIMD Extensions to Collision Detection," Intel Application Note AP-812, January 1999.
`http://www.intel.com/cd/ids/developer/asmo-na/eng/19049.htm`

[James99] James, Adam. "Binary Space Partitioning for Accelerated Hidden Surface Removal and Rendering of Static Environments," Ph.D. thesis, University of East Anglia, August 1999.
`http://www.sys.uea.ac.uk/~aj/PHD/Postscripts/bsp.pdf`

[James00] James, Adam. Andy Day. "Conflict Neutralization on Binary Space Partitioning." *Computer Graphics Forum*, vol. 19, no. 2, pp. 153–163, June 2000. http://citeseer.ist.psu.edu/james98conflict.html

[Jenkins97] Jenkins, Robert. "Algorithm Alley," *Doctor Dobbs Journal*, September 1997. See also http://burtleburtle.net/bob/

[Jevans89] Jevans, David. Brian Wyvill. "Adaptive Voxel Subdivision for Ray Tracing." *Proceedings of Graphics Interface 1989*, pp. 164–172, 1989. http://pharos.cpsc.ucalgary.ca/Dienst/Repository/2.0/Body/ncstrl.ucalgary_cs/1988-332-44/pdf

[Jolliffe02] Jolliffe, Ian. *Principal Component Analysis* (2d ed.). Springer Verlag, 2002.

[Joshi03] Joshi, Bhautik. Sebastien Ourselin. "BSP-assisted Constrained Tetrahedralization," *Proceedings of the 12th International Meshing Roundtable*, Sandia National Laboratories, Albuquerque, NM, pp. 251–260, September 2003. http://www.imr.sandia.gov/papers/imr12/joshi03.pdf

[Joy86] Joy, Kenneth. "A Dissection of Fujimoto's Algorithm," Technical Report CSE-86-6, Department of Computer Science, University of California, Davis, September 1986.

[Kalvin96] Kalvin, Alan. Russell Taylor. "Superfaces: Polygonal Mesh Simplification with Bounded Error," *IEEE Computer Graphics and Applications*, vol. 16, no. 3, pp. 64–77, May 1996. http://csdl.computer.org/comp/mags/cg/1996/03/g3064abs.htm

[Karasick89] Karasick, Michael. "On the Representation and Manipulation of Rigid Solids," Ph.D. thesis, Department of Computer Science, Cornell University, NY, March 1989. See also Technical Report TR 89-976. http://historical.ncstrl.org/tr/ps/cornellcs/TR89-976.ps

[Kay86] Kay, Timothy. James Kajiya. "Ray Tracing Complex Scenes," *Computer Graphics (SIGGRAPH 1986 Proceedings)*, vol. 20, no. 4, pp. 269–278, 1986. http://doi.acm.org/10.1145/15922.15916

[Keil02] Keil, Mark. Jack Snoeyink. "On the Time Bound for Convex Decomposition of Simple Polygons," *International Journal of Computational Geometry and Applications*, vol. 12, no. 3, pp. 181–192, June 2002. http://www.cs.unc.edu/~snoeyink/papers/convdecomp.ps.gz

[Kirk92] Kirk, David (ed.). *Graphics Gems III*. Academic Press, 1992. http://www.graphicsgems.org/

[Klimaszewski97] Klimaszewski, Krzysztof. Thomas Sederberg. "Faster Ray Tracing Using Adaptive Grids," *IEEE Computer Graphics and Applications*, vol. 17, no. 1, pp. 42–51, January 1997.

[Klosowski98] Klosowski, James. Martin Held. Joseph Mitchell. Henry Sowizral. Karel Zikan. "Efficient Collision Detection Using Bounding Volume

Hierarchies of *k*-DOPs,"*IEEE Transactions on Visualization and Computer Graphics*, vol. 4, no. 1, pp. 21–36, 1998.
`ftp://ftp.ams.sunysb.edu/pub/geometry/cd-tvcg-97.ps.gz`

[Knittel00] Knittel, Günter. "The UltraVis System," HP Labs Tech Report HPL-2000-100, 2000.
`http://www.hpl.hp.com/techreports/2000/HPL-2000-100.pdf`

[Knott03a] Knott, David. Dinesh Pai. "CInDeR: Collision and Interference Detection in Real Time Using Graphics Hardware," *Proceedings of Graphics Interface 2003.* `http://www.graphicsinterface.org/cgi-bin/DownloadPaper?name=2003/139/paper139.pdf`

[Knott03b] Knott, David. "CInDeR: Collision and Interference Detection in Real Time Using Graphics Hardware," Master's thesis, Department of Computer Science, University of British Columbia, 2003.
`http://www.cs.ubc.ca/grads/resources/thesis/Nov03/David_Knott.pdf`

[Knuth97] Knuth, Donald. *The Art of Computer Programming, Volume 2: Seminumerical Algorithms* (3d ed.). Addison-Wesley, 1997.

[Knuth98] Knuth, Donald. *The Art of Computer Programming, Volume 3: Sorting and Searching* (2d ed.). Addison-Wesley, 1998.

[Konečný97] Konečný, Petr. Karel Zikan. "Lower Bound of Distance in 3D," *Proceedings of WSCG 1997*, vol. 3, pp. 640–649, 1997. See also Technical Report FIMU-RS-97-01, Faculty of Informatics, Masaryk University, Brno, Czech Republic. `http://ftp.fi.muni.cz/pub/reports/1997/pdf/FIMU-RS-97-01.pdf`

[Konečný98] Konečný, Petr. "Bounding Volumes in Computer Graphics," Master's thesis, Faculty of Informatics, Masaryk University, Brno, Czech Republic, 1998. `http://decibel.fi.muni.cz/HCILAB/publications/thesis.ps.gz`

[Krishnan98] Krishnan, Shankar. Amol Pattekar. Ming Lin. Dinesh Manocha. "Spherical Shell: A Higher-order Bounding Volume for Fast Proximity Queries," *Robotics: The Algorithmic Perspective: WAFR 1998*, pp. 177–190, 1998.
`http://www.research.att.com/~krishnas/MY_PAPERS/wafr98.pdf`

[Lahanas00] Lahanas, Michael. Thorsten Kemmerer. Natasa Milickovic. Kostas Karouzakis. Dimos Baltas. Nikolaos Zamboglou. "Optimized Bounding Boxes for Three-dimensional Treatment Planning in Brachytherapy," *Medical Physics*, vol. 27, no. 10, pp. 2333–2342, 2000.
`http://www.mlahanas.de/Papers/preprint/bbox.pdf`

[Laidlaw86] Laidlaw, David. William Trumbore. John Hughes. "Constructive Solid Geometry for Polyhedral Objects." *Computer Graphics (SIGGRAPH 1986 Proceedings)*, vol. 20, no. 4, pp. 161–170, 1986.
`http://doi.acm.org/10.1145/15922.15904`

[Larcombe95] Larcombe, Mikki. "Re: Arbitrary Bounding Box Intersection," *comp.graphics.algorithms* usenet newsgroup article. Message-ID <1995Oct11.130545.22985@dcs.warwick.ac.uk>, October 11, 1995.

[Larsen99] Larsen, Eric. Stefan Gottschalk. Ming Lin. Dinesh Manocha. "Fast Proximity Queries with Swept Sphere Volumes," Technical Report TR99-018, Department of Computer Science, University of North Carolina, Chapel Hill, 1999. ftp://ftp.cs.unc.edu/pub/users/manocha/PAPERS/COLLISION/ssv.pdf

[Larsen00] Larsen, Eric. Stefan Gottschalk. Ming Lin. Dinesh Manocha. "Fast Distance Queries Using Rectangular Swept Sphere Volumes," *Proceedings of IEEE International Conference on Robotics and Automation*, 2000. ftp://ftp.cs.unc.edu/pub/users/manocha/PAPERS/COLLISION/icrassv00.pdf

[Lengyel02] Lengyel, Eric. "The Mechanics of Robust Stencil Shadows," *Gamasutra*, October 2002. http://www.gamasutra.com/features/20021011/lengyel_01.htm

[Levine00] Levine, Ron. "Collisions of Moving Objects," *gdalgorithms-list* mailing list article, November 14, 2000.

[Li98] Li, Tsai-Yen. Jin-Shin Chen. "Incremental 3D Collision Detection with Hierarchical Data Structures," *Proceedings of ACM Symposium on Virtual Reality Software and Technology (VRST 98)*, pp. 139–144, November 1998. http://www3.nccu.edu.tw/~li/Publication/

[Lin91] Lin, Ming. John Canny. "A Fast Algorithm for Incremental Distance Calculation," *Proceedings of the 1991 IEEE International Conference on Robotics and Automation*, pp. 1008–1014, April 1991.

[Luebke95] Luebke, David. Chris Georges. "Portals and Mirrors: Simple, Fast Evaluation of Potentially Visible Sets," *Proceedings of the 1995 Symposium on Interactive 3D Graphics*, pp. 105–106, 1995. http://www.cs.virginia.edu/~luebke/publications/portals.html

[Luebke02] Luebke, David. Martin Reddy. Jonathan Cohen. Amitabh Varshney. Benjamin Watson. Robert Huebner. *Level of Detail for 3D Graphics*. Morgan Kaufmann Publishers, 2002.

[Lumelsky85] Lumelsky, Vladimir. "On Fast Computation of Distance Between Line Segments," *Information Processing Letters*, vol. 21, no. 2, pp. 51–61, 1985.

[MacDonald90] MacDonald, David. Kellogg Booth. "Heuristics for Ray Tracing Using Space Subdivision," *The Visual Computer*, vol. 6, no. 3, pp. 153–166, 1990.

[Mäntylä88] Mäntylä, Martti. *An Introduction to Solid Modeling*. Computer Science Press, 1988.

[McConnell93] McConnell, Steve. *Code Complete*. Microsoft Press, 1993.

[McGuire00] McGuire, Max. "Quake 2 BSP File Format," June 7, 2000. `http://www.flipcode.com/tutorials/tut_q2levels.shtml`

[Meisters75] Meisters, Gary. "Polygons Have Ears," *American Mathematical Monthly*, vol. 82, pp. 648–651, June/July 1975.

[Melax00] Melax, Stan. "Dynamic Plane Shifting BSP Traversal," *Proceedings of Graphics Interface 2000*, pp. 213–220, May 2000. `http://www.graphicsinterface.org/proceedings/2000/140/`

[Meyer02] Meyer, Mark. Haeyoung Lee. Alan Barr. Mathieu Desbrun. "Generalized Barycentric Coordinates on Irregular Polygons," *Journal of Graphics Tools*, vol. 7, no. 1, pp. 13–22, 2002. `http://www.cs.caltech.edu/~mmeyer/Publications/barycentric.pdf`

[Michelucci96] Michelucci, Dominique. "Arithmetic Issues in Geometric Computations," *Proceedings of the 2nd Real Numbers and Computers Conference*, Marseille, France, pp. 43–69. April 1996. `http://www.emse.fr/~roelens/lisse/PUBLIS/PS/1993-1996/dm-nro-1996.ps.gz`

[Miettinen02a] Miettinen, Ville. "RE: A Better Method of Removing Duplicate Vertices…," *gdalgorithms-list* mailing list article, July 3, 2002. `http://sourceforge.net/mailarchive/message.php?msg_id=1777716`

[Miettinen02b] Miettinen, Ville. "RE: Generating a (Near) Optimal OBB from a Set of Points," *gdalgorithms-list* mailing list article, December 5, 2002. `http://sourceforge.net/mailarchive/message.php?msg_id=2623767`

[Mirtich96a] Mirtich, Brian. "Fast and Accurate Computation of Polyhedral Mass Properties," *Journal of Graphics Tools*, vol. 1, no. 2, pp. 31–50, 1996. `http://citeseer.ist.psu.edu/mirtich96fast.html`

[Mirtich96b] Mirtich, Brian. "Impulse-based Dynamic Simulation of Rigid Body Systems," Ph.D. thesis, Department of Computer Science, University of California, Berkeley, 1996.

[Mirtich97] Mirtich, Brian. "Efficient Algorithms for Two-phase Collision Detection," in *Practical Motion Planning in Robotics: Current Approaches and Future Directions*, John Wiley & Sons, pp. 203–223, 1998. See also Technical Report TR97-23, Mitsubishi Electric Research Laboratories (MERL), 1997 and `http://www.merl.com/reports/TR97-23/`

[Mirtich98] Mirtich, Brian. "V-Clip: Fast and Robust Polyhedral Collision Detection," *ACM Transactions on Graphics*, vol. 17, no. 3, pp. 177–208, July 1998. See also Technical Report TR97-05, Mitsubishi Electric Research Laboratories (MERL), 1997. `http://www.merl.com/papers/docs/TR97-05.pdf`

[Mitchell90] Mitchell, Don. "Robust Ray Intersection with Interval Arithmetic," *Proceedings on Graphics Interface 1990*, Halifax, Nova Scotia, pp. 68–74, 1990. `http://www.mentallandscape.com/Papers_graphicsinterface90b.pdf`

[Mitchell00] Mitchell, Mark. "Type-based Alias Analysis," *Dr. Dobb's Journal,* October 2000.

[Möller97a] Möller, Tomas. Ben Trumbore. "Fast, Minimum-storage Ray/ Triangle Intersection," *Journal of Graphics Tools,* vol. 2, no. 1, pp. 21–28, 1997. http://www.graphics.cornell.edu/pubs/1997/MT97.html

[Möller97b] Möller, Tomas. "A Fast Triangle-Triangle Intersection Test," *Journal of Graphics Tools,* vol. 2, no. 2, pp. 25–30, 1997. http://www.ce.chalmers.se/staff/tomasm/pubs/tritri.pdf

[Moore66] Moore, Ramon. *Interval Analysis.* Prentice-Hall, 1966.

[Moore88] Moore, Matthew. Jane Wilhelms. "Collision Detection and Response for Computer Animation," *Computer Graphics (SIGGRAPH 1988 Proceedings),* vol. 22, no. 4, pp. 289–298, August 1988.

[Mortenson99] Mortenson, Michael. *Mathematics for Computer Graphics Applications* (2d ed.). Industrial Press, 1999.

[Motzkin53] Motzkin, Theodore. H. Raiffa. G. Thompson. R. Thrall. "The Double Description Method," in H. Kuhn and A. Tucker (eds.), *Contributions to the Theory of Games, Volume II, Volume 8 of Annals of Math Studies,* pp. 51–73, Princeton University Press, 1953.

[Mulmuley94] Mulmuley, Ketan. *Computational Geometry: An Introduction Through Randomized Algorithms.* Prentice-Hall, 1994.

[Murali97] Murali, T. M. Thomas Funkhouser. "Consistent Solid and Boundary Representations from Arbitrary Polygon Data," *Proceedings of the 1997 Symposium on Interactive 3D Graphics,* pp. 155–162, April 1997. http://www.cs.princeton.edu/~funk/symp97.ps.gz

[Myszkowski95] Myszkowski, Karol. Oleg Okunev. Tosiyasu Kunii. "Fast Collision Detection Between Computer Solids Using Rasterizing Graphics Hardware," *The Visual Computer,* vol. 11, no. 9, pp. 497–511, 1995. See also Technical Report 94-1-047, University of Aizu, Japan, 1995. ftp://ftp.u-aizu.ac.jp/u-aizu/doc/Tech-Report/1994/94-1-047.ps.Z

[Nagle02] Nagle, John. "Re: Collision Points with SOLID," *comp.graphics. algorithms* usenet newsgroup article, Message-ID <3C4089BC.80907@ animats.com>, January 12, 2002. http://groups.google.com/groups?selm=3C4089BC.80907%40animats.com

[Naylor93] Naylor, Bruce. "Constructing Good Partitioning Trees." *Proceedings of Graphics Interface 1993,* pp. 181–191, May 1993. http://www.graphicsinterface.org/pre1996/93-Naylor.pdf

[Nettle00] Nettle, Paul. *Generic Collision Detection for Games Using Ellipsoids,* Unpublished manuscript, 2000.
http://www.fluidstudios.com/publications.html

[Omohundro89] Omohundro, Stephen. "Five Balltree Construction Algorithms," Technical Report TR-89-063, International Computer Science Institute, Berkeley, CA, November 1989. http://www.icsi.berkeley.edu/ftp/global/pub/techreports/1989/tr-89-063.pdf

[O'Rourke85] O'Rourke, Joseph. "Finding Minimal Enclosing Boxes," *International Journal of Computer and Information Sciences,* vol. 14, no. 3, pp. 183–199, June 1985.

[O'Rourke98] O'Rourke, Joseph. *Computational Geometry in C* (2d ed.). Cambridge University Press, 1998.

[Ostgard03] Ostgard, Nathan. "Quake 3 BSP Collision Detection," March 28, 2003. http://www.nathanostgard.com/tutorials/quake3/collision/

[O'Sullivan99] O'Sullivan, Carol. John Dingliana. "*Real-time Collision Detection and Response Using Sphere-trees,*" Technical Report TCD-CS-1999-10, Computer Science Department, Trinity College, Dublin, February 1999. http://www.cs.tcd.ie/publications/tech-reports/reports.99/TCD-CS-1999-10.pdf

[Paeth95] Paeth, Alan (ed.). *Graphics Gems V.* Academic Press, 1995.
http://www.graphicsgems.org/

[Paoluzzi89] Paoluzzi, Alberto. M. Ramella. A. Santarelli. "Boolean Algebra over Linear Polyhedra," *Computer Aided Design,* vol. 21, no. 8, pp. 474–484, August 1989.

[Preparata85] Preparata, Franco. Michael Shamos. *Computational Geometry: An Introduction.* Springer-Verlag, New York, 1985.

[Priest91] Priest, Douglas. "Algorithms for Arbitrary Precision Floating-point Arithmetic," *Proceedings of the 10th Symposium on Computer Arithmetic,* pp. 132–143, Grenoble, France, June 1991.
http://www.cs.cmu.edu/~quake-papers/related/Priest.ps

[Prokop99] Prokop, Harald. "Cache-oblivious Algorithms," Master's thesis, Massachusetts Institute of Technology, Cambridge, MA, 1999.

[Puppo97] Puppo, Enrico. Roberto Scopigno. "Simplification, LOD, and Multiresolution: Principles and Applications," *Eurographics 1997 Tutorial Notes PS97 TN4,* 1997. http://www.disi.unige.it/person/PuppoE/PS/EG97-tut.ps.gz

[Purcell02] Purcell, Timothy. Ian Buck. William Mark. Pat Hanrahan. "Ray Tracing on Programmable Graphics Hardware," *ACM Transactions on Graphics*

(Proceedings of ACM SIGGRAPH 2002), vol. 21, no. 3, pp. 703–712, 2002.
http://graphics.stanford.edu/papers/rtongfx/

[Quinlan94] Quinlan, Sean. "Efficient Distance Computation Between Non-convex Objects," *Proceedings of IEEE International Conference on Robotics and Automation*, pp. 3324–3329, May 1994.
http://www.cs.bell-labs.com/who/seanq/icra94.pdf

[Redon02] Redon, Stéphane. Abderrahmane Kheddar. Sabine Coquillart. "Fast Continuous Collision Detection Between Rigid Bodies," *Computer Graphics Forum (Eurographics 2002 Proceedings)*, vol. 21, no. 3, September 2002.
http://www-rocq.inria.fr/i3d/i3d/publications/redoneg2002.pdf

[Reinhard00] Reinhard, Erik. Brian Smits. Charles Hansen. "Dynamic Acceleration Structures for Interactive Ray Tracing," *Proceedings of the Eurographics Workshop on Rendering Techniques 2000*, Brno, Czech Republic, pp. 299–306, June 2000. http://www.cs.utah.edu/~reinhard/papers/egwr2k.pdf

[Ribelles01] Ribelles, José. Paul Heckbert. Michael Garland. Tom Stahovich. Vinit Srivastava. "Finding and Removing Features from Polyhedra," *Proceedings of 2001 ASME Design Engineering Technical Conference (DETC 01)*, September 2001. http://www.uiuc.edu/ph/www/garland/papers/polyfeat.pdf

[Rimon92] Rimon, Elon. Stephen Boyd. "Efficient Distance Computation Using Best Ellipsoid Fit," *Proceedings of the 1992 IEEE International Symposium on Intelligent Control*, pp. 360–365, August 1992.
http://citeseer.ist.psu.edu/rimon92efficient.html

[Ritter90] Ritter, Jack. "An Efficient Bounding Sphere," in Andrew Glassner (ed.), *Graphics Gems*, Academic Press, pp. 301–303, 1990.
http://www.graphicsgems.org/

[Robison96a] Robison, Arch. "C++ Gets Faster for Scientific Computing," *Computers in Physics*, vol. 10, pp. 458–462, 1996.

[Robison96b] Robison, Arch. "The Abstraction Penalty for Small Objects in C++," *The Parallel Object-Oriented Methods and Applications Conference (POOMA '96)*, 1996.

[Robison99] Robison, Arch. "Restricted Pointers Are Coming," *C/C++ Users Journal*, July 1999. http://www.cuj.com/documents/s=8050/cuj9907robison/

[Rockafellar96] Rockafellar, R. Tyrell. *Convex Analysis*. Princeton University Press, 1996.

[Rogers98] Rogers, David. *Procedural Elements for Computer Graphics* (2d ed.). McGraw-Hill, 1998.

[Rossignac92] Rossignac, Jarek. Abe Megahed. Bengt-Olaf Schneider. "Interactive Inspection of Solids: Cross-sections and Interferences," *Computer Graphics (SIGGRAPH 1992 Proceedings)*, July 1992.

[Röttger02] Röttger, Stefan. Alexander Irion. Thomas Ertl. "Shadow Volumes Revisited," in Vaclav Skala (ed.), *Proceedings of Winter School of Computer Graphics (WSCG)*, pp. 373–379, 2002.
http://www.vis.uni-stuttgart.de/~roettger/data/Papers/SHADOWS.PDF

[Rundberg99] Rundberg, Peter. "An Optimized Collision Detection Algorithm," MSc thesis, Department of Computer Engineering, Chalmers University of Technology, Gothenburg, 1999.
http://www.ce.chalmers.se/staff/biff/exjobb/

[Ruspini] Ruspini, Diego. `gilbert.c`, a C Version of the Original Fortran Implementation of the GJK Algorithm.
http://realtimecollisiondetection.net/files/gilbert.c

[Salesin92] Salesin, David. Filippo Tampieri. "Grouping Nearly Coplanar Polygons into Coplanar Sets," in David Kirk (ed.), *Graphics Gems III*, Academic Press, pp. 225–230, 1992. http://www.graphicsgems.org/

[Samet90a] Samet, Hanan. *Applications of Spatial Data Structures*. Addison-Wesley, 1990.

[Samet90b] Samet, Hanan. *The Design and Analysis of Spatial Data Structures*. Addison-Wesley, 1990.

[Sauer01] Sauer, Florian. "Dealing with Memory Constraints: Bringing Dr. Jones to the Infernal Machine," Presentation at Game Developer's Conference, San José, 2001. http://www.gdconf.com/archives/2001/sauer.doc

[Sayood00] Sayood, Khalid. *Introduction to Data Compression* (2d ed.). Morgan Kaufmann Publishers, 2000.

[Schneider02] Schneider, Philip. David Eberly. *Geometric Tools for Computer Graphics*. Morgan Kaufmann Publishers, 2002.

[Schömer00] Schömer, Elmar. Jürgen Sellen. Marek Teichmann. Chee-Keng Yap. "Smallest Enclosing Cylinders," *Algorithmica*, vol. 27, no. 2, pp. 170–186, 2000. http://www.mpi-sb.mpg.de/~schoemer/publications/ALGO00.pdf

[Schorn94] Schorn, Peter. Frederick Fisher. "Testing the Convexity of a Polygon," in Paul Heckbert (ed.), *Graphics Gems IV*, Academic Press, pp. 7–15, 1994. http://www.graphicsgems.org/

[Schroeder01] Schroeder, Tim. "Collision Detection Using Ray Casting," *Game Developer*, vol. 8, no. 8, pp. 50–56, August 2001.
http://www.gdmag.com/src/aug01.zip

[Segal03] Segal, Mark. Kurt Akeley. *The OpenGL Graphics System: A Specification (Version 1.5)*, October 2003.
http://www.opengl.org/documentation/specs/version1.5/glspec15.pdf

[Seidel90] Seidel, Raimund. "Linear Programming and Convex Hulls Made Easy," *Proceedings 6th Annual ACM Conference on Computational Geometry*, pp. 211–215, Berkeley, CA, 1990.

[Shene94] Shene, Ching-Kuang. "Computing the Intersection of a Line and a Cylinder," in Paul Heckbert (ed.), *Graphics Gems IV*, Academic Press, pp. 353–355, 1994. http://www.graphicsgems.org/

[Shewchuk96a] Shewchuk, Jonathan. "Robust Adaptive Floating-point Geometric Predicates," *Proceedings of the Twelfth Annual Symposium on Computational Geometry*, pp. 141–150, 1996. http://www.cs.cmu.edu/afs/cs/project/quake/public/papers/robust-predicates.ps

[Shewchuk96b] Shewchuk, Jonathan. "Triangle: Engineering a 2D Quality Mesh Generator and Delaunay Triangulator," *First Workshop on Applied Computational Geometry*, pp. 124–133, May 1996. http://www-2.cs.cmu.edu/afs/cs/project/quake/public/papers/triangle.ps

[Shirley00] Shirley, Peter. *Realistic Ray Tracing*. A. K. Peters, 2000.

[Shoemake98] Shoemake, Ken. "Plücker Coordinate Tutorial," *Ray Tracing News*, vol. 11, no. 1, July 1998. http://www.acm.org/tog/resources/RTNews/html/rtnv11n1.html#art3

[Skiena98] Skiena, Steven. *The Algorithm Design Manual*. TELOS (Springer-Verlag), 1998.

[Snyder93] Snyder, John. Adam Woodbury. Kurt Fleischer. Bena Currin. Alan Barr. "Interval Methods for Multi-point Collisions Between Time-dependent Curved Surfaces," *Computer Graphics (SIGGRAPH 1993 Proceedings)*, pp. 321–334, 1993. http://doi.acm.org/10.1145/166117.166158

[Stepanov] Stepanov, Alexander. Stepanov Benchmark Code. http://www.physics.ohio-state.edu/~wilkins/computing/benchmark/stepanov.html

[Stewart02] Stewart, Nigel. Geoff Leach. Sabu John. "Linear-time CSG Rendering of Intersected Convex Objects," *The 10th International Conference in Central Europe on Computer Graphics, Visualization and Computer Vision 2002 (WSCG 2002)*, vol. 2, pp. 437–444. http://www.nigels.com/research/wscg2002.pdf

[StøltingBrodal01] Stølting Brodal, Gerth. Rolf Fagerberg. Riko Jacob. *Cache Oblivious Search Trees via Binary Trees of Small Height*, Technical Report BRICS RS-01-36, BRICS, University of Aarhus, Denmark, October 2001. http://www.brics.dk/~rjacob/Publications/brics-rs-01-36.ps.gz

[Stone98] Stone, James. John Porrill. *Independent Component Analysis and Projection Pursuit: A Tutorial Introduction*. Unpublished Technical Report, April 1998. ftp://ftp.shef.ac.uk/pub/misc/personal/pc1jvs/papers/ica_tutorial.ps.gz

[Sunday02] Sunday, Daniel. "Fast Polygon Area and Newell Normal Computation," *Journal of Graphics Tools*, vol. 7, no. 2, pp. 9–13, 2002.

[Sutherland74] Sutherland, Ivan. Gary Hodgman. "Reentrant Polygon Clipping," *Communications of the ACM*, vol. 17, no. 1, pp. 32–42, 1974.

[Szécsi03] Szécsi, László. "An Effective Implementation of the *k*-D Tree," in Jeff Lander (ed.), *Graphics Programming Methods*, Charles River Media, pp. 315–326, 2003.

[Tampieri92] Tampieri, Filippo. "Newell's Method for Computing the Plane Equation of a Polygon," in David Kirk (ed.), *Graphics Gems III*, Academic Press, pp. 231–232, 1992. http://www.graphicsgems.org/

[Teller92] Teller, Seth. "Visibility Computations in Densely Occluded Polyhedral Environments," Ph.D. thesis, Computer Science Division (EECS), University of California, Berkeley, 1992.
http://graphics.lcs.mit.edu/~seth/pubs/pubs.html

[Thibault87] Thibault, William. Bruce Naylor. "Set Operations on Polyhedra Using Binary Space Partitioning Trees," *Computer Graphics (SIGGRAPH 1987 Proceedings)*, vol. 21, no. 4, pp. 153–162, 1987.
http://doi.acm.org/10.1145/37401.37421

[Toussaint83] Toussaint, Godfried. "Solving Geometric Problems with the Rotating Calipers," *Proceedings of IEEE MELECON 1983*, Athens, Greece, May 1983. http://www-cgrl.cs.mcgill.ca/~godfried/publications/calipers.ps.gz

[Tzafestas96] Tzafestas, Costas. Philippe Coiffet. "Real-time Collision Detection Using Spherical Octrees: Virtual Reality Application," *Proceedings 1996 IEEE International Workshop on Robot and Human Communication (ROMAN 96)*. Tsukuba, Japan, pp. 500–506, November 1996.
http://www.softlab.ntua.gr/~ktzaf/Publications/Tzafestas_ROMAN_96.zip

[Ulrich00] Ulrich, Thatcher. "Loose Octrees," in Mark DeLoura (ed.), *Game Programming Gems*. Charles River Media, pp. 444–453, 2000.

[Veldhuizen95] Veldhuizen, Todd. "Expression Templates," *C++ Report*, vol. 7, no. 5, pp. 26–31, June 1995.
http://osl.iu.edu/~tveldhui/papers/Expression-Templates/exprtmpl.html

[Vlack01] Vlack, Kevin. Susumu Tachi. "Fast and Accurate Spatio-temporal Intersection Detection with the GJK Algorithm," *Proceedings of the International Conference on Artificial Reality and Telexistence (ICAT 01)*, pp. 79–84, 2001.
http://sklab-www.pi.titech.ac.jp/~hase/ICATPHP/upload/30_camera.pdf

[Voorhies92] Voorhies, Douglas. "Triangle-cube Intersection," in David Kirk (ed.), *Graphics Gems III*, Academic Press, pp. 236–239, 1992.
http://www.graphicsgems.org/

[Wald01] Wald, Ingo. Philipp Slusallek. Carsten Benthin. Markus Wagner. "Interactive Rendering with Coherent Ray Tracing," *Proceedings of the EUROGRAPHICS 2001*, pp. 153–164, 2001. `http://graphics.cs.uni-sb.de/Publications/2001/InteractiveRenderingWithCoherentRayTracing.pdf`

[Walker99] Walker, Robert. Jack Snoeyink. "Practical Point-in-Polygon Tests Using CSG Representations of Polygons,"Technical Report TR-99-12, Department of Computer Science, University of British Columbia, November 1999. `http://www.cs.ubc.ca/labs/imager/tr/pdf/walker.1999a.pdf`

[Walster98] Walster, William. *The Extended Real Interval System,* 1998. `http://citeseer.ist.psu.edu/walster98extended.html`

[Wang01] Wang, Wenping. Jiaye Wang. Myung-Soo Kim. "An Algebraic Condition for the Separation of Two Ellipsoids," *Computer Aided Geometric Design*, vol. 18, no. 6, pp. 531–539, July 2001. `http://3map.snu.ac.kr/mskim/ftp/ellipsoid.pdf`

[Wang02] Wang, Wenping. Yi-King Choi. Bin Chan. Myung-Soo Kim. Jiaye Wang. *Efficient Collision Detection for Moving Ellipsoids Based on Simple Algebraic Test and Separating Planes,* Technical Report TR-2002-16, Department of Computer Science and Information Systems, University of Hong Kong, 2002. `http://www.csis.hku.hk/research/techreps/document/TR-2002-16.pdf`

[Warren93] Warren, Michael. John Salmon. "A Parallel Hashed Oct-tree *N*-body Algorithm," *Proceedings of Supercomputing 1993*, pp. 12–21, 1993. `http://www.thesalmons.org/john/pubs/papers.html`

[Weghorst84] Weghorst, Hank. Gary Hooper. Donald Greenberg. "Improved Computational Methods for Ray Tracing,"*ACM Transactions on Graphics*, vol. 3, no. 1, pp. 52–69, January 1984. `http://doi.acm.org/10.1145/357332.357335`

[Weiler88] Weiler, Kevin. "The Radial Edge Structure: A Topological Representation for Non-manifold Geometric Modeling,"*Geometric Modeling for CAD Applications*, North-Holland, pp. 3–36, 1988.

[Weiler94] Weiler, Kevin. "An Incremental Angle Point in Polygon Test," in Paul Heckbert (ed.), *Graphics Gems IV*, Academic Press, pp. 16–23, 1994. `http://www.graphicsgems.org/`

[Welzl91] Welzl, Emo. "Smallest Enclosing Disks (Balls and Ellipsoids)," in Hermann Maurer (ed.), *New Results and New Trends in Computer Science*, vol. 555 of *Lecture Notes in Computer Science*, Springer-Verlag, pp. 359–370, 1991. `http://citeseer.ist.psu.edu/welzl91smallest.html`

[Wu92] Wu, Xiaolin. "A Linear-time Simple Bounding Volume Algorithm," in David Kirk (ed.), *Graphics Gems III*, Academic Press, pp. 301–306, 1992. `http://www.graphicsgems.org/`

[Xavier97] Xavier, Patrick. "Fast Swept-volume Distance for Robust Collision Detection," *Proceedings of the 1997 IEEE International Conference on Robotics and Automation*, Albuquerque, New Mexico, April 1997.

[Yong00] Lu, Yong. Rajit Gadh. "Constrained and Aggregated Half Space Volume Decomposition: Generating Cutting Patches with 'Internal' and 'External' Extending," *Proceedings of the Eighth Pacific Conference on Computer Graphics and Applications (PG 00)*, pp. 262–271, 2000.
http://csdl.computer.org/comp/proceedings/pg/2000/0868/00/08680262abs.htm

[Zachmann95] Zachmann, Gabriel. "The BoxTree: Exact and Fast Collision Detection of Arbitrary Polyhedra," *First Workshop on Simulation and Interaction in Virtual Environments (SIVE 95)*, University of Iowa, July 1995.
http://web.informatik.uni-bonn.de/II/ag-klein/people/zach/papers/

[Zachmann98] Zachmann, Gabriel. "Rapid Collision Detection by Dynamically Aligned DOP-trees," *Proceedings of IEEE Virtual Reality Annual International Symposium (VRAIS 98)*, Atlanta, Georgia, pp. 90–97, March 1998.
http://web.informatik.uni-bonn.de/II/ag-klein/people/zach/papers/

[Zachmann00] Zachmann, Gabriel. "Virtual Reality in Assembly Simulation: Collision Detection, Simulation Algorithms, and Interaction Techniques," Ph.D. thesis, Department of Computer Science, Darmstadt University of Technology, Germany, May 2000. http://web.informatik.uni-bonn.de/II/ag-klein/people/zach/papers/zachmann_diss.pdf

[Zhang95] Zhang, Lixin. Jing Xiao. "Derivation of Contact States from Geometric Models of Objects," *Proceedings of the IEEE International Conference Assembly and Task Planning*, Pittsburgh, pp. 375–380, August 1995.
http://citeseer.ist.psu.edu/395383.html

Index

About the CD-ROM

All code (fragments and pseudocode) presented in the book can be found on the accompanying CD-ROM and is subject to the License agreements below.

No additional files are on the CD-ROM. A file is provided for each chapter (except for Chapters 1 and 2, which do not contain any code), containing all code presented in that chapter.

ELSEVIER CD-ROM LICENSE AGREEMENT

BUT NOT LIMITED TO, ACTUAL, SPECIAL, INDIRECT, INCIDENTAL OR CON-SEQUENTIAL DAMAGES. IF THE FOREGOING LIMITATION IS HELD TO BE UNENFORCEABLE, OUR MAXIMUM LIABILITY TO YOU SHALL NOT EXCEED THE AMOUNT OF THE PURCHASE PRICE PAID BY YOU FOR THE SOFT-WARE PRODUCT. THE REMEDIES AVAILABLE TO YOU AGAINST US AND THE LICENSORS OF MATERIALS INCLUDED IN THE SOFTWARE PRODUCT ARE EXCLUSIVE.

If this CD-ROM Product is defective, Elsevier will replace it at no charge if the defective CD-ROM Product is returned to Elsevier within sixty (60) days (or the greatest period allowable by applicable law) from the date of shipment.

YOU UNDERSTAND THAT, EXCEPT FOR THE 60-DAY LIMITED WARRANTY RECITED ABOVE, ELSEVIER, ITS AFFILIATES, LICENSORS, SUPPLIERS AND AGENTS, MAKE NO WARRANTIES, EXPRESSED OR IMPLIED, WITH RESPECT TO THE CD-ROM PRODUCT, INCLUDING, WITHOUT LIMITATION THE PRO-PRIETARY MATERIAL, AND SPECIFICALLY DISCLAIM ANY WARRANTY OF MERCHANTABILITY OR FITNESS FOR A PARTICULAR PURPOSE.

IN NO EVENT WILL ELSEVIER, ITS AFFILIATES, LICENSORS, SUPPLIERS OR AGENTS, BE LIABLE TO YOU FOR ANY DAMAGES, INCLUDING, WITHOUT LIMITATION, ANY LOST PROFITS, LOST SAVINGS OR OTHER INCIDENTAL OR CONSEQUENTIAL DAMAGES, ARISING OUT OF YOUR USE OR INABILITY TO USE THE CD-ROM PRODUCT REGARDLESS OF WHETHER SUCH DAM-AGES ARE FORESEEABLE OR WHETHER SUCH DAMAGES ARE DEEMED TO RESULT FROM THE FAILURE OR INADEQUACY OF ANY EXCLUSIVE OR OTHER REMEDY.

Software License Agreement

This Software License Agreement is a legal agreement between the Author and any person or legal entity using or accepting any software governed by this Agreement. The software is available on the CD-ROM in the Book, *Real-Time Collision Detection*, which is published by Morgan Kaufmann Publishers. "The software" is comprised of all code (fragments and pseudocode) presented in the book. No additional files are on the CD-ROM.

By installing, copying, or otherwise using the software, you agree to be bound by the terms of this Agreement.

The parties agree as follows:

1. *Grant of License.* We grant you a nonexclusive license to use the software for any purpose, commercial or non-commercial, as long as the following credit is included identifying the original source of the software: "from *Real-Time Collision*

Detection by Christer Ericson, published by Morgan Kaufmann Publishers, © 2005 Elsevier Inc".

2. *Disclaimer of Warranty*. We make no warranties at all. The software is transferred to you on an "as is" basis. You use the software at your own peril. You assume all risk of loss for all claims or controversies, now existing or hereafter, arising out of use of the software. We shall have no liability based on a claim that your use or combination of the software with products or data not supplied by us infringes any patent, copyright, or proprietary right. All other warranties, expressed or implied, including, without limitation, any warranty of merchantability or fitness for a particular purpose are hereby excluded.

3. *Limitation of Liability*. We will have no liability for special, incidental or consequential damages even if advised of the possibility of such damages. We will not be liable for any other damages or loss in any way connected with the software.